drawing distinctions

drawing distinctions

the varieties of graphic expression

patrick maynard

CORNELL UNIVERSITY PRESS
ITHACA AND LONDON

First published 2005 by Cornell University Press
First printing, Cornell Paperbacks, 2005

Printed in the United States of America

Design by Scott Levine.

Library of Congress Cataloging-in-Publication Data

Maynard, Patrick, 1939–
 Drawing distinctions : the varieties of graphic expression /
 Patrick Maynard.
 p. cm.
 Includes bibliographical references and index.
 ISBN-13: 978-0-8104-4324-4 (cloth : alk. paper)
 ISBN-10: 0-8014-4324-5 (cloth : alk. paper)
 ISBN-13: 978-0-8104-7280-0 (pbk. : alk. paper)
 ISBN-10: 0-8104-7280-6 (pbk. : alk. paper)
 1. Drawing—Philosophy. 2. Drawing—Technique.
 I. Title.
 NC703.M33 2005
 741.2—dc22
 2005015050

Cornell University Press strives to use environmentally re-
sponsible suppliers and materials to the fullest extent pos-
sible in the publishing of its books. Such materials include
vegetable-based, low-VOC inks and acid-free papers that are
recycled, totally chlorine-free, or partly composed of non-
wood fibers. For further information, visit our website at
www.cornellpress.cornell.edu.

Cloth printing 10 9 8 7 6 5 4 3 2 1
Paperback printing 10 9 8 7 6 5 4 3 2 1

περίφρων Πηνελόπεια, Ἀρτέμιδι ικέλη
Odyssey 17, 36–37

contents

illustrations

preface

The aim of *Drawing Distinctions* is to argue the great importance of drawing and to advance our understanding of it as an autonomous activity. Systematic and fully philosophical, this book is also an effort at extended criticism, both theoretical and applied, which attempts to say how drawings are done, how they work and mean, and why they are important to us. Such a project could by no means be limited to issues of art or aesthetics; therefore, while the discussion develops steadily toward consideration of drawing as fine art, I argue the overall case in wider scope. Indeed, basic work on the many "practical" uses of drawing will prove highly relevant to understanding it as art, where graphic means are applied "at full stretch." Thus we will include systematic appreciations of the drawings of small children, engineers, and designers; diagrams in instructional manuals; depictions on Mayan pot paintings and prehistoric wall decorations, as well as those of Pompeii and the Renaissance; works by such artists as Michelangelo, Zou Fulei, and Cézanne, and cartoons by the creators of Tintin and Curious George. Cartoon connoisseurship, combined with close appreciations of medieval and modern engineering sketches, children's first efforts, route maps, and decorative patterns will prepare us for a planning sketch by Leonardo, a presentation piece by Dürer, Chinese nature paintings, and poignant drawings from Goya's personal sketch books. Close attention to these individual cases will be clearly situated in recognizable contemporary contexts of art history and criticism, cognitive and developmental psychology, philosophy, and practical drawing instructions.

Drawing itself is rarely seen as *itself* but is rather taken for granted these days. Therefore Part I of *Drawing Distinctions* begins with an argument for the practical importance of "all kinds of drawing." Today, when photography receives much public notice and theorists write of "representation," little is said directly about drawing. But drawing is far more important than photography. A modern world could not exist without drawing, since all the manufactured items of that world, including cameras, must be drawn several times before they can be made, and many could not be used without further drawings. Thus, whatever other factors are involved, the line between the modern technological world and that of traditional crafts coincides with one drawn by drafters. In support of this thesis, Part I introduces readers in a nontechnical way to the kinds, basic techniques, and uses of design and engineering drawings. This discussion inevitably leads to projective systems—notably to perspective—which are pursued, for breadth and greater interest, through historical debates about the place they played in the development of modern technologies since the Renaissance. The rest of Part I concerns the wide use of drawings today in everyday practical contexts.

From a consideration of the practical uses of drawing emerge a central thesis and a strategy: a "tool-kit" conception of the treatment of drawing, one that opposes assumptions of reductive unification, especially the most influential ones, which are associated with projective accounts of perspective. This tool-kit approach is developed throughout the book up to Part IV, where it addresses art. In assembling this kit, the expositions and arguments of Parts II, III, and IV run along a progressive line, called "the course of drawing," beginning with the child's first marks and early drawing challenges and ending with master drawings. To begin this movement, the early chapters of Part II are guided by research in the developmental psychology of children's drawing. That developmental work, like most cognitive psychological work on drawing today, follows the trends of research on visual perception and is therefore spatially based—sometimes exclusively spatial. Part II seeks to expand the usual account of space, then begins broadening drawing research beyond spatial considerations.

This widening of scope, and the need to provide a theoretical account of depictions, even for children's drawings, introduces two philosophical accounts: a presentation of Kendall Walton's theory of visual depiction and a closely linked, original, critical exposition of E. H. Gombrich's work on convincing representation, focused on his classic *Art and Illusion*. Here I present new arguments about the topics of spontaneous visual imagining and the perceptual category of depiction as a kind of artifact of visual display. Part II closes with discussions of Mayan pot painting and Italian Renaissance wall paintings in terms of the neglected but highly important topic of decorative depiction. Thereby, Part I's issues of linear perspective receive additional development, while the important theme of contour line emerges, leading into Part III.

Part III renews the "course of drawing" theme, as the practical tool-kit approach systematically develops a case for drawing's autonomy and prepares us to consider drawing as art. "Course of drawing" is understood in two ways: in historical terms, connecting to Part I's Renaissance topic, and in terms of individual drawing education and development, retrieving Part II's childhood beginnings. Both discussions are organized by a progressive treatment of specific drawing elements such as line and tone, tools for rendering spatial and other effects. Throughout we make close study of the best practical and theoretical books on drawing: Philip Rawson's *Drawing,* which provides historical and cross-cultural contexts for accounts of how drawings work, and an earlier classic, Josef Meder's *Die Handzeichnung.* I hope that readers will improve their understanding not only of drawing but of painting, photography, and cinema through this presentation, which includes attention to other standard books by drawing teachers. To carry the account further toward artistic meaning—and control the strong spatializing dispositions of even this advanced "course of drawing" account—Part III closes with a consideration of Michael Podro's "sustaining recognition" approach, illustrated by treatment of some great drawings.

The project outlined is clearly ambitious: it begins with the vital importance of design drawing, proceeds through the child's first marks to a theory of effective depiction, and then offers an account of standard devices of advanced drawing, from human prehistory and across cultures. With that basis, an important objective of Part IV is the identification and rooting out of culturally pervasive dualist conceptions of depiction: between surface and depth, medium and representation, recognition and aesthetic experience—and finally between the work and the actions and purposes of artists. Part IV concludes with the most important argument of all, a principled case for how drawing *as* depiction—not only in addition to depiction—can be creative art: that is, art replete with mental, psychological, and moral content. This is argued by close attention to works by Rembrandt and Cézanne.

This being no less than an attempt to explain how, from our first scribbles to great art, there can be different kinds of meanings in our marks, I hope to be excused from attempting surveys of views about a number of the topics included. Since we are on a long excursion, we will proceed in the company of helpful companions when we meet them, taking leave of them if that suits our purposes—when we meet others headed in our direction or when we reach the end of a line of thought. There will be long stretches where such guides are useful, others where we proceed on our own. The singularity of the journey means that it must be opportunistic, venturing toward destinations unrecognized by others, with abrupt encounters and de-

partures. Inevitably some readers will be puzzled by a direction or think they know a shorter path. Nevertheless, given recent growth of literature on topics concerning "depiction" and "visual representation" in psychology, philosophy, art history, and other fields, some review of at least the more philosophical side of that seems in order, if only for comparison with our approach to drawing, which will appear unusual, even peculiar, by refusing to be confined to those topics. Empirical vision research on drawing will only be touched on, although aspects of it will be consulted in the following chapters.

Partly to situate *Drawing Distinctions* for the reader relative to well-known works, I will shape a little history, beginning in 1960, with Gombrich's refutation, in his great *Art and Illusion,* of the old and widespread idea of depiction as the imitation of "visual appearances." Only in retrospect do the fact and manner of Gombrich's achievement appear obvious—although these are not widely understood to this day, even by his expositors, and imitation-of-appearances conceptions still recur in sophisticated forms among those in position to know better. What Gombrich compellingly demonstrated is that what he termed "convincing representation" in visual depiction is a constructive process, where—as is clear from drawing practices—the instruction to "imitate appearances" is useless. Anyone who wants to make an effective depiction, he pointed out, has a number of different jobs to do, particular effects to pull off. As children, we all encountered this, when we wanted to make a face look surprised or lovely, a box look six-sided, something appear heavy, sharp, wet, flying through the air, resting on or growing from something. Learning to pull off such effects—and they are endless—is a matter of acquiring what we are calling tool kits of devices, and there are basic, more or less universal, tools within these kits. Lest we think that complacent possession of such kits suffices, or that their jobs are automatically done with modern technologies, consider the rather comic words of Alberto Giacometti, who insisted that depicting what he saw was "the only thing worth doing," as he referred to "thirty-five years of dishonesty":

> How can I make a nose really perpendicular? The simple fact is that I don't know how to do anything. . . . When I was a young man, I thought I could do anything. And that feel-

ing lasted until I was about seventeen. . . . Then I suddenly realized that I could do nothing. . . . I started with the technique that was available . . . , which was more or less the impressionist . . . , and I worked at that until about 1925. Then suddenly . . . I found that it was impossible. So I had to start from scratch, searching. And it seemed to me that I'd made some progress, a little progress, till . . . about 1956. Since then things have been going from bad to worse.[1]

Artists, art historians, and critics hardly took note of this aspect of Gombrich's sensible arguments from practice. However, with its author's mental breadth and great labors, *Art and Illusion* took advantage of a second, independent line of evidence against the monolith of "visual appearances" and in favor of a constructive approach to understanding depiction, supplied in abundance from the vision studies of the 1950s, whose lead Gombrich explicitly followed and which was confirmed by cognitive and linguistic researchers in the ensuing decades. When psychologists began experimental inquiry into environmental perception, they had to analyze it into modules—sense systems, cues, particular effects. Much of this experimental work consisted in techniques for separating these factors, testing and comparing them, and putting them back together. As is usual in cognitive studies, the commonsense gloss on how it all works often proves a poor guide. As our visual blind spots, color and acuity differences between cone and rod vision, and many other phenomena show, it is not in the nature of cognitive processes to announce their modularity. Continuing research is making explicit what image makers had known tacitly for millennia by wit, genius, or trial and error's stumbling onto perceptual effects—consolidating them, passing them on through workshop practice, and always, as Giacometti indicated, remaining open to critical scrutiny and refashioning. In arguing all this so interestingly and effectively, Gombrich did much for the status of "effective representation" in art as well, at a time when it had sunk low in theory and practice.

Still, Gombrich may not have fully appreciated the wider implications of his insight for understanding visual representation—that is, not only for breaking up the standard monolith of an "appearance" that could be "imitated" but also for the

positive opening of a theoretical case for the autonomy of representation, even of representational arts. That is a question of what can be done with the elements of perception, once freed for representation by what we might call Gombrich's "lysis," but here perhaps he stayed too close to the cognitive studies that had helped him achieve it. It is a disappointing tendency of much of those studies even today to overlook the autonomy of representation. Having demolished one copy conception of perception, these studies would reconstruct another one for visual representation. For, all too often, the effort is made to understand pictorial representation as the reassembling of perceptual elements freed by the "lysis" in pretty much the same way that environmental perception does—then to debate how this is possible, given that, on the one hand, many of the pieces will be missing and, on the other, specifically pictorial ones appear to intrude. This way of thinking gives up what had been achieved: it shatters the monolith of "the appearances" that could be imitated, only to have representation mimic the synthesis of nonrepresentational perception out of the pieces—and therefore to find it once again deficient—in the reconstruction. The tendency of such thought is reductive, with the surprising logic that, if representation draws heavily for its materials upon environmental perception's structures and routines, then such is basically what visual representation is; hence that an understanding of visual depiction can somehow be derived from the psychology of environmental vision: a depressingly common assumption among those who now debate the derivations. That inference is a fallacy of the material cause, of the kind identified by Aristotle in the "you are what you eat" arguments of the reductionists of his own time. The case for autonomy that I argue might then be understood as one about what Aristotle called "form": that the representational practices of human beings have their own deeply rooted nature, in terms of which they actively take from environmental perception the things they need, which they recombine and use according to their own forms and purposes. A more advanced case for autonomy, leading to a case for the autonomy of the arts of visual depiction, is that in making their own syntheses such arts are free to draw in many other elements *besides* the perceptual.

The moral of this story is simple: no general theory of representation, no theory of depiction or of visual representation—thus the negative point, but where could be found a convincing, relevant account of the basic forms and functions of representation and, in particular, of visual depiction? This was a matter of a theoretical definition, one that—going back to Gombrich's book—he was not obliged to produce. His was the sufficiently daunting project of being thoughtful about what "naturalism" in visual representation is, so as to explain how this could have a history and strongly influence Western visual art forms, given their projects—or, as he liked to say, the varying "functions of the image" in different times and places. Gombrich's accomplishments there were sufficiently brilliant. Speaking of tool kits for doing jobs, what was wanting was a conceptual tool kit for thinking about representation beyond the cultural baby talk of "imitation," "illusion," "realism." These difficult theoretical questions were left to philosophers, and within a decade were taken up by Nelson Goodman.[2] Goodman's *Languages of Art* presented a nominalist, empiricist theory of representation that stressed its autonomy, as well as that of art, but it did so with a vengeance that would have delighted Oscar Wilde's idealist, aestheticist doctrine that "Life imitates Art far more than Art imitates Life."[3] Indeed Goodman so asserted the autonomy of "representational systems" as even to question the grounding of what Gombrich called "convincing representation" in the psychologists' perceptual cues and routines. Perhaps not since John Dewey's similarly surprising entry into philosophy of art had an eminent philosopher so stirred the complacent centers of philosophy to the marginalized field of aesthetics, and in time psychologists took note.[4]

Since this is not the place to assess the successes and failures of Goodman's theoretical effort, it suffices to note that his theory of depiction—like "semiotic" or referential theories generally—has seemed unsatisfactory to many, specifically regarding the beholder's perceptual experience, which needs to be shown as essential to the nature of such representations and crucial to our interest in them. It is not clear, for example, how Goodman's emphasis on "delicacy of discriminations" (reminiscent of Hume's like title) or his generally cognitivist approach might explain, say, the erotic interest of visual images as things seen.[5] Partly in response to Goodman, a number of vision-

centered approaches to pictorial depiction sprang up, leading to Richard Wollheim's remark, "Philosophical theories of representation abound"[6]—alas, not a good opening sentence for an article, as it is false in two ways. It is false because most of the slight articles to which Wollheim referred, with their meager analytic vocabularies, hardly constitute theories, false again because (for the reason already given) few of these actually concern representation. No theory of representation, no theory of pictorial representation; yet fools rush in—to what would be called in athletics a series of unforced errors. Although Goodman opened his treatise with an issue about depiction, he wisely deferred his account of pictures for more than 80 percent of his book. Unfortunately, even Wollheim, who defended a perceptual essence for pictorial depiction and its autonomy, and was highly critical of both psychological and philosophical perceptually based approaches on the issue of content, was not so prudent. Postulating a sui generis primitive form of perception, Wollheim strangely reserved the term "representation" for pictures of a certain kind: those in which, on a marked surface of which we maintain steady awareness, the peculiar spatial perceptual effect obtains of one thing seeming to be in front of or behind another.[7] The remarkable implication of this is that sculpture in the round is not representation, nor is relief work. Thus Wollheim's account excluded from representation Michelangelo's *David* but not his Sistine paintings, or Barbara Hepworth's figurative sculptures but not her drawn studies for them, and implied that Pisano's and Ghiberti's doors of the Florence Baptistery go in and out of representation, depending on the depth of the undercutting.

Regarding the crucial issue of representational content—of what can be represented, as opposed to what can represent—Wollheim, unlike other perceptualists, did face the basic problem, with a set of additional requirements: that the experience is constrained by "tallying with" the intention of the artist, that it is particularly "permeable to thought" in a way in which "seeing face to face" is not, and that imagination may add to it (223–226). But, aside from the question of whether Wollheim does capture representational content, his account of intentional meaning and hence of art, insightful as it is, seems to be added on to his account of representation rather than developed out of it, so that representation as *art* is still left in question. Worse, Wollheim's theory of pictorial depiction shares with the other visual approaches a general failing in scope, far beyond its strange isolation from sculpture. The example of sculpture might suggest masks, masks suggest dance and theater, these in turn suggest music with words, then poetry and storytelling, cinema and television (including acting, dialogue, and music along with the pictures), and so forth: in short that loose family of productions we usually call "representations" normally understood as appealing to the imagination, whatever other uses they might be put to. No general account of representation, none of pictorial representation: when alleged theories of "representation" do not notice that their accounts of paintings on theater backdrops have nothing to tell us about the props on stage or the activities of the actors, dancers, and singers in front of those depictions, something has gone seriously wrong—similarly when an account of what makes an illustration to a Dickens story a "representation" cuts that discussion off from the vivid writing on the page that closes upon it, or a cartoon drawing from its speech balloon. Thus it was left to Kendall Walton to produce an actual theory of representation and only then of visual depiction (wisely not until page 292 of *Mimesis as Make-Believe*), which put the perceptual element in the right place—at least by the time of that book's publication, just thirty years after *Art and Illusion*.

In so doing, *Mimesis* stands as one of the philosophical achievements of its time, accomplishing what many had not thought possible. Since we will be considering in detail only selected aspects of Walton's theory in the following chapters, I must explain that claim briefly. For present purposes it may be enough to say, speaking of theater, that Walton's theory performed a classic rescue.[8] It was Plato and Aristotle who brought to consciousness a set of ancient, vital human activities for serious study under the concept of mimesis. But though they had many penetrating things to say about mimesis, their worst and most careless comments proved the more influential, for this family of activities, now misnamed by the Latin *imitatio,* was placed in servile conditions for millennia—also scattered (as is usual in such stories), parts of it under grave suspicion of the Second Commandment. So, although efforts were made across the centuries to rescue and socially elevate parts of the family (usually by separating them from the rest), it was not until the eighteenth century that En-

lightenment thinkers, casting about for an idea with which to bind together a new (and itself questionable) collection, "the fine arts," recollected that ancient grouping—though still under the wrongful name "imitation," which it continued to bear even with the Enlightenment's second contribution of unifying the whole under a supposed faculty of "imagination." And although the label "imitation" in time gave way to "representation," the imitation association has proved hard to shake, despite well-meaning efforts by semiotic approaches—bringing down new indignities from modern and postmodern art movements. As indicated, it was Gombrich's great service to contend with the imitation idea for visual representations and to emphasize connections not only among all the visual arts but also with literature. Yet it was left to Walton to rescue and reunite the whole family, as autonomous and important, even under a rightful name. Still, a good ending requiring a "happy ever after," the story cannot end there. Drawing, representation, art: these are three overlapping topics, each of great significance. Although much important drawing is neither representation nor art, *Drawing Distinctions* may be understood as an extended argument about how drawing can be a representational art, not only effective representation.

This book completes a project started long ago in the Philosophy Department of Cornell University, when my director, Frank Sibley, recommended the recently published *Art and Illusion* for issues wanting philosophical reworking, then left for England. With a Woodrow Wilson Dissertation Fellowship, I began to struggle with questions unformulated by philosophers, trying to fit to Gombrich's rich perceptual account a way of thinking about representational content, which in the philosophy of the time seemed to mean something propositional. Gombrich's idea of pictorial "schemata" proving a blind alley and semiotic approaches unhelpful, I was attempting an account of content with a notion of nonreferring "representation-as" when Goodman gave a talk at Cornell, using the identical phrase. Goodman remained encouraging, but although he wrote in March 1965 that his book was not "ready to go to press for another year" and that it would be "several months yet before any of the manuscript is in usable form," his nonpropositional theory of representational content was to be unavailable for another three

years. Meanwhile I worked at an unheard-of research topic and eked out a dissertation, partly expressed in my first professional publication, which includes some of the first substantive criticisms of Goodman. One of the satisfactions of the present work was to retrieve and build on the central positive ideas regarding Gombrich in that early research.[9]

Goodman's theory eventually proved unsatisfactory, while Walton's theory continued to build through the 1970s. I slowly worked my way clear of culturally ingrained fallacies about perspective, read psychological and (with the encouragement of Aaron Sloman during a sabbatical in Sussex) artificial intelligence studies of image perception, hosted John Willats during his visit to Canada on a Commonwealth Fellowship, and from the next sabbatical began research and teaching on photography. When Walton's *Mimesis* came to completion at the end of the 1980s, I began to work out from it to address two difficult form/content issues in connection with visual art: how to articulate the perceptual reciprocity of image and medium and how to define the place of mind within representation. Within three years of the publication of *Mimesis*, I produced a paper critically reviewing work on depiction and extending Walton's theory to show, in principle, how to include artists' mental content.[10] More sustained work on that difficult topic had to await consolidation of my work on photography in the first philosophical treatise on that subject, *The Engine of Visualization*,[11] written, like the present book, under a Social Sciences and Humanities Research Council of Canada research grant, during a sabbatical leave. The present book took longer, since drawing is, as I knew from the outset, the more difficult and important topic. It also has a different organization. While *Engine* has the advantage of being the working out of a thesis that can be clearly stated in a few sentences, *Drawing Distinctions*—as just outlined—is a quest carrying us across wide fields by unaccustomed paths.

Fortunately, this book does have in common with its predecessor the advantage of relying heavily upon the work of good and generous friends who are also leading thinkers in their fields. Neither Part I nor the beginning of II would have been conceivable without the research of John Willats. Although I had cleared my head on the subject of perspective before meeting Willats, that was about all I had accomplished with regard to spatial as-

pects of drawing. Although I had collected my children's drawings, until I met Willats I had no real idea how to relate them to my work.[12] Clearly, *Drawing Distinctions* would have been impossible without Walton's theory. And at a crucial place in this book, where it turns directly toward art, I rely on two ideas of Michael Podro's: "reciprocity" and the particularly inspired "sustaining recognition." To these three friends I owe, beyond their ideas, the encouragement of friendship. Lovers of visual art may envy a November day in London I spent with John Willats at the National Portrait Gallery and with Michael Podro at the National Gallery and at an Auerbach exhibition in the Royal Academy. I am particularly indebted to two philosophical psychologists at the University of Western Ontario: Keith Humphrey, for current vision research, and J. Peter Denny, for symmetry studies and for encouragement of my beginning efforts to conceive design in anthropological terms. The perceptions and encouragement of another philosophical psychologist, Hugo du Coudray, at Portland State University, are but part of a lifetime's tutelage, since he, as my eldest brother, has, more than anyone else, shaped all my understanding. I am grateful to an eminent scholar of Chinese art, James Cahill, for encouragement and practical advice.

Last to mention here is Richard Wollheim, who by his specific acts of generosity and immediate and unfailing confidence helped sustain my work over decades. Richard would have approved of some theoretical parts of this book, other parts not, though I think of it as carrying forward his main ideas and purposes. When I first told him of the project he immediately asked whether it was to include connoisseurship; I hope that he would have accepted much of this book as an example of what he called "substantive aesthetics."[13] I had expected to see Richard at the American Society for Aesthetics meetings in San Francisco in October 2003, where I presented some of the ideas for this book, but our last discussions were to be at two conferences in the summer of 2000: "The Creation of Art," at Aarhus, and "Reconceiving Pictorial Space?" at Bielefeld. Both were gifts from the gods toward completing this project, and I am grateful to their organizers—Berys Gaut and Paisley Livingston at Aarhus, and Heiko Hecht, Robert Schwartz, and Margaret Atherton at Bielefeld—for inviting me. The long paper that the first conference prompted, and that the subsequent volume of conference papers permitted, forced an indispensable working-through of ideas central to this project. My interaction at the Bielefeld conference with outstanding psychologists and philosophers regarding pictorial perception was a unique opportunity: rich both in information about current empirical research and in its wealth of fruitful conceptions and "drawing distinctions."[14] For all our differences, I hope that the other symposiasts find the spirit of Bielefeld continued here. Such focused gatherings are ideal for stimulating interaction and productive thinking, solving problems, and reformulating research.

Late in the project, two other events proved vital. First, several funded trips to Italy confirmed my ideas about the perceptual realities of rendering space by perspective and other means, and about the centrality of the greatly neglected topic of decoration, which I have tried to bring forward in this book. A long-anticipated visit to Pompeii turned confirmation into inspiration. The latter term applies as well to an event of a different sort. It was thanks to James Cutting's Bielefeld paper, whose influence is otherwise apparent in several places in this book, that I took notice of the prehistoric drawings at Chauvet Cave, published five years earlier. To encounter the immediately comprehensible works of the skilled, practiced hands of our most distant ancestors, kept in place by limestone walls for nearly forty thousand years, was an affirmation of the efforts of *Drawing Distinctions,* which makes a sustained case for an important but neglected group of deeply human activities whose roots and meanings we may still only guess at—suggesting, perhaps, that this is indeed a work of philosophy. I could not have argued my case by putting these images before the reader were it not for the generosity of the Chauvet project's director, Jean Clottes, editor of the beautifully produced and illustrated *La Grotte Chauvet: L'Art des Origines,* from which our figures are taken, generosity that lifted my spirits and this entire project.[15]

The prominence of illustrations in this book, unusual for a philosophy book, deserves discussion. I trust that readers will immediately understand that the project of illustrating a study that claims to be about "all kinds of drawings" might be rather daunting. Probably most will not realize the editorial limitations that must be put on projects like this, or the constraints of permissions. As for the

former, I emphasize, as I did in *The Engine of Visualization,* that this is a theoretical philosophy book, not a picture book, and that no figure appears here except as evidence to support an argument. The choice of figures was made on the basis of multiple such uses. Accordingly, the reproductions do not represent the taste of the author so much as the needs of the argument and the accessibility of images. The amount of Dürers, for example, does not express my artistic preferences, and I am surprised by the absence of Matisse, with whose works I have spent countless hours. Here I note that although museum holdings became increasingly available on the web while this book was being researched and written, the present selection, like that of the previous book, was greatly assisted by the holdings of the libraries of the University of Western Ontario.

As to permissions for things chosen, the generosity of Jean Clottes, Peter Horemans at Moulinsart (for the Tintin illustration), and the Fogg Museum are, understandably, singular. Many works are unobtainably lodged in private collections (a problem for showing Cézanne, Constable, Twombly), photographers and commercial firms charge commercial fees, and the permission costs of even great museum repositories have risen steadily. I am grateful for financial assistance in this from the Academic Development Fund, Dean of Arts funds, and, most specifically, for a J. B. Smallman Publication Fund, all at the University of Western Ontario, for allowing the number and quality of attributed figures. In some cases I was obliged to render images myself, which had the good effect (near the end) of realizing the ancient motto *Nulla dies sine linea* and helping me look longer and appreciate more fully—as readers may recall for themselves from the well-grounded exercise of copying or tracing even simple patterns. Dismissive things have been written about Wollheim's practice of looking at individual paintings not for minutes but for hours on end before writing about them[16]—written probably by some who have settled for a moment before a television, rising several hours later, wondering what they had been doing—but such are merely expressions of the restiveness of a particular culture of impatience. Anyone who has copied even part of a design, in any context, knows how quickly the time goes by as one looks and looks and keeps seeing more, and drawing is an efficient way of allowing

our slower integrative perceptual processes to work.

Some of the visual limitations of *Drawing Distinctions* are owing to my individuality and failings. On the first score, my daughters were reasonable about permissions charges for their childhood drawings, which I had faithfully dated and kept. Speaking of the disciplines of sustained looking, Part III gives great emphasis to European drawings of the human figure but rather less to nature drawing. That is partly owing to our main guide in III, Rawson, but also to my regular practice of life drawing. With more words and budget, I would have included portrait, botanical, still-life, and landscape work, and also the representation of places as places. As to failings, I particularly regret the absence of work by women artists, and there is a serious weakness in my examples due to the lack of really modern drawings. I had hoped to repair both omissions somewhat by including something by Canadian-born Agnes Martin, but was concerned about doing her printing justice. In connection with the illustrations, I am grateful to Cornell University Press and my editor, Roger Haydon, for the special format provided this unusual philosophy treatise, in which so much of the argument depends on what can be seen in the marked patterns on the pages, sensitively placed by Scott E. Levine. That reflects only part of his commitment to a project involving semi-technical descriptions, expositions of theories across a range of disciplines, close description of a variety of drawing uses, art connoisseurship, and, above all, sustained philosophical argument and theory development concerning the complexities of our cognitive processes. That writing posed a challenge, and, whatever its remaining unclarities, it was greatly improved through the close, patient copyediting of John LeRoy and the direction of Ange Romeo-Hall.

Perhaps accounts of process, expressions of gratitude, and apologies are incomplete explanations without comment on the personal motives in writing another book about a philosophically nonexistent topic. I would not have written it except that drawing has been a part of my life's activity for my whole life, even when, like a musician looking wistfully at an unused instrument, I have not been able to practice it. Book writing as brain damage: the personal costs of completing such a project en-

tail a thousand mistakes and humiliations in the rest of one's life—hope being vain that, due to computing, the world might better understand what it is to have one's "hard drive" occupied for months on end. Still, the writing part of me owed it to the drawing part. Also, as an artist, from several generations of artists in different arts, I am privileged to have some way to defend an art, as art, in a mass-media age. Good drawing of any kind requires perceptual sensitivity, skill, and thus dedication. Like any meaningful activity, it entails appreciation of the richness that is always around us, open to any with the patience and discipline to perceive. From this comes satisfaction, opposite to the quick gratifications within cycles of dissatisfaction that drive a consumer marketing economy. It is predictable that such an economy would attempt, as Philip Rawson said, to "debauch" our perception of visual images through an overflow of easy imitations, so that slow and difficult—because active—processes of appreciation might fall into disuse, given that cycles of gratification presuppose real yet unrealized needs. But that this conspiracy is only partially successful is reflected in the growing popularity of museums in our time. Therefore this turns out to be a book with political implications, as is any invitation to slow down and appreciate what we already have, here both in the varied activities of drawing and in what drawings show us. We take too much for granted.

Then there is philosophy. In *Drawing Distinctions,* as in *The Engine of Visualization,* I have tried to defend philosophy out of love of it. In particular, I have attempted to show, at least in one style, how an attempt at clear, open thinking-through of important matters, not relying on jargon, rhetoric, references to fashionable authorities or personal polemics, can treat concrete matters of meaning in distinctively philosophical ways—that is, in depth with connection. Within philosophy, I have recommended to a word-bound discipline the marginalized fields of images, suggesting, for example, to philosophers of mind their loss in leaving out imagination. The reward of these efforts has been in making them near the best of my abilities; one writes the best book one can, given the conditions. In that I take my cue from the playwright, but also Stoic, David Mamet: "While you are intent on an *objective,* you do not have to compare your progress with that of your peers, you do not have to worry about a *career,* you do not have to wonder if you are doing your job, you do not have to be *reverent* to the script—you are at work."[17]

PATRICK MAYNARD

London, Ontario

drawing distinctions

part I

all kinds of drawings

introduction

PHILOSOPHY AND DRAWING

This is a book of what might be called "philosophical criticism of drawing." It is philosophy in that it seeks explicitly stated, critical, and interrelated understandings of things that matter much to us. Its procedure includes the typically philosophical activities of inventing, borrowing, clarifying, and reshaping distinctions in order to mark meaningful differences; next, of arranging these distinctions as systematically as possible while criticizing, even rejecting, a number of widely accepted conceptions and distinctions, with an effort at fairness of formulation and openly argued reasons. The purpose of the philosophy is "criticism" as understood in a nonnormative but still traditional sense of the term, which has been quietly but succinctly expressed as follows: "to promote interest and attention, and provide insight."[1] Therefore, while theoretical, the project is an effort at what Aristotle called "productive studies": never theory for its own sake, but rather for better understanding of its subject, which is at every point assumed to possess value in its own terms, greater than that of any theory of it.

"Philosophical" here needs another explanation. Although we will sometimes consult philosophers, the book does not attempt to be philosophy in at least one familiar sense, that of expositing the principles or methods of some famous philosopher or school and then arguing their application to recognized problems about drawing. There are no philosophies or major philosophers that have taken an interest in drawing; there are no recognized problems about drawing, in philosophy. Even outside philosophy, drawing, as such, may be said to be a barely existing theoretical topic, while the philosophical literature that touches on drawing as drawing is close to nil. Why then a philosophical study of it? We do not need philosophical studies of everything important, and some critics may hold that we already have too many theories of things, especially in that vaguely defined region called "aesthetics." Indeed, since there is a robust modern philosophical tradition of demolishing topics and undercutting whole theoretical enterprises, why add a fresh topic? In reply, I will be arguing several points. First, a large portion of what is written theoretically about "representation" or "painting" might as well be written about drawing—indeed, might better be, as typically that says little about color and nothing about paint. Next, a number of lively and interesting specialist topics now being advanced in separate areas of research—by psychologists, philosophers, historians, art and communication writers, and others—might benefit by being brought into closer mutual contact, placed in general view, and exposited for nonspecialist readers. For this unification the term "drawing" serves best; it is preferable, for example,

to the vagaries of such common but misleading labels as "representation," "art," "pictures," "painting," "media," and "visual thinking." To the extent that the effort of unification proves productive, the theoretical topic "drawing" has sufficient instrumental justification. Our approach will therefore be philosophical in another way, a risky way: attempting to combine the insights of special fields of study while going beyond any single field.

This might be called a philosophical "breadth requirement," but for philosophy there is always a depth requirement too. Thus the project has a second motive. If the topic "drawing" can serve existing researches, can these researches in turn serve its broader topic? To what extent might the diversity of drawing activities form a connected story, describing a field of human activity that we need to recognize, appreciate, and advance: advance, for example, through our educational programs in an increasingly technological age? Accordingly, we will be investigating in what ways there may be basic human activities of drawing, manifested in a variety of forms, from the cave walls of our Aurignacian ancestors over thirty thousand years ago to the computer screens of our time. Thus the kinds of drawing to be addressed are, in principle, all kinds. I hope to "promote interest and attention, and provide insight" regarding maps, blueprints, technical designs, visual displays of information, rough chalk drawings, children's drawings, cartoons, and works of fine art from all societies.

DRAWING AND ARTS OF DRAWING

Such an ambitious project raises questions of method and organization. Timelines are good organizers. Thus it is no wonder that one of drawing's offshoots, photography, should continue to have so many interesting historical presentations, or that the all-time best-selling book on visual art, to which I will be referring, is called a "story" of art.[2] But drawing, unlike photography or cinema, is not the technological invention of certain people at a certain time, and it has no clear path of development such as we can trace for photo imagery. The early story of drawing, unlike that of photography, can hardly be told, since drawing existed at high levels of accomplishment in a prehistory many times longer than its history and for which we have no evidence of origins. To be sure, within

historical time, drawing's development may sometimes be traced partly along technological lines, and we will take advantage of that whenever we can. Different materials and techniques matter much in drawing, as we find with the great differences between the Asian use of the brush as against the European preference for drier materials. In the West the development of graphic processes such as woodcut and engraving, of materials such as silverpoint, chalk, and graphite, and now of computers helps explain many significant differences. Still, one of the defining and attractive features of drawings among visual images is that, rather like storytelling, some of its basic techniques have changed so little since prehistory. Not only would the great bison of Chauvet Cave be immediately understood by most cultures through the millennia, so would be its techniques of production. Vasari related with skepticism Pliny's just-so story that Gyges of Lydia "once saw his shadow cast by the light of a fire and instantly drew his own outline on the wall with a piece of charcoal," adding that Pliny says that "for some time afterwards men used to compose their works using only line and without colour," and there is at least truth in the charcoal outlines of that story.[3] An important part of our research in this "course of drawing" will follow Pliny's topic of graphic outlines, but neither the history of lines nor that of the implements for making them provides sufficient basis for the inquiries we must make, if we are to understand not only the means but the meanings for which they are used. And, for philosophers, meaning matters most.

Speaking of meanings, for practical purposes of organization we will take as our goal an account of drawing not only as art but as a *fine art*, on the clear understanding that neither the account nor the examples supplied will be limited to art. The advantage of this approach is that drawing as art will be understood rather as poetry has, in being called "language at full stretch": that is, as a rich development of the resources of all kinds of drawing, extended for further meaning. Such a conception of art—as inclusive rather than remote—should keep our general account of drawing from being too narrowly channeled. Our conception of art will be one accepted by many modern artists, as well stated by Saul Steinberg. "The whole history of art influenced me," he remarked. "Egyptian paintings, latrine drawings, primitive and insane art, Seurat, children's drawings, embroidery, Paul Klee."[4] But

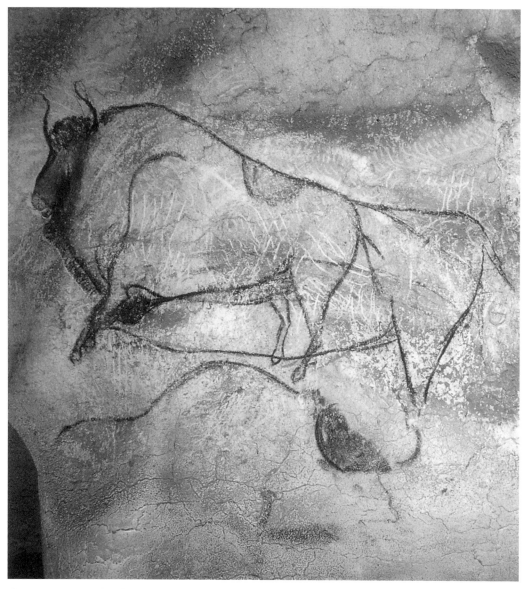

Fig. 1. Great Bison Panel, End Chamber, Chauvet Cave. From Jean Clottes, ed., *Chauvet Cave: The Art of Earliest Times* (Salt Lake City: University of Utah Press, 2003), by kind permission of Jean Clottes.

such an approach might appear to produce an opposite problem. It may seem to express too relaxed a conception of art, on which "art" is equal to the broad topic of drawing itself, rather than serving as a goal to guide our studies of drawing generally. To make matters worse, despite continual changes in the English language, we are hampered by a tendency of the word "art" to carry the connotation of visual art. That appears to be one of those historical accidents that nobody gets round to fixing, like

the "qwerty" typing keyboard (designed to slow down nineteenth-century stenographers but still used today on computers), 35 mm still-camera film (since its inventor had a stock of 35 mm cinema film), and the term "audience" to include people who read novels or look at movies, paintings, and dance. Worse, we witness a near equivalence of meaning, where not only does "art" connote the visual but the converse is also at play. Thus the office in any business where they make pictures or

Steinberg considering many kinds of drawings (also such things as writing fonts, car designs, buildings, appliances, hairstyles, etc.) through his art, that is, through a distinctive (whimsical) artistic visual sensibility, which he invites us to share (fig. 2). That kind of inclusiveness of materials, transformed by a temperament, is what we generally expect of art of all kinds, and part of our task will be to see how this is possible for drawing. Thus I propose for a theory of drawing a somewhat similar procedure to the artist's. Working our way toward better appreciation of drawing as an art should then help us organize a much broader investigation of drawing.

This raises another problem about method. If our procedure is to work steadily in the direction of drawing as fine art, rather than (as we so often find) beginning from examples of such art, where shall we begin? One attractive possibility is to begin at the beginning—not the beginning in prehistory, which is already wonderful art, but with our personal beginnings as children. That will be our main procedure in Part II, where we open with children's drawings. From there it will be the ambitious project of this book to investigate "the course of drawing," from the first marks children make to the greatest graphic arts of different cultures. However, although few of those few who continue to draw after childhood wind up as artists, as the next chapter argues, the work the rest of them do is of enormous importance to everyone else, work that requires consideration in anything that could be called a theory of drawing, or of drawing as art. Rather than starting with the first marks and then splitting the accounts between "practical" and artistic developments of the course of drawing, we will begin with a case for the importance of drawing's more practical developments, after which we can set out along a single, longer path toward art. The advantages of this policy will become clearer as we proceed.

Fig. 2. Saul Steinberg, "Self-Portrait," 1946. © The Saul Steinberg Foundation / ARS, New York / SODRAC, Montreal.

other visual displays tends to be called "the art department." Such relaxed general usage shows up in research circles as well, where anything having to do with making "pictures" is likely to be titled "art." All that makes it unclear to some what is meant by art as a culmination of various activities of drawing.

Perhaps there is an answer in the likely meaning of Steinberg's remark. Steinberg's idea is not that all kinds of drawing are art. Rather, he looks at it all in a certain way, that is, as an artist, borrowing whatever may be of use to his own drawings—there being, after all, an old saying among visual artists: Use your eyes, plagiarize. Thus we find

1. picture of a drawn world

If you invite people today to name the most important kinds of images produced by the modern world, you can expect mention of some sort of photographic image, most likely still photography (possibly advertising or journalistic) or moving photography—that is, films or television. Ask them to exclude photo images of any kind, and it is likely that they will next suggest some kind of painting or work of art. It requires not deep research but only a moment's thought to see that these answers are wrong. By far the most important modern kinds of images would be drawings, and not artistic ones but technical and design drawings. Without such drawings it is hard to see how there could *be* a modern world. For there would be neither the kinds of technological thinking nor the kinds of manufacture that make industrial and postindustrial societies possible, nor their use and maintenance. Design, manufacture, use: this bold claim has three parts, each of which could introduce interesting histories, told by experts. Although members of the trio of topics are not entirely distinct, let us consider each briefly in turn, beginning with what we would assume to be the most "creative" part, *design,* with that word's main denotations in our time: engineering design, architectural design, and design of manufactured articles of everyday use.[1]

It requires no expertise to notice, first, that the broad range of complexity and precision that char-

acterizes many modern designs, whether these be implements for household, basic industrial, or high-tech use, requires thinking and communication impossible without suitably complex and precise drawing methods, realized directly by human agencies or their mechanical aids and computers. It is not just that the plans for modern machines, buildings, structures, and so forth are too complex to be carried in detail in anyone's head; such plans, even in the head, are likely to exist there in terms of drawings. Modern designers not only think with drawings, they have usually think *in* them. As the engineering historian Eugene Ferguson writes, "It has been nonverbal thinking, by and large, that has fixed the outlines and filled in the details of our material surroundings"—and not just any kind of nonverbal thinking, for, as Ferguson argues, during the last five hundred years this thinking has been done, and communicated, through drawings of particular kinds.[2]

THE MODERN WORLD: DRAWING THE LINE

In that bold claim we must be wary of ambiguity. If we say that modern times can be characterized as those in which anything that gets made must be drawn first, we clearly intend manufactured items: furniture, telephones, generators, computers, cars, airplanes, highways, cardboard boxes, nuts and

bolts. But do we also mean that the drawings themselves are of a different, modern kind—that is, that new techniques of drawing had to be invented in order to invent all those other things? The answer to that is pretty clearly affirmative: modern engineering drawing is a distinctively modern invention. Indeed, in *The Maze of Ingenuity* the technological historian Arnold Pacey addressed what he terms "the gradual emergence of the discipline of technology from the state where simple drawing techniques were being used in 13th-century architecture, to the point where sophisticated mathematical and experimental procedures were being developed in many branches of engineering around 1800."[3] But, significantly for our purposes, Pacey is among the few who *identify* that emergence by the drawings: "One way of judging when, in history, the discipline of technology evolved from the various branches of craftsmanship which preceded it would be to study the varying extent to which technical drawings were used at different dates. In contrast to the craftsman, the practitioner of fully-developed technology does all his work on paper, and uses scientific data to calculate the performance of his constructions before they are built." So we have two modern technological questions, one about the extent to which drawings are used in making new kinds of things, and another about the new kinds of drawing.

The next chapter will consider one current answer to the latter question, a quite dramatic one: that with the development of Western "naturalism"—or, more probably, with a new conception of space—modern design drawing partakes of a sudden, radical shift due to the invention of Renaissance "linear" *perspective*. As we shall be seeing in detail, this shift is widely supposed to constitute a thoroughgoing reconception or redefinition of drawing, and even of pictorial representation itself. However misleading the more general views are, it is impossible to ignore them and the reasons for holding them. That alone would be reason to begin with an account of linear perspective in preparation for a general theory of drawing, for, so powerful is perspective's grip on common and expert conceptions alike, to ignore it would be to twist out of shape our understanding of any aspect of drawing we cared to treat, whether that of design, planning and instruction, children's free inventions, entertainment, decoration, or fine art. And even with this early treatment, so great is the influence

of these conceptions that we will have to rework the topic of perspective with each drawing subtopic that we encounter. Theory turns to therapy.

Before considering these matters, even only as they pertain to the restricted topics of practical design and manufacture, a few simple qualifications are in order. First, if some methods of design drawing turn out to be distinctively modern, this does not mean that all are. We need to keep in mind the great importance to the modern world of drawings that involve no particularly new ways or skills of drawing. To take a seemingly simple example of Ferguson's, consider the mere line of an engineering "performance curve" for some kind of material, situation, or structure (fig. 3). Though visually unimpressive, such a performance curve could well serve as a frontispiece to a study of the technological differences between what we call "the modern world" and the one in the West that preceded it. What this kind of drawing shows is neither a thing—a "substance"—nor a mechanism, nor a moment in time, but rather the relationship of quantified, variable characteristics. It is "the trace of a mathematical relationship between properties of a body, a device, or a system":[4] properties such as stress, strain, pressure, volume, temperature, whether made by hand or mechanically. Modern engineers, as opposed to traditional craft workers, have to learn to visualize materials and systems this way. Still, although it is a new kind of drawing, this diagram can hardly be said to involve any new drawing system, and the same holds for other kinds diagrams essential to modern technology and other kinds of design, for example, circuit and wiring diagrams—and we might say, "No circuit diagrams, no modern age" (fig. 4). Though it may not appear that such diagrams involve any kind of *drawing* that was not done for millennia, the meanings of such drawings are significantly different. Thus, even where new graphic systems are entailed by new ways of drawing, we should be careful not to take too boldly the already bold claim that the modern world depends on kinds of drawing. What follows are further important qualifications of the claim.

First, we must admit how little we know about the part that drawing, including design drawing, played in preindustrial times and places, where a multitude of impressive structures, intricate or massive, were planned and made, some fraction of which survive to impress and inspire future gener-

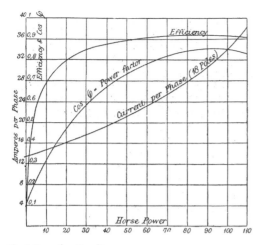

Fig. 3. Curve function diagram.

ations. Few records remain of the designs for the fine handicrafts, clothing, tools, ships, buildings, and other artifacts of the historical world. Although ancient authors say little about them and few traces of their planning remain, the great pyramids, aqueducts, and similar structures did not arise on their sites, the way roads sometimes simply developed along paths or tracks without graphic planning. Nor did the stone cutters of old hand up rough approximations for the masons to fit into great arches. A few ancient inscriptions survive: a ziggurat plan from Ur, four thousand years ago (fig. 5), and in Europe a few medieval sheets, such as the thirteenth-century drawings of Rheims Cathedral by Villard de Honnecourt, which pro-

vide us with glimpses of that still essential technique of plan and elevation drawing in architecture, the use of set squares and compasses in design and execution (fig. 6). Let us call again on an expert witness, Pacey:

Architects made relatively few drawings on paper or parchment, and these were not to scale. Sometimes, though, they sketched out ideas on the walls of the building they were erecting. . . . To a large extent . . . the designer of a building worked out details of the plan in the process of surveying and setting it out on site, no doubt with much repetition and correction. Details of piers, arches, and windows were regularly drawn out full size on large, carefully smoothed "tracing floors." . . . Two have survived in England, at Wells and York. In each case, the floor surface is of plaster of paris, and is covered with lightly inscribed lines, which are the superimposed remains of many drawings. . . . No modern draughtsman would need his compasses so frequently, . . . clear evidence that Euclidean geometry rather than measurement was the basis of drawing. The smaller drawing instruments of the time included set-squares as well as compasses for drawing out patterns and templates that masons could employ to check the shape of stones they were cutting, a well as being used on the tracing floor.[5]

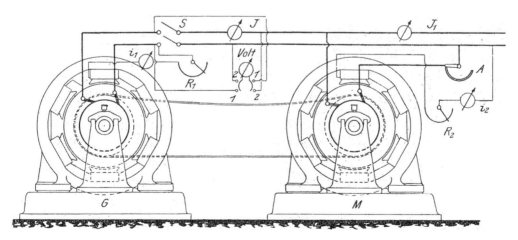

Fig. 4. Circuit-wiring diagram. From Rudolf Krause, *Messungen an Elektrischen Maschinen* (Berlin: J. Springer, 1903). Digitized by Robert Binkley.

In a mid-sixteenth-century engraving by Giulio di Antonio Bonasone, Socrates, the "happy artisan," plans a stone relief with a stylus, compass, and set-square. However accurate that portrayal, there is evidence that in classical times the drawings from which fluted temple columns were made were incised on the stone floors directly on site and later polished away, and this may have been the procedure for many cultures. Besides such broad planning, drawing also occurs in the artisanal work of many cultures. On all scales of work, artisans of the past, just as today, have marked directly (often by tracing) on and off their materials—stone, hides, cloth, wood, metals—before cutting, bending, or folding them, often in ways that we would naturally call drawing. This kind of drawing involves the activities of not only calculation and measurement but also, as Pacey notes, of adjustment, reconsideration, and preplanning, which characterize technological, architectural, and other kinds of designing. These reminders of facts about craft work, besides broadening our design drawing considerations to include many who are not architects, also introduce several themes important for our later considerations of drawing.

For example, it is important to remember, when considering drawing as art, that many important activities of drawing do not result in separable entities called "drawings." As Pacey indicates, the activity of drawing often takes place in the process of making things, and it sometimes entails making marks on the worked materials, which disappear with other parts of the process in the finished work. As the technological drawing historian P. J. Booker writes, such drawings "have been neglected in modern times because, in studying drawing, there is a tendency to concentrate upon what is marked on pieces of paper, and to forget that much of what today we would call detail drawing was marked on the actual stone or wood in the past instead of on paper."[6] For this Booker introduces the useful expression "constructional drawing" with a telling example. Consider the different drawings you might make *of* a cone (say, a simple circle or triangle) from the (fan-shaped) drawing you would make, directly on a piece of paper or metal, if you planned to cut and fold it into a cone of that height and slope; also consider the constructive

calculation involved in the latter (48). Consider also the different things you would likely *do* to make these drawings. Similarly, we might contrast the drawing on the package containing a dress pattern with the drawing inside it, and a multitude of other examples may come to mind. Easy observations these, no sooner remarked than recognized: they are emphasized here not simply because they are normally overlooked truths in accounts of drawing.

The philosophical point is that the neglect Booker notes deprives us of connections that we need in order to articulate, in criticism and theory, our experience of more "replete" drawings, notably those we consider as works of art. For example, that "constructional" detail drawings and other kinds of design drawings should disappear into their products does not mean that they perish there; we will later consider how they may be manifest in the shapes, organizations, and forms in and of works of art. Also, we can better understand what some modern artists are doing in otherwise puzzling productions, if we see them as "thematizing" constructional drawing activities.[7] As for earlier artists, the issue of artistic thematization is both more important and complex, once we find the connection here between the practical and the theoretical, as emphasized by no less a source than Isaac Newton, who introduced his great work on rational mechanics in the following terms:

He that works with less accuracy is an imperfect mechanic; and if any could work with perfect accuracy, he would be the most perfect mechanic of all, for the description of right [straight] lines and circles, upon which geometry is founded, belongs to mechanics. Geometry does not teach us to draw these lines, but requires them to be drawn, for it requires that the learner should first be taught to describe these accurately before he enters upon geometry, then it shows how by these operations problems may be solved. ... Therefore geometry is founded upon mechanical practice, and is nothing but that part of universal mechanics which accurately proposes and demonstrates the art of measuring.[8]

Fig. 5. Relief drawing board from statue of Ur, showing ground plan for ziggurat. Louvre. After P. J. Booker, *A History Engineering Drawing* (London: Chatto and Windus, 1963), pl. 3. Author's rendering.

Fig .6. Stonecutter using rule, set square, and compasses. From Denis Diderot, *Encyclopédie, Recueil des Planches,* vol. 1, "Architecture, Maçonnerie," pl. 1, detail. From P. J. Booker, *A History Engineering Drawing,* fig. 32.

"By these operations": let us recall that the propositions of Euclidean geometry are sometimes expressed in terms of drawing operations. Thus, for example, Euclid's famous Proposition 31 of Book I, "Through a given point to draw a straight line parallel to a given straight line," includes in its proof the phrases "be constructed" and "has been drawn," and such is fairly typical. That not only reminds us of the central importance of constructional drawing in the proofs of classical geometry but opens the very large topic of the place of constructional drawing in mathematical and scientific proofs and arguments generally. More broadly, such has long been part of the stock in trade of philosophical instruction, as philosophy students worldwide have long been brought up on the brilliant geometrical proof of Plato's *Menon* (as far as we know, original to that philosopher), whereby a drawing operation not only provides a practical means for doubling the area of any squared flat surface, but is also based on mathematically incommensurable lengths (fig. 7). Such proofs are the subject of a growing expert literature, which may be considered as a development of our general theme.[9] For artistic purposes, there is at least this for us to note: that the drawn shapes we see may have been understood in terms of operations (here, of compass and square) not visible in the product (see fig. 58). This point applies to various cultures. For example, a popular Chinese manual states, "Drawing by square and rule (*chieh hua*) cannot be put down as work only of artisans"—presumably meaning design drawing practices—since, in accord with the disciplines of Zen Buddhism, "Drawing with square and rule is a similar discipline of purification in the art of painting, among the first steps for a beginner."[10] This provides our first important example of what we will later call "process history" in drawing.

In summary, we should notice that the fact that we reach a historical point where there are records—material and other—of separable design drawings should not tempt us to suppose that they began then. Also, even though we must admit that in our own time hardly anything gets made or built without previous elaboration in a series of drawings, leaving in some cases long paper trails, this may have less to do with the technology of our age than with its economic organization. In earlier times it was unnecessary to file patents for devices such as stirrups, plows, wheels, cranks, and water

Fig. 7. Constructional drawing instructions. From Plato, *Menon* 82–85.

mills or to file building plans for a temple such as Angkor Wat. But such qualifications begun, there can still be little doubt that, especially over the last two and a half centuries, the modern world is to a high degree the drawn one, therefore unlike any other, and that whatever other factors are involved, the line between it and the traditional world, past and still existing in many parts of the globe, is scribed by drafters.

"THE RATIONALIZATION OF SIGHT" I: BOLD CLAIMS

Let us consider how this modern situation came about. In answer to the question whether the design of the modern world required a radically new approach to drawing, a reconception of it, I mentioned a general reply that has been strongly affirmative: a reply that gives central role to the Renaissance invention of "linear perspective," beginning over five hundred years ago. That some should think this way is hardly surprising, given the popularity of a view often associated with the art historian Irwin Panofsky, that the advent of perspective was responsible for a good deal more than that. Consider, for example, these claims about the early Renaissance from Nikolaus Pevsner's standard short guide to European architecture: "The invention of printing towards the middle of the century

proved a most powerful conquest of space. The discovery of America towards its end produced results nearly as important. Both must be named with the discovery of perspective as aspects of Western space enthusiasm."[11] A hardly less bold comment is due to William Ivins, who introduces one of the most effective recent phrases for the perspective phenomenon: "the most important thing that happened during the Renaissance was the emergence of the ideas that led to the rationalization of sight"—by which Ivins means the development of Renaissance perspective.[12] Such sweeping claims (which we will loosely call "Panofskian") are, of course, not shared by all those who hold that perspective was a crucial part of the Renaissance. It is more common for historians to restrict audacious perspective claims to art history, holding that perspective (perhaps along with a return to classical forms) is the decisive discovery of early Renaissance visual art.[13] Again, the more extravagant Panofskian conceptions are not shared even by all those who hold a view cut down to the concerns of this chapter: that it was a revolution in drawing systems that made modern design possible. Still others, as we shall soon see, try to make the historical argument by closer attention to specific cases. So there is a spectrum of audacious claims. Yet, for all their differences, across the full Panofskian and the less sweeping hypotheses runs another distinction, clearly marked by Ivins in the following comment: "The most marked characteristics of European pictorial representation since the fourteenth century have been on the one hand its steadily increasing naturalism and on the other its purely schematic and logical extensions" (12). Thus, among those who emphasize a more dramatic historical turn, with perspective just at the turning point, some will stress "naturalism," others what Ivins calls "rationalization," and we will see in detail how those two positions differ. For his part, Panofsky was clear about putting the weight of his general thesis concerning perspective on the rationalization function, not on naturalism. From the beginning he sharply distinguished perspective's rationalizations from visual experiences and saw the former as based on "bold abstractions" that not only are removed from but stand in opposition to "the actual subjective visual impression" or "psychophysical" reality, and this distinction is central to his historical thesis.[14] Some have even (inaccurately) taken his influential application of

Ernst Cassirer's phrase "symbolic forms" to Renaissance perspective as a rallying point for opposition to claims of "naturalism" for it. Regarding only our specific topic of design drawing, I will argue that Panofsky's is the better course, whatever the plausibility of his other speculations about the meaning of perspective. But even then, I will suggest, "Panofskian" statements about the importance of perspective require much qualification, for two reasons. The first reason is that perspective does not turn out to be a main design drawing system. The second is that some of the methods that have rather better claims existed for millennia before Renaissance perspective and are still in wide use today, even outside the technical contexts now being considered. The proper historical question, I will argue, is how the advent of perspective might have been necessary for shifting old, standard drawing methods in the direction of modern engineering design, which has made a modern world possible.

METHOD: THE DIALECTICAL ENGINEER

Let us take advantage of this existing spectrum of ideas about the historical primacy of perspective for modern design by considering some of these ideas critically, looking for conceptions and distinctions that will be useful later. This might be called a "dialectical" or "Socratic" approach, which, as Aristotle remarked, works by critical examination of "common beliefs, the things believed by everyone" or "by most or by the wise (and among the wise by all or by most or by those most known and commonly recognized)," though not every belief.[15] Among a number of people—indeed within the same person at different times or even at a given moment—such beliefs will typically be somewhat unclear or at variance with one another. In other words, the normal situation will be somewhat confused and conflicted. Linear perspective is a candidate for such an approach, as vague and ambiguous ideas of it are widely spread in our thinking, well beyond the drawing context.[16]

Our method will therefore imitate that of its subject, design drawing itself. Generally speaking, we all recognize how we develop our ideas by communication. Although speech is popularly considered an interpersonal communication of ideas, it is often intrapersonal as well, since often it is only in

speaking to another that we are able to develop our ideas or know what they are. We frequently do not know what to say until we try saying it, and conversation among reasonable people can be expected to be a give and take of reformulations. This goes as well for other kinds of thinking, including the visual: "To design is to invent," declares Ferguson, but Leonardo da Vinci's famous coded, individualistic invention notebooks, deciphered only by a few in later generations, are hardly paradigms for Ferguson's inventive modern engineers. "A complex modern device such as an internal-combustion engine is usually designed by a team of engineers," Ferguson reminds us, "the specialized knowledge of each one contributing to meeting the various requirements of the overall design. The team is invariably led by an engineer who keeps the overall design in mind, even as unanticipated problems force its modification." "The set of drawings for an engine may number several hundred," he adds (these renderings involving yet more drafting staff), and they have different functions: "they show designers how their ideas look on paper. Also, if complete, they show workers all the information needed to produce the object."[17] In modern design there must be enough on the page or computer screen or in the model that the design team can communicate with its members, and the members communicate with themselves as the project develops. Thus Ferguson distinguishes three kinds of engineering sketches: the "thinking sketch," the "prescriptive sketch," and the "talking sketch." The last is "produced constantly in exchanges between technical people," who have been seen "taking the pencil from one another as they talked and [drawing] together on the same sketches."[18] Thus "back to the drawing board" has meaning even before drawings get to a board.

Dialectic, Aristotle also remarked, involves critical questioning: it "cross-examines" the disputants in an attempt to "resolve the puzzles and contrarieties."[19] In this Aristotle was a better student of Plato's Socrates than is usually recognized, for it was part of Plato's genius to recognize that understanding of important matters of human life is best worked through in the context of existing opinions and disagreements, rather than in development of one line of thought. Engineer, designer, theorist, or citizen: realistically, that is where we must begin, and to where we must return, in nonauthoritarian societies. By paying sympathetic but critical attention to the conflicting ideas of others, we derive stimulation, materials, and direction for our own thinking, and bring checks against it. That will be our procedure in discussing the topics of perspective and related drawing systems.

Yet, in theories about drawing, as in drawing itself, dialectic has its limits. For example, in the present context of inventive design, we know how in early stages of invention we often do not wish to deal with others' comments—since, as Einstein once remarked, it is not good for the young plants if we dig them up to see how the roots are doing. Also, without strong direction this method may end in a confusion of comments from various quarters. Here we may invoke that philosophical antidialectician, Descartes, and remark that we are unlikely to get sufficiently clear about the main aspects of drawing unless we can also put aside many common notions and follow a very different order of inquiry from that of dialogue, beginning from the simplest things and thinking our own way through, in an orderly way, to the more complex, with plenty of reviews and illustrations, as Cartesian—not Socratic—method requires. It might be added that, in the realm of drawing, nothing is more suited to a priori, orderly, Cartesian exposition than is linear perspective, with its apparent simplicity and mathematical clarity. Alas, as already mentioned, the confusions and controversies that these very presentations have created is the very reason why we must first take up the whole topic of drawing dialectically, in terms of common notions and those held by the "wise." Granted, first principles are necessary—also a method of taking things in order, step by step, avoiding unnecessary assumptions. But, for finding such principles and basic ideas, let us recall Aristotle's advice, that "once we have catalogued the beliefs of the many, our approach to them will begin from their own views . . . , and we will redirect them whenever they appear to us to be wrong . . . , which is useful for the philosophical sciences, because the ability to survey the puzzles on each side of a question makes it easier to notice what is true and false. Moreover it is useful for finding the primary things in each science." "This," he added, "is distinctive of dialectic, . . . for since it cross-examines, it provides a way towards the principles of all lines of inquiry."[20] Such survey and cross-examination will be our procedure in seeking general principles of drawing when we consider controversies about the histori-

cal place of linear perspective in the invention of the modern era.

"THE RATIONALIZATION OF SIGHT" II: NATURALISM

As remarked, the boldest and most influential suggestions by "the wise" about the general importance of new methods of drawing (or "new methods of graphic representation") for the modern world may conveniently be associated with the writings of Erwin Panofsky. Though diverse and somewhat ambiguous, Panofsky's ideas continue to exert strong influence. Here, as first testimony, are a typical three statements by him:

P1. "In the Italian Renaissance the classical past began to be looked upon from a fixed distance, quite comparable to the distance between the eye and the object in that most characteristic invention of this Renaissance, focused perspective. As in focused perspective, this distance prohibited direct contact—owing to the interposition of an ideal 'projection plane'—but permitted a total and rationalized view."[21]

P2. "The rise of those particular branches of natural science which may be called observational or descriptive [was] directly predicated upon the rise of the representational techniques."

P3. "It is no exaggeration to say that in the history of modern science the advent of perspective marked the beginning of a first period; the invention of the telescope and microscope that of a second; the discovery of photography that of a third."[22]

Addressing, as he does, large issues of natural science and history (mercifully, not our topic), it is remarkable that Panofsky here says nothing directly about our topic, technological design. Nevertheless, his statements have been taken by some as extendable to that topic. And although, as reported, Panofsky stresses rationalization (William Ivins's "purely schematic and logical" applications), not *naturalism*, a naturalistic extension is sometimes attempted along that line. That is, to

some it has seemed plausible that the increased "naturalism" usually associated with "the representational techniques" of Renaissance artists would be of assistance to designers, and for reasons suggested by Ferguson: notably, naturalism increases their powers of visualization.

Let us consider these ideas. Compare an often reprinted thirteenth-century drawing of a water-powered saw (fig. 8) by Villard de Honnecourt with technical drawings typical of the Renaissance. Apropos a design revolution wrought by "linear perspective," Ferguson remarks that Villard's drawing "is ambiguous, although it would not be difficult for the mind's eye of the reader who had seen an up-and-down sawmill to move the elements into their proper places."[23] He adds: "On the other hand, . . . [a Renaissance] drawing tells a reader what the sawmill looks like and how it operates"; and for three-dimensional objects "such drawings can be interpreted by most viewers" (while allowing that "perception of depth in a picture on a flat surface depends upon a cultural background not shared by all people").[24] In line with this, it is easy to understand the naturalistic appeal of a general conviction that the Renaissance drawings have (to quote art historian Samuel Edgerton) greater "objective power," that looking at them, unlike the Villard, is almost like looking at what they represent. The best of such drawings, at least, provide "precise information about the physical world not only without need of explanatory texts but without need for the viewer to refer to the actual objects depicted"[25]—or, as another expositor puts it: they "depict machines as they really appeared, rendering their structure in life-like detail." The predictable skepticism, fashionable today, about this "almost looking like" seems refuted by our very time's fast-developing techniques of design: the photography, physical model building, animation and rotation, stereo vision, and so-called virtual simulations that designers, like other specialists, depend upon. History shows that the engineer's "mind's eye" of the imagination, which is capable of inventing various mechanisms to exploit the powers of nature, is in turn greatly assisted by imaging technologies that tap the natural powers of the human visual system.

Consider further Ferguson's phrase "looks like." Often, when speaking of naturalism in terms of "looking like," we actually mean just what we say: "looking." This is not, as usually supposed, a mat-

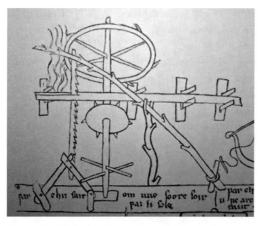

Fig. 8. Villard (Vilars) de Honnecourt, Water-powered saw. From J. B. A. Lassus, *Album de Villard de Honnecourt, Architecte du XIIIe Siècle* (Paris, 1858), detail of ca. 24 × 16 cm, fol. 22 verso (Lassus pl. 43), photographic reprint: Paris, 1976. Courtesy of Professor Carl F. Barnes, Jr.

ter of one thing resembling another; it is a matter of our own activities of seeing the one being like our activities of seeing the other. Since we are now thinking technologically, let us apply this approach to drawing techniques themselves. Human-made waterwheels are effective sources of power because, by artifice, they successfully transfer natural forces into ones directed by people. Linear and other forms of perspective might also be effective because they transfer powerful natural cues of space perception—cues that work for almost all sighted creatures—into the perception of drawings, paintings, photographs, and also three-dimensional media. Again, what we do when watching moving pictures is significantly like what we do when watching moving objects; what we do when looking at two images through a stereoscope is significantly like what we do when looking at things with binocular vision. It is not that what we actually see (a row of images on a strip of 35 mm film, or two printed on a card) seems to *resemble* what it depicts, this then having a similar perceptual effects upon us: rather the reverse. Through history, we discover how our perception works and we exploit this perceptual knowledge, as, in E. H. Gombrich's words, we slowly learn by trial and error to pick nature's perceptual locks.[26] Nor is Ferguson's uneasy footnote about cultural relativism—"depends upon a cultural background not shared by all people"—a problem here, as the issue is not how, relatively, drawings look when some of them do

not work for us, but how they look when they do work—and why they work when they do. For example, though many people have difficulty at first with stereo viewers, the effect when they do work is nonetheless remarkable.

Even with this defense of a first dialectical objection against the naturalism thesis about modern design, we have more to learn from rather more difficult "puzzles and contrarieties." A frequent objection to the naturalism line has been that it overlooks the simple fact that there are different kinds of design visualization, as Ferguson's own example of engineers visualizing in terms of performance curves seems to show. Looking at these curves could not be like looking at what they show, since they show things that cannot be seen. It is common to perceptual imagining that, for example, something difficult to remember, such as a mass of data or an equation, is easier for the visual system to grasp and to retain as a simple curve (see fig. 3). But that is not all, for the point to take from the abstract curve example applies as well to things that *can* be seen. Thus the historian of science Michael S. Mahoney has replied to Ferguson's naturalistic argument as follows: "During the fifteenth and sixteenth centuries, the methods of depiction clearly improved. . . . The machines represented on the two-dimensional page looked increasingly like their three-dimensional models seen in action. . . . But to show what machines do or how they are assembled is one thing; to show how they work is quite another. . . . A picture of a windlass, or of a system of pulleys, cannot in and of itself set forth the laws that define the device's mechanical advantage."[27] Laws: this is a devastating argument, by a philosopher of science, against extending the naturalistic account to modern *science*. Despite the common label "scientific illustration" for technological illustrations (or for our own example of the performance curve), we will not join in ongoing arguments about the place of visualizing in the sciences. We have a big enough job to do, uncovering principles of design drawing that will help us understand drawing as depiction, drawing as art.

VILLARD'S SAW

Even staying clear of scientific diagrams, Mahoney's objection can be adapted to our topic if, as a first step, we consider not only looking at draw-

ings that resemble what they depict but looking at the things themselves—for example, at a water mill saw. Modern histories of visual and verbal art remind us that such mills are often picturesque sites, from which point of view, at least in the engineering sense, most of what we see is visual noise. For that reason abstracted diagrams and maps are often better than both the real thing or any naturalistic portrayal of it. For general design purposes, the Villard will serve, even today—as what engineers call a "sketch" (as opposed to what is technically called a "drawing")—while a splendid teacher of the historian of technology, Lynn White, takes us round Villard's "mill," a "sawmill with sapling spring."[28] In Villard's sketch a stream turns the waterwheel, which turns the axle, which does two things; for, as White points out, this drawing "presents the first industrial automatic power-machine to involve two motions." First, the axle's rotating spindles capture, in turn, the edge of the scissor-action board, which is pulled, while steadying the saw attached to it, in power downstroke. That downward action bends the sapling attached to the saw's other end, so that when the saw-blade is released as each turning peg slides over the board, the freed sapling springs back to shape, repositioning the blade in upstroke. Meanwhile, as we have power to spare, the claws of the rotating wheel of the disk at midshaft provide "an automatic feed keeping the log pressed against the saw" (118). Thus an epitome of basic power and motion transference, which carries us through the linear motion of the stream, to the rotary motion of the wheel with all its rigid attachments, to the reciprocating motions of the rest, notably of the swishing sapling and reciprocating saw-blade (as well as the linear progression of the log).[29] It also illustrates two main forms of kinetic energy at work. A moment's thought reveals how automobiles reverse the order. Household tubular door-lock assemblies also transfer rotation of knob and spindle to linear motion of the bolt, again made reciprocal by spring-action return. With more moments one might consider how similar Villard's saw is to mechanical clockworks (fig. 9). The resemblance being clear in Villard's schematic, absent Renaissance naturalism, what is there to criticize?

There is more "contrariety" to consider, for Samuel Edgerton gives our drawing the poor mark: faulting it for "naïveté." Villard, Edgerton remarks, "tried to depict a stream turning an undershot wa-

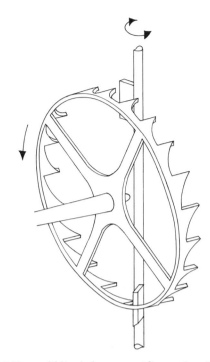

Fig. 9. Verge and foliot clock escapement diagram. From Hugh Tait, *Clocks and Watches* (Cambridge, Mass.: Harvard University Press, 1983), fig. 1. Author's rendering.

terwheel attached to a spur gear, simultaneously forcing a horizontal timber into the teeth of an up-and-down moving saw. His solution for illustrating the transmission of vertical to horizontal motion was to show each element as seen from its characteristic aspect, so that the whole drawing appears incongruously flattened or squashed."[30] Here, as in good dialogue, criticism assists our understanding, providing ideas about aspects of the Villard we had overlooked, though they were latent in the grammar of our three descriptions of it so far. Part of the drawing's seemingly childlike "naïveté" lies not only in its itemizing the things that we conceive to be in the scene (rather than the perspective shapes and effects as one would actually see them), but also in itemizing the things we conceive in terms of independently namable substances denoted by those nouns used in the descriptions by White, Edgerton, and myself. Thereby Villard not only makes more evident the separate components of a power train—relevantly as separate—but provides a group of what we will be calling graphic "categorials," or "nominal" classifications for them (stream, wheel, axle, sapling, saw, log, blade, etc.),[31] as items one could find or fashion separately, rather like a

catalogue or recipe book: "take and combine as follows . . ." (handy practical advice, especially for someone living around the 1230s, without hardware or builders' shops). Yet, as we all know from photographs, the naturalistic devices of perspective and shading often fail to register clearly just this kind of crucial information, it being a common ambiguity of photos that we cannot clearly pick out distinct objects and their assembled parts, or tell where one ends and another begins.

Later, as we develop more systematic tools for describing drawings, we will be able to make clearer why this is so. We will also see how drawings like Villard's define by means of categories, indeed by "characteristic aspects," and better understand Edgerton's terms "incongruous" and "flattened." Finally, in fairness, we should not really be considering the Villard in the terms of building from a design; rather, we should be considering it in terms of thinking up designs—a point that well fits Edgerton's comment that Vil-

lard's diagram is "not an actual working drawing" but a sketch: "only jottings of ideas that occurred to him as he travelled about the country practicing his profession." "Since no uniform code of engineering drawing existed in the Middle Ages," Edgerton adds, "Villard was forced to follow his instincts" (114). However, where design *invention* is the topic, examination of modern engineers' and architects' jottings might not unambiguously support the case either for naturalism or for uniform codes. Here Edison's scrawls come to mind—and for architecture, more interestingly, Frank Gehry's loose line thinking-drawings. Such arguments as Edgerton's may have more force when we turn to the second part of our topic, modern graphic innovations crucial to *production,* for which a closer look at the Panofsky "perspective" inspiration may provide a transition. To begin let us consider more closely why, from the point of view of actually making things, the modern world is the drawn one.

2. instruments of change

Granted, Villard's sketch would give only a general idea to someone who wished to build such a water-powered saw. Indeed, at first, the reverse of Edgerton's vertical/horizontal criticism seems to obtain: there is a problem of horizontal-to-vertical arrangement in the linkage between the axle and the saw. Looking ahead to the Renaissance (as Ferguson and Edgerton would have us), we notice that, despite their later fame and interest, the more advanced mechanical designs of Leonardo—even the ones that might have worked—actually went unrealized in his own time. Such of course is the fate of many design drawings, for the hard fact is that it is one thing to design and another to realize, and the gap is not simply one of design feasibility. Even with revolutionary design thinking, we would not live in the material surroundings of a modern world were we not able to produce out of physical resources the tools of modern technologies. And since designs typically develop as adaptations of, or at least depart from, existing mechanisms in concrete problem situations, such revolutions could hardly occur. Thus physical realization normally requires other forms of visual presentation besides those of initial design. Most obviously, there have to be graphic methods for guiding production and manufacture, and not just for complicated structures. In order to reach that point we usually need additional methods of display, since, typically, there will be no production unless others, not always expert, agree to it.

Thus, within engineering and architectural firms there are special techniques, people, and departments for presentation rendering. Sometimes this is because the renderings have to do with visualization in the special and important sense of how things, if produced, would look to people in the relevant conditions. In sum, as Ferguson notes, engineering design drawings "have two principal purposes. First, they show designers how their ideas look on paper. Second, if complete, they show workers all the information needed to produce the object. The information that the drawings convey is overwhelmingly visual. . . . Such drawings, resulting from nonverbal thinking and possessing the ability to transfer information across space and time, are so constantly present in offices in shops that their crucial role as intermediaries of engineering thought is easily overlooked."[1]

We need to add that business and legal relationships to makers are normally defined by reference to drawings. For example, in setting out tenders for architectural construction, a phrase might run: "contractor shall check all dimensions in the drawing and report any discrepancies to the architect before proceeding." Such are samples of the indispensable intermediaries of design and execution, and a fuller study of production drawing than we can undertake would have much to say about the specific demands of communication that shape these drawing "languages."

There is another basic point to make about our present drawn world. Modern manufacturing, being in large multiples, usually with components, requires clear, precise, standardized plans, in what Edgerton called "a uniform code of engineering drawing," possible only through the specialized graphic representations of technical drawing. The designs have to be exact, so that engineers, designers, and architects can think with them and give clear instructions for making their different components, often at scattered sites. Manufacture of implements of any complexity usually requires many detailed subassembly as well as assembly drawings. As it is often highly specialized, machinists have to understand quite precisely the aspects of the design that pertain to them (often without knowing much about the other aspects) so that they can translate that understanding into the specifics of their own tools and procedures. This holds true for the manufacture of such design-simple artifacts as signs, pencils, bolts, cans, and shoes and certainly for more complex mechanisms. More and more it also holds for stand-alone or embedded computers and their components—including the vital microcircuits that are made directly from drawings. Even apart from the economies of manufacture, there are therefore necessities of standardization, due to modern dispensability, mass markets, and outside regulations, also requiring precise methods of graphic communication.

Even when a modern commodity does not have to be drawn before it can be made, given that all artifacts are produced from materials shaped by other artifacts, those tools of manufacture will themselves have been drawn in order to be produced by other machines, and so on. This is true even for such crucial modern commodities as petroleum products, wood, water, grain, ores: though they need not be drawn to be produced, the mechanisms by which they are extracted, processed, and transported to market must be. Thus, whether or not they are themselves complex and precise, all modern artifacts and processed materials arise from substrata of drawings that are. Again, such was not the case before the modern age of industrial production—and such is not the case even in much of the so-called modern world of our time, when billions of people still use preindustrial methods for their most important activities. Thus the chronological line that separates millennia of traditional craft and manual labor practices and

modern productive technologies, like the cultural line that today separates postindustrial from traditional societies, is drawn as much by designers and engineers as by capital, organization of labor etc. As a result, today in "the developed world," just as we might divide countable individual things as artificial and natural, we might almost as well divide them between the drawn and not drawn. With apologies to the poet Lawrence Ferlinghetti's "Pictures from the Gone World," we can even say, of one world's "pictures," that the modern world is a *drawn* world. For this world, the gone world is one that does not have to be drawn in order to exist.

FAMILY PROJECT

It is often noted that modern methods of engineering and architectural drawing are "projective"; that is, they can be elegantly systematized as a family in terms of projective geometry—although projective geometry was not developed until the very end of the eighteenth century by Gaspard Monge, and his work was not widely known for some time after that.[2] Within this projective family, many historians agree that, whatever their precursors—and we have already seen how unsystematized plan and elevation techniques have been used for millennia in constructional drawing—the conscious systematization of projective forms stems from their most famous member, perspective—or, as the eighteenth-century British perspectivist Brook Taylor named it, "linear perspective." Taylor's term distinguishes linear perspective in two ways: first, from atmospheric perspective and the perspective of acuity, which makes distant square towers look rounded; second, from the other members of the projective family, which are sometimes loosely, and confusingly, called "perspective," by an "all hands on deck" kind of synecdoche. To save words, from now on I will use "perspective" to mean "linear perspective," unless otherwise qualified.

It may have been discourteous to Panofsky to have introduced even extensions of his views to design drawing in terms of naturalism—showing things "as they really appear"—for what he actually writes of is "a total and rationalized view," offered for the first time by Renaissance perspective. There is no obvious relationship between naturalistic appearance and such rationalization—and, as earlier noted, at least for Renaissance perspective, Panof-

Fig. 10. Perspective 1: plane intersection.

sky held such rationalization to conflict with perceptual experience. Having briefly considered naturalism, let us now look at Panofsky more closely in his own terms, to see what case can be made in those terms for the *historical* primacy of perspective among modern design methods. To do this, and for later reference, we will need to investigate generally what "a total and rationalized view" of space would be, and to see what this might mean for techniques of modern design drawing—notably for the historical place of perspective. We begin by being more explicit about what has been meant all along by modern design drawing systems being "projective."

The standard heuristic for understanding all such systems is a geometrical model. For that we posit three kinds of things: an object or objects (usually straight and cornered: often a cube or other box) with features to be projected; a plane surface (usually flat) on which the projection takes place; and a group of straight projection lines (call them "projectors") coordinating points between the other two. It is clear that we are playing a *dimensional* game here: 0D (zero-dimensional) points at places on a 3D object are to be coordinated, by 1D projectors, to 0D points at places on a 2D screen. Then, connect the dots: by means of these located 0D points, identify 1D "projected" lines on the screen, and thereby 2D shapes. Most of the technical drawing systems that designers use may be described by the following projection rule: that all the projectors be mutually *parallel*. Yet there are other possible orderly nonparallel projectors, some of which have very important uses. The most important group of these follows the rule that all the projectors share exactly one common point (sometimes called "the central projection point"), which we shall consider the "focus." Perspective is picked out of this group by an additional rule, that the screen be between the focus and the object (fig. 10); we see Leonardo thinking about where to place this screen in a diagram in the margin of his "Nativity" sketches (see fig. 58). That distinguishes perspective from an important kind of projection that we find modelled every day, when a small, bright light casts shadows in what is called "reverse perspective," familiar from cartography, where it is called "stereographic projection" (fig. 11, bottom). Systems approximating reverse perspective have wide history of use across various societies, where they appear not so much as a kind of perspective as an operation on—exaggeration of—what we shall be calling "oblique" techniques. But before considering what we usually term "perspective" more closely, let us first distinguish among the designers' more common set of parallel projection systems.

We understand best what we demonstrate for ourselves, and probably the most effective way here

Fig. 11. Cartographic projections: orthographic and stereographic. After P. J. Booker, *A History of Engineering Drawing*, fig. 1. Author's rendering.

is by use of a physical model: having a light *source,* the sun (since its rays, serving as projectors, come in sufficiently parallel) shining at right angles upon a wall or similar surface, which we will call a *screen,* against which its *rays* cast shadows of a skeleton or translucent object, which, as a shadow-caster, we may call a *scrim.* Again, cartography presents us with a standard case of this, called "orthographic projection" (fig. 11, top). For more general demonstration however, taking something with straight edges and right-angled corners, there are obviously two ways of changing the shape of its shadow as cast by the sun. The first method is by rotating the frame, the second is by inclining the projection surface to the sun's rays, either by slanting it or by waiting until the sun moves. So it is with the drawing systems thereby modelled. For the specific purposes of design drawing, it has proved useful that just a few of these angular manipulations be standardized and named.

Before considering them, it is important to emphasize that sunray and shadow provide us with only a very helpful physical model. More than five hundred years of confusion about perspective have stemmed from what might be called a heuristic fallacy: a careless transfer of adventitious aspects of the physical model to what it is supposed to help us understand. For this reason I have introduced the terms "source," "ray," "scrim," and "screen" for describing the model, whereas what these help us understand are labelled by a different set of words: "projector," "object," and "projection plane." A main difficulty in the model has concerned light rays: it is important to remember that our projectors are only modelled by such rays. Not only must we avoid understanding projections as essentially about rays of light, we must avoid construing them causally at all. In shadow modelling of projection, we speak of the rays causally, as having direction: they come from the sun, pass (or are intercepted by) the scrim, strike the screen, and produce an effect there. Unfortunately, this model has encouraged a bad habit of saying that things "in the real world" project their shapes onto the projection plane. Obviously, with design drawing the causality runs the other way, from the drawing to the object it helps to make real, if it is built. We must therefore conceive of projection in terms of the projectors that only *coordinate* points between screen and scrim, without causal direction. With that as warning, let us carry on with the conven-

ience of shadow talk, considering geometrical projections in terms of the physical. And let us for the time being also consider these shadows in terms of something distinct: the drawn lines whose production they might guide.

Returning to our projective classifications, all those that involve rotations of objects projected while keeping the projectors at right ("ortho-") angles to the projection surface, are called "orthographic" or "orthogonal" on opposite sides of the North Atlantic. Two kinds are usually emphasized in name and use. In the main one, common to engineering and architectural drawing (ambiguously also called "orthographic"), the face or main axis of the thing to be drawn is placed parallel to the plane of projection (fig. 12). When this is a bottom "face," it is a plan (in architecture, a "footprint") of the kind already mentioned. (Except when context allows for other kinds of plan projections, especially oblique ones, by "plan" we will mean "orthographic plan.") When, however, the face to be drawn is not parallel to the projection plane (fig. 13), we get other orthogonal systems, the best known of which in engineering drawing is the "isometric," as in the familiar isometric cube, where we see a rectangular form (fig. 14). As noted, the second way of departing from right-angle projection is by slanting the projectors themselves relative to the projection surface (fig. 15). This technique includes two famous varieties, the "oblique" and its subclass, the axonometric, familiar from architectural illustrations (fig. 16). The oblique, I remarked, comprises a very important subfamily of projective methods. Before considering it let us keep in mind that, despite the confusing use of the words "ortho-" and "oblique" for subvarieties, our main distinction concerns the angle of the projectors to the projection surface: these must be either orthogonal or oblique. Of secondary importance are the inclinations of the object's features (notably its faces) to the projection surface. Accordingly, we will call the general orthogonal class "orthogonal" and its subvariety "orthographic," while "oblique" will have to be disambiguated by context.[3]

To understand the relative advantages of these kinds of projections for design, let us review them briefly in terms of actual drawing practices. Here the ancient orthographic method provides the most valuable characteristic of being able to transfer directly lengths and angles from measurements, from drawing to construction, or vice versa.[4] "Di-

Fig. 12. Parallel projection 1: orthographic.

Fig. 13. Parallel projection 2: orthogonal nonorthographic.

Fig. 14. Parallel projection 3: isometric.

Fig. 15. Parallel projection 4: oblique.

Fig. 16. Parallel projection 5: axonometric.

rectly" here includes scaled transfer, of course, but, as Arnold Pacey reminded us, direct, congruent transfer by *tracing* is a most basic drawing operation, which we have all performed. The orthographic's familiarity and simplicity should not make us to take it for granted. Its fundamental property of being "metrical" or congruent—that is, of allowing us to superpose one figure on another with all endpoints coinciding at the same time—is basic to a multitude of practical operations. Indeed, since the nineteenth century, mathematicians and physicists have taken it to define Euclidean space itself. Orthography has other perceptual satisfactions, perhaps (as we shall later consider) rooted in the sense of coincidence of aspects of the original and the projection. Orthography in fact seems to be more than just one projective system along with others—more than even parent to them all—since, as we will soon see, what we might term "orthographic values" show up in other projective systems as well.

Orthographic design drawings are usually scaled down, allowing not metric congruence but only "conformal equivalence," which in school we learned to call "similarity." Now it is standard procedure to join two—or, more usually, three—orthographics of different sides of an object for manufacture, projected as though they were on the sides of a box into which the projected object is placed (fig. 17). The technical term for that is "development," and again, just to be confusing, the two sides of the North Atlantic have different conventions, with diverting histories of explanation and justification.[5] For obvious reasons, the ortho-

graphic is the ancestral and most important projective system, different from all the others, which find ways to show the top, bottom, and side planes and edges that the orthographic cannot display without development.[6] Here we encounter a typical cost-benefit situation. Strict congruence being a fundamental value in drawing, as in many practical operations, we may still give up the strictness for conformal equivalence, since, even with development's preserving conformality for all main faces, the orthographic method does not exhibit the important joins or edges among those faces. Such information being crucial, we tip the scrim, give up conformality, and allow angles to differ, so long as all straight lines remain straight and all parallels remain parallel. Such transformations are known as "affine."

Among affine orthogonal systems, the isometric is the most used in engineering. Isometric projection's early-nineteenth-century promoter, William Farish, systematized it precisely for the reason of making the joins perspicuous. There, as in the orthographic, one draws all verticals as vertical lines with lengths true (to scale). Isometric projection, however, rotates the drawing so as to eliminate the orthographic's signature horizontal lines, thereby focusing on just those lines for width and depth that cannot be shown in the orthographic without development. According to Farish, "isometrical" projective drawing has great advantages over the orthographic, which is "unintelligible to an inexperienced eye; and even to an artist," as "it shews but imperfectly that which is most essential, the connection of the different parts of the engine with one another."[7] ("Connection": we note for future reference an important topological theme.) In technical isometric drawings all horizontals are usually set at 30° to the baseline (or at 60° to the vertical), which, as its inventor pointed out, happens to work quite well perceptually, since "any person who has ever looked at a picture" of the kind, he claimed, "cannot for a moment have a doubt that the angle represented is a right angle" (117). Lines neither parallel to the vertical nor to these two preferred angles will not show true lengths, and of course isometric drawing, being only affine, does not provide direct to-and-fro transfer of angular measurements.

While we have so far been thinking about projection in terms of flat faces, of course curved ones need to be drawn as well. A nice feature of isome-

Fig. 17. First and second angle (quadrant) developments from orthographic projections.

Fig. 18. William Farish, isometric diagrams. From "On Isometrical Perspective," *Cambridge Philosophical Transactions* 1 (1822), pl. 1.

try is its strict similarity of elliptical projections of circles, allowing Farish to standardize templates for circles on flat faces and also for drawing regularly curving objects, not just cornered ones, with good legibility: see Farish's figure, whose subfigures, incidentally, provide us with examples of constructional drawings (fig. 18). This term "legibility," which returns us to Ferguson's stress on visualization, underscores the often overlooked distinction between *projective* systems and *drawing* systems, which may employ them. As tools for technical drawing, projections are subject to constraints that no mathematical system describes, constraints due to the biologically and socially specified, contextualized visual systems of their human users, to which Farish made reference, even when assisted by artificial processing systems. These constraints long precede regularization of these systems. Thus, looking back to our Villard (fig. 8), we find him coming up short with one contour line, where he fails to carry his line de-

scribing the tree-fork enough over that for the sawn board, creating a perceptual ambiguity that psychologist call "false attachment" or misleading contact of the two. Those of us who have struggled with assembly diagrams (angles often too shallow for isometric) know how the same drawing mistake might incur another, literal, kind of "false attachment" (fig. 19). Design use of any of these pro-

Fig. 19. Furniture assembly instruction. Author's rendering.

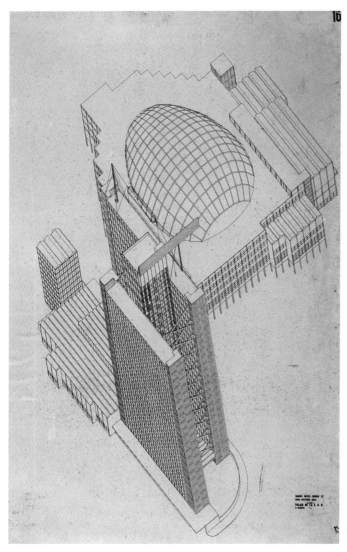

Fig. 20. Hannes Meyer and Hans Wittwer, axonometric architectural drawing. Pen and black and white inks on card stock laid down on board, 141.0 × 102.1 cm, DR1984.0705. From "Competition for the League of Nations Building in Geneva, 1926–27." Collection Centre Canadien d'Architecture/ Canadian Centre for Architecture, Montréal. (Note concession on verticals.)

jective systems must be controlled, for purposes of human legibility.

As to the widely used *oblique* projection group (produced by slanting the rays, projectors, rather than the scrim), this usually brings horizontals back into the diagram, guaranteeing again conformality—true length ratios and angles for faces and features parallel to the projection plane. To avoid depth ambiguity, oblique projection is usually drawn in three controlled ways. In its *axonometric* variety, the oblique seems to imitate the orthogonal group's isometric by rotating away from the horizontals (fig. 16). Projectively speaking, one begins with an orthographic plan of the represented structure, which is then rotated either 45° (as here) or

60°/30° up from the horizontal. A big advantage for the axonometric variety of oblique is that, in containing the plan of the object, it can be worked up directly from plan drawings, of floors or roofs— thus its wide use in architectural drawing (fig. 20). By contrast, its unrotated oblique cousins do not conserve true lengths or angles of the plan. These are often so drawn that their facing elevations send off the plan lines at either 45° or 30° angles to the horizontal, and then follow this practice: if tipped as far as 45°, orthogonal distances are drawn "foreshortened" to half-scale (called "cabinet oblique"); if only 30°, orthogonals are drawn true (called "cavalier oblique"). For general use we will apply the term "oblique" loosely, even to the building in

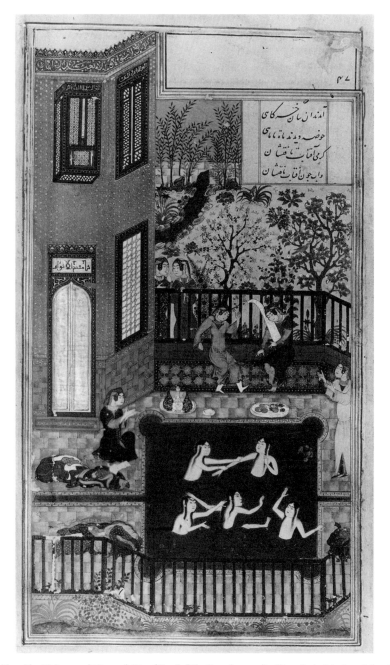

a Timurid picture (fig. 21), which shows its pool orthogonally, as well as others that vary further from the technical definitions. There are many such, and although they are the last of the parallel projection group, they are far from least, once we really think about "all kinds of drawing." In their countless uses, including art, the orthographic and the oblique approaches—the latter liberalized to include the "horizontal" oblique and the "vertical"—have claim to be the two most important ways of

laying down drawing lines. In both cases it is not the system per se (often the two are mixed in un-systematic ways) but the characteristics that we are studying that are important to us. To appreciate this, one need only look at the variety of pictures in newspapers and magazines to see how common are the mixtures of methods that approximate these projective systems, to exploit combinations of their characteristics. This experiment includes not only the comics but also photography—especially advertising work—where, despite being perspective devices, cameras (and subjects) are often positioned so as to stress orthography or to minimize perspective diminutions, in imitation of ancient oblique and modern isometric styles.

PERSPECTIVE

We have just seen how the parallel projection systems present us with a hierarchy of properties and values: metric, conformal, affine. Whatever is metric or congruent is also guaranteed to be conformal, and what is conformal is guaranteed to be affine. As we carry the exercise over to nonparallel projection systems, we move lower down the hierarchy of system properties, giving up even affine's parallelism and retaining only its straightness of line, along with coincidence of points along lines. It is at this low level in the projection family that we encounter perspective. What, we might ask, could be its attraction?

We will soon consider how one goes about actually drawing something in perspective; for the moment, however, let us consider only how we might conceive it in relation to its parallel-projection cousins (fig. 10). With perspective we get no shadow model, although we saw that such is easy—in fact natural—for "reverse perspective." Indeed, although a camera might provide a good, familiar physical model, it may be as well to avoid modelling perspective by any physical situation at all and use instead simple diagrams—so long as these, too, are considered carefully. There we see how, by rotating our cube or box, we get what is often called one-point, two-point, and three-point perspectives (fig. 22). Nothing corresponds to our main operation with the parallel group—slanting the projector—because the perspective kit comes with only one orthogonal projector, and, as its projectors are radial, not parallel, we cannot very well slant them. Still, there are a couple of operations that we can perform. First, we can shift the area of the projection that we choose to draw from. That is, for purposes of drawing, we can pick out a sector of the projection plane which is increasingly oblique to the orthogonal projector. Such is the basis for anamorphic drawings. More significantly, we can increase the imagined distance between the projection and focal point and the things or features projected, while keeping the projection area itself fairly constant (fig. 23). The effect is to put a sort of "collar" filter on the projectors, narrowing them down toward the orthogonal projector—rather as one does with a hose nozzle, turning it from "spray" to "jet," while wanting to cover the same area, and so having to move back. The remaining projectors in use will then be increasingly near parallel to one another, unlike their original "spray." It becomes difficult to distinguish drawings made by such perspective projections from those by parallel projections, and with architectural drawings it sometimes takes careful looking to tell the differ-

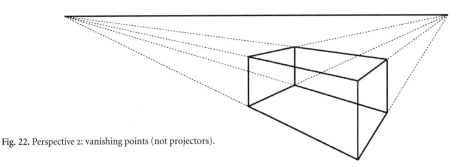

Fig. 22. Perspective 2: vanishing points (not projectors).

Fig. 23. Perspective 3: reduction. (Compare fig. 10.)

ence. Next, we can tilt the projection plane to simulate oblique projections.

In many design drawings perspective is not subjected to such extreme manipulations. What then are its characteristic drawing properties and advantages? We can list for now only a few; others need richer illustration than these simple diagrams can provide. First, perspective shares with orthographic projection and the obliques the properties of having true lengths and true angles for all features parallel to the projection plane. Again, like 45° oblique projection, it presents foreshortening, although not to a fixed scale. Perspective foreshortening of side planes increases with distance from the projective plane, but it increases at a decreasing rate, while "forelengthening" occurs for those planes at greater distances from the orthogonal projector. Meanwhile, what makes perspective most strikingly different from other projective systems is that the

projected *size* of features decreases, and as a direct function of distance from the projection plane: twice as far off makes half the size (fig. 24). The results of these three properties working together may be seen in a standard diagram such as Brook Taylor's (fig. 25), and it is their interaction (that is, steady-rate diminution with distance combined with falling-rate foreshortening) that produces perspective's unique shape transformations.

Looking ahead, it is not surprising that perspective has been a stimulus to art. As we shall see when we consider drawing as art, artists above all like to work not only with relationships but with relationships of relationships—and especially with interactive ones. In whatever contexts of use, these interactions also make perspective extremely sensitive to changes in the variables just noted.[8] Like a vehicle with quick and wide reactions to the controls, perspective can swerve wildly. This holds, too, for the natural perspective of animal vision, whose potentially wide swings are dampened by a number of governors, whereby sensitivity to information is heavily filtered for noise. The so-called constancies of vision, much studied by psychologists, are one set of devices; another is the shielding blur of peripheral vision—although more than one perspective theorist has been lured into positing a curved visual space as what "we really see." Regarding linear perspective in drawing, its "expert drivers," in the nice phrase of art historian Martin Kemp, have done thrilling things in art and in design. Still, given its extra, interactive variables, and absent standardized controls of perspective projections comparable to what we have seen with oblique, it is an inconvenient system for design.

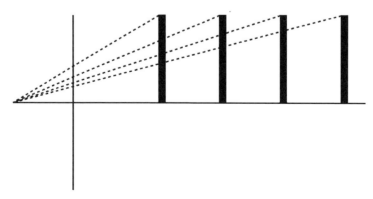

Fig. 24. Perspective 4: diminution function.

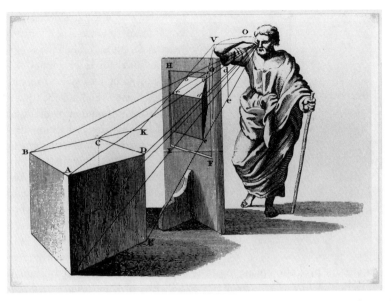

Fig. 25. Brook Taylor, standard perspective heuristic. From *New Principles of Linear Perspective* (London, 1719), fig. 1.

CARTOON CASES

Speaking of combinations, and having done this much work, we deserve a bit of entertainment—but not a diversion, for although we have begun with design drawing, every term and distinction there introduced was meant to aid our understanding of "all kinds of drawing." Drawing being a continuous activity, it should come as no surprise that, as just mentioned, the specialized system properties we have been reviewing should have much wider, relaxed uses, partial and mixed. As an exercise, let us consider which features of the systems reviewed are prominent in familiar cartoon styles. It should not be surprising that orthographic values are strong (fig. 26), given that the pattern on the surface thereby coincides closely with main faces and axis silhouettes by which we quickly recognize objects. Of course, orthographic projection being the system that does not show orthogonal planes, the "floor" is presented edge-on, as in this Hergé drawing, where all figures stand upon a common groundline. Strict orthography is, however, often relaxed in such drawings for at least a little "vertical" oblique, precisely to provide a floor on which to locate figures (as in the next frame of the comic, which shows the broken glasses on the floor), and a few perspective diminutions may be introduced (as with the table legs). Such mixes are

the norm. The obliques also have wide use in cartoon as in other kinds of nontechnical drawing, stressing horizontals, verticals, and also diagonal edges which (foreshortened or not) indicate a three-dimensional arrangement of objects and show three surfaces of things. While keeping the latter two virtues of oblique, however, many cartoonists favor diagonal rather than horizontal object baselines—though steadied always by clear verticals. While these diagonals are usually less than Farish's 30°, it is remarkable how often something close to isometry does appear, as in a Dave Blazek drawing (fig. 27), where even the human figures are defined by axes closely conforming to those of the carpentered objects. Whether truly isometric or not, some main advantages that this approach shares with isometry seem clear. Shaped like a propeller—or an inverted Y, whose stem makes an emphatic vertical—the technique divides the surface into roughly equal pie-shaped thirds. For engineering designs, we have considered this technique so far in terms of convex, positive objects. But when "popped" concave, that Y pattern yields three valuable graphic properties: a "three-space" container-like set of axes, with a strongly orienting vertical line, establishing a floor and two enclosing walls, which meet at the (usually occluded) Y junction (fig. 28). Thus a space is defined, one where, typically, objects and their parts are aligned with the

Fig. 26. Hergé, *The Adventures of Tintin: The Blue Lotus.* © Hergé/Moulinsart 2003.

"... so you're saying, not only how do I know the garbage you threw over my fence was real, but maybe the *fence* isn't real, and ... hey, this is the same trick as last time!"

Fig. 27. Dave Blazek, "Living Next Door to a Philosopher," *Loose Parts,* July 27, 2000. Tribune Media Services and kind permission of Dave Blazek.

wall axes, also set out on that floor. We see this in Roz Chast's cartoon (fig. 29), where the Y junction closes off and limits the little scene.

Worth the cost of orthographic values, these seem to be valuable spatial properties that, we shall later see, are exploited in far more complicated drawings. Much professional photo work (one sees this in commercial advertising, with its emphasis on single objects) attempts to defeat the built-in perspective of cameras to retrieve these ancient values. But now a common theme provides nice contrast between Chast's cartoon and another style from the same magazine (fig. 30), where, along with a ground plane or floor and clear verticals, orthography is recovered for main object faces and axes, while for others diminution is introduced. All but the last are characteristics of oblique projections; the last, diminution, gets us back to perspective: how shall we consider it within the greater family?

MODELLING PERSPECTIVE: DÜRER'S DEVICES

By contrast with our presentation of the parallel projection subfamily, so far we have avoided considering perspective in terms of a physical model, notably light. This is unusual, since the most common method for presenting perspective is in terms of a model, and by far the most common model is that of light rays, such as sun-cast shadows on a wall. There is a reason for the avoidance, as heuristic physical models of perspective have proved to be the source of much confusion on that tortured topic. One physical model, harmless in itself, has strings or threads representing the projectors. Consider a woodcut by Albrecht Dürer, which we may call "Lute" (fig. 31). It shows a shop procedure,

Fig. 28. Three-space mathematical diagram.

Fig. 29. Roz Chast, "George Gershwin, Psychiatrist," *New Yorker*, February 7, 2000. Copyright © 2004, The Cartoon Bank, ID: 43268.

"My daddy's rich and my ma is good-lookin', but I'm a mess."
Fig. 30. Robert Weber, *New Yorker*, April 26, 1999. Copyright © 2004, The Cartoon Bank, ID: 41232.

a difficult one, for modelling the projection plane physically.[9] More common are two other models (favorites of expositors for over five hundred and fifty years) that demonstrate perspective in terms of light—and worse, in terms of eyes looking into the light. Besides being mixed (as in another Dürer, his woodcut of a man drawing an urn, fig. 32), these two models are often mixed up—as, for example, in the famous one by Taylor (fig. 25), which does not show a drawing procedure. In Taylor's, the projectors, like strings, are held up to someone's eye, though the solidity of the projection plane they pierce counts against their being strings.

In the earliest (1436) existing description of perspective as a projective drawing method, Leon Battista Alberti describes the projection plane "as if it were a pane of transparent glass,"[10] yet what pierce it are not light rays (a conception used only after Kepler) but rather what Alberti termed "visual rays," which, at least for the outline contours of things we see, he conceives to run outward from the eye "like the willow wands of basket-cage, and make . . . this visual pyramid" (47) around the orthogonal "central ray" in the middle, which he terms the "prince of rays." On that ancient "extramission" account, Alberti thinks of the visual

rays as basic, and of light and color as flowing down them from objects to the eyes. Alberti's projectors are therefore modelled rather more like what we would call sight lines, and since his projection plane is transparent, such physical modelling makes sense. On the more familiar, modern "intramission" model, however, selected straight 1D light rays run from the represented objects through a glasslike plane of projection to join at a focus. Unlike the Alberti model, light rays of course do not presuppose vision or an eye positioned at the focus. But, alas, Alberti's is usually muddled with the modern model, and an eye is placed at the light-ray focus, not only gratuitously (that is, as what in graphics is called "chartjunk") but also disastrously, since it has led generations to believe that perspective must be understood basically in terms of eyes.

Speaking of eyes, we should see trouble coming. In good Cartesian order, what we need to introduce is linear perspective, a technique that may be used in design and other kinds of drawing. But to explain perspective a model is useful, perhaps a projective model like perspective's parallel cousins. As in them, light rays are to be used to model the projectors, although now shadows cast on a projection surface cannot be the result. It would be pos-

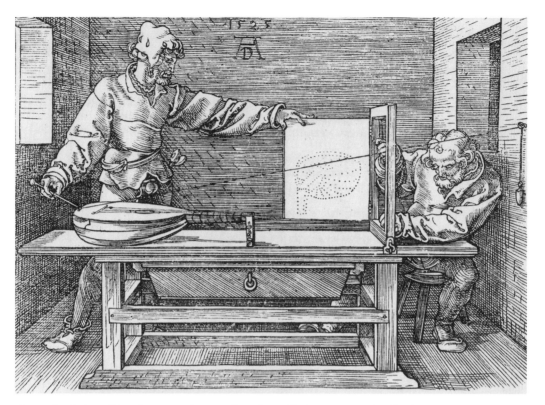

Fig. 31. Albrecht Dürer, "Draughtsman Drawing a Lute." Woodcut. Collection Centre Canadien d'Architecture/Canadian Centre for Architecture, Montréal.

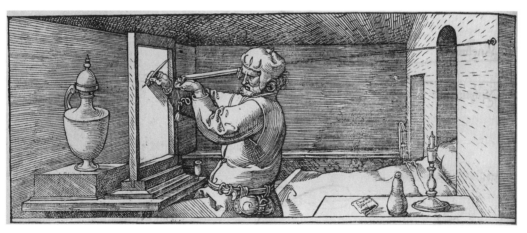

Fig. 32. Albrecht Dürer, "A Man Drawing an Urn." Woodcut. From *Underweysung der Messung*. The Metropolitan Museum of Art, Harris Brisbane Dick Fund, 1941. (41.48.3).

sible (as mentioned before) to change the model to a pinhole camera, whose 0D aperture strongly filters the projectors. However, more usually (as with Panofsky) the projection plane is imagined as between the objects and the focus of the projectors. So, given that the projectors are modelled as light rays, that plane needs to let them through. Therefore the plane is physically modelled as something like a piece of glass, or a veil: Panofsky's "windowpane." So far, no harm done. Then, needlessly, ar-

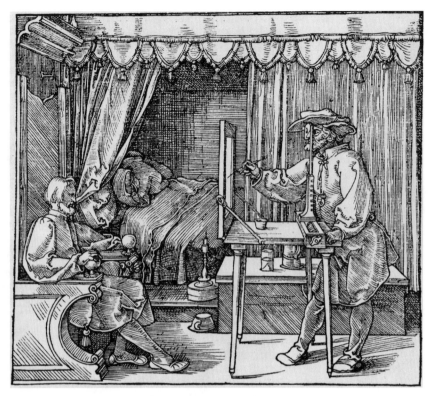

Fig. 33. Albrecht Dürer, "Portrait." Woodcut. Collection Centre Canadien d'Architecture/Canadian Centre for Architecture, Montréal.

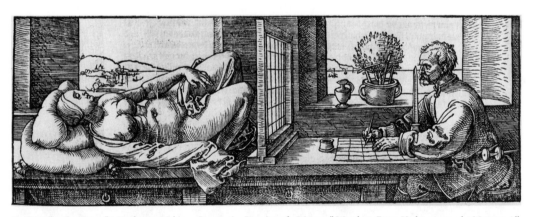

Fig. 34. Albrecht Dürer, "A Draftsman Making a Perspective Drawing of a Woman." Woodcut. From *Underweysung der Messung*. All rights reserved, The Metropolitan Museum of Art. Gift of Felix M. Warburg, 1918. (18.58.3 [recto]).

bitrarily, usually and fatally, the projectors' focus is modelled as an eye. Thus perspective, which was to be explained in order to understand a technique of drawing—that is, producing something to be looked at—is modelled in terms of that very looking at. It is no wonder that when these two acts of looking—one belonging to the model, the other to the function of the thing modelled—are brought together, confusion results. And that is not the end of it. Discipline lost, the ideas of the projection surface and of the drawing surface are also commonly conflated. Complete collapse ensues as the other projective systems are considered as limiting cases of perspective, with the spurious eye at an "infinite" distance off, so that the projector light rays come in parallel to it. Thus the standard view.

As simple preventative against such needless confusion, let us look at the full set of four woodcuts by Dürer, comprising some of the earliest, most influential, and most often printed demonstrations of perspectival drawing. If we may continue to tag these illustrations to various editions of Dürer's books on proportion, two of which we have already considered, we have "Portrait" (1528) (fig. 33), "Lute" (1525), "Nude" (1532) (fig. 34), "Urn" (1528). We note that, in what is called "central" perspective, all feature strong orthographic elements of frontal faces and planes and are controlled by vertical and horizontal edges of these faces.[11] Inadvertently, in these four Dürer neatly demonstrates the independence of the terms of our sadly conflated perspective-drawing distinctions. In "Portrait" and "Lute" the drawing surface is also the projection plane, but in "Nude" and "Urn" it is not. In "Portrait" and "Nude" the projectors are entirely modelled by eyed sight lines (remembering that Dürer, who writes of "points of sight," lived too early to be thinking of light rays), while in "Lute" and "Urn" they are not (over two-thirds of the projector in "Urn" being modelled by a silk string). Thus, for the cross-cutting categories "projectors = sight lines?" and "drawing surface = projection plane?" we get the answers: Yes/Yes ("Portrait"), No/No ("Lute"), Yes/No ("Nude"), Partly/Yes ("Urn"). Together, the four demonstrate that neither sight lines nor light rays are necessary for either modelling perspective or for drawing in it. They show that eyeballs need not inhabit the foci of perspective projectors. They also make graphically clear that "projection plane" and "drawing surface" express distinct conceptions, which, while sometimes applying to the same things, should no more be conflated than should be "German" and "drafter," which also sometimes apply to the same things.[12] These are simple, obvious, but very important lessons, which must be kept in mind if we are to avoid standard confusions about linear perspective. When we need to recall these sets of drawing distinctions, we will refer back to Dürer's woodcuts by the labels given.

PANOFSKY'S PERSPECTIVE I: PANOFSKY'S PURPOSES

This understanding of perspective as one of a wider family of projection systems for drawing should put us in position to reconsider Panofsky's historical thesis about drawing and the modern world. Our initial question was exactly how the advent of Renaissance perspective is supposed to have shifted the basic conception of design drawing toward its modern forms. One answer, regarding inventive design, had been in terms of "naturalism," and some of the serious qualifications there regarding designs are easily carried over to builders. A quick way to see this is to imagine giving good photographs of a complex machine or building to a builder and requesting a replica. But even for a simple piece of furniture, a sheaf of them might fail to indicate the essential parts and joinery. So, although good photos are obviously useful, for construction we usually resort to schematic projective drawings (see fig. 19)—ones somewhat like those just discussed, with the controls mentioned—rather than to sketches like Villard's, which we can now say lacks consistent "dimensioning," "scaling," and system, rather than that it lacks "naturalism" or is "incongruously flattened or squashed." For the achievement of systematized perspective, we saw that Ivins produced a phrase that has caught on: "the rationalization of sight." By this Ivins meant something more like Panofsky's "total and rationalized view" than naturalism, for Ivins, too, clearly distinguished the pair: "The most marked characteristics of European pictorial representation since the fourteenth century," he remarked, "have been on the one hand its steadily increasing naturalism and on the other its purely schematic and logical extensions."[13]

Regarding Panofskian views about Ivins's so-called rationalization, there are now two basic questions: How, according to Panofsky, does perspective achieve this rationalization? and How, according to others who have followed him, is that achievement carried over to the rest of the projective family? Before answering these two questions, in justice to Panofsky another note is in order. Let us keep in mind that he wrote as an art historian. According to him linear perspective in Europe had two broad historical stages, classical and Renaissance: indeed, Panofsky's main historical topic was to explain why Europe did not, could not, evolve the second stage out of the first, but had to begin all over again. Notice that this is a historical theme, with a counterfactual claim, and we best understand his idea of "rationalization" in that context. Panofsky was fully satisfied that in Greek and Roman painting perspective existed (fig. 35). But "Graeco-Roman painting," he maintained, while "striving for and ultimately

achieving a perspective mode of representation,"[14] never reached the "total and rationalized view" of modern perspective. It does share with the modern a "picture-space" effect, which "may be defined as an apparently three-dimensional expanse, composed of bodies (or pseudo-bodies such as clouds) and interstices, that seems to extend indefinitely, though not necessarily infinitely, behind the objective two-dimensional painting surface." Ancient or modern, any drawing surface treated this way "has ceased to be an opaque and impervious working surface . . . and has become a window through which we look out into a section of the visible world" (120). Panofsky's art-historical claim is that antiquity attained, in his words, a "prospect through a window" pictorial conception (129), but that this project was abandoned in medieval times because of the dominance of architecture, whose aesthetic rendered the drawing surface once again opaque—an event Panofsky termed "surface consolidation" (131). Then (to continue his story), beginning in the fourteenth century, the "picture-space" project was recovered and successfully advanced to become our distinctively " 'modern' concept of space"—of "a clearly defined pictorial space and within which a definite amount of volume is allocated to every solid and every void" (136). In chapter 1 we identified three very speculative claims of Panofsky's, regarding the idea of Renaissance (P1) and the origins of modern science (P2, P3). To summarize what was just stated, we can consider an additional pair, restricted to his perspective art theory. In this modern renascence of the ancient "pictorial-space" project, Panofsky writes,

> P4. "The painting surface, while no longer opaque and impervious, has nevertheless retained that planar firmness which it had acquired in the Romanesque and preserved throughout the High Gothic period. The painting is again a 'window.' But this 'window' is no longer what it had been before being 'closed.' Instead of being a mere aperture cut into the wall or separating two pilasters, it has been fitted with . . . an imaginary sheet of glass . . . and thus able to operate, for the first time in history, as a genuine projection plane." (138)

The modern perspective achievement was thus via an aesthetic dialectic of ancient and medieval treatments of a drawing or painting surface. First, an imaginary window "prospect" is opened in the surface, then that is closed, only to be opened again, but now understood in a new way, as though glazed, carrying what Panofsky calls an altogether different "windowpane feeling" (138), which, unlike the antique, retains a sense of the surface. It is worth noting here how easy it is to see how a standard twentieth-century drawing and painting aesthetic could fit to this scheme, as again denying "the windowpane feeling" and strongly reasserting the surface, and in due course we must restore this usually overlooked aesthetic context of Panofsky's arguments. But although the work done in this chapter will prepare us, we are not yet in position to deal with such aesthetic matters (later I will argue that Panofsky's evocative contrast contains a fallacy). Let us therefore stay within the narrower topic of Panofsky's contribution to the idea that linear perspective brings about the "rationalization" of representation, which is widely maintained as crucial to modern technologies. His contrast of ancient and modern perspective continues as follows:

> P5. "The space presupposed and presented in Hellenistic an Roman painting lacks two qualities which characterize the space presupposed in 'modern' art up to the advent of Picasso: continuity (hence measurability) and infinity. It was conceived as an aggregate or composite of solids and voids, both finite and not [as with the modern] as a homogeneous system within which every point, regardless of whether it happens to be located in a solid or in a void, is uniquely determined by three co-ordinates perpendicular to each other and extending *in infinitum* from a given 'point of origin.' " (120–121).

Similarly, in his early, best-known work, "Perspective as 'Symbolic Form,' " Panofsky had written that, on the modern conception, "the material surface of the painting or relief on which the forms of single figures or things are drawn or modelled is negated as such and becomes simply a 'picture plane,' on which is projected the whole of that space seen beyond it and containing within itself all separate objects." As for that space, "it denies the difference between in front and behind, right and left, bodies and what lies between ('empty

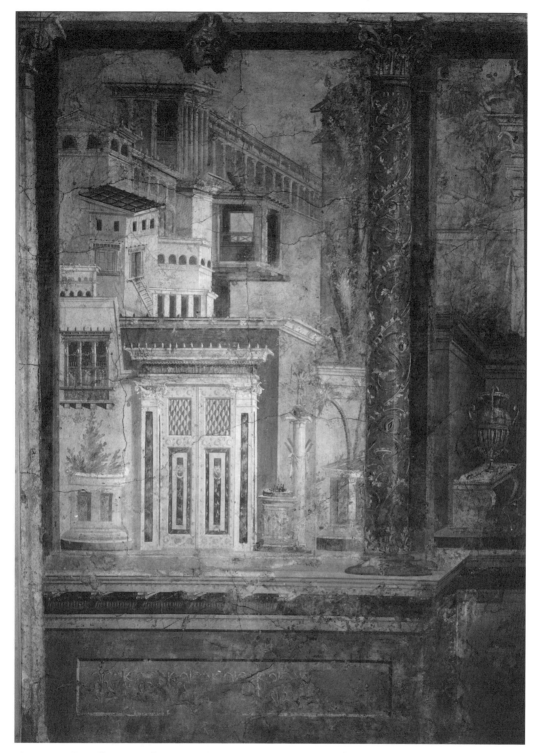

Fig. 35. Pompeiian wall painting, villa at Boscoreale. The Metropolitan Museum of Art.

space'), to let the whole of the parts and contents of space merge in a single continuous quantity."[15]

Here is an insightful analysis on which, different as they are, the classical perspective drawing comes out rather like what we found with Villard's drawing. It, too, is based upon "lumpy" substance or thing conceptions (things which bear spatial and other relations, to be sure), rather than upon a conception of a homogeneous metric space, in which objects are defined. It is a question of which comes first, substances or space, and again Panofsky has interesting (aesthetic) theories about the transition as being neither sudden nor complete. Fifty years after Villard's sketches, we find that even for Giotto, one of the "two great innovators" of the line leading to modern perspective, "space is generated by the solids instead of pre-existing them," for "he conceived of three-dimensionality not as a quality inherent in an ambient medium and imparted by it to individual objects but as a quality inherent in the individual objects as such" (119–120). Panofsky's contrast has strong appeal when we look at classical works, since it certainly appears that the artists there thought first in terms of nominally distinguished kinds of substances, which, as they worked them together, they adjusted into something similar to linear perspective. This does still seem (as a famous book title goes) "the natural way to draw," even today, when we are so accustomed to linear perspective in photographs, drawings, and paintings. We all start out as "Villardians," as it really does take a particular kind of training to set out one's perspective space first, then work in the things and features to be depicted. Before going on to the technological development of this account, consider two arguments why we remain "Villardians" even after we have learned perspective, even in our most advanced technical drawings.

A first, usually overlooked point can be derived from Panofsky's own words. According to Panofsky, on the modern conception, "every point" in the imagined space is presupposed as uniquely defined in 3D along what we call Cartesian coordinates, and "the whole of that space" is projected onto the plane.[16] However, this conception is seriously incomplete, for, should we attempt to make a physical projection in this way, all perspective drawings would be the same drawing (fig. 36). It seems that to be a useful drawing technique, perspective needs severe filters on the whole space. It is

for this reason that the standard heuristic diagrams, in their many variations, demonstrate, just as we did, the projective correlation of only a *few* selected points in the imagined space with those on the projection surface (see fig. 25). Of the many possible filters on the countless available points, we standardly choose two and, understandably, in a Villardian way. It is usual to draw only a few 3D figures—"carpentered" ones, usually in outline—and to project points from these, to guide placement of points from less carpentered figures by relations to them. Which points? If we choose all, we get something of possible use, a solid silhouette, but for design drawing we usually choose only a few: again, which? Left free to select points, as is well known, we might derive any 2D figure we wish from any imagined 3D figure, so all drawings could again come out the same. It is normal practice to put a very heavy filter on the projection and select only particularly descriptive points from the surfaces of the objects, notably those along edges—especially at vertices (as in the Taylor)—and the "outline" ones, which Alberti favored for his "willow wand" projectors and which we will later call "occluding contours" of figures. The hardworking fellows in "Lute" are depicted as well aware of this procedure. This still leaves them (and us in every case) with a connect-the-dots puzzle, usually unremarked when we draw in the lines the way we want them, relative to the motif object, as I have in all our preceding diagrams. Let that not go unremarked by the theorist.

All this shows that drawing with the modern conception of perspective presupposes a great deal of Villardian interpretation, nominal or categorial, of "things."[17] The difference is only that the categories themselves have been attenuated from nice substantials, such as "wheel, saw, sapling," to

Fig. 36. "Every point" perspective projection.

"*pavimento* (tile floor), edge, vertex," and even "point, surface, line." And, for design use, even the last three will have to get reinterpreted back in the direction of substance-categorials: we have to be able to tell one *thing* from another—this cube, that cylinder—in order to tell apart the "solids and voids," as Panofsky says. It may seem trivial to remark that not only in machining and casting but in all construction, we have to distinguish our solids from our voids and identify each solid part as a distinct entity. That kind of graphic articulation calls for specific drawing techniques, entailing additional skill or software. Therefore, not what the system linear perspective has done, but what *we* have done with it, is to rearrange a kind of drawing already "conceived as an aggregate or composite of solids and voids," without which we can scarcely do, and which no projective system could produce for us. To put this another way, the drawing theorist John Willats makes an important distinction between, on the one hand, perspective and other projective "drawing systems" and, on the other, "denotational systems," as follows: the one tells us where the marks go on the surface, the other tells us what they mean. But I have been arguing that we cannot even know which marks to draw—much less where to put them—unless we already have an idea of what they will mean.

I said, "left free to select points, we might derive any 2D figure we wish from any imagined 3D figure": that point, routine by now, is here put in a Villardian way against Panofsky. If at first projection we were embarrassed by too much data (fig. 36), and hence no information, now the embarrassment is that each of these filtered data points is itself projectively overloaded. Consider this a priori and through everyday experience. A priori, we see that even if we presuppose a projected space "in which every point," as Panofsky writes, "is uniquely determined by three co-ordinates perpendicular to each other" (x, y, z), all such points along a projection line to the surface share the same address on that surface. For example, in the Taylor diagram (fig. 25) *any* point along the "B-line" would project the same *b* onto that surface. This applies as well to environmental perception. From experience, without contextual help, we cannot tell from a distant point of light in the dark how far away it is (thus the binary star ε Aurigae, featuring a three-trillion-kilometer-wide component, 3,400 light-years distant, may be mistaken for

an airplane or a streetlight). Although we do better for closer lights, due to binocular vision, that does not help in the case of the perspective 2D projection. Indeed, ordinary perception demonstrates most of the time how, even with far more context than a starry sky provides—including aerial perspective, which we have not yet considered—we are increasingly vague about how far off things are. Notoriously (often dangerously) we radically underestimate distances for faraway or "vista" scenes.[18] Even when we move closer or have binocular help in good light, we are still very approximate about spatial relations, especially with natural forms such as trees and bushes (a point E. H. Gombrich liked to stress), but also with architecture, despite precise perspective projections. Thus Ivins was surprisingly careless to write, "Perspective may be regarded as a practical means for securing a rigorous two-way, or reciprocal, metrical relationship between the shapes of objects as definitely located in space and their pictorial representations."[19] It is certainly not two-way, and we rely heavily on Villardian object-hypotheses to filter these bewildering ambiguities even from perceptual consideration, which would make seeing too wearying, even when we could resolve the ambiguities.

PANOFSKY'S PERSPECTIVE II: "POST-PERSPECTIVE" ARGUMENTS

After reviewing these general historical and conceptual accounts of Renaissance perspective directly owing to Panofsky, the question now is how others might have extended them to a historical thesis about the place of perspective in the development of other "rationalized" modern design techniques. As remarked, Panofsky himself had nothing direct to say about constructive design techniques. When we look to him for applications, we find him in the P2 and P3 quotations making statements far too expansive for our purposes, speculations about the importance of Renaissance "representational techniques" (notably perspective) to "the rise of those particular branches of natural science which may be called observational or descriptive" and the importance of perspective to the "history of modern science." Nonetheless, Panofsky's other writings contain specific remarks concerning Renaissance science that are at least relevant to engineering. These occur in his com-

ments on Leonardo's drawings. Although, ironically, he leaves aside Leonardo's design drawings, he does focus on the well-known anatomies, where we find important techniques common to the two kinds.

At work again in these anatomical comments is Panofsky's master idea of "a new approach to the visible world," based "upon a new definition of artistic construction and representation," which began in the fourteenth century but was not "rationalized into a philosophical and mathematical theory" until the fifteenth. Here, in familiar terms, Panofsky writes of a crucial reconception of the surface as no longer that "*on* which figures and thing are depicted" but rather "as an imaginary windowpane *through* which we look out into a section of space"—using Leonardo's expression "*pari-eto di vetro*," a wall of glass.[20] As remarked, histories of Renaissance technological design appear to include a spectrum of views that still take Panofsky as a point of departure. For example, in a series of books and articles Samuel Edgerton has argued an extension of Panofsky's general thesis regarding the rationalization of perspective to applied technology.[21] Edgerton, too, postulates the historical arrival of a new windowlike treatment of the drawing surface, by which the artist "will think of the various details in his pictures as seen from a more or less fixed view point"—an attitude, he holds, that led not only to linear perspective but to chiaroscuro or well-developed light and shadow effects (169). The significance of these methods for technological drafting, he holds, is that "the 'realistic' artistic techniques and conventions" of linear perspective and chiaroscuro made possible a kind of "artisan-engineer" drawing, opening the way to modern engineering design and construction.[22] So here we have the Panofskian supplement, applied to graphic design and the modern world. Perspective, Edgerton claims, made possible the drawing of objects and their parts as "perceived in their proper size, scaled according to distance" and with "accurate dimensions and proportions to scale," and it also opened the way to what he terms the "postlinear perspective" techniques of the exploded, rotated, and cutaway views essential to engineering drawing (177, 192, 183). In various writings Edgerton attempts to illustrate this advance by comparisons of Renaissance drawings with some from previous times and different cultures. Among his pre-perspective European drawings we find

our Villard; among his cross-cultural examples is a Chinese copy of a European drawing of a water-raising device.

We have already seen that, regarding claims about what Panofsky called "a total and rationalized [drawing] view," in itself perspective projection provides no revolutionary drawing system—indeed no system at all—unless accompanied by directions about what kinds of marks to make by its guidance. Also we have seen that for effective design drawing those directions require supplements and a controlled context. All that is admitted by design historians of the perspectival camp when, as often happens, they fill out their histories of perspective with a number of other "representational techniques," including what Edgerton calls "postlinear perspective" practices, although it is not made clear how these practices *presuppose* perspective.

Returning to Panofsky, to illustrate these supplements by a well-known case, he and others have made large claims for Leonardo's anatomical drawings, to the effect that they show great advances over medieval efforts in content and in method. As often observed, Leonardo's anatomies, or "natural designs," exhibit consistent perspective, attention to proportion, and separation of "working parts"—and we may add, separation of working systems too: detailed and rotated views of the skeletal, muscular, circulatory, and reproductive systems. Now, Panofsky held that in the anatomies Leonardo also pioneered the "correlation of perspective images with vertical and horizontal sections, the demonstration of the internal organs 'in transparency'; the reduction of muscles to mere 'strings' in order to clarify," and "serial cross sections."[23] Other historians have accorded Leonardo some additional inventions, also essential to modern design, notably explanatory texts with letters keyed to the drawings, cartographic coordinates, "exploded" images, and dotted alignment lines.[24] As for whether any of these presuppose perspective, however, we find that in his own brief for the fifteenth-century Sienese engineer Mariano di Iacopo (called "Taccola" or "Jackdaw") Edgerton disagrees that Leonardo is so much the innovator.[25] Though no artist, Taccola, as Edgerton shows, had good design drawing sense. For example, he makes the fit of parts clear to what Ferguson called "the mind's eye," sometimes by drawing a thing in such a way as it "cannot normally be

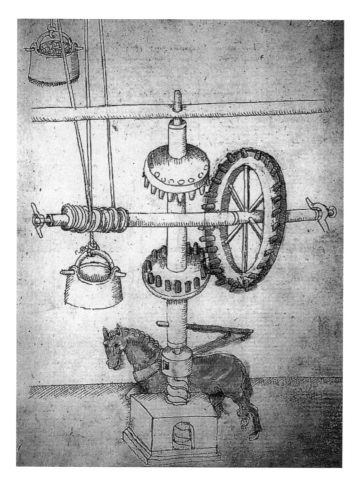

Fig. 37. Taccola (Mariano di Jacopo), Brunelleschi's ox-lift device. From *Il Libro de Ingegneria,* Palat. 766. Biblioteca Nazionale Centrale, Florence. By permission of Il Ministero per i Beni e le Attività Culturali.

seen in a single view"[26] but is nonetheless visualizable, as we see in his important record of his friend Brunelleschi's ox-hoist for lifting the almost two-ton sandstone beams of his dome in Florence (fig. 37).[27] A little here and more clearly elsewhere, Taccola also deployed a number of the so-called "post-linear perspective" devices that have been credited to medical illustrators such as Leonardo. That is interesting because, as we are now in position to see, many of Taccola's drawings are not actually in perspective but rather in orthographic and varieties of oblique (sometimes reversed for clarity of the object, like Villard's axle). In other drawings Taccola uses some perspective diminution, though not consistently. Thus, by Edgerton's own testimony, rather than being "postlinear perspective," such devices are independent tools added to the practical drafting "toolbox" at various times. With that much indication of how we find Panofsky's historical theory of perspective extended in the direction

of modern design drawing, let us now consider the theory dialectically, with four objections and some replies.

PANOFSKY'S PERSPECTIVE III: ASSESSMENTS

Our inquiry appears to have turned up a historical irony: beginning with the Renaissance itself, we have been accustomed to versions of a dramatic story of perspective's birth—or, as Panofsky would have it, transfigured "renascence"—interwoven with accounts of a renaissance of art, naturalism, and much else, whereas we have no cultural drama of the development of the other projective systems, the ones that actually make the modern, designed world possible. In a fanciful way one might say the following. Besides perspective's strong public-relations efforts, what allows this situation is that perspective is what we might call "a manifest sys-

tem" of drawing, while the other systems are not. That is because perspective is a visually *pictorial* technique for making things (pictures), in which it, perspective, appears, while the others tend today to be considered specialized techniques for making more important things, such as buildings, machines, and devices of all sorts, in which they do not appear. In other words, as more than a "contructional" technique, in the final production perspective is usually onstage, while the others stay off, behind the scenes—so much so that when they do appear they go largely unremarked, or are mistaken for primitive or faulty perspective. And now, it seems, that in this Mary and Martha situation, we find insult added to injury: perspective is accorded historical prominence regarding the backstage work as well, for it is considered the system that pulled into line the old undisciplined crew, shaping it up for serious, modernizing achievements.

Two criticisms of such impressions are apparent from the preceding. The first—for reasons made clear in exposition of the projective family—is that, as Booker remarks, "perspective projection is not a primary medium for modern engineering drawings."[28] And, as we just saw with Taccola, it was not a primary medium for engineering drawing for part of the fifteenth century either. Indeed the uniformity and systematization we find in the modern curriculum regarding the really important design systems of orthographic, isometric, axonometric, and oblique projections look more like rationalizations of Taccola's techniques—even of Villard's. Few today would condescend regarding the structures of the choir of Burgos Cathedral, of Rheims (drawn by Villard in details, plan, and interior/exterior—though faulty—elevations), Sainte-Chapelle, Westminster Abbey, to name a few three-dimensional designs contemporary with Villard.[29] No doubt the advent of perspective was in some ways important in this gradual process of "rationalization," but why consider it crucial? As Caroline Elam remarks, even the famous first theoretical writer and proponent of perspective, Alberti, was also "the first to point out . . . [that] perspectival representation, while beguiling to the eye and useful for conveying ideas to uninstructed patrons, impeded the accurate recording of measurements in architectural drawing, because of the distortions produced by diminution into distance."[30] As for design in the next century of the High Renaissance, which had mastered perspective, Michael Hirst re-

marks that "Michelangelo's rejection of perspectival conventions for architectural drawing came relatively early, and its importance has been neglected," adding that in his design sketches Michelangelo sometimes used reverse perspective.[31] Finally, Raphael, in a famous 1519 letter to Pope Leo X concerning the archeological survey of ancient Rome, distinguished constructional from design drawing and separated it from perspective as better rationalized. He also provided more rigorous instruction on the method used by Villard at Rheims three hundred years earlier, in which an architectural drawing includes plan, façade, and internal elevations:

> And because the method of drawing that belongs to the architect differs from that of the painter, I shall state what seems to me appropriate to understand all the measurements and to know how to find all the parts of a building, without error. The drawing of buildings, so far as the architect is concerned, therefore should be divided into three parts, of which the first is the . . . ground plan, the second deals with the exterior . . . the third, with the interior. . . . [For the elevation] always measuring the whole on a fine scale, one should draw a line of the width of the base of the whole building, and from the center of this line [a perpendicular] . . . ; in this shall be the line of the center of the building. . . . [All vertical elements of the façade shall be included according to scale in a system of parallel verticals . . . ; an analogous system of parallels to the base line is used for the horizontal elements.] The third part of this drawing, which we have defined as the interior wall, . . . is no less necessary than the other two, and is made in the same way from the plan with parallel lines, like the wall of the exterior; and it shows one half to the building from the interior, as though it were divided in half.[32]

"To find all the parts of a building, without error": thus a second, more radical, and a priori criticism of the Panofsky view comes right out of our projective-family diagrams. If modern linear perspective presupposes what Panofsky calls "a total and rationalized view," due essentially to positing "a homogeneous system within which

every point, regardless of whether it happens to be located in a solid or in a void, is uniquely determined by three co-ordinates perpendicular to each other and extending *in infinitum*," such is presupposed just as much by all other members of the family of projections, as is graphically evident. Not only do the diagrams for all the systems use the same "three-space" or 3D object—and also 1D projectional coordinations of (select) 0D points there with those on a 2D surface—but extraction of that spatial information is most ambiguous with perspective. Possibly Panofsky is right about perspective's place among *pictorial* practices, but, even allowing for "the mind's eye," it should be clear now that design is not simply a pictorial practice, as Raphael points out. The historical challenge to the Panofskians is to explain why in getting from Villard's design practice to Raphael's we should need to bring in perspective.

In review, we have seen that, before Villard, three-space indications were recorded for millennia worldwide, in orthographic drawing, direct tracings, and scaled drawings. Historians report that Michelangelo made drawings "for the making of metal templates to guide the masons," and medieval and Renaissance European stonemasons served apprenticeships in quarries rough-cutting and dressing stone, according to templates.[33] Similar practices would have been followed worldwide through ancient times. Regarding the use of tracing in drawing more generally, let us never overlook the "metric" spatial assumptions made in the age-old "constructional" drawing processes of tracing by rotation of templates, left/right, top/bottom, or along a plane—operations we have all performed and essential operations for what we call symmetry of design (mirror and rotational), a main drawing procedure everywhere. In view of all this, what case can be made for the historical priority of perspective in spatial rationalization? As we have seen, what makes the perspective diagram singular is that its projectors converge at (or radiate from) a focus, rather than being parallel; however nothing in Panofsky's case for a "homogeneous" three-space rests on that characteristic. Indeed, we have just mentioned the difficulty of calibrating perspective drawings, as compared with their standard working design cousins, in order to dampen two kinds of ambiguity. And there is still worse in store for the extended Panofskian view. Elaborations of the foregoing objections will now follow, taken

from historical studies but armed with a fresh drawing distinction. As it will be very important throughout this book, now is a good time to introduce Peter Booker's indispensable distinction between "first and second geometries" in drawing.

HANDS ON: FIRST AND SECOND GEOMETRIES

When considering the standard, quick, and appealing expositions of perspective and other projective systems by means of the shadow and other diagrams, as we have just done, we might recall a line from *Pride and Prejudice*: "The power of doing anything with quickness is always much prized by the possessor, and often without any attention to the imperfection of the performance." Indeed, for all its usefulness, understanding a family of drawing techniques as based on such projection models has proved profoundly misleading—all the more misleading, since, with the invention in the late eighteenth century of projective geometry, such expositions can be accomplished more elegantly without recourse to our diagrams. For, as John Willats has stated (referring to Booker), when it comes to actually making and using drawings our projective diagrams "have little practical significance or psychological reality," "having been invented during the nineteenth century by textbook writers who wanted to give engineering drawing an air of authority by bringing it into line with Renaissance accounts of linear perspective."[34] More recently the computer and computer-assisted drawing (CAD) have been changing even the heuristic practice, since their programs are algebraic developments of systematic projective geometry. The use of computers may already be entering the visualizing imaginations of drafters—which may be all to the good, should that carry them clear of the physical projection models of shadow and camera. All to the good because, rather than the models providing an "air of authority," among the theoretically wise, the reverse has been the case.

When it comes actually to drawing—to getting a useful design drawing down on a surface—in order to direct the fabrication of something, models of projection, especially of families of it, are rarely helpful. As Michael Mahoney states, there is a gap between accounts of theory and practice in

histories of medieval and Renaissance engineering drawing. "What remains largely untreated," he points out, "is the structure of the engineering community: who became an engineer, how did he do so, what did he do in carrying out his *métier*? Until that set of questions is answered, it will be difficult to know precisely what purpose was served by the literature on machines."[35] We surely must address Mahoney's question, What did engineers actually do? It is remarkable how often overlooked is the simple fact that the projective diagrams shown above do not tell drafters how to draw—particularly remarkable regarding perspective. Consider Panofsky's account. Panofsky shows that the practice of perspective in the Renaissance was sometimes expounded in theoretical books in terms of glazed windows or things of the sort,[36] although it is by no means clear what thinking in terms of such glazed windows has to do with attaining the internal space advantages of perspective. Next, Panofsky provides no evidence that the working draftsmen who learned the new methods were in any way influenced by such analogies. The glazing heuristic supplies no instruction about how to make a perspective drawing, about what kinds of marks to put down, or where to put them. Furthermore, not everything manufactured is cubic, and when it comes to general directions, a common one for perspective drawing of smooth and "soft" objects such as human bodies—rather than the right-angle edged ones of the standard heuristic—is to think of the drawing plane not as before the object but as cutting through the middle of it. In that way one may achieve a strong silhouette or occluding contour shape, enclosing the object. It is often better to work the relations of the approaching planes outward from that. What were and are, then, the actual constructional working methods of drafters?

Willats observes that a good way to consider the practical directions for making drawings is in terms of what Booker terms their "secondary geometry" as opposed to their "primary geometry," which our projection diagrams illustrated.[37] To avoid repetition, it will help to use the abbreviations "geo 1" and "geo 2." Booker introduces the geo 1 / geo 2 distinction with regard to maps of the globe, which are often described through geo 1 shadow projections, rather as we did the drawing systems (see fig. 11). Of course mapmakers would not work that way, but rather by "geo 2"—that is,

by "a method of drawing a stereographic grid without recourse to the idea of projection at all." Applied to perspective constructions, primary geometry drawing would be "concerned with a . . . system of projectors piercing the picture plane," whereas secondary drawing geometry for perspective "would allow points to be placed in a picture by means of following a few rules and without invoking the primary" (33). As Willats puts it, with geo 2 perspective rules we maintain "the two-dimensional geometry of the picture surface without recourse to the idea of projection" (370).

Once pointed out, we can see this basic distinction to have been latent in our own thinking all along. For example, Raphael's account was in straight geo 2 language: he tells us what marks to put down on the surface, with no reference to projections. Even when describing the geo 1 family of projections, I was writing in geo 2, laying out the isometric, axonometric, and oblique systems. For example, in considering how, in the oblique system, if the plan lines are drawn at 45° angles from the facing elevations, the convention is often adopted of drawing them foreshortened to half scale. Those were instructions about what to do on the drawing surface, given a set of measurements, with geo 1 references to projections to a plane tucked in only occasionally. Fortunately, most of the instructions for drawing all the diagrams above can be stated in terms of such geo 2 operations on the drawing surface: that is, in terms of rules of "constructional drawing": first draw this sort of line there, then that one. For example, as Willats points out, our orthographic projection can be simply defined as "the system in which there are no orthogonals, and the front faces are drawn as true shapes" (12), with no reference to projections.

Let us briefly go over perspective again, in terms of Booker's geo 1 / geo 2 drawing distinction. Geo 2 rules are all about drawing, about the marks we make on a drawing surface. It is important to remember that in speaking of straight lines such as orthogonals, we will no longer be referring to *projectors,* as that is geo 1 language. To begin with what is very simple and well known, let us review the rule for laying down straight lines "representing" (to use a colorless word) edges, cracks, wires, texture, shadow edges, and the like. We know that perspective, unlike the other systems mentioned, features what Brook Taylor named "vanishing points" (VPs) on the projection surface for straight

lines that we want to represent: indeed, perspective can be singled out from its cousins as "the VP system." Bringing a group of straight lines to a common VP is a geo 2 rule that we all know, having followed it at some time, for example, in drawing railroad tracks. Now although people who should know better often speak of "the vanishing point" in drawings, photographs, and so forth, they use Taylor's expression very badly. What is usually meant is the common VP for the represented *orthogonals*: that is, the common point where the representations of all orthogonal lines must stop, if they are not already stopped for other reasons—notably by running off the physical edge. But there are normally many other straight lines to draw besides the orthogonals. All represented straight lines can be put into groups of parallels, which may be classed basically as two: groups of lines that are parallel to the surface as well as with one another, and groups (including the orthogonals) that are not. Drawings can sometimes be classified as to whether their dominant lines belong to one or another of these groups. Looking back to Dürer's quartet of woodcuts, "Lute," for example, features many lines of the first sort, of the horizontal and vertical groups, with one significant diagonal. As with orthographic drawing, in perspective drawing the first group can in principle be extended as parallel right across the surface, and although the lines may run off the area of projection (which Dürer avoids with his horizontals in all four), they themselves have no vanishing ends.

By contrast, the groups of parallel lines that are not parallel to the surface all have vanishing points, places on the surface where one must stop drawing them, even if one has not come to the end of an edge or run off the drawing area. Each of these groups forms a sheaf, with a common VP on the surface, and at a unique place there. Orthogonals being an important subclass of these, their VP is an important one, which may be called "the central VP" or "CVP." This simple kind of perspective, a main one in design drawing, is sometimes called "central perspective"—a quite meaningful geo 2 category, as we see in the Dürers—but too often confused with linear perspective itself. Most perspective drawings show a number of other VPs (e.g., Taylor's perspective diagram), but many show no CVP. It is therefore disappointing to find even "the wise" sometimes referring to "the vanishing point" of the most famous of all early per-

spective constructions, Brunelleschi's legendary one of the Baptistery of St. John in Florence, as a paradigm of CVP, when standard reconstructions show several VPs but no CVP, for the simple reason that drawing it requires no orthogonals at all.[38]

Panofsky in "Perspective as 'Symbolic Form'" gives an account of perspective similar to ours (that is, in terms of groups of projected parallels), adding an important subclass to the nonorthogonal ones, where "the following laws hold": "Parallels, in whatever position have a common vanishing point. If they are in a horizontal plane, this vanishing point is always on the so-called 'horizon,' that is, on the horizontal line drawn through the [CVP]." He adds that "if they form an angle of 45° with the picture plane, the interval between their vanishing point and the [CVP] is the same as the 'principal distance,' that is the same as the interval between the [focus] and the picture plane."[39] Actually, there will be two such points on the horizon, on opposite sides of the CVP, usually called the "distance points" (short for "distance vanishing points," or DVPs), and these, we shall see, have a very important role in historic, practical geo 2 perspective procedures. Just before considering that, and speaking of early Renaissance diagrams explaining linear perspective, we should notice that classic, influential presentations are mixes of geo 1 and geo 2. The earliest and most famous, Alberti's, begins with a geo 1 projective conception of a picture as a "cross-section" of a "pyramid" of his "visual rays."[40] But his description does not tell us how to draw a picture. And when he gets down to business, his actual rules are entirely phrased in the geo 2 language of shop craft: "I will tell what I do when I paint. . . . First of all about where I draw. . . . Here I determine as it pleases me," and so on. Alberti begins his geo 2 rule list with a rectangle and says: "I divide the base line of the rectangle" in equal parts. He positions the CVP within this quadrangle ("where it seems best to me, I make a point") but mentions no horizon line. He runs lines from his baseline divisions to the CVP, to represent evenly spaced orthogonals. The next problem—the next, crucial, geo 2 rule sought—when drawing a tile floor (*pavimento*) concerns the intervals at which to cross the orthogonals, in order to set down a group of lines of our first classification (those parallel to the surface), thereby representing evenly spaced edges retreating into space. One may recall from childhood a dodge for

Fig. 38. Perspective transversals construction: spacing for fence drawing.

cates a 45° DVP, is the basis of another approach exposited in the early sixteenth century by Viator (Jean Pélerin), which is perhaps a better candidate for a Booker prize, as Viator's is all in geo 2 language, making no reference to projection (figs. 22, 39).[41]

On this perspective method (from which the childhood dodge derives), we begin with a horizon. Two 45° horizontal "distance-points" or DVPs are placed on it on opposite sides of the CVP to form a trio ("*tiers points*") on the horizon.[42] One of the horizon DVPs together with the CVP provides two sets of equally spaced rays, by whose crossings we can "fix" selected points in the drawing, as in his diagram (fig. 39). Most notably, we can locate the transversals by marking equal intervals on the baseline (as shown), then connecting these to the selected DVP and to the CVP. The resulting intersections of the DVP lines and the CVP's orthogonals locate points through which to draw the transversals. For finding the transversals, one can also dispense with the orthogonals, using the crossing points of the two horizon DVPs. Thus Viator's method, being essentially three-point, has us, early on, drawing perspectives of corners edge-on—rather as they are presented to us in isometric and axonometric methods (fig. 39). Given that this method was widely used (often combined with a CVP *pavimento,* as in Leonardo's famous Uffizi *Annunciation,* which puts the DVPs on the picture's edges and stresses DVP diagonal pavings), it is misleading to call even very early Renaissance perspective "central projection." As we saw with

evenly spacing the rail intervals on a fence diminishing to a VP (fig. 38). If you run a center line to the VP and put in your first two closest palings, a diagonal locates the base of the third paling. Then you can repeat the process until it is out of sight, a nice example of an iterative or "keep doing the same" production rule. Alberti's own rule, however, is roundabout. He takes "a small space" off to the side, where he draws an orthographic representation of a projection to a focus. He then transfers the (scaled) results of this to his first diagram, to find the transversals. Next, he draws a diagonal through the result to check it, and finally draws a horizon line through the CVP (57–58). Although Alberti seems unaware of it, his diagonal, which lo-

Fig. 39. Viator (Jean Pélerin), distance-points diagram. From *De Artificiali Perspectiva,* 2nd ed., (Toul, 1509).

cartoons, corner views hold much appeal (see figs. 27 and 29).[43]

GEO 2 PRACTICAL: FIXING DÜRER'S URN

To review our important primary/secondary geometry distinction and, specifically, the CVP perspective rule for the latter, let us go over an example. Consider again one of our Dürers, "Urn" (fig. 32). Although this *depicts* a geo 1 approach to perspective, Dürer would have drawn it by geo 2 methods, probably by distance-point. And although the woodcut is based on a drawing by Dürer (see note 11), it is probably posthumous, and other hands have made a rough job of it.[44] A straightedge shows loss of even the elementary geo 2 CVP rule, as the extensions on the left of some of the loosely drawn orthogonals fail to join the big sheaf of the others at the CVP marked at the wall for the other orthogonals. Not only is the door frame awkwardly drawn, ironically, the depicted draftsman is at pains to draw in perspective an urn that is indicated with careless perspective. "Fixing" this lopsided figure provides us a useful review. At a glance, it looks wrong; since the picture's horizon is around the draftsman's eye, it is clear that the rim of the lid, which is just below the horizon, should not present much curvature (fig. 40). Further out of whack is the broader shoulder of the urn, whose ellipse shows far too much height: it is between the isometric ellipse of Farish's urn (fig. 18) and a correct perspective. A standard geo 2 method for drawing round objects in perspective is called "crating": we place a constructional box around the urn, as though we were going to store it. To fix the shoulder, we need to find the projection of the box's square into which a circle representing the edge of the shoulder would fit, something like a shallow rhomboid. Two sides of this shape are easy to find: we might imagine the front and back of the crate to be parallel to the front and back of the plinth the urn stands on. The edges of the crate's left and right sides, being orthogonals, would be directed, along with all the other orthogonals, to the CVP clearly marked just left of the door. This follows our simplest geo 2 perspective rule, but the crucial question is *which* horizontals and orthogonals we should draw and connect to show the box's sides. Here we encounter the old problem of transversals. To solve it, as we saw, we must find at least

one of the two distance points (DVPs) along the horizon, and, as always with perspective, that entails making a crucial assumption. Since we can pick out only two horizontal rectangles that show their opposite corners (the plinth and the table), if we assume these to be square, their diagonals represent 45° directions, whose crossing points at the horizon set up the first transversal (like the picket-fence geo 2 rule). More convenient is the plinth's diagonals: "x marks the spot" through them, telling us that the urn is pushed back from the plinth's center. The extension of one of these diagonals crosses the horizon, yielding a DVP outside the left margin of the drawing. From that point we can draw a sheaf of lines, picking out a couple to indicate the crate's corners, where the lines cross its front and back edges. Drawing the square top of crate, then the curve of the urn's rim inside it, we would flatten Dürer's ellipse to around a third of the height in the woodcut. Once again, we defer discussion of how the picture *looks* to a later chapter: the point here is how far short perspective falls, regarding Raphael's "all parts" and "without error" requirement.

In summary, the Booker-Willats geo 1 / geo 2 distinction, by providing us with critical tools sadly lacking in the history of controversy about perspective, allows us to strengthen the two criticisms of the historical thesis that Renaissance perspective was the key instrument of change toward modern design drawing. In the case of geo 1, as we have already seen, even if perspective does encourage a "windowpane" attitude, that is neither simply because it is projective nor simply because it presupposes Panofsky's "homogeneous system within which every point . . . is uniquely determined by three co-ordinates perpendicular to each other."

Fig. 40. Detail study of Albrecht Dürer, "A Man Drawing an Urn." The nested ellipses show Farish's isometric, the urn shoulder as drawn in Fig. 32 (averaged) inscribed within it, and an approximately corrected perspective by "crating" inscribed within that.

These features are shared by perspective's half-dozen cousins—which are, in addition, more perspicuous regarding three-space properties. Now we see that, in terms of actual procedures, it is questionable how much early modern designers needed geo 1 conceptions, whereas, for sure, they needed to add a more systematic set of perspective geo 2 procedures to their drawing "tool kits."[45] For half a millennium, geo 1 fallacies have muddled not only understanding of linear perspective but of the Renaissance itself.

Second, we are in position to see, in the surviving or inferred technological drawings of various cultures and times, that many of these tools were already in use before the "renaissance" of perspective—though, of course, less organized, with fewer degrees of precision, and in unsystematic mixtures (see fig. 21). The antiquity of geo 2 rules of plan and elevation are indisputable. Besides being used in ancient architecture, as Panofsky points out, they are evident in the carving of dynastic Egyptian figure sculpture.[46] As for Egyptian painting, we can even clarify cliché: an Egyptian way of drawing human figures was by well-chosen geo 2 orthographies, elided by graceful linear transitions. Revisiting Villard's saw (fig. 8) with our new analytic tools, we see how his "naïveté" consists in using drawing tools from too many geo 2 methods, which in his time were a long way from being codified in different consistent systems with distinct powers. Absent physical or mathematical geo 1 thinking, an early thirteen-century artisan has used something like geo 2 oblique on the two circular shapes around the axle, except for a dash of perspective shortening of the lower parts of both, presumably to keep them down. While his saw blade, sapling, and forked support are in orthographic, the log and the guide structure seem to be in overhead oblique, as orthographic would not show the guides' positioning accurately. Unimpeded by modern conventions, an orthographic blade makes its way through an oblique log, to reveal the cut. The crucial point of contact between wheel teeth and log is orthographic, though neither object is. To appreciate the rotating spindle pegs in oblique better than before, *we* must rotate, too: that is, turn the sheet upside down (also better to see the insertion of the axle in its mount). Then we observe how that problematic principle of contact and action against the orthographically rendered scissor mechanism suddenly makes more visual sense (although the axle rotation becomes clock-wise). Let us not be hard on Villard. "Visual sense," "relevant clarity to interpreters": this imagined rotation of Villard's sketch will be useful to us if it helps us not take so much for granted as we might with a modern diagram. It reminds us that (as Ferguson argues) precision is of value only within a general "mind's eye" grasp of what is going on.[47] But what is it that gives a drawing visual sense, makes its subject visualizable? These are nice questions, which a philosophical study of drawing is obliged to address.

GEO 2 HISTORICAL: WHAT IS "POST-PERSPECTIVE"?

Using Booker's drawing distinction in consideration of Panofskian claims about the crucial place of linear perspective in the evolution of modern design drawing, let us, as before, move to the alleged "post-perspective" part of those claims. In contemporary engineering drafting, geo 1 and geo 2 rules are mixed into the typical curriculum, which includes study of the principles of descriptive geometry, projection of single points, line, planes, and curved shapes, and of three-dimensional bodies. Students study the principal projections, with stress on "developments" in orthographic drawing and on isometric, axonometric, and perspective methods. In all this, geo 1 projective methods may be heuristically useful, but geo 2 procedural drafting methods are prominent: now more so with computers. Engineers study sectioning and dimensioning. Besides sectioning, real assembly drawings are important, with attention to the forming (including the casting) and the fastening of built-up components by bolts, welds, rivets, and so forth. For proportional dimensioning, engineers have to know the relations of scale to materials and functions. In summary, for our topic of design production, two values typical of modern drafting emerge: a high degree of relevant precision with spatial complexities of certain sorts, and a good measure of relevant clarity to interpreters, entailing a historical extreme in standardization. Such qualities were not foreseeable in Renaissance Italy, or before it or elsewhere. The histories of these values in different parts of the world require more careful study.

Modern architectural drafting shares many of the same features, and here especially it is important for our future work that we be careful about categorizing whole *drawings* in any of the terms

just explained. When discussing these and other kinds of drawings, let us recall another Villardian point, that whatever methods we discuss, it is usual practice to *combine* methods in single drawings. As Elam points out, in Renaissance architectural design, where detailed orthographic elevations of buildings—especially of facades—were standard, often a "draughtsman (like Serlio) has been unable to resist the use of perspectival elements to enhance the sense of depth," including one-point perspectives down the middle.[48] Again, although a drawing of a building or device can be mostly in one-point perspective, we hardly wish to restrict ourselves to cases where all edges or faces are either parallel or at right angles to one another; therefore in single drawings two- and three-point perspectives normally appear. For modern design drawing, including engineering, perhaps the most important instance of combination is the already mentioned "development": three orthographic renderings—of the elevation, end-elevation, and plan—of something brought together onto a single drawing surface.

Now that we have reviewed the geo 1 shadow-projection presentation of these drawing systems in a few cartoons, we can see how the idea of geo 2 rules can be even better extended along the whole theme of the book, "all kinds of drawings," and beyond to photography and moving pictures. When we look beyond this chapter's design topic into pictures (relaxing the rules and expecting mixtures), we find masses of examples of geo 2 methods at work with no lurking geo 1 projection. It turns out that the mixed Villardian tool kit of devices is common. In conclusion, having considered the geo 2 forms of the main devices of the parallel systems in which our modern world is drawn, and finding them to exist both well before and during the modern period—in industrialized and in traditional societies—it would appear not only that the stream of systems is very old, very wide, and very natural to human societies but that, rather than culminating in modern drawing systems, it flows right around them.

DEFENDING PANOFSKY: DISTINCTIONS OF SCALES

By now the Panofskian idea of the historical primacy of perspective in producing the modern world seems seriously in question. First, we have

seen not only that perspective is not a main design system but that the main systems are independent of it, making recourse to it neither in theory nor in practice. If anything, as the standard diagrams show, perspective, both in conception and in execution, is often based on orthographic constructions. Next, we have found that these other systems, quite as much as perspective, presuppose Panofsky's "homogeneous system within which every point, regardless of whether it happens to be located in a solid or in a void, is uniquely determined by three co-ordinates perpendicular to each other and extending *in infinitum*." Then, we saw how in expert practice, as opposed to our amateur introduction, the rules for these systems (including perspective) are largely geo 2 or (on computers) algebraic, not depending on physical projection. We now appreciate that the modern design forms of most of these systems can be understood as special developments from widely based drawing methods that long predate perspective, methods richly and diversely developed, even systematized, in a variety of cultural and specialist traditions.

But as our dialectical procedure invites replies, we must inquire to what extent the Panofskian could turn that very historical evidence around in counterargument, by asking what does distinguish the modern technical design forms of the parallel systems from their ubiquitous, older geo 2 techniques. The answer, generally stated, would be that the older systems consist in a series of devices, dodges in our drawing tool kits, whereas by the early nineteenth century modern drafting techniques had become rigorously systematized, remarkably developed, and, of course, standardized in particular ways. In what ways? Here it seems open to the Panofskian to reply that part of what we are requesting is a development of what Panofsky meant by the phrase "a homogeneous system within which every point . . ." etc. For example, refined as they are, neither Egyptian and Mayan orthographic depictions (see fig. 65) nor some Chinese oblique depictions are systematized *that* way. While providing, for example, clear planes of recession, such drawings do not really give us the three-space homogeneity of design systems.[49] We can be more exact about what that means. Since, in criticizing the Panofsky view, I introduced some basic drawing distinctions (notably the geo 1 / geo 2 distinction), it is only fair that in defense of Panofskians, we introduce here another important

set of distinctions. Responding to the engineering arguments regarding "scaling," let us review some standard distinctions regarding scales or categories, known as nominal, ordinal, interval, metric (or ratio).[50] In good Socratic style, we will find them to be conceptions with which we are already well acquainted.

The *nominal* we already know from the "thingyness" theme out of Villard. Next, put in terms of these additional scale distinctions, we can say that although nontechnical drawing systems such as the Mayan provide clear indications of the order in which things recede or come forward (one thing behind another, a third behind the second, therefore also behind the first), they do not employ uniform standards of the relative proportions of these spatial differences. Useful words for saying this are "ordinal" and "interval": regarding depth relationships, such drawings are clearly and uniformly ordinal but not clearly and uniformly interval. This is a description, not a criticism. Sometimes in evaluating things all we wish is a rank ordering; other times we look as well for groupings within the order, thus running a second nominal classification over it, where we count not the original items but their rank clusters: in making decisions, short lists are formed that way. A classic case of the literally nominal and ordinal, "Abraham begat Isaac, and Isaac begat Jacob, and Jacob begat Judas . . . , and Judas begat Phares" (Matt. 1), gives clear order without much information about relative intervals of begetting. But, "Then Abraham . . . said in his heart, 'Shall a child be born unto him that is an hundred years old? and shall Sarah, that is ninety years old, bear?'" (Gen. 17:17) suggests that the "begat" descriptions deliver *some* interval information. That is, we assume that certain intervals of begetting are normal, otherwise Abraham would not have fallen on his face and laughed.[51] Similarly, we can assume a great deal about the spatial intervals in the Mayan drawing, whose rough intervals are guessed contextually, and, as noted with the Villard, the contexts include identification of the categories of objects involved—that is, via the nominals. "Scaling" by our background knowledge of the recognized objects in such drawings, we get not only rough interval judgments but also some unconscious dimensioning: that is, we apply an absolute or *metric* scale as well. ("Absolute" here just means relative to a much wider context, in which we know not only that a leg will be larger than a hand but also how big a leg or hand is.) This, in more precise terms, is what Panofsky meant when he insisted that the space assumed by Renaissance perspective differed from the ancient form, since "it denies the difference between in front and behind, right and left, bodies and what lies between ('empty space'), to let the whole of the parts and contents of space merge in a single continuous quantity."[52] With our new vocabulary, this means that in the Renaissance, we begin precisely to posit not only the spatial ordinal but also the spatial interval, independently of the nominal.

But the Villardian point is that this scaling independence is not complete. As earlier argued, for the nontechnical Renaissance drawings Panofsky discusses, we typically begin with some sort of object recognition, from which we derive immediate dimensioning of perspective drawings while we are taking in the ordinal and interval information. That the bed in Dürer's "Portrait" is understood as much wider than the chair is partly derived from our recognition of those objects. Since recognition is an ongoing (and going back over) process, it is to be expected that we confirm, modify, refute such scalings and also change the parameters of the job as we go along, assisted by additional factors not yet discussed. This introduces the theme that I will be calling "reciprocity," but here, at another threshold of discussing the perception of drawings as art, we step back again and note that the reduction of such contextual processing is the reason why engineering drawings come with standard templates indicating not only title, draftsman, sheet, file, and so forth but also "scale," and why dimensioning notations are required parts of the drawing (fig. 41). In Panofsky's defense, he does say that the independence in question is presupposed (for the first time) by perspective constructions, whereas it may not hold for our interpretations of drawings based on them.

With our new vocabulary and clarification, the Panofskian, in reply to my four objections to the case for priority of perspective for design, might ask why the ancient, broad stream of geo 2 devices for perspective's cousins developed its narrow, specialized band of modern design drawing, possessing the scaling features just clarified, only subsequently to Renaissance perspective. It seems unlikely that these devices would have flowed their merry ways along through modern design techniques without the invention of perspective, which

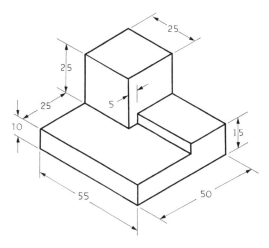

Fig. 41. Engineering dimensioning drawing. Author's rendering.

forced production of precise interval scaling upon its systematizers. Ivins appears to indicate just this:

> On the immediately practical side it is hardly too much to say that without the development of perspective into descriptive geometry by Monge and into perspective geometry . . . modern engineering and especially modern machinery could not exist. Many reasons are assigned for the mechanization of life and industry during the nineteenth century, but the mathematical development of perspective was absolutely prerequisite to it.[53]

The Panofskian can point out that this "mathematical development" in turn presupposed the geometric projective invention of Renaissance perspective. In terms of the drawing distinctions introduced above, we might therefore restate the Panofskian historical position, more modestly, as follows. Ancient perspective could never have arrived at the precise interval scalings necessary for the shape and dimensional specifications of modern design drawing simply by accumulation of the geo 2 perspective (and other) techniques it developed. The full set of geo 2 perspective tools in any modern drafter's toolbox could only have been derived by conceiving perspective projectively, as geo 1. For only with that conception could a rigorous set of geo 1 tools be developed, from which we could then derive their geo 2 correlates; only then

could those principle be set in mathematical forms. Thus (goes the reply) Panofsky was right to answer his initial, valid question, of why modern perspective did not develop out of the accomplished perspective of the Graeco-Roman world, by saying that it *could not* have. Ancient perspective was never based on even rudimentary geo 1 conceptions. As a result, all it might ever have acquired would have been a collection of geo 2 perspective rules, derived from observations and trial and adjustment. But as to observation, the so-called constancies of vision would have blocked our empirical discovery of rules of perspective such as diminution as inverse to distance or the falling off of foreshortening with distance. There is much evidence that people do not observe that way.[54] Such observations could never have produced the rigor of even the most basic perspective rules, such as the laws of vanishing points or for placing transversals, and far less have suggested how to produce the shapes of circles and other curves presented obliquely. Without geo 1 constructional rules, no drafter could have hoped to produce a proper perspective of an object such as Dürer's urn. Such (the defense might continue) was Panofsky's basic thesis, and in that he is surely right. And regarding its extension to design drawing, what the Panofskian might now add is that perspective, alone of its family of drawing systems, was cast in projective form in the Renaissance, opening the path for its sister systems. Thus, on this argument, Renaissance perspective is truly the most decisive stage in the transformation of a wide set of drawing techniques into those that have made the modern world possible.

With that response, we may now retire from the historical perspective and modern design discussion with some general conclusions. Our approach has been dialectical, and regarding that, Aristotle wisely remarked that a good account "will resolve the puzzles and contrarieties. It will do this if it appears reasonable that the contrary things seem true": "if what is said is true in one way, and not in another."[55] Leaving aside his more audacious cultural claims, Panofsky, I have just argued, may well have been right about the historically crucial importance of modern perspective to drawing systems. Furthermore, those like Ivins and Edgerton who would extend Panofsky's case explicitly to modern design, hence to the existence of the modern world, may also be in a way right. Still, Panofsky and others appear to be mistaken in other

ways. Renaissance perspective's difference from ancient practices is indeed owing to its projective model, but this has little to do with positing an eye at the projective focus. Furthermore, briefly to mention visual experiences, perspective has little to do with what Panofsky called a "windowpane feeling" for those who make perspective drawings, especially since such people normally follow geo 2 rules or, when working from life, estimate relative angular sizes directly (for example, by the clichéd method of holding up a pencil or brush), without imagining any intervening screens. Finally, the "windowpane" has even less to do with those who only look at the finished drawings, for the obvious reason that, when looking at the forms of things through actual windowpanes, we do not experience them as projected onto the surface of the glass.

Speaking briefly of art at this point, what then of the often retailed view that, as Edgerton put it, the perspective "notion of 'picture as window' is truly the basic difference between Western painting after the Renaissance and the arts of all other cultures anywhere else in the world"?[56] Well, Panofsky had already refuted *that,* by reminding us of ancient Roman "picture as window" paintings. His own thesis, as we have seen, was crucially different from Edgerton's. For him, what distin-guishes Renaissance perspective is not a window treatment but a window*pane* treatment. Whatever else he meant by it, the basis of his claim was that at a certain point in the Renaissance a historically in-novative geo 1 projective conception of perspective appeared, essential to the modern development of that drawing system. In this Panofsky seems to have been right—thus, as Aristotle said, his ideas are "true in one way, and not in another." All this underscores another simple, obvious point, which is frequently overlooked in the present context and exaggerated in others. The point is that what holds for the guiding conceptions of the person who *makes* a drawing need not hold for the conceptions of those who well *understand* the result. That point will later be something of a challenge for my own account of drawing as an art, since I will need to argue that sometimes the conceptions of spectators do closely correspond to, or at least take account of, those of the drafter. Thus, even if it had been true—and it is generally not—that people who make perspective drawings think of the surfaces upon which they draw as projection screens, it would not have followed that those who look at these drawings conceive of them as projection screens. Any who doubt the relevance of making the last two obvious points need only look to the many standard presentations of perspective.

3. drawing and graphic displays

So far, we have been following a distinction between design and production drawing, which, though real and meaningful, is not sharp. In modern engineering, architecture, and other design, there will be much overlap between methods of design and production drawing. As remarked at the outset, however free the inventive thinking may be, any modern technical designer must eventually think and work within the graphic protocols of production. But now another point must be made, that in modern societies the line dividing drawings necessary for the production of artifacts from those done for the users of the artifacts is clearer, since much of that line's "contour" separates ever more specialized users of drawings and an ever widening, globalized population of nonspecialized ones.

In *Republic*, book 10, Socrates observes that since the "user of each thing has most experience of it," the user should "tell a maker which of his products performs well or badly in actual use," because "the one who knows is the user" (601e–602a). This is nowadays called "feedback," but it is the users who frequently need the instructions. Thus, large as are the design and manufacture drawing topics, they only begin the story of what makes certain kinds of drawings distinctively important in a modern, technological world. For besides the production of that world, there is the problem of coping with the damn thing, once produced. Living in environments so filled with complex designed and con-

structed implements, with new ones in constant production, people in modern societies must frequently consult guides in order to use, monitor, and maintain their artifacts and made environments. Thus, coping with a world made from all those drawings entails an additional layer of designs. These are typically drawings of a rather different order from those of design and of manufacture. They are fashioned by different talents, according to special principles, and for a different market: notably that of users who, in international mass markets, are not specialists. Particularly in competitive consumer economies, graphic designers of this sort must be experts not only in visual communication but in visual rhetoric. Thus the so-called information age that replaced the so-called industrial age is increasingly a thing of "user-friendly" interfaces devised for a broad spectrum of people. Just as a road map covers the same ground as does a geological map but in a different way, so the average user's guide to an automobile, personal computer, camera, microwave oven, or other appliance contains no information about how to make or even fix one. Although drawing is but one resource in this huge economy of information, it is a central one, meriting careful and informed investigation, for—having mentioned maps—we might say that without such drawings we are, literally and figuratively, lost.

Fortunately the large topic of the visual display

of quantitative information is already well treated in our time, for example in fascinating studies by Edward R. Tufte.[1] Tufte's topic is broader than the concerns of this chapter; it includes other kinds of visual display besides drawing and applies to more than comprehension of modern instruments. Yet all his principles apply to our topic. Let us consider just a few lessons from a pair of important examples of Tufte's. Regarding "graphical displays," consider a familiar public transport schedule. Here are two ways of printing a London Underground "tube guide" for the weekday morning rush hour: first in typographic form, then in "stem-and-leaf" form.

Departures: Typographic Form

06:03	09:11
06:26	09:19
06:44	09:21
06:54	09:29
07:12	09:37
07:21	09:40
07:37	09:45
07:50	09:47
08:00	09:53
07:07	09:59
08:17	10:01
08:24	10:08
08:33	10:12
08:44	10:18
08:49	10:22
08:53	10:33
08:55	10:42
09:03	10:52

Departures: Stem-and-Leaf Form

06:03	26	44	54							
07:12	21	37	50							
08:00	07	17	24	33	39	44	49	53	55	
09:03	11	19	21	29	37	40	45	47	53	59
10:01	08	12	18	22	33	42	52			

For general users, stem-and-leaf seems the winner. More economical in space and ink, it is also easier to take in, as there is less print to look at, and what is there has a more perspicuous visual shape. The simple visual layout of stem-and-leaf provides an overview of temporal events in easily memo-rable, two-dimensional form. We can "see" the train service flow and ebb and, by grasping a visual shape, more easily compare and keep in mind services at different stations, as well as on weekends as opposed to weekdays and holidays. By glancing at the breadth of the stacked minute-indications, we can readily note the frequencies of service. The times are set out in an "at a glance" form, which is highly relevant because we use trains in contexts where hours "on the hour" are salient to our planning, discussing, and remembering—mapping out our days. Thus, in reply to the possible objection that the stem-and-leaf table, as opposed to a typographic form, introduces artificial gaps between the last train of one hour and the first of the next (though the actual interval can be as short as two minutes), I think that we would say that the "carriage return" back is no problem. Further advantages ensue. Vertically, rough correspondences between "minutes past the hour" during the heaviest hours help us estimate times getting to trains, correlated with our other on-the-hour activities. Furthermore, as Tufte points out, the "leaves of numbers can grow from *both* sides of the stem"—for example, in Japan neatly corresponding to train times on opposite sides of a platform.[2] With regard to drawing, although both methods are clearly what are called "conventions," it is interesting to consider, in terms of human use and perception, why one convention is *preferable* to the other. Indeed, any method of displaying such information could be termed a candidate convention, yet few would in fact be chosen in any society. Most that we could dream up would simply be too inconvenient, too illegible. For those interested in cultural differences regarding such choices, some of Tufte's favorite examples of such ingenious designs are taken from Yokohama railroad systems.

Although this kind of visual display is not drawing, its design calls on abilities shared with drawing. Indeed, it is usually closely combined with drawing and other techniques of display. This brings us to our second simple example. The timetable, showing different times at a given place, wants complement: a graphic that shows us different places—timelessly. It happens that our particular train schedule is a close companion to recent variations of the brilliant London Underground "map" designed by Harry Beck (fig. 42), which, being a famous kind of drawing (besides its Lon-

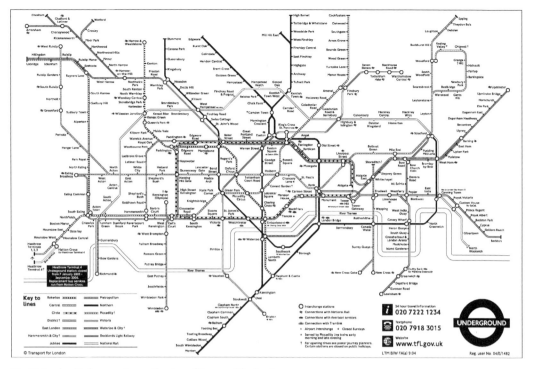

Fig. 42. London Underground map. Courtesy of Transport for London.

don varieties, it has been adapted by cities such as Rome), will later repay close attention here. Speaking of drawing conventions, Beck's is well known for its dominant emphasis on two spatial features, linear order and connectivity, and for relaxing such geographical properties as proportional distance and shape (while for clarity, using only 45° and 90° angles). Its likeness to standard conventions of electrical wiring diagrams has been noted.[3] What the diagram shows, with its lauded simplicity and clarity, for millions of residents or visitors from all countries and walks of life, is simply how to get from point A to point B, directly or not so directly. Unlike a map, the diagram's basic job is not to show space as distances, shapes, or angular directions of travel—not even to show the relevant data of when the "underground" is really underground, or how far down it gets—some stations are ear-poppingly deep. Though printed as a "tube map" (that for an individual station is called a "tube guide"), it is therefore a carefully drawn (and much redrawn) diagram, though one that relents slightly and significantly in the direction of a map. As with the departure schedule, several observations about

this rather more complex case will be useful for considering different kinds of drawing, where a gap exists in theories.

MINDING GAPS: TOPOLOGICAL VALUES

The main observation has two parts. First, such a drawing *amplifies* quite specific properties of what it represents, and in so doing it partly *filters* others, including some standard geographical ones. To quote one commentator, in Beck's diagram "distortion was thus of the essence. But whereas distortion may often be whimsical, devious or just plain inept, this was purposeful, straightforward and skilful."[4] Next, the properties it makes salient are, as mentioned, certain kinds of spatial properties, different from those most emphasized in the drawing distinctions of the last chapter. These are *topological* properties, popularly represented as those spatial properties that would remain constant even if the diagram were drawn on an elastic sheet that is stretched in any part or way, so long as not torn. None of the distinctive, valuable characteristics of

the projective methods of chapter 2 survive such transformation, given that straightness, verticality and horizontality, length, area, and angular size are all non-topological—that is, not "invariant" under topological stretching operations. But, unlike the earlier diminishing sequence of the metric, conformal, affine, perspectival systems, the topological system's loss of even residual characteristics of perspective is offset by highly valued properties in life and art, such as continuity, enclosure, and separation, which are by no means guaranteed by the projection family. To understand the amplified aspects in the Beck drawings, consider them initially in terms of places: notably, stations. Above all, the diagrams must exhibit clearly which stations are or are not *between* groups of others, and, of course, on which lines they lie: that is, characteristics that survive deformation. Here the set of scales introduced with regard to perspective's properties will help us be more precise. The stations are set out *ordinally*: that is, from any station, we may find the correct order of all the others along a given line—the first, second, third . . . in a given direction. Compare this with the complementary departure timetable. That is also ordinally arranged along a linear scale (for we do want the times in order), but, unlike the diagram, the schedule must also feature an *interval* scale, which cannot be preserved through stretching. In other words, just knowing which train comes after each, like our line of biblical "begats," will not do. "Mind the gap": one wants also to know the equalities of temporal gaps between departure times, whereas the diagram pretty well disregards equal intervals.[5]

One might use the label "topological drawing" for the train map. The same label may be applied to electrical circuit diagrams, with reservations. It is true that some other important kinds of spatial (shape) characteristics are absent in these cases (along with other relevant nonspatial properties of the situation). Still, it will be important to remember that while most drawings do not in this way select for topological properties, and therefore would not be labelled "topological," what might be called topological *values* of order, connection (and disconnection)—and also containment—are essential to most kinds of drawing. (The point is like our earlier one about orthographic values in nonorthographic projections.) Consider, for example, a familiar sort of interlace pattern found in the design traditions of various cultures (fig. 43). This pattern

"thematizes," plays on, the elusiveness of the topological characteristic of 1D continuity that is involved in determining whether it could be a single string, balanced against shape symmetries that would not survive topological stretching. Such is a relatively simple case of what I will call "topological values" in a design, at play with other values. Speaking very generally, spatial continuity/discontinuity and order, along with contact and containment, hold deep psychological importance for us. Indeed, most drawing that is art thematizes (especially with regard to depicted live bodies) our experience of such seemingly simple matters. Since we usually seek such values in such depicted entities, and since tensions and anxieties may be evoked by this—and also reassurances and deep satisfactions—it is more the shame that, in discussions of art, topological space values have been cloaked by the long shadow of perspective.

Similar points hold for the special kinds of technological drawing discussed earlier. With the mere mention of wiring and similar connectivity diagrams, we briefly considered an almost purely topological drawing without which the modern world, "unwired," would not run (see fig. 4).[6] Had we room to carry the present considerations back over the earlier detailed discussions of technical drawing, we might further investigate this realm of shape properties and watch its interplay with other spatial properties and values. A main theme of the last chapter's treatment of projective systems in drawing was that, for all our emphasis on the spatial characteristics of outline shape, scale, and dimension, and on Panofsky's "every point, regardless of whether it happens to be located in a solid or in a void," none of that is of practical use for making things unless we can distinguish the physical bits from the empty spaces between them, tell which surfaces or edges of things are continuous, distinguish one component from another, see which are inside or around which others, which are in contact precisely where, and so forth. (Inspection of our so-called postlinear perspective devices may suggest that many of them are related to more basic topological rendering values.) Earlier I defended Villard's resolute "naïveté" as emphasizing the thing-nominal identifications of the different components, arguing that although it usually goes unmentioned, all the projective systems presuppose such identifications. As I emphasized in the preceding chapter, Panofsky characterized per-

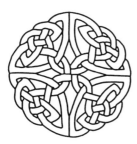

Fig. 43. Interlace pattern.

spective's revolutionary rationalization of drawing as no longer based on Aristotelian substances, but rather as setting things in a modern Cartesian space that "denies the difference between . . . bodies and what lies between ('empty space'), to let the whole of the parts and contents of space merge in a single continuous quantity." Yet a place for everything without things to go in those places is useless in design. Topological space also presupposes objects, but not in the complacent manner of projective space, for, unlike the projective, topological space is in turn presupposed by the concept of substantive, namable (nominally classified) objects—which presuppose continuity.

Returning to Beck's diagram, there are at least two other general morals for our investigation of "all kinds of drawings." One concerns the diagrammatic "purity" of the Beck drawing family. We noticed that the drawing relents somewhat geographically, perhaps most evidently with the schematically shaped and positioned "tubular Thames," which, although not an important part of the diagram, is hardly what Tufte would call "chartjunk."[7] Overall, perhaps the diagram gives way to map-likeness most significantly in its general north-south-east-west presentation—not invariant through many rubber sheet distortions. And there are subtler concessions. For example, although Beck, seeking simplicity, initially ran the southern portion of the solid black Northern Line straight down—which departed "further from on-the-ground geographical reality"[8] and located the Northern Line's South Wimbledon station far from the District Line's two Wimbledon stations—a leftward bend was later indicated on the diagram, even before the Victoria Line's extension across the Thames to Brixton made that topologically necessary.[9] None of this affects the dominantly topological shaping of the diagram. Indeed, a main point

about topology is that neither top/bottom, left/right, nor shape-bending efforts matter; the results will always be "topologically equivalent." But, aside from providing the most general compass directions, the main purpose of other indications (e.g., different colors or line codes) is not, after all, to provide additional *information* in the labelled diagram. Rather they serve mainly as user-friendly background for our "pure" reading of order and connectivity. In general, it is good to remember that, in the interpretation of drawings of any kind, one perceptual action may not only background another perceptual action of a different kind, without adding to it or intruding on it, but also change function and come forward, reversing roles or conflicting with the other. This will be important to drawing as an art.

CORRESPONDENCE

A final generalization from this simple case might appear to be the most obvious and important of all. By contrast with the timetable we consider this a drawing—at least a diagram, if not a map—because of a kind of resemblance. As there are several kinds of important shared spatial features between the two-dimensional diagram and the situation it stands for, we might say that drawing and situation it represents (whether it exists or not) are similar or *correspond* significantly in these ways. A practical example of correspondence is that the general directional correspondence just mentioned allows people physically to orient the diagram with what it shows: that is, with the top of the sheet pointed north—just as with maps. With maps we can be more precise, since we often turn a map around to orient marks on it with the visible things that they denote, in order to read off angular headings. With the diagram, however, such correspondence is not close, since we cannot read off angles or distances in any but the grossest ways. Inspection shows, however, that some effort was made to ensure that the characteristics of the diagram corresponded to what they represent: notably the essential topological ones of continuity/discontinuity and of ordinal arrangement. Since correspondence will be an important topic in later chapters, let us consider these elementary correspondences more closely.

The diagram is made up of drawn lines; what they represent is a set of railway lines. The two kinds of lines are both, in this context, predomi-

nantly 1D lines across predominantly 2D grounds, where they may cross and separate, run parallel or at angles, come between or go around others, and so forth. Next, the *order* of the station markings along the drawn lies must be the same as the rail order of the indicated stations themselves. Furthermore (with two seeming exceptions, necessary ones) wherever a rail line is shown as continuous, the line representing it on the sheet is also continuous. The first exception is the interchange markings on the diagram, where the converging lines are broken by hollow circles. Interestingly, earlier versions of the Beck drawing maintained color continuity by producing separate, tangent circles for each rail-line, with edgings of those lines' distinctive colors flowing round (Beck having been forced for some years to double, even triple, station names, as well).[10] Resort to this technique led to more instances of a second apparent exception to the diagram's correspondence: the breaking of drawn lines where others cross them, not at interchanges. However, although this is a physical exception to correspondence, it is perhaps not a perceptual exception: when one line is drawn over another, we easily imagine that the occluded line continues beneath it. Since, for example, we visually experience the drawn line for the Euston to Warren Street part of the Northern Line as continuing beneath the line triplet that actually interrupts it there, rather than as stopping and starting again, this may constitute no exception to the continuity correspondence for map lines and rail lines after all.

INFORMATION DISPLAYS: MULTIVARIATION

We can extend these observations about Beck's classic, ingenious user drawings to a variety of everyday examples and to the topological space values they mix with other drawing values, including the projective varieties considered earlier. We find them, for example, in familiar diagrams for tying knots (fig. 44) and in a host of jottings we make for practical purposes. Something like a Beck diagram may carry us to our destination when we go by public transport, but when we travel on our own we often jot down rougher schematics. No need to provide a figure for this; obviously, ordinal and continuity considerations ("turn right at the second light, then go straight on till . . .") prevail

here, along with general geographic directions. More complicated is the sort of directional diagrams we consult at airports and museums. These usually need to preserve the map characteristics of shape and proportional size in a way that neither our little jottings nor the Beck diagram do. For that reason parallel systems are the norm. Perspective, if there is any, is constrained to very slight diminutions. Since such buildings often have different levels, we can expect an "explosion" or separation of floors. But because the plans of different floor levels may differ radically, they are best kept three-dimensionally aligned, as in engineering assembly drawing. A guide to the first and second levels of the "world's oldest public museum," Rome's Capitoline Museum, provides an example (fig. 45). Since these maps are orthographic there need to be several of them, and here, as with engineering drawings, questions arise regarding connections between them. For that reason such maps are often in oblique, to aid our tracing the essential topological characteristic of continuity of (our) pathways between the levels. This nicely illustrates the difference between use and design/construction drawings. Given bodily capacities and social sanctions (climbing in and out of windows, scaling walls, crawling through ductwork, or entering staff service areas not being options for users), possible path continuities are essential bits of knowledge for navigating such complex, tiered sites. At the inauguration of the Kimball Museum its architect, Louis Kahn, remarked that whenever he entered a museum the first thing he wanted to do was to lie down. Yet the adage "You can't get there from here" (while staying on the same floor) often holds as we circle round seeking conveniences. Of course, service personnel, firefighters, and investigating police use maps with more expanded continuities: something familiar from cinema and television dramas. Another common user example of a drawing stressing certain spatial values is the simple, largely topological diagram that a medical practitioner may draw for a patient to explain a situation or treatment—the drawings themselves sometimes being part of the "informed consent document," for example, by orthodontists.

From these elementary distinctions in drawings, let us return to the broader issue of drawing for users of modern technologies. For his part, Edward Tufte approaches the subject of visual presentation—Ferguson's "mind's eye" consideration—

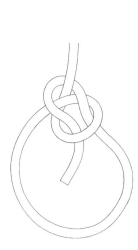

Fig. 44. Bowline knot diagram. Author's rendering.

Fig. 45. Map of Capitoline Museum of the Palazzo dei Conservatori, Rome. Author's rendering.

by noting that the two-dimensional nature of display surfaces is a source of both frustration and intelligent design. Tufte characterizes the challenge of making effective "graphical displays" (most of which we could reasonably describe as drawings) as basically "the escape from flatland":

> We envision information in order to reason about, communicate, document, and preserve . . . knowledge—activities almost always carried out on two-dimensional paper and computer screen. Escaping this flatland and enriching the density of data displays are the essential tasks of information design. Such escapes grow more difficult as ties of data to our familiar three-space world weaken (with more abstract measures) and as the number of dimensions increases (with more complex data). Still, all the history of information displays and statistical graphics—indeed of any communication device—is entirely a progress of methods for enhancing density, complexity, dimensionality, and even sometimes beauty.[11]

One reason why anyone interested in drawing would profit from Tufte's broader study of graphical displays is that much of what is written about

drawing (and painting) has actually been concerned with these problems in ways that are much too limited. Drawing tends to be thought of as a method of *depiction* or picture making—often as a preliminary method called "sketching." That is the first mistake. As for depiction, that is almost universally taken, especially in theoretical literature, as essentially an "escape from flatland": that is, as a challenge of getting three-dimensional situations down on two-dimensional formats. We will later see to what extent visual depiction and representation are nowadays theorized largely from that basis, in approaches that, while presented as competitive, turn out to be variations on a common 2D/3D theme. I will be arguing that this is a mistake. With apologies to Tufte, one of the advantages of approaching drawing from his broader perspective of effective visual display of complex information is that our thinking may be freed from "3D land," as well: that is, from the pervading conception of drawing as tied to spatial indications in the narrow sense of three-dimensional depth. For, given that Tufte does not approach the topic of graphical display in terms of "pictures of things," but rather, refreshingly, through an inductive search for principles for solving the practical problems of making all manner of information visually accessible to us, escaping the two-dimensional

physical surface, for Tufte, actually includes getting on not only to three variables but to what he calls "multivariate" situations. Although many drawings deal with the multivariate, artistic ones are especially known for that. Thus a basic strategy of this book, as it moves toward artistic drawing, will be to add successive layers of such (interacting) variations, extending beyond space. Hence, Tufte's general approach could amount to a liberation of inquiry regarding "all kinds of drawing." His many examples within the class of graphical displays suggest a liberation of conceptions and methods as well, provided that we can find analytic tools adequate to the wide range of diverse examples open to us—tools, for example, such as Booker's "constructional drawing," the family of projections with their metric and affine properties, Booker's geo 1 / geo 2, the four measurement classifications, topological space, and other drawing distinctions we can add to our kit.

4. drawing/disegno

If it should seem peculiar that a philosophical criticism of drawing began with chapter 2's discussion of rather technical, specialist aspects of drawing in modern times—including a lengthy debate with historians—and only lately turned to more general uses, these tactics were partly owing to the low-involvement status of drawing in our time. Most people would profess very little interest in drawing as a subject, and even less in the activity. This is partly due to the hegemony of photographic forms of image making. As a generalization, it might be said that what perspective has done to other drawing systems, including its projective cousins, photography has done to drawing: Mary and Martha again. Therefore the great importance of drawing needed arguing. Next, to make headway with an understanding of all kinds of drawings, we had to begin assembling tools from a variety of contexts. Such a conceptual tool kit might have been attempted in a number of ways; but the design context, where (critically sifted) standard vocabulary and systematic thinking were already in place, provided a good start. And when it comes to drawing as a fine art—or just as a means of personal expression, surely the job of the philosopher is to emphasize the connections among things that we tend to overlook. A main theme of this study is to show that we gain a better understanding of drawings if

we can learn to relate what we see in a museum to the sketched directions or transport diagrams that got us there and the building map that guides us around. Latent in the everyday use of drawn displays is a rich supply of conceptions and functions that are also basic to works of visual art. When described by scholars and critics, however, these conceptions may appear too specialized or complicated for general comprehension—even when they are "thematized" or taken into the very subject matter of the artworks.

Still, as preparation for the fullness of drawing, beginning with issues about modern design—important as these may be—runs risks, not just of being too technical or too much caught up in historical debates, but of unwittingly taking on assumptions that will confine or skew our investigations. There is an expression in figurative drawing for a wrong start that leads to increasing distortion, like a mislaid course of bricks that ruins an entire wall: "out of drawing." Of particular danger is our initial heavy emphasis on spatial techniques and values, that our discussion so far has been cast largely in spatial terms, and, to confess, will continue that way for a while. Lest our theory of drawing thereby go out of drawing, let us step back and consider matters most basic to the entire inquiry, beginning with the word "drawing."

WHAT IS DRAWING?

So far, the very terms "draw" and "drawing" have had little explanation. Despite my recent promises about the multivariate, by starting with design/production we have been assuming that drawings are basically *spatial* entities, that signify or represent basically spatial relationships. Discussion of "correspondences" was all spatial. Our main sets of drawing distinctions have been made regarding different kinds of *spaces*—most recently, for example, the topological, as opposed to the projective that has received so much more attention due to the prominence of perspective. By approaching the topic as we have, through its practical importance, we have been understanding drawings in terms of shapes, layouts, and connections of spatial kinds on flat or at least two-dimensional surfaces, which must represent similar spatial situations in order to represent anything else. We did so when we displayed the causal structures of machines, as with Villard's saw. Yet, even from an engineering point of view, such drawings have done little to render other essential physical characteristics—in the case of mills, characteristics such as the liquidity of the water, the rigidity of the structures, their masses and textures. Essential physical forces such as torque, tension, compression, shear between surfaces, and so forth have yet to find graphic expression. As to the characteristics of the drawings themselves, the spatial situations we expect such drawings to represent will be of various dimensions, including 2D and 3D, though they will represent other kinds of spatial features and also nonspatial characteristics as well: accordingly, we have been thinking about these drawings mainly in terms of one-dimensional entities, *lines*—rather precisely laid out lines—in blueprints, schematics, wiring diagrams, complex machine designs, and so on—on two-dimensional surfaces.

This, it would seem, is pretty much how people normally think of nontechnical drawings, as opposed to paintings, sculpture, and the like. So if we have gone astray here, that is not necessarily because of our technical beginning. Still, as philosophers, we must think clearly and critically about what we are doing. Let us begin to consider more closely this spatial entity, the drawn line, as specifying a variety of spatial aspects. The word "draw" in the simple phrase "draw a line" has something like the following meaning: an object such as a fin-

gertip, piece of chalk, pencil, needle, pen, brush (small ones formerly being called "pencils"), having something like a tip, which we therefore refer to as "a point," is intentionally moved (drawn) over a fairly continuous track on a surface. This action leaves, as the trace of its path, a mark of some kind, and is done for that purpose (see fig. 2). We note in this simple account some important implications for further investigation. First, "draw" appears here as a word for a certain kind of intentional physical action. Most lines made on surfaces by points are not drawn. Indeed, most such markings are not done by agents at all, others are accidental; thus neither glaciers nor persons can claim credit for many of the interesting lines they score on the surface of this and now other planets. The second point is how the drawing action is described in terms of a particular kind of space, one that we have encountered several times: that is, *dimensionality*. A simple drawn line runs us through dimensions: a point (a 0D entity, roughly speaking) is drawn in a fairly continuous path (a 1D entity) over a surface (2D for present purposes), which may be flat or curved, smooth or bumpy. Of course, all three of these entities are actually three-dimensional, but we are speaking relatively. Thus, before considering drawing "geometrically" as we usually do, in terms of space as *shapes*, straight or curved, we are already thinking of it dimensionally.

Of course, in addition to lines, we also draw zero-dimensional dots and two-dimensional blobs. Usually, if noticeably two-dimensional entities are thereby built up we tend to call it "painting" rather than "drawing." Still, marking *lines* over continuous surfaces seems to be at the heart of our idea of drawing, and if that seems rather like writing, we can recall that for some civilizations, and in some languages (such as Greek and Danish), the two go together. For example, moments of John, chapter 8 concerning the woman taken in adultery have been illustrated, but not often the one where, following the accusations, Jesus said nothing but stooped down and "*egraphen*" on the ground: the verb can mean "drew" as well as its usual translation, "wrote." Such linkage of "the arts of the brush" is also important in China and Japan as well as in Islamic societies (see figs. 21, 50, 70). As contrasted with "painting," "drawing" seems to carry a third common connotation, regarding the *salience* of the markings done in this

way, and here we find a couple of related ideas at work. First, we expect drawn marks not entirely to cover the two-dimensional ground, to leave much of the surface unmarked—very different from painting, "splodge," which standardly consists in covering a surface ("laying in"), indeed usually with a sense of layers of coverage. Next, it is typical that in drawings these individual marks remain for the most part separately identifiable. Of course, these two rough connotations of "drawing" admit many important borderline cases and exceptions, but even then part of their effect as drawings is due to being exceptions to these general expectations, which we will be investigating at length. To remind ourselves of the connotations just listed, let us consider some everyday, unskilled drawings, regarding the intentions we typically have in making markings of the kinds just described.

One colloquial expression for not being able to draw well is "I can't draw a straight line": a valuable comment, as it makes clear how we assume that every drawing, before it is, as in our examples, a diagram or representation of anything, is a drawing of such things as straight and curved lines and shapes. All too often, those who consider the topic of drawing are overeager to address representation—although, according to Vasari, the great artist Giotto knew better. For when Pope Benedict IX sent a courtier to Florence to see whether Giotto was as good an artist as reputed, and the courtier asked him for a sample to take back to Rome (not before collecting drawings from other Tuscan masters, while he was about it),

> Giotto, who was a very courteous man, took a sheet of paper and a brush dipped in red, closed his arm to his side, so as to make a sort of compass of it, and then with a twist of his hand drew such a perfect circle that it was a marvel to see. Then, with a smile, he said to the courtier: "There's your drawing." As if he were being ridiculed, the courtier replied: "Is this the only drawing I'm to have?" "It is more than enough," answered Giotto. "Send it along with the others and you'll see whether it is understood or not."

According to the story, Giotto's sample was "as drawn without moving his arm and without the help of a compass."[1] Yet, also according to Vasari, the young Giotto was recruited to art by the great artist Cimabue, who came across the ten-year-old "who, while the sheep were grazing near by, was drawing one of them by scratching with a slightly pointed stone on a smooth clean piece of rock. And this was before he had received any instruction except for what he saw in nature itself" (37). Thus Giotto did drawings of sheep and also drawings of circles. That there is an important meaning difference between these two "drawings of" is a central distinction for later treatment. For now, just considering lines, we need to remember how we frequently do draw just them, freely or with help of a straight edge or a compass (also with computers). Why might nonspecialists draw just such lines, straight or bent, without drawing anything else by means of them? There are many reasons. For example, to measure something we make a mark at the end of a measuring interval. Often this is done by another simple means: superposition. One thing being physically laid out against another, we draw marks on the latter at places along, or at an extremity, or a whole bounding edge of, the former. Note how such copying and comparing of lengths brings us close to another thing we often do by drawing lines: copying and comparing shapes. For example, we often draw shape outlines by superposition in order to cut something out. Then our drawing marks (earlier called "constructional") function as a means for transferring shape characteristics from one object to another, or from one side of an object to another side.

Such everyday practical operations are so common that we are in danger of taking them too much for granted. But, given that so much attention is given to drawing as the production of three-dimensional information on two-dimensional formats, it is worth emphasizing how much drawing is of the very flat on flat. Indeed, it is worth considering how the three-dimensional projective practices described in chapter 2 may have evolved from just such procedures. For example, the all-important orthographic projections we have several times considered may be derived from such superpositional tracing. As with measuring, people often trace shape outlines this way, placing the one against the other. We do this in order to cut or otherwise physically shape the object drawn on—and note how, with flat objects, cutting with knife or scissors is an action that is (as Matisse found with his paper cutouts) significantly akin to drawing, since it involves a basically one-dimensional point

moving over a surface along a linear path, straight or curved. Obviously, cutting essentially involves separating, and, as we shall later stress, it can be very significant that we experience drawn lines as separators. Sometimes, however, the object drawn on—and perhaps cut—serves as intermediary, as a template for drawing on other things. Then the drawing marks function as means for transferring shape characteristics from one object to others— and also, significantly, from one part (for example, one side) of a single object to another part.

Considering such familiar operations, we might record an observation, given that failure to remember it has confused accounts of drawing and even of depiction generally. When we reproduce shapes by this kind of drawing, exploiting metric, orthographic physical projection, it is hardly ever the case that we are *representing* anything. We are not, notably, representing the traced object. For example, neither clothing cutout patterns nor other constructional drawing templates used for tracing out shapes on surfaces would normally be considered *representations* of those things. Nor would even the drawings we make on the worked fabric normally be considered representations, either of the template or of the object (e.g., an article of clothing or a bit of carpentry) being made from it, despite its being a drawing on a two-dimensional surface that we see as corresponding both to its original and to the thing to be made from it. A fortiori, the drawings are not taken as *pictures of* the templates or objects. It was already clear from such cases of constructional drawing that one very common conception of representational—also of a depictive—drawings, as two-dimensional shapes on surfaces visually recognizable as similar to their exemplars in overall shape, is an inadequate one, which should never have seemed plausible. On the later subject of art, it will be good to keep this point in mind when we consider abstract or nonfigurative artistic drawings, some of which have positive roots in this ordinary kind of drawing, and need not be considered, as they often are, negatively as rejections of depictive drawing.

Related to the last point is a far more general one about worldwide activities of drawing. It is an ancient and continuing practice to copy interesting shapes from nature. That is often done by tracing—by superposition, as just mentioned—and sometimes such tracing is drawing. Stencil tracing of human hands, for example, are almost always found in rock and cave art throughout the world for tens of thousands of years. Sometimes these are made positively, by applying pigment to the hand and stamping; sometimes negatively by blowing pigment against a hand in contact with a surface. Sometimes they are done by scribing the stone around the outline of such a hand. Although the results clearly resemble hands, this does not entail that they depict hands, any more than a footprint noticed to be like a foot is thereby taken to depict it. It is easy to see how people, perhaps noticing how leaves naturally deposit traces of themselves on surfaces, have made such tracings themselves by means of superpositions. That holds for a multitude of objects that have fairly flat surfaces. This helps us see how people might draw interesting shapes from nature without superposing them and where there is no particular question of representation. Finding interesting shapes in nature, they attempt to derive similar ones, but what interests them might be the shapes themselves, not their derivation. By analogy, seeing how burrs stick tenaciously to fur and fabrics, George de Mestral invented Velcro; yet, source connotation hardly explains Velcro's wide use. Similarly, we need not always assume that drawn shapes *inspired* by natural ones have those sources as part of their meaning, and this point holds for many decorative shapes. Just as natural burrs and Velcro exemplify an interesting property, so may a drawn shape and a natural shape: another point, much stressed by some modern artists, that we must keep in mind when considering nonfigurative art.

DRAWING PATTERNS

Thus shapes. The same observations hold for their repeats—or, as we say, their patterns. So far, our basic question, What is drawing? has been fruitfully understood in terms of the question, What do we draw? And just as we see that we draw such things as lines, shapes, and so forth, we draw *patterns*. Consider a central case. We noticed how, for practical purposes, it is important to be able to transfer shape characteristics from one part (for example, from one side) of a single object to another part. Thus we can make top and bottom or left and right more the same. The general term for that is "symmetry," which modern commentators understand as picking out a particularly important process or

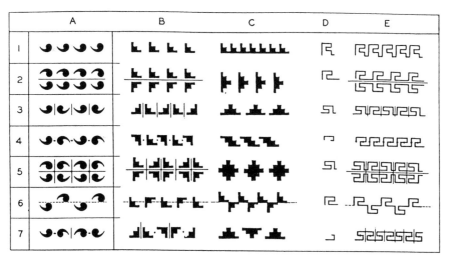

Fig. 46. Symmetry diagram. From Anna O. Shepard, "The Symmetry of Abstract Design, with Special Reference to Ceramic Decoration," *Contributions to American Anthropology and History* 9, nos. 44–47 (Washington, D.C.: Carnegie Institution of Washington, 1948), fig. 2.

activity of shape transfer by superposition or trace drawing, for when we trace copies of shapes by superposition, we can then make several kinds of valuable realignments of them. Briefly noted, symmetries in a plane are usually classified into three, as by the archaeologist Anna O. Shepard (fig. 46):

There are only three classes—bilateral, rotational, and radial—and we see innumerable illustrations of them in geometric figures and forms of nature. Examples of bilateral symmetry are found in an isosceles triangle, a pansy, and a human figure; of rotational symmetry, in a parallelogram, . . . a swastika (nature eschews this class of symmetry); of radial symmetry, in a square, a daisy, and a starfish. The characteristic which they possess in common is that a fundamental part is repeated regularly about an axis. Each class is defined by the motion employed in repetition. In the bilateral figure it is mirroring; in the rotational, it is rotation about a point with an even number of repetitions within a revolution. The radial figure combines both reflection and rotation. All that is required for symmetry classification is identification of the fundamental part and of the motion by which it is repeated.[2]

Michelangelo's paving design for the Piazza del Campidoglio (fig. 45) reminds us that symmetries may also be combined or used in different directions. As with projections, symmetry classifications vary. Sometimes radial symmetry is not counted as distinct, since it (for example, Giotto's circle and fig. 43) can be seen as a combination of the other two. It is usual to include as symmetries results of the important operations of simple translation of shapes along a plane and two-stage *glide* ("slide") *reflection*: reflection (horizontal or longitudinal) followed by translation along the reflection axis, in a sort of screw action (fig. 46:6).[3] This suggests not only combinations but sequences of symmetry operations, which can be distinctive of decorative styles. For example, J. Peter Denny argues for distinctive preferences of orders in the pottery decorations of Iroquoian and Algonquian peoples, the former tending to vertical reflection + glide reflection + rotation, the latter to vertical reflection + horizontal reflection + rotation. Figure 47 shows a hypothetical vertical + glide + rotation sequence, developed from a simpler, actual Iroquoian band pattern. Study of this shows the necessity, stressed by Shepard, of distinguishing design *elements* from spatially separate design *units*. Some researchers suggest that preference for symmetry operations represents a basic form of visual cognition, which opens some large questions. The theory of symmetry/asymmetry in nature, perception, and craft has been receiving welcome attention in recent decades, far too much for us to consider. Design symmetry is important for us to at

Fig. 47. Four band symmetries based on Iroquoian element. Actual Iroquoian vertical reflection (*top*); three hypothetical developments, showing operations, in descending order: translation, vertical + horizontal + rotation, and vertical + glide + rotation. From J. Peter Denny, "Symmetry Analysis of Ceramic Designs and Iroquoian-Algonquian Interactions," *A Collection of Papers Presented at the 33rd Annual Meeting of the Canadian Archaeological Association,* ed. Jean-Luc Pilon, Michael W. Kirby, and Caroline Thériault, 128–145 (Ottawa: Ontario Archaeological Society, 2001), detail of fig. 1, "Seven Band Symmetries Using an Iroquoian Element." Author's rendering.

least note here because it is a readily recognizable and well-distributed feature of nonrepresentational drawing and, as we shall see later in detail, an essential aspect of representational drawing as well. One can hardly talk about drawing without encountering it. Thus the vocabulary of symmetry studies comprises an important part of the vocabulary for understanding and discussing spatial aspects of drawing. Two other significant ideas need to go into our "all kinds of drawings" conceptual drawing tool kit.

First, bringing in pattern frees *form*—that essential, difficult concept of drawing—from its usual confinement to object *shape*, contour, and boundary (and think how often "form" is defined as "shape"). A point for future reference is that although pattern may be a more abstract or higher-order form concept than is shape, such is not so for perception, which frequently picks up patterns more directly than it does the elements of which they are constituted. In the case of visual patterns, we will be more aware of the flicker pattern of sunlight through fence palings as we pass along a shaded way than we are aware of the gaps between individual boards; and as for touch, it is keyed to texture and its changes rather than to shapes of individual bumps and pits. Artists attempt to render these patterns, too. And since patterns—for example, the symmetry patterns just reviewed—often appear as repeated, even as "infinite" patterns in much great art of the world, where they show rigorous form with no implication of boundaries, we should keep them in mind when we consider, as we must in the following chapters, Western object-bounded or completion conceptions of form in drawing. The second point also concerns this crucial, difficult word "form." Like the very word "draw," essentially "generative" conceptions of symmetry such as those just cited—generative, that is, in terms of plausibly real, sequential operations necessary to produce patterns—hint at ways in which markings may be perceived in terms of their production or, to adopt Michael Leyton's term, "process histories." A similar point was made earlier regarding constructional drawing procedures; with Booker's term, we can now consider how finished drawings may be understood in terms of their actual geo 2 constructional processes. By contrast, consider yet another unhelpful aspect of the prevailing geo 1 projection heuristic—the heuristic interpretation of the geo 1 rules, not the rules themselves. There the postulated fictive—often fantastic—operations merely terminate at the marked surface, giving no instructions about the order in which the actual drawing marks on the surface are to be made (and, as we have seen, projection, by itself, gives no information even about where to make marks on the surface). Geo 2 heuristics, however, like symmetry conceptions, essentially concern sequences of actions of marking that take place on the surface: "first do this, then do that." They are, in other words, conceptions of *drawing*.

WORDS FOR DRAWING

If such physically formative conceptions are implied by the English "drawing"; this is not so with other languages, some of which feature rather more purpose than process connotations—ones closer to our design-drawing beginnings. For "drawing," other languages have terms such as *le

dessin in French, *dibujar* in Spanish, *disegno* in Italian, and *tarh* in Farsi, some of which, unlike the English, can mean simply "design." But linguistic connotations vary. Having first considered at length a function of design drawing that precedes manufacturing things, in chapter 3 we also considered drawing, whether specialized or not, as somewhat independent of the purposes of production and planning. The drawing of maps, for example, was just one example of a general practice of drawing, whose purpose is to render things, processes, and situations more intelligible. Similarly, the discussion of symmetry and pattern strongly suggested layout, planning on two-dimensional surfaces. Historically, much human skill, ingenuity, and practical accomplishment has gone into the maps, diagrams, and other visual displays of the preceding chapter, and if the technical design production function is rather better indicated by words for drawing like the *le dessin, disegno,* and *dibujar,* perhaps the German *zeichnen* stresses more the overlapping aspect of *display* that we saw in chapter 3, an aspect common to what might be called the two families of "drawing" and "*le dessin/disegno.*"

It is also very clear that most designations for drawing, particularly European ones, have another connotation besides intentional spatial markings, or even of representations of the kinds we have been considering, and that is the connotation of drawing a *picture*—indeed a picture *of* something. Although some of the drawings so far examined have been pictures of objects and situations, as much possible as we have avoided considering them that way. The reason is that we will have a depleted theory of depictive drawing if we do not realize that there are other kinds of drawing, independently constituted and of independent importance. In short, the banner flying over the whole discussion so far might read: "Diagrams, Patterns." Nonetheless, aside from the fact that, whether we know it or not, the nature and the quality of modern lives depend crucially upon certain kinds of drawings, there was a world before the modern one, a world in which drawing had many important values, some of which are retained in our time. Impulses to draw appear in all cultures—even in the earliest, over thirty thousand years ago (fig. 1)—as well as in most children today, and in many cases these are obviously impulses to figurative, depictive drawing. It is therefore time to see what can be done by way of a fuller systematic account of "all kinds of drawing" that includes the depictive kinds. That is the project of the next two chapters, as we further develop the basic tools of our conceptual kit for understanding drawing.

part II

the course of drawing

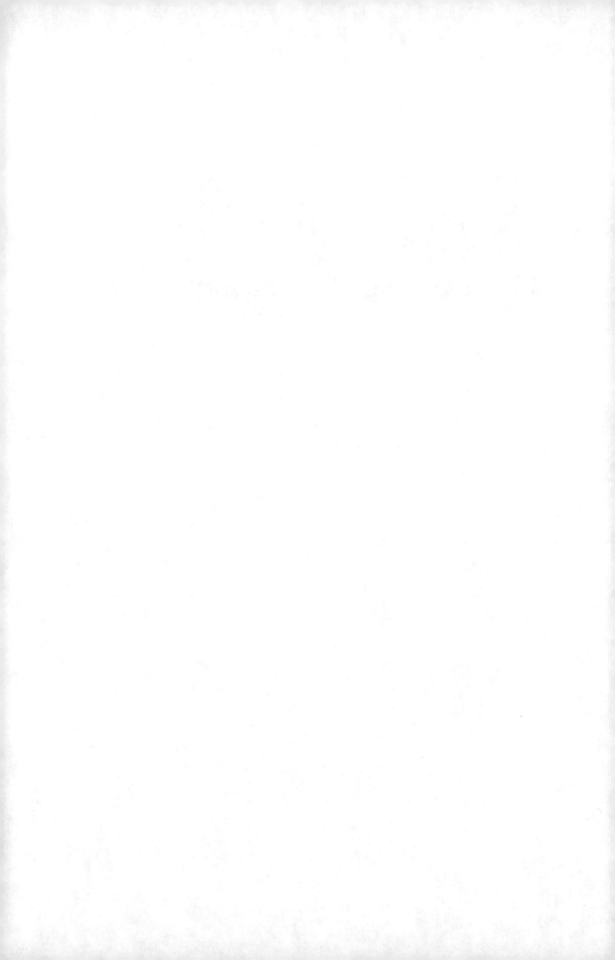

5. the forms of shape

We need a new starting point in order to reach first depiction and then drawing as an art, depictive or not. Having begun the inquiry of Part I with highly specialized, skilled, economically important kinds of drawing, we now take an opposite tack, considering the first drawings of small children and then what might be called their natural development, up to those points of difficulty at which people, by their second decade, cease to draw in serious ways—aside from the professionals discussed in Part I, and those we call artists, the topic of Parts III and IV. We will follow some existing developmental studies, as we previously did some historical ones—knowing that at certain points we will have to go our own way if we are to approach anything like a general theory of drawing. The work done in Part I should be of real use to us on this new path; at the same time, taking up related topics again in so different a context may serve to review, test, and, most importantly, develop them.

CHILDREN'S DRAWING: EXTENDED STUDIES

Let us begin concretely, from what is unquestionably visible in a drawing as a marked surface before us, independently even of its depicting anything. A young child makes drawing marks on some sort of surface. Such are physical, intentional activities; we see children doing them, try-

ing to (fig. 49). How shall we describe the marks children make? John Willats has suggested that we begin with their dimensions. This is an approach strikingly different from the norm, which is to go straight to shapes and depicted subject matter, mentioning dimensionality only with regard to the 2D drawing surface (Tufte's "flatland") and the 3D situation represented, but aside from that neglecting dimensionality altogether. Willats points out that while, strictly, the child's marks will always have some noticeable breadth (be 2D),[1] at least by the third year they will vary with regard to their *effective extendedness*. In chapter 4 we considered how drawn marks tend to be effectively 1D— that is, *lines* (fig. 48). Still, some may be virtually (not really) *unextended*, or 0D: dots, spots. Others might be noticeably 2D: blobs of paint or short strokes with broad-edged markers. Now we well know that children do not just attempt to make marks of these various dimensions; they also attempt to draw *shapes* by their means. Shapes: we have already seen how for drawings the word "shape," like "space," can mean crucially different things. The first six sections of this chapter will work through different kinds of shape, developing terms presented in Part I in broader context.

Keeping these formative factors in mind, we need some new words, to consider such markings in terms of what Willats calls "picture primitives," that is, the elementary form-making units in "pic-

Fig. 48. Enclosures drawing by EL: "tadpole" at top, angry bee in center.

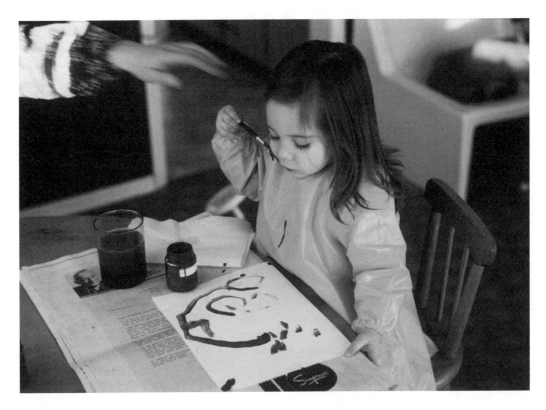

Fig. 49. Child (EL) drawing (three years old).

tures." However, as we are still working from Part I's broader idea of drawing, which does not yet assume the pictorial, let us just call them *drawing* primitives. A moment's thought shows why Willats's mark/drawing primitive is necessary. While a classification of drawing primitives, like that of mark primitives, can be made in terms of dimensions of extendedness (often corresponding to the marks' extendedness), drawing primitives do not always correlate simply with the effectively 0D, 1D, and 2D physical marks just noted. Continuous, curving lines can be formed by chains of straight marks or by dots; of course, visible skips in physical marks do not always register with us as breaks in lines. A particularly important example of the mark primitive/drawing primitive distinction concerns 2D "*regions*," a conception essential to all our accounts of drawing from now on. In summary, Willats observes that "regions in a [drawing] may be realized physically using patches of paint or blobs of ink, or blank areas enclosed by an outline," and adds, "thus it is crucial to observe the distinction between the *marks* in a [drawing] and the more abstract notion of the [*drawing*] *primitives* represented by these marks."[2] The examples of patches, enclosures, and fillers are important. A child who marks out a region with a large patch of paint may also, given only a crayon, indicate such a region with scribbled lines, and we should think of the child here as drawing the same thing but by different means and motor actions. Gaining the important ability to indicate a *closed line*, often a roughly circular one, on a surface (fig. 48)—that ability upon which so much of what we come to do with drawings depends, ever after—a child may use such an unfilled enclosure simply to define the region. That ability is understandably much remarked upon by drawing theorists, not only for the motor success entailed but for the use of line to distinguish inside from outside, and so to set out, to segregate, individual, positive objects against a ground.[3]

Following his dimensional approach, Willats would have us enrich the original dimensional extendedness approach to drawing primitives by noticing another obvious fact about the regions just mentioned. Not all drawn regions have the same dimensional *emphases*. For example, some may be elongated while others are fairly symmetrical. So, in addition to effective extendedness, it is useful to have a secondary notation for this kind of emphasis. Willats suggests that we qualify the dimensional label (or index) with an *index of extension*.[4] Fairly symmetrical regions, whether round or square, are alike notated as "2_{11}." The "2" is for the dimension, 2D, while the two subscript "1"s show that both dimensions are about equally stressed (and one might use fractions or decimals for finer discrimination). By contrast, markedly oblong 2D regions might be notated as "2_{10}," the subscript "0" beside the "1" registering relative lack of emphasis in one of the two perceptually effective dimensions. In summary: allowing drawing primitives a maximum of two dimensions on a surface, they may be classified (omitting fractional emphases) as fourfold: 0D (dots), 1D (lines), 2D (regions, whether indicated by dots, lines, blobs, etc.), and 2D salience subscript (0 or 1) together with 0 and 1 salience 2D subscripts. Part III will argue that, as parts of drawings, these primitives continue to be artistically important and interesting, in themselves as well as for what they lead to. So also are the physical markings upon which they rely, and the relationships between the marks and the regions as well. Speaking of art, it is important to remind ourselves how some cultures carry just these factors to the highest artistic levels (fig. 50), keeping in mind that not all have been so specially interested as has been the West in developing figurative depiction to enhance their visual imaginings.[5] Of course what we call "modern art" demonstrated again that no theory of drawing production entirely focused on figurative values could be satisfactory.

SHAPE'S FORMS

So far, as in Part I, we have avoided talking as much as possible about drawings that *depict* or drawings as *pictures of* things and situations. However, it is simply too awkward to try to discuss shapes in the course of drawing without mentioning depiction. Therefore, for present purposes, let us mobilize our everyday, unexplained concept of depiction—being "a picture of"—on condition that this will be soon subjected to theoretical treatment. Speaking of depiction, we know that young children produce what Norman Freeman calls "post hoc attributions" of depictive meaning for their markings.

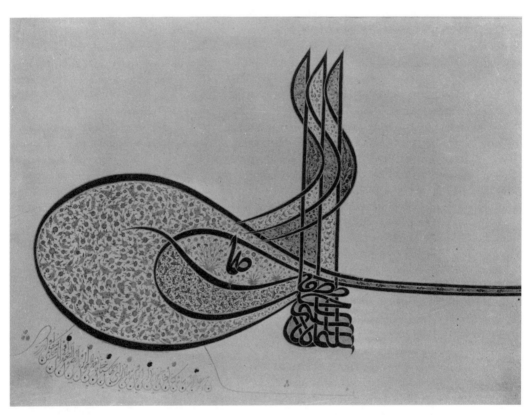

Fig. 50. Tughra of Sulaiman the Magnificent, Ottoman. Ink, colors and gold on paper, 52.1 × 64.5 cm.

Identifications are also "ad hoc" (for this case only), since, as children draw, they often announce what it is that they are drawing, provide narratives of subject matter, and it is a grumpy adult indeed who would challenge what Claire Golomb calls the child's "romancing" and then "reading-off."[6] Nevertheless, although they continue to mix their marks with declarations and titles, children very soon develop sufficient graphic skills to produce drawings that do not need much of what we might call "categorical" identifications: that is, looking at their drawings, others can fairly accurately discern what they show. To understand some of the challenges here, let us think (still only spatially) about the sorts of things and situations that children might typically try to depict, but, for now, only by means of what we are calling "dimensional picture primitives." Depicted things or situations, real or purely imaginary—observed, fancied, or feared—usually have spatial dimensions and various kinds of extendedness: indeed, they often (but not always) feature the famous *third* spatial dimension. Here, again, regarding the spatial features that our spatial picture primitives depict, Willats suggests that we use a notation of dimensional indices, just as we did for the drawing primitives by which children depict them.[7]

As examples of children's first depictive projects, with their basic syntax of picture primitives, consider personages—surely a frequent subject of depiction, from early childhood onward (fig. 51). Freckles or bits of earth may be taken as 0D or small 2D items; hairs as lines (1D); flushed cheeks as 2D; ears and eyes as either 2D or flattish 3D things; heads usually (but not necessarily) as volumetric 3D entities. With such 2D and 3D things we have, as we did with picture primitives, questions of salience.[8] After all, 3D things such as legs and arms are significantly like spaghetti and unlike such other 3D things as heads and apples, in being most saliently extended along one dimension. Willats suggests that we note the former limbs as 3_{100} to show that, while they are considered distinctly 3D, only one of the three dimensions is salient. By contrast, ears might be considered as 3_{110} and heads as 3_{111} for their salient extensions, and fractional subscripts are optional. Since three-year-olds usually have a repertoire of four picture primitives for representing the seven degrees of extendedness noted, producing that seven by those four would seem a trick. However, picture primi-tives are just that: primitives, that is, basic units for use in combination, and, as ever, relationships multiply meanings. Pictorial neighborhood—context for relative sizes, positions, juxtapositions of marks—can give different dimensional interpretations to the same picture primitives, always remembering that interpretation is a two-way affair. Once a mark is taken as indicating a certain kind of scene feature, adjacent marks are subject to drawing index interpretations based on their likely scenic meanings. A classic case in child drawing is shown in the early "tadpole" person drawing (top of fig. 48), where eyes (scene 2_{11}) within a head (scene 2_{11} or 3_{111}) are clearly indicated by the sizes and locations of several 2_{11} enclosure markings.[9] But see what, around three years old, children can do with this tool kit (figs. 51, 52).

Even if dimensionality and extendedness are fundamental spatial categories of representation, they are far from being the only important ones. We learned in Part I to consider *topological* and other characteristics denoted by the protean term "shape"—but from now we must also keep in mind our new elementary trio of marks, primitives, and depicted objects or features, introduced via dimensionality. It should be clear from observation that rendering topological characteristics,

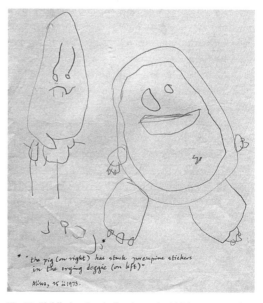

Fig. 51. Child's drawing, bully picture, by AM (two years and eight months old). "The pig has stuck porcupine stickers in the crying doggie."

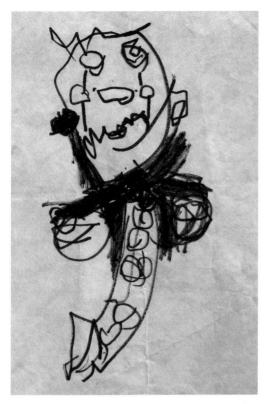

Fig. 52. Monster, drawing by NM (three years and three months old).

notably those having to do with depicted *connectedness,* is a basic shape value in drawing. We find even very young children, as they master their first drawing marks, not only repeating them but relating them on the surface, notably, joining the marks. (This shows in all our child figures.) When they relate their marks, it seems no wonder that children derive their first powers for evocative, noncategorical depiction. This we see already in the "tadpole" (fig. 48), where enclosure primitives placed inside a large 2D primitive depict eyes being within a body (or on it). Next, the lines proceed outward from that main enclosure, so that their topological relationships can depict another crucially important kind of connectedness: attachment, another example of correspondence. Here we touch on a most important issue, so basic as to be usually overlooked. Readers may demonstrate to themselves that some shape drawing projects are heavily topological by drawing the side of a bicycle. But as we saw in Part I, even where topological interests do not so clearly define drawing tasks, topo-

logical *values* will. Surprisingly, this topic remains theoretically undeveloped.[10] In the example of rail schedules, we appreciated topological issues as ordinal, presupposing nominal matters. Rail stations already being distinguished as countable entities (a nominal matter), we considered their order along given rail lines. However, as noted, usually the situation is a bit more complicated, as—at least with physical substances— topological questions of continuity and connectedness are basic to our ideas of object identity. Since very often one "thing" means one continuous body of continuous surfaces, just counting objects usually presupposes continuity. This is much the case with living bodies, notably with human ones (from childhood the chief subjects of representation), and we are particularly sensitive about their intactness.

Speaking of discontinuity, we must now break with these important issues to consider the broader topic of the diversity of shape in drawing. We have already considered the idea of shape as overall proportion, via the saliency subscripts. For example, "2_{10}" and "2_{11}," as applied to both picture and scene primitives, signify a narrow and a full region, and such would normally be considered as "differently shaped." Equally, however, while sharing one-dimensionality, curved lines will be seen as having different shapes from straight ones; one dimension up, a straight 2_{10} (a carrot) and a curved 2_{10} (a banana) will strike us as differently shaped, in a manner crucial to *symmetry,* that large, interesting topic earlier encountered. Also, as we further open up the resources of shape, we would have to note how "pointed," "round," and so forth are shape descriptions of a kind that we did not consider when describing children's extensional shape primitives or their topological characteristics. Children's developing control of each of these factors at the mark, primitive, and object/feature levels greatly increases their depictive repertoires. Since shapes of any of these kinds in drawing would form a very large topic, soon engulfing our project, let us commend them to further drawing studies and restrict our discussion now to a sufficiently daunting one, which any theory of drawing is bound to address: contour.

SHAPE AS CONTOUR

"Dent" becomes "bent" when push comes to shove, as "bent," like "twisted," has a different con-

notation from "dented." That is not simply a question of scale; "bent" and "twisted" have to do with changes within the axes of objects (often suggesting processes), "dented" more with local variations.[11] Object axis shape also combines with larger frameworks, notably that of gravity—making, for example, the big difference between the tree's only being bent from heavy weather and its leaning from the roots. As Ernst Mach pointed out, as in the *Menon* diagram (fig. 7) the outer square with its corners, and the inscribed diamond with its points, are conformally the same shape, but, rotated on an axis of symmetry, they have different appearances and names. By contrast, terms such as "dented," "bumpy," "jagged," or "smooth" denote what we might call, with a rather ambiguous term, the "contours" of objects, rather than their axis shapes. With contour, things become very interesting for drawing and for any plausible account of it. According to cartoon mentality, young children draw in "stick" or "pin" figures, but that is fairly unusual. Although children commonly use 1D primitives for leg, arms, and fingers, they usually draw bodies by roughly parallel lines or 2D enclosures (see figs. 48, 49, 51, 52), whose lines they begin to articulate. By contrast, stick figures lend themselves to pure axis thinking, which suggests a rather more advanced stage. We are most familiar with contour shape through a line, notably an enclosure (dimensional index 2) generally called the "outline" of a thing, which is used in a way remarkably different from what we have so far considered in this chapter. Indeed, so universal is contour drawing across the ages that it stands in our minds as a paradigm for "drawing" generally.

In discussions of drawing, "contour," from the root meaning "to turn," is significantly ambiguous. First, we need to distinguish contours as shapes in drawing (that is, contour as a use of line) and contours as boundaries of the objects depicted in drawings. Regarding each, we face further variations in use. Sometimes "contour" in drawings denotes lines running all over a surface that indicate the 3D or relief shapes. In perhaps the most famous modern "how to draw" book, Kimon Nicolaïdes uses the term "cross contour" for the line that "follows around the shape of the figure somewhat as a barrel hoop follows the rounded shape of a barrel," but "dips down into the hollows and rises up over the muscles."[12] At least in its highly "rationalized" form, this is a modern draw-ing tool, probably from the sixteenth century and possibly deriving from shading strokes, although Roman mosaicists' similar use of *opus vermiculatum* (wormlike work) ran the tesserae similarly "in wreathed lines resembling the undulations of worms." Cross contour has great significance for modern reproductive technologies, where it is most familiar from the standardized engraving lines that shape heads portrayed on paper currencies worldwide.[13] Usually, however, "contour" denotes not the overall surface but the boundary and shape outline of bodies or features of bodies, particularly when they are curved or irregular. One writer on the arts of drawing, Philip Rawson (to whom we will make extended reference in Part III), classes drawn contour as an important kind of drawn outline, noting that outline can run "round an enclosure which does not necessarily correspond with a single object, such as an area of empty space," whereas, presumably, we would not count such negative spaces as having contours. We will follow Rawson's usage.[14]

Understood as a characteristic of bodies, not of the negative spaces between them, "contour" needs another two highly significant drawing distinctions. First, although Rawson calls contour of objects "a kind of shaped edge," our general use of the term is rather wider than that, including, for example, rounded forms such as balls and eggs that are notably lacking in edges. It is therefore standard to distinguish merely *occluding* contours from true edge contours.[15] Telling apart the true edge contours from the merely occluding ones is often an important part of understanding drawings, as it is of understanding real scenes. It is obviously a very important issue for the interpretation of technical production drawings of the kinds discussed in Part I. Next, regarding a kind of drawing that we call "contour drawing," particularly when this is an occluding contour, outlining positive bodies is not enough. As the drawing teacher Roger Kaupelis points out, a simple demonstration—of a "rule of thumb"—shows why.[16] Trace your slightly flexed thumb, he suggests, and you will likely produce a flat pattern—an outline that is a flat silhouette—which may not be easily recognizable as a three-dimensional object, whereas a true contour drawing would probably be made by a series of convex lines, forming little junctions with one another. This is a purpose of "blind contour" drawing exercises, where one looks at the model but not at the

drawing and stops each line when a part of the object's contour seems to end.

Shape, in the limited sense of contour or outline of drawn bodies—still the standard way of approaching children's drawings—once had diverting "explanatory" exposition. For example, the illustrator Walter Crane speculated in 1900 that outline "is the earliest mode of expression among primitive peoples, as it is with the individual child" because (allegedly) children recognize things by silhouettes. "As children we probably perceive forms in nature defined as flat shapes of colour relieved upon other colours," Crane postulated. "To define the boundaries of such forms becomes the main object in early attempts at artistic expression." "The attention is caught by the edges," Crane adds, thus the child neglects details and draws a simplified shape.[17] To be sure, the overall outline shape of objects is a key to visual recognition for both children and adults, and it is widely used for depictive recognition as well. It takes not much experiment, however, to demonstrate to oneself how obscure silhouettes can be: no wonder Greek black-figure pot painters incised internal lines to clarify their figures.

For our entire understanding of drawing, there is a more basic point to make about Crane's just-so story. It is typical that such speculations assume direct, en bloc transfer of perception or conceptions to motor actions of drawing, so that the latter "express" the former (the child's mentality), as though drawing were not itself a task demanding strategies of approach. Not long after Crane, Harold Speed took a seemingly opposed tack in his *Practice and Science of Drawing,* explaining child drawing in terms of the child's "mental world" being "associated more directly with touch than with sight." Thus, when asked to draw something, the child allegedly "thinks of it first as an object having a continuous boundary in space." "This his mind instinctively conceives as a line," Speed remarks, capturing "the idea of an object in the mind."[18] It seems strange that working artists such as Crane and Speed, writing drawing books, should have so underestimated, even overlooked, the very challenge of how to put marks down on a surface to mean something like what one intends—in other words, the activity of drawing. Fortunately, more recent researchers such as Willats and Norman Freeman observe that drawing itself is a challenging task requiring rather

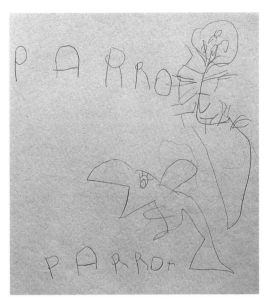

Fig. 53. Parrot, drawing by EL (four years and three months old). Nest with eggs shown above.

complex procedures.[19] Claire Golomb reports that small children often work hard at their early drawings, with the tools, physical abilities, and techniques they possess, aware that they cannot get down quite what they wish, sometimes changing their accounts of what they are drawing to fit the results.[20] "Children," she observes, "do not strive to represent all they know; they are satisfied when the drawing 'looks like it.'" Thus a four-year-old comments: "That's for legs; I can't make them straight. I can only make the legs, can't make the whole thing . . . I can make the head too, and the hair" (59–60), and this is typical.

If we think then of the young child as working at making deliberate marks of various kinds, contour or "outline" drawing skills of either of the sorts described may eventually become available to the child when, for example, a long region (2_{10}) rather than a single line is used to represent a leg, which, as Willats remarks, "brings closer the possibility of matching the shape of the region" to that of the limb it depicts.[21] With the whole region indicating the extendedness (and direction) of the limb, the lines put down to enclose the region may take on auxiliary functions. For example, local variations in regions can come to depict local variations in the shape of the limb. Developmentally, this opens new avenues for

drawing: the depiction of local shapes of objects by means of characteristic outlines of faces, sides, or aspects of objects. This seems to be occurring in a four-year-old's drawing of a parrot, which began with the beak (fig. 53).[22] A next, fateful, stage in the development of contour in some traditions—daunting to developmental theorists—is what we saw called projection, including perspective. Here the label "projection" is somewhat misleading because (as we saw in Part I) the useful heuristic geo 1 ideas of projection have, in most real cases of drawing, neither practical nor psychological reality either for drafters (especially not for children) or for viewers, and throughout this account we are interested in the realities of drawing production.[23]

CHILDREN'S "PERSPECTIVES"

Regarding what is usually termed drawing "perspective," almost as important as *what* we say about it is *when* we say it. By contrast, the norm in psychological, philosophical, and like studies is to go at pictures from the start with contours—indeed perspective contours, given that that, as we saw in Part I, the standard exposition of perspective itself is made with contour drawings. It is not only that contour virtually defines drawing for many, but projection—even perspective projection—is often taken as *defining* depiction itself, sometimes explicitly, though most often implicitly. Thus in the first theoretical text on the topic, Alberti wrote: "Should you ask some what they are doing when they cover a plane with colours, they will answer everything but what you ask. . . . They should know that they circumscribe the plane with their lines. When they fill the circumscribed places with colours, they should only seek to present the forms of things seen on this plane as if were of transparent glass" (something apparently not known, say, to Sassetta, when the next year he began to paint a polyptych for Borgo San Sepolcro).[24] Alberti, as noted in chapter 2, had an extramissive idea of what he called the "pyramid" of rays between eyes and what they see. In modern psychological circles, J. J. Gibson's influential intromissive version of that went as follows: "A faithful picture is a delimited physical surface processed in such a way that it reflects (or transmits) a sheaf of light-rays to a given point which is the same as

would be the sheaf of rays from the original to that point," a more relaxed later version of this being: "Now, a picture is nothing but a more convenient way of arranging matter so that it projects a pattern identical to real objects."[25] Indeed, absent any real theory for approaching our topic in proper order, it is common to find theorists parachuting in entire "theories of representation" this way. But that makes no sense. It makes no sense for real actions of drawing, which begin with making marks; also none for understanding the development of drawing, its different uses, its capacities to call on many aspects of us to provide meaning. As should be abundantly clear from Part I, this is not to denigrate projective drawing, or projective contour drawing, depictive or not.

At what points then do the various so-called "projective" techniques of chapter 2 become relevant in the early course of drawing? Sometimes with drawing single objects; certainly when drawing scenes involving several objects in spatial relations. Beginning with singletons, Willats and others have done intriguing empirical work with children on the entry of various "projective" devices in drawing development.[26] As we watch these devices appear in children's work, the wisdom of Booker's geo 1 / geo 2 distinction shines through. When tracking, for example, the development of children's drawings of several-sided objects with distinct faces, such as tables and houses, no one is going to suppose that geo 1 conceptions of projection are at work. Most children understandably begin with orthographic presentations and avoid several-sided situations, for which they have to solve the problem of showing the (topological) attachments of sides of rectangular objects to other sides. When they do face these situations, geo 2 strategies are obviously called for, notably those for dealing with edges and corners of objects, where two or three sides meet. What is at stake here for the child is not a matter of giving a sense of space or depth, but rather of working out some simple topology—that is, of continuity: of how to put the legs of a table on the table while also showing its top, or of how to make the sides and top of a box go together as one knows they do. At such crucial times, children are rather like engineers faced with the daunting challenges of assembling the objects in their drawings intelligibly, rather than with concerns about giving a visual impression of depth. It is hardly surprising that this is usually a major

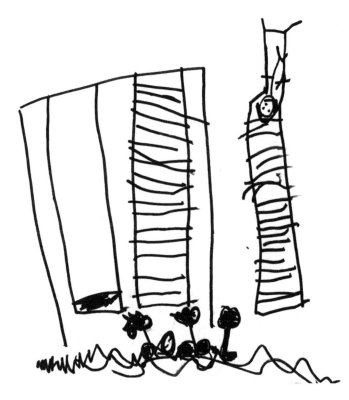

Fig. 54. Playground, drawing by AM (about five years old).

point of crisis for children, which—perhaps given the failure of education to provide them with standard geo 2 techniques for resolving—most of them never pass, and it may be at least a contributing cause of the general abandonment of drawing by most children before their teens.

Here the insufficiency of the standard, appealing distinction between knowing and seeing—between drawing what one knows conceptually should be there and drawing what one actually perceives—becomes apparent when we realize that older children may struggle to draw the sides that we would be able to *see* while hiding the ones we would not be able to see.[27] This is not to say that, for example, Roger Fry was wholly mistaken in claiming that, just as with children, historically "all early art has been strongly conceptualized, all images tend to represent objects rather than appearances."[28] As we shall soon see, such a distinction strongly shaped E. H. Gombrich's famous work on depiction. Indeed, researchers such as Willats accept a distinction between "object-centered" and "view(er)-centered" strategies in drawing.[29] However, as just indicated with the child's drawing challenges, it is misleading to work from a dualism

of conceptual/visual images. It seems quite plausible that sighted creatures should represent the visible world to themselves in object-centered ways, but that does not exclude view-centered awareness. What matters is that the one object is a leaf, the other a lion, even though the visual system must also register that from some views a leaf will occlude a lion. Although we introduced perspective and other projective systems into children's drawing in the plausible context of perceptual contour shapes, from a developmental standpoint, as Willats has argued, these systems appear better understood in terms of the advanced design concerns of chapter 2: showing the faces of objects and their crucial junctions. It is interesting that Alberti also conceived of linear perspective as a tool for dealing with relationships of object faces or planes. "Now, since in a single glance not only one plane but several are seen, we will investigate in what way conjoined planes are seen," he wrote. "Since bodies are covered with planes, all the planes of a body seen at one glance will make a pyramid packed with as many smaller pyramids as there are planes."[30]

In general, children do not initially deal with planes or faces of drawn objects. Rather, as their

EPICTETUS *lived in Rome in a little house which had not so much as a door all the Attendants he had was an Old Servant maid and all his houshold stuff an earth.n Lamp.*
 Vincent *Obsop: l. 3. Anth: ad Epig: Epictet:*

Fig. 55. Epictetus in Rome, frontispiece to Ellis Walker, *The Morals of Epictetus, Made English in a Poetical Paraphrase* (London: Newton, Manson, Hammond, Davidson, 1788). Engraving, plate impression 14.5 × 9.0 cm. Digitized by Robert Binkley.

drawing projects broaden to include spatial features of any of the kinds discussed, and in scenes containing multiple objects, children confront a number of vexing spatial tasks, which they often deal with in ingenious and delightful ways. Consider, for example, what a projective approach such as what we called "oblique" might do with a child drawing a playground scene (fig. 54), where the challenge lies not in showing what things look like, or even capturing the V shape of a slide, but in showing the slide's going up and down. Here we find an almost five-year-old wielding mainly 1D marks, dealing with the challenge by orthographic means, while preserving topological connectivity values. As with Villard's axle, this drawing might

be appreciated by looking at it from two orientations. (Folding the drawing might suggest even its relation to a constructional approach to drawing a slide.) Not surprisingly, Willats finds that, after the orthographic, geo 2 oblique drawing rules are among the first discovered and most widely used by children, and the same seems to hold historically. As noted in Part I, distinctively perspectival geo 2 rules, such as for converging contours for parallels running back into space, come later and piecemeal. If not yet furnished with paint boxes, children, like everyone else, approach their projects with drawing tool kits—that is, repertories of devices, which we have been tracking from their first marks. And it needs to be emphasized that just

a

b

Fig. 56. John Willats, object-centered drawing stimulus pictures. From Willats, *Art and Representation: New Principles in the Analysis of Pictures* (Princeton, N.J.: Princeton University Press, 1997), fig. 8.8 (detail). See 240n32.

as different artists make very different uses of devices such as linear perspective, from very early on children deploy their common drawing tools highly effectively and individually—as our illustrations show.

According to popular testimony, "projective" challenges might better be termed "the curse of drawing." Some adults report that frustration there led them to abandon drawing; many art teachers steer students clear of concern with getting such spatial relationships "right" (often using the scare quotes). Indeed, excluding just that section of the more advanced drawing tool kit was a main step in the abandonment of classical educational drawing techniques. Underrated in all this are the actual constructional problems that children (as well as drafters through the centuries) themselves identify, for example, in the combined use of the orthographic and oblique tools just mentioned. Thus the illustrator for an eighteenth-century English verse translation of the Stoic philosopher Epictetus (fig.

55) perspectively diminishes the image of the distant (anachronistic) Saint Peter's and puts it higher on the page, while setting out the philosopher's "little house" in oblique, which, as earlier noticed, maintains frontal orthographic values. But, wishing similarly to favor the right side wall, he has mixed in a geo 2 horizontal oblique method, sacrificing another spatial value we have stressed (topology) in its connection to the back wall. As Willats points out, this is a common technique, and common problem, in child drawings.[31]

Through an easy and ingenious experiment devised by Willats, readers may test for themselves the power of drawing rules or procedures even in adult copy work (fig. 56). Let us follow his instruction to make a simple sketch of the main perspectival features of this street scene, placing the lamp posts at correct intervals and at right heights. To orient this, we should also sketch in the orthogonals representing the curbs, the stringcourses through the middle of the buildings, and the roof lines. Here even practiced drafters will feel the tug of procedures that work from object-centered interpretations of what is depicted, even in copying the lines in a drawing: perhaps an unsurprising effect, once we recall the problems many of us encounter even in tracing simple pictures.[32] In addition Willats reminds us that, besides having procedures, we must employ them stepwise, thus working by perceptual feedback as our drawings progress, quite unlike computers that have internalized the same geo.-2 sequential rules for drawing, for example in oblique.[33] The sequence idea is a theme that will be greatly expanded in Parts III and IV, in order to understand drawing as an art.

In summary, it is clear that, for all its natural roots in infant work, drawing development is unlike language development. As they grow older children encounter technical difficulties in their own drawing projects and, absent help in solving these, are usually frustrated, even stopped, short of the advanced techniques for perspective images that are all around them. We have raced through some of the kinds of shape issues in children's drawing. In Part I we considered brief geo 1 accounts of strictly projective techniques and sketched some geo 2 accounts. Carrying that material forward with a responsible empirical account of the developmental course of drawing—including testing to what extent they constitute a modern

curse of drawing, or to what extent they might be reworked as a modern curriculum—are projects beyond our means here. As it is, we face sufficiently daunting challenges for our theoretical inquiry, since we can no longer put off the business begun, of accounting for fully perceptual or *depictive* drawing. Just making clear the reasons why these are daunting challenges will be an accomplishment, since serious problems regarding depiction have scarcely been registered in the literature. In the following chapters we will attempt to understand these challenges and to answer them clearly and explicitly, in terms of a theory.

6. depictive drawing

CHALLENGES OF DEPICTION

Expert testimony, such as that by Freeman, Golomb, and Willats, confirms what common experience will tell: the act of drawing sets tasks. Drafters, tiny or not, face challenges like any other artisans: with the tool kits they assemble from implements improvised, taught, or borrowed, they adapt to the practical problems at hand. As earlier indicated regarding perspective, drawing professionals, likewise, are affected by new technologies and corresponding changes in markets (which may deskill them). By analogy, theorists of drawing, too, have their tool kits—conceptual ones—for dealing with their challenges, but here it is usually more a matter of taking on sets of analytic tools, some specialized, some borrowed from other areas, than of reinventing them for ourselves. We are at work here critically with a tool kit of ideas, sorting and reordering what we borrow and improvise, in the attempt to provide an approach to all kinds of drawing—eventually, art. But a problem already identified in Part I begins to press. Up to this point, we have been following, critically, the research strengths of theoretical and empirical drawing studies, concerning what is often called "pictorial space." In Part I we considered drawings both in their various spatial aspects and in terms of the kinds of spatial—or at least spatially based—information that they present. In chapter 5 our consideration of the development of drawing followed pretty much the same spatial approach: we discussed the marks children make, the actions that children thereby perform, the things they thereby represent, the challenges they encounter. Much of the effort so far has been to expand the usual conceptual repertoire for describing such drawing and to organize the results, keeping in mind the actual course of drawing development. And, as in Part I, spatial issues have been paramount in two ways: first, with respect to the visible spatial properties of the marked surface that the drafter produces, and second, with respect to the spatial characteristics of subject matter thereby indicated. It is time to answer some hard questions about both.

First, concerning the visible resources with which we draw, no one would limit them to their purely spatial aspects. For obvious example, tonal (dark and light) features of drawings are obviously an important class of depictive resources not yet mentioned. It may be replied that tonal variations of marks are normally combined with the various spatial aspects that we have been studying. An example of this ready to hand is the swelling of cross-contour, increasing tone, in the etching lines that model faces displayed on paper currencies.[1] Historically, the analysis of shade and shadow effects, both in practice and in theoretical writing, was close companion to Renaissance systematizations of linear perspective. Thus Alberti's comments on

color, shade, and shadow in normal vision immediately precede his famous geo 1 introduction of perspective; Dürer's *Painter's Manual* presentation of perspective begins with "I shall also speak of light and shadow"; while Leonardo announced: "Lights and darks, together with foreshortening, comprise the excellence of the science of painting."[2] Such are typical remarks of that age, when, as we shall later see, tone was usually treated spatially. But eventually we will have to consider the question: What *other* visible resources can we find in the marked surfaces that constitute drawing? The central strategy of Parts III and IV will be to argue for realms of less spatial but visually evident properties.

Next, there is a related question of what can be *drawn* by the spatial resources so far discussed. While emphasizing spatial characteristics of various kinds all along, we have never been restricted to them, not even with the technical drawings or the Dürers. After all, even our Villard sketch "visualized" process, motion, and causal action besides spatial characteristics. Furthermore, we noticed that most of the drawings in Part I represented substances—also that, far from things reducing to spatial characteristics, spatial characteristics presuppose categories of substances. This clearly holds for the young child's drawings. In addition to drawing faces, people, plants, animals, slide and swing sets, actions, even quite young children manage not only depiction of moods and attitudes, as we already see with the three-year-old's angry bee of figure 49, but also psychological and social relationships. A picture such as figure 51 by an even younger child stands as sufficient proof of that. No plausible account of the early course of drawing could minimize those aspects of children's imaginative activities. While the drawing child is, as we saw, immediately faced with spatial challenges, it would be absurd to understand the child's actions entirely or even mainly in terms of these, which usually concern the technical means, rather than the ends, of the child's efforts. Thereby a second challenge arises: How can an account of drawings, understood in terms of their visible spatial characteristics, even when combined with those of tone, hope to account for even tiny children's representations of nonspatial, nontonal entities and situations? Or we might ask, How can an approach to drawings largely in terms of their visible spatial characteristics, together with the spatial entities

that we can allow that they represent, account for the obvious fullness of drawing's representational subject matter? Is the idea that visible spatial characteristics of marks on surfaces get us to produce the corresponding represented spatial ones, and that the latter are then the *gateway* to everything else? Such are questions that any space-based theory of pictorial representation must answer.

These challenges need to be taken in order, but there is a prior one. Like the two concerning spatial bias, but more generally and more bluntly, this one asks what it is that we are trying to do in a chapter regarding representation and depiction. Consider for example the last few children's drawings discussed. While using the terms "depict" and "depictions" I have offered no explanation of how any of them *depicts* anything, even any of the purely spatial properties we have considered. If that was not a serious problem in Part I, it is now. Then we were largely concerned with drawings that present information, drawings that allow us to think, construct, move about; such were their functions. Not forgetting the great importance of such drawings for design and communication, technical drawings may be considered as graphic instructions; the term "diagram" fits many of them comfortably. Thus the lines in constructional drawing such as patterns and templates have the clear operational meanings of "cut here," "measure from here"; and many of the other kinds of technical drawings that we considered are also designed to allow direct or indirect transfer of measurements. It is not surprising that, even long before computer scanning, such drawings should frequently have been constituents of machines, sometimes quite simple ones, guiding their automatic shaping of materials, with no recourse to cognitive processes. However, there is no similar function for most children's drawings; there is no similar function for most of the drawings we most value, largely because of their depictive *content*. We need a real theory of depiction if our account of all kinds of drawing is to do justice even to the content of a young child's scene of a bully and its victim, even in its spatial aspects (fig. 42). Let us consider this challenge through some simple examples most recently to hand.

Beginning, say, with the playground drawing (fig. 54) and focusing at first only on the spatial properties and spatial meanings that we have considered, what can we say? Our analytic tools so far have us saying that, by drawing 1D marks, along

with a few oDs and 2Ds, the child produces some regions but mainly lines (remarkably, we notice that the drawing does not much depend on region primitives). Mostly, these lines do not constitute *outlines*, rather they tend to indicate objects that also feature pronounced 1D dimensionality: notably the frames, ropes, rungs, and struts of the playground equipment. The lines also indicate some cracks, such as the child's mouth, but they appear to be without textural use. As to contours, only a few, such as those of the slide base and the flowers, show general shapes. With the few regions (e.g., those indicating the child), contour use is not clear and local shapes are hardly indicated, though there may be axis shape. Connectivity and direction matter much here: despite the child's hasty way with the marks indicating the slide steps, it is clear what sort of sequences and connections are indicated. Also, as mentioned, the separate objects are approached rather "orthographically"—that is, in terms of the objects' front faces, and occlusion of marks is carefully avoided (except for the child on the slide) along with other depth indications. In that regard, and in others to be treated later, some artists might appreciate this drawing for "respecting the surface."

In these descriptions I have used the terms "indicate," "show," and "form"; one might also say "represent," "denote," and so forth. The question is, what do such words actually mean? They do not have the operational meanings of the constructional and some other types of technical drawings just mentioned—a simple point that holds equally for most of the drawings that nontechnical people look at. They do not have the form meanings that we considered with patterns, such as "interlace," "leaf shape," and so on. Perhaps the most common account of what such words mean would be in terms of "bringing to mind what is not present"— an ancient account, said or implied in various contexts since Augustine and Isidore of Seville.[3] But that is a careless formulation, since many drawings (like other depictions) depict themselves (see fig. 2), so that at least part of what they depict certainly is present.[4] Also "bringing" or "conveying" to the mind is unclear or doubtful, since we often already have in mind what we find in pictures, this being particularly true when we are making them. Nonetheless, some mental or "in mind" function does seem crucial, if we can only understand what this reference to mind means. Let us consider what

might be said to be "in our minds" when we look at the child's picture. That includes not just objects, their spatial characteristics and relations but, even in a simple drawing like this, a situation, which might be glossed as follows: "Next to a swing set and climbing frame, in a grassy spot where flowers grow, a child goes down a slide." However, though the picture is indeed designed (successfully) to put such a situation in our minds, that is not enough to tell what words like "indicate," "form," and so forth mean, because the very same may be said of the description just quoted—but it is not a depiction. Such observations invite yet another venerable tradition, which takes many forms: the tradition of likeness or resemblance, which says that the distinctively depictive aspect is that the presence of these things (the objects, situations) "in the mind" is brought about by certain elements of the picture being rather like them. Let us consider this briefly, on the basis of the work we have done.

Our spatial work so far has enumerated a number of these elements, via what Part I called "correspondence." Our metric, affine, perspective projective, and topological discussions have focused on these valuable properties of drawing systems. Notably, we have considered the cost/benefit aspects of orthography. More simply, in connection with a child's drawing (fig. 54) we note how basically 1D marks may be correlated with 3D objects, such as the ladder rungs, that have strikingly 1D dimensional emphases. This involves several kinds of correspondence matching. For example, the depicted features and objects are arranged sequentially the same way the marks are; also the axis shapes of the former are approximately correlated with the shapes of the latter (disregarding the curvature of some of the marks defining rungs, which, charitably, we would not take as depicting bent rungs). Again, overall orthographic "face" shapes of the objects pretty well match those of the clusters of marks and primitives that depict them, and there are also clear correlations of the important topological properties of continuity, connectedness, separation, and so forth. But while such observations are very relevant to how this drawing works as a depiction, they still do not tell us what depiction is. In considering various kinds of spatial matchups, what we have described are, on one hand, a marked surface displaying various spatial properties, and, on the other, a scene. The problem is with the separate "hands." There is our percep-

tual experience of shapes on a surface, and there is an "experience in the mind" of a situation in a playground. But, as experiences, the account leaves the perceptual one and the "in the mind" one distinct, however automatically the former leads to the latter. And here let us take from the child's picture what will later be a profound point about the great artist's: that understanding pictorial representations, like understanding things we perceive generally, is often a sustained process of recognition, undergoing revision as well as addition.

There are different ways of arguing against the "in the mind due to resemblance" approach to depiction. Following are two, equally devastating. First, a sweeping counterexample. Everything in the correspondence account holds equally well for shadows. Cast shadows also lie on surfaces, corresponding in all the spatial respects we have studied. Furthermore, we daily, automatically or not, interpret such shadows in terms of objects, taking 0D, 1D, and 2D shadow states as "indicating" similar features of things and also 3D objects, noting continuities and breaks, and of course axis and contour shapes, with more or less approximation. The fact that a few—very few—such shadows *do* also function depictively (in shadow play) in itself proves the hopeless insufficiency of various accounts of depiction long in favor, especially the projective ones.[5] The fact that perceptual experiences of shadows are so different in the two cases should be clear. As indicated in chapter 4, similar remarks can be made about how we see tracks and similar traces of objects, and "we" in all such cases includes animals and insects as well as humans. Seeing the marks on the surface, we often do have things and situations "in mind" because they are similar in specifiable ways—we can even say that the former "represent" the latter, but this puts us no closer to saying what depiction is.

Another problem has several times been identified. To express depicting we began with terms such as "indicate," "stand for," "represent." This is theoretical jargon: we would not likely use any of these terms in talking with children regarding their or anyone's else's pictures. Truth is, we do not usually use such terms in adult conversation either. What terms do we use? As has often been noted, in most languages, the most relevant verbs in use mean "is" and "are." After all, as Plato wrote, "being expert at drawing he produces things that have the same names as real things":[6] not "this rep-

resents a person" but "this is a person." E. H. Gombrich observed that when making a snowman we make "a man of snow." "We do not say," he continued, " 'Shall we represent a man who is smoking?' but 'Shall we give him a pipe?' "[7] The same holds for drawings. A child would most likely describe our picture by saying, "That's a swing" (slide, flower, girl, step, frame, etc.), and so would we, sometimes with the question "What is that?" (or, alas, as the child gets older, "What's that supposed to be?"), a request about the subject matter, not about the marks as such, and often focused by pointing in the direction of the relevant area of the drawing surface.[8] Furthermore, as Gombrich's example suggests, we often simply refer to parts of depictions in terms of what they depict. We also say that we *see* them. We say that we see the picture, but we also say that we see what is in it: a dog's sad face, a child on a slide. But we do not actually see these things; what we actually see is a marked surface. What could we mean when we say that we see the subject matter, and why do we insist on speaking this way? "Putting in mind" approaches have never even addressed such elementary questions.

On closer examination, we find that we usually mix references to what is in the picture and to what we see in a seemingly confusing manner—except that we are not confused. For example, having read that the curved contour modelling method arose in Italian engraving of the early sixteenth century, we might look back at "the German linear scheme" of our Part I Dürers to see to how much of the method was already in use there.[9] There we find considerable use of a similar woodcut technique in the groups of lines that indicate shaded areas without blocking them completely with ink. Also Dürer does often take advantage of this technique to curve his shading strokes so as to suggest concavity and convexity, though only in summary manner. It might be added that for deep shadow Dürer used cross-hatching as well, though sparingly. We see a little of this under the skirt of the seated man in figure 33, where we can barely make out the form, some more by the bed, and at the far right below the curtain. An interesting case is in figure 34, where on the left sleeve of the draftsman we find cross-hatching of two sets of contours, whereas the neck of the nude is rather crudely modelled as a cylinder. Notice how in such comments we naturally mix references to seeing marks and lines and

also to seeing people, furniture, and so forth; how we say that there is cross-hatching on a sleeve without meaning that the sleeve is embroidered. We have it both ways, mixing locutions: "Made of pen and ink, she will win you with a wink," sang the chorus of Betty Boop cartoons. To continue with testimony from the wise: "If I see the picture of a galloping horse," Wittgenstein asked, "do I only *know* that this is the kind of movement meant? Is it superstition to think I *see* that in the picture?"[10] Yet (to quote Alberti), should you ask someone what we are doing when we speak and act this way, they will answer everything but what you ask. This however will not do for a theory of drawing that includes depiction, as any adequate account must. Therefore before we take another step even with children's drawing, we have theoretical work to do.

WALTON'S THEORY OF DEPICTION

Fortunately, at this crucial point, our theoretical course flows into a worked-out philosophical theory with clear and rigorous terms, distinctions, and connections to experience, so that my job becomes for a while that of theoretical exposition. Thanks to work by the philosopher Kendall Walton, an adequate answer to the "in mind" challenge turns out to be simple. It is, literally, a matter of having a little imagination: that is, having it in the right places in the account. Very briefly, according to Walton, the way in which we have things and situations "in mind" with representations is by imagining them: that is, representations are things with the function of mandating that we imagine in certain ways, mainly depending on their relevant properties. So far, this might not seem much different from the traditional "bringing to mind" approach. With depictive representations—and, more specifically, the visually depictive ones that concern us here—this imagining must be perceptual in an even more closely prescribed way. Clearly in the case of pictorial and like depictions we do not just imagine represented things and situations, but imagine seeing them. The same may be said of vivid fictional writing. What is additionally required for visually depictive representation, and not just representation of the visual or even visually evocative representations, is a more viewer-involved perceptual participation in the imagining. The requirement is that we imagine of our very act

of seeing the picture that it *is* the seeing of what we are imagining. Thus visual depiction involves not only imagining something and imagining seeing it, but also imagining something about our own perceptual actions. Regarding the child's picture, not only are we to imagine seeing the outdoor scene of a child upon a slide, tuliplike flowers, an empty swing, and so forth, we are to imagine of our activities of looking at the patterns of marks on surface that form picture primitives that this is the seeing of the playground scene. With this third condition Walton ingeniously captures the distinguishing perceptual aspect of depiction, separating it from mere visual access to information, from merely imagining that something is visible, and even from just imagining seeing something—all of which conditions are fulfilled by vivid descriptions, spoken or written, which we would not consider to be visual depictions.

The third condition is of perceptual self-imagining. By casting the perceptual aspect of depiction this way, it solves a fundamental problem for any theoretical approach to depiction, a problem that, far from being solved by anyone else, is usually not even recognized by philosophers, psychologists, and others. Broadly speaking, most theoretical approaches to depiction try to capture one or other of the terms "visual" and "representation" and abjectly fail to deal with the remaining one. Sign and symbol theories start from the representational end, considered as some sort of "referring," and their struggle is to explain representational content in terms of things referring to other things (typically illustrated with arrows). What then of the visual in depiction? A standard tactic is to try to eke out some kind of visual correspondence ("resemblance") between the signs and what they refer to (posing problems with fictional depictions, for example, those of Mickey Mouse, which refer to nothing and do not much resemble mice).

A bolder version of the symbol approach that we find, for example, with Nelson Goodman, disdains visual resemblance or any other kind of correspondence and seeks to understand depiction syntactically, that is, with regard only to the "signs" themselves. For Goodman the difference between the depictive and the diagrammatic is entirely syntactic, the former being the more "attenuated" (less "replete") representation: that is, less of its characteristics (such as color and line thickness) are representationally relevant. Thus he also ex-

cludes the "pragmatic" or viewer aspect from his analysis, and thereby perceptual experience. As for visual perception, on his account, it is a mode of access to a complex skein of reference relationships. One problem with any such "semiotic" account is that it provides an inauspicious basis for understanding our interest in depictions, it being unclear, for example, how a child's delight in Mickey Mouse pictures could be understood in terms of registering paths of reference linking such pictures (as Goodman suggests) to related "signs" and their referents, apparently including mice, Goofy pictures, Mighty Mouse pictures.

By contrast, members of an opposed camp of theorists—and this includes most psychologists and philosophers who have written on the topic of visual depiction—try to understand it directly through an account of visual experience, and are immediately trapped there. By attempting to explain depiction as a kind of visual experience, this camp suffers a worse affliction than that of their semiotic opposites, since they lack an account of representational content. Goodman could, at least in principle, explain why a page of Dickens and its facing page illustration represent the same fictional content, though he is unable to capture the significance of the rather salient fact that only the latter does so by visual means. To return to Walton, that novels, plays, musical pieces, ballets, and movies can be based on one another—be "translations" of one another—belonging as they do to a broad family of representations, would seem to be a fact that any theory of visual representation must take into account: also that all such works belong to a class of "fictions" or "works of the imagination" that everyone recognizes, both long before and after they have encountered any theories of it.

Given the wide appeal of perceptual approaches, it is important to see that their failure is more abject than that of their reference competitors, for not only are they unable to place depictions among other representations, they are not even able to capture the representational character of depictions. Most of the depictions printed in this book represent things that they do not depict: notably the hidden sides of depicted objects. It is not true of those sides that we imagine seeing them, but only that we are to imagine seeing things that have them. Even regarding what we are mandated to imagine seeing there, the representational content does not reduce to our perceptual experi-

ences. That the marks on the left of figure 51 show a dog punctured by porcupine stickers is part of the content of the picture, whether or not someone imagines seeing them that way or not. That is part of what the picture mandates us to imagine about what we see and about our seeing of it, whether or not we comply.

Next, let us consider more broadly that crucial constituent of Walton's third perceptual condition for visual depiction: the idea of self-imagining, that is, of one's own actions as *objects* of imagining. This should not seem an unfamiliar idea. Imagining things about our own actions as we perform them is not an unusual human activity, even among those who try not to lead lives of fantasy. Large sectors of modern economies are given over to promotion of such self-imagining, notably to imagining how we appear and act. There are even many things that people do mainly so that they can imagine about them. That, Walton points out, is clearest with children, who play active games of make-believe in which their real physical actions, utterances, and psychological states are, like the toys and other "props" they employ, imagined to be somewhat different ones.[11] It should therefore come as no surprise that, even among adults, rather more sedate activities such as looking at things should also be imagined about. Indeed we might perform them, or at least shape their performances, in order to imagine about them. Relevant to our own subject, Nicolaïdes gives standard advice about how to do contour life drawings: "Imagine that your pencil point is touching the model instead of the paper. Without taking your eyes off the model, *wait* until you are *convinced* that the pencil is touching that point on the model upon which your eyes are fastened."[12] Similar directions to self-imagine are common in teaching people to swim, hit a ball, and so forth. "Visualize," "pretend," "imagine" are common instructions there, as in "Imagine that you are attempting to breathe very deeply from the abdominal area" (yoga instruction). This is different from Plato's "Imagine people living in an underground, cavelike dwelling" in *Republic* 7, possibly closer to a commercial from that modern cave of shadows, television, "Imagine that this piece of glass is your dentures," because in the former cases we are to imagine something about our own actions. With depiction, the central objects of self-imagining are our perceptual actions. Like many original theorists, what Walton has done is to draw

our attention to something that we all know very well and to put that alongside something else we know very well, to solve a basic problem. "The work of the philosopher," Wittgenstein also wrote, "consists in assembling reminders for a particular purpose."[13] There being so many things that we all know very well, the trick is to pick out and assemble the ones that meet that purpose. Let us see how well Walton's account deals with the challenges we considered.

The account explains why shadows can be like depictions, even be depictions, but only when we look at them in a special way. Then, as we well know, the contrived shadow of a hand on a wall has us imagine something rather different; there are art forms, such as Balinese shadow puppetry, that rely on this. Also, the uncontrived shadow of a right hand may look different, as we change its orientation and imagine it as a left hand, palm toward us, in an indefinite space. What we ordinarily call "imaginative" children are often much affected in this way by cast shadows; there was a genre of cinema called "film noir," which relied so much on these suggestive effects as to merit the name "film ombre." Such examples bring out the difference between being a depiction and merely being like a picture: shadow play is actually depictive only when that is the function of the shadow. Depictions and other representations are, on Walton's theory, *functional* items. They are usually purpose-made artifacts, but sometimes adopted situations like the figures in the constellations and the Man in the Moon are depictions for societies that give them that function—a relative matter.

This approach also easily makes sense of Gombrich's snowman story. A snow figure's function is not only to have us imagine that it is a person, that when we see it we see a person, but to stimulate in us other make-believe actions that treat it as a person: "give him a pipe" names one such verbal action. Even with pictures the imagining game extends beyond our visual activities. Another observation by Wittgenstein is relevant here. Concerning a "picture-face," Wittgenstein remarks: "In some respects I stand towards it as I do towards a human face. I can study its expression, can react to it as to the expression of the human face. A child can talk to picture-men or picture-animals, can treat them as it treats dolls."[14] No wonder, if this is a matter not only of imagining a face but also of imagining things about some of our *own* actions

regarding it. Thereby, Walton's approach has the crucial feature of eliminating the embarrassing dualism described above, which besets our thinking about representations and our attitudes and policies regarding them. With depiction, there is no need to say that we have the experience, on the one hand, of marks of varying tone arranged on a surface, with their dimensional, shape, and other properties, and, on the other hand, of seeing a child on a slide. There is no reason to say that we have two experiences: one of seeing the marks on surface and so forth, another of having the depicted situation "in mind." Rather, we have one experience—that is, a way of seeing the marked surface imaginatively, in the ways described. As Richard Wollheim long insisted, these are "two aspects of a single experience"; they are "not two experiences," although "each aspect of the single experience is capable of being described as analogous to a separate experience."[15] And that one might see the marked surface and not imagine anything, or imagine something like what it depicts and not see the surface, no more shows that we cannot see the marked surface imaginatively, as a single action, than the fact that we can smile without greeting and also greet without smiling proves that we cannot smile greetingly or greet by smiling, as a single action.

In short, Walton's account, as briefly sketched so far, stresses the significance of imaginative participation, self-imagining, for visual depictions. An important distinction still needs drawing, however. After all, when we look at the child's picture, we are not part of its scene—thereby, as the saying goes, we are not in the picture. Although we must imagine something about ourselves (notably that we see a playground), that plays no part in the imagined content of the picture. Instead, here, as usual, we are dealing with *two* fictional situations, one nested in the other: the situation set out by the drawing, and a wider situation that includes it but also includes our activities of perceiving. As we look at the picture, it is the former situation that we investigate: and investigate is what we most often do with depictions, continuing with additional recognitions of what we imagine seeing there. A point to be elaborated later is that, unlike the child's drawing, for many pictures this proves a seemingly endless process, and a highly rewarding one, entailing repeated viewings, shared observations, and earnest study. Of course most pictures in the mod-

ern world are made for quite different purposes and require only quick subject recognition.

From these considerations additional parts of Walton's account of depiction emerge. The first is that since we, children or connoisseurs, look at depictions first to identify their subject matter, depictions do more than simply cause us to imagine seeing: they *mandate* or prescribe the seeing of certain things while leaving other matters indefinite. This is another way in which the old "bring to mind" approach falls far short, as though a Rembrandt were a Rorschach. Thus the "function" of depictions just mentioned is to prescribe certain kinds of imagining activities to those who look on them.[16] There are of course many ways of mandating imagining; we often say, for example, "Imagine that . . ." or something to that effect: by means of the child's ad hoc identification we called "categorical" prescription. Many pictures work partly through categorical prescription, often also through words, titles, or accompanying statements. Thus the child's comment helps us to imagine seeing a porcupine quill–punctured dog in figure 51. Still, since it is essentially perceptual, depiction cannot consist mainly in such categoricals; at least much of it must depend upon what we spontaneously imagine seeing when we look at the picture, based on what it makes visible there: that is, based on the conditions visible. Hence Walton calls this "conditional" prescription, and all depictions require it, whatever categoricals, by way of titles, conventions, and so forth are also brought in.

As we noticed before, young children's post hoc ascriptions regarding their drawings are often such that we simply take their word for it, there being little in the visual conditions presented to inspire or to guide our visual imagining. But imagining about our visual actions it must be, in order to be depiction. This explains why, some children's drawings are borderline cases of depiction. Also, the fictional worlds (such as the playground) we investigate in drawings are, besides not being very fulsome in detail, not very *vividly* imagined ones. For example, there is far more to see and more to imagine seeing in the Dürer drawings, for Dürer's devices include highly developed techniques for providing us with rather more to imagine than does the child's and also with a stronger sense of solid objects distributed in space, as seen from a fairly definite position—though (I am quick to add) there are quite different ways of developing

vividness in other traditions. These are not evaluative comments. No claims are being made about whether it is better for a drawing to be depictive than not, or to be more or less close to the borders of depiction. Rather, we are attempting to state clearly what depiction is, with our leading emphasis on visual experience.

The failures of approaches to depictive representation through theories either of reference or of visual perception testify to the importance of getting the perceptual aspect of depiction right, together with its representational content, understood by Walton in terms of mandated imaginative content. To fill out the fully perceptual nature of depiction as just outlined, Walton adds two more experiential conditions. The first condition concerns the blending of the two essential depictive components of imagining and seeing. One, already stressed, is that in depiction the "phenomenal character of the perception is inseparable from the imagining which takes it as an object. . . . Imaginings also, like thoughts of other kinds, enter into visual experiences. And the imaginings called for when one looks at a picture inform the experience of looking at it. The seeing and the imagining are inseparably bound together, integrated into a single complex phenomenological whole. . . . [T]hey must be thus integrated if the picture is to qualify as a picture"[17]—that is, as a depiction, rather than as something like a map or chart that one, through practice, effortlessly reads. Again, such experienced unity of the activities of seeing and imagining by no means implies effortless experience: rather, it implies perceptual experience, which is not the same thing. One often sees real things only with difficulty, as when peering in the dark or looking through a litter of things in clear light. As will be emphasized in Parts III and IV, it is important that as art, depictive drawings present us with difficulties that develop just that aspect of environmental visual experience, thereby extending or "sustaining" recognition. It is important to emphasize this to avoid a confusion that sometimes attends the topic of what depiction is. Some have pointed to an undeniable relativity, due to culture or special training, whereby one can "read" a drawing (as Nelson Goodman wrote) "by virtually automatic habit," since "practice has rendered the symbols so transparent that we are not aware of any effort, of any alternatives, or of making any interpretation at all"—as though that were relevant

to the topic of depictions, but it is not.[18] For, as we have seen, the perceptual experience that distinguishes depiction goes beyond Part I's topic of ease in visual access to the kinds of information in drawings we considered there—a very important topic, but a different one.

VIVACITY

We now introduce the topic that will guide our studies through this part of the book and into the next: vivacity. The second experiential condition that Walton adds is that the experience be relatively rich and vivid[19]—which indicates why the child's drawing may tend toward a depictive borderline. This condition is necessary to present depiction as fully perceptual. To understand how the condition is attained, we need to step back and consider why it was useful for people, from prehistoric times onward, to develop such perceptual forms of imagining. We have seen that visual depictions (including depictive drawings) can be defined *functionally* as mandating that we (1) imagine certain objects and situations, (2) imagine that we see these things, and (3) imagine that our actual seeing of them is the seeing of the objects and situations we imagine. A main purpose of our making up activities that have such conditions seems obvious: pictorial depictions mobilize the presence and vivacity of our actions of seeing them to the advantage of the acts of imagining that they prescribe. Depiction can thereby be recognized as one of the earliest discovered and longest lasting basic human technologies, and of simple and ingenious efficiency. Given that the purpose of some of the marks we make is to get people to imagine perceiving things, and given that to do this people must see those marks, why not take that seeing into the action of imagining, thereby borrowing for the imagining the force and immediacy of actual perception?

From at least the time of David Hume, psychological theories have been propounded concerning how depictions can, as Hume said, thus "enliven" our conceptions of things—or, in his term, make them more "vivid." Regarding participatory actions with holy images in "the Roman Catholic religion," Hume archly commented:

> The devotees of that superstition usually plead in excuse for the mummeries, with which they are upbraided, that they feel the good effect of those external motions, and postures, and actions, in enlivening their devotion and quickening their fervour, which otherwise would decay, if directed entirely to distant and immaterial objects. We shadow out the objects of our faith, say they, in sensible types and images, and render them more present to us by the immediate presence of these types, than it is possible for us to do merely by an intellectual view and contemplation. Sensible objects have always a greater influence on the fancy than any other; and this influence they readily convey to those ideas to which they are related, and which they resemble.[20]

This psychology has recently been taken up by art historians interested in the functions of such images. Thus the art historian Michael Baxandall influentially argues that an authorized major function of Christian images was to do exactly that, regarding objects of devotion.[21] However, lacking an analysis of depiction, these writers cannot explain how pictures, just by being depictions, have a vivifying function for our imaginings, even before a few of them are channeled into the historically specialized functions of serving as what Baxandall calls "lucid, vivid and readily accessible stimuli to meditation" on holy subjects (41)—or selling consumer products in our time. Walton's theory explains for the first time how we are implicated in self-imagining just by looking at something as a depiction, and how our imagining may be enhanced not just by "the immediate presence of those types" but by our own internal actions of perceiving them.

To be made sufficiently ample, clear, and convincing, we will need to go over Walton's theory of depiction again, from other perspectives. However, let us now take what we have in hand, to pay a debt incurred in Part I. There, absent a theory of depiction, we had avoided issues of visual experience as much as possible, emphasizing the visual mainly as a mode of access to the information borne in the drawings. One of the themes of this book is that we will understand all kinds of drawings better if we appreciate the different uses or functions that we give them. I was concerned to establish in Part I that depiction, though one broad function of drawing, is far from being its only important func-

tion. That was a reason for delaying a theoretical treatment of depiction. I also mentioned that not only does drawing have different functions but a given drawing can have various of these, some ancillary to others. Now that we understand that drawings, insofar as they are depictions, involve the kinds of participatory visual imagining just outlined, we are free to think of depiction in three possible ways: as a central function of a given kind of drawing, as accompanying a different function, or as ancillary to it—and to consider mixes of these functions.

So it is with the design drawings and diagrams examined in Part I. With important exceptions, we had treated them mainly as sources of information to which we have visual access, not as sources of information about what is visible. To be sure, we mentioned architectural presentation drawings that show how things might look: these are clearly depictive (see fig. 20). But for the most part the function of the design drawings we considered was to contain information about the shape and working of artifacts in a form perspicuous to visual inspection. Similarly, the Beck-style diagram, like the departure schedule that complements it, did not purport to show us how anything looks or to engage our imaginative participation. Such was not its function. Nevertheless, we must recall Ferguson's view that not only visual access but also *visualization* of what is represented is a necessary function of many of these graphic examples, for the simple reason that they thereby exploit our natu-rally given visual capacities, to hold a great deal of information together. To be sure, we do more than make measurements from such drawings; we comprehend structures by their means, through the imaginative visualizations that they prescribe. Yet, even granting Ferguson this, it is still true that the parts of our visual systems thus activated must be kept narrowly channeled. This, besides the standardization and other factors described in Part I, is a main reason why modern engineering design drawings are so carefully disciplined, since it might defeat their purposes if, in looking at them, we imagined, visualized, ranges of properties other than the spatial ones that they are designed exactly to specify. Such drawings work, as we saw, by what J. S. Mill called "the method of detail," and C. S. Smith "the power of partial isolation," by which our natural tendency to "see things" is controlled by severe filters. That makes designs indeed the *specialized* drawings we took them for in Part I, since, on the other hand, the function of bringing us to imagine seeing is not ancillary but central to most of the drawings we know, beginning with the children's that we have been considering. Drawing as art usually exemplifies this opposite extreme. Thus part of what makes drawings as art so much harder to describe is that they truly "draw" on us, to provide even wider resources of imagining than are normally accessible in pictures. Investigation of that "drawing power" will be the central project of Parts III and IV.

7. convincing depiction

GOMBRICH'S PRINCIPLES OF CONVINCING DEPICTION: THE FIRST TRIO

With an actual theory of depictive drawing in place, we are now free to return to our account of drawing and consider perspective and similar drawing systems in terms of perceptual experiences.[1] Walton's correct insistence on the perceptual, the visual, as an experience that is the purpose of depictions, not just a mode of access to them, inevitably raises the question of how it all works. Thus, besides a *what* of depiction, we are bound to wonder generally about the *how*. How is it that certain marked surfaces, describable in the terms we have been presenting, manage to evoke such experiences? Having embarked on this "course of drawing" account, we are bound to encounter once again a simple resemblance interpretation, one that Hume seems to have assumed. By looks and manners certain persons or creatures certainly can put us "in mind" or "enliven" our thoughts of others, owing to resemblances, including some we find indefinable. So it might be thought that depiction works this way, that some independent ground of visual resemblance enables the imaginative seeing that a depiction mandates. Thus, all over again, someone will point out that 1D marks correspond to 3D objects that are strikingly 1D in dimensional emphasis, the objects arranged sequentially the same way the marks are; that axis

shapes are also approximately correlated, the overall orthographic "face" shapes of the objects matching those of the clusters of marks and primitives; also that significant correspondences occur in topological properties of continuity, connectedness, separation—not, now, as explaining what depiction is, but as showing how it works.

To an extent this seems correct, it surely being no accident that the 1D marks *are* often used effectively to depict 3D objects that are strikingly 1D in emphasis, that round regions are good for depicting things that are round, both in 2 and 3D, and so forth.[2] Yet, a main thesis of E. H. Gombrich's 1960 classic *Art and Illusion* was that such a resemblance or correspondence account of how depiction works perceptually is far too simple. Since Gombrich's ideas are so important that an extended theory of drawing must inevitably examine them, here is the place to do so. As with our work with Panofsky on "the rationalization of sight" in Part I, this entails an exposition of some of Gombrich's influential ideas—with sensitivity to the author's context—followed by a dialectical examination of these ideas through contrary views and criticism, from which should emerge additional analytic tools for our theory of drawing.

To begin with the author's context, Gombrich's contributions to our topic may be found in his account of what he called "the problem of convincing representation, of illusion in art," or of "a plausible

rendering of visual effects that create the illusion of life-likeness."[3] Let us keep clear about this. How "convincing" depiction works perceptually is Gombrich's topic, not the nature of depiction itself, which was the topic of the last chapter. It is important to remember that Gombrich never attempted to define depiction—nor needed to. Early on he wrote: "The artist who wants to 'represent' a real (or imagined) thing does not start by opening his eyes and looking about him but by taking colours and forms and building up the required image."[4] "Building up": if the truth of this claim seems obvious, its implications seem generally to have been missed. However, with our geo 2 "hands on" practice from Part I, we should be better able to appreciate the revolutionary meaning of Gombrich's insight: that such standard phrases as "resembles" or "imitates appearances" are useless, both to those trying to depict something—or, like our children, beginning to learn how—and to those trying to appreciate what that effort entails. Our analysis of the spatial aspects of children's drawings also confirms Gombrich's remark that "as soon as we start to take a pencil and draw, the whole idea of surrendering passively to what is called our sense impressions becomes really an absurdity. If we look out of the window we can see the view in a thousand different ways. Which . . . is our sense impression? But we must choose; we must start somewhere; we must build up some picture of the house across the road and of the trees in front of it."[5] We have seen how the child does this in terms of marks that comprise primitives with various spatial properties. Now, having set out some of our author's own context, let us consider Gombrich's positive proposals about "convincing" or vivid depiction, not as he did, but in six principles arranged in two trios, supported by quotations taken from various writings but focusing on *Art and Illusion*.

Not, however, to lose context, we note that Gombrich's theoretical interests, like Panofsky's, concerned art and cultural *historical* issues, and while Panofsky's were more sweeping and speculative, their interests were significantly related. Gombrich, too, was concerned with what he considered to be broadly significant changes in the making of visual images through the ages; and, like Panofsky, his thinking became theoretical when he sought not only "to describe but to explain the reasons" for these changes.[6] Finally, like any theorist who seeks to explain, Gombrich had to discover and to articulate explanatory principles, and to coordinate them. His, too, was a tool-kit project.

This brings us to what I will call his *first principle*: As individuals and as societies, we must begin with depictive efforts that are not very convincing perceptually and relatively schematic, then gradually improve on them by trial and error. Our insistence on children's need for drawing procedures and on our ability to identify in children's drawings the procedures they are using well prepares us for this. For his part, Gombrich—sometimes himself arguing from the evidence of children's strategies—in *Art and Illusion* named it "making comes before matching" (116), but I will call it simply his Anti-Imitation Principle. What specific problem does this first principle address? Early on, Gombrich set "the problem of convincing representation, the problem of illusion in art" as one rejected by modern aesthetics, which he would take up in his book (5). Obviously, "convincing" is a broad and possibly ambiguous term: what did Gombrich mean by it? In general, he meant what was related in the previous chapter: the perceptually vivid experience of "seeing" whatever is depicted, as opposed to what might be called "legibility," which we found in the technical designs of Part I.[7]

Such sensory vivacity applies to many things: renderings of substances (people, buildings), features (junctions, surfaces, edges), and a limitless mass of effects of what used to be called "modes and relations," such as the most famous ones of art commentary, which carry us outside the reach of the child's tool kit: effects of depth, motion, mass, texture, and softness—but also wetness, resting against, being uncountably many, solidity, sticking to, furriness, being glistening, and so forth without end, but never leaving out perhaps the most important: movement—dynamic effects and life. Back to context: an art historian with "a story of art" to tell—and he always insisted that his earlier and all-time best-selling history, *The Story of Art,* had to do just that—Gombrich, like many others, had shaped his narrative of Western visual art largely in terms of depictive arts, especially painting.[8] Finally, he had focused on one main kind of "convincing representation," what he called "naturalism," as a central theme in giving that "story" a shape, and he had dealt—as historians usually do—with broad turning points in Western art: Egyptian, classical Greek and Roman, medieval, Renaissance, Impressionism, modern. Two points

need to be stressed here. First, one about art: Gombrich's emphasis on naturalistic convincingness, far from implying that art consisted in naturalistic effects, was intended to help one who insisted that "there is no progress in art" find a developmental narrative theme for its history. Next, Gombrich's approach was never just a convenient postulate: he did mean to show how and why kinds of naturalism (or nonnaturalism) were the *goals* of artists and their societies. This brings us to Gombrich's direct concerns in *Art and Illusion*. He wished in that theoretical book to explain why the naturalism postulated in his history has a history: why it could not be immediately achievable, and would show development. His Anti-Imitation Principle was the basis of that account. What does it entail?

Ask in what this matching consists, and we come to what I will term his second principle, and again to an issue of resemblance. Gombrich's point is that both common ideas and those of "the wise" tend to be mistaken about the items matched. According to Gombrich, effective depiction of any kind concerns, above all, the working of visual *effects*, "pictorial effects," on viewers of certain sorts.[9] We can call this, for short, his Effects Principle. As just mentioned, Gombrich's many discussions show that he was aware that the kinds of pictorial effects greatly vary. We know well how some drawings catch a likeness in a few strokes (see fig. 57), while others give us a sense of mass and weight; some represent measurable space in every direction, while others evoke a sense of restless or harmonious movement, still others catch atmospheric effects, and so on endlessly and in combinations. Thus depictive drafters, like other artists, are those who manage in their media certain effects—basically effects of visual recognition—for various types of human viewers under various conditions, with different expectations, and for a variety of purposes. Central to *Art and Illusion* is the idea that this is a *piecemeal* perceptual investigation. Here is a first testimony (using Gombrich's initials to identify his remarks):

EHG 1. Long before experimental psychology was ever thought of, the artist had devised this experiment in reduction and found that the elements of visual experience could be taken to pieces and put together again to the point of illusion. (329)

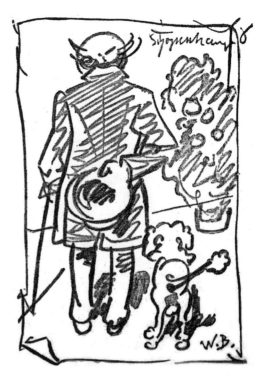

Fig. 57. Wilhelm Busch, Schopenhauer and his poodle, 1876. From Otto Nöldeke, ed., *Wilhelm Busch: Sämtliche Werke* (Munich: Verlag Braun and Schneider, 1943), 8:253. (Original, in Frankfurt Schopenhauer Archive, destroyed in 1944 air raid.)

Having stated that Gombrich's first two principles will guide our own researches from now on, I will make explicit a basic "modular" strategy for our own theory of depiction, one of whose implications is that we will never depend theoretically on any background, global conception of "realism" in depiction.[10] Instead of thinking of convincing, vivid, or naturalistic depiction as somewhat matching or resembling a monolith, that of "visual appearance," we will always consider appearances as various assemblages of effects, largely derived from environmental ones. This sets us radically apart from most approaches, whether explicit or tacit. So profound is Gombrich's insight here that it merits a careful listing of some of his other remarks about his all-important "effects" principle of vivid depiction:

EHG 2. What a painter inquires into is not the nature of the physical world but the nature of our reactions to it. He is not concerned with causes but with the mechanisms

of certain effects. His is a psychological problem. (49)

EHG 3. All art originates in the human mind, in our reactions to the world rather than in the visible world itself. (87)

EHG 4. The problem of illusionist art is . . . that of inventing comparisons which work; . . . of finding the patch on the window that might be mistaken for a house in the distance when viewed from a given spot. (301)

EHG 5. All artistic discoveries are discoveries not of likenesses but of equivalences . . . and this equivalence never rests on the likeness of elements so much as on the identity of responses to certain relationships. (345)

EHG 6. The history of art . . . may be described as the forging of master keys for opening the mysterious locks of our senses to which only nature herself originally held the key. . . . Like the burglar who tries to break a safe, the artist has no direct access to the inner mechanism. (359)

EHG 7. [Having listed such spatial cues as foreshortening, shadow-modelling, highlight]: The question is not whether nature "really looks" like these pictorial devices but whether pictures with such features suggest a reading in terms of natural objects. (360)

And here is his combination of the first two principles, twelve years on from *Art and Illusion*:

EHG 8. Art does not start out by observing reality and trying to match it, it starts out by constructing "minimum models" which are gradually modified in the light of the beholder's reaction till they "match" the impression that is desired.[11]

Is there any common source for effective depictions of various sorts? Can we say anything general about how depiction works? Here is Gombrich's answer: in speaking of such a skeleton keys, he introduces what we may call a *third principle*: that in finding devices for convincing depictions, visual artists are exploiting corresponding ones in environmental perception. Looking slightly ahead, let us call this continuity and transfer idea the Same Mill Principle.[12] It is important to see that it is independent of the two previous. Relativists about depiction accept Gombrich's Anti-Imitation Principle—indeed, credit him for it—and might also accept Effects, but would reject this third, which would root pictorial perception in natural, even human universal, facts of environmental perception. In addition to the skeleton key metaphor cited in EHG 9, here are some other expressions of Same Mill from Gombrich's earlier, classic essay, "Meditations on a Hobby Horse or the Roots of Artistic Form." There Gombrich was concerned to argue a universal biological basis for effective depiction:[13]

EHG 9. The artist who goes out to represent the visible world is not simply faced with a neutral medley of forms he seeks to "imitate." Ours is a structured universe whose main lines of force are still bent and fashioned by our biological and psychological needs, however much they may be overlaid by cultural influences.

In the "figurative arts," as in animal behavior, given the particular "demands of the organism," the basic effective depictive devices may be considered as follows:

EHG 10. They are keys which happen to fit into biological and psychological locks, or counterfeit coins which make the machine work when dropped into the slot [for] the common denominator between the symbol and the thing symbolized is not the "external form" but the function.

In short, Gombrich discovered that convincing visual depictions indeed typically do "look like" what they depict, but only in the following sense: that the experience of looking at them would be significantly (with regard to recognition and experience) like that of looking at what they depict—that is, it would stimulate "like" or analogous perceptual resources.[14] There is therefore significant continuity between pictorial and environmental perception, the former effecting what we might call "transfers" of the latter into pictorial contexts. Thus, Gombrich would later write, regarding *Art and Illusion*:

EHG 11. For this book rests indeed on the assumption that the illusion which a picture can give us can be explained by the similarity of our reaction to the picture with our reaction to the visible world.

EHG 12. We feed the information from the picture plane into the same kind of mill into which we also feed the information from the optic array.[15]

Exploiting Gombrich's mill metaphor, let us again consider such depictive devices not only as a tool kit of techniques but as a set of technologies. Like all technologies—for example, like water mills—depictive devices *transfer* naturally given mechanisms—in this case, those of visual perception—to bring about their own ends: vivid visual effects in pictures. It needs adding that, since the same water mill can sometimes saw logs and at other times grind grain, depending on the connections, Gombrich is here interested in pictorial effects corresponding to those in nature: boards for boards, not for felt or flour.

Together, the three principles of making and matching, rendering effects, and continuity or transfer give Gombrich a *double* story to tell and to defend against criticism: first, how and why basic depictive effects work for people under relevant conditions in terms of their perception of the world around them (a roots story); second, how and why variations satisfy or fail to satisfy people under different cultural and other conditions (a twisting, complex, branch-and-leaf story). As for the first story, once we give up the idea of imitation of appearances, it becomes difficult to generalize about what devices will prove effective. "Hands-on" observation seems to confirm that convincing depiction is largely a matter of building a toolbox of effective devices—dodges—passed on, studied, borrowed, stolen, or invented, though occasionally systematized, as with geo 1 and geo 2 spatial rules. Children, at least so far as we have considered them with their use of line markings, are already beginning this potentially unending process; they will be depictive artists to the extent that they continue to follow the process out, for meaning. In this connection, as we work toward the goal of treating drawing as a fine art, it is important to add that visual artists not only use these tools, characteristically they play variations on them: they thematize

them (make the tools themselves part of the subject), extend or deny them, bend them in new ways, put them in opposition, stress what seemed like marginal aspects of them. Such goes pretty much for all the arts.

Let us now pass Gombrich's second and third principles in dialectical review, comparing them not only with the general gloss of "capturing the appearances of things" but also with the theoretically unifying impulses of "the wise," before going on to his next trio of principles. It seems appropriate to do this by resuming our themes of contour-line drawing and linear perspective.

TESTING THE TRIO I: CONTOUR

Line, particularly contour line, takes precedence, as being by far the more important resource for all kinds of drawings since the emergence of modern humans (see fig. 1). We accomplished something on the subject of contour lines in Part I, and so far Part II's "course of drawing" investigation has reached contour as a kind of shape, as manifested in the first variations children make in their 1D marks denoting dimensional primitives, notably regions. We summarize this advance by quoting an independent source, the contemporary drawing teacher Ron Bowen:

> Line is the first and most essential drawing element. Lines set up a sense of direction along their length, and we follow them. But they also automatically call up associations with containing edges. This cognitive connection between line and edge is perhaps the strongest of all perceptual/pictorial connections. It is hardly surprising then that the most common use of line in drawing is to define edge or contour.[16]

Given its unparalleled importance for drawing, line provides an excellent way for us better to understand how Gombrich's "like looking" principles of the visual in depiction, and especially his tool-kit principle of bringing off effects, differ from standard resemblance approaches. It is also an excellent opportunity for better appreciating Gombrich's Same Mill Principle of "transfer" and "continuity" between pictorial and natural visual cues and effects. Consider, by contrast, how many writ-

ers on drawing have insisted that since "there are no lines in nature," the drafter's line is "conventional" or pure artifice—or at least have emphasized the remoteness of lines in pictures from what we find in pictures.

In a "metalogue" by Gregory Bateson, daughter asks, "Daddy, why do things have outlines? . . . I mean when I draw things, why do they have outlines?" To which he replies: "Do you mean 'Why do we give things outlines when we draw them?' or do you mean that the things *have* outlines whether we draw them or not?"[17] In 1857 Eugène Delacroix defended visible "touch" in paintings by arguing, "Many of those painters who avoid the touch with greatest care, alleging that it does not exist in nature, exaggerate the contour, which also is not to be found there."[18] Similar things are sometimes said about line itself. Thus the modern art critic William Seitz, a century later: "One of the clichés of art criticism asserts that a line, being an abstract convention, has no analogue in nature."[19] The following is a sampler of other answers, some of which will guide our inquiries in Part II. Possibly all pertain to outline, but as arranged here they explicitly start from outline and contour, then generalize to line itself.

1. The outline is the one fundamentally unrealistic non-imitative thing in this whole job of painting. Colours generally try to reproduce the effects of nature, tones and shadows also do their best. But outline the foundation of all drawing . . . is in truth no more than a bold artistic dodge.

2. Line, as such, does not exist in nature; it is a man-made invention, an abstraction, developed as an agent for the simplification of statements of visual fact and for symbolizing graphic ideas. Nature contains only *mass,* the measurements of which are conveniently demonstrated in art by the use of lines as *contour.*

3. The drawn line shows quite simply that painting is a language of symbols. Line does not have a physical existence. . . . Line, even though it does not objectively exist in nature, is the basis of most drawing.

4. Nature presents our eyes with coloured surfaces to which painted areas of pigment may correspond, and with inflected surfaces to which sculptural surface may correspond. But nowhere does it present our eyes with lines and the relationships between lines which are the raw material of drawing. For a drawing's basic ingredients are strokes or marks which have a symbolic relationship with experience, not a direct, overall similarity with anything real.

5. Points, lines, and planes do not really exist in our three-dimensional universe; these elements are but mental concepts. Artists are aware that when they draw a "line" with charcoal or pencil, they are creating nothing but the symbol of the mental concept of a line.

6. "*Lines?* I see no lines!" said Goya, one of the greatest masters of line. He meant that there are no lines in nature—that line is an idea, an abstraction.[20]

Such resemblance or correspondence conceptions of depiction account for historical "explanations" of the practice of contour line, such as, for example, the one C. L. Dodgson (Lewis Carroll) offered to the illustrator Walter Crane:

My theory is that among savages there is a much earlier stage than outline drawing—viz. mere reproduction (in clay etc.) of the solid form. . . . The next step I should expect would be alto-relievo . . . and this would gradually flatten down. Then the effect (with a side light) would be of a flat surface with strong black lines of shadow marking the outline of the form represented. And the next step would be to *paint* lines representing these shadows: and such lines would be broad at first, and would narrow on discovering that their breadth was not an essential feature. However, this is all rather theory than actual knowledge.[21]

Thus by baby steps we may patronize our most ancient ancestors, the Aurignacian artists of Chauvet Cave, for example.

What revolution does Gombrich's Effects Principle work against the resemblance assumptions behind such statements? It suggests that all such thinking goes wrong from a plausible starting

point. Plausible, because as testimonies 1 and 4 put it, hands-on rules of depiction do sometimes call for copying. Thus, a century before Villard, Theophilus wrote in his handbook for artists: "The pigment called flesh-color, with which faces and nude bodies are painted, is prepared thus. Take . . . the white which is made from lead and put it without grinding . . . into a copper or iron pot; set it on blazing coals and burn it until it turns a yellowish tan color. Then grind it and mix white ceruse and cinnibar with it until it looks like flesh."[22] A plausible beginning also because, as already remarked, it seems logical that a marked region of a certain dimensional index should "represent" something of the same index. So it might seem plausible to suppose that this is how depiction in general works, that is, by points of correspondence between what is visible in a picture and what is to be imagined. The ancient error of understanding representation as "imitation" solidified the similarity misconception implied by such views. Seeing lines in pictures, our sources look to see if we can find the same in nature, failing which, they argue that lines—notably outlines—are "nonimitative," "symbolic," conventional—and thus inventions. Ironically, in the course of these struggles, the essential visual component of depiction, the beholder's perceptual *experience,* is lost.

On Gombrich's approach, the error of these ways of thinking consists in their looking in the wrong places for the wrong sorts of visual correspondences. Again, people who are even loosely called "visual artists" are typically those who try to pull off perceptual effects, notably visual effects of innumerable (not just spatial) kinds. In depiction, these are the perceptual effects of faces smiling, waves moving, sun shining on walls, bodies turning, glances exchanged, rain, objects being of weight and volume, marble smooth and cool, one thing's resting on another, hair growing out of a head, fabric being rich, a blade's being sharp or dangerous, a frog's being about to leap, a fish being startled, metallic luster, the way people stand when looking for the bus, shadows settling as a day draws to a close, a road winding into a distance, grief—to begin an unending list. These include the first challenges for the child, too, as we begin drawing—and as figure 51 shows, children by no means go for what might be considered the simplest.

As earlier emphasized, none of this entails Gombrich's Same Mill Principle of continuity or transfer. Indeed, as remarked, relativists and conventionalists such as Nelson Goodman would be happy to apply the views quoted above to *all* depictive devices, to say of all that they are "a language of symbols," "man-made inventions" for "symbolizing graphic ideas." Not so Gombrich, who argued (EHG 9–12) that the drafter works with human perception, discovering "keys" in nature for perceptual effects that can be worked in their media. Regarding his Same Mill, it fits Gombrich's approach that a vexing empirical research question about pictorial effects persists: *Why* do such lines work so well in depicting contours of objects, even where there is no edge—as we find when we look at the smooth forms of the human figures and their clothing in our Dürer drawings, or at the pots, candlesticks, and the like, by contrast with the many edged artifacts also shown there? Is this due to some general perceptual phenomenon, such as that the contours of objects and drawn lines are sites of sudden visual change or high contrast? Or is it due to a cluster of phenomena, including shading effects on objects, whereby even rounded ones show darkening of the edges as they turn away from us? Speaking of shade, note that even Dodgson's speculation is in the direction of such research (which Crane termed "quite characteristically theoretic and ingenious"). Dodgson was supposing that the perceptual mechanism of finding low contours by their cast shadows would be transferable to pictures that do not depict contours as casting shadows. More recent researchers however put the universal efficacy of the outline down to other causes.[23] These are contemporary research issues, and common to most of those who study them is the assumption that the widespread success of such devices in depiction would be owing to a continuity of pictorial perception with the way we commonly perceive things in our environments, through some sort of transfer.

Before turning to the second important expository case, perspective, let us take the opportunity to develop the third principle's idea of "transfer." As we just saw, the activity of perceiving outline drawing seems based on general capacities for perceptual transfer. Transfer often goes two ways, and the researches just mentioned seem to be only part of the empirical case for strong correlations between environmental and specifically pictorial perceptual abilities. We bring to bear upon, or transfer to, pictorial perception many environmental per-

ceiving abilities. To a lesser extent, transfer can run the other way as well, directly or indirectly. For example, the recent enlargement of the portraits on many currencies seems a two-step transfer, whereby our keen abilities at facial recognition are transferred to that of faces on bills, thereby to our recognition of counterfeit bills. Furthermore, contrary to Gombrich's remark: "The illusions of art presuppose recognition; to repeat the phrase from Philostratus, 'No one can understand the painted horse or bull unless he knows what such creatures are,'" even as young children we acquire many of those recognition abilities from pictures—pictures that in contemporary contexts flow by in an extraordinary variety of unsorted styles, including simple drawings (colored or not), cartoons, photographs, logos, silhouettes, TV images, and so forth.[24] This two-way process of transfer continues through adulthood in both everyday and highly technical contexts, such as simulation training. Of course, perceptual transfer of object and feature recognition capacities is only part of our story of the visual in depiction, for visual experience is more than a matter of recognition. When, for example, we watch an animated cartoon in which a succession of still frames produces the experience of something moving, growing, or otherwise changing, the idea is not that we will just recognize that such and such is happening, but rather that we will *experience* it as happening—vividly experience this in imagination. The same is true for countless other visually depictive effects that artists through the ages have found "convincing."

TESTING THE TRIO II: PERSPECTIVE

Let us now test Gombrich's principles with the important devices of linear perspective. In Part I we saw how misleading a unified geo 1 picture of perspective is with regard to actually drawing in perspective. In the present, broader context of depiction, geo 1 seems not very helpful either, for explaining *why* perspective drawings tend to produce visual effects, including the experience of spatial depth. As Gombrich characteristically put it, "the student of images need not ask whether or not we 'really' see the parallel tracks of the railway converging. . . . What concerns him is the degree to which a perspectival representation evokes or compels an illusion of depth."[25] People tend to

think of linear perspective monolithically as a single thing, such that if we have any of it, we have all of it, at least in some degree. However, our historical discussion with Panofsky in Part I suggested that linear perspective is, rather, a revolutionary systematization of a group of different drawing devices, with independent histories of use in various traditions. Also, as some of our contemporary examples there showed, we continue to use combinations of these devices as they suit our purposes. This fits the "tool kit of effective devices" approach, which is again confirmed by work in contemporary vision theory, psychology, artificial intelligence, computer modelling, and related fields.[26]

In general (we will soon qualify this) contemporary vision research also agrees with Gombrich regarding his Same Mill Principle (see EHG 12), arguing, or at least assuming, that the same principles that explain why particular visual effects (notably spatial ones) work in nature will also explain why they work in pictures in corresponding ways. Indeed much of the vision researchers' attention to pictures has been derivative, owing to the fact that for experimental control purposes it is often easier to work with pictures when investigating environmental phenomena. Next (corresponding to Gombrich's Effects Principle) whether trying to explain animal vision or to simulate it, in setting up experiments empirical inquirers into visual effects have been, for obvious reasons, obliged to separate such properties, and this procedure applies to perspective. "Linear perspective," writes the psychologist James Cutting, "often cited as a single source of information, is really a concomitance of occlusion, relative size, relative density, and height in the visual field, using the technology of parallel straight lines and their recession."[27] No theory of projection could be expected to explain what importance the properties of perspective that it entails would have for a human visual system: such is obviously a psychological question, not a mathematical one. Thus we take note of the visual effects of the occlusion and foreshortening properties, the diminution and line convergences that distinguish perspective, and the interactions of these, along with other effects that the projective theory of perspective would not emphasize, but that vision researchers have discovered are important to humans—such as relative height in the visual field. Also such researchers usually add to these a group of other spatial layout indicators, including relative

density (or density gradients), aerial perspective (see fig. 30), and binocular disparity (available with stereos) as "cues" or "sources of information," effective in real environments and in drawings. It is fairly standard for researchers to study these separately and in combinations, in controlled situations, in order to discover how well and when they are effective with people and other creatures. For example, if occlusion is declared to be the strongest of these indicators of depth, this could only be an empirical finding about what works with people, something that the theory of perspective could not be asked to predict.

Nevertheless, more than with line and contour, when we turn to linear perspective, we find "the wise" attracted to a theory that turns out to be just a version of popular resemblance or imitation of appearances ideas. This approach was criticized by Nelson Goodman, who exposited it as follows: "A picture drawn in correct perspective will, under specified conditions, deliver to the eye a bundle of light rays matching that delivered by the object itself."[28] If naïve thought might suggest a monolithic reification of "appearances," which might then be copied, this theoretical version supposes other kinds of reification: a bundle of light rays, the visual field, the structure of an optical array, and so forth.[29] In chapter 6 we already encountered variations on this idea from the time of Alberti. Another classic expression is that of Brook Taylor, the author of the terms "linear perspective" and "vanishing point": "the Rays of Light ought to come from the several Parts of the Picture to the Spectator's Eye, with the same Circumstances of Direction," wrote Taylor, "as they would come from the corresponding Parts of real Objects seen in their proper Places."[30] Emphasis on "direction" makes Taylor's version rather more interesting than many. However they are formulated, such ideas have proved to be perennially appealing explanations of why linear perspective, as described in Part I—and as exemplified throughout Dürer's woodcut quartet, in part by some of the cartoons and graphic displays of Part I, only a little bit in Villard's mill, and not at all in the child drawings—tends to be effective in producing a perceptual sense of pictorial depth. Yet the explanation is highly implausible for all these cases, as it actually says nothing about depth or any other kind of perceptual indicator.[31] I hasten to add that this is not because reference to the structure of an array of light or to a visual field is too abstract. As we remarked in our consideration of band patterns in chapter 4, perception is sometimes more adept in picking up higher-order structures than in registering the nature of their constituents. Later we will even consider how overall structure in perspective may itself be perceptually and depictively meaningful.

The widespread resemblance assumption we are considering here is different. It simply assumes, a priori, that something appropriately *perceptual* will happen with people when they look at pictures that to some (unspecified) extent meet the ideal of "matching," having "the same circumstances of direction," or the like. It is worth adding that overall "matching" of light incidence would also be fairly useless for teaching perspective drawing, especially when compared with real geo 2 and related instructions, such as: "draw receding parallels with converging lines," "draw distant objects as smaller regions, usually placed higher up the page," "make your shapes seem to overlap, to indicate their going back in distance," "lighten, loosen—even break—your contour lines for further-off buildings and mountains," and so forth.[32]

In summary, Gombrich's *Art and Illusion* is rightly admired for his brilliant use of a strategy, which in retrospect looks rather obvious. Wanting to know why "convincing representation" should have a history, he persuasively broke the grip of ancient conceptions of "the imitation of appearances" by a few simple moves. First, he replaced the two-term relationship these ideas connoted (something like "the image and the world") by a three-term relationship, which includes perceivers. The "looks" in "looks like," he in effect argued, needs to be understood as a verb: that is, visual representations are convincing when they get us to *do* something perceptual with them, rather like what we would do with their motifs. Better stated, Gombrich broke the study of the convincing representation down into a series of distinct devices: shade and shadow, highlight, perspective, texture, movement, physiognomy, and so forth, each with its history of discovery and use. Thus, according to Gombrich, any account of a convincing representation must be an attempt to show how image makers pull off groups of such particular effects for suitably prepared viewers. The roots of this, he maintained, are biological.

Gombrich's principles seem (after the fact) ob-

vious, because, first, it is clear from hands-on acquaintance that the instruction to "imitate appearances" is basically useless. Anyone who wants to make a convincing depiction, Gombrich pointed out, has a number of different jobs to do, a number of different particular effects to pull off. Other evidence for his modular approach comes from modern vision studies, and in his "tool kit" approach regarding visual effects Gombrich was explicitly following their lead. When modern psychologists began experimental inquiry into perception, they had to analyze it into modules—sense systems, cues, particular effects—and to consider the relationships of these. Much of their experimental work consists in techniques for separating these factors, testing and comparing them, then putting them back together, and, as is usual in cognitive studies, a commonsensical gloss on how it all works often proves a poor guide. After all, as our visual blind spots and the color and acuity differences between cone and rod vision show, it is not in the nature of cognitive processes to announce their modularity. Perceptions are made up of a variety of sense reports, but these do not arrive in differently marked folders: they are experienced as one thing. Thus arises the naïve tendency to think that we just see things, that something monolithic—"the appearance"—is taken in as a whole. So it was thought that this appearance might be "imitated." It took research to make explicit what image makers knew tacitly, that perception does not work like that. As Gombrich stated, image makers had in effect been doing similar analyses (though unsystematically) for millennia before the vision sciences were dreamt of, and with similar overall results: stumbling on perceptual effects one by one, putting them together in different ways, passing these on through workshop practice. As a result, while to perception each effective combination seems complete, it is only by comparison of different methods that people might notice one to be lacking in effects found in others.

But Gombrich had qualifications.

"THE BEHOLDER'S SHARE": THE SECOND TRIO

I mentioned qualifications regarding the last pair of principles—ones large enough to inspire a second trio of depictive principles, of which I will be more critical. To understand Gombrich's crucial qualification, one needs to know that vision researchers hold a variety of views regarding what I have termed continuity and transfers between environmental and pictorial contexts. Some psychologists have been strongly skeptical about any continuity of environmental and depictive visual contexts, while others have at least urged caution about assuming that the perceptual "mills" are the same.[33] For Gombrich's part, as a historian, perhaps the most sustained theme of *Art and Illusion* regards the diverse branching and twining that pictorial effects make from their environmental roots, while still remaining genuinely visual. If there were a single empirical root story to tell, historically there would still be a "many routes" story to tell. Indeed, some may be puzzled that one who would later seek "to bridge the gulf Professor [J. J.] Gibson has deliberately opened between the world of pictures and the real world," and argued that "we feed the information from the picture plane into the same kind of mill into which we also feed the information from the [natural] optic array," should have insisted in that book on an important fourth principle, that of a "tremendous gulf that separates the reading of pictures from the sight of the visible world," and continued: "Simply to equate the one with the other . . . is to bar one's way to the understanding of representation."[34] We can call this Gombrich's Gulf (or discontinuity) Principle. In one way, it may be understood as an amplification of his Anti-Imitation principle. This raises the question how it and that first principle stand in relation to the Same Mill Principle, which stressed continuity of pictorial and environmental perception. One might be left wondering whether Gombrich's views were in contradiction, wavered, or changed.

What, according to Gombrich, was this "gulf," and was he able to bridge it, consistently with his other principles? In his usual accounts of it, a gulf would be due to the fact that a picture, typically 2D and unchanging (itself, and also with regard to viewer motions), presents "a relative poverty of information" or "a good deal less information than the object it represents would exhibit."[35] Indeed, in various writings Gombrich saw "the problem of representation as an experiment in reduction, the cutting down of information available to the viewer," as "an experiment in 'doing without,' an exercise in reduction."[36] He especially stressed the

static nature of pictures in *Art and Illusion*: "This vital difference between the stationary image with its confusions of overlap and the resources of life to sort them out."[37] "The first reduction," he would later write, "is the elimination of the time element, the freezing of the flow of information on which we rely in our orientation . . . in all our commerce with the visible world," given still pictures' "confinement of the information to simultaneous cues."[38] For that alleged deficit, depiction must provide some sort of "compensatory moves."[39] The concept of compensation he found in a method of perceptual hypothesis and test, which he called "projection" and "the test of consistency." The pair might be put into a fifth principle of Gombrich's thinking on the topic of convincing depiction, which, adapting a famous phrase of his, we will call his Beholder's Share Principle. Gombrich uses the term "projection" in the psychological sense well known from inkblot tests and similar phenomena, which had been important instances in support of his Same Mill Principle, but also—as we shall soon see—more widely.[40] It may be said that, while perceptual projection is for Gombrich the main mechanism that carries us beyond the alleged poverty of pictorial displays, "consistency" is what keeps projection under control. Indeed, according to Gombrich, the relative incompleteness and ambiguity of pictures can even be turned to the beholder's advantage when it "mobilizes his projective faculty." "The importance for art," he holds, "of mobilizing the beholder's projective activities in order to compensate for the limitations of the medium can be demonstrated in a variety of fields."[41]

There are several points to make about all this. First, Gombrich's emphasis on a gulf between environmental and depictive seeing actually presupposes basic *continuity*—that is, that the business of seeing something in a picture is sufficiently like that of seeing something in real life, so the idea of the former as a "reduction" of the latter makes sense. Next, Gombrich was much influenced by J. J. Gibson's emphasis on the difference between the pictorial 2D "frozen array" (to use an expression that still has currency) and the 3D "flow of information" in real scenes, given that such flow weakens, even disappears, in what is called "vista space" (say, over thirty meters away)—views frequently depicted in Asian and Western traditions.[42] In addition, a theory of all kinds of depictive drawings should not limit us to single pictures. From comic strips we have become familiar with picture sequences that exhibit changes of relative angular size and ordinal positioning of things and features in scenes they depict. Finally, even everyday comments about convincing depictions capturing the essence of people, creatures, things, and situations register an insight: when it comes to the experience of visual recognition, much of that flow of information is noise anyway, which wants filtering. Indeed, Gibson himself came to hold that our visual systems are tuned to the "invariances" of this flux, not to the shifting array: "perception of a detached object is not compounded from a series of discrete forms of that object," he would write, "but depends instead on the invariant features of that family of forms over time."[43]

Still, there are views of things and there are views; clearly some visual aspects of things are more representative of all the rest than are others. Regarding specific spatial properties, we saw this well exemplified in the drafting techniques of Part I. A simple but very important example is our emphasis on Y or corner junctions, which show more "views" (or faces) in isometric, axonometric, and oblique systems. Thus it takes little theoretical imagination to see how Gibson's approach might be turned to a theory of effective depiction for more than spatial layouts. In this theory, depictions, like the "characteristic curves" we considered in chapter 1, capture and code the "invariant properties" through one set of shapes rather than through a shifting array.[44] What one seeks there is what might be called the object's visual "form"—to use a word derived from the Greek "*eidos*," which, rather than meaning "shape," can mean the principle that produces different shapes under varying conditions, something that we look for in environmental perception and in pictures. It is a truism that recognizable form is often disappointingly absent from photographs, for all their reputation for visual truth, while a few lines in a drawing can distill many looks of a person or other creature into one, and also suggest a movement or "flow of information" of a visual kind. Henri Matisse remarked that, for recognition, "characteristics of a drawing . . . do not depend on exact copying of natural forms, nor on the patient assembling of exact details," adding that "in the leaves of a tree . . . the great difference of form that exists among them does not keep them from being

united by a common quality. Fig leaves, whatever fantastic shapes they assume, are always unmistakably fig leaves." And then, of a set of line self-portraits: "the different elements which go to make up these four drawings give in the same measure the organic makeup of the subject. These elements, if they are not always indicated in the same way, are still always wedded in each drawing with the same feeling—the way in which the nose is rooted in the face—the ear screwed to the skull—the lower jaw hung."[45]

As we know from cartoons and caricatures, visual "form" can be impossible to describe, though perceptually salient. It comes as no surprise that a famous former Pinkerton included, among the four simple rules of "shadowing" someone, the need to keep behind the subject. He remarked that "a detective may shadow a man for days and in the end have but the haziest idea of the man's features. Tricks of carriage, ways of wearing clothes, general outline, individual mannerisms—all as seen from the rear—are much more important to the shadow than faces."[46] Such are exactly the sorts of forms often captured in simple drawings (for example, fig. 57).

"THE RIDDLE OF STYLE": GOMBRICH AND PANOFSKY

Let us turn now to a second set of issues regarding Gombrich's gulf, those of culture and history, and raise what Gombrich once termed "the whole wretched question of how many of the means of art are conventional and how many natural."[47] As stated, according to *Art and Illusion* "projection" (with consistency tests), being the main basis of "compensation" for the difference between environmental and pictorial perception, is much controlled by our "mental set"—that is, "the attitudes and expectations which will influence our perceptions and make us ready to see . . . one thing rather than another."[48] That is hardly debatable, as we know from peculiarities of personal experience of things like Milton's "calling shapes, beckoning shadows" of *Comus*. Some readers may remember watching the starving prospector daintily eat his shoe in Charlie Chaplin's 1925 *Gold Rush*; others may recall the lonely courier and his hand-printed volleyball in *Castaway* seventy-five years later.[49] The mental sets that artists rely on are usually a

function of general culture. That Gombrich should at this point attach cultural and historical roots to the biological roots of his third principle should be no surprise. As an art and social historian, he had early insisted that "psychology alone can never suffice to explain the riddle of history, the riddle of particular changes."[50] Indeed, his approach to explaining differences and changes in images was to look for differences in the various concrete and documented *functions* assigned to images in particular societies at particular times: a variety of functions calling for a variety of viewer actions, for which he coined the phrase "the beholder's share" or "the beholders' collaboration."[51] Everyone admits that perceptual interpretation is much dependent on context. Whether we are tour guides, teachers, specialist researchers, or individual inquirers, much of our sustained words and other efforts with images is intended to restore such context for beholders from different times and traditions. Gombrich took these questions to the level of simple object and feature recognition in pictures.

By comparison, consider again Panofsky. Although best known for iconology, the study of the symbolic meanings of images, for present purposes what is significant is his treatment of what he called "pre-iconographical" or subject-matter recognitions.[52] Of that he wrote: "The matter seems simple enough. The objects and events whose representation by lines, colors and volumes constitute the world of motifs, can be identified . . . on the basis of our practical experience. Everybody can recognize the shape and behavior of human beings, animals and plants, and everybody can tell an angry face from a jovial one."[53] His phrase is "seems simple," for Panofsky immediately cautions that "practical experience is indispensable, as well as sufficient, as material for a pre-iconographical description, but it does not guarantee its correctness. . . . While we believe ourselves able to identify the motifs on the basis of practical experience pure and simple, we really read 'what we see' according to the manner in which *objects* and *events* were expressed by *forms under varying historical conditions*. In doing this, we subject our practical experience to a controlling principle which can be called the *history of style*" (11).

What is Gombrich's view about these matters? With regard to Panofsky's initial point, regarding "practical experience," Gombrich in effect replies

that, due to "reduction of information," practical experience is not always sufficient even for Panofsky's tentative perceptual recognitions of objects and events in pictures. But Gombrich acknowledges Panofsky's other point, concerning historically varying depictive "forms." Much of his use of the phrase "the beholder's share" in *Art and Illusion* is to explain what he takes to be one of the most sweeping historical changes in the function of images. That was a "turning point," as he calls it, to "a new function of art," "where art becomes emancipated" so "an entirely new idea of art" evolves, which stresses an "interplay between the artist and the beholder" in which the artist "gives the beholder increasingly 'more to do' [and] draws him into the magic circle of creation."[54] Thus the theoretical development of one of his main themes in *The Story of Art,* where he had written: "But one has to know how to look at such paintings. . . . To achieve this miracle, and to transfer the actual visual experience of the painter to the beholder, was the true aim."[55]

Now, such remarks already seem to commit Gombrich to a distinction, which, curiously, he never observes. Recall the gulf problem in Gombrich's fourth principle, an alleged reduction of information in pictures. As far as that account goes, pictorial perception seems no different from extremely restricted views in environmental perception. Indeed, vision theorists are in the habit of treating pictorial perception just this way. But although he does not explicitly state it, Gombrich's gulf problem appears to be of a different order. In its cultural implications it is not much like the problem that forest dwellers face when judging the size of things on a distant plain, of novice divers when estimating sizes and shapes underwater, and so forth. Gombrich, after all, labelled his topic in *Art and Illusion* "the riddle of style."[56]

As we can tell by referring to our accounts of the projective drawing systems in Part I, and of children's drawings in chapter 5, Panofsky's differences of stylistic "forms" does not resemble what happens to shapes under moving water, in fog, or at twilight. The question is, How does Gombrich account for our understanding of differences owing "to the manner in which objects and events were expressed by forms under varying historical conditions," to quote Panofsky? To answer that, we may look to Gombrich's version of the "impressionist" revolution in the function of images just mentioned. "The idea of art," he remarks, "has set up a context of action within our culture and has taught us to interpret the images of art as records and indications of the artist's intention. To react adequately to the sketch, we instinctively identify ourselves with the artist. Our primary hypothesis is that what he does will make sense somewhere." For example, in a planning drawing, Michelangelo's "rapid scrawls where he intended to indicate statues would not make sense by themselves, but they do in their context."[57] What is this "context of action"? Gombrich means the context of Michelangelo's being the kind of fluid, creative design drawings we alluded to in chapter 1. Yet—when we consider even a far more finished but similar planning drawing by Leonardo (fig. 58)—one implication of this plausible account that seems to have been overlooked by Gombrich (and by almost everyone else), perhaps because it is so simple, is that whether we look at such sketches, at finished drawings, or at children's or engineers' work, basic to our "mental set" is that they are *drawings*—indeed, sometimes *depictive* ones of a certain kind, made for certain purposes.

Since the topic of this chapter is the visual experience of drawings, it is high time to state explicitly that the most salient visual aspect of drawings is that they *look* like drawings, and that depictive drawings normally *look* like what they are: depictive drawings. This also goes for the elements of drawings: for the marks that constitute them, for the primitives that marks produce, and for the shapes that primitives make. "Line," "region," "picture," "drawing," and "depiction" are everyday categorial classifications, as familiar to us as are "house," "tree," "urn." Not just verbal categories, these are perceptual categories as well, for we do regularly identify, without thought, things as houses, parts of houses, shadows of houses, pictures of houses, and so forth. Even a natural fissure or undulation in a cave wall looks different to us when we become confident that the prehistoric artist has exploited it to establish a contour or to suggest relief. Thus, as we investigate drawn lines, regions, their various shapes, and also depictions, in this study we are investigating some of the most common objects in our lives. Unlike particle physicists, astrophysicists, and economists, we are theorizing about everyday objects of visual perception, for it is usually possible to tell, just by looking and without specialist training, that something *is* a

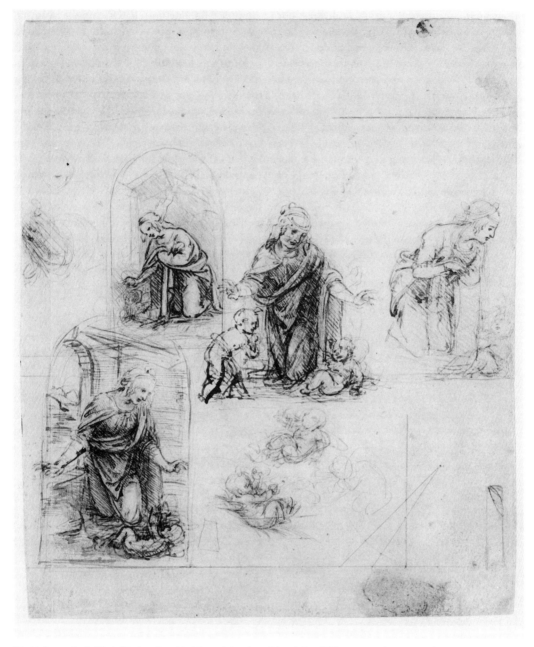

Fig. 58. Leonardo da Vinci, "Designs for a Nativity or Adoration of the Christ Child; Perspectival Projection," 1480–85. Metalpoint partly reworked with pen and dark brown ink on pink prepared paper; lines ruled with metalpoint, 19.3 × 16.2 cm. All rights reserved, The Metropolitan Museum of Art. Rogers Fund, 1917 (17.142.1).

drawn mark, a line, a region, a picture of something. Pieces of paper look, even at a glance, like pictures, drawings, depictions, as opposed not only to looking like telephones and cups of coffee but also to looking like telephone bills, personal letters, manuscript pages, written recipes. Going through the newspaper, small children easily tell the comics from the news stories and classified ads, also from the news and advertising photos and other drawings.

All this is so obvious as to be neglected by theorists who write about how pictures look: that is,

they tend to forget that pictures typically look like nothing so much as pictures. But as Chauvet Cave establishes, we have been recognizing drawn depictions, ceaselessly, since long before there were telephones, paper, and coffee cups—even wheels—and we are no better today at distinguishing a cave wall painting, a footprint, a bear skull than we were in those times. What is the significance of that? Most people will readily accept that identifying something as a telephone rather than as a cup or newspaper is highly relevant to everything we do with it, whether we think about that or not. "Mistakes happen": a watercolor brush goes into a teacup. Worse, the coffee cup, not the stir-stick, goes into the wastebin. And how did the cell phone find its way into the refrigerator? Still, it requires serious trauma—mistaking, for example, one's wife for a hat—fully to bring out how much we take for granted in the multitude of categorial classifications that form the backdrop to our attention as we go about our business.[58] We need to give closer attention to this idea of perceptual categories and pictures in order to assess Gombrich's alleged gulf and his "wretched question" of what is conventional or natural. That, literally, entails opening a whole new chapter, one that argues a principle on which the rest of the book depends.

This is the remarkable principle that we normally regard depictions as depictions.

8. depictions as depictions

PERCEPTUAL CATEGORIES: SIX POINTS ABOUT PICTURES

In everyday as well as in theoretical conceptions the assumed categorial background for the use of articles such as depictive images seems to be treated differently from those for most other everyday implements, such as cups or telephones.[1] Pictorial perception often falls to a metaphor, "transparency," not normally applied to the assumed backgrounds of our other categorial recognitions, such as those for cups, disposable objects, creatures, conveyances. According to this metaphor, the visible aspects of a picture that make it evidently to be a depiction, the aspects of a drawing that make it evidently a drawing, of a drawn line that make it evidently that—along with all the categorial background assumptions that go with it—are supposed to *disappear* from perception, automatically, or by the help of a series of suppressive pictorial technologies. "Transparency" means that we no more perceive these things than we do our glasses, contact lenses, or windowpanes when we look through them—or if we do perceive them, filter them out as noise. The absurdity of this analogy should be clear if we consider what would happen if, looking at even some of the cartoons we have displayed, we were unaware of their being drawings of different kinds—if we actually filtered out the visual aspects that show them to be cartoons. Perhaps

a better analogy with transparency is language use, where one is focused on what is being said rather than on the language in which it is spoken or written. Multilinguals (such as Gombrich) report being sometimes unable to say in what languages they have just been communicating, so focused were they on content, and people mix languages.[2] It may even be that conscious awareness that one is using a given language would cause interference in communication. However, William James's comment on the result of mishearing "*pas de le Rhône que nous*" as English illustrates the fallacy of inferring from these undeniable facts that mobilization of the right language's capacities is not an essential aspect of one's linguistic perceptions.[3]

This theoretically overlooked issue of background categorial classifications has several important implications for Gombrich's Gulf Principle. Let us briefly review only the most obvious. First, we all know that simple categorial differences affect how things look. Gombrich himself liked to remind us how "we sometimes see a small object which is close to our eyes as if it were a big mountain on the horizon, or a fluttering paper as if it were a bird. Once we know we have made a mistake, we can no longer see it as we did before."[4] This, like mistaking a bug on the window for a bird or jet plane, vividly demonstrates how nominal assignments dramatically affect the experience of metric ones, such as size, distance, and speed.

Other perceptual qualities are involved, as we all know when we change a perceptual label from "snake" to "stick" or "snakelike stick" (and wish our horse would do the same). As Goodman observed, the same facial expression no longer looks friendly when classified with the label "hypocritical." This observation leads us to a second implication of background categorial classifications: the perceptual importance of a very significant pair of categorials we apply to objects, "natural/artifactual."[5] Once we notice that something is a wig or a decoy duck, it looks different to us—or rather, we look at it differently. Yet "picture," "depiction," "drawing," "sketch," "study," "cartoon," "drawn region," "drawn mark," and so forth are also relevant artifact-categorials backgrounding aspects of everyday perceptual experience, just as much as "glove," "cup," "automobile," and "wire," are artifact-categorials backgrounding other aspects of it. Children recognize, discuss, and depict (fig. 59) items of the former as well as of the latter.

A third implication of background categories is that "artifact" commits us to another basic category, having to do with how something came to

be—that is, by action with intention. Thus in chapter 4 I described drawing in terms of a marking action that "leaves, as the trace of its path, a mark of some kind, and is done for that purpose," and added that this account implies that "draw" is "a word for a certain kind of intentional physical action." But these examples lead to a fourth implication: typically, "artifact" involves another category of things produced not only *on* purpose but *for* a purpose. As Noam Chomsky puts it, "Whether something is properly described as a desk, rather than a table or a hard bed, depends on its designer's intentions and the way we and others (intend to) use it, among other factors."[6] A fifth implication is that usually the purpose is *itself* straightforwardly functional: it has to do with doing something on purpose. The hierarchy of "artifact," "for a purpose," and "functional use" is obviously important to our perceptual and verbal categorial equipment. "Functional" is an essential perceptual category, capable of strongly influencing perception of natural objects and artifacts. Indeed, if we failed to apply such categories as "cup," "spoon," "funnel," "house," "television stand," and so forth, we would literally not be able to tell by looking at an artifact "which way is up" or much else about it. Not knowing which way is up means not identifying the main axes of an object, and that has meaning for our other perceptions of its shape. For example, an archaeologist looking at a battered cobble or quartz fragment as a possible tool looks at it in terms of some of the shape characteristics we have been discussing—dimensional emphasis, axis, edge, contour—but also with such functional categorials as "blade" or "retouched scraping/cutting edge," all which affect the very actions of looking and thus the appearance of the stone. The same is true of the appearances of natural forms adjusted to function for mimetic representation. An obvious case is where the natural forms are human bodies and their actions, out of which the performance art forms of dance, mime, and drama have emerged. Depictions being items of this most common artifact sort, let us now be more specific—that is, identify their "species"—by means of a sixth and final point about the categories under which we normally understand pictures.

As artifacts, depictions, including most drawings, fall into a broad class of what I will call "displays," which may also include aspects of the natu-

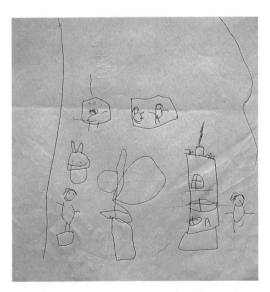

Fig. 59. Museum drawing by AM (four years and five months old). "That's a little girl in it, castle, Mary and a knight, picture of a girl, statue of a butterfly, bunny statue, statue of a girl." (Detail: complete drawing joins building enclosure lines at top.)

ral world.[7] As we noted in chapter 2, visual displays are not only visible things, they are things designed to be seen. Furthermore, since being seen is their main reason for existing, this separates them from most other artifacts, which are designed to be visible only so that we can use them efficiently and safely. But there is a further point to be made about visual displays. Being visible is not only their essential function—that on which their other functions are based—they operate by being understood as presented *for* that function. In other words, displays must appear to be intentionally visible, and for a purpose. All that we must grasp literally as quickly as a wink, since if someone winks at us, we need first to perceive the movement, next to understand that it has been made perceptible to us as an action, by intention—but even that is not sufficient, since we also have to grasp the purpose of doing this. Was that a blink or a wink? Who was meant to see it—and seeing it, to see it as meaning what? As Claudette Colbert says in *Midnight* (1939), "The moment I saw you, I had an idea you had an idea." Missed signals occur at all levels of such common processes, which include facial and bodily expressions far more subtle than winks: eye movement, including contact held slightly longer than one would expect, changes in breathing, shifts in posture—all, by the way, actions for which artists have found means for evoking graphically, as the stuff of comedy or tragedy.

In summary, the overlapping artifact classes "drawings" and "pictorial depictions" belong to a subclass of visual displays made by marking on surfaces, which includes also writing and many other kinds of markings. When we take a marked surface to be a visual display we therefore expect to follow patterns intentionally put there in order for us to see and to understand as such. For example, when we pick up what looks to us like writing, our main perceptual activity is the distinctive one of trying to read what is there. What, in general, do we do when we take something to be a depiction? Fortunately, Kendall Walton's theory of depiction has already made that function explicit and systematic. In conclusion, unless someone can give a reason why drawings are perceptually exceptional, any of the six factors just listed can be expected to be relevant to the perception of them—notably to those that depict—where by "perception" I mean both how the things look and the kind of looking we do.

When we revisit Gombrich's Gulf Principle with these half-dozen considerations about perceptual categories, there are clear implications for his alleged "tremendous gulf" between environmental and pictorial perception and his ensuing "wretched question." One is that in understanding what Gombrich calls "the beholder's share," the categorial background to depictive experience can be no mere aspect of his favored mechanism of "projection," the imaginative completion of the visually ambiguous.[8] Next, his gulf between pictorial and environmental perception can hardly be what he says it is. Speaking metaphorically, environmental vision files do not arrive with "functional artifact" stamped on their covers, whereas pictorial ones do.[9] Therefore, the biggest gulf that must exist between these two kinds of perception is that while the former is controlled by the complex background thing-classifier "functional artifact: depiction," the latter is not. Gombrich's "wretched question" thus turns out to be a confused one, since the fact that artifact categories background normal perception of pictures in no way prohibits the transfer of natural environmental perception into such contexts.[10] Indeed, I shall argue that these categories standardly inspire such transfers. One of the main theses of this book is that depictions invite us to bring *a number* of resources to their perception, some culturally dependent, some universal to humans, indeed to all sighted creatures. Rather than there being an either-or choice between what is natural and what is conventional, there are instead interesting, complex accounts to offer about the different ways these resources mix.

FACES IN STRANGE PLACES: A PROJECTIVE CHALLENGE

Most are unlikely to grasp the significance of the simple thesis just argued, that we see depictions as what they are: depictions, artifacts with a certain general purpose, like those in our daily life. Or if we grasp the significance, we are not likely to retain it. Many, including advanced vision researchers, blithely neglect that everyday, useful categorial assignment, "depiction," which allows us, as cinema viewers, to look with unconcern at images of what are clearly to binocular vision four-meter high mobile "human faces" on surfaces, and also endure sudden jumps of image, light and scaling without

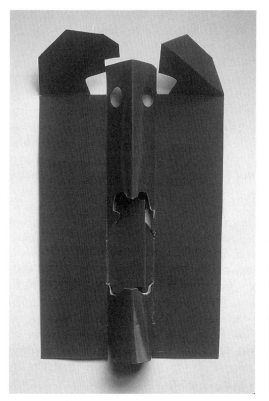

Fig. 60. Faces in strange places: Starfit packing.

Fig. 61. Faces in strange places: birch eyes.

the slightest disorientation. Speaking of images on screens, an existing psychological literature that accounts for our ability to deal with frequently oblique sight lines to surfaces—which sometimes posits a calculation from a tacit awareness of the surface—usually neglects another tacit understanding, that what we are seeing is a depiction.[11]

I have been arguing that Gombrich's fifth, Beholder's Share, principle—designed to deal with the gulf of his fourth principle—fails to include the most basic aspect of any beholder's share: the perceptual categories of depiction. Let us consider a defense of Gombrich by going back to his Same Mill Principle, regarding the natural roots of convincing depiction. The first bits of testimony cited in exposition of that principle (EHG 6, 9, 10) remind us of the well-known penchant we have for seeing what appear to be faces in things (figs. 60, 61). "We know that there are certain privileged motifs in our world to which we respond almost too easily," wrote Gombrich in his early "Meditations on a Hobby Horse." "The human face may be outstanding among them. . . . What wonder that it is

so easy to 'make' a face with two dots and a stroke even though their geometrical constellation may be greatly at variance with the 'external' form of a real head?"[12] The natural basis of what I have called transfer here Gombrich conjectured to be "inborn release mechanisms" of perception (borrowing a key term from Konrad Lorenz). Gombrich added: "The greater the biological relevance an object has for us the more will we be attuned to its recognition" (7), and he called the result "projection." He wrote similar things in *Art and Illusion,* and some modern psychologists agree. For example, Roger Shepard, who also strongly argues for transfer as the basis (even the satisfaction) of most depictive effects, comments that an indication "that our heads are filled with circuits tuned to the human face is our tendency to 'see' faces in the most diverse objects around us."[13]

Any of us can easily confirm this by simple experiment. If we draw a series of enclosures and decorate them at whim with constellations of two roughly 0D marks (spots), and one or two 1D (line) segments, we find it hard *not* to produce the

Fig. 62. Pantheon, butterfly marble.

visual effect of faces, each with a different physiognomic expression. This can be done without looking at what we do. Not drawing a face is then a more difficult task than is drawing one. Indeed, not doing so is a challenge in life (nude) drawing, due to nipples, navels, belly folds. As automobile headlight and grille designers know, there are marketing problems about those that seem to have bad expressions.[14] All this gets the infant drafter going in one kind of vivid depiction (see fig. 51). So the challenge is this: what becomes of the whole case for the importance of background *pictorial* categorials to depictive experience if this physiognomic transfer phenomenon, so central to effective depiction, seems not to need the distinctions between the natural and artifactual, the intentional and accidental, and the pictorial and nonpictorial, and sometimes works even more effectively for "faces" in trees and other objects than in our own drawings? Before answering that question we need to consider the physiognomic cases in more depth.

The challenge seems reinforced by Gombrich's further extension of his term "projection." To understand that we need only his chapter title, "The Image in the Clouds," and our

imagination will do the rest. Having already considered shadows, we know how such images also occur out of mists. Reflective symmetries of irregularities often work, too, for example, when slices of wood or veined stone are adjoined "butterfly" fashion in reflective symmetry. Thus the medieval philosopher Albertus Magnus reported that in Venice he had seen marble sawn for San Marco: "And it happened that when one marble had been cut in two and the cut slabs were placed side by side, there appeared a most beautiful picture of a king's head with a crown and a long beard"; a similar effect may be seen today in the Pantheon in Rome (fig. 62).[15] Then there are alleged divine manifestations, such as the iridescent apparition of the Virgin Mary, "clearly limned into four tinted glass panels" of the Seminole Finance Corporation Offices near Florida's highway I-19.[16] That is only the beginning. For the heroine of Ludwig Bemelmans's *Madeline* a ceiling crack "had the habit of sometimes looking like a rabbit," but we do not stop there: whole visual panoramas float before our eyes. The lines from *Antony and Cleopatra* that Gombrich chose as the epigraph for his chapter—

Sometime we see a cloud that's dragonish,
A vapor sometime like a bear or lion,
A towered citadel, a pendant rock
A forkèd mountain, or blue promontory
With trees upon't, that nod unto the world,
And mock our eyes with air.[17]

carry us not only into the inorganic but also from substance to scene, to vistas, as do the boiling summer cumulus, glowing embers and leaping flames, the turning eddy in the brook, grain in wood or stone, and so forth with no easy end. But now Gombrich's extension of his "projection" idea from the context of biological releasers (the Same Mill Principle) to his Beholder's Share Principle needs further explanation, for it seems unlikely that his theory of "privileged motifs in our world to which we respond almost too easily," such as face seeing—reflecting what he termed "our biological and psychological needs"—will account for all the effects opened by "the image in the clouds." In other words, there would be no point in his or Shepard's claim that "our heads" are "filled with circuits tuned to" *everything* that we can thus imagine or "project." Nor does such imagination stop even with a wide variety of substances.

Though one grows weary of citations of Leonardo about such effects in damp walls and variegated stones, Leonardo mentions not only being able to "see there battles and strange figures in violent action" and "divine landscapes" but also nonsubstantives such as "expressions of faces and clothes."[18] Lacking a Bemelmans or Shakespeare to remind us of these more subtle effects, which slip from memory as easily as dreams on waking, we still see upon slight introspection that imagination of what used to be called "modes" and "relations" may also appear this way without clear dependence on substances such as faces, rabbits, trees, or mountains. That should come as no surprise, since in Part I we considered drawings that show mathematical relationships between properties of things, such as stress, pressure, and temperature, and we went on to consider pattern perception as not dependent on perception of individual shapes. Ordinary perceptual awareness works in similar ways. Just as from the corner of the eye or in the dark we may be aware of movement but not exactly of some *thing* moving, so in many cases of "projection" we derive the sense of various effects with no clear substances to pin them on. It is good to recall this, since, as earlier re-

marked, our account of drawing has so far been rather fixed, Villard-like, on objects—indeed on their spatial characteristics—but, as cautioned, there is a danger of our treatment of drawing becoming "spaced out." Biological vision is not simply fixed on objects, their shapes, and their positions in space; neither is depictive imagining.

Our whole engagement with the topic of depictive drawing, through Walton's account of depiction, Gombrich's concerning vivid or "effective" depiction, and the issue of "projection," has had the welcome effect of liberating us from dependence on the rendering of objects in space, even from psychologist David Marr's "what things are where" conception of sight. Gombrich has not been credited enough for his efforts to "rid art history of its obsession with space and bring other achievements into focus, the suggestion of light and texture for instance, or the mastery of physiognomic expression."[19] He does not credit himself enough, for it is interesting to read his later confession, pertaining to "the beholder in this vital act of projection," specifically regarding classical painting and sculpture, but in words that apply as well to other cultures and media of depiction:

> We sense the tension of the muscles under the surface, we see the play of the body under the garment, we feel the presence of the mind behind the smile. In discussing the illusions created by art, art historians (including this writer) have concentrated too much on the pictorial inventions of foreshortening, perspective, or light and shade, and failed to analyse the illusion of life that a Greek statue can give.... We are not "taken in," as we may be by a wax figure in suitable setting. And yet it is hard to remain conscious of the fact that we look at an opaque block of stone rather than at a breathing body beneath the clinging drapery. There is an illusion of transparency, created by such masterpieces as the sculptures from the Parthenon, the Caryatides of the Erechtheion, and the balustrade of the Temple of Nike in Athens: the vivid illusion of a figure underneath the folds and of pulsating life underneath the skin.[20]

And surely, a sense of life movement is one of the most sought-after effects of "convincing" depiction in any medium, in any age.

Gombrich's observation brings us back to our topic of depictive categories in perception. Welcome as are his remarks about depictive "illusion" of life, material texture, and motion, they nonetheless restate the general view of the irrelevance of basic depictive categories when confronted with vivid representation. "It is hard to remain conscious," he says, and lest that seem a mere metaphor of the passage—for he does qualify it—it is time to identify a sixth principle of *Art and Illusion*: Gombrich's insistence that in a picture "to 'see' both the plane surface" and its depiction "at the same time" is impossible. We will call this his Incompatibility Principle. According to Gombrich, experience of the subject of depiction and awareness of the object that we are literally seeing are mutually exclusive. "To understand the battle horse is for a moment to disregard the plane surface. We cannot have it both ways," he wrote there, adding elsewhere: "Critics wrote and still write as if we could see both the surface and the representation, but artists knew better."[21] We either imagine seeing the face in the picture or we experience the marks, the enclosure, the shape on surface that produce that experience, but not both at the same time. Gombrich took this perceptual exclusion principle as a basis for *Art and Illusion,* calling it part of that book's very "theme-song" (13), and it is important to see why. In Part IV we will consider the broader issue of this so-called "duality of depiction," concerning which there is a spectrum of theoretical opinion.

At this point, however, a fair understanding of Gombrich's ideas must emphasize what is often overlooked, that his is a specific *historical* thesis. To be sure, Gombrich's is a far broader issue than Panofsky's, for if Panofsky wished to explain why perspective should have run its particular history, Gombrich needed to say why "convincing representation" should have any kind of history at all. Gombrich's answer was based on his psychological thesis that effective depiction works from the perceptual ambiguity of the marks it comprises, on "the many possible meanings of each colour and form," while the automatic action of perception— what he came to call "the variability of vision"— "will tend to hide ambiguity from us as long as possible."[22] This is why the discovery of effective recognitional techniques is piecemeal, providing a history for Gombrich to relate. Further, Gombrich assumed that such perceptual ambiguities, once hit

upon, continue to hide themselves to depictive perception.

Art and Illusion is not a systematic work. It has been left to us to identify six principles from this book and from related essays by Gombrich and examine their logical and theoretical interrelationships. We should now review them. Gombrich holds that "convincing representation" is gained by a process of "making and matching," rather than copying of appearances (his Anti-Imitation Principle), that is, a psychological investigation of effects on human visual systems, in terms of what devices cause it to "project" (Effects Principle), which devices basically exploit the visual system's wide variety of environmental perceptual routines (Same Mill Principle). The matter was not so simple, however, for two reasons. First, according to Gombrich there exists a gulf between normal pictorial and environmental perceptual situations (Gulf Principle), mainly owing to the former's being an "experiment in doing without," and therefore ambiguous—which ambiguity is managed by a socially cultivated tendency to "project" (Beholder's Share Principle), impelled by experience with depictions and controlled by consistency tests. Second, even then, exploiting the Effects Principle process makes slow going because of our inability to be perceptually aware of the intrinsic ambiguity of the visual stimuli (Incompatibility Principle), which it exploits. It is for that reason, he held, that we have to grope our way along by making and matching, trial and error, in search of tools for the depictive kit, providing "convincing representation" with a history. Thus our review of the six principles, part of which Michael Podro elegantly summarized in two sentences: "For Gombrich, to understand how depiction works we must examine how the painter mobilizes the mechanisms of recognition. Painters, so he argued, learn by trial and error to construct forms that yield experiences convergent with—but always distant from—those of the prepictorial subject."[23]

In this chapter, so far focused on criticizing Gombrich's Gulf Principle, I have argued that he exaggerates the difference between depictions and actual scenes in visual terms, while overlooking the more important perceptual difference that is due to the background categories of perception that guide such vision. I have held that pictorial perception's being guided by such categories does not

conflict with Gombrich's visual effect principles (Effects and Same Mill), which constitute his greatest contributions to the subject. But this position, I have argued, besides entailing a drastic revision of his Beholder's Share Principle, entails the falsity of his Incompatibility Principle, with which it is, on Gombrich's own formulations, strictly inconsistent. In good dialectical style, let us argue this by consulting Gombrich's own examples. One might attempt that case simply from Gombrich's Beholder's Share Principle, where the "mental set" responsible for "projection" clearly presupposes identification of the visual "stimulus" as a depiction of a certain kind. Just as taking a context as humorous (as when we assume someone is joking) sets us up to look for the funny aspects, so taking a visual display as a depiction sets us up to respond imaginatively to visual promptings. Were one not experiencing the Leonardo drawing (fig. 58) as marks placed on a surface for a specific purpose and *at the same time* experiencing what it depicts, it could hardly be, as Gombrich remarks, that "we instinctively identify ourselves with the artist." And, speaking of artists, they could hardly draw their depictions unless they "could see both the surface and the representation," that is, have simultaneous experience of the depictive effects and of the marks they are making as marks on a surface.

I take that as sufficient for refutation of Gombrich's Incompatibility Principle. Still, we can make more positive use of argument through a related dialectical reply, in connection with Gombrich's own remarks about "effective representation" in sculpture quoted above, given that the point applies to all depictive media: drawing and painting, tapestry, photography, cinema, ceramics, mosaic, niello, the work of gold- and silversmiths, topiary, and so forth. According to Gombrich "it is hard to remain conscious of the fact that we look at an opaque block of stone rather than at a breathing body." But had we lacked background consciousness that what we see is stone, not life, an expressive sculpture would not evoke life; if we did not see the figure as still stone, the drapery it depicts would not seem to flow, be moved by the wind, be diaphanous or clinging.[24] All this is an instance of a standard situation regarding "convincing" depiction, that a depiction's giving the sense of some property P perceptually presupposes that we take it to be *non*-P—indeed, often to be opposite to P: inanimate, not organic; flat, not deep; mono-

chrome, not colored; handmade, not natural. Since Gombrich mentions sculpture from the Parthenon and Erechtheion of Athens, no one unconscious that what one sees there are depictions, sculptural ones, would experience their transparency or life. For example, the "Iris" figure from the Parthenon is described by the British Museum as "shown as if just alighting on the Acropolis. Her drapery is pressed flat against her body and flutters out at the edges."[25] This object, faded now to monochrome marble, will be seen by us—with our automatic "ancient sculpture" background categorizing—to be broken, to have lost parts (as Gombrich says elsewhere, to be "sadly mutilated") that once depicted head and neck, arms, right breast, and legs below the knees (also a pair of wings). However the *depicted* figure is not for a moment experienced that way, as we admire the surviving features that Gombrich points out to us, and of which he writes elsewhere, of a related figure, "how beautiful this broken figure still is, even without head or hands."[26] Indeed, Rodin's 1890 bronze *Iris* (who is apparently not landing) is formed to be like a broken or at least incompletely sculpted figure. Meanwhile, the British Museum's Erechtheion caryatid, which stands 2.3 meters high, supporting a heavy entablature, has lost its "nose" and both "arms" below the elbows.

What are we to say then of these alleged "illusions" of art? Clearly the background categories that hold for perceiving depictions do not hold for actual visual illusions—not even for well-known ones, which produce only a tendency to believe. For example, we do not need to believe that the two segments of the Müller-Lyer illusion are equal as a perceptual *condition* of their appearing unequal (fig. 63). That is only one indication that speaking of convincing depictions in terms of "illusions created by art" has always been mislead-

Fig. 63. Müller-Lyer illusion.

Fig. 64. Assyrian lion hunt relief from North Palace of Sennacherib at Ninevah, ca. 650 B.C. British Museum. Author's rendering.

thus of a Michelangelo he observed that "the simple shape of the block was always reflected in the outline of his statues, and held it together in one lucid design, however much movement there was in the figures."[28] Finally, having considered the sculpture of the Parthenon by comparison, so great is the agony of an arrow-riddled lion of the Assyrian work in a nearby gallery that perhaps we are to imagine that the depicted animal's claws dig into the *stone* surface (fig. 64). But just to begin to "analyze" depictive works in this manner is already to abandon Gombrich's Incompatibility Principle, for all media. Later we will attempt to develop a basis for such analyses, where the categories of artifact, intention, and physical process are brought into the account of what we will call "sustained recognition."

FICTIONAL WORLDS

Let us return to the challenge about perceptual categories and depiction, which arose out of natural "projection" phenomena. The challenge was, If we can experience these absent background depictive categories, what basic use would such categories have to picture perception? Again, this is a question about the artifact category "depiction," easily answered in terms of the account of Walton's theory of depiction in chapter 6, which we now understand as constituting an analysis of the content of the standard category "depiction" when applied to drawings and other visual works. On that account, "depiction" applies to *functional* artifacts. Their function is to elicit and to control what might be called, in Richard Wollheim's phrase, certain "imaginative projects" and are, according to Walton, projects of a distinctive kind. In review, not only are we to imagine, *on* seeing the depiction, that we are seeing its subject matter, we are also to imagine *of* the former seeing that it is the latter act of seeing. We are therefore induced and directed to imagine something about ourselves, of our own activities of seeing—though that imagining is not to be confused with the imagining of subject matter. Furthermore, what we are to imagine will typically extend beyond what we imagine directly seeing, just as, when we actually see things, what we take to be true of what we see goes beyond what we directly see. More is represented than is depicted. Finally, the mandated depictive experience being

ing.[27] As for Gombrich's remarks about illusion in sculpture, these would be metaphorically true, perhaps, to the effect that relatively speaking, our necessary background awareness of the stone plays a somewhat different role with the sculpture of sixth-century B.C. Athens than it plays with that of other times or places. Therefore the analysis that Gombrich calls for might be put in terms of finding principles for better understanding the many ways in which background categories interact with the foreground depictive activities they allow. For example, speaking of those Greek figures, it is common for modern artists to prefer earlier dynastic Egyptian figures, which work from our awareness not only of stone but also of the hardness and shape of the original granite blocks from which they were taken. Awareness of the presence and strength of that stone, as stone, enhances our experience of the depicted royal figures as powerful, enduring, and present. Indeed, when writing as a sensitive beholder of sculpture rather than as a theorist, Gombrich seems aware of this very point;

fully perceptual requires degrees of spontaneity, richness, and vivacity in the experience. In summary, according to Walton, a depiction "is a representation whose function is to serve as a prop in reasonably rich and vivid perceptual games of make-believe."[29] Consideration of the required vividness was, after all, what led us into an extended investigation of Gombrich's account of "convincing representation." Depictions being functional objects of this now well-defined sort, whenever we look at a drawing as a depiction, that is the understanding that controls our experience of them.

In light of this, what should be said about our natural "projection" examples? They are not depictions because they are not functional artifacts. With them we are merely exploiting natural cases for imagining. Just as cupping our hands to drink does not mean that our hands are cups, but only that they can be used like cups, or as the log we sit on is not a bench although it can be used as one, so the image in the clouds does not mean that cloud formations are depictions. This functional difference has very important implications for understanding the differences between depictions and mere projections. Recall that Panofsky had mentioned "correctness" in identifications of subject matter. A most important feature of depictions is that they have what Wollheim calls "a standard of correctness and incorrectness" regarding what we are to imagine when we look at them, while cloud formations, leaping flames, moldy walls, trees, and so forth do not. With the latter we imagine whatever they prompt us to imagine, and our imaginations are free to wander, but they provide us with nothing objective to investigate in that regard.[30] Earlier quotation of Marc Antony's lines from *Antony and Cleopatra* will likely remind us of an exchange from *Hamlet* (3.2.393–399):

HAML. Do you see yonder cloud that's almost in shape of a camel?
POL. By the mass, and 'tis like a camel indeed.
HAML. Methinks it is like a weasel.
POL. It is backed like a weasel.
HAML. Or like a whale?
POL. Very like a whale.

Depictions and other fictions, including literary ones, are very different in this regard, since they mandate certain imaginings, not others, while leaving still others unclear. This is a crucial point, meriting closer examination.

Although we considered this in chapter 6, some readers may still be skeptical of the whole idea of mandates and prescriptions. Why not suppose only that representations are things with the function of prompting or eliciting free imaginings, leaving it to biological and social factors to produce similar responses? An answer can be found in clearly narrative fictions. Reading a novel or seeing a film or play is partly a matter of finding out what we will imagine next, but not in a way that is like a dream experience. Our normal interest in such representations is in finding out "what *happens* next." This interest, like our similar interest in the real world, is investigative. Representations, as Walton holds, generate fictional worlds, and much of our commerce with them consists in finding out what is true and not true in those worlds—or, better, what is fictional and not fictional in those works. It is for this reason that we pay close attention, reread passages in novels, ask others about what we did not catch in films.

To appreciate the generality of this issue, consider a literary work known to all, Dickens's *A Christmas Carol*. When the ghost of Marley appears to him, Scrooge marks the "very texture of the folded kerchief bound about his chin, which wrapper he had not observed before": thus within the story a fictional character notices features of that world. Likewise when we, outside the story, read the lines "There was something very awful, too, in the spectre's being provided with an infernal atmosphere of its own . . . ; for though the Ghost sat perfectly motionless, its hair, and skirts, and tassels were still agitated as by the hot vapour of an oven," we might realize that we had missed a passage a few pages back—"the hair was curiously stirred, as if by breath or hot air"—when we read of Marley's face appearing on the door knocker, and we might go back and reread for better understanding. That is what investigation of the fictional world of a novel is like. This possibility of investigation, allowing for being correct and incorrect, noticing what is there or failing to do so, reading carefully or reading in too much, is also the basis of much of our interest in visually figurative representations such as drawings and sculpture, whether narrative or not.

Having introduced this well-known literary fiction to help explain the idea of what is fictional

in a work, let us review Walton's crucial distinction between what is fictional in a work of literature or pictorial depiction and what is fictional about the beholder. Given background conditions that we all assume, but probably could not define or defend, Dickens's words on the pages we read make it fictional—mandate that we imagine—that although "Marley was dead, to begin with," his phantom visited his former business partner, Ebenezer Scrooge, for a specific purpose. As we read, we imagine certain things of ourselves too: for example, that *we* are completely convinced that Marley is dead. Walton stresses that it will not do merely to accept that it is fictional that Marley is dead, for that would be refusing to engage in the story; and it certainly will not do to imagine that Marley's being dead is fictional, because, as the narrator rightly tells us, "There is no doubt that Marley was dead. This must be understood, or nothing wonderful can come from the story I am going to relate." Nevertheless, the event of our believing that about Marley is no part of the fictional world of the story, for we are not characters in it. Also, as we read or hear it, we are not mandated to imagine the beliefs of the millions of others who have also done so. On such grounds alone, without opening wider issues, Walton seems right in distinguishing the fictional world of that story from the fictional worlds that include it but also include your and my imagined interactions, which he calls our "game worlds."[31] The same holds for all such representations with which we engage, including visual ones.

OUR OBJECTS OF IMAGINING

There is a second importantly relevant issue raised by "the image in the clouds" and similar phenomena. To this point, we have considered such natural phenomena in connection with a criticism of Gombrich's Beholder's Share Principle, which I have been concerned to supplement. However such "projection" phenomena may also have a bearing on Gombrich's Incompatibility Principle, criticized at length above, for there may be interesting cases of "projection," according to Gombrich's Same Mill and Beholder's Share principles, that are actually inconsistent with it. Contrary to Gombrich's rivalry ideas, even seeing faces in trees (fig. 61) need be no competitor to experiencing

seeing trees for what they are. This is not to go back on the claim that such things are not seen under the category "depiction." The present point is different: visually experiencing something to be a tree trunk, and not forgetting that for a moment that it is one, we can *also* apply other categorials to it: "eyes," "face," and the like. As remarked, we sometimes not only imagine substances, features, and actions in objects such as clouds, flames, old walls, and trees—as well as states such as shadows and reflections—but also imagine the one thing *of* the other, without dropping their appropriate labels. For example, we sometimes "see" not only eyes in a tree but the tree as *having* those eyes— which entails being aware of its being a tree. Not to notice this common phenomenon is to miss what Gombrich might have called "the Arthur Rackham of it all": the way that trees, as trees, can seem to *have* faces, eyes, arms, menacing stances, gestures, motions, rather than merely providing "screens" against which we are encouraged to imagine those things.[32] It is not even sufficient for such cases to say that we have concurrent but incompatible specifications of two situations running in two visual processing tracks, although, if visual recognition is like thought, that seems quite likely to be the case.[33] These particular cases seem to be rather like metaphors where the "wrong" category can still be used to organize perception of something that is being correctly categorized. That effect is not to be taken for granted, for in the first place, vivid projection is not something we can produce at will. After all, Marc Antony continues his "black vesper's pageants" quotation above by saying: "That which is now a horse, even with a thought / the rack dislimns and makes it indistinct / As water is in water." In the second place, this example shows how, unlike the tree eyes, Gombrich's projections (say, a horse) do not usually modify the correct identifications (clouds) to yield visual metaphor.

Lest one more argument against Gombrich's Incompatibility Principle seem like hard treatment, let us turn this last objection to positive use. To do that is to develop a very important part of what we have taken from Walton's theory of mimetic representation: the distinctions among the trio of roles of mandating imagining, causing imagining, and being an *object* of imagining. Earlier we considered depictions and similar representations only in their roles of prompting and prescribing imagination. As for objects of imagining,

we have stressed that, with depiction, our very acts of looking at, say, drawings become *objects* of the imagining—that is, that we concurrently imagine about them. This raises the obvious question whether things that prescribe or that cause imagining may also be objects of imagining. For practice, let us begin by considering our accidental, nondepictive examples and ask whether a cloud, stain, iridescence, tree trunk, or other form may not only be the inciting cause, or prompter, of our episode of imagining seeing, but also be an object of that imagining as well.[34] I just suggested that a tree may prompt us to imagine of itself, as a tree, that *it* has eyes. Then the tree plays a double role: prompting the imagining and being imagined about. This would not be true for the faithful who view "Our Lady of I-19." Presumably, they do not imagine that what has prompted their experience of seeing the Virgin, which is undeniably an optical effect on glass, *is* the person they take to be manifested by that effect.[35] When Scrooge doubts his senses and says to Marley's apparition, "You may be an undigested bit of beef," the "be" is metaphorical. What Scrooge means is that his poor digestion of meat, mustard, cheese, potato, gravy, and a toothpick (to include his other candidates) may be a cause or inciter of a vivid episode of imagining; he does not mean that maybe he imagines *about* that digestive state, or of any complex carbohydrate involved, that *it* is the shade of his former partner.

Returning to depictive representations, a question arises: When are they objects of what they mandate we imagine? In other words, when are they "reflexive representations"? An answer is complicated by the different uses that societies have given depictions. In general, of figurative depiction, Walton suggests that pictures are typically not reflexive, while sculpture may be.[36] For example, looking back to our Dürer examples from Part I, if we were to point to small marked areas in three of them and say, "That is an inkwell," it might seem unconvincing that we mean that one is to imagine of the marked area on the page that it is an inkwell. However, it seems more likely that, pointing to "Iris" and saying, "That is a winged goddess," we mean that we are to imagine that the stone is Iris—so that, for example, the stone's being affixed to the Parthenon means that we are to imagine that the goddess Iris had alighted there, or that when we move relative to the stone that we move relative to Iris. Although there are traditions

of treating pictures and their parts in similar ways (for example, in religious processions), the Dürers seem to belong to a larger class of pictures that are not given that sort of function. Wittgenstein noted how a "child can talk to picture-men or picture-animals, can treat them as it treats dolls," yet such is an only occasional use, even for children, in a society that produces more pictures in a number of minutes than previous ages did in centuries. Still, here is a thought: our Dürers are not just about drawing in perspective, they also are, exemplify, drawing in perspective. Linear perspective, which is generally considered a means of suggesting depth relationships among the things represented, is also a way of imagining a relationship between those imagined things and the picture surface itself—thus the phrase "a prospect through a window." Does that not suggest that the marked surfaces of the Dürers are, after all, represented: that is, represented as open (or, for Panofsky, "glazed") windows? If so, then these pictures would be in that respect reflexive representations, objects of the acts of imagining seeing they mandate. Thus our investigation of depiction returns us to perspective and similar drawing systems, but now we are armed with a theory of depiction. Before carrying this forward, review is in order.

PAWAHTÚN'S LESSONS

While we have been critical of Gombrich's second trio of principles (questioning the Gulf Principle, radically revising the Beholder's Share Principle, urging rejection of the Incompatibility Principle), this critique does not affect his first trio. Let us review that trio in the context of the conceptual kit we have been building, by attention to a fresh example, a rollout reproduction of a Mayan painting on a pot (fig. 65). At a glance, anyone would notice that the pot surface has pretty clearly been drawn on. Most who understood the categories "depictive drawing" and "writing" would be able to distinguish the two types of markings here, although they are formed with the same implements, by similar motions, and probably by the same artisans. However the writing glyphs are identified, what does careful scrutiny tell us about these markings show, or say? I venture that while few in history—and only a few experts in our time—could work out the sense of them, many of the billions of

Fig. 65. Scribe God Pawahtún, Mayan vase painting, 8th C. Pot height 9.7 cm, Justin Kerr rollout photography, K1196 © Justin Kerr.

people who have lived, including the Abelam of New Guinea, the Inuit, dynastic Egyptians, Ming Dynasty Chinese, Scythians, and so forth (including in this count not only adults but quite young children), would have little trouble with the general drift of its pictorial part. By "general drift," I mean that most people would have little difficulty distinguishing depicted objects and their features (such as edges, "faces," junctions) as distinct objects and features. Next, drawing on our common "projection" tendencies, they would have no difficulty identifying these as human figures, as people in certain postures, doing kinds of things, indeed with certain demeanors, although interpretations of these would differ.

Besides high levels of perceptual agreement regarding what is depicted, there would be wide familiarity with what is broadly called the picture's "style," that is, the basic pictorial means by which its depiction is done. People would tend to see the pictorial display as made up of marks of the different types we have considered: a few dots and blobs, but mostly rather 1D drawing components—that is, lines of discernible thickness, shape, and orientation which have clear and varying depictive meanings. As a *decorative* depiction the display is basically an affair of clearly separable lines, mostly curving, laid out in rhythmic relationship around the pot. Most of them would be understood as outlines—as enclosing regions on the surface that in turn depict bounded forms. While none of them shows polarity—that is, their edges are about the same on both sides—they would also be understood as "out-lines" in the sense discussed earlier, of indicating the outside bounds or borders of features or things (there being a lack of shading, modelling, or internal detailing). As border markers these lines would be taken as indicating occluding

contours and edges of depicted things. For example, some that would be understood as depicting vestments show the edges of those things, others the vestments' occluding contours as they are folded, twisted, or wrapped around. Not all the lines would be taken as outlines, however. In a few cases they would be given "object" interpretations: that is, taken as depicting patterns on fabric or as coinciding with threads, strings, hair. And there are a few other meanings, as well. For example, besides the lines limning objects, a few indicate features such as the small plane of a lip (some drawing theorists classify separately the line-formed cracks and wrinkles we see here).

This account of understanding a drawing should also allow for misunderstandings or unclarities, since imagining seeing things in depictions, just like actually seeing, is a matter of hypothesis and testing by repeated closer viewings. Misunderstanding the pictorial means in this picture might entail misidentifying some contour lines as indicating objects rather than features, or taking occluding contours to be edges, or misidentifying regions by not grouping related lines. In the case of contour lines depicting attire, it might not always be clear which line depicts an edge, which an occluding contour—a situation familiar from everyday environmental perception. But regarding the human body, it being a smooth kind of thing, not surprisingly most lines depicting it here consist in the occluding contour sort.

Thus the obvious points. Let us look more closely at these lines to see how, besides indicating regions and denoting the inside and outside of depicted features and things, they carry depictive meanings. Shape and relationship being their main depicting characteristics, we notice how, despite these lines being basically 1D, they flex, displaying

depictively significant broadenings and attenuations. For example, one of the three fairly continuous lines defining necks and backs shows significant thinning then swelling as it moves downward (and downward it seems to go). By contrast, the consistency of the other two indicates sleeker forms and thus a fullness, signifying depth, as well. Thereby we add to our toolbox the idea of lines having direction, of *moving,* which will have much use in Part III. This points to a more general feature of the human body's contour lines, well known to drafters throughout the ages and insisted on by life-drawing teachers in modern times: that the body's occluding contours push so strongly toward convexity that any concave line will tend to look like a bite out of the solid form.[37] As we compare the curved lines for body contours with those for cloth edges, we find our Mayan generally following the Western rule, though not always. There are some actually straight lines, but on close inspection most these actually curve slightly out from the form. Among the concave a few define backs of necks (since for this Mayan artist a head is mostly face). The little bend or hook indications where an upper arm meets a torso merit special attention. It has been described by Jan Koenderink and Andrea van Doorn as depicting an "end-junction" at the place where a depicted contour stops, when one *smooth* form meets another.[38] This is always a tricky little spot in the drawing of smooth forms, since such hooks usually indicate 3D "saddle" shapes: convexity in one direction combined with concavity in another. One can spot the use of this device in drawings of all types, for example in contemporary cartoons as well as in great Chinese brush drawings.

Regarding the variety of line junctions (not the features they depict), which we encountered in Part I, here we are clearly in a different environment from the Dürers, where carpentered forms prevail. If we look back at just the top bit of Dürer's "Urn" (fig. 32), we find that the ceiling gets put on the walls by two Y junctions. The woodcutter almost muddles the one on the left, and awkwardly almost turns the T junction of the left side of the drawing frame with wall and ceiling into a confusing Y. The facing edge of the frame's board there is defined by joined upside-down Ls, its joinery meets the drawing surface with a Y—and one can work through most of the picture this way: I would not care to count the number of such junctions. By contrast, understanding the Mayan involves few such negotiations, as there are few L, Y, and arrow junctions. Unsurprisingly, it contains a number of the more basic T junctions, which we usually understand as indicating one edge, or occluding contour, occluding another. This is an important device for indicating three-dimensional spatial arrangements.

Probably the most noticeable difference between the Mayan and the Dürers, however, lies with space in the sense of depth, for the Dürers are clearly "perspective drawings," whereas the former is orthographic on a ground line, indicating depth only ordinally by occlusions signaled by T junctions (for example, an arm in front of a torso, hip or leg, which is in turn in front of another leg). The Mayan exhibits what art writers usually term "shallow" space; the Dürers, the revolutionary perspective depth. Indeed, such methods of 3D arrangement in pictures have long captured most of the attention from theoreticians, critics, and practitioners, though we now have more precise tools for describing them than have been available. If we look back at the Mayan drawing, however, we see that besides these transitive orderings by T junctions (for example, an arm in front of a torso, hip or leg, which is in turn in front of another leg), this familiar drawing device has an even more basic spatial function than depth. It also has that *topological* function that we saw to be essential to object identity—that is, the discontinuities together with "joinednesses," of bodily parts. In other words, although T-junction occluding contours "cut off" bodily parts locally, more complex relationships provide reassuring routes along which we find them joined. As mentioned before, this is a matter that has always been of great importance for depiction, especially for depiction of organic beings (given special meaning here by a grisly Mayan iconology of severed body parts). As argued in Part I, continuity, contact, and their opposites are important indicators of unity and individuality for such substances generally. Topological values go beyond continuity and discontinuity. Another very important topological characteristic to review is containment: one thing being inside or enclosed by another. Thus we are again reminded that the word "space" has other important pictorial meanings, notably of shape, and "shape" denotes the diversity we have seen.

Returning to some observations in chapter 5,

we should look to the basic shape category of dimensionality—that is, to the predominant 0, 1, or 2D characteristics of components of the picture (such as spots, blobs, lines, or regions) as well as to the more famous three-dimensionality, but also the important 0, 1, 2D object characteristics they come together to depict. "Shape," whether applied to the physical marks, the drawing surface, the pictorial components, or the things and features depicted, has still another important meaning, some of which we have indicated by considering lines or feature contours as straight and curved, sharp and rounded, or bent, curling, twisted, folded. Speaking of characteristics of the physical marks, the *glyphs,* too, share many of these spatial features. Even for those of us who cannot read them, they seem to be made up of dots, blobs, and lines, mainly curved ones, which frequently join to enclose 2D regions on the surface. In shape these regions are often cobble-like—that is, neither round nor square but rather suggesting a combination of the two. Also, while being distinct from one another, a few appear to touch. All the main ones enclose other shapes, which sometimes touch one another, sometimes do not, and may in turn enclose other marks.

One might say that it is through all these spatial properties of the picture and of what the picture depicts that we get to its real subject: the attitudes, relations, thoughts, and actions of human or humanlike agents. I suggest that one of the most striking facts about this picture is how easily we see the actions and attitudes of its protagonists, not just their postures and attire. Attending to Panofsky's "preiconological" identifications, we immediately recognize in it familiar human situations and actions, such as wearing clothes and adornments, being old or young, sitting, facing another, leaning forward, gesturing, pointing, addressing someone, listening or looking, demanding attention, being intent or surprised, anxious, serious, insistent, respectful. However precise we would be is a small matter. Most people would have little trouble saying which of the following actual, standard Mayan vase-painting iconographic labels would clearly fit the picture: "Armadillo"; "Battle standard shown in war and ball game"; "Cache vessel containing bones, severed hands, eyeballs"; "Enema scene, apparatus, pot"; "Fish under water eating flower in headgear"; "Goddess of childbearing, midwife"; "Net headgear"; "Penis perforator"; "Prognostica-

tions"; "Scarves knotted over neck, shoulders, over head"; "Scribe-artist headgear bundle"; "Snakelady entwined with Och Chan"; "Upended frog"; "Vision serpent."[39]

To complete the review we need to recall that on Walton's theory depictions will represent situations not so obviously recognized just by looking. Even at Panofsky's "preiconographical" level, we will need to be assured that, according to scholars, those "breath" lines connecting the scribe god Pawahtún's chin to glyphs function like the cartoon speech balloons of our time (see figs. 26 and 29). Also, one of the glyph utterances is, as might be suspected, in numbers, which the scribe god reads from his text. Now although the pictures probably do not depict the things said, the breath lines do depict the action of Pawahtún saying them. Of course, the pictures could depict him whether or not he was saying anything, could depict him speaking even if there were no glyphs, maybe even depict him saying precisely those things (for example, if the contents were written in the line above). But, perhaps, addition of breath lines and glyphs accomplish what their correlates do in cartoons: rather than merely depicting the god speaking and showing what it is the god says, they depict the action of those spoken utterances as issuing from him (like the "Sniff" in fig. 29). Besides imagining seeing him speak and seeing what he says, we imagine seeing Pawahtún physically uttering those things; we therefore have a somewhat more *vivid* sense of his saying them.

Pawahtún's utterance has something important to teach us, too, for the theory of depictive drawing. As our cartoon traditions, from at least the end of the nineteenth century exemplify, depiction contains an open-ended list of devices, often called "conventions," which on their own do not depict. These include action lines for motion, ambient stars for collisions and sensations (fig. 26), fumes for anger, flying droplets for stress and effort, and so forth.[40] Other traditions contain many others, such as enlarged images that signal social or political importance, and there is a multitude of interesting cases. The point here is that use of such devices need not make images less depictive. Given that a picture has sufficient sensory vivacity by some devices, these others may become depictive: that is, they may incite us to imagine seeing motion, concussion, anger and so forth and to imagine that the seeing of the picture is the seeing of

those situations. Thereby more differences between environmental and depictive perception become apparent, and the central importance of the idea of perceiving under the category "depiction" becomes clearer.

This review of main ideas of Part II has been expressed via two sets of hypotheses: one regarding what a drawing depicts or represents—including objects such as people and clothing, actions, psychological attitudes, not just features and spatial relationships—another regarding its pictorial components. To be sure, most of one's confidence about the first group of hypotheses is anchored in a universal face-seeing tendency, which, as we saw earlier, extends to recognition of bodily attitudes, as well. Perhaps one would not be so confident of universality in the recognition of, say, the spatial relationships of objects in the Dürers. But concerning the second set of hypotheses, our grounds for confidence may be even more solid. It seems that all cultures that depict do so generally by the means we have been analyzing—most commonly by lines, whose relationships have the meanings described—however much their drawings differ in style, subject, and function. What is the basis for such confidence about the responses of people in different cultures over millennia? Our own responses provide a good test case: the relative ease with which we understand depictions from many lands and many ages. Lest this suggest that, due to modern technologies of reproduction, we can boast remarkable fluency with various depictive styles, there is another empirical test that we can easily run, through our perceptions. We can "triangulate" on the situation by setting beside the Mayan brush drawing any of the Dürer woodcuts or any typical depiction from dynastic Egypt, China, or the Aurignacian caves. Although the Mayan drawing, from the eighth century, belonged to a tradition unknown to Europeans of Dürer's time, there is no doubt that Dürer would have understood it. Nor is it doubtful that the Mayan and the Chinese artists would have basically understood one another's work, although there is no evidence of interaction or common root between their cultures. If there be lingering doubts about such broad claims, they should be dispelled by our drawings from Chauvet Cave, sealed off in a cave in France for tens of thousands of years until their discovery in 1994. There can be little doubt that the Mayan, the dynastic Egyptian, the Chinese, and

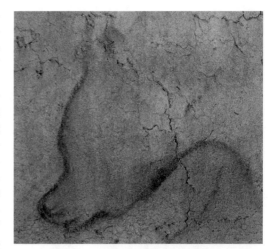

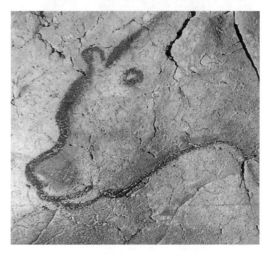

Fig. 66. Bears, Cactus Gallery and Recess of the Bears, Chauvet Cave. From Jean Clottes, ed., *Chauvet Cave: The Art of Earliest Times* (Salt Lake City: University of Utah Press, 2003), by kind permission of Jean Clottes.

Villard and Dürer would all have understood these pictures with much the same ease.

Such a universality signifies more than the no doubt striking *eidē* or visual forms of big cats and similar creatures, since any of the artists just mentioned, as well as the sculptors of the Greek and Sumerian figures mentioned earlier, might have picked up their marking instruments and completed these drawings in coherent ways, using lines. That is not to say that the use of line does not vary in these different techniques. Consider the use of occluding contours on rounded forms—a significant technique that we have been stressing. The Chauvet's, unlike the others, displays polarity (figs. 66, 78), is sharper toward the

outside of forms, but softer toward the inside, suggesting something like shading, as the rounded forms turn away from us—a shading sometimes joined with figure infilling strokes (fig. 78). Also it is debated whether overlap of forms there indicates spatial ordering. Yet, based on images like this, we have excellent grounds for supposing that the Mayans and others would have recognized lions and horses in the markings at Chauvet Cave and also understood most of the graphic means by which they were depicted. It seems impossible that this could be by luck.

All this strongly confirms Gombrich's second and third principles, suggesting that such devices of convincing depiction are rooted in fairly specific abilities universal to humans, where the most likely candidate is our common biological environmental perceiving equipment, aspects of which, in most societies, are transferred to depictive contexts. Also interesting is what all this does not show. It does not show that such transfers must be made, nor that effective depictions cannot occur by other means. We well know that object depictions can be produced without outlines, indeed without lines at all, there being more than one way to draw a cat. Nor does it imply reductionism. Just as important for the way these devices work is what guides the seeing of marks, whether on a pot, a wall, a sheet of paper, or a screen. This is something seemingly common to all people: the category "depiction," capable of assimilating much besides such perceptual effects. The significance of this universal basis for our project should be clear. Without it there would be no way of investigating "all kinds of drawing" from all times and cultures, with conceptual tool kits of principles and drawing distinctions. This investigation must now be developed in the direction of art. For that project, as part of a decoration, the figure of Pawahtún may have something more to teach us.

9. decorative depiction

The Mayan review consolidated much of our earlier work on spatial aspects of drawing within Walton's perceptual-experience theory of depiction: much, but not all, since this excluded linear perspective. It may seem that the example, besides stopping short of that important topic, diverted us from it by being essentially decorative. The object of the present chapter is to show how this impression is mistaken, and, as in chapter 2, the argument has historical reference. In chapter 8 I suggested that the question of reflexive depictions provides a novel approach to Panofsky's "window" theory of Part I, and thereby a new "perspective" on perspective. In brief review of our treatment of the window idea, many believe that the perspective "notion of 'picture as window' is truly the basic difference between Western painting after the Renaissance and the arts of all other cultures anywhere else in the world."[1] But Panofsky, who remembered Roman wall decoration, held that what distinguishes the Renaissance conception is not a window but a window*pane* idea—that is, a geo 1 projective drawing conception. I argued that in this Panofsky went too far, making explicit a mistake only implicit in less thoughtful sources who have placed it (to borrow a phrase from Nelson Goodman) in our stock of "common nonsense": the idea that picture surfaces are imagined by beholders as windowlike, due to a geo 1 conception of linear perspective in terms of projection screens.

The main source of this nonsequitur is a shockingly simple confusion of "windows." Because drafters who draw by geo 1 linear perspective techniques sometimes (as in Dürer's "Portrait" and "Urn") actually use glazed windows for drawing surfaces, and since pictures (usually framed ones) are sometimes imagined by viewers to be like window apertures, with linear perspective these two "windows" may be carelessly assumed to be identical. Judging by "Meditations on a Hobby Horse," not even Gombrich proved exempt. Using Ivins's expression (and citing Panofsky in footnote), Gombrich wrote of "that 'rationalization of space' we call scientific perspective by which the picture plane becomes a window through which we look into the imaginary world the artist creates there for us," adding: "In theory, at least, painting is then conceived in terms of geometrical projection."[2] As we have seen, aside from his knowledge of classical wall painting, Gombrich's "tool kit" first three principles in *Art and Illusion* should have protected him from this fallacy. Linear perspective works as a "bouquet" of separate naturalism devices derived from environmental perception, including occlusion, foreshortening, and diminution. Furthermore, it is almost embarrassing to have to point out that when people look through actual glazed windows they do not imagine what they see as projected to the glass. Thus it is important to remember another line of Gombrich's: "it is dangerous to

confuse the way a figure is drawn with the way it is seen."[3] To deepen our understanding of perspective as depiction—that is, as a tool for visual imagining—let us now consider all this more closely.

PLANE RELATIONS

With the idea of objects of imagining we have conceptual tools for approaching some long-confused issues. Putting aside the "windowpane" idea, any discussion of pictures as windows, whether perspectival or not, would benefit by beginning with a simple set of distinctions among three items. Although the three derive from old practices, linear perspective took them over and "thematized" them—that is, turned what were means of depiction into part of the pictorial subject. The first is the depth ordering of things and their features (notably their surfaces) that we imagine seeing in the picture. These are often identified in terms of "successive planes," an ordinal conception. Perspective, besides allowing for greatly more ordinal arrangements than we find, for example, on the Mayan pot, provides opportunity for interval arrangements as well. Perspective gives scope for a proportional sense of the distances among imagined surfaces receding in depth. In the roughly orthogonal Mayan, by contrast, any sense of such intervals depends on identifications of items ordered by occlusion: for example, our sense of the distance from a figure's out-turned right foot and right arm, relative to his left hand. Regarding perspective, we need to stress "opportunity." We cannot suppose that all perspective pictures automatically realize this interval capacity, or all to comparable extents. Still, that capacity is a well-realized general feature of Italian Renaissance perspective, dealing as it does with urban scenes well suited to its ordinal and interval measuring powers, thus evincing Ivins's "rationalization of sight."

Metric possibilities arise where we can assign a zero point for the succession of planes. This we may find in the imagined spatial relationships—if any—of the series of depicted planes to the physically located picture surface. That is the second topic, the very one raised by the picture-as-window notion, which has us consider the picture surface as an object of imagining ("a window") and the picture as a *reflexive* depiction. But one needs to be cautious about the usual generalizations here.

Sometimes scenes in pictures, including perspective ones, definitely appear to recede behind the picture surface, but not always. Much depends on formatting. Contemporary magazines, for example, often take cover images right to the edge, with no framing, and also partly occlude images with print. In such cases, the ordinal succession sometimes seems to be: printing first, depicted figure next, cover surface third. Cast shadowing increases such effects. In other cases the photographed scene seems "to come right out of the surface," to be below it, to be at least partly at its surface, or to be imagined in several of these ways.

Finally, we need to notice a third, usually overlooked topic of the imagined relationship of the depicted spatial orders to *other* surfaces in the actual environment in which the observer is situated. It will not do to assume transitivity of relations here: that is, if something in a picture is imagined behind the picture surface, and the picture surface appears to be behind another actual surface, we cannot assume that the thing in the picture will be imagined as behind this other surface. Consider how one experiences the occluding heads of the cinema audience against the screen: in no depth relationship to the imagined recession of planes in the picture. Lack of transitivity may be demonstrated by the experiment of holding a perspective picture up against a real background, or looking at camera (therefore perspective) images on a television screen. I suggest that the experiment will usually yield the following: spatial depth relationships within the image will be whatever they are, and, if one pays attention to the screen, all that will appear to begin slightly behind the screen. However, these depicted depths will likely bear no imaginary relationship to the actual surroundings. In other words, if one can see past the screen into another room (or down the aisle of an airliner that is showing a movie), no matter how deep the perspective is in the picture, no imagined plane in the picture will be experienced as lying behind or in front of what is visible in the rest of one's field of view. That is, the two parts of one's visual field bear no imagined depth relationships. What this strongly suggests is that perception is able to run several "windows"—in a rather different sense of the term—simultaneously but separately, like split-screen displays. Perhaps this is not surprising, considering what vision normally copes with. An area of one's visual field might

contain a mirror reflection from water or glass surfaces, surrounded by direct-line vision. Direct and reflected vision may even occupy the same areas of the field, when we see through partially reflective surfaces to other surfaces: thus (perhaps through moving shadows and sparkle) one sees cloud and sky, with intervening dark, overhanging boughs, reflected from a pond surface, overlaying underwater reeds and stones, yet the fisher's vision is not confused. In such cases it is no simple matter ordinarily to arrange these different depths before and behind us: possibly environmental vision runs a different kind of "window" there, too, as unrelated depths.

DRAWINGS ON THINGS

Understanding therefore that the imagining of notional spaces within pictures often involves no imagining about the picture surfaces that bear them, or other surfaces in the environment, should make us better appreciate the cases where they *are* imagined as related. Cases where they are so imagined abound in Renaissance works, perspective or not. Like pot painting techniques, linear perspective arose in an image environment rather different from the "unlocated" screens and pages that prevail today, and therefore call for specific visual experiments regarding their special spatial effects. Fortunately, we can still perform these experiments, since many survive on site, where we find a fair proportion of them—some of them most famous—on walls, ceilings, and doors, performing a general function no longer central in modern times: *architectural decoration.* These two words are telling about such environments, whether secular or religious, and the effects of imagining seeing there. Architecture: the depictions typically relate to their immediate architectural environments spatially. Decoration: the depictions are typically parts of very complicated image environments, involving images that are 3D as well as 2D, nonperspectival as well as perspectival, and nonfigurative (with much symmetry patterning), and that are related to their immediate spatial environments in the way that we call "decorative." This is not peculiar to the European Renaissance. Indeed, until quite recent times, most visual art, figurative and not, has been decorative, in whole or part. A theory of all kinds of drawings needs to account for them,

and here the field is open to us, given that depictive theorists hardly notice it.

What do we mean by "decorative"? Often the word is used synonymously with "ornamental." However, as Suzanne Langer remarked, sometimes it relates to the word "decorum" in its root sense of what is fitting to the object decorated.[4] "The immediate effect of good decoration is to make the surface, somehow, *more visible,*" she wrote, "to concentrate and hold one's vision to the expanse it adorns." On our theory, decoration can enhance the visibility of what is decorated by having us imagine in accordance with what we already perceive. One familiar example of such décor is simply running a horizontal band round a jar, as on the Mayan piece, thereby emphasizing the constant curvature of the vessel and perhaps its division into base and lip; drawn lines are frequently used to articulate different spatial and functional parts of more elaborate pots. Symmetry patterning of the kind introduced in chapter 3 is also used for decorative purposes, for example, where the pattern suggests rhythmical movement in the directions of the pattern's development, perceptually transferred to the surface on which it lies. Such imagined directions on the surface easily interact with our seeing the direction of the actual curvatures there. Similar effects are worked by figurative drawings.

Sometimes in the history of pottery—say, of Attic pieces—the pot simply provides a convenient area on which to put a figure. In other works figurative decoration, perhaps as Langer says, brings into perception selected aspects of the surface. For example, the axes of standing animals (including humans), suggesting gravity, are often very different from those of fish or from radial organisms such a flowers, octopi, and so forth, frequent subjects of decorative design the world over (fig. 67); therefore their correlation with the axes of pots—perceived in terms of gravity, overall shape, or functional parts—is often perceptually meaningful. The scene on our Mayan jar would be viewed, and its text read, scroll-like, by turning it on the cylindrical jar's gravitational axis, which corresponds to the depicted gravity axes of its human figures, no more than three of whom would be visible at a given time.[5] The ordinarily shallow surface patterning space of that depiction enhances this effect, as do the strictly profile views of the characters. Picture further pays back pot by encouraging us to turn the pot in our hands round its axis of

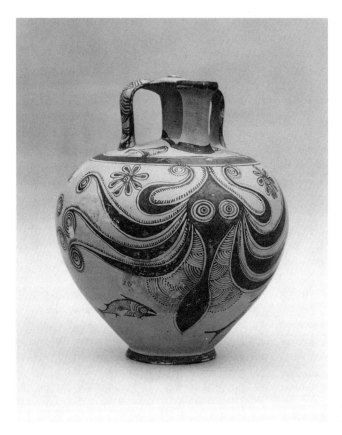

symmetry. Narrative in depicted scenes can also provide imagined rhythms and directions along the surfaces where they are depicted. The richness of possibilities here includes dimensionality, as parts of pots have three-or one-dimensional extensiveness. Our sense of rounded pots—as these have double curvatures (including the saddle shapes mentioned earlier)—is usually in terms of swelling at the belly: this, too, can be enhanced by the depiction of swelling forms (say, of an octopus) where the ground reciprocates. Thus pots: one might move on to drawing design for fabrics and other things that move, now that we understand depiction as combining perception and imagination.

Further, our work on the tree-faces projection puts us now in a unique theoretical position, given that decorations are often carried over to the forms of pots, among many other artifacts. That is, sometimes the form of the artifact decorated by surface depiction is imagined differently even as a 3D object, or in terms of other spatial features we have been studying: notably topological features. For example, on a British Museum astragalos pot from Aegina, of the "knuckle-bone" type (shaped like an ox's knuckle and possibly depicting one), are painted floating figures of the god Aeolus directing a dance of the winds, and perhaps we are meant to imagine the cavity in the pot as his cave.[6] Spear and arrowhead forms may have suggested animals to some of our very early ancestors, for they are often worked up in these forms. Handles have always invited decorative treatment, sometimes by being shaped so as sculpturally to depict animals, plants, and many other objects: the list of examples is unending. So is the list of appliances commonly so treated, including pots, dishes, door knockers, stirrups, ship prows. As we saw with psychological projections, no illusion is involved, only our metaphoric ability to recruit a "wrong" category to the perceptual experience of something held under correct categories, sometimes to qualify perception of it. Decoration allowing reciprocity, sometimes the physical feature seems more to serve the representation than vice versa. Conical stalactites

of Chauvet Cave were painted with female pudenda, like the "Venus" figures of that age. "As in most decorated caves, the reliefs and volumes of the wall were frequently used by the artists," investigators report—for example, to "suggest the shape of a body and turn the drawing into a three-dimensional image."[7] And the cave walls themselves may have become objects of imagining, for, as Jean Clottes stresses, "In the flickering light of the torches, animal forms seemed to spring out of the rock, its hollows or its reliefs," by no accident: "Nothing forced the artists continually to draw animals emerging from holes in the wall" (210).

LOCATION

All such cases teach us that decoration, including decorative depiction, can give drawing designs what Philip Rawson calls "location." Designs have location, in this special sense, when the surfaces that they embellish already have independent categorial identity—"lives of their own." As Rawson points out, "That a drawing is on a sacred monument obviously adds something special to it. Graffiti on walls convey a very different meaning from similar scribbles made on a piece of note paper. That graffiti exist in a certain place is part of their meaning."[8] Of special interest for decorative depiction are drawings on "located" things, some aspect of which the design makes us more perceptually aware, often by having us imagine something about it. This is very different from the situation of the most common depictive media, cinema, and TV, it being rare for an image on such a screen to be experienced as decorating the screen. Starting at least with the nineteenth-century invention of stereo viewers, modern grounds for images are shorn of categorial identity. As unobtrusive as possible, they exist only for the sake of bearing their images.[9] This is also true of many of the printed pictures that we see, particularly the photographic. Much recent theorizing of pictures has been strongly affected by this local cultural perspective of unlocated images. One influential account has attempted generally to theorize pictures in this manner, on the basis of their being artifacts called "markings."[10] Markings are held to be two-dimensional patterns that "appear on a surface, but they do not refer to the surface—their information content is 'decoupled' from its real-world

source": that is, the "visual information" they bear has "nothing to do with the state of the immediately present world from which it comes. Decoupling of the information from its source is the necessary defining condition for the production and perception of markings" (171). This is a very restricted idea of even markings, as it excludes the many marks we put on surfaces precisely to make those surfaces more visible, like the lines we sign on, the dotted lines along which we cut and fold. It excludes road markings, Plimsoll marks on ships, measure marks, constructional drawings, sprayed marks showing where to dig or where underground utility lines are located, and so forth, for all of which the claim that "the informational content of the marking does not refer to the surface" (ibid.) essentially fails.

Possibly such an anti-location account would pick out an interesting subset of markings, but it is hardly one to capture those that are pictures. Decorative depictions are but one variety that makes this clear.[11] Decorative design, including decorative depiction, not only presupposes but brings to our attention features of the independent natures of what they decorate, even where the category is as seemingly bare as "wall surface" or even "surface" (which Panofsky said the Romanesque reasserted). Now, as decoration seems a sort of visual praise, it must, like verbal praise, be selective of the attributes of the object celebrated. Therefore, it is capable of exaggeration, making, for example, a column seem taller than it is, a pot more delicate. This brings us to the interesting situation of decoration that Langer seems not have considered: the kind that has us imagine its location as *other* than it actually is, or even opposite to that. This raises the question of when it ceases to be decoration in the sense given, which introduces again the topic of perspective depiction, as decorative of surfaces.

RICH RENAISSANCE CONTEXTS

Let us try out this brief account of decorative depiction on a most familiar example, Michelangelo's Sistine ceiling, to recover the architectural context with which we began. That work is first to be considered, as Gombrich says, "as a piece of superb decoration,"[12] standing, like other Italian architectural paintings of the Renaissance, over a geometrically patterned floor and above registers

of works by others. Also, as it works its way with the axes of the building it decorates, it sets fictive columns, capitals, and entablatures into relationship with the arches of actual windows and the concave, triangular spandrels formed when the flat semicircles above them meet the shallow barrel vault of the ceiling—typically not in a systematic way. Thus, as is usually the case in medieval and Renaissance European decoration—even more in Baroque—as we look at its panels we are mandated not only to imagine seeing the scenes within them but also to imagine something of the very physical surfaces on which they lie, and then something of the architecture of which these surfaces are parts. Often therefore we are to imagine the building itself to be somewhat other than it is, and thus to imagine something similar of the space in which we stand, and thereby of ourselves and our actions, as both the building and our location within it become objects of imagining: a normal architectural decorative situation worldwide and throughout history. Contemporary versions are found in restaurants, for which we might use the phrase "all new décor": plaster walls are painted to suggest stone, brick, or cracked plaster; appropriate scenes are painted on walls; additional props may be introduced, sometimes including the dress and demeanor of the serving staff. We are therefore invited to imagine ourselves seated in different surroundings, maybe different geographical locales, appropriate to the menu.

Could such architectural treatment be decoration in the sense defined? Answers would seem to be on a case by case basis; a few general comments must suffice. Regarding the Sistine, for example, Gombrich observes that one may be surprised "to find how simple and harmonious the ceiling looks . . . how clear the whole arrangement."[13] Very generally, such treatment of walls, chapels, and rooms draws attention to them as distinct entities, visually defining spaces in them. Householders know how even several good coats of uniform paint can make a wall surface seem a solid, unified expanse. In medieval and Renaissance decoration, the sense of gravity in depicted columns, walls, and figures parallels that of the actual walls and the beholders. Divisions among scenes—often executed as depicted architecture—usually divide wall spaces proportionally. Again, most of the architectural decorative drawing of the time was done, as in the Sistine, in clear contour shapes emphasizing

surface pattern, even when (unlike Michelangelo) they also indicate deep spaces, and these patterns are usually related to the shapes of the surfaces. This underscores our earlier point that while perceiving picture primitives such as regions for the sake of imagining seeing subject matter, we may still remain aware of them as regions. Emphasis on shaped regions was part of the aesthetic of Renaissance drawing, and the fresco technique encouraged working in separately colored, shaped areas. Such shaping may also have given visual stability to the painted regions when they were viewed from different distances and angles. In general, one can say without paradox that a clear sense of the surface, which Panofsky's aesthetic misleadingly attributed to a "windowpane feeling," is usually maintained there.

The place of linear perspective in "window" spatial effects that typify Renaissance decoration also needs to be understood in normal decorative context, where ordinal recessions of planes, in three- as well as two-dimensional media, are common. Ever since what Panofsky called Graeco-Roman wall painting, a first step in wall decoration is often taken in the framing, real or simulated, where low relief of moldings often gives way to simulation, mainly by means of shadow (fig. 68). By this technique (still used for faux effects in interior design) framing can be taken back but also *forward,* with the result that wall elements are sometimes imagined to be either behind their actual positions, in front of them, or at their actual positions. This may merge with depicted architecture in the framed image, which, centuries before "the rationalization of sight," employed such depth cues as occlusion, foreshortening, diminution of forms, and convergence of parallels to indicate receding planes—often behind the wall, as on the canonic conception (see fig. 35). In some cases, however, such devices are used to bring part of the depicted scene in front of the actual surface, and all that, though greatly intensified, remains basically the same with the advent of linear perspective.[14] Thus a canonic early piece of geo 1, windowlike or "through-the-wall" perspective construction, Masaccio's *Trinity* in the Dominican church of Sta Maria Novella in Florence, features a painted tomb and step imagined to project *outward* from the wall by the same means that put most of the depicted scene behind it. In another noted wall decoration, in Raphael's Vatican *Stanza della Segnatura* (in-

cluding his so-called *School of Athens*), the painted figure of Sappho in *Parnassus* leans backward against—throws her shadow against—the cornice of the window that pierces the wall on which it is painted.[15] Still later, in the Franciscan church of Santa Croce in Florence, Vasari, employing shade and perspective, painted on the south wall behind Michelangelo's tomb a baldachino suspended against a stone entablature on that wall, framed by shadowed columns and capitals, just like the actual architectural features around it. There is a multitude of such examples, suggesting once again that, where they occur, through-the-wall (and, of course, through-the-ceiling) effects may owe much to the framing of scenes on those surfaces: in other words, to suggested occlusions, a more powerful cue for recession of planes than perspective diminution.

In short, as remarked in Part I, linear perspective being a sometime tool of depiction, not itself a kind of depiction, it dictates nothing about the de-

pictive experience of its forms relative to the ground on which they are drawn. From previous times we have the examples of anamorphic drawing and, from our own, 3D film devices, to show us that perspective effects can suggest space in front of the marked surface. And, as our TV experiment showed, we are daily presented with examples of perspective recession that, in unlocated images, stand in no depth relationships to their surrounds. When, in the Renaissance churches and palaces mentioned (as in the Roman Second Style; see fig. 35), efforts at integration are undertaken besides simply the occluding framing of views, linear perspective may be used to integrate the fictive space of pictures with ever wider actual spatial contexts of the building. A feature of Baroque design was to carry this process through consistently, often employing genuine optical illusion depth effects, sometimes with integrated sculptural works and other three-dimensional props. In view of all this we surely, sorely, need to recast standard ideas about perspective as producing "windows" in picture surfaces. Depicted scenes in linear perspective may or may not appear behind the surfaces that depict them—may or may not appear in any depth relationship to those surfaces. Furthermore, often when depicted scenes do appear in such spatial relationships to their grounds, we are meant to imagine that: then the ground becomes depicted, also. The ground may then be depicted to be shaped and located as it is, or otherwise. Also, it can be depicted to be what it is, a wall or ceiling—only slightly pushed back to allow a ledge on which figures stand—or as something else, notably as an opening giving out on a scene, as in Roman perspectives (fig. 35). In some cases such depiction may extend to other surfaces and spaces besides that of the ground, reaching indefinitely outward even to the heavens, in which case these surfaces and spaces too are included in the imaginative project. Such effects are not automatic, however; complacent overgeneralizations are misleading, and we stand to gain by observing cases one by one.

Last chapter's question about reflexive pictures—depictions that have themselves as objects of imagining—has turned us along an unaccustomed path. In this chapter we have marked out a central class of decorative objects, which have, as it were, lives of their own—that is, identities as things in our environment under the categories of functional artifacts: pots as containers, cups for drink-

Fig. 68. Painted molding, Church of San Salvatore in Ognissanti, Florence. Only shadow (*left*) and sign not faux.

ing, handles for grasping, walls for division and support, and so forth. We have considered figurative forms in the decoration of such objects, as often occur on painted pottery, noticing that these depictions often mandate certain kinds of imagining about the very objects they adorn, rather than treating them simply as screens. We also noticed that the objects themselves are often, at least partially, formed or finished so as inspire imaginings about their shapes and functions. When such perceptions are applied to architecture, the idea of de-

pictive decorative reflexivity provides a context in which to reconsider the emergence of linear perspective in the Italian Renaissance—a conception very different from that reviewed in Part I, and now better rooted in actual historical and artistic contexts. But since the subsequent history of perspective in depiction is a complicated affair, we must put it aside once more, to resume our studies of the course of drawing—where we are sure to meet it again, there seeming to be no such thing as a last word on that checkered subject.

part III

drawing's resources

10. advancing the drawing course

A quotation from Saul Steinberg introduced the theme of "all kinds of drawing" at the beginning of this study: "The whole history of art influenced me," he wrote. "Egyptian paintings, latrine drawings, primitive and insane art, Seurat, children's drawings, embroidery, Paul Klee." Another line from that source helps us rejoin our account of the course of drawing where we left it, back in our study of the drawings of childhood (the age when most of us abandoned drawing as serious participants): "I am among the few who continue to draw after childhood is ended, continuing and perfecting childhood drawing—without the traditional interruption of academic training."[1] This raises two questions. The first, which we can only briefly mention here, is why most people stop then. Since almost all young children draw spontaneously, just as they dance, sing, and play imaginative games, the decline of drawing in individual development raises questions of cause and of significance, about which the drawing theorist and historian Philip Rawson offers these four:

[1] Out of the many, many children who draw and learn by drawing, only a few go on drawing into their teens and adult life. [2] This is a great shame, [3] for it means that the process of learning to see by drawing stops. [4] It seems that as children get older the culture they belong to gradually imposes its standards and types upon them, as well as a repertoire of

graphic signs and an ideology, a visual system of values. Nowadays, comics, television imagery and especially photographic images . . . and other advertising material, are overwhelming all other artistic possibilities, even in Far Eastern countries. All children are feeling this pressure, especially between the ages of eight and twelve. Good teachers can keep genuine art going for them. But many children begin to despair of being able to make images "as good as" those the media show them, so they give up. Some of those who carry on may become artists and work on behalf of those of us who have given up.[2]

The four theses that I have numbered state (1) an alleged phenomenon: only a few children keep drawing; (2) its evaluation: this is a shame; (3) a reason for the evaluation: we no longer learn to see by drawing; and (4) an attempt to explain the phenomenon: our culture overwhelms us and we give up. Taking up Rawson's fourth, "curse of drawing" point, similar ideas are widely expressed and no doubt have some truth; still, we have already wondered how far they go. We have little indication that in the past or in other societies children continue to draw. Also, in modern societies we find most older children not continuing to sing and dance either; indeed, few of us who have had early training on an instrument keep it up. To some extent this too may be owing to technological devel-

opments—amateur playing of music by adults sharply declined during the twentieth century, partly due to radio and recording—but that still leaves much unexplained.[3] In chapter 5, following ideas of Willats, I suggested that children encounter their own, internal problems in drawing. Thus one impediment may be a cultural failure to transmit simple geo 2 rules that would help children deal with 3D topological features, also with other aspects of layouts that are part of their imaginative as well as real worlds. That might be one example of a general failure to make available to children enough of the available drawing tools to help them develop their imaginations graphically, along that endless list of qualities and characteristics opened in chapter 7. Alas, it may be that modern ideas of self-expression have stultified self-expression. Whatever the causes, the result is that such imaginative activities play an important role in early individual development and then cease to, and active participation is largely abandoned.

Closer to themes of this part of the book is Rawson's third point, about significance. It might be argued that in most cases ceasing to draw is not very important to development: after all, people go on to other challenges not available to children. In reply, Rawson's speculations are at least interesting. He believes that something important to human development is thereby lost, which might not have been—what he calls a "process of learning to see by drawing." What is that process, and why might it be important, both for those who draw and for those who continue to look closely at drawings? According to Rawson, children's drawings typically "objectify" their conceptions and feelings, "externalise the internal processes of the psyche," but do so in terms of "graphic forms" that tend to correspond with those of speech,[4] that is, verbal categories: thus the standard issue of "knowing" and "seeing" in children's and others' drawings. This would perhaps be better described as an issue of objects and shapes. It is easy to show that drawings of objects, from observation or not, tend to be controlled by identifications of distinct objects and their parts, often verbally, as Rawson says: heads (with eyes, nose, mouth), necks, bodies, arms—in that order, as we have a strong tendency to draw the body from the top down (the shoulder is a non-anatomical entity of particular difficulty for novices).

There are standard "therapies" for such object-category tendencies, upon which drawing courses, and best-selling books, are based. Some consist mainly in techniques centered on the following simple point. As we often recognize objects by their shapes (in the various kinds of that described), but tend to draw them by their object-classifications, all we need do is learn techniques for drawing them by their shapes rather than by their names.[5] Such techniques include tracking along contours of objects without looking at the drawing surface: indeed, probably too much of this has been made, as though it were a drawing procedure, rather than as a therapeutic treatment for inadequate procedures.[6] Teachers of life (nude) drawing stress main axes, notably those of the chest and hip for standing figures, along with the main vertical line of balance. Students are taught interval measures, or proportions, and how to get approximately right the "negative shapes" between parts of things that they are drawing, their relationships among each other and to the positive shapes. Such are additional examples of transfers: of availing ourselves in our drawing procedures of what works in actual vision—that is, the shapes of things, notably their contours from different points of view. The great gain is not only more "effective" depiction in Gombrich's sense but also a revelation of the interest of shapes and of their relationships independent of objects. Once these shapes are made interesting in themselves, the student is well positioned in the course of drawing, able to deal with many situations. Once these shapes and what they describe are related to one another and to the surface in interesting ways, the student begins to draw not just things and their features but *pictures*—something which most people do not easily comprehend, which is most difficult, but approaches what we mean by "art."

However, any such talk of techniques—tools for the drawing kit—raises a problem for our project of working through all kinds of drawing in the direction of drawing as art. For Steinberg also remarked that "to make a good drawing, a poetic invention of the moment, . . . demands the elimination of all our talent (ready-made vocabulary). It demands genuine clumsiness. In fact," he added, "the best clumsy ones are Cézanne and Matisse."[7] Mention of Matisse, among the greatest of modern draftsmen, brings to mind his own comments about teaching: "Gustave Moreau loved to repeat 'The more imperfect the means, the more the sensibility manifests itself.' And didn't Cézanne also say: 'It is necessary to work with coarse means'?"[8] Just as we are to embark on the ambitious project of describing the historically developed drawing tool kit, progressing in the direction of

art, modern artists and teachers tell us that art involves abandoning any kit, and we will soon hear the same from other traditions. We are no longer talking about technical drawing, nor can we rely on vision research. Simply stated, the challenge is this: for any drawing technique added to the kit, we can find its abundant, accomplished use in work that is artistically empty; for any technique, we can find its absence, abrogation, in works that are artistically great.

Three points in reply to this challenge outline Part III. The first point addresses our concern with cases in Part III. All drawing as art uses some of the basic drawing techniques we will be examining, usually crucially, but these being tools, we must give close attention to how they are used (or disdained) in specific works of art, and not rely on generalities. The next two points define the structure of Part III. The present chapter undertakes a survey of the advanced course of drawing, providing information necessary to any theoretical treatment of drawing that hopes to connect with real phenomena. It then develops Gombrich's continuity principles, as set forth in Part II, but as it progresses a theme will develop, that of the draftsman's autonomous use of those nature-based perceptual resources. Chapters 11 and 12 consist in an argued series of steps beyond those perceptual resources, showing the increasing autonomy of the medium of drawing itself for the production of artistic meaning. The third point of reply to the challenge is that we now enroll in the advanced course with the good guidance of theorists and drawing teachers with broad and deep understandings of art. Let us meet them.

THE DRAWING KIT

Just as Part I followed lines of thought developed by Ferguson, Booker, Panofsky, and Tufte, and Part II those advanced by Willats, Walton, and Gombrich, we begin a new set of topics in companionship with Rawson and a few other authors, including Joseph Meder, from whose classic *The Mastery of Drawing* I have borrowed the phrase "the course of."[9] This chapter addresses the standard Western advanced course of drawing, for, *pace* Steinberg, we can hardly understand the significance of drawing for many mature people with an account of a kit assembled in childhood. As Gombrich insisted, the history of drawing is one of consolidated traditions and technical developments, of discovered and recovered techniques of rendering, passing from one generation and culture to another. This must be kept in mind even for artists who reject these traditions.

As a first step, Meder reminds us that medieval and Renaissance teachers alike insisted that "the path to art begins in conscientious use of what has been already accomplished, in drawing from the best existing" works, according to the old workshop rule that "copying must form the basis of instruction." Thus in "Giotto's day as in Rembrandt's previously existing masterworks offered the same examples for outlining, comparison of sizes, relationships between near and distant objects, and sensitivity to light and shade"[10]—all topics of the present chapter—and Chinese traditions offer much the same. Dangers of restricting oneself to copy work are also stated in these different traditions. A statement in Joshua Reynolds's "Second Discourse"—"I consider general copying as a delusive kind of industry. . . . How incapable of producing anything of their own those are who have spent most of their time in making finished copies, is an observation well known to all those who are conversant with our art"—may be put beside that of Tung Ch'i-ch'ang a century and a half earlier: "Those who study the works of the masters of the past and do not introduce some changes are garbage that should be disposed of by a fence. If one imitates the models too closely one is often farther removed from them."[11] Yet though such strict copy traditions hardly exist today, the technical devices that they instilled have become constituents of every kind of drawing, widely used in illustration and commercial imagery, and standard to photography, television, and cinema. We need to become acquainted with them.

Rawson begins his account in a more modern "elements" idiom, congenial to Part II. In his treatise *Drawing* and the more popular *Seeing through Drawing*, he advances, as Gombrich does in his first principle, a resolutely anti-imitation theory of drawing and depiction, arguing for a strong perceptual autonomy in drawings, in terms of what he calls their own "grammar" and "syntax."[12] "It should be obvious," he remarks, "that drawing never copies things in any simple-minded way; it creates a conviction of reality in our minds in its own special terms" (*StD*, 35). Like us, Rawson wishes to assemble a better set of analytic tools for describing drawing. "There are no accepted names for the facts of artistic execution as there are for the facts of musical language," he observes; indeed, it will be difficult "at first for the reader to pick out the visual facts, because there is no traditional method of identifying

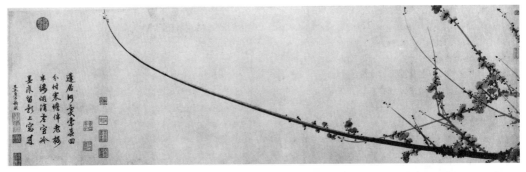

Fig. 69. Zou Fulei, "A Breath of Spring," 1360. Handscroll, ink on paper, 34.1 × 221.5 cm. Freer Gallery of Art, Smithsonian Institution, Washington, D.C.: Purchase, F1931.1.

them . . . and no one has picked them out before" in certain cases (*D*, vii). In accord with our course of drawing account, he approaches his subject "from the point of view of the maker of drawings" though in the direction of drawing appreciation (*D*, vi). Next, just as in Part II we began, as Rawson recommends, "concretely, from what is unquestionably visible in a drawing as a marked surface before us," for his part, Rawson's terms "are chosen because they designate things that can actually be found in drawings by looking, and because they can be explained clearly and consistently" (*D*, vi). Finally, as just mentioned, when he comes to describe what is unquestionably visible, Rawson, too, begins with marks on a surface. But here we note a significant difference between the accounts: Rawson's great contribution is that he avails himself of richer resources than we have so far, yet he is able to proceed systematically. We began Part II with Willats's insights about marks considered only dimensionally, and we followed this lead through other kinds of spatial attention before turning to the topic of depiction, which somewhat freed us from the purely spatial conceptions of drawing that dominate theoretical work on the subject. Rawson invites us to look afresh at the marked drawing surface to see what is "unquestionably visible there," and that is not confined to spatial characteristics.

RAWSON'S RESOURCES

Rawson begins literally from the ground up by describing the kinds of material supports in drawing and pointing out the obvious importance of size or scale. As observed in chapter 9, the fact that a drawing is done on silk, paper, or flesh, or as graffito on the side of a bridge, is something that we see, which can make a great difference to a drawing's appearance and meaning (see *StD*, 14). This is a topic we reached late in the last chapter in our discussion of decoration, and the term "location" used there was due to Rawson (*StD*, 14). Rawson begins there. Tone or value—that is, degree of dark and light—is another obviously crucial feature that we have barely mentioned. Again the location and direction of marks, or clusters of them, on the surface is a noticeable feature. That bare fact of format is the beginning of what Rawson, borrowing a distinction from Henri Focillon, identifies as two broad classes of approach to design: "*l'espace limite* and *l'espace milieu*, space as limit and space as environment" (*D*, 201). We reached the limited format idea in chapter 9 when considering how fresco decorations divide wall spaces up proportionally, in patterns usually related to the shapes of the architectural surfaces they cover. Rawson adds that, typically, also with space as limit, "Indian drawing begins by accepting the format as an established . . . area, which it then subdivides . . . on the basis of a rhythmic design," whereas by contrast, with space as environment, "Far Eastern drawn designs are based upon a few nuclei scattered over the open surface of the format," from which "the design evolves outward into the negative, undefined area of the surface, never enclosing it all or defining it, implying always that it extends without a break beyond the limits of the format" (*D*, 203). Our Chauvet Cave drawings provide other examples. A common basis for such differences is the shape of the ground itself. Modern Western people are used to drawing surfaces rather like screens—smooth, monochrome, rectangular drawing formats (thus the phrase "the blank canvas")—the edges of which are brought into perceptual play against the marks. However, this has not always been so: for

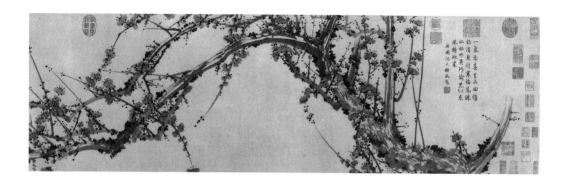

example, again not in Paleolithic times (fig. 70). This does not mean that physical format alone determines whether space as limit or space as environment is possible. Drawings on strongly shaped areas can appear to extend beyond them, and it is possible for a cave drawing or one on any open expanse to suggest a limited space. Following such ideas out even slightly would carry us into questions of form and composition for which we are not yet prepared. For now it is enough to state what we might otherwise take for granted: that the relation of marks to format may be a basic "visual fact" of importance to how the display looks.

Even brief mention of marks on surfaces suggests an important factor we have barely touched on: the shapes and apparent movements of groups of marks. Rawson's term "scattered" certainly describes the visible appearance of some groups of marks, and a host of other such terms naturally occur in our descriptions, some of which, like "scattered," may also suggest a process of production. In a typical passage of Chinese connoisseurship, the ninth-century writer Chang Yeng-yüan observes that in the sixth century "Chang Seng-yu made his dots, dragged strokes, hacking strokes. . . . His hooked halberds and sharp swords bristle as dense as forests."[13] Such movements are displayed magnificently in Zou Fulei's "A Breath of Spring" of 1360 (fig. 69). Types of brush strokes were named by Chinese teaching in terms of "texture strokes": "hemp fiber," "ornamental dot," "cutting mountain," "uniform and connected water," and so forth,[14] but formative descriptions are also made without metaphorical reference to physical questions. For example, we saw in chapter 4 how symmetry patterns may be seen in terms of a generating principle and can seem to develop in one or two dimensions, moving in directions. In-

dividual marks and groups of marks usually have a seeming direction relative to the surface or to the viewer's framework. When looking at them in drawings, we tend to see them in terms of groupings, as spreading, as going up and down or diagonally, and so forth. Lines can seem to run in directions along their 1D lengths, even to vary in speed as they do so. Thus we speak, for example, of a "spiraling line" or otherwise use suffixes to describe marks. Lines, seen as such, appear to us to have many qualities; thus a note in one of Pierre Bonnard's pocket sketchbooks: "Relaxed lines, sober lines, turbulent lines, oscillating lines, solid lines," to which Antoine Terrasse adds that Bonnard—who, like Rembrandt, is known for the variety of his marks—"responded to the demands of his physical sensibilities, expressing each by a different sign: a dash, a stroke, a comma or a spiral scroll."[15] Particularly with regard to modern art, much has been written about what Rawson calls such "kinetic" aspects of drawn marks for their own sake. With regard to lines, Paul Klee's note is famous: "An active line on a walk, moving freely, without goal. A walk for a walk's sake. The mobility agent is a point, shifting its position forward."[16] Rawson, too, gives early attention to such factors, emphasizing contextual effects more than isolated marks' qualities—that is, attending more than Klee to "directional value in relation to the co-ordinates of the field," to orientation left and right (D, 84, 92), and then, as we shall soon see, to line as a divider. Above all, Rawson gives understandable emphasis to the relationships of lines—notably, to what he calls "transverse" relationships of lines across the drawing surface. For a modern sculptor such as William Tucker drawn lines may be weighted parts of a structure, independent of issues of movement or facture (fig. 71).[17]

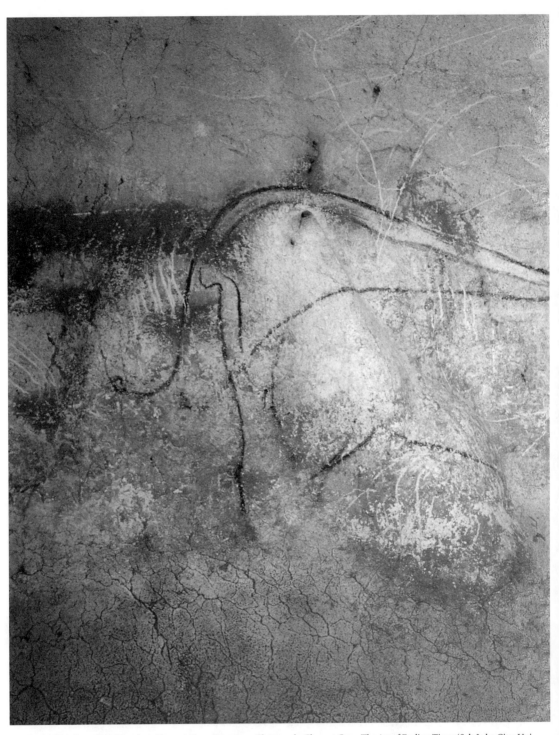

Fig. 70. Two lions, End Chamber, Chauvet Cave. From Jean Clottes, ed., *Chauvet Cave: The Art of Earliest Times* (Salt Lake City: University of Utah Press, 2003), by kind permission of Jean Clottes.

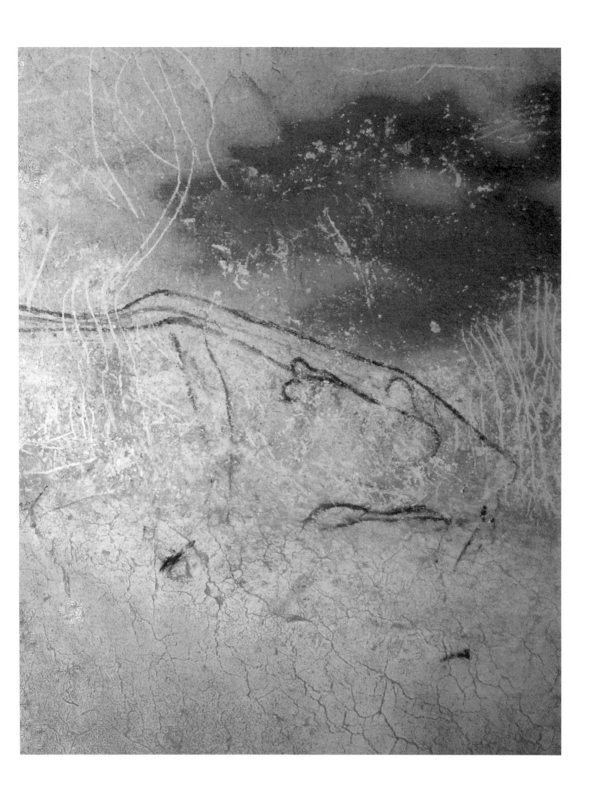

Just as, according to Rawson (*D*, 127), distinct drawn lines can make continuities by running the same way, so can his account and our own. To bring Rawson's ideas into even closer connection with our earlier course of drawing account, let us begin with his observations about drawn *lines*— particularly about contour lines, which we introduced earlier. An indication of how Rawson's is a more physical, "factured" account than ours so far may be found in what he sets in contrast with line (1D) marks and primitives. In chapter 5 we began thinking, with Willats, of lines in terms of "effective extendedness" before moving on to picture primitives, in the same terms. However, while Rawson also thinks of lines dimensionally, his main unit of contrast is more than dimensional: it is "the blob." "Blob" applied to drawing immediately conjures not just a shape but a way of making one. Our work in Part II should be useful in explaining the paradox of such "shapeless" shapes. Blobs are shapes dimensionally—that is, they are possibly 0D, as spots or speckles, but more likely 2_{11}. Blobs will not usually have shapes of 1D or even of pronounced 2_{10} extension, and will tend to be lacking in axis, direction, and outline shape. The reason for this is their chance or randomly constituted appearance. The category "blob" thus appears to combine shape (and shapeless) categories with a causal one: the shape as due to the productive process. There is therefore an important lesson about drawing in the blob—as in the smear, splotch, blot, scratch. Indeed, we see and describe drawing marks more easily in terms of such combinations of shapes and productive processes than, for example, in our simply dimensional ways, for which we had

to introduce rather technical language in order to abstract important aspects from "the visual facts" before us. "Blob" is literally a more concrete term than our spatial lexicon has been, given that "concrete" means the coalescence or growing together of various factors into one. Though one draws lines, regions, and shapes, one hardly draws blobs: thus the difference between them is more than spatial. Nevertheless, if we do not exactly draw them we may still draw *with* them, for example, Rawson points out, with the Chinese *po-mo* technique, as in Shih-t'ao's "Ten Thousand Ugly Ink Dots" of 1685, and the dots (*tien*) speckling his leaf for the Elder Yü (fig. 72). It is also to be noticed that, while contrasting with lines, blobs enter into important combinations with lines in many drawings, for example, either as smears along or puddles at the ends of ink strokes; they are often used for shadow. Rawson has interesting things to say about the visual meaning of blobs (*D*, 81–83), in their varying contexts; however he has far more to say about lines.

WESTERN LINES

Rawson's treatment of lines also runs along with ours, beginning dimensionally, then moving to shapes—particularly to what he, too, calls "enclosures"—focusing on contour, and working through the third dimension. Rawson's inquiry also encounters perspective in its proper rather than usual place. Dimensionally, Rawson begins rather as we did in chapter 4, considering drawing as the trace of what he calls "a point that moves" (*D*, 15) over a 2D surface. I had described that trace in terms of an action that leaves "as the trace of its path a mark of some kind," therefore as the result of "an intentional physical *action*"—an idea further developed in our treatment of categorials of purposive production in chapter 8. Rawson's approach is slightly different. While not stressing the intentional aspect so explicitly, he again makes far more use of the temporal, physical process of drawing. In other words, regarding "things that can actually be found in drawings by looking," Rawson insists that in the drawn line we see "a mark that records a two-dimensional movement in space," holding that there is in "every drawing an implied pattern of those movements through which it was created" (*D*, 15), which we can all learn to appreciate. Let us defer critical consideration of this claim to chapter

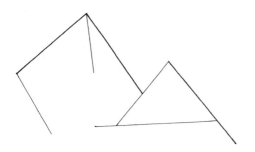

Fig. 71. William Tucker, drawing, 1974. Ink on paper, 21.6 × 28.0 cm. Author's collection.

Fig. 72. Shih-t'ao, leaf from Album for Taoist Yü, leaf 160-3. Ink and colors on paper, 27.5 × 23.75 cm. Formerly in C. C. Wang Family Collection.

12 and consider first what Rawson has to tell us about the more strictly spatial aspects of line in producing our essential quartet of shape, contour, enclosure, and 3D effects, as we turn now to what he describes as a "discussion of lines, enclosures, and volumes . . . devoted to the kind of visual concepts used in addition to the purely kinetic expression of lines" (*D*, 93).

"Shapes," writes Rawson, "are made out of marks" (*StD*, 27). Although lacking both Willats's dimensionality concepts and his explicit distinction between marks and picture primitives, this use of the noun "shape" to name a thing on the surface, rather than just a characteristic of something there, aligns Rawson's vocabulary with Willats's conception of picture primitives. That correlation is most significant when Rawson conjectures a simple but basic cultural distinction between marks. "Drawn shapes can be created in a large

number of different ways. Some draughtsmen, especially in the Far East, have produced very long linear shapes which are virtually single marks," he writes; but, "At the other extreme, many Western artists have repeatedly gone over their drawn marks, which are usually short, single strokes, revising and modifying them, rubbing them out and redrawing."[18] Much of what Rawson has to tell us about drawing simply concerns the uses that the West has given that shortened drawing line. And "shortened" seems the appropriate word, since, as we go back in our course of drawing account, it is not one that comes early: "Children," he points out, "nearly always draw with longish lines" (*StD*, 30)—an observation that seems borne out by all our illustrations. His general claim also seems borne out in Paleolithic works (see fig. 69).

Before considering the uses of the shorter line, we can hardly avoid mentioning its likely causes,

Fig. 73. Shen Shih, "Sunset in an Autumn Valley: Landscape with Man in House," 1544. Detail, hanging scroll, ink on paper, ca. 96.5 × 30.5 cm. Collection the University of California, Berkeley Art Museum. Photographed for the UC Berkeley Art Museum by Benjamin Blackwell.

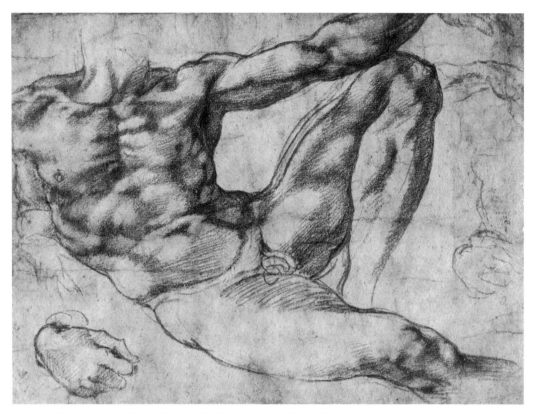

Fig. 74. Michelangelo, "Study for the Figure of Adam," ca. 1510. Red chalk over charcoal, 19.0 × 25.7 cm, corpus 134 recto. © Copyright The British Museum.

which introduces another formative factor that we have so far overlooked: the physical materials and motor activities by which lines are laid down. Rawson, like many others, observes that differences in writing tools and habits come into play here: for instance, the Asian vertical brush holding, free-arm technique of the standing artist, contrasted with the Western habit of elbow-supported finger and wrist action with stylus, pen, pencil executed while sitting (D, 88–89). Such remarks, though valid, are easily exaggerated. Shen Shih's brush marks and primitives seem short (fig. 73), whereas it is standard academic practice in the West to draw just as we paint, with a free arm, from a standing position at an easel, and an underhand grip on the chalk, brush, or charcoal. Similarly, though there is much to Rawson's comment that "graphic habits, derived from their customary manner of reading a page" affect a culture's drawing and appreciation activities, this should not be understood complacently. If Western pictures tend to "read" left to right, due to Western writing habits, this is not true of such canonic Western works as Michelangelo's *Creation of Adam* (see study in fig. 74) in the Sistine and

Botticelli's *Primavera* in the Uffizi. Still, there is an important truth to such ideas, as Rawson points out regarding the long, subtly varying curves that characterize much Chinese and Japanese drawing, "to draw such lines firmly and clearly demands—as well as an unsupported hand—a sustained act of concentration of a kind not natural to Western artists. Western lines tend to be short-breathed" (D, 91–92): speaking of breath, Zou Fulei's "A Breath of Spring" (fig. 70) is a scroll 220 cm wide, displaying many "long-breathed" marks of over 25 cm in varied directions.

There are great advantages to long lines, particularly to long contours, and artists in all traditions strive to sustain them. However there are tradeoffs, since, according to Rawson, "long lines are intrinsically two dimensional," and he continues: "You read them by following them over the surface of the paper. When a linear draughtsman wants to convey the third dimension, he has to use special devices, and avoid joining all his lines up into a single continuous silhouette," which will appear flat (StD, 30). So rare is surviving useful commentary on drawing from ancient times, it is remark-

able to find clear corroborating testimony of concern about this very matter from Pliny, in praise of Parrhasios: "He is unrivalled in the rendering of outlines [yet] . . . where an artist is rarely successful is in finding an outline which shall express the contours of the figure. For the contour should appear to fold back, and so enclose the object as to give assurance of the parts behind, thus clearly suggesting even what it conceals."[19] Since conveying the third dimension happens to be something particularly valued in the West, let us consider how it is done.

DRAWING DISTINCTIONS: SPACE AND RELIEF

Trained up as we are with dimensional ideas, we can set out the issue that will guide the whole chapter as follows. On a two-dimensional surface, a zero-dimensional implement moves, producing one-dimensional traces that are perceived as one-dimensional entities, lines. Whether or not these are used to form two-dimensional enclosures, their tendency is to produce two-dimensional partitions of the surface. However, that works against three-dimensional effects. As a depictive technology, then, those are among the trade-offs of linear drawing, which require either non-volumetric drawing traditions or repertoires of volumetric compensatory techniques—for which Rawson provides us valuable cross-cultural histories. The following extended passage from Rawson states his ideas so clearly that it only remains to insert numbers to separate and order them logically:

[1] Since the essential fact about line is that it is a two-dimensional trace on a plane, it has *in itself* no three-dimensional value. [2] When a line is recorded on a flat drawing surface the mind always accepts it first as functionally a separator . . . simply to mark off one side of itself from the other. . . . [3] At bottom, lines represent limits, borders. And when they are applied to defining notional [depicted] realities such as human figures . . . they are used to establish the two-dimensional limits of the objects. . . . [4] The effect of drawing continuous, unbroken outlines round any notional object is always to bind such an outlined object closely into the plane of the picture surface, turning it

into a two-dimensional silhouette. . . . [5] But every drawing style that seeks to go further has to evolve some procedure to deal with the fact that all lines are intrinsically two-dimensional separators. . . . The 'life' and independent volumes of notional [depicted] bodies are, as it were, in bondage to the fact that lines on a plane surface can only ever present some form of two-dimensional cut-out. This means that to achieve a three-dimensional sense in drawing it is not enough simply to give continuous outlines to objects the drawing represents. Something more is always needed. [6] There are many possibilities; and most of them represent some means for driving the eye away from the outline towards the centre of the outlined form. (*D*, 95, 97)

Rawson's sixth remark raises a question about a topic just discussed: the independent interest of lines. Hence another observation should be added:

[7] Generally speaking, any emphasis upon the expressive quality of line as such . . . tends to emphasize the flatness of the cut-outs; and so those styles of drawing which are interested in an independent three-dimensional plastic presence have tended to play down both the immediately expressive and the decorative quality of their lines in favour of two major linear resources. (*D*, 104)

These "resources," which we will take in order, are what Rawson calls "depth-slices" and three-dimensional "sections"; but he goes on to mention five more resources, mostly linear, for suggesting volume in bodies and then four more, including perspective, for "deep space." There is a good reason for separating the resources into two such groups, namely, a tradition of distinguishing two kinds of three-dimensional rendering in drawing, which we encountered earlier. Thus, at this point we mark a basic drawing distinction, which both guides the next few sections and links them to our study of the early "course of drawing." When Rawson refers to the three-dimensional in the above statements, the topic is the depiction of bodies, not their locations in space—a distinction between

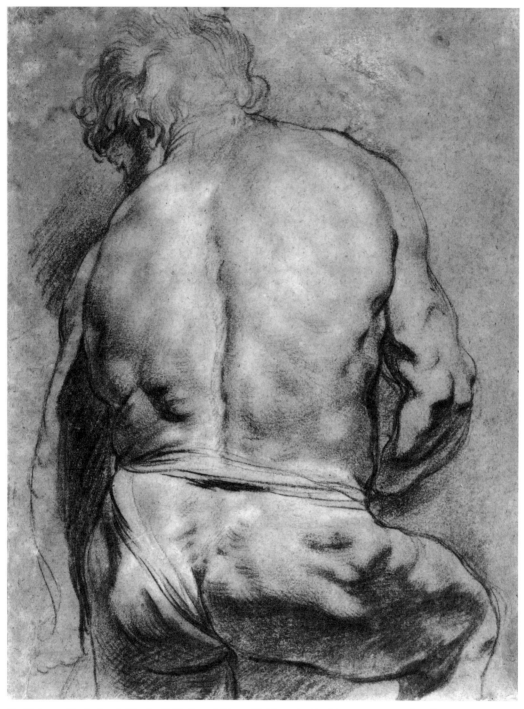

Fig. 75. Arnout Vinckenborch, "Study of Male Figure." Charcoal heightened with white, 37.5 × 28.5 cm. Fitzwilliam Museum, Cambridge.

what Meder calls *Körperplastik* and *Raumplastik*.[20] Meder's first expression means something like "shaping bodies in volume," the experience of space belonging to bodies themselves, whatever kind of general system they might or might not find places in. It seems close to Panofsky's description of space "as an aggregate or composite of solids and voids," rather than "as a homogeneous system within which every point, regardless of whether it happens to be located in a solid or in a void" (see chap. 2, para. P4). Most careful descriptions of space in drawings, depictive or not, register this difference. For example, Booker writes that "drawing is essentially a transformation of solid objects or space relationships into a two-dimensional medium."[21]

A simple sign of difference in spatial conceptions is that while we are used to describe depicted *space* as receding (notably in perspective), we are equally used to speaking of depicted *volumes* as advancing or pushing out toward us—or, as Rawson puts it, "making the near parts of forms seem to advance" (*StD*, 35). The latter effect is "relief" (in Italian, *rilievo*), about which Arnout Vinckenborch's Rubensian picture tells more than a thousand words (fig. 75).[22] Emphasis on bodily bulk, as more than the recession into space that depth-slice occlusions produce, brings us back to our chapter 5 consideration of the forms of space that things can be given in drawings. There, readers will recall, we halted the account just as children began adding local shapes to dimensionality and overall shape in their enclosure markings. We were beginning to consider contour shape but then confronted the formidable topic of depiction, which occupied most of the balance of Part II. Besides, at the mention of contour we also confronted another large topic: that of drawn shapes as they reflect "projections," including perspective. Now, while our basic topic, marks and drawing primitives and how they yield an experience of shape and volume, is closely related to the topic of projection, it should not be subsumed under that concept, and certainly not under "perspective," since marks and primitives have far older, broader, and still independent histories. Faced with these twin issues of depiction and perspective, throughout the rest of Part II we only managed to keep the project of shape and volume moving fitfully, for example, through attention to contour line. We now recover that topic, for the child as for the advanced drafter.

RENDERING VOLUME I: DEPTH-SLICES AND PLAN-SECTIONS

Regarding relief, Rawson's remark 3, on "two-dimensional limits of the objects," introduces the idea of "enclosures" (regions) on the drawing surface, especially those with the function of defining depicted objects. This significantly narrows that more basic function of line as a perceptual separator, indicated in remark 2. When in chapter 5 we considered line both as a mark and as a picture primitive, we were not yet in position to consider it fully perceptually: that had to wait for chapter 8's treatment of depiction. Previously to that treatment we had considered lines in terms of properties such as dimensionality, topology, length, and shape rather than in terms of what they have us imagine when we see them. However, artists such as Mondrian are known precisely for presenting lines as perceptual dividers of the picture surface while avoiding enclosure effects and open contours. Such nonfigurative effects help us appreciate the extent to which even works that do rely on enclosure may in addition give their lines an independent dividing function. To be sure, as Rawson writes, "One of the most important things lines can do is to create shaped enclosures." Though he says "shaped," we have learned from Willats that what Rawson actually intends is our topological concepts of continuity combined with separation, for he adds: "Children use such complete enclosures very often" to mark off separate units. "To enclose it in an outline is the fundamental graphic way of visualising the separate identity of a thing-concept." Rawson adds, "But, in practice, good draughtsmen go beyond simple closed outlining of shapes" to produce "implied shapes which are . . . left open-ended, so that they run into each other, join and overlap." Thereby they "define the spaces between those things, the spaces that bodies need to move in, the space that surrounds them, or shapes which bond parts of different things to each other" (*StD*, 34–35), which perhaps even our almost three-year-old was already doing (fig. 51). In chapter 6 we already followed Kaupelis's advice to make that part of our concept of "contour drawing" itself.

Now "depth-slices." The short overlaps in drawing, cited in chapter 5 earlier by Kaupelis's "rule of thumb," already introduced Rawson's key "depth-slices" technique, practiced by most cultures. That consists in "drawing ranks of overlapping edges . . .

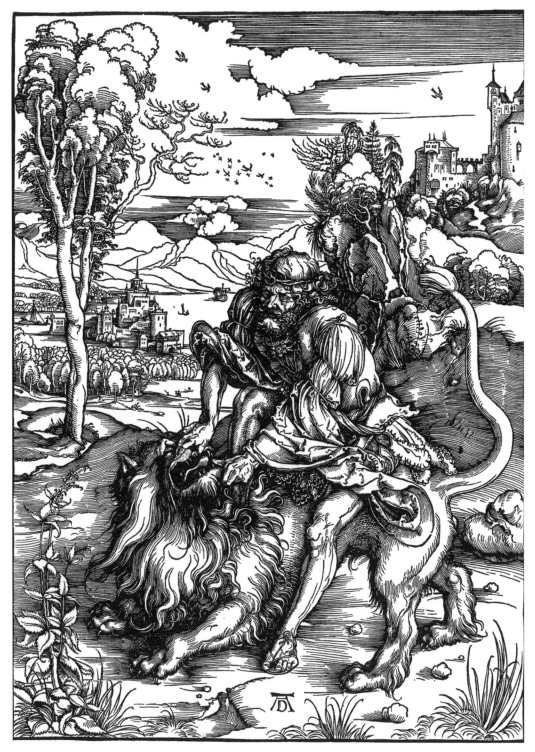

Fig. 76. Albrecht Dürer, "Samson Killing the Lion," 1498. Woodcut, sheet 40.6 × 30.2 cm. From Willi Kurth, ed., *The Complete Woodcuts of Albrecht Dürer* (London: W. and G. Foyle, 1927), by permission of Dover Publications, Inc.

stressing the overlaps." The device is immediately recognizable as a suggestion of occlusion, the most dependable source of depth effect. In review, Rawson holds that while contour-indicating outlines tend to bound planes flat on a surface, it is still possible, by controlled sequences of short contour strokes with at least one open end, to set up layers of such planes and so suggest depth. "Each linear edge thus stays in its own notional two-dimensional plane," he states, "whilst the plasticity of the whole notional object is created by an accumulation of suggested slices depicted by elevation-sections of the object. So strong can the effect of phrasing be that it can create the impression that a continuous contour linking a series of depth-slices actually runs back into depth" (*D*, 105). Thus Dürer carries us off into vistas in "Samson Killing the Lion" (fig. 76), having depth-slices walk us through the middle foreground. This is one advantage of the shortened line.

Looking back to our full Rawson quotation about line and relief, we begin to work up our main theme of artistic autonomy. While firmly accepting an anti-imitation principle akin to Gombrich's first and related Gulf principles, so great is Rawson's insistence on the autonomy of drawing that he would not only reject Gombrich's Incompatibility Principle, he would not accept even the terms of Gombrich's Beholder's Share Principle of compensation. Thus the phrases "play down" and "something more is needed" in Rawson's statement 7 do not mean, as they would with Gombrich, that drawings provide incomplete or ambiguous information and are therefore in need of supplement. For Rawson there is indeed a perceptual conflict between the 2D emphasis of lines and 3D imaginary space; however, this conflict is not, as it is on Gombrich's Incompatibility Principle, one of mutual exclusiveness. Rawson writes that "in most of the world's best drawings a very large part of their vigour and expression derives from a kind of tension or conflict between the two-dimensional and the three-dimensional," and he then states a basic drawing principle of his own:

The methods which follow will include those which have as their purpose the development of the two-dimensional aspect, of the three-dimensional, or of both together. My point here is that in those drawings which are universally recognized as masterpieces

there is a vigorous conflict between a highly-developed two-dimensional surface unity, and a highly-developed three-dimensional plasticity. The higher the point to which both are developed, the stronger the drawing. . . . Usually one side or the other tends to predominate, but one is never allowed to swamp the other. . . . Although there is no doubt at all that a dense, flat structure appears in all good drawing, there is equally no doubt that unless such a structure is challenged by a strong three-dimensional counterpoise, it remains wall-paper. (*D*, 79, 81)[23]

Rawson applies this to the best artists, "much of whose effort was spent trying to create vivid bodies in the third dimension as well as a taut surface, and who wanted their darks to have a double value, both two-dimensional and three-dimensional."[24] Here as elsewhere Rawson takes perceptual "tension or conflict" to be a positive drawing resource.

According to Rawson a main technique followed (though not invented) by European drafters consists in suggesting positive enclosures by depth-slice markings. Indicating the volume of bodies is usually done not by drawing around the whole enclosure but rather by leaving some of its sides open, a method reinforced when "pairs or triads of contours relate to each other across the surface so as to suggest slice-enclosures, . . . whilst its ends are kept 'open' for the sake of plastic continuity" (*D*, 155–156). So effective is this technique that the line-segments need not even form T junctions, so long as their phrasing is right (*D*, 155). For drawing organic bodies—particularly human ones—we noted the normal Western teaching that the segments be kept curved and convex, to indicate double-curvature. We can look to a leading teacher of human figure drawing, Robert Hale, for statement of the standard rule: "There are hardly any concave planes in the human body," he remarks. "Beginners are forever taking great bites out of the body with concave lines. But a study of the masters will show that they do not use concave lines to outline their forms, except in the rarest of circumstances."[25] Something similar holds for the planes and contours of animals and plants. Consider Leonardo's most familiar "Vitruvian Man" (fig. 77). The draftsman there maintains a manner of strong orthographic linear silhouette, scribing continuous passages of sure contour lines. Yet, along with this

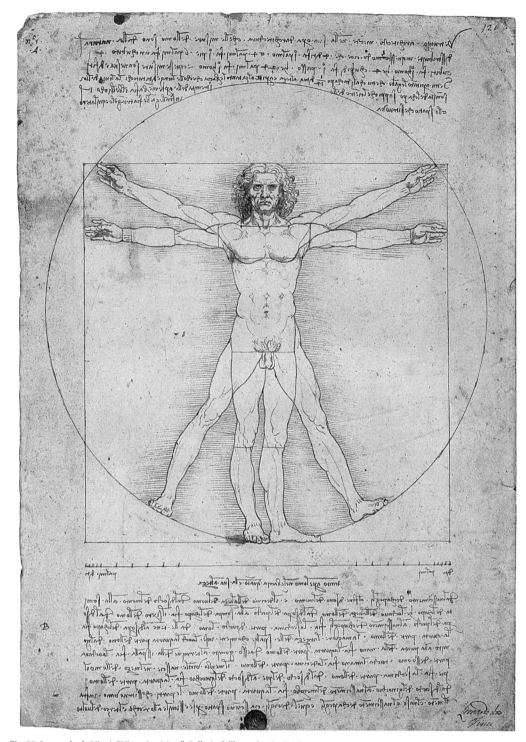

Fig. 77. Leonardo da Vinci, "Vitruvian Man." Gallerie dell'Accademia, Venice.

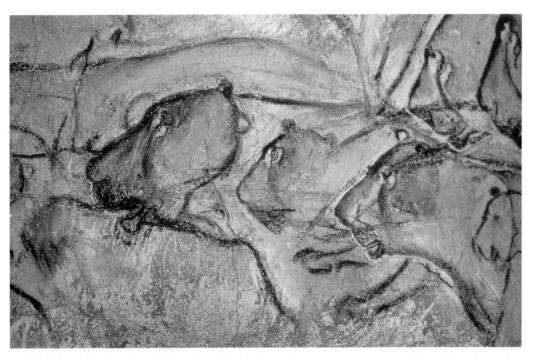

Fig. 78. Lion Panel, End Chamber, Chauvet Cave. From Jean Clottes, ed., *Chauvet Cave: The Art of Earliest Times* (Salt Lake City: University of Utah Press, 2003), by kind permission of Jean Clottes.

"firm, factually delimiting contour" (*D*, 114) Leonardo imparts a sense of volume by use of short, phrased depth-slices. Where contour concavity seems to occur (for example, where wrists meet forearm muscles and thighs knees), we reinterpret it as junctions of convexities, with an immediate effect of experienced volume. An interesting case is the figure's right knee in abduction, where we can see how, as Leonardo's beautiful linear outlining curve approaches the knee, it comes in conflict with his indication of convexity, resulting in a blob.

One might claim that the convex contour depth-slice is one of the first tools in the kit, as it is handled with assurance in cave drawings at least thirty-thousand years ago (figs. 66, 78).

While Rawson argues further important developments with depth-slice regions, let us focus on the related "plan-section" method, which involves exploiting bends, particularly along true edge contours, to indicate volume, without relying on occlusion. As remarked in chapter 5, from early childhood drawn lines are often used to indicate the picture primitives we called regions or enclosures.[26] In fact, much of Rawson's theory of West-

ern drawing is devoted to just this function. "One of the most important groups of Western techniques," he repeats, "clusters about the problem of creating a sense of the full three-dimensional volume of bodies and things. A great deal of artistic invention has gone into them. They are used to supplement the more universal technique of overlapping" (*StD*, 37). It is standard, for example, to pick out, emphasize, or exaggerate curved edges within bodies. This is perhaps why, as we saw in chapter 2, the illustration violated the very perspective rules Dürer was teaching in the shoulder of his urn (fig. 32). In many drawings attention is given to the curve of lines depicting eyelids to indicate the roundness of eyeballs, and Rawson points out that Greek pottery painters used the outline of the pectoral muscle (as in the Leonardo) to indicate 3D sections, while ripples along the edges of drapery were emphasized by medieval and Renaissance artists, including sculptors.[27] Rawson relates these to the arrow junctions that characterize engineering drawing systems, which we noted in chapter 2 when discussing isometric and oblique practices: "the three-dimensional effects such lines achieve depend upon the angles or curves at their

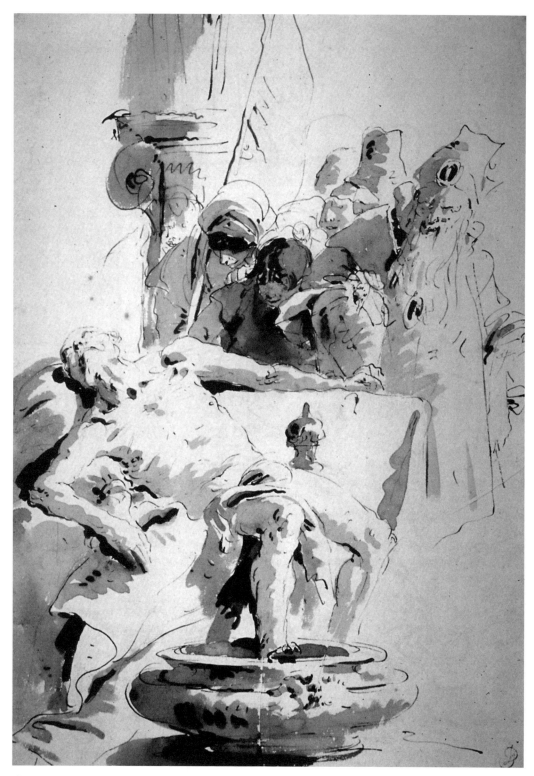

Fig. 79. Giovanni Battista Tiepolo, "Fantasy on the Death of Seneca," ca. 1735–40. Pen and brown ink with brush and brown wash, over black chalk on ivory laid paper (creased), 34 × 24 cm. © Reproduction, the Art Institute of Chicago. Helen Regenstein Collection, 1959.36.

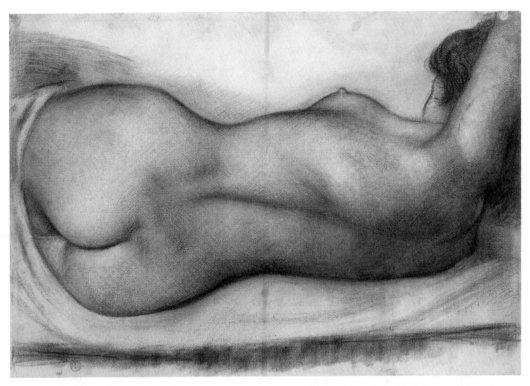

Fig. 80. Aristide Maillol, "Reclining Nude," ca. 1931. Red conté crayon with touches of charcoal on white laid paper, 53.8 × 77.8 cm. Photograph by Greg Williams. Gift of Mr. and Mrs. William N. Eisendrath, Jr., 1940.1044. © Reproduction, the Art Institute of Chicago.

corners" (*D*, 107). We find the plan-section technique used in many kinds of drawings, where drafters wishing to indicate volume stress the curved edges of cylindrical objects such as cups and bowls (fig. 79), although tipping them forward into true circles, as in the axonometric method, tends to flatten the result.

Projection, and especially perspective, bears an interesting general relationship to plan-section techniques. Studies of perspective normally say little about its use in drawing the human body—as opposed to placing it in ambient space—but practitioners know of its great importance for suggesting coherent masses in depth. Artists are fond of tipping the cylinder and egg shapes into which they must simplify the masses of living bodies, so as to exploit curves along sections through their axes. The tipping is more visible because of the rough mirror symmetry of the human body (thus males' nipples are not useless). The bony prominence of our double-curving clavicles or collar bones are additional Designer-sent landmarks for the drafters (fig. 79)—

more so when tilted down (fig. 74), as they help carry the volume from the chest clear around to the top of the back (the acromion of the "shoulder" blades, or scapulae) over difficult terrain, while connecting the upper arm to the rib cage and shoulder girdle in a convenient arc round the cylinder of the neck.[28] Plan-section lines for the neck cylinder are also sought, especially where human design has conveniently provided necklines (fig. 58), neck clasps, and necklaces, the contours of whose tipped curves may also be seized upon. The other important girdle is of course the pelvic, and it is common to make constructional lines for the horizontal axes of both, controlling our sense of axis shape for the whole figure. Rigidity is a basic fact about that lower girdle, providing what Hale calls "a constellation of fixed points," more dependable for showing not only the volume but the horizontal attitude (pitch and yaw) of the whole mass, which also serves to push parts of the figure forward or back. These landmarks not being evident, however, it is important, as Hale urges, to know one's "pelvic points," notably the

forward prominences, and to stress them.[29] The Fleming Arnout Vinckenborch (see fig. 75) also knew his posteriors around the sacral triangle (which he makes more visible than it would be), and though few can draw so well in modern times, the sculptor Maillol knew to fix a pelvis that way (fig. 80). Give an artist two triangles, quips Hale, and get back a pelvis.

RENDERING VOLUME II: BRACELETS, BUBBLES, FACETS, AND OVOIDS

Having just considered imaginary plan sections, similar advantage is taken of real bracelets on limbs to indicate smooth recession in space, which introduces the familiar device of "bracelet shading." So familiar is this tool that we may be surprised to learn of a dramatic historical account. Within the Western tradition of depicting volume in bodies, Rawson places the invention of bracelet shading as late as the work of fifteenth-century German artists, with their habit of "deeply curved" lines. It was adopted by Dürer, from whom, Rawson reports, it passed to Leonardo and Raphael, replacing the Italian technique of parallel shadow hachure lines—for, as we notice in our earlier illustrations (figs. 58, 77), in the 1480s Leonardo was still working with the parallel. Rawson conjectures that via engravings bracelet shading passed to other parts of the world, notably to Indian artists in the Mogul court (D, 107, 109–110).

We briefly considered Dürer's woodcut drawing methods in chapter 6, relating rendering techniques to new reproductive technologies. It is interesting to look in detail at the interaction of image-making technologies in such work (fig. 76). For his 1498 "Samson Killing a Lion" cut, the lines defining the back contour of the hero's leg illustrate Rawson's depth-slice technique, while bracelet shading on his thigh further indicates volume through shadow and section. On the adjacent lion, curved lines pass from indicating fur texture to convex then concave surface contours that signify cast shadow, breaking our convex contour rule as they reach the animal's haunch, where we also find a little cross-hatching. (Above, parallel lines show the relative darkness of sky against clouds.) Speaking of hairy beasts, the body and limbs of Doctor Seuss's Cat in the Hat are often rendered by bracelet shading strokes, which, like the Dürers,

slide into texture and then shaggy pelt contour marking. This is a representative example of a basic drawing principle: a kind of mark can serve several distinct functions simultaneously or successively as it moves along.

According to Rawson, another technique for rendering volume by suggested enclosures is sufficiently distinct to say that it came to prominence only in sixteenth- and seventeenth-century Europe. This is the oval or "bubble" method, which "consists of drawing pairs of opposing convex curves which our eye reads as outlines containing between them a rounded volume" (StD, 39). The curves may also be contours, limiting a thigh or forearm—as we see in the Leonardo (fig. 77). Once again, however, artists are free to invent such "parentheses" forms as they like and to build up objects out of chains of them, adding side shadows and highlights for each (fig. 81).

Rawson next gives attention to two embellishments of drawing by enclosures that also bring shade and shadow into play: the "facet" method and what he calls "ovoid stylization." The facet method works by adding lines within the contours, building up suggestions of raised facets between them—that is, of prominences with receding sides. Such inner "shed lines" are perhaps most familiar as the boundaries of tonal areas (D, 160–161). "The principal artistic aim is to shift the viewer's attention away from edges to frontal faces" (D, 161), Rawson writes, and we shall further see how this development of techniques for "driving the eye away from the outline" is part of an important trend in Western art. It is certainly a well-used technique for articulating masses in the human body, it being standard practice to conceive of the body in terms of a series of boxes, with front and side plane junctions further beveled into facets, often by means of tones. The front of the knee provides a good example of this, the kneecap presenting the frontal facet of a box that widens as it runs back, thus presenting visible side planes that are often darkened (fig. 81).[30] We will consider this again when the subject is shade.

Rawson suggests that such facetting, with a roughly frontal face accompanied by foreshortened and opposed side planes, produces something like a stereometric or binocular effect (D, 175). True facetting invites shadowing on at least one side of a shed line (as in Rubens), with significant results. Regarding tonal enhancement, it should be added

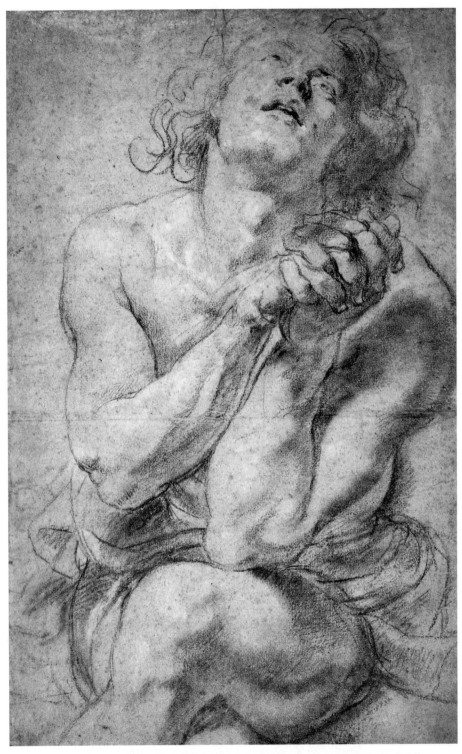

Fig. 81. Sir Peter Paul Rubens, "Seated Nude Youth." The Pierpont Morgan Library, New York. I, 232.

that one usually reserves the strongest contrasts for what are to be the dominant plane breaks, the ones that fix the axes and volumes of the main masses, using the darkest tones on one side and bringing in brighter light where it meets another facet, then treating the subsidiary breaks with less contrast. One of the best ways to lose the sense of volume—our main topic here—is by not establishing dominant breaks: that partly accounts for the comparative lack of volume in drawings based on photographs. Still, as always, departures from a rule of art, intentional or not, can lead in interesting directions. For example, that medieval artists seem not to have well understood the depth-slices and shading of classical depictions of drapery meant that they were free to produce beautiful surface patterns with them, which served their decorative interests.

A good place to look for overall facetting is in drawings of the human back (as in fig. 75), a part of the body that clearly provides the drafter less to work with than the front, even in males. It is normal there simply to invent planes along constructional lines that do not correspond to any contour.[31] Facets indicate edges, even when, as usual in drawing people, these are clothed in rounded forms. In *Creation of Adam* (see fig. 74), both drawing and fresco, Michelangelo negotiates one on that figure's left side, producing a marvelous concavity by sequences of convexities along a dark facet coming up to a lit front face.[32] Sometimes constructional lines for facets are visible, but even when not, one frequently senses their presence. This is hardly a matter of advanced connoisseurship; it is clear that the draftsman, in laying down strokes, is starting and stopping along invisible lines. Facetting's providing such a nice Gombrichian first- and second-principle nonimitative device, it is interesting to consider the thesis of art historian Millard Meiss that this technique may find its origins in a drawing procedure, epigraphy, the facetting of three-dimensionally drawn initials.[33] Paul Hills suggests that marquetry and intarsia work also "lent themselves to crisp divisions between planes," as different woods and stones, cut geometrically, were contrasted in juxtaposition; and, certainly, the decorative environments of Italian pictures are rich in such work.[34]

According to Rawson "a fundamental discovery" in rendering convexity in bodies was the method of "ovoids." Here the convex contours of enclosure slices are related to opposite lines within them, suggesting "a complete ovoid or ovoidal cylinder" (D, 160). That discovery might rather be termed a rediscovery, for, according to Rawson, it belongs to various historical times and cultures, including Athenian pottery decoration, Roman Pompeii, and India. It is found in Leonardo and in Dürer ("who understood it imperfectly"), from whom it passed to Dutch and Flemish art, notably Titian, Veronese, Rubens, Poussin, to be rediscovered by Delacroix, Cézanne, and others (D, 160–161). Perhaps Michelangelo's drawings and his Sistine paintings show this technique in use—although always auxiliary to the contours. Rather than Adam's rib, let us consider his groin at Creation, notably the rendering of the flexed adductor muscle of his left thigh adjacent to it—the muscle that gets sore from horseback riding. Both in the preparatory cartoon and in the fresco (where Michelangelo brought his ovoids selectively forward by painting lighter shapes over middle tones) the adductor constitutes a Rawson "ovoid." Hale discusses that very muscle's rendering in study drawing, in a way that also illustrates the Rawsonian front-lit, side-shaded "facet" effect: "If I throw a light on the oval as Michelangelo has done, I get the feeling of a light front plane and a dark side plane. I grade the values to give the illusion of roundness and the oval form becomes clearer. I am using a language, a language of expression."[35] Hale's final point applies throughout this chapter: according to Gombrich's first trio of principles, the drafter deploys graphic effects that are based on natural ones, not according to nature, but as he or she wishes, to get depictive effects: as Hale puts it, the drafter "invents all kinds of lines he cannot see at all."[36]

Finally, neither ovoid nor shadow is called on in a technique taught by another of our drawing teachers, Nicolaïdes, who emphasizes that Meder's "*Körperplastik*" is a matter of weight: "weight is the essence of form," he insists, criticizing "cast-iron clouds and balloon-like women" of many pictures.[37] His book teaches a technique for showing bulk that involves working from the "core, the imagined center" of the depicted mass—not of the flat shape—outward toward the contours, rather like a sculptor modelling clay around a wire near the figure's core. Although this chapter began with line, Nicolaïdes instructs, "Your drawing will not show anything that looks like a line. It should be a

solid, dark mass," with marks working outward from what is perceived as the core (34–35). Thereby the artist exposes yet another error of projection-based approaches to drawing. As the psychologist Leyton has pointed out, our category "living things" is of things that "grow and evolve" from a center, "and it is this history that is seen in them," whereas the assembled objects of Part I "are usually the simple concatenation of box-like elements."[38] Projection cannot represent this basic, formative-topological aspect of perception—worse, as in much photography, it so suppresses the experience as to make us forget its importance. Every amplifier is a suppressor.

We may summarize the theme of this section, Rawson's remark 6 concerning techniques for "driving the eye away from the outline," with a well-known comment by Delacroix: "The Classic artists grasped things by their centres, the Renaissance by line."[39] Summary should not serve as conflation, however, since our understanding of drawings depends not only on an effect of volume but on the means taken to produce that effect. According to Rawson a technique common to such diverse artists as Leonardo, Rubens, and Cézanne—drawing things as "convex in all directions" by lines with "shading . . . used to 'help out' such phrased contours"—was "violently" rejected by Rembrandt in favor of an autonomously tonal approach (D, 163–164). It may surprise some that Rembrandt's work, though much admired by his contemporaries, was also criticized for its "neglect of clear draftsmanship, which was thought to necessitate complete outlining."[40] Even today some artists do not to care for it for the same reason. Here as always, when discussing tools in the kit we must never forget that deeper values than technique are at issue. This will be even clearer as we now turn to techniques of tone.

SHADE AND SHADOW

"Tone," Pliny informs us, is a term for strength, and everyone knows that tonal or "value" differences are powerful volumetric shapers. "Shading" is perhaps the best colloquial term, but in one of its meanings "shade" denotes a different effect than shadow, in nature as well as art. Long before drafters began taking advantage of shadow effects, shading was worked along the contours of objects to indicate volume. In classical Greek, Roman, medieval, and Indian traditions we often find "the dark tone of the outlines extended by shading in towards the centre of forms," Rawson observes, often by "many small strokes" parallel to the contour, sometimes by small bracelet strokes and by cross-hatched combination of both, showing "the graded recession of the surface towards its edges" (D, 109–110; cf. StD 39–40). Commonly, however, this is done in a single stroke, by a "polarity"—that is, by maintaining a sharper edge on the outside of a contour than on the inside. We see this already at Chauvet Cave, where the feathered inside contour can also be joined to outright tonal filling (figs. 1, 66, 78). Such shading, still a dependable method of counteracting the flattening effect of descriptive outlines, has been a main drawing and painting tool for millennia in many traditions. Although documents are scarce, by luck we have a general statement from Theophilus: "By this method, round and rectangular thrones are painted, drawings round borders, the trunks of trees with their branches, columns, round towers, seats and whatever you want to appear round. . . . white is on the inside and black on the outside."[41] An interesting, simple explanation of shade is that it indicates foreshortening of side planes—or, as the artist William Hogarth well put it in the mid-eighteenth century, it shows "how much objects, or any parts of them, retire or recede from the eye."[42] Thus, for a familiar example, Antoine de Saint-Exupéry loosely rimmed the asteroids of Le Petit Prince in watercolor inside his contour pen lines. A similar effect is derived in photography by axial lighting, called the "limb effect," where the light source is directed along the axis of convex, especially rounded bodies placed against a light background—a cliché today in magazine cover photos. The photographer Ansel Adams described the effect of such lighting: "As we approach the edge of the curve, most of the light is reflected away from the camera, and if the object is against a light background, its edge appears quite dark. . . . Forms are revealed by variation of line and surface values rather than by juxtapositions of light and shade."[43] We see this at work in the red chalk drawings of the modern sculptor Aristide Maillol (fig. 80). Chapter 7 raised a Gombrich Same Mill Principle question of the basis for the universally used contour line itself. Some have thought that this line is in part due to such shade effects in nature.[44]

Shade, however, differs from shadow, which implies a blocking of light ("holes in the light") reaching a portion of a surface, either by another object or by the opposite side of the object itself. Shade effect is not due to light being intercepted but rather to its being spread over a greater area, as a surface turns away from its light source. It is therefore sometimes called "slant/tilt" shading. This is the phenomenon that makes the sunlight stronger when it is higher overhead, making winter different from summer.[45] In addition, as any surface turns further from a light source, it proceeds to self-shadowing, beginning with half-light, or penumbra. Such transitions from slant/tilt shading to partial then full self-shadowing can be amplified by micro-shadowing and highlight, or specular reflection, due to textures. As Rawson remarks, open-weave fabrics such as nylon stockings are designed thereby to make limbs look more volumetric and shapely (D, 113).

By contrast, true blocked-light or shadow effects in nature, as in art, are usually divided between cast shadow, on the one hand, and attached shadow, modelling, and self-shadow, on the other—the terminology being unfortunately not uniform. Rawson presents the distinction gracefully: "In fact, a vast amount of European drawing has been based upon equating the dark marks made by pen, crayon and brush with the shapes of shadows on the unlit sides of bodies, and of shadows which bodies cast onto other bodies by interrupting the light" (StD, 41). Usually "cast shadow" means shadows projected from one body onto the surface of another, while "attached shadow" means self-shadowing—for example, the difference between night and day as one side of the globe blocks the sun's light on the opposite side. For terrestrial objects, however, bathed in the earth's atmosphere, it is less a matter of black and white, since their shadowed surfaces are lit by lesser secondary lights from the sky and other objects. In his 1740 "Fantasy on the Death of Seneca" (fig. 79), Tiepolo clearly separates cast from self-shadow by emphatically darkening the former, as though it cuts out the secondary lights as well, while in 1635 Poussin's interweaving of the two kinds was part of the melody of his composition (fig. 82).

Understandably, some writers (for example, Gombrich) use the term "attached shadow" differently, to denote a very important group of cast

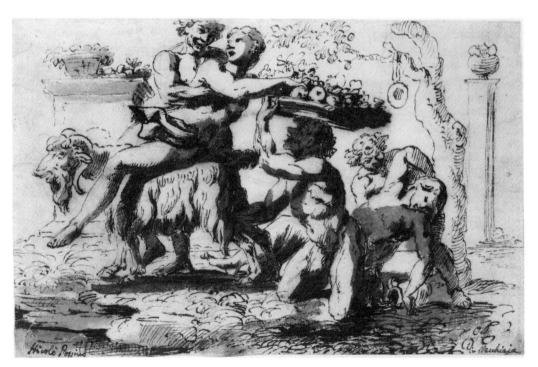

Fig. 82. Nicolas Poussin, "La Fête de Pan," ca. 1635. Pen and brown ink, brush and brown wash, over faint black chalk underdrawing, 13.3 × 20.6 cm. The Metropolitan Museum of Art. Purchase, David T. Schiff Gift, 1998 (1998.225).

shadows: those that run continuously from the dark side of a lit object to the ground it rests on. Correspondence of topological continuity of marks on a drawing surface is a strong cue for an important 3D topological continuity in the scene depicted, as it makes the object look like it is in contact with the ground. We only need to look at comics to see the importance of that kind of continuity: when it is broken, signifying that the object is just above the ground. Many cartoons that use no other kind of shade or shadow have little spots attached to and beneath figures to signify ground contact, which are called "Waltzian" in honor of a psychologist who extensively studied that cue in nature.[46] However it is remarkable, going through newspaper cartoon strips, how infrequently any kind of shade or shadow effect is used. Among children's classics, neither Laurent de Brunhoff's Babar books nor Hergé's Tintins use cast shadows except for special effects, say, when attention is given to sun- or moonlight, and shade finds very limited use there. Babar drawings, for example, are almost devoid of even Waltzian shadows; surprisingly, so are the Tintin drawings, despite a suave use of perspective and parallel projection techniques and indications of reflection on polished or wet surfaces. H. A. Rey's Curious George drawings feature cast shadows, often not continuous with the figure, to show the mischievous monkey in flight above the ground. Here again the term "convention" is useless; these are situations in which graphic devices whose rendering effects seem clearly based on natural ones are deployed (or not) depending on what the drafter wishes to accomplish, for the trade-offs with shadow effects seem to be considerable.

Photography (including moving pictures), not being a line medium, comprises a tonal family of media and is therefore much more dependent than drawing on shadow, tone, and local value differences. Indeed, some of the resistance to color, in both photography and cinema, is due to color's tendency to detract from the continuous tonal gradations that both chemical and electro-optical photography have made easily obtainable. Largely lacking the resources of line as a divider, one of photography's challenges is categorial: the separation of different objects and features from one another, since false attachment and other ambiguities are so prevalent there. However, photography—and not just the so-called film noir but much of

cinema and television—have strongly thematized cast shadows. These modern media might make shade and the two kinds of shadow (attached and cast) seem obvious tools for the picture-making kit, but, as often observed, throughout world history drafters have been reluctant to exploit them, especially cast shadow. Their use is rare in children's pictures, and virtually unknown to some great drawing traditions. Meder summarizes the situation thus, interestingly stressing the Waltzian function:

> *Cast Shadows* . . . were a fact which was only slowly accepted by the arts. It is hard to understand why painters and draughtsmen so long neglected the value of the cast shadow as a measurer of space and a "pointer" to the light source, unless they were so much more interested in mere convexity than they were in depth, or so jealous for the harmony of their compositions, that they did not like dark stripes hitched to the feet of their figures. Gothic pictures, from Giotto on, were almost shadowless, and fourteenth-century drawings give figures floating in the air for lack of shadows to hold them to earth. Even in the early Renaissance emphatic cast shadows were avoided, and draughtsmen contented themselves with short, dark strokes . . . starting from the feet of the figures.[47]

Gombrich, too, observes that the modelling self-shadow "was destined to become the distinguishing mark of the Western tradition," and he adds: "It was different with cast shadows, which seem to have come and gone, very much like our shadows when walking along a lamplit road."[48] Self-shadow seems to be held in reserve throughout the history of Western art, but after classical times it may not have been fully exploited in Europe until early in the fifteenth century, when its modelling technique "gradually eclipsed" shading, according to Rawson, "with the development of chiaroscuro . . . first in Flanders and then in Italy" (*StD*, 41). Slowly the tone of contour lines themselves was taken into this chiaroscuro structure, reversing the auxiliary relationship that had prevailed when tone was restricted to enforcing the linear effects of contour, depth-slices, and facetting. The use of side lighting, as contrasted

with that of front and back, came to be emphasized, although "side" is not quite the term for the usual source, which is closer to forty-five degrees in front of the plane and from above. Furthermore, secondary front and side lights are commonly employed to keep shadows from being blocked. A dark contour on one side and a lighter one on the other came to signify shadow and light, and thereby the direction of the light source (fig. 81).

As we noted before with facetting, self-shadowing was a specially important technique in figure modelling. When extended, it produces what has been called the "third contour." This is a subtle, fairly continuous terminator line or broader zone, which separates the lit and self-shadowed surfaces and whose changes carry information very much like that of the occluding contours, but because it is situated between them, it provides a sense of relief.[49] Particularly as used on human figures (fig. 79), the main plane breaks thus indicated become very useful for indicating the directions of the main axes of things. These axes may then be orchestrated perspectively or by other projection methods. Besides this *Raumplastik* use, they have greater use for *Körperplastik* and for composition. Thus in drawing the figure Hale advises: "By thinking of the dominant plane break, you establish the concept of the controlling or dominant masses, which will give strength to your design and character to your drawing. You then create the strongest contrast of values between the front and side planes of these dominant masses."[50] A more subtle example than Tiepolo's is the right forearm modelling in Rubens's study for a painting of Daniel (fig. 81), where Hale has us notice that the plane breaks are not in straight lines, that values move in two dimensions, and that the contrast for the main outer break (on our right) is greater than that for the ulnar furrow, keeping "the big massing of the arm" clear (88). The subtlety is broadly compositional, too, as Laning points out that "the third contour, the turn of the form," comes into this drawing at the knee, is carried into the arm's cast shadow on the thigh, runs up the contour shadow of the left arm, loops shoulder to forearm, asserts clenched knuckles, then defines larynx, chin, nose, brow, ending at Daniel's right eye, which "points sharply upward," its glance carrying beyond the frame.[51]

With this introduction, we are now ready for somewhat higher studies, a clear and systematic consolidation by two expositors who combine real understanding of art with contemporary empirical research about light, shadow, and human vision. These are Paul Hills and Michael Baxandall, who sum up and advance the preceding observations as follows.[52] "For representing 'relief,'" writes Baxandall, "two main rationales of tonal modelling have commonly been used in European art since the Renaissance, often in combination." The first comprises the shade and shadow methods just reviewed, which assume a main source of cast light. The second "rationale" implies no such source—or at most a diffuse illumination such as one finds indoors. European art was pretty much content with the second rationale "for something like a thousand years, from the decline of Classical Roman painting to the thirteenth century."[53] This is what Baxandall calls the "modelling tone" method, and it is very similar to slant/tilt shading, where facing surfaces are always lighter, with increasingly tilted surfaces proportionally darkened as they are depicted turning away along the direction of sight, thus darkest at occluding contours. The first rationale, which had in ancient times suggested directional illumination, was reintroduced in the early Renaissance gradually, with Giotto, by presenting the modelling tone as due to a light source: an even, low-contrast illumination from the direction of the beholder, but now rotated slightly to the side: "This accommodates any second-rationale elements into any first-rationale frame of reference . . . ; it licenses them (at whatever level of awareness) as more or less consonant with front lighting." With the introduction of linear perspective, however, the school of Masaccio introduced directional light and shadow as an additional framework, systematizing it while downplaying the modelling-shadow "second rationale"—indeed, swinging "the light source round to the side, only a little in front, and sometimes even behind the picture-plane" (147). More subtly, "Masaccio often accents his terminators" to get that third contour effect, as his "terminators register a section of the object running straight through the picture, perpendicular to the picture section"—or nearly so. Thereby "foreshortened (thus stimulating us to conceive depth) on this side of the object," these terminator lines are "projected by our stimulated minds for the other invisible side, giving us an armature on which we can conceive it as a rounded volume" (148).

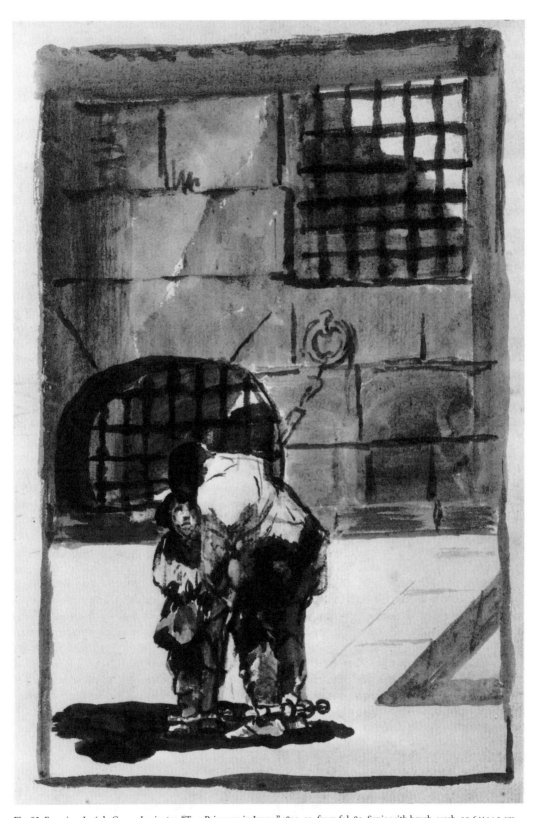

Fig. 83. Francisco José de Goya y Lucientes, "Two Prisoners in Irons," 1820–23, from fol. 80. Sepia with brush, wash, 20.6 × 14.3 cm. All rights reserved, The Metropolitan Museum of Art.

Such is a basic account, according to which a long course of art history might be illustrated with a few objects and a circling lamp. Naturally, there are more subtle variations of the method, two of which involve combination and local variation. As for the first, Baxandall stresses that we will find both the old and new systems used together in the same drawings. Next, recalling our earlier thought about higher "derivatives," contemporary vision research allows us to articulate the "second rationale" use of dark/light effects. That is, dark/light contrast at different points of drawings often turn out to register local *contrasts* there, where a middle tone running throughout an entire drawing (say, as on a toned ground) represents at any point in the drawing only the local average value, which fluctuates across the drawing surface, so that tones above or below it at any point only represent relative brightnesses relative to their local meaning (149–151). We seem to work by local effects: just as a line in a drawing may vary between implying occlusion and defining edge contours to indicate an object, a crack, or a shadow (see fig. 76), so one tone—even that of the drawing ground—can represent different levels of brightness within the same picture, depending on the local depictive environment. Perhaps related to this is Jan Koenderink's finding that, regarding changes in light, we have a much better local than global awareness. Rather like commuters with Beck's diagram, we need not burden ourselves with fuller spatial maps, since, as Koenderink argues, by "ecological optics" we "may take *the consistency of the world* for an axiom" and focus on local fragments of it.[54] My suggestion is that, by the Same Mill Principle, depiction transfers this way of working (if only sometimes to frustrate it).

These points have a more general reference which will become increasingly important through the arguments of subsequent chapters. I will call it *reciprocity*. For one might ask here, of these relatively simple matters, How it is possible that perceived pictorial elements that evoke, in what Baxandall calls "our stimulated minds," vivid experiences of imagined seeing could rely for their effects upon local subject-matter identifications? Indeed, a similar question might arise regarding depth-slices or occlusion, which are accepted as the strongest of all depth indicators: Does not the very interpretation "occluded form" already presuppose an established depth ordinal relationship? "By context" is probably a right answer to such questions, just not a very specific one.

Thinking about local variations provides an opportunity, in the midst of these considerations about shade and shadow, to recall that the broader topic is tonal: the place of dark and light among the clear "visual facts" that provide resources for drawing. Even regarding light, we must not imply that drawing always treats it in terms of modulation by surfaces, lest we again become theoretically "spaced out." As Matisse, for example, several times stated, "The drawing should generate light," and it may be misleading to describe figures in medieval art as illuminated from without—say, by axial lighting. An important, often overlooked task of depictive drawing is to provide a sense of different substances, textures, things: a sense that flesh is softer and warmer than stone, that stone is of a different texture than wood; and something similar could be said of much nonfigurative drawing. These effects are often suggested by combinations of darks and lights so that, by contrast, different *untouched* areas of the surface will appear, to our stimulated minds, to be of differing brightness. Matisse again: "In the absence of shadows or half-tones expressed by hatching . . . I modulate with variations in the weight of line, and above all with the areas it delimits on the white paper. I modify the different parts of the white paper without touching them, but by their relationships. This can be clearly seen in the drawings of Rembrandt, Turner, and other colourists in general":[55] thus our Tiepolo (fig. 79) and Goya (fig. 83). Another fault of "shades of perspective" approaches to illumination is that everything in a drawing may appear to be of the same texture and temperature. Just as seeing involves the other senses, so does imagining seeing.

SHADOWS STEAL

Tone was brought into the account subsidiary to line effects. Yet felt tensions between continuous contour, however indicated, and shadow modelling may be ancient, judging by the testimony of Dionysios of Halikarnassos. "In ancient painting the scheme of coloring was simple and presented no variety in the tones," remarks this first-century B.C. writer, "but the line was rendered with exquisite perfection, thus lending to these early works a singular grace. This purity of draughtsmanship was gradually lost; its place was taken by a learned technique, by the differentiation of light and

shade." As Rawson reports (*StD*, 41), with the development of Renaissance chiaroscuro, artists in Venice particularly began to break up lit-side occluding or edge contours in favor of this inner contour, as we see in the Tiepolo. This might seem a minor natural development, yet its significance must have appeared great, judging by the reactions. Even two centuries on, William Blake, champion of "firm and determinate lineaments unbroken by shadows," felt that morally this use of chiaroscuro was going over to the dark side: "The great and golden rule of art, as well as of life, is this: That the more distinct, sharp, and wiry the bounding line, the more perfect the work of art."[56] Thus he disdained Rembrandt, Rubens, the Venetians, the Flemish, and the rest of what he termed "the slobbering school." The following is typical of his polemics: "If the Venetian's Outline was Right, his Shadows would destroy it & deform its appearance.... Broken Lines & Broken Masses are Equally Subversive of the Sublime."[57]

Similar reactions have led to psychological speculations, both negative and positive, about the loss of contour and the entry of shadows. As late as 1917 Harold Speed (who, as we saw, thought of contour in terms of touch) expressed old reservations about the Impressionists' "loss of imaginative appeal consequent upon the destruction of contours by scintillation, atmosphere, etc., and the loss of line rhythm it entails."[58] Later, the psychologist Marion Milner would remark about her own drawings that "the outline represented the world of fact, of separate touchable solid objects.... So I could only suppose that in one part of my mind, there really could be a fear of losing all sense of separating boundaries; particularly the boundaries between the tangible realities of the external world and the imaginative realities of the inner world of feeling and idea."[59]

That is one worry; another concerns what happens when not only lights but darks are brought in to dissolve descriptive contour. Even modern, avant-garde aesthetics could see that as a problem, as when the critic Jacques Rivière complained in 1912 that illumination is not just "a superficial mark" arresting objects at a moment of time but one "profoundly altering the forms" of objects, which "prevents things from *appearing as they are,*" the essential features of objects being "obscured in the shade, while those highlighted are of the least interest."[60] It is an interesting issue in drawing, as in life, how we distinguish cast-shadow patterns on things from real contours, holes, and local color variations such as Hale's "edge of the model's sunburn."[61] Cast shadow forms, after all, are not actually things; they are not even properties of the surfaces they modify, but mainly information about other objects cast on them as a screen, sometimes causing interruptive contrasts. Nevertheless artists learned to deploy cast shadows effectively, a famous case being the shadow of the outstretched hand in Rembrandt's misnamed *Night Watch* group portrait, which has been discussed by the philosopher Merleau-Ponty.[62] Finally, there is the large psychological issue of darkness, especially when it is, as so often with shadow, indicated by blobs out of which actual forms must emerge.

For Titian, the greatest Venetian scorned by Blake, the use of attached-shadow techniques for suggesting volume might have seemed a natural evolution of the linear techniques. Rawson suggests that Titian's greatest contribution to drawing may have been his production of the ovoid forms we considered earlier but made "entirely out of tone"—even losing contour outline: "It takes the eye away from its hypnotic attachment to edges, and focuses it on the centres of volumes, the surfaces nearest to it. It can then move over these, from centre to centre, in a due hierarchy of order and emphasis which offers a true psychological scale of attention. For in perceiving anything real one does not look at its edges but at *it*, at its middle" (*D*, 166–167)—looks along what, as noted in chapter 2, Alberti called the "centric ray" or "prince of rays." Cézanne's work, for which he is often considered "the father" of modern pictorial art, may have been motivated just this way, judging by remarks of his that hark back to the preceding section: "The eye becomes concentric by looking and working. I mean to say" (he explains, with a remark reminiscent of Delacroix's) "that there is a culminating point and this point is always—in spite of the formidable effect of the light and shadow and the sensations of color—the point that is nearest the eye." And his dictum was, "Bodies seen in space are all convexes."[63]

Of course artists of Titian's tradition learned again to thematize shadows, combined them with other tones in their drawings, and showed that object anxieties could be overcome. Seurat, for example (fig. 84), worked shadows together with his

other darks to discover distinctive silhouetted forms for individual objects—to be sure, at the expense of the relief his colleagues valued. Rather less autonomously, more common uses of shadow produce a sense of volume and three-dimensional space. In chapter 9 we considered a low-relief effect in decoration which involves simulating self-shadow on architectural features such as columns and walls (fig. 68). Recent magazine design shows how merely an indicated cast shadow around some sides of a picture can seem to lift it slightly off the page. Here we have, by a simple mirror reversal of that ancient polarized line of shade suggesting the curvature of an object, an indication of its cast shadow separating it from the plane. All these cases tend to confirm Gombrich's first two principles: that drafters do not "select" from a scene before them but rather (even when there is such a scene) build up drawings by putting marks down on surfaces, marks that work effects of certain sorts, depending on the contents and mastery of the tool kits available. As Rawson emphasizes in a related context, "works of art are, in fact, *made*; they are artistic constructs. . . . The term 'selection' describes the process so inadequately that it is virtually useless" (*D,* 23). Regarding light, Hale points out that the artist "understands that light can create *or* destroy form: thus, he must be the creator or destroyer of light." He continues: "Skilled artists can create these light conditions *even though they do not exist.* An accomplished artist is able to create his own light . . . sources, disregarding, if he wishes, those that *do* exist. . . . I assure you that it is possible to arrange your sources of light so that a cylinder looks like the window of a prison cell and a sphere like a soiled poker chip."[64]

Thus on the Sistine ceiling, within figures still strongly controlled by closed contours, Michelangelo mainly uses self-shadowing to model his figures volumetrically while their cast shadows on nearby surfaces help place them with the local architecture, real, imagined, or both, without much concern about consistency between panels. The effect is a locally consistent modelling of shade and self-shadow within the scenes. In the fresco depicting the creation of Adam, for example, modelling

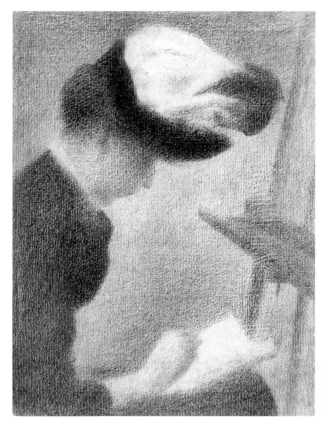

Fig. 84. Georges Pierre Seurat, "Woman Seated by an Easel." Conté crayon, 30.5 × 23.3 cm. Courtesy of the Fogg Art Museum, Harvard University Art Museums. Bequest from the Collection of Maurice Wertheim, Class of 1906.

enhances the collar-bone girdle effect mentioned above, and the artist combines it with a cast shadow (of the Creator) introduced for dramatic effect. Cast shadow, however, is a complex kind of information, whereby part of something's occluding contour shape is used to indicate the form and volume of something else. Without careful control, this can constitute instead a kind of visual noise, as often happens in photographs, with one message muddled by interference from an irrelevant one, and there are many warnings about the careless use of cast shadow—including, in portraits, the ones under our noses and chins that suggesting mustaches and beards on women.

By themselves, shadow borders or contours, we all know, can be a serious problem for environmental vision. Fortunately, our sun has a broad enough disk that its rays produce a softening penumbral transition to shadow edges that it casts; even so, its illumination contrast can be excessive. As perceptual psychologists point out, "Although shadow borders are a nuisance for object segregation processes, they may be useful for recovering the relief of the surface on which the shadow falls."[65] We see this in a select part of the fresco: otherwise Michelangelo skips cast shadow entirely, as on the left leg of our "Study for Adam" (fig. 74), except for the toes (entirely occluded in our drawing)—which in the fresco are not among his better creations. Rawson's point is that within the European tradition, great artists such as the late Titian, Rembrandt, and Goya gave real autonomy to shadow as well as to the dark markings that depict them. In Goya's "F album" sepia drawing, "Two Prisoners in Irons" (fig. 83), important as are the broken contours for describing figures, and the oblique-projection diagonal at lower right for indicating depth, the system of shades and shadows has become prominent, their darknesses combining with color darkness.

SHADOW'S PATHS

Thus shadow cast into drawing more than several powerful ways of suggesting volume and relief, and—it is high time to say—much more, when shadow achieves autonomy from volume. Whether the marks that depict shadows are blobs, parallel hachure lines, or curved strokes to impart transparency and relief-shape, the amount of surface covered by shadow marks will greatly increase, with inevitable distraction from contour. That blind people understand contour perhaps suggests that dark and light are not essential to it, even with recession.[66] But with shadow, as tone or value differences become more significant in a drawing, and the dark increases, tonal balance itself becomes a new resource and a fresh issue, and so does everything that this balance can mean, from figure-ground relations to deep psychology. An important drafter's tool that emerges is due to the fact that shadows, as quasi-objects, tend to make up or become autonomous subjects—which, in addition to the double meanings just mentioned, can cause interference. Also, groups of shadows, sometimes with noticeable contours, as we saw with Rubens's "Daniel," can form their own patterns—what Rawson calls "shadow paths." These may compete with the contours of actual objects, as we see in the Tiepolo and magnificently in the Poussin "Bacchanal" (fig. 82). Thus, shadow mass and shadow path became main resources of picture making, sometimes imparting psychological meaning. Pity is that Blake did not know about his great contemporary Goya, who like him, was able to look at all of human nature. In his tableau "Three Soldiers Carrying a Wounded Man" (fig. 85), probably also from the late "F album" of 1815–20, a stricken combatant, pale with pain, carried by two comrades, consoled by another, exits down right the field of action. Talk of "topological values" and containment: two tipped ovals of encircling arms support the burden, while the negative oval region that links them and the arched one below it knock holes through the sad procession. Goya's attachment of the great rock at the sheet's left margin pushes the wounded figure, face white as paper, out from the surface. And it yields a false attachment: a shadow on the rock has us imagine the left bearer like an angel flying in from that side, while that bearer's actual white legs seem to be those of the victim, who is then imagined toppling into his depicted pose. Thus ambiguities about regions, enforced by independence from depicted figures of the dark ink regions (which in Goya's albums we may hesitate to penetrate), create multiple interpretations, orchestrated in a slow rhythm of glide symmetry translations through the hunched figures.

A second large issue that shadow introduces is one already mentioned: that of light and its source, as we see in both our Goyas, the Tiepolo, and oth-

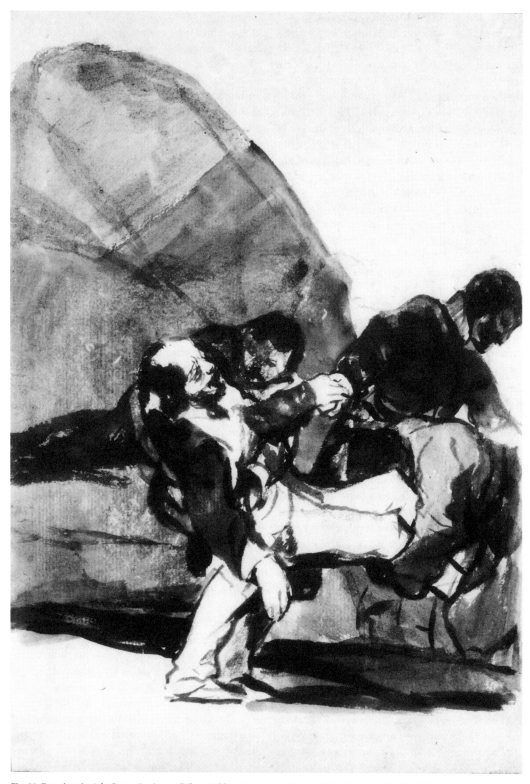

Fig. 85. Francisco José de Goya y Lucientes, "Three Soldiers Carrying a Wounded Man," 1812–23. Brush with brown ink and brown and gray wash over black chalk on ivory laid paper, 20.5 × 14.5 cm. Clarence Buckingham Collection, 1960.313. Photograph by Kathleen Culbert-Aguilar, Chicago. © Reproduction, the Art Institute of Chicago.

ers. In nature every cast shadow carries information about the shape and tilt of the surface where it falls, about what we call the "scrim" that casts it, and about the nature and position of the light source or sources.[67] But it is important to realize that in depictions shadow effects do not necessarily imply a light source. We noted that drafters of many traditions have used subdued self-shadow to provide some convexity to figures as simply a way of drawing figures, without thinking about the light source. Still, the most frequently represented but undepicted individual in the history of depiction is probably our sun, whose position (Meder's "pointer") and influence is sensed in many pictures—even when not thematized, as it is, famously, in Dutch painting and Impressionism. Aside from its sources, illumination is itself a great theme of the visual arts of many traditions, whether they show shadow or not. When given uniform direction throughout a picture (as we see in a number of our illustrations for this chapter), illumination becomes akin to what we saw perspective to be in chapter 2: an autonomous organizing force rather like gravity, capable of powerful control of the appearance of everything in the picture, according to a few interacting variables. We have seen how Western traditions in drawing have been identified by use of one or the other of these organizers, and when they are successfully brought together they create immediately recognizable "field" effects distinctive to it—that is, such structures of pictures can be noticed at a glance, even before object recognition is very far along. Indeed they interact at each point, for one of the technical tasks of academic perspective study was to draw cast shadows in perspective and to shadow forms correctly so as to clarify perspective.

In review, we began this chapter, Villard-like, with lines, and we stayed with the individual substances they delineate, considering ways in which drawing techniques make these substances—especially their corporeal volumes—not just legible but perceptually effective and vivid to our imaginations. There is an excellent reason for that strategy, since in both individual and historical development things that are spatially characterized and related serve as the main basis of our drawing projects. That account has broadened from its basis, in the vivid depiction of the spatial existence of individual objects in relationship, to the spatially described marks and grounds that present them, and

to ourselves as located in space. We have begun to consider not only groups of such depicted things but also imagined entities that correspond to no substances at all. Always keeping in mind the autonomous characteristics of marks and primitives such as lines and enclosures, we have added to our drawing kit the more abstract framework characteristics of direction of light and perspective. So, just as traditional studio training students were allowed to graduate to "composition," now that we have completed *rilievo* or volume-rendering effects in this chapter's crash course, perhaps we qualify for study of literally the bigger picture.

FIELDS

Nonobjective shapes of any of the kinds that we have investigated should not be considered, as in our Goyas, as alternatives or rivals to the objectively depicted ones. To begin again by easy steps, in the image traditions of many cultures strong shapes serve to constitute groupings of various sorts. Earlier we noted that depth-slices, even when not implying object enclosures, can indicate relative occlusion depths of multiple entities, such as trees or mountains rising from mists, as in Chinese drawing, or Dürer's almost willow-ware fantasies in "Samson." In all traditions strong enclosure forms contain multiple objects. In many drawings, such as Goya's "Wounded Man," we may first be aware of a strong enclosure design and only then begin to investigate the depictive forms they bind or blend. In others, overall enclosure and enclosed shapes are perceptually more equal, as for example in our Michelangelo fresco, where the Creator's cloak, enclosing the unborn, provides a familiar example. However, that example also introduces a significant compositional factor not shared by most groupings of depicted objects through the overall shapes or forms that run through them. Indeed, according to Rawson, "we reach the point which represents the unique technical achievement of European art, the method of linked bodies in space," which he holds to be its "most transcendent or symphonic" achievement, late arrived at and thereafter mainly lost to figurative art. It "goes beyond the graphic symbols and elements" we have been considering, while presupposing them, he says, and it is a method of organizing the picture so that "all the positive bodies in it compose

closely . . . interlinked sequences, with an inherent direction, over a basis of negatively conceptualized areas in which open space is treated virtually as 'substanceless body' " (D, 177–179). Such form, as a continuous corporeality running through objects, may be achieved by all the means we have just considered, since it depends on "a vivid three-dimensional sense" in both the recessional and the volumetric sorts that we have been considering. Poussin's bacchanalian drawing (fig. 82) provides a good example. Regarding subject matter depicted this way, Rawson adds the following:

> Humane figurative art, which focuses on the expression of human feeling and of personal interaction, by representing people moving in their world, is capable of developing complex images of shape by means quite unknown to other styles. The artist can compose a network of implied bodily movements among the living . . . figures he constructs which take on all kinds of subtle spatial significance. . . . [T]hey may suggest complex patterns of going and coming, turning and acting, the meeting of hands and eyes, the shifting groups of feet and heads, encounters of whirling drapery. All these may suggest what has just happened and what may be about to happen, backward and forward in time. (StD, 48–49)

As for the individual figures, they "seem poised in the course of varied movements which need both time and space to complete" (StD, 54). This achievement, Rawson holds, presupposes the spatial devices we have considered, and was fully developed in the West in the post-Renaissance period, when

> artists composed interwoven chains of three-dimensional bodies, which are linked by all the varied resources of flat design across the surface. But our eye reads continuities of sense running through them along which it is able to interpret . . . a developing human interaction. . . . Our sense of space may be extended by events which we understand to be progressing in time, and hence to need more room to complete themselves than the picture actually shows. So time may be incorporated into the image; this space-

time nexus generates what I call a "field." (StD, 49–50)

Goya's "Wounded Man," with its complex chains of human links, appears to exemplify such a sense of time and action.

Of course many traditions, such as our Mayan vase painting (fig. 65), narrate human interactions, showing both bodily and mental attitudes. Furthermore, many link the depicted forms into patterns. Rawson's point seems to be that a continuity of development in bodily volume or in pictorial depth was necessary for setting up such time-space "fields," although he holds that once discovered, no such literal narrative is required, given that modern art has made the field "the artist's principal goal" (StD, 54). From the European idea of organizing entire pictures not just as great chains of beings but as chains of human ones, that seems (almost) predictable. That there should be such a development, within that tradition, of methods of rendering objects in bulk, of depicting shape and spatial relationship, should be even less surprising when we consider how, for millennia, a main function of the tradition was to serve sacred narratives through dramatic physical and psychological interactions, in which the corporeal, anatomically functioning human body often served as the principal agent of expression.[68] Thus our frequent recourse in this chapter to examples from life drawing. This approach seems grounded in human psychology, given that much of our imaginative life concerns living beings, particularly humans, with a good deal of emphasis on their bodies in action. How the actions of these bodies are conceived is a basic issue in the understanding of drawing. It is interesting that Heinrich Wölfflin should report that Michelangelo disapproved of Dürer's scheme of bodily proportions for not basing itself on anatomy. We know that, for all his work on anatomy, Leonardo favored soft, slender bodies, while it is largely to Michelangelo that we attribute the dynamics of strong muscular, skeletal action (developed by subsequent drafters, down to modern comics), which strengthened practices of drawing from the nude—about which Meder's comments are still worth reading.[69] Through such practices perspective became a significant factor within the handling of human figures.

Philosophically, it is revealing to compare that late Western approach with that of other traditions,

including European ones. While providing "fields," the antiheroic narratives of Rembrandt and Goya are antianatomical with their main forms (figs. 83, 85). Max J. Friedländer wrote perceptively about Pieter Brueghel's movement-based rejection of the classic technique with the human body, based on an object-centered "straight and upright figure" (fig. 77), enriched "by a displacement, a foreshortening, an inclination, a turn." Brueghel, he remarks, "never seems to apply foreshortening to an ideal figure, but begins with the action, and from one particular angle seizes the ever-changing contour as a whole," as a distinctive silhouette (including dress): "Therein lies the secret of the manifold variety of movement" in his figures.[70] Even regarding individual aspects of human bodies, where with Hale's help we considered the rendering of the shoulder girdle in Western life-drawing traditions, Rawson provides a contrasting case: "An Indian Rajput draughtsman never bothers to delineate and define the complex of bone and muscle at the front of the neck and shoulder, where the collarbone and breastbone meet. To do so would be an artistic irrelevance, a totally unnecessary vulgarity. His 'truth' is a truth of feeling, where what matters is a continuum of sensual response to polished surfaces, conveyed by fluid lines running over unbroken, generalized areas symbolic of volumes" (D, 23).

As to the general topic of "interwoven chains," which includes the Western bodily forms, although Rawson thinks that we can find something like it in the rock "dragon veins" method of the Yüan dynasty artist Wang Meng, he remarks that most Chinese art "emphatically does *not* use it" (D, 183). Wholeness in that tradition tends to reside instead in a spaciousness of nature (see fig. 72), out of which human, animal, and other forms emerge, whereas by the "linked bodies in space" method, the main forms tend to be human ones involved in dramatic actions. One of Rawson's favorite examples for the post-Renaissance technique is Poussin, who in some works (fig. 82) orchestrates complex interweavings of forms and surfaces generated by this method, through complicated human dramas—where he often disregards continuity and quality of contour.[71]

11. forms and frameworks

In considering Rawson's "fields" as chains of bodies in space and time, we moved from the rendering of volumes of individual things to their relationships in the organization of whole pictures. While Rawson, like Meder, treats that difference in terms of the difference between shallow space and deep space, or between space as bulk and space as container, he sees that more is at issue. Let us begin with our old topic of recession into deeper space, including numbers of bodies and empty spaces. It is easy enough to see how the two main techniques of overlap (depth-slices) and continuous side-surfaces work there: one simply does with a succession of bodies what one does with a single one. Beginning with what artists often identify as the nearest depicted point or surface, one works (as we saw with Dürer's Samson) back into space by use of these techniques, object by object, in ordinal steps (*D,* 166, 200–201). However, there are other techniques, including perspective and other projective systems, that can precede the drawing of any individual objects: these provide what I will call "frameworks" into which objects are placed.

THE FLOOR

Rawson stresses that the "floor," or ground plane, is an important presupposition and precursor of spatial frameworks. In Mayan and Greek pottery (figs. 65, 92), in some cartoons (fig. 26), in dynastic Egyptian works, and in many developed children's drawings the only sense of a common base beneath the figures is a base line, sometimes right at the edge of drawing surface (*D,* 204). However, most traditions—in the West, China, Persia, Japan— often like to include a floor which rises in the picture as the depicted space recedes, so that for things located on that floor being higher up in the picture tends to signify being further back. (Two cartoons and the Dürers in Part I show this, while the Villard does not.) The floor not only provides this important depth cue but has two other significant implications, based on environmental experience. One of these (briefly noted in chapter 6) is relative height: for objects resting on the floor the *ratio* of the part below the horizon to the part above is an index of the height of the object, relative to the viewer's height.[1] This is owing to another implication of the floor. Once given, we may imagine it as continuous with the one on which we are stationed, with the result that an important kind of self-imagining may be evoked, involving not only our visual actions but also our proprioceptive senses of position, support, and gravity. Sometimes, as in Goya (fig. 83) and Dürer (fig. 87), the floor plane is an actual floor, whether our own or not.

A related technique is that of "depth bands" dividing the floor. This is familiar from the rather

disjunct trio of foreground, middle ground, and background standard to Chinese and some Western traditions, sometimes with intervening bands (*D*, 209; *StD*, 44–45), and is usually indicated by large depth-slice overlaps. A standard, reliable Western device for this, still evident in photography, is to use the foreground as a *repoussoir* or stage-framing device, which places the main narrative events in the middle ground and lets distant objects function as a flat, stagelike backdrop. In this version, the three bands frequently receive quite different treatments: the framing foreground is barely more than silhouette; the middle band is worked in some depth and with lighting, which allows discriminations of objects and actions; and the faraway is handled in aerial perspective, that is, in lighter tone and with less distinct contours and textures (fig. 30)—which, as we shall be considering, are often registered by change of scale in the depictive marks that indicate them. It all sounds like *Giselle*. Sometimes, however, most attention is given the foreground, while the middle ground functions to carry the floor back and the background merely signifies that there is some sort of world beyond. In general, trios are useful compositional devices in all visual arts—as well as in the dramatic (as perhaps Aristotle is the first to register).[2]

Shall we call these merely drawing conventions? Once again, according to Gombrich's Same Mill Principle, it seems likely they are transfers from a three-depth-band framework organizing our environmental perception into hither, thither, and yonder, similar to trios of time and space marked in various languages. James Cutting has argued that our perceptual space may be usefully divided into three bands: personal, action, vista. A sense of personal space may reach about as far as we can, maybe after taking a step or so; while action space extends to around thirty meters, which is about the limit of binocular vision and the distance within which we can throw something accurately.[3] As Cutting remarks, this is rough and relative to physique and situation: thus, alas, Acis (fig. 86), who gave his giant, boulder-hurling rival the high ground. Speaking of Cyclops, beyond the outer limit of action space, notoriously, it tends visually flat—along with our powers to estimate depth, sometimes humorously, sometimes tragically. As judgment of vista depth compresses markedly from true ratios for all but specially trained people,

the distant mountain seems to stay at the same distance, like the horizon, although we have been travelling toward it for hours; swimmers underestimate distances to safety, and so forth. Even with considerable lateral motion, in our natural theater of perception the far scene remains a stable backdrop, like Hokusai's views of Fuji, while action-space relationships among objects shift markedly. Perhaps because depth-band boundaries are vague and dependent on viewers, their positions, and natural conditions, we consider views "picturesque" when, uncharacteristically, the three spaces actually *look* separate.

Like all the standard resources we are reviewing, the next important point concerns how artists exploit these tools for interesting results. As noted before, artists have a distinct tendency to experiment with and also thematize their means. For example, Rawson remarks that the unwinding scrolls of Far Eastern art may shift "the foci of the design to and fro from one space-band to another," sometimes for a while dropping a band from depiction (*D*, 210). Once floors become standard, avoidance of their clear indication—or of them entirely—becomes significant. Landscape depth bands may be indicated while their floors are veiled in mist; Baroque artists could so overfill available floor space with figures as to exceed its possibilities, whereas Poussin remains a classical artist in that "he refused to abandon the logic of the floor" (*D*, 205), even as in the crowded figure 82. Rawson remarks that, by contrast, in his later works Cézanne tends to remove "all sense of floor," working rather as though there were only elevation but "no ground plan," thereby also cutting off the sense of floor continuity between the viewer and the scene—a strategy that later became a principle: "The floor has been exiled from most modernist design," Rawson states (*D*, 205–206).

It is here, appropriately well into the story, that Rawson introduces linear perspective, but it is also here that Rawson's account suddenly lets us down—curiously, for an author on Indian and Chinese painting, he has nothing to say even about the wide use of other projective drawing systems.[4] Rawson would put perspective in its place. First, he treats it generically as an accessory to floor and depth-band effects: "it means organising the overlaps and relative scales of objects on the floor to convince us of the space-content of the image," which entails "correct placing of the feet of objects

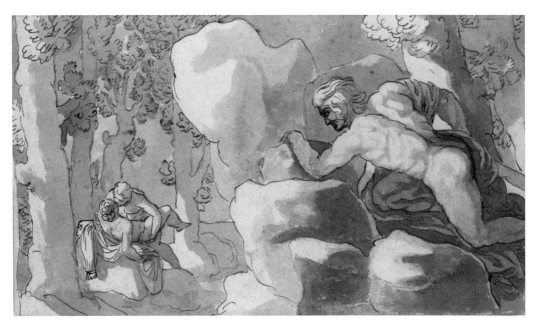

Fig. 86. Nicolas Poussin, "Polyphemus Discovering Acis and Galatea," ca. 1622. Graphite underdrawing, pen and brown ink, brown wash, 18.5 × 32.3 cm. Collection Her Majesty Queen Elizabeth II.

on the floor of the drawing; they should compose a rhythmic series of intervals," he adds, "co-ordinated both with the system of overlaps and a scale of proportion" provided by perspective (*StD*, 47). Rawson minimizes the importance of linear perspective for drawing as an art, however: its image, he insists, "does not belong to the category of aesthetic form" (*D*, 219). But the same can be said for every other drawing device (except the time-space field) we have considered—indeed, I have presented perspective as a systematic "concomitance" of several devices. As tools they, like their perspectival grouping, can be used in various ways, and all provide abundant evidence of uninteresting as well as interesting use. Unfortunately, however, Rawson, like many others, singles out linear perspective as a mere technology, considering it "mechanical seeing." This is partly because he accepts the fallacy that perspective "is valid only if it is based upon one strict assumption—that the eye . . . is fixed to a single, theoretically unvarying viewpoint," that of a "peephole" (*D*, 217).

This brusque dismissal is in some respects attractive; minimizing the importance of projective systems in the history drawing would make the whole topic far more tractable. In any case, Rawson sets his course along a subtly interesting path,

that of rhythmic themes and development in drawing composition, emphasizing that this is what "gives ultimate relationship and meaning to . . . elements of drawn form." The first thing to determine in any drawing is, he remarks, "Which elements carry the rhythm?" (*D*, 194–195). Here we do seem to cross a value line in the exposition of drawing tools, since the fact of having attained a rhythm in a drawing, carried by certain elements, seems to imply that the drawing may be artistically interesting, whereas the fact that one has done a drawing with depth-slices, ovoids, or perspective does not. Rawson's problem seems to be the multiple roles of perspective in drawing. As a coordinated set of devices, perspective deserves at least as much attention as the closely related techniques of shade and shadow. But perspective, as a drawing system or set of instructions about (as Willats says) "where the marks go," might appear to be a specious competitor to rhythmical variation and other compositional principles. Baited by the usual claims about "optical accuracy," Rawson uncharacteristically forgets to consider the device not only in terms of a general theory but also in terms of its varied historical use by artists. Even apart from issues about how convincing it is, perspective has proved to be a most important tool both for com-

position and for placement of imagined scenes in relation to their settings, particularly to the beholder. This calls for another example. Since Dürer's woodcuts of physical devices helped along the way, study of a more finished engraving is appropriate here.

PERSPECTIVE LOOKS: A QUALIFICATION

Projective systems, also perhaps illumination, may be called "frameworks," because they are functions that can be applied right across a drawing surface, affecting everything there. Indeed, projection systems provide literal examples of such functions, since computer drafters are able to apply mathematical functions that transform all the drawn shapes on a surface. Everyday experience alone makes us realize how changing one's position on a scene, or the sun's changing the lighting provide vivid examples of framework changes. These frameworks are but two aspects of what Rawson says is "unquestionably visible in a drawing as a marked surface before us"—though broader and even more relational than the devices we considered in the last chapter. Now, it is a fact of perception that, besides registering changes in such frameworks, we can also sense the individual frameworks, often immediately. As we see at a glance with Dürer's engraving of "Saint Jerome in His Study" (fig. 87), pictures often *look* to be mainly in perspective or in an orthogonal system, even when they are only pretty much so.[5] Perhaps that is not surprising, given that similar global adjustments take place in environmental vision as well, when we look into far distances (perhaps with telescopes and binoculars), and perspective effects approach parallel-projection effects, making scenes look different. Thus most people, while knowing very little about vanishing points, can still see the "grain" of a picture running roughly toward them, even when this is only approximate.

This overall "look" of a projective system qualifies my earlier criticisms of holistic perspective-projection versions of the influential imitation of appearances idea, rejected by Gombrich's first principle. Probably people accustomed to linear perspective in pictures are more aware of natural perspective as a fairly ubiquitous structure in environmental perspective; therefore an important aspect of the look of the latter may well be captured by the look of the picture. Thus, besides the earlier-emphasized "concomitant" effects of diminution, overlap, foreshortening, and so forth, there does seem to be an overall phenomenological aspect to perspective in pictures, which may, after all, add to its "effective" or vivid depiction. From at least chapter 4, I have insisted that it is often easier to sense higher-order structures; and it does seem possible to work up perspective frameworks in pictures with quite bare indications of anything else, while still imparting a quite particular sense of a space. This kind of "look," as a drawing resource capable of interesting thematization, bears further investigation. Let us consider it through Dürer's familiar drawing.

"SAINT JEROME IN HIS STUDY"

Saint Jerome was long a most popular figure for depiction in European art, both as a penitent in the wilderness and as a scholar in his study, and many depictions of these two motifs exist in museums around the world, Dürer being but one of many artists who depicted him in several ways and by differing media.[6] Dürer's 1514 version is one of a famous trio of his engravings, perhaps for presentation or a special market, which includes "Melancholia I" and what is usually called "The Knight, Death and the Devil." While perspective figures prominently in all three, it is the "Saint Jerome in His Study" version alone that exemplifies Meder's sense of "the illusion of concavity,"[7] making the others resemble low relief. If before we saw the philosopher Epictetus in his crooked "little house" (fig. 55), here we provide the scholar with an accomplished theater of perspective, except that theater's standard "four walls" conception is not enough, since the artist makes us equally aware of both floor and ceiling. The wall we do not see is the one to our right, while the famous imaginary front one is strongly evident, and its relationship to the visible floor sets us, as imaginary observers, in metric relation to all we imagine seeing. This "floor" is one we can so vividly imagine as connecting with our own platform that we have the sense of standing just a couple of steps down from it. Light comes from a represented but undepicted source to our left, which catches the corner of the pillar's base. We look through "the fourth wall" into the private cell of the scholar, where, as

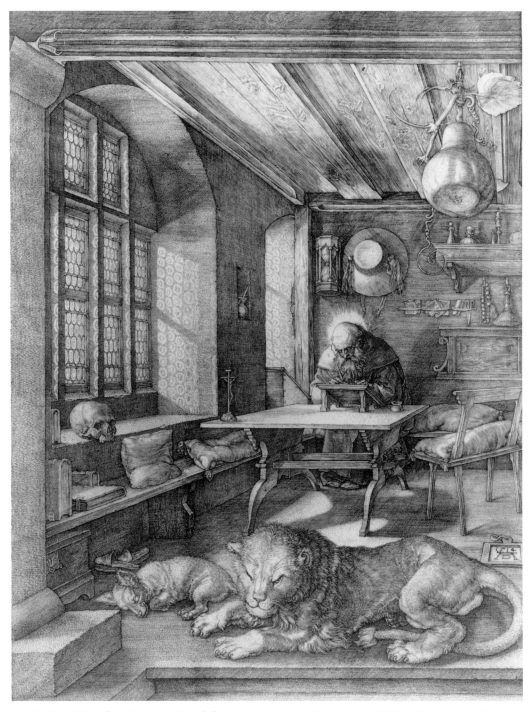

Fig. 87. Albrecht Dürer, "Saint Jerome in His Study," 1514. Engraving, 24.7 × 18.8 cm. Bequest of William P. Chapman, Jr., Class of 1895. Courtesy of the Herbert F. Johnson Museum of Art, Cornell University.

Panofsky remarks, "The threshold of the room is blocked by St. Jerome's lion, who, dozing with contented boredom, yet keeps a drowsily suspicious eye on possible intrusions from the outer world. . . . The Saint himself is working at the far end of the room, which in itself gives the impression of remoteness and peace. . . . Engrossed in his writing, he is blissfully alone with his thoughts."[8] Vistas shut out, everything depicted is within Jerome's imagined personal space or near action space, all that we imagine seeing is likewise. How unlike him is the scholar in his vista space tranquillity, part of the flow of nature that typifies Chinese portrayals (figs. 72, 73).

The atmosphere of "Saint Jerome" is, as Panofsky observes, mainly achieved by Dürer's handling of the two frameworks, perspective and illumination, and both do make immediate impressions. Before considering them, however, it has been our method to review more local graphic devices. Beginning at the mark level, we may say that marks are evident—not so much as individual marks but more as textures, almost microtextures, with changes across different kinds of surfaces, for example, stone, wood grain, animal fur. The consistent impression in looking at this print is that one is viewing an extremely well-worked surface.[9] There is much stippling with oD marks, otherwise very short 1D marks prevail, and where the latter are longer we have the sense of a straight edge at work on the copper plate. Regarding lines, it is mainly in the furniture that we find congruence of mark and primitive, whereas the 1D primitives defining edge-features of the architecture seem to be made of many small marks.

Let us take advantage of this to draw an important set of general distinctions regarding such congruencies. Rawson points out that congruencies or noncongruencies between marks and depicted features may be very meaningful: "lines can be drawn so that the scope of the line as it is traced in its curves and inflexions corresponds exactly with the contour of the form." Then "the movement of the drawing-point shapes the form and coincides with its contour, embracing and defining it." By contrast, he continues, "lines can be drawn so that no single touch or stroke alone claims ever to embrace and define a form; each touch is smaller than any unit of curve or form" depicted. He adds: "The actual phrased line which emerges in the agglomeration of touches is thus an invention in its right, and

did not happen as a consequence of a comparable phrasing of the hand's actual movements." When the latter technique is used well, the effect may be that "the form is allowed, as it were, to speak with its own voice and is not subjected to a dogmatic and emphatic contour" (D, 114). With our conceptual kit we can develop these perceptions in two ways. The distinction between "touches" and the "phrased line" show awareness of our picture primitive / mark distinction. Next, there should be consideration of the congruence and noncongruence between either of these and a third factor: the depicted things or features (possibly what Rawson means by "the contour of the form" and by "denote curved surfaces" [ibid.]). For example, the Mayan drawing keeps marks, line primitives, and features (such as the occluding contour of an upper arm) in close congruence, while Michelangelo's contour marks seem to stroke the very forms they reveal (fig. 74). Zou Fulei's single ink droplets coincide with individual shapes, depicting individual flowers, and by a similar breathtaking process his single brush strokes form single lines, depicting distinct twigs, whereas the dancing blue and pink dots of Shih-t'ao's leaf for the Taoist Yü yield few such correlations (figs. 69, 72). Indeed, depicted things (or should we say, depicted processes?) are evoked from line and region primitives, themselves guessed from marks that stay so willfully dominant that the facture and depiction merge as one, in a theme of process, not of substance or of geometric space as in "Saint Jerome."

In Dürer's engraving, both kinds of lines that we identified function truly as dividers, defining the hard surfaces of the room largely in terms of edge contours. Into this are placed a few rounded objects, mainly organic ones bounded by occlusion contours. This "edgy" environment is famous for its perspective arrangement, which we will consider in a moment, but, as we saw in Part I, we must be careful what we attribute here to perspective specifically. Other systems would have provided edges as well, and also been receptive to the armature that embraces the scene, giving us a sense of its containment: notably the big Y junction formed by the structural beams of wall and ceiling that bring three confining surfaces together, closing off the scene, a device that we saw to be common in isometric projections. Objects like the standard, anachronistic cardinal's hat on the wall might as well be rendered in a parallel-projection

system. A few smaller significant Y junctions reveal three sides of significant objects, such as the pillar base on the left, thus giving us the basic plan view while producing depth by side planes off orthographic frontal faces, which are appropriately shadowed. The many sharp T junctions, indicating occlusions and thereby ordinal recession, would have been, like other junctions, true junctions, stopping points for the artist's pen and the engraver's stylus. These indicate occlusions, setting objects such as the gourd, the surfaces behind it and the scholar's books into ordinal depth. Yet our recent work on Rawson helps us notice what is lacking: how relatively little Dürer relies on depth slices. As we shall consider in a moment, it is remarkable how little occlusion he allows for his main objects. Rather, we get presentation of frontal planes parallel to the picture surface, with most ordinal and interval depth indicated by the side-plane technique, along faces slanted to our view. Also, as Rawson pointed out, even with the organic bodies Dürer does not work much by ovoids. Even where there are a few describing the lion's haunch, textural strokes dominate. Nor could this scene be described in terms of the later "chains of bodies in space," since within its unity of perspective and illumination the bodies remain distinct—in fact, seem to be worked up one by one, the graphic devices depicting them never flowing from one to another.

Turning now to the two larger frameworks, Panofsky summarizes them, in their relationship, very well. The "exact geometrical perspective"— which would seem to be "almost inimical to psychological expression"—provides a "picture space, impeccably correct from a mathematical point of view," but of "enchanted beatitude," by deployment of three of its variables: the horizon, the location of the central vanishing point (CVP), and the distance from it of the distance vanishing point (DVP): or, in geo 1 language, the distance out to the construction point, earlier exhibited in the four Dürer woodcuts. The horizon is low—running just above the top of the crucifix on the table; the CVP is far right, almost off the sheet, where Dürer leaves a convenient little dent in the cupboard. The construction distance is short: half the height of the picture, putting the 45° DVP with which Dürer designed the space on the beautifully shadowed window-embrasure (on a vertical line with the

bench support below the tasseled cushion). Thus, assuming our floor continuity effect, Panofsky remarks: "The shortness of the distance, combined with the lowness of the horizon, strengthens the feeling of intimacy. The beholder finds himself placed quite close to the threshold of the study. . . . Unnoticed by the busy Saint, and not intruding upon his privacy, we yet share his living space and feel like unseen friendly visitors rather than distant observers." Despite this, the third variable, "the eccentricity of the vanishing point [CVP] . . . prevents the small room from looking cramped and box-like because the north wall is not visible; it gives greater prominence to the play of light on the embrasures of the window; and it suggests the experience of casually entering a private room rather than of facing an artificially arranged stage"—as is so often the case, we may add, in so-called "central perspective" pictures where the CVP is near the center.[10]

Panofsky's astute observations here will not be fully appreciated unless we go through them with the analytic tools we have been assembling. First, we need to add that the engraving is set out not only with a CVP but with a compositionally strong *sense* of one, as its longest lines are scribed most emphatically, with the most prominent surfaces and edges aligned conveniently, either along the orthogonals aiming at the CVP or at right angles to it, vertically and horizontally. Next, Panofsky does not explain how the eccentric CVP placement "gives greater prominence to the play of light on the embrasures." According to chapter 2, given perspective's sensitivity to this variable, the short construction distance entails that the side-plane diminution and orthogonal convergence rates will be steep. Panofsky neglects to point out, however, that putting the CVP so far to one side has the effect of stretching all that recessional information over a greater part of the picture on the left, thereby providing a wider screen for the play of light and texture across those surfaces, which, as shaded side-surfaces, steadily carry us back in space. Should this sound complex, all one needs to do is hold the picture at distance of about half the height of the picture, or if this is too close, at three-quarters of the height, and then focus near the middle of the right edge, level with Jerome's beard. The room will then seem much smaller, more box-like, while our sense of its depth strengthens greatly. Some shapes will change: for example, the

plinth on the left becomes almost square. We will return to the effects of this alternative view soon, but for now what we need to add is that, having discussed Panofsky's observations of Dürer's control of three of our perspective variables from chapter 2—construction point distance, left and right vanishing point locations, and horizon—Panofsky is equally conscious of how the artist deploys two additional variables from that chapter.

These are the disposition of the objects in the room and the orientation of the room's structure relative to the picture surface. "The apparently irreducible impression of order and security which is the very signature" of Dürer's engraving, Panofsky observes, "can be accounted for, at least in part" by the distribution of objects in the room: free and casual, but "no less firmly determined by elementary perspective construction than if they were attached to the wall. They are either placed frontally like the writing table . . . , the animals, the books and the skull . . . , or orthogonally . . . , or at an angle of precisely forty-five degrees like the little bench. . . . Even the slippers . . . are arranged so that one is almost parallel and the other exactly at right angles to the picture plane" (155). We now see how costly to his account was Rawson's dismissal of linear perspective as a drawing system. Earlier, treating linear perspective as a concomitance of devices, we had noted that drafters are free to pick from among these occlusion, rate of foreshortening, diminution, and textural gradient change. But now we see another way in which they can take perspective apart and use the bits. By manipulating the five variables that control perspective, an artist has achieved what are usually called "expressive" effects difficult to attain by other methods. We notice also that Gombrich's first three principles are again well instantiated. Far from imitating appearances, the artist has provided us with an effect impossible to achieve in environmental vision: a view of a perspectively organized scene, but not a view from its construction point. Thus art outdoes nature, using natural means.

Then there is the second framework, the drawing's much admired light: an "extraordinarily delicate rendering of early dawn greys project a powerful sense of coloured light; the study of the saint is literally permeated by it, exuding a rare and calming harmony," according to one writer.[11] As Panofsky observed, use of the first three perspective variables provides that "greater prominence to the play of light" around the windows, and play is what he means, for he remarks that the perspective "regularity might seem dry or even pedantic were it not softened, or indeed concealed, by the delightful gambol of light and shade. Space and light constitute a perfect balance of stability and oscillation. Yet even the most pictorial effects are obtained by rigorously graphic methods."[12] How does the light repay the help that we just saw perspective give it? We note that the whole framework of illumination and shadow is rotated away from right angles to the picture plane and the perspective: thus the shadows of the window mullions are cast against the embrasures, and not in parallel, while the glass disks project their shapes there as well (fig. 88). Although it is perspective that is usually thought in terms of projection, the actual experience of projection here comes from that dominant light source, along with its reflections, as on the ceiling.

In the last chapter we considered kinds of shadow. Self-shadowing helps to model the forms and reinforces the perspectively defined planes of this engraving. As for cast shadow, it is used selectively, notably in the shadow of Jerome's table, which will bear close consideration. But first, Panofsky mentioned "graphic methods," and our experience of the effect of light in the picture is inextricable from that of the surface as marked. Indeed, one's first impression of this engraving is of an overall silvery surface, which depicts a scene suffused by a similar light. The lights from the roundels against the embrasures seem rainbowlike, and a photoreproduction of Dürer's print does little justice to its extraordinary tonalities, including the gloss of the wooden ceiling. (Remarkably, Vasari admired the play of light on the embrasures.) As Wölfflin stressed, light and shadow bring with them a sense of movement, both movement as temporal states that may suddenly change and movement as a shifting spatial pattern throughout the picture: delicate tracery on a vertical surface, hard cast shadow on a horizontal floor, faint, indefinite casts mingled with reflections elsewhere. As for Panofsky, his comments take us back to the nature of the drawing marks: "A maximum of effect is achieved with a minimum of effort and complication, as can be seen, for instance, in the shadows cast upon the window embrasures by the latticed windows. The phenomenon is as pictorial and subtle as the treatment is graphic and simple: the 'bull's-eyes' themselves are rendered by outlines

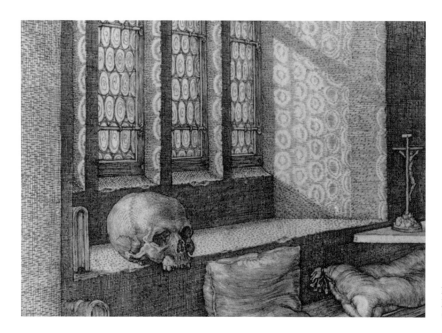

Fig. 88. Dürer, "Saint Jerome in His Study" (detail of Fig. 87).

without hatchings, and their shadows by short horizontal hatchings without outlines. That is all" (156).

We will consider this astute comment again. But here we may ask whether all the visual facts really fall on the side of the "consistency, clearness and, above all, economy" that Panofsky sees, both in all that is depicted and in the means of showing it. Critics have noticed that the short distance and eccentric CVP have some effects not mentioned by Panofsky. William Ivins, for example, is scathing: "The top of the saint's table is of the oddest trapezoidal shape. . . . Neither is it level with the floor under it [which] is not flat, for somewhere between the table and bench at its right it takes a sudden tilt and slides off in a new direction. The bench, . . . to look like Dürer's picture of it, would have a shape that would astonish everyone, including Dürer."[13] The perspectivist Lawrence Wright sees more faults. Dürer, he correctly notes, actually made an error in a main diagram explaining perspective in his *Manual,* and that was no fluke: he had attempted to combine Alberti's and Viator's geo 2 methods. The result in "Saint Jerome" includes problems besides the ones Ivins lists: that "the saint is too small and has not enough room for his chair, that his hat is too big, that the gourd does not hang straight," and that the "real fault in the table is that a rectangle enclosing its feet does

not fall squarely under its top."[14] Was Dürer aware of these problems, and did they discourage him, as Wright suggests, from subsequent complex perspective efforts?

It seems reasonable that if the artist invited us to prolonged acts of recognition in this fine-grained drawing, he would have allowed us to notice the discordancies. Indeed, there is evidence that he put in a few more, not owing to perspective. We noted the relative lack of occlusions in the picture (compare in fig. 84 the different purposes of Seurat's avoidance of object occlusions). For a historical perspectivist, Dürer's works are remarkably Villardian, "object centered," so much so that he can hardly bear to overlap one nominal entity's image by another. For example, the dog's unoccluded contour lets it float in its dreams above the plinth by its head, which missed occluding it, and is barely tacked down behind by the tip of the tail of the drowsy but active lion guard, who also just saves the signed tablet from levitation. The tablet, but not quite the table—for an exception that best proves the occlusion rule about ordinal depth effects is Dürer's remarkable neglect where the table leg slips out of occlusion by the lion, making false attachment to the lion's head. The result is that the table, with its already odd top, is in danger of levitating above the lion, an impulse counteracted by the firm anchoring of the other legs by Waltzian or

attached shadows. But what kind of anchors are they? These shadows are projectively impossible. The depicted shadows would be oblique projections of the window made by the parallel rays of the sun, thus what we earlier called "affine" transforms of the window opening shapes. The perspective *presentation* of them would not be affine, since perspective transformation gives up parallelism: still, perspective projection on a flat surface does retain edge straightness. Dürer knew full well that straight edges do not project curves onto planes, but rather straight lines, like the shadow the bench casts. Yet the shadow of the level tabletop takes a distinctly odd turn, echoing the curve of the lion's tail and, with its likewise impossibly narrowed continuation under the table, beginning to hint that all is not quite so "*gemütlich*" and "*stimmungsvoll*" as Panofsky thought.[15]

Well, Wölfflin's impression was a bit different from Panofsky's. "What oneness of figure and atmosphere!" he wrote. "The saint is like a spider in a web of lines and lights that is as indispensable to his existence as he is to the web."[16] Wölfflin's theme was a German feeling for interconnectedness, movement, and life, and he also observed, "In his youth Dürer made a drawing of some soft cushions whose creases, despite their precise form, seem to change before our eyes" (63): perhaps we see this, too, in the animate cushions that surround the saint. Dürer's playfulness begins to pop out with faces in other strange places besides what now emerges as a skull-like shadow-cast under the uneasy table. As we look up at the string, goblin stem, and leaf of the gourd hanging above, we are reminded of a third important framework, our own gravitational alignment with that emphasized by verticals in the picture. That lit gourd, which Jerome's famous translation as coming up and withering in a night,[17] groups with the saint's illuminating head and the sunlit skull on the windowsill, with a facial axis at right angles to his, in fairly obvious similitude, as the sand clock sifts above. No wonder if, besides Panofsky's warm "enchanted beatitude," some "darker vibrations" appear, in the words of Eugene Rice, who adds that the relation of the skull and crucifix comes clearer if we imagine it from Jerome's point of view. Were we to imagine him looking up, writes Rice—and the picture seems to invite such imagining—"he would see the skull in profile and directly in line with the crucifix."[18]

Let us consider what we imagine seeing, if we actually look at the picture from the closer, right-edge construction position suggested above. As the window wall shortens and the depth effect increases, the room shrinks, the gourd comes in front, almost over our heads. The shadow contrasts increase as the light becomes less mellow, in shafts rather than oblique suffusions—a more dramatic illuminant: what does it illuminate? The skull, which Panofsky found "inconspicuously placed" and looking "friendly," then seems to gaze directly at the crucifix along a pronounced lateral plane, that is, on a plane parallel to the picture plane, defined by the table edge. We see the crucifix and skull then not as seen by Jerome, not in profile and from the opposite side, but from our different point of view. The result for our "imaginative project" is remarkable: the axis of the picture tends to rotate ninety degrees, as what is seen—the window-framed skull, seeming to gaze at the crucifix—becomes the invariant, while our own view joins Jerome's as one view, not a favored one—a variable.[19]

Is Dürer's "Saint Jerome" then a puzzle picture or a pop-up? That there are these two ways of our looking at the picture does not make it like an ambiguous picture, for, once seen, one way is taken up into the other. For example, the skull seen in the normal way becomes more intent in its gaze after being seen from near the projection point. This does not mean that Panofsky's sense of "warm, bright and peaceful seclusion in a well-ordered study" evaporates, but rather that it becomes modified. But then, that is how environmental perception works too, with our two big frameworks of perspective and illumination. It is normal for vision to take several looks at things from different viewpoints, and we adjust our vision to what someone reports from a different perspective. That a cloud suddenly veils the sun, changing the scene and taking the sparkle from eyes, the sheen from hair, does not mean that a person seems altered: we are used to seeing things in different lights.[20] This goes for pictures, too: it is normal to look at them in different lights. Contrary to geo 1 prejudices, this holds no less for pictures that emphasize perspective than for any others. Enlightened galleries are letting in natural light, and—observing people away from theater and TV screens—we find that it is normal to advance toward pictures and to retreat, carrying the information from each view

into the others[21]—thus part of our interest in "hard copy" printing of even our digital photos. Such study is all the more relevant to a picture like the "Saint Jerome"—a "master cut," as Panofsky calls it, whose technical brilliance invites and rewards many minute observations as well as overall study, and the evidence is that the artist gave prints of it to connoisseurs.[22]

Once again, our drawing tool kits are just that—collections of devices—while, obviously, art depends on what is done with them. Whether or not Dürer's treatment of perspective in that great engraving is the result of a mistake, the important thing for our purposes is that artist has made good use of it. This drawing provides one of a multitude of examples of how the technology of linear perspective, derived from natural sources, can take full advantage of those sources while developing autonomously—rather as water mills, constrained by physical laws, take advantage of those laws to evolve the shapes and uses we, not nature, give them, through clocks, modern turbines, and other offshoots. Telephones and sound recording have taken our audio communication away from ancient constraints of space and time; similarly, linear perspective allows us to exploit nature's structures while liberating us from its constraints to viewing points.[23]

Still, to understand drawing, we need to be even bolder regarding the autonomy of the marks we make. Even though artists such as Dürer are free to take apart and manipulate the variables of perspective and illumination in distinctively graphic ways and for distinctively pictorial purposes, these visual framework effects—along with the more local resources such as contour, shadow, and shading previously considered—provide good examples of Gombrich's Same Mill Principle: that is, of transfers (not imitations) through continuity of environmental perceptual effects to picture perceptual contexts. We recall that a main hypothesis of chapter 7 was that graphic representation would probably not become sufficiently vivid to qualify as depiction unless it were rooted in some rather direct transfers, discussed by Gombrich under the heading "projections." However, Rawson also rightly insists that drawing has its own resources, and anything that hopes to be a good drawing must give special emphasis to these. From this point onward, the theory will move steadily in that direction, emphasizing resources of drawing increasingly remote from those of environmental vision. I will even argue that drawing thereby exceeds those resources, thus that the Gulf Principle is not a deficiency principle. Turning away from our emphasis on transfers from natural perception will not mean turning away from the phenomenon of transfer, however. Rather, the rest of the book will widen the scope of "transfer" to cover discontinuous kinds, as drawing is presented as assuming more of our mental and psychological life.

12. drawing's own devices

So far, in considering advanced drawing resources, we have followed outstanding expositions and developments of what—it might be objected—are simply generally accepted ideas. To emphasize "seeing through drawing," as does Rawson, is normal. Nicolaïdes says right away: "Learning to draw is really a matter of learning to see—to see correctly—and that means a good deal more than merely looking with the eye. . . . The sort of 'seeing' I mean is an observation that utilizes as many of the five senses as can reach through the eye at one time."[1] Often drawing books begin with a list of drawing "elements," where (see the quoted testimony in chapter 7), line, especially contour, is given preeminence. We can expect most sources to say something like the following sample: "Line is used . . . in three ways. (1) It functions to separate areas. In doing so line defines boundaries. . . . (2) Line also establishes a sense of movement. . . . directional movements that give the composition its dynamic energy. (3) Line also creates a textural tone. . . . Each type of line has its own expressive character. . . . The simplest line suggests direction, divides space, has length, width, tone, texture, and may suggest contour."[2] We can also expect some hints of theoretical ideas from such sources. Thus the same author writes: "Whenever an extended mark is made upon a surface, whether with brush, pencil, or pen, a line is created" (287). What we do not ex-

pect is for the idea of extension to be elaborated and put into relationship with other spatial conceptions, as in chapter 5.[3] That such texts do not develop their perceptions theoretically is hardly surprising, given that they are written neither by nor for theoreticians, and that, as remarked in Part I, little adequate theoretical vocabulary exists to sustain them. For his part, Rawson was determined to move the standard job on theoretically, yet "to avoid using cant terms of criticism which are so often uttered glibly without any explanation of what they mean, . . . and . . . refer to subjective, unformulated emotional expressions." Instead, as we have seen, he sought terms "chosen because they designate things that can actually be found in drawings by looking, and . . . can be explained clearly and consistently" (*D*, vi)—and, we may add, that cohere theoretically. In accomplishing this Rawson presented ideas that set him apart from most other writers and teachers on the subject, and these ideas concern not so much matters of technique as the most basic issues: a conception of drawing that separates it from other visual media, and a theory of drawing's deepest sources of its meaning, which has the most to say about its significance, for individual development and for understanding it as an art. This chapter attempts to establish just how far Rawson moves that project forward and when we must turn to other theoretical resources.

Our thinking about frameworks such as projective systems, and about illumination and shadow as drawing resources, already shifted the discussion to a different stage of our advanced drawing course. Our account of drawing, from infancy on, has been rather Villardian, that is, based on individual objects, then working outward to larger groups and scenes, rather as Villard's mill (or the child's playground) drawing does. This is even true of much of our recent consideration of mass in objects, partly due to our beginning emphasis on the dividing effects of line, then on the enclosure powers of contour. Those uses of lines or 1D primitives tend to present separate shapes against the drawing ground, and to depict separate bodies or the spaces between them, and these 2D shapes then come into relationship with one another and with the format, the borders of the drawing surface. Such is the basis of much effective graphic design that is called "layout" or "composition"—a late stage in old studio training practice. An easy step away from such thing-based conceptions might consist in noting that—as is much stressed by drawing teachers— our shape awareness also includes the "negative shapes" between the object contours we draw. For example, if we look again at our favorite area of the *Creation of Adam,* we find that in both our "Study for Adam" and the fresco Michelangelo was so interested in the teardrop shape of the negative space between Adam's upper arm and thigh that he enclosed it in a contour, which does several things. First, it gives us the categorial sense of an "entity," though one for which we have no ready verbal category (thus the ad hoc "teardrop"). Next, this entity is given the sense of active convexity, even while the line is producing on its opposite side some of the West's most famously forceful bodily convexities. Michelangelo achieves this partly by defying the corporeal convexity rule at two places of anatomy: at the figure's left armpit and at the roughly symmetrical point on the thigh, where in our preparatory drawing he had remembered to correct himself with a tiny arc—painted out in fresco. The resulting negative shape resembles that of the bony prominence of the knee. Furthermore, by rotational symmetry from its apex, the negative shape groups with the positive form of the left thigh and, more importantly, becomes part of an even larger negative volumetric entity, by means of

the "third contour" path of self-shadowing that includes Adam's biceps line, curves through his nipple, and back toward his thigh, suggesting passivity in the figure's pose. This is only one case of contour and enclosure, but the same holds for all the other devices we have considered.

Although, concerning both perception and art, it is risky to say that we could predict anything, we can perhaps sometimes say that we are not surprised by these uses—or should not be. Indeed, on the approach taken here beginning with Gombrich's early principles, we should not be surprised if two sorts of things happen. If the devices described in the last chapter have the power to evoke effects depicting objects as shaped volumes, we should not be surprised if artists use them (as we saw with Goya's "Wounded Man") to produce effects that do not run particularly toward depicted objects, things. We should also not be surprised if they are used to connect groups of depicted objects and features into interconnected whole beings, as though they were all parts of continuous bodies.

Even within figurative works the basic graphic spatial techniques of enclosing contours, depth-slices, plan sections, bracelets, bubbles, facets, polarized lines, chiaroscuro, parallel hatching, and so forth can be deployed across distinct features and objects, even among units that are not objects, as we just saw with a negative shape and volume, and there is nothing to prevent them from having multiple functions. Thereby drawings can suggest 2D shapes and 3D or even volumetric "entities" to our vision—part substance, part negative space—for which there are no ready categories. As mentioned regarding the Creator in the *Creation of Adam,* such entities often enclose depicted things, making unities of the bodies they group: sometimes whole scenes are unified in this way. But such entities may also cut across depicted substances, as we saw with Seurat (fig. 84) and the shadow paths of Rubens and Poussin (figs. 81, 82), making up units for space perception that associate things with different meanings from those of standard substance categories.

One effect of the long brushed lines characteristic of Chinese nature depiction can be the lack of clarity as to what are the forms and what the depicted features and objects, with the philosophical suggestion of the impermanence or arbitrariness of our insistence on lexical units or categorials applied to some transient forms but not others (fig.

72). By contrast, in "Saint Jerome" we found a Villardian emphasis on distinct objects each presented with its clear *eidos*, its characteristic texture and closed form, which, as we saw, the artist can hardly bear to occlude. Indeed, were it not for Dürer's frameworks, notably the engraving's soft tonality, his picture would be in danger of going to bits, given that it does not work by the methods just indicated. Its negative shapes are hard to identify and unimpressive when found, and Dürer's marks and lines enclose few forms that do not directly correspond to things or features of things.

DRAWING DYNAMICS I: GOYA AND SHIFTING

Gombrich's tool-kit approach to "convincing representation" opens the way to see how artists have developed its effects autonomously. Any technique used for producing vivid spatial depiction of substances might also be used to suggest spatial entities—shapes, volumes, axes, directions, movements—that correspond to no substance categorials and are therefore not things that would be mentioned in describing what a picture is a picture *of*. An easy step from what we have just established is to see that, if such noncategorial entities can be suggested in figurative pictures, as Rawson stated, "All the drawing techniques we have mentioned can be used non-figuratively" (*StD*, 35).[4] Indeed modern criticism has tended to turn the matter around, to insist that figurative pictures rely upon abstract shapes, volumes, tensions and movements. This sometimes leads to a sharp dualism (to be treated in Part IV) of "fatal abstraction." Avoiding such tendencies, let us consider a fully figurative drawing, Goya's "Two Prisoners in Irons." On page 164, in connection with shadows, we noticed a 45° oblique diagonal and angle made by the shaded level, lower right. Now it might be said that the function of that is to "balance the composition," but, as often, it is not altogether clear what "balance" means—or why it is good to be balanced. Let us experiment with it—while avoiding simplified diagrams (criticized by Rawson, *D*, 185). When we cover the shape (even replace it with a detail such as a Goyaesque shapeless bundle) it is evident that something radical happens to the picture: while there are important diagonals, the emphatic horizontal/vertical grid controls the entire picture, enforcing its ortho-

graphic presentations of the back wall, its stone blocks and iron bars. The small prisoner's frontal presentation is stressed by linkage to the opening directly behind. The drawing format, divided into vertical thirds, then appears quite vertical, stressing the vertical axis of the figure of that prisoner. Goya, we are told, drew quite slowly: now put back that angle shape—and amplify it with the parallel diagonal chain, as Goya saw he should—and several things immediately happen. First, the oblique depth indication pulls the small figure back into space relative to the stooping one. More importantly, the whole dynamic of the picture changes as Goya liberates perception from dominance by the grid. The drawn and indicated 45° angles that Goya frees up from that grid become activated into their own strong system—stressing the slope of the larger figure's back. A simple, revealing case is the joins of the keystone above the barred gate. Before, they were seen symmetrically, as enforcing the frontality of the gate, like antennae sticking out of its form; now they are dissociated into different systems, the right-hand one paralleling the chain and oblique shadow, the one on the left indicating a diagonal axis through the two prisoners. Even the vertical joins of the stone blocks reform a stairlike diagonal down to the right.

This discussion allows us to be more concrete about what Rawson called "transverse linear relations." With a term used by modern artists, let us look briefly into the important phenomenon of "shifting" in this drawing.[5] Shifting happens between our big shadow angle and the darker pool of ink defining the figures' joint shadow, as the two shapes seem to tug at one another. Perceptually, they seem to move, to slide past one another in a shearing action, rather as objects in different depth planes slide as we move past them. A horizontal movement is then set up throughout the drawing: thus the dark shadow pool, pulled toward the right margin, drags along attached shapes. Thereby the marks defining the human figures acquire additional dynamics. They look different to us, so we imagine what they depict in a different way. The smaller figure, which had seemed very frontal and vertical, seems to be pulled laterally toward the dark wedge. These dynamics show why, contrary to common opinion, drawing a picture does not consist in drawing things or in drawing scenes containing things—or even in "balancing" things in composition. What is it that people who do not

understand the arts of drawing fail to understand? It is that drawing a picture is usually a matter of dynamics. Thus there are many who can draw things well but simply cannot draw pictures, while others draw pictures without drawing the things in them particularly well.

DRAWING DYNAMICS II: CÉZANNE'S SHADES

Another way to set up dynamic interactions is purposely to oppose the working of one spatial device with another. Rawson, we recall, had insisted on this with his 2D/3D tension, held to be necessary to all great drawing. As a further step toward modern, nonfigurative drawing, let us consider Cézanne (fig. 89), who has been called the "Moses of modern art" and is a key figure in the emergence of nonfigurative modern art out of the spatial practices we have been reviewing. Here we find clear evidence of dynamic interactions through the "push/pull" exploitation of familiar devices from our drawing tool kit. In chapter 10, regarding relief, we considered the prehistoric (fig. 78) and widespread technique of shading in from contours to give figures some sense of volume. That, we saw,

may be done in continuous tone or by lines, sometimes parallel hachure. But there is literally a flip side to this when, polarity reversed, shading runs outward from the contour, suggesting a darker ground behind, as with the left shoulder in the Vinckenborch (fig. 75). Unless countered, this runs some danger of flattening the contour of the figure, like a playing card. As Hale points out, in life drawing, "Almost every beginner shades behind the form, . . . because they erroneously believe that the black rear form will push the front form forward. The professional realizes . . . that the way to bring the front form forward is to intensify the contrast between the planes of the front form. The cast shadow *is* used at times on the rear forms, but it tends to kill the planes and destroys the illusions of true shape when it is misused."[6] A moment's thought suggests another danger: unless controlled (see Michelangelo's "Study for Adam"), shading inward from contours may be mistaken for shading of a kind that Hale deplores: an even clumsier mistake. But, recalling Steinberg's comment that "the best clumsy ones are Cézanne and Matisse," Cézanne's drawings and paintings greatly exploit just that ambiguity.

Better to appreciate that, let us observe how a

Fig. 89. Paul Cézanne, Sketchbook No. 2 (Trees), 1875–86. Graphite and pen ink drawings on paper, bound into a book, 12.4 × 21.7 cm, 1 page 25. Photograph by Greg Williams. Arthur Heun Purchase Fund, 1951. © Reproduction, the Art Institute of Chicago.

typical (though not very good) drawing by that artist provides a review of various themes of Part III.[7] Blake would not have been amused by such works. Like Poussin (fig. 86), who influenced him, Cézanne draws with broken contours that are almost not contours at all, for he builds them with short strokes, resolutely not completing them around objects and abandoning them where they lack shade or shadow borders. Like Poussin, he is more or less indifferent to line quality, since he displays relatively little of it. Poussin's compositional studies give much attention to shadow paths (fig. 82); more radically, as Rawson notes, "The basis of all Cézanne's drawings is the evolution of carefully structured shadow-paths," to whose service he impresses lines (D, 119). Thereby, says Rawson, lines lose their movement and even their basic outline and contour separating functions—a progression, he suggests, from painterly Dutch drawings of the seventeenth century, with its "mobile sequences of loose lines ... defining shadow paths." Somewhat closer to the testimony of our artist, who chose his words carefully, is Rawson's observation that Cézanne's lines retain "linear significance" while giving up their edge and contour functions "as a consequence of their imitating the brushwork of the painter in setting down areas of shadow" (D, 117)—if we leave out the emphasis on shadow and think instead about color. Cézanne, it is reported, opposed efforts to "circumscribe the contours with a black line" as "a fault that must be fought at all costs," warning: "you will soon turn your back on the Gauguins and the Van Goghs!" He is also known for remarks such as "There is no such thing as line or modeling; there are only contrasts," and "One should not say modeling, one should say modulation."[8] The contrasts intended seem to be of color, with which he sought depth effects. Still, instructive for our theoretical purposes is that Cézanne saw this as a transfer from natural effects. In lieu of contour and modelling, he said, "nature, if consulted, gives us the means of attaining the end."

Now to his "clumsy" use. Cézanne characteristically shades both inside a contour and out from it (assisted by duplicated contour marks), which introduces an ambiguity, even a reversal, in figures such as tree trunks and walls with the space enclosures of distant objects beyond them. His shading of positive forms also gives edge and thereby contour meaning to the voids beside them. The result

is that his negative enclosures not only form "windows" between depicted figure volumes, but these emerge as positive figures rather than grounds (fig. 89), so that distant objects contained in their spatial envelopes bulge forward between the framing contours. But the effect, rather than an ambiguous figure flip-flop, provides a simultaneous triple vision: a strong awareness of the marked surface as such and of two opposed imagined spatial motions, with a solid experience of depth. Noticing that, we start looking for other deployments of this "clumsiness," which we immediately find in the drawings of his great contemporary Seurat, which work on entirely opposed principles. Here (fig. 84), above the hand, negative shapes contend toward flatness, bulging the negative space (which resembles the one we found in the "Study for Adam") forward by "shading" it. Later artists, including nonfigurative ones, would carry on such effects. Two advantages here of our tool-kit approach are that, first, it frees us of the restriction of thinking of the nonfigurative in terms of "abstraction"—that is, as due to leaving out much of what is "there" (note how the monolith of "the appearances" arises again)—and second, it frees us of the frequent assumption that such pictures rest on vague, associative object suggestions. Rather, artists may freely *play* with devices normally used to evoke objects but not actually use them for that purpose.[9]

FORM AND FACTURE I: TOUCH

The superbly controlled stroking touches of the Seurat introduce the next resource. As noticed in our consideration of "the blob," Rawson's approach is distinguished by the emphatic place it gives to signs of physically productive processes in its account of drawing resources. In our study of drawing resources, for example projective systems, I have emphasized transfers from activities of environmental perception. An important aspect of Rawson's approach is his insistence on perceptual transfers from drawing processes themselves. In discussing our Dürer "Saint Jerome," we attended to spatial congruencies (and noncongruencies) of marks, primitives, depicted features, and subjects, but not to the mark-making process. True to our promise of not being "spaced out," we now begin a series of steps that extend our attention to nonspa-

tial resources visible on the marked surfaces of drawings, including correspondences beyond spatial congruence.

Pictorial elements at the level of marks, picture primitives, and shapes possess many characteristics that may correspond with aspects of depicted things and situations. We have seen how even non-depictive diagrammatic drawing depends upon such correspondences, as it is common to diagram separate units by putting down lines that together construct separate enclosures, whether tangent or set apart. From such rudimentary cases we noted how drawing correspondences need to consist not in *looking* similar but in *being* similar. The region on the surface is like the 3D entity it represents by being closed, not tangent, and positioned between one region and another, just as the represented entity is. I stressed earlier how orthographic methods capture a highly valued correspondence. Next, we saw that correspondence is not restricted to pictorial and represented entities. Different pictorial components may correspond as well—may be "congruent." For example, some lines are congruent with the marks by which they are made, but a line may be composed of a number of marks. Lines may even be indicated by marks none of which touch it. The same holds for enclosures: in the "depth-slice" and "ovoid" techniques, as Rawson points out, enclosures are indicated by lines that do not touch. Congruence between pictorial elements and depicted things is, however, more difficult to describe, though easy to experience. It is easy enough to describe *non*congruence, due to noncorrespondence, at those levels. For example, the imagining of continuous occluding contours of objects is routinely elicited by marks and line primitives that leave gaps and are thus not wholly congruent with the contours; 1D junctions are often indicated by drawn lines that do not touch and thus do not fully correspond to them. Depending on the kind of drawing, congruence and correspondence may or may not be the better means. Again, we saw, from the young child's "tadpole" figure how a larger unit of 2D shape may be made by topological connections of enclosures and attached lines, none of which is congruent with the overall shape. When it comes to representation, all, some, or none of these graphic elements may correspond to objects, to parts of them, or to groups of them. They may also correspond or not to features of objects—notably to occluding contours or

to oD features such as junctions, like that of the plinth in the Dürer engraving (fig. 87) or where the edge of the bench is occluded by the pillar on the left).

An oft-noted, significant aspect of this, which we observed with the youngest children's drawings, is the relationship between picture-primitive and verbal categorials, such as between a drawn enclosure and a thing or part of a thing. "One of the most important issues," writes Rawson, "in the whole question of graphic enclosures is this: many art styles, particularly those usually called primitive, make their units of enclosure correspond exactly with those units of the notional world for which there are spoken names. . . . As individual art styles develop, however, we find that the area of the notional world designated by particular enclosures slips progressively further out of correspondence with named things. . . . In the most sophisticated styles all the enclosure-units define elements of visual sense which lie beyond the reach of words" (*D*, 151–152).

We move away from purely spatial correspondences when Rawson remarks on a quality of "softness or gentleness," when the "line which emerges in the agglomeration of touches . . . did not happen as a consequence of a comparable phrasing of the hand's actual movements" (*D*, 114). In describing Asian treatments of small depicted elements, Rawson notes direct correspondences of marks to depicted things: "it was customary to represent, say, bamboo leaves, twigs, or orchid leaves each by means of a single sophisticated stroke of the brush, creating an organic correspondence between the object and the graphic symbol" (fig. 69)—indeed such strokes were sometimes named for the depicted element. Once this correspondence is made, visible variations in the marks, such as pressure changes, may count as drawing units, which yields a "homogeneity of touch between the small items in a drawing and the larger notional objects drawn with bigger lines" (*D*, 101). Rawson generalizes this theme to other traditions, to include again noncongruencies, under the topic of "touch scale" in drawings:

> The touch may in general be fine and small . . . or it may be broad and compel the eye to a certain distance from the subject, as with Rembrandt. . . . In some styles this touch may accurately correspond with small

details of objects which are near to hand, such as twigs, wrinkles of cloth, or the shadow of a pebble . . . [as] often in Chinese drawing [fig. 70]. But in other styles small elements may need many touches to suggest them. . . . In styles like those of Cézanne and Renoir all small elements such as twigs and leaves are totally suppressed even in the foreground, and all objects are treated as "bundles" or masses. (*D*, 212)

FORM AND FACTURE II: TIME

The aspect of physically formative signs in the drawing to which Rawson gives most emphasis is time. "A stroke, even a dot, takes time to make," he will typically write, "and so shows to the spectator its beginning and its end. Herein lies the vital, unique quality of drawing, which distinguishes it from the other visual arts—its expression of time, movement and change" (*StD*, 24). Following is a fuller passage from *Drawing*, which (again divided by number inserts) shows the development of these ideas.

[1] Drawing is done with a point that moves . . . , a tool acting as some kind of surrogate for the hand with its fingers, has made a mark that records a two-dimensional movement in space. . . . [2] [Since] such movement is the fundamental nature of drawing . . . there always lies at the bottom of every drawing an implied pattern of those movements. . . . [3] Therefore in appreciating drawings, no less than in making them, one has to be continuously aware of the character and qualities of the sequences which went into their composition. To get at these one has to look into the drawing carefully to find the order in which its parts were executed. . . . [4] This quality of underlying movement is, of course, the special "charm" of drawing. . . . [5] There have been [only] a few great European artists, among them Rembrandt and Goya, who have succeeded in carrying over into painting the full quality of drawn movement. But for thoroughgoing preservation of the qualities of drawing in painting one has to look to the Far East—or to Western "action painting" based on Far Eastern ideas. (*D*, 15)

Thesis 1 closely agrees with the views of this study since Part I; 4 and 5 are important developments of Rawson's views, but 2 and 3 (linking production to perception, artist to viewer) are the ones that most concern us here. In them Rawson stresses "order" and "sequence" and is explicit about what we might call "sequence facture."[10] As we saw in chapter 2, temporal values may be ordinal, interval, or metric. Rawson explicitly mentions sequence—ordinality—but probably intends comparative intervals as well, when stressing principle 3 in his later book: "If we do not follow through in time the traces left by the artist's moving hand we are bound to miss the point" (*StD*, 24). In such strong formulations, Rawson's position will draw criticism: let us consider some likely ones.

A general objection already argued in connection with perspective was the fallacy of material causes. This is the mistake of exaggerating the importance of production in the understanding of works, for example, in assuming, as many do, that since photographic exposures are made in split seconds the essence of all photographs is that they are "frozen moments" of past times, and we have Gombrich to remind us that "it is dangerous to confuse the way a figure is drawn with the way it is seen."[11] Still, it may be said in Rawson's defense that, right or wrong, no fallacy is committed—neglecting the "Therefore" in statement 3, which represents no inference. More indicative of his reasons are statements 4 and 5, where he distinguishes drawing from other visual forms in these terms. He invites us to see whether we agree that the data, looked at in these terms, are better understood and more interesting. Many will agree. John Elderfield notes "how a drawing's very identity presents itself to us, to an extent beyond that of any other work of visual art, as the direct record of the movement of the artist's hand." "A drawing is intrinsically the record of movement in time," Elderfield continues, adding interval time to Rawson's ordinal: "More often . . . a drawing comprises a network of recorded movements, which tend usually to slow in their accumulation. And our appreciation of a drawing like this requires that we retrace these movements, their duration and their accumulation, from the evidence they have left behind."[12]

A more pointed objection concerns whether such "an implied pattern of . . . movements" meets Rawson's own criterion of the "visual facts," "things that can actually be found in drawings by looking." In reaction to expressionistic tendencies

in art and in its understanding, in the late twentieth century there rose to dominance in philosophy, art criticism, teaching, and practice itself a "cooler" approach, deeply skeptical of both our capacity to recognize in works the actual sources of their production and of the relevance of whatever of that we do discern. This reaction was itself often excessive; there is space here for only brief indication of its motivations. A main one was a predominantly "aesthetic" conception of art, according to which the aesthetic was to be understood as the perceptually "immediate." It was thought that, in arts such as drawing where the artwork is the product of a previous productive activity, productive activity could form no part of what is immediately perceptible. The production of the work was said to be an event belonging to the (often remote) past and to some other place, whereas the immediate—and thus the aesthetic, which is allegedly what is relevant to experience of art (typically called "the object itself")—belongs to a different, present order.[13]

There would be many things to say about this version of an ancient atomist, sensationist, observer-based philosophy. For present purposes all that concerns us is its remoteness from the actual perceptual experience of "the object itself." Normal perceptual experience, for human and other animals, comprehends the past and the future as part of the present experience, and it is unlikely that such creatures could survive otherwise. Regarding the past, this is particularly true regarding just what is at issue: the formative or causal agencies responsible for the present condition. Notwithstanding Hume's typically atomist-empiricist declaration "All events seem entirely loose and separate," contemporary psychologists tend to agree that "people possess beliefs about naturally occurring objects (or natural kinds) that attribute their identity to the processes of their origin."[14] The same goes for artifacts, as shows up in our ways of talking about them. Those who claim not to understand how past causes may be perceived in present states presumably have difficulty with standard menu items such as "aged," "baked," "tossed," "mashed," "sautéed," "slices of," "whipped," "freshly brewed," and difficulty not only with saying "dry-braised green beans" (though easier to pronounce than "fixing Dürer's ewer") but with perceiving them as such. Some of these words may have very vague meanings for us; none implies a detailed sequence, but at least we

know that they represent some kind of processing that took place previously to our being served the results—anthropologists not being the only ones who give significance to the "raw/cooked" duality.

Many of our everyday substance and mode categorials present effects in terms of their causes, for the very good reason that this is how they *appear* to us. Perception, like speech, could hardly operate without production noun categorials such as "cut," "scrape," "crack," "rut," "protrusion," "warp," and "dent," since things do and must *look* to us to be cut, cooked, smoothed, crumpled, and so forth. Trackers and detectives are not the only ones who discern them in terms of productive processes. Everyone possesses such surface-describing adjectival vocabularies—which in English may favor *s*'s, such as "scarred," "scorched," "scratched," "shined," "smeared," "smoothed," "soiled," "spattered," but can be carried through the alphabet with "age-worn," "baked," "cleaned," "distressed," "embellished," "freshly wiped," "gnawed," "hand-polished," "incised," "juice-stained," "knocked-about," "lovingly cared-for," "marred," to do just half the alphabet, which "xeroxed," "yellowed with age," and "zapped" might complete. Such everyday words describe how things look to us; things usually do look as though they have come about in certain ways and had history since. A tire track in the mud looks like it was made that way; it does not just look like a negative volume of a certain dimensionality, axis, and contour shape. At least one psychologist, Michael Leyton, is so taken with the place of "process history" in perception as to argue that perception itself is essentially in terms of it.[15] That is an extreme position, but useful as antidote to sensationist atomism. However, the weight of the case should not rest on vocabulary, where our main point is the perceptual experience of drawings.

As we shall soon see, part of Rawson's case for drawing's education of vision is the idea that drawing may present experienced things in terms of processes for which there are no such ready words as those just listed, not even expressions we can contrive from their combinations, and that therefore drawing constitutes an important expansion of our expressive means. With regard to the theme of drawing resources, we may understand Rawson's "kinetic" thesis of drawing production as follows: productive process and history is not only an important aspect of the appearance of drawings, it is a factor that may be actively ex-

ploited by the drafter for drawing purposes, including depictive and representational ones. In these terms, we learn more about the efficiency of drawing as an imagining-seeing technology. In chapter 6, I noted that depiction itself is an efficiency technology that exploits the following fact: given that we need perceptual access to representations to find what they would have us imagine, depiction subsumes that very access as part of what we are to imagine. Correspondingly, given that a sequence of productive processes must occur in order to get a surface marked, and also given that those processes will usually be visible to some extent in the result (as Rawson remarks in statement 2 above), it should not surprise us that drawing exploits that visibility, too, as a drawing resource. Indeed, Rawson all but defines drawing in these terms. It is of course possible to cover one's tracks, and many drawing techniques include ways of effacing signs of stages of production. But with the important exception of our Seurat, we have explicitly considered drawings as constituted of drawn marks that remain "pretty much separately identifiable," and together these criteria go some way toward agreement with Rawson.

From these replies to two common skeptical views regarding the visibility of facture, we turn to challenges to more specific parts of Rawson's sequence-facture thesis. It is important to notice that this thesis provides a range of options. Regarding the visibility part of principle 2, all our illustrations show to some degree how they were made. In most cases we have a sense of a something sequential, even if we do not know what the sequence is. For example, the design drawings of Part I are purposely fashioned not to show so much of the process of their construction (although even that shows something about their process). Although made by geo 2 steps, they tend to mask this sequence, making it hard to discern the order in which lines were put down and the direction in which they were drawn. Confirmation of Rawson's idea of normal drawing may be taken from this, given that design students are taught to roll the pen between their fingers as they draw a line in order to produce an evenness where facture would normally be detectable. By contrast, the children's drawings of Part II exhibit process, though not by design—part of their charm—

whereas the Maillol, Poussin, Goya, Tiepolo, Zou Fulei, and Seurat provide a spectrum of cases of such design. Still, we may object that even for the drawings that exhibit sequence facture, statement 3 (about appreciation) by no means follows from 2 (about visibility), and it will be doubted whether these drawings are best understood by close attention to those sequences. Once again, the issue surely depends on cases, and our approach to "all kinds of drawings" should actively resist assimilating them to a single kind.

Still, in response to these qualifications, it might be replied that Rawson's theory is centered on drawing as an art, and that although it is intended to apply to many other kinds of drawings, his comment that "if we do not follow through in time the traces left by the artist's moving hand we are bound to miss the point" really concerns art specifically. Regarding the resources of drawing as art, two issues arise: the visibility of formative factors and the import of what is visible. It is Rawson's view that with practice ("one has to look into the drawing carefully"), we can come to perceive the sequence facture in most drawings. If we are skeptical about this, there are two points to make. First, as he has cautioned, "It may be quite difficult at first for the reader to pick out the visual facts"; second, we should expect that thoughtful, including theoretical, writing about drawing will teach us to perceive important aspects of drawing that we perceived before less clearly or not at all. After all (as David Sanford has remarked), there is little point in the beginning medical students complaining that they cannot see what the teacher refers to in an x-ray: by the time they graduate they will have learned to. One of the great merits of *Drawing* is the manner in which Rawson takes the reader through the sequence-facture rhythms of a number of works from various traditions and various media, and nothing I have attempted in exposition substitutes for his case studies (notably in *D*, 219–243).

In conclusion, a more speculative issue about the general significance of educating our perception of drawings takes us back to questions of chapter 10. According to Rawson, "movements suggested by traces of the drawing-point ought actually to guide the motions of the eyes"; thus, at least with artistically interesting works, we can learn "advanced scanning procedures from artists . . . thereby educating the eye," for "artistically minded people actually see (and so perceive

and understand) more" (*D*, 17). The implication of this statement is that not only does drawing educate our vision of pictures, it also shapes our environmental vision. This may be plausible regarding observational drawing—for example, the life drawing that Hale describes—but could it also apply to nonobservational drawing? Presumably it can, because environmental vision has also been shown by psychologists and physiologists to be a "scanning" process, though a far more elusive one. Here Rawson's view seems to be that by involving, slowing, and orchestrating subject recognition in pictures, drawing can affect environmental recognition habits. "Someone who reads the drawings of masters can assimilate new ways of scanning the sensuous characteristics of his world," writes Rawson, so that one's "own mind can develop fresh patterns of active experience and perception" (*StD*, 23). There appears to be some evidence for this in the well-known phenomenon of one's environmental perception being temporarily affected by works of art that held one's attention through their strong sense of form, even when these works do not depict similar things, or depict anything at all. I will later argue that when looking at drawings that are works of art one does have the sense of being in good hands, and sometimes one can take this strong seeing back to everyday experience. Accordingly, Rawson is critical of what he considers a miseducation of vision by much advertising imagery, which is designed only for "immediate visual impact" (*D*, 19). At this point, however, Rawson's theory may seem thin and his evidence remote, in terms of "things that can actually be found in drawings by looking."[16]

As important as facture, including sequence facture, is to drawing, we should not base our conception of drawing's visible formative structures on it. While it has been a serious mistake to overlook the formative aspect of drawing, it would be an error to put the case wholly in terms of kinetic perceptions, whether in terms of broad gestural indications, scribbles, angry cuts, and painstaking delineations or in terms of our expert's more subtle and informed analyses. Rather, the work we have done on drawing structure or "grammar," in terms of how marks define primitives and so on, is what an essentially *formative* conception of drawing must rely upon, although this conception must include visible facture.

MEANING AND SECONDARY FORMS

As we saw at the beginning of this Part III, Rawson makes a case for the value of drawing for learning to see, and he regrets that drawing activity normally fades away early in life. Some of that loss might be that children cease thereby to elaborate their own imaginative projects and become increasingly dependent on the projects of others. This is an important point, but it could not be what Rawson means by "learning to see through drawing." Indeed, there is a limit to the case for the value of drawing, since, for all his focus on depictive rendering techniques in drawing, surprisingly, he downplays concern with subject matter itself, calling it merely "the tenor" of drawings. "The *meaning* lies not in the tenor, but in how it is treated," he states, and this has to do with "the complex of forms with which [the artist] invests the . . . subject" (*D*, 5).[17]

How do these forms bring meaning and importance to drawing? One of Rawson's main speculations about the education of vision through drawing involves use of the ambiguous term "form." That we use perceptual, verbal, and other categories in perceiving, thinking, and communicating is undeniable. Explicit verbal and perceptual recognitional categories apply "forms"—that is, criteria of what is relevantly common—to aspects of experience in order to classify them. There are notoriously difficult theoretical problems in philosophy and psychology concerning how we come by our "primary forms" of experience or thought and what the content and criteria for any of them are. For example, the object in figure 32 has been identified as a ewer, an urn, and a vase: which is it? A ewer is a large pitcher (thus the large, curved, single handle), usually with an oval body (which this partly has), but also with a long or flaring spout (indicating fluid contents) that is significantly lacking here. So perhaps figure 32 shows a one-handled urn: as emphasized in chapter 8, such names have functional meanings, and neither the function nor the material of the object seem clear in this woodcut.

Thus the vagaries of everyday visual and conceptual forms. Rawson is not the first to insist that there exist alongside such forms "many analogies which we make unconsciously between those features that we seldom recognize consciously at all, since they . . . cut across the categories of utilitarian form-recognition" (*D*, 25).

Well-known psychological theories hold that deeply tacit forms affect our experiences, and may, in seemingly irrational ways, mold our conceptions, attitudes, and actions. Rawson, however, is interested in many other "secondary forms" for we which we cannot claim depth-psychological importance—perhaps, for example, the remarkable hat form that seems to blossom in the Seurat (fig. 84). He even suggests that by far most of the mental groupings we constantly make are of this secondary sort, which we may try to express in figurative language or by use of the arts. The advantage of such kinds of expression, he conjectures, is that by thus "vivifying" these secondary forms, "we can make ourselves aware of that lost part of ourselves, our suppressed perceptions and memories" (D, 26). As a way into such subtle matters, a simple example is called for. Of course not all of Rawson's "secondary" categories or forms are spatial, and not all spatial categories (we have been at pains to understand) are shape categories; nevertheless, we have considered one good, relevant shape example: negative shapes. Depicted enclosures, we observed, include negative shapes as well as positive, contour-bounded ones. As we saw with the "Study for Adam" (fig. 74), the same contour lines often do double service, positive and negative. It is a truism that artists need to be aware of such negative shapes, sometimes consciously: that they must in fact *draw* them. Negative shapes also exist in environmental perception, where both our perceptual and verbal categories may be focused on positive shapes of things, but this does not mean that we are unaffected by negative shapes as we go about our visual business. It is unlikely that they could mean so much in drawing, as they do in the Michelangelo, unless they also meant something in normal perception. Rawson indicates that drawing is capable both of making more salient, and of developing to particular significance, the negative shapes unconsciously registered in environmental perception.

To the extent that Rawson's thesis locates meaning in drawing in its making us aware of such neglected aspects of experience, it might be considered one more example of what is called "expression theory" in the arts. Drawing, such an approach might hold, provides us with a means of bringing to attention and further exploring some of the transient, inchoate, and often seemingly irrelevant associations that normally attend our focused perceptions, conscious thinking, and social discourse. In this way, art, like science, shows how apparently unrelated things are related. Rawson's would then join a widely dispersed set of theories and speculations of a generally "associationist" sort often found in writing about art in modern times—and not even the most advanced writing, since Harold Speed remarked in 1917, "The commonplace painter will paint a commonplace picture, while the form and colour will be the means of stirring deep associations and feelings in the mind of the other, and will move him to paint the scene so that the same splendour of associations may be conveyed to the beholder."[18]

Within philosophy of art, a much criticized aspect of associationist accounts of artistic meaning is that they provide only instrumental (evocative, therapeutic) accounts of Rawson's "secondary forms," whereas artistic values must be intrinsic to the work. That Rawson does intend something intrinsic to the artwork seems indicated by the following two extended passages, the first of which likens meaning in drawing to meaning in verbal metaphor. Early in his treatise *Drawing*, Rawson writes:

> The marks made . . . in any drawing he looks at become part of the spectator's world of phenomena. His analogizing faculty sets to work upon the marks, their patterns and arrangement. They evoke analogous forms from his unconscious fund. Certain groups of marks . . . will be representational. . . . But the main bulk of the marks will not just refer directly to everyday objects but will "qualify" them by investing them with analogous forms from quite other fields of experience. The represented objects . . . , serving as one term to the bridge of metaphor, will thus be endowed with a kind of metaphorical radiance shed on them by the experienced analogy associated with them from those other fields. Most of these visual forms have no immediate utilitarian sense, so their meaning can only lie in their contents, and in the feelings that are associated with the chains of instances composing the content. (D, 26)[19]

Elsewhere Rawson provides examples of this, beginning with a sentence to which we will return in different argument contexts:

The fact that we know we are looking at a work of art puts us into a special reflective frame of mind in which our inner fund of forms becomes accessible to us. . . . We are free to match its forms by analogy with the contents of our memory fund; and when this realm of inner response is activated and linked up, a special kind of reflective consciousness is generated in us. . . . In a good drawing even the smallest units of form, the marks and lines, will evoke analogies. And many elements of a drawing must connect with our experience of other works of art, as well as of nature. So, for example, a certain curling line created by a draughtsman may, through analogy, suggest to us experiences and feelings derived not only from actual moving water, human gesture, curls of hair and eddies of clouds in the wind, but also from similar lines we have seen in other works of art which meant the same sort of things. . . . [W]e must expect it [analogizing] to read everything it can from the lines and shapes a drawing presents. . . . [T]he artist's job is to make sure that only right responses are invoked. (*StD*, 21)

By "analogies" Rawson apparently does not mean analogies in the sense of "rhymes" within the picture, yet these, too, seem important for artistic meaning. Consider an early drawing by Poussin, his 1622 "Polyphemus Discovering Acis and Galatea" (fig. 86, p. 175)—our second eavesdropper illustration. Here, as often in classical art, analogies of tree trunk and limb forms to human bodies are evident; but we also sense muscular effort, shown by shadow-assisted ovoids, rippling through the natural scene, including even the boulders. Boulder to buttocks is particularly important, since besides Polyphemus's rage at his discovery of the lovers, Poussin's subtle psychology expresses the Cyclops's fascination—even participation—in what he sees, his posture (by chapter 3's symmetry operations) closely analogizing not only to Acis's but also Galatea's. Perhaps Polyphemus is not the only one who enacts what he sees. Having earlier considered Vinckenborch's mighty back and Maillol's soft one, proceeding to the sacral triangle noted in chapter 10, let us add Poussin's. When we compare the three drawings' treatment of those pelvic points, we are prompted to draw on our kinaesthetic awareness to sense the differences among Vinckenborch's, Maillol's, and Poussin's three figures, as we understand their imagined bodies. As Richard Wollheim maintained, visual though it be, art of this Western tradition is rooted in often barely conscious experiences of our own bodies—"sensations of activity, sensations of moving the limbs or muscles"—upon which it constantly draws, so that even nonfigurative modern art is continuous with the figurative. But now we have gone beyond Rawson's secondary-forms thesis, on which he rests much of his case for artistic meaning in drawing. By considering first internal analogies—"limbs like limbs"—then analogical enactments by the depicted figures in the Poussin, we reached the topic of our own imaginative enactments in participatory perception of pictures.[20] Such participation has personal meaning beyond having analogous forms "evoked" from our unconscious. Like depictive perception itself, it takes special meaning from being something that we are doing: from a present active participation, not just the evocation of something past.

This is not to deny Rawson's account of evocation. However, that account also needs to be interpreted in terms of our perceptual activities, directed at drawings, lest associationism lead us to another "different hands" problem, like the one we encountered in chapter 6 regarding depiction itself. By his reference to visual metaphor, he does appear to intend the right sort of associative account. According to Rawson, the graphic elements themselves—and he does distinguish "marks, their patterns and arrangement"—not just what they depict, can have multiple functions. They have the direct depictive roles we have considered and besides—presumably at the different levels of mark, primitive, shape—may bring to the mind made receptive by depictive context other, unrepresented situations, which "invest" the subject matter with additional meanings. In this he seems surely right; the crucial theoretical question is, what does "invest" mean? Something more than just the evocation of unnoticed experiences and feelings seems intended—and that is necessary to keep the theory of drawing from collapsing at this crucial point. Our theory has all along been structural: beginning with the child's first marks, different factors, spatial and otherwise, have been introduced, always

as parts of a development to higher complexities. Such is our project. To think of "secondary forms" as providing meaning just by introducing feeling associations at points along the way would be to arrest that development and to leave this book's account of meaning in drawing unstructured—as though all the argument for structural elements in drawing had succeeded only in providing more niches for association, like the goblin gourd in the Dürer or the teardrop shape in the Michelangelo. For this reason, Rawson's everyday terms "evoke" and "responses" seem inadequate; surrealism alone should not provide the basis for drawing's theory of meaning. All therefore rests on Rawson's term "qualify," which implies that in depictive drawing the associated material be not only brought in as perceptual enrichment but also consolidated in the very work of depiction of objects, features, and situations.[21] In other words, we would need to see how the depiction is *assisted* by these secondary forms, not just how they might ornament it.

To make the theoretical issues again sensuously concrete, consider a parallel situation from architecture. When discussing faces in strange places, we considered one associationist effect of the interior decorative marble of San Marco in Venice (illustrated by a similar "butterfly" symmetry: fig. 62). Paul Hills also tells us, regarding those heavily veined marbles, that "not surprisingly, descriptions of marble call forth similes from cuts of meat, rashers of bacon, brawn, salami, or the layers of beef fat. Other veneers—particularly the Greek gray marbles—open depths as between layers of cloud. From a distance the butterfly patterns read as an opening of the heart of things and the spreading of what was inside upon the surface."[22] If these are examples of Rawson's "secondary forms," they seem more to the present point, even though their associations are recognized by common terms or allusions—Hills offers the example of "onyx, the word for finger-nail applied since antiquity to a variety of quartz" (41). But, simply as a collection, associations do not "qualify" or "invest" the architecture in the way we require. (Worthy of a cartoon: tourists are viewing a great architectural work; their thought-bubbles contain salamis, clouds, fingernails . . .) Hills intends something more interesting. "Archetypal associations of body and marble abound," he writes: "The rituals of the commemoration and preservation . . . in sar-cophagi of stone and marble drew upon and reinforced these associations of marble and the body." Crucially for our purposes, Hills includes an activity of imagining, with the building as object of imagining: "The walls of the greater body, the building, may be imagined as membranes, semi-diaphanous. . . . By touch and sight marble veneers are located upon the inner surface of the wall, yet their patterns, mobile and undulating, offer an invitation. Some seem to pulse, contract and expand like body tissue" (41), and Hills reports a "tradition of reading into marbles, or the effect of marbles, similes of daylight, fire or cloud." He continues, "The idea of metamorphosis, or of one material taking the form of or meaning an allusion to another, is common in anagogic meditation. In this light, to see similes of cloud and fire in the marble columns of San Marco is entirely fitting a Christian church. If coral breccias readily suggested fire, the undulating veins of Greek grey marbles evoked the waves of the sea" (45).[23]

It seems a great contribution of all the arts not only to draw on wide realms of experience and memory, including much that is fugitive or seemingly inconsequential, but also to have us put that *to use.* Thereby we demonstrate to ourselves that no aspect of our experience need be irreparably lost or devoid of value, since in principle any might be mobilized for the understanding of an artwork. The effect is a sense of wholeness, which has great independent significance, apart from the feeling contents in which Rawson wishes to ground his case for meaning. Quick confirmation of this thesis comes from opposite situations. We all know that activities that we consider "uncreative" tend to call on only very restricted parts of ourselves. Creative activities would be the opposite, and, as activities, things we do, they would call on dimensions of ourselves, not simply awaken them. Thus, to represent that sense of wholeness it is not enough to argue that drawings induce situations in which normally fugitive psychological activities or barely conscious visceral senses are evoked to expression, or even that such expressions bring with them associated feelings and emotions. The point must be that "secondary forms" effects are not only summoned but also put to work in the process of pictorial recognition, as resources integrated with those provided by the "primary forms" of normal recognition, which we have been studying.

It may seem paradoxical to suppose that secondary forms could not only be evoked (along with feeling associations) but also put to such work depictively. As remarked, Rawson likens the way drawings have meaning to metaphor, and that seemed a promising comparison, since metaphor is often no mere matter of bringing, in a diverting manner, the conception of one thing to the normally unrelated conception of another. Contrary to John Locke, use of figurative language can be more than a show of "wit lying most in the assemblage of ideas, and putting those together with quickness and variety, wherein can be found any resemblance or congruity, thereby to make up pleasant pictures and agreeable visions in the fancy."[24] There is increasing theoretical appreciation of the fact that effective figurative linguistic devices strengthen and extend our descriptive powers—including an efficient interaction of the two basic, seemingly independent grammatical representations, the semantic and phonetic (the latter including not just the sounds but the sensory-motor aspects of their articulation). For example, to continue Marc Antony's analogy to seeing things in clouds, the hero concludes, "thy captain is / Even such a body. Here I am Antony, / Yet cannot hold this visible shape," thereby likening himself to a vaporous state, which by the line "The rack dislimns and makes it indistinct" is itself likened, "As water is in water," which exploits the dissolving sounds—maybe also the articulatory action—of the English word "water." Thus the transience of humans, the shapes of evening clouds, water poured in water, combined with the sound of the words, even the sense of saying them, are for that occasion combined under a "secondary form" (which will itself not long hold) in such a way as not only to bring these things to consciousness but to use their connection to "qualify" or represent life. Regarding imaginative speech and literature, there is nothing new about such a gloss. A large body of literary criticism describes works in detail this way; furthermore, there are many theories about it—indeed many just about the use of figurative language, metaphor, and imagery: to rehearse any of these now would be to drown our own project. Following are only a few considerations about how Rawson's "secondary forms" might function in depiction.

The best way to argue the case would be through close attention to particular illustrations, identifying the analogies called on at different parts of drawing structures and showing how these are brought into the working of the depiction. That would entail the slow and challenging tasks of connoisseurship, for, as Rawson writes in his book *Ceramics,* "the problem for this book will always be that it is dealing with imponderables and unnamables. The text must amount to a sustained and varied invitation to the reader to use his own intuition"[25]—which intuition Rawson educates along the way, and again the theorist can offer no substitute for that. However, an auxiliary way open to theory is to work from general observations already widely accepted. Caricature seems to be one straightforward example of how seemingly unrelated categories can metaphorically "qualify" a depicted thing, and Rawson avails himself of it. "Caricaturists use analogy in a very emphatic way," he reminds us, adding that "in fact, there is no clear borderline between caricature and any other form of drawing" (*StD,* 20–21). Often caricature works just by exaggerating selected proportions while retaining recognizability.[26] Sometimes, however, caricature seems to work by Gombrich's Beholder's Share projection principle of seeing one thing in another thing that is otherwise remotely related. As Rawson remarks, the famous Philopon drawings (discussed by Gombrich in *Art and Illusion*) of Louis Philippe's head turning into a pear come to mind.[27] There are many other such examples—again, some closely related to our "faces in strange places" phenomenon.

One common type of caricature, when effective, combines immediate recognizability of the subject and an independently strong sense of willful marks, lines, and facture (not of things)—giving the impression of a whimsical disparity of the two, and of the unlikelihood that the latter could produce the former (fig. 57, p. 96). Thus the trick is virtuosic, as the joke is that the gloomy philosopher Schopenhauer's personality could be effortlessly evoked by such simple and unlikely means: effective caricature is usually reductive. (Even the Philopon comes down to that: it is about the marks, with a pear as the middle term.) Still, our theoretical question remains, whether such disparity of subject and means provides quite what Rawson needs. On the affirmative side, it does seem that typically, in such drawings, all levels—drawn marks, picture primitives such as lines and enclo-

sures, shapes, and so forth—are usually not only salient but saliently at work. Often there is a special emphasis on facture, part of the effect being that we seem to see the visage taking form, *being drawn*—and it is fairly common that this will appear to have been done swiftly and with very few marks. In such cases the implied movements and shapes of the marks seem willful, even arbitrary—not, as in other drawings, controlled by the subject—like flights of birds that have settled here but might suddenly go off in another pattern and direction, landing there. On the negative side, that all these elements should be active and visible only allows for the possibility of their accruing secondary forms. Showing that they actually do, and then suggesting how this becomes part of the material for the higher-level recognitions, could once again be accomplished only through particular studies—"cartoon connoisseurship."

In summary, to the extent that Rawson is right about the "kinetic" aspect of drawing facture and "secondary" forms, he will have done much to fill out our rather spatially based work, for it was our objective to identify the artist's main resources in "things that can actually be found in drawings by looking," notably "the facts of artistic execution." But that is best argued from cases and the reader's own "intuition," and challenges of a strictly theoretical nature would still remain. Regarding both facture and analogy, it is one thing to ground them in "the visible facts," alongside various kinds of shapes and tonal characteristics that none will dispute. But it is something else to show how either facture or analogy could play a role as intrinsic to drawing as that of shape and tone characteristics. This is particularly so regarding depiction, where the issue still remains how facture and analogy—like the dimensional, topological, and other shape characteristics of marks and primitives we have studied—might be used in order to depict.

Next, there seems to be a more specific problem regarding the case this chapter makes for the autonomy of drawing. Rawson's "analogical" account has a feature that usually poses a problem for expression theories. As he argues the case, drawing, like other arts, provides a means for articulating already existing matters—what he calls "secondary form" connections—and no doubt he is right. People have many beautiful or at least interesting perceptions that go by unexpressed, and it is no doubt a liberation to them to have adequate means

for working these out in physical media. One of the better aspects of photography is that it has provided such pictorial means for billions more people than was ever before possible, and such has been the declared intention of important inventors like William Henry Fox Talbot and Edwin H. Land. That is also the aim of the dedicated drawing teachers consulted in these chapters. Nevertheless, if we wish to speak of self-expression here, a standard objection to expression theories mentioned above is that they tend to present art forms too much as means to other values, rather than in terms of art's own value. Is the alternative, then, some form of aestheticism?

Rawson's account of meaning in drawing has helped us to this point, but here we take leave of it. As the very words themselves suggest, "expressive" and "aesthetic" approaches generally come at issues from the different perspectives of the producer and the perceiver. For example, Rawson, as mentioned, works from a "standpoint . . . not primarily that of appreciation" but rather "as it were from the other side, from the point of view of the maker of drawings," thereby hoping to "offer new insights to those whose interest in drawing is purely appreciative" (*D*, vi). Thus his case for the importance of "seeing through drawing" is based on the practice of drawing, although he carries it extensively into purely appreciative acts. Having sketched these problems, let us now consider them from the other perspective, that of drawing connoisseurship. Here Michael Podro provides us with an insightful approach, developed through sensitivity to the artist's role and greatly emphasizing drawing's own devices.

TWICE OVER

Rawson sought artistic meaning in drawing largely in terms of what he termed "analogies." Yet, as I suggested regarding caricature, it might be said that the most significant analogies that drawing discovers via the marks it makes are not between things the marks depict and untold items of experience, but rather between what is depicted and the drawing forms and procedures themselves. One way that such correspondences enrich content in visual art is through that visible facture that Rawson himself emphasized, when, as Michael Podro puts it, a "line relates itself to the figure twice over,

once by its shape and once by its apparent impulse." Then the "line connects shape to movement as they can be connected only in drawing."[28]

This phenomenon would be "twice over" in the following way. First, the line, by its spatial characteristics in context, produces an effect of the sort we have considered: for example, an occluding contour of an imagined body. However, as a drawn line, we have noticed, it may have direction, emphasis, and speed, all of which enhance our sense of the quality of the depicted contour. Leaf-, blossom-, or branch-depicting brushstrokes in Chinese painting will often be made by movements outward from those that depict a bearing stem, noticing which makes more vivid the sense that the leaf is not just attached to the stem (a spatial, topological idea) but grows outward from it, as we see in that amazing, attenuating, meter-long stroke that dominates half of "A Breath of Spring" (fig. 69). Chang Yen-yüan reports that in the calligraphic drawing method of the eighth-century brush painter Wu Tao-tzu, "bristling whiskers rooted to the flesh is entirely satisfactory."[29] A quite different case is the contrast of ink-marking actions in Goya's "Two Prisoners in Irons" (fig. 83). There the thick, rough iron bars of the prison are indicated by thick, rough 1D strokes, and the dark pool of the ankle-manacled figures' combined shadow is made by a pool of dark ink.

Although many other cases of the sort have already been indicated, Podro wishes us to see at this point that there is often a *reciprocal* action: that is, our imagining the contour that the line evokes gets us to imagine something back into the contour-defining line itself. Podro remarks: "We recognize a figure in the lines of a drawing, and when it is a figure in movement we may . . . imagine the impulse of the line"—even when that impulse "may itself be something we only imagine, and only come to imagine by virtue of the movement of the figure it delineates."[30] In other words, in some cases we would not experience the drawn line as moving that way unless we took it as depicting a figure in motion. In return, the line thus imagined will likely have further effect on the figure it serves to depict. Far from this being a fine point for connoisseurs, such reciprocity is basic to our understanding of drawings. To see this, let us go back to our basic theory of drawings as depictions. One of the requirements for the depictive as opposed to the diagrammatic is that depiction involves, be-

yond visual access, a certain kind of visual experience regarding what we actually see and what we imagine thereby seeing. In lines quoted in chapter 6, Kendall Walton argued not only that in depiction the "phenomenal character of the perception is inseparable from the imagining which takes it as an object" but that this also holds the other way around: "Imaginings, like thoughts of other kinds, enter into visual experiences. And the imaginings called for when one looks at a picture inform the experience of looking at it. The seeing and the imagining are inseparably bound together, integrated into a single complex phenomenological whole. . . . [T]hey must be thus integrated if the picture is to qualify as a picture."[31]

There is good evidence for such perceptual reciprocity even at quite elementary levels of depictive perception. We might seem to have good evidence from standard so-called "perceptual constancy" examples. As R. H. Thouless observed in a classic essay, it is common, for example, for even experienced drafters to underestimate the rate of convergence of orthogonals when doing observational drawing, for when he asked subjects to choose among a series of elliptical disks the shapes that corresponded to a circular disk that was tilted in degrees away from them, he found that they had a strong tendency to underestimate the degree of foreshortening, indicating, Thouless argued, a tendency toward "regression to the real object."[32] (Possibly that was the error with Dürer's urn.) But does this tell us anything about how *drawings* look to us? As we saw from Willats's elegant experiment in chapter 5, explanations of drawings in terms of shape constancy effects must be qualified by factors of drawing procedures, which may provide little evidence about how the line patterns look. There is little reason to suppose that, to those who copy Willats's street scene (fig. 56) by drawing flattened roof lines and even upward sloping string-course lines, the *lines* of the original seemed to bend those ways. More convincing is a general fact about all sense perception, indeed all activity: the task strongly influences the performance. Looking at a drawing as a depiction has us look at the pattern of marks differently than does looking at it for other reasons, and artists standardly turn their works upside down to see their mark patterns not organized by depictive meaning. Even within depictive seeing, the marks themselves seem to disappear or to appear with different shape, stress, and

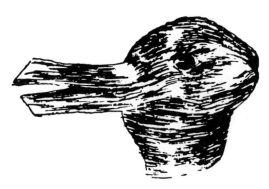

Fig. 90. Duck-rabbit, *Die Fliegenden Blätter*. From E. H. Gombrich, *Art and Illusion: A Study in the Psychology of Pictorial Representation*, 3rd ed. (London: Phaidon, 1968), fig. 2.

pattern when we shift depictive interpretation, as may be seen with the original duck-rabbit, not as made famous by Wittgenstein, but in the original retrieved by Gombrich (fig. 90).[33] Seen as a rabbit's mouth, a dark straight line, which passes unnoticed on the duck reading, becomes evident, and with pictures, as not only detective stories but in life, we may be made to look foolish for overlooking the truly evident evidence before us. Depictive drawings greatly complicate these simple effects— indeed, as we shall soon see, they work actively to do so. In summary, it is not only of great significance for depiction that our interpretation of depicted scenes is (obviously) strongly influenced by our perception of the properties of the lines generating them, but that our visual experience of these lines—what we notice about them, how we group and orient them—is reciprocally influenced by our imaginative perception of the scene we take them to depict. That this experience feeds back into the interpretation of the scene is an elementary fact of perception with great significance for depiction. The question remains whether such reciprocity holds for nonspatial properties as well.

We should expect it to. The integration that Walton's theory of depiction calls for generally is of a reciprocal nature. As already argued in chapter 8, the perceptual category "depiction," under which we see a drawing, entails that the activity of looking will be guided by an interest in imagined visual recognition. When we look at a still-life drawing as a depiction, our looking is guided by the purpose of imagining seeing a still life. Then, as in every kind of active perception, the activity of seeing will involve many "passes," with anticipations and ad-

justments, shifting of hypotheses, and so forth. For a quick illustration, taking advantage of our work on Dürer's "Saint Jerome," one may take in at first glance the inked region of the table-leg shadows. However, once their critical "Waltzian" function is grasped, perhaps one looks at them with more attention, "cooperating" with their work, and then perhaps wondering how parallel sun rays could cast triple shadows off two bench legs—or, noticing the shadow inside the lion's tail, whether an unseen surface to the right reflects sunlight back only there: so one might try imagining that. More subtly, when Charles Talbot agrees with us that in this engraving "contour and modelling lines convey both plastic form and surface texture with the utmost economy and never lose their graphic quality and decorative interest," we need to give serious thought to that last "and."[34] It is common to take "and" as linking two different topics, in this case depiction and "graphic quality," which alternate for our attention. Yet the close viewpoint that confirms what Panofsky noticed (fig. 88, p. 181), that the "bull's-eye" shadows are indicated simply "by short horizontal hatchings without outlines," reveals more regarding the depicted scene, since the facture of those shadows appears as a modulation of the facture for the embrasure, just as the depicted shadows carry information about the glass roundels by modulating the depicted embrasure's stone texture, which then appears all the more continuous beneath it.[35]

"Facture" also denotes material, or rather the handling of it. A normal way that "twice over" depiction by reciprocity works is through the heightening of our awareness of certain characteristics of the drawing elements, particularly at the mark level, in terms of the physical materials used, as Hills's architectural example showed. In a Chinese brush drawing, seeing the distinct strokes of ink wash that define a crab's legs enhances our imagining seeing them as jointed entities. Seeing how the brush has become drier as it approached the point of a long branch, bamboo stem, or blade of grass helps us imagine that the branch, stem, or blade, too, is reaching its limit of growth—as in "A Breath of Spring." Speaking of dryness, here is a brief, dry review of how the "twice over" drawing resource works. Taking certain marks on the surface under the category of depictive drawing, we imagine seeing objects in certain situations with certain characteristics. Doing this, we give renewed

attention to characteristics of the marks as physical marks and notice more of their aspects that may correspond to the depicted properties. Such correspondences may go nowhere, but when, rewarded by a good fit, we become more aware of such characteristics of the marks and we see the depicted scene in a different way. The stopping point of this reciprocal action varies with the drawing.

This happens in all media, but in a book on drawing we may still notice how oil paint proved particularly conducive to such effects. As Podro remarks of a Veronese painting, "the sense of the brush across the heavy weave canvas intimates the physical immanence of the woman's back while the shifts from opaque to translucent paint gives a sense of a visual density into which we look."[36] From the fifteenth century on, the new technical resources of oil paint opened to Europe realms of "effective depiction" that transformed image making, shifting it from drawing-centered spatial concerns toward what we saw Gombrich identifying as achievements in "the suggestion of light and texture." Thus the early-nineteenth-century philosopher Hegel praised the triumph of just that technology, and of the human spirit, over nature in the textural-rendering powers of Dutch painting. "Velvet, metallic lustre, light, . . . the glitter of wine in a transparent glass . . . are brought before our eyes in these pictures, things that we scarcely bother about in our daily life," he wrote. "But what at once claims our attention in matters of this kind, when art displays it to us, is precisely this pure shining and appearing of objects as something produced by the *spirit* which transforms in its inmost being the external and sensuous side of all this material."[37] Missing from Hegel's account, however, are the many *reciprocal* effects that the medium brought on—standardly recognized as "painterly effects"—which were gradually thematized on their own to a point of equal importance. For that let us turn to a modern critic. Robert Hughes notes of Goya's *The Third of May* how

the improvised bluntness of his painting is tragically expressive, even . . . down to the blood on the ground, which is a dark alizarin crimson put on thick and then scraped back with a palette knife, so that its sinking into the grain of the canvas mimics the drying of blood itself: it looks crusty, dull and scratchy, just like real blood smeared on a surface. . . . The wounds that disfigure the face of the man on the ground can't be deciphered fully as wounds, but as signs of trauma embodied in paint they are inexpressibly shocking: their imprecision conveys the sense of something too painful to look at, of the aversion of one's own eyes.[38]

This is "twice over" reciprocity: looking at some paint, under the category "depictive painting," one cannot help imagining that this is an act of looking at figures, actions, situations—we would otherwise literally have to turn away from some pictures.[39] Still, recognizing these, one attends more closely to the paint, but now to the paint *as* paint, not just as shaped color and texture: indeed one attends to the working of that paint and takes part of what one observes back into the imagining experience—that is, one imagines something of this visual experience.

The crucial point is that, unlike Rawson's analogies, this imagining involves no third term; the analogy is direct between imagined subject and depictive medium. As with perception normally, one often shares these experiences with others and consults their suggestions about seeing, just as we do when we read Hughes's observations. Yet although such effects are frequently noted by critics in particular cases, they are left unsystematized, and thus, amazingly, are actually doubted in an age remarkable not only for its technologies of the *suppression* of such reciprocal effects in depiction but also for such suppression in the presentation of other works.[40] It is a point of Podro's not only to demonstrate reciprocity through a wide variety of cases within the visual arts but to give theoretical standing to this resource with the phrase "sustaining recognition."

SUSTAINING RECOGNITION

Podro's approach to the appreciation of depictions seems simple, even obvious—once he thought of it. It is based on what might be counted as four empirically demonstrable observations, none of which should come as news. The first is that our engagement with pictures and similar works, depictive or not, is almost inevitably grounded in efforts at subject-matter recognition. The second is that, as already explained and argued in Part II, this

recognition involves attempts to transfer our normal environmental recognition abilities under the concept of depiction—that is, usually not directly.[41] Podro's third point is that such recognition of subject matter may be "sustained." Like most kinds of recognition, subject-matter recognition is not well exemplified by instantaneous "got it" spotting activities. This principle appeals to the obvious facts that people take time looking at even very simple pictures and that they often revisit the same picture with interest many times, over decades, through changing circumstances of life. Among relevant empirical confirmations of the last two points is that art museums and galleries flourish in contemporary society: they could not otherwise. Podro's fourth idea is that while recognition in depictions may be thus sustained for a number of reasons, the main reason, especially with what we term art, is due to an activity just instanced in the "twice over" discussion: "that the recognition of the subject is extended and elaborated by the way its conditions of representation, the medium and the psychological adjustments the painting invites become absorbed into its content."[42] Podro states all this in the opening sentence of his book *Depiction*: "At the core of depiction is the recognition of its subject, and this remains so even when the subject is radically transformed and recognition becomes correspondingly extended; it remains so not because we seek the subject matter *despite* the complications of the painting but because recognition and complication are each furthered by the other, each serves the other" (5).

If this seems like a connoisseur's approach, notice that it is firmly rooted in the subject-matter recognition of a child's drawing and of a child's being invited to find things in pictures, including great works of art. Its roots remain there, as we never have to follow the desperate lead of those who say that as we go on in our understanding of art we must set aside such naïve impulses. That contrary view is based on straightforward empirical errors about the nature of recognition. The first error is that subject-matter interest in pictures entails deflecting interest to something that is not the picture, something that the picture "refers" to. This should have no appeal once we have abandoned, as we have since at least chapter 6, the confused diagram of depiction as representation and of representation as reference, consisting in correspondence, with an arrow pointing away from one item toward another (in terms of chapter 3, a bad mental graphic). Whatever subsequent uses it is put to, depictive perception actually flows the other way. Under the concept of depiction, a wide variety of seemingly unrelated activities (including Rawson's analogizing), centrally featuring transfer of activities normal to visual recognition, converge in the distinctive activity of understanding something as a depiction.

The second common error is to think that recognition of anything consists simply in categorial applications: what is called "labelling." That is the more interesting muddle, part of which is an overgeneralization of the fact that, for practical purposes, perceivers must recognize many things only fleetingly, with what Rawson calls "primary forms," and shift attention to others. Such, however, is only one kind of everyday recognition, for we ordinarily also look at things with curiosity, interest, concern, puzzlement, amusement, scorn, disgust, longing, embarrassment, satisfaction, and so forth, and as we do we recognize and re-recognize aspects of them according to these motives—which may shift among themselves as we look. Given that, depictions, as displays—particularly those that we treat as works of art—can be *designed* for such longer looking and repeated lookings, rather than for quick recognition. With depictive works of art normal recognition is made more challenging. As Podro remarks, "Paintings address us, and they do so in part through creating uncertainty; our engagement with them involves a continuous adjustment as we scan them for suggestions on how to proceed and for confirmation or disconfirmation of our response" (vii). That would be different from making isolated observations about, say, features of the Dürer "Saint Jerome," because, as Podro says, such activity "risks narrowing and simplifying attention—it interrupts their interdependence and their absorption in our synoptic view, our sense of the subject emerging within the painting," where "the viewer waits upon the suggestions the painting will offer within the framework of other recognitions." Our consideration of "Saint Jerome" showed that we "do not resolve a series of separate questions of what is signified in specific areas or aspects" of the work (13, 15).

Podro's point must concern more than synoptic

vision, since a kind of synoptic vision may be found simply in our usual activity of exploring the fictional world that depictions present, rather as we explore aspects of the real world. As mentioned earlier, such is highly relevant to works such as the Dürer, rich as it is in things, surfaces, and their relations. To be sure, among the straightforward ways in which that engraving sustains recognition is by inviting us to identify depicted things at the categorical level (sand clock, aspergillum, hearth brush, carafe, candle, rosary, scissors, inkwell), to wonder about their iconological meanings (why the pot in the niche? the dropped ceiling? the unequal wall division at one window?), and to see all these together in their places in a room in which they bear the inexhaustible multitude of spatial relationships that real things do.[43] By contrast, in the fictional world of the drawing by Shih-t'ao (fig. 72) we look in vain for distinct objects of such sorts, finding neither incentive nor reward for triangulation of their relative positions—which is partly but not entirely owing to the setting not being "carpentered." Yet, what the Dürer print provides is a display, in the sense in which what it depicts could not be a display, even if a few of the depicted objects, such as the skull and crucifix, are shown there as positioned for display. This means that the activity of recognition in depictions must differ radically from that outside them, as one goes back and forth between clues within the depicted fictional world and clues from the properties of the graphic elements that evoke them. It is the overall development of our understanding of the scene through this reciprocal action that Podro means by a "our synoptic view, our sense of the subject emerging within the painting" (13).

In conclusion it is worth noting how Podro's "sustaining recognition" approach repairs Rawson's theoretical difficulties with depictive subject matter. As we have seen, regarding subject matter in drawing arts, Rawson is somewhat ambivalent, insisting on a strong tension between two-dimensional and three-dimensional experience in good drawings and holding that "figurative drawing scores heavily over nonfigurative" (D, 57). There is a strong tension in Rawson's thinking, too, as he sharply distinguishes interest in subject matter from his main topic, "form and formal method." He insists that the latter ("the truly visual qualities") "are what matter" and sharply criticizes

approaches that focus on the former. "The objects of the tenor may well seem to be engaging in a kind of drama of their own which does not depend quite solely on the way in which they are rendered by graphic symbols," he says, adding: "This aspect of a drawing is the easy part which most academic critics and popular writers seize on. . . . It is the aspect on which poorer artists have concentrated. It is also the aspect of drawing on to which fastens the mind which is shut up within its everyday utilitarian perception conditioned by words"—before concluding: "It would not be wrong to say that many iconological classics written by academic scholars could have been written . . . from verbal descriptions of the figures and objects in pictures" (D, 244–245). Rawson rightly criticizes the familiar treatment of depictions solely as a means for presenting fictional worlds, understood in terms of nonpictorial categories. There may indeed be many who look at pictures that way, and there are technologies of depiction that encourage it. However, this is probably not a fair description of most people's experiences of the kind of depictions we are discussing, whether they know it or not, given that people lack adequate tools for expressing such perceptions. Podro reminds us that even "simple" recognition is a complicated process. As for artists, the ones who concern us here certainly "did not set out to show the look of the world as something previously known, but rather to extend the thread of recognition in new and complex structures of their own."[44]

Podro's idea that we extend that thread reconnects with our thoughts about the earliest stages of the course of drawing. It also consolidates two of Rawson's main themes of meaning: first, facture, with his sequence theme, where he insists that looking at drawings takes time; second, his analogizing theme, which Podro's approach firmly turns the right way: that is, puts to work in the central task of recognition, once we realize that subject matter recognition is artistically important. Sustaining recognition also confirms the autonomy theme of Part III, that depictions, and especially works of art, draw on much more than our environmental recognition powers, even where the main task is subject-matter recognition. Yet there is more work to do on drawing resources, both those of the artist and the conceptual ones we are developing, if we are to provide argued and sys-

tematic theoretical answers to what Podro states as his central questions: "How does our imagining use what is there for perception? How can we describe, in general, the mesh between imagining and the use of our prepictorial capacities for recognition?"(6). This is because, regarding drawing as art, as Plato has a character say at a crucial point in his own dialogue, "The most important thing, that should have been said, has not been said," at least not explicitly.[45]

part IV

the fullness of drawing

13. drawing's dualisms

The early promise of this project was to work through a wide diversity of drawing practices in the direction of art—that is, to an understanding of drawing as art, as a culmination rather than a dismissal of that range of drawing activities. Since the middle of Part III, as the theme of the autonomy of drawing's devices developed, we have been on the way to realizing that promise, using our analytic tools to understand drawings as works of art rather than using drawings that happen to be art to illustrate theories. The basic strategy of Part III was to demonstrate how—particularly with regard to figurative depiction—drawing's own devices may combine with those more directly derived by transfer from environmental perception. It is the project of Part IV to show how that work has further implications, which, once made explicit and put in order, may provide us with a philosophy of drawing as an art.

But to carry out this project, we must explicitly confront a serious resistance to any work that has these implications. This is a tangle of habits of dualistic thinking about depiction, a barrier of thorns that is so entrenched that although Parts II and III have already cut away the branches, it is sure to rise up anew unless we now get to its roots, which unfortunately lie deep. The root dualism is an idea that understanding depictions consists in applying to them a rather monolithic ability in environmental perception—though sharply reduced to the circumstances of recognition that pictures allow—while admitting, in some cases, the addition of other abilities to register particularly pictorial characteristics. We get an *aesthetic* dualism when these characteristics are considered "expressive" or "formal." By now, our strategy should be clear: we need to bear in mind that, beginning with the simplest and most obvious recognitions, drawings themselves draw on us: that is, that they call upon not one group of perceptual abilities but on a number of our perceptual, cognitive, and other capacities, all of which may be combined and brought into play in different ways depending on the tasks at hand. I have called this the drawing tool-kit approach.

One inspiration for this approach is vision research's breaking down of monolithic conceptions of environmental perception. Commentators on art have been slow to realize the significance of various vision researchers' analyses of environmental vision into a concomitance of cues and components—sometimes called "modular."[1] Nevertheless, as we have seen, at least when they turn to pictorial perception, sooner or later these very researchers are themselves drawn back toward monolithic thinking—often through simplistic geo

1 projective fallacies of linear perspective (the "imitation of appearances" idea in variant form), which is why the study of perspective has so gnarled and twisted pictorial studies out of shape. Here Gom-

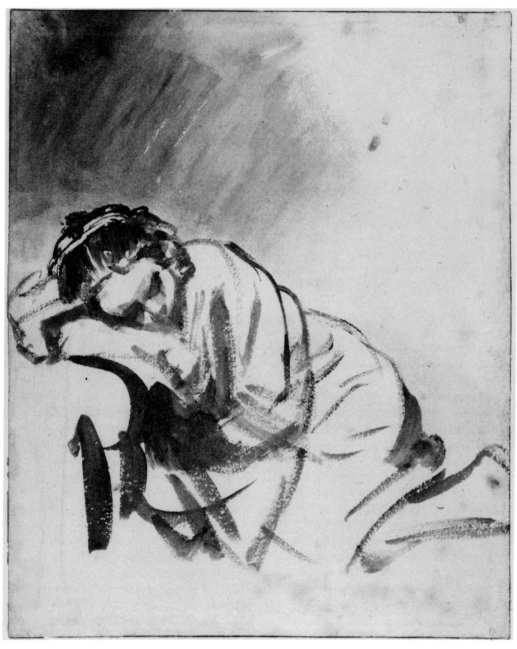

Fig. 91. Rembrandt, "Hendrikje Asleep," ca. 1655. Brush in brown ink and white body color, 24.6 × 20.3 cm. © Copyright The British Museum.

brich deserves credit, not only for resisting these tendencies regarding depiction—for making explicit why no monolithic preconception even of environmental perception could withstand the hands-on knowledge of image makers since prehistory—but for providing a positive alternative.

Gombrich taught us how, long before the analysis of perception began among psychologists, physiologists, ethologists, and artificial intelligence researchers, images makers have through trial and error discovered and consolidated various "tool kits" of devices for bringing off visual effects for

human observers under various conditions, consistent with what Gombrich always insisted was the socially varying functions of the images. For images makers, as Gombrich insisted in his first principle, instructions to "imitate appearances" or to "produce likenesses" have always been useless. But Gombrich explained how, even then, for most perceptual devices to work they must be transferred from environmental perception to a different perceptual context, partly controlled by what he called "the beholder's share"—a cooperative activity.

Yet that raised a most important issue for the whole theory of drawing, one, however, which Gombrich tended to overlook. For, once perception of something as a drawing is understood to involve integration of different, even independent, pictorial devices, successfully transferred from their natural sites in environmental perception, the question is open as to whether pictorial perception might integrate *other* factors as well. Of course it can, though it is not in nature of the case that we should be aware of this in our experience of the product. The same goes for nonpictorial perception. As far as that goes, when looking down a path one is usually just aware of seeing things at distances, for such sight does not also signal the means by which we have its experience. Why should it? Stereo effects, heightened as we move along, strongly affect our sense of space for nearer things, but no "wall" is signaled where, in "vista space," these no longer do the job. Convergence and texture gradation changes may do most of the work in the middle ground of "action space," whereas, as one looks up into distance, occlusions of houses, trees, and so forth, along with atmospheric perspective and reduced acuity (fig. 30), take over, but again there is no easily discernible line where that baton is passed from one information source to another—no signal "Objects in vista may look closer than they are." And there is no reason why there should be, any more than when we are eating, something should signal to us which part of the experience is due to taste, which to smell, touch, or vision.[2] Artists exploit this natural "blended" perceptual situation to make selected mixes of transferred natural effects that would not occur naturally. They also work into them devices of their own—including elements often referred to as "conventional." These include drawing's own devices—the movements of lines as lines, for example, and effects of facture—and, as in perception generally, these components tend to blend in experience. For its own purposes, which are those of pictorial and not environmental perception, visual arts thus pick apart the weave of environmental seeing, some strands of which they rework into different patterns, woven in with threads of its own.

As an illustration, consider one of Rawson's discussions of contour depth-slice techniques. Rawson notes an accomplished style, common to the Far East and Europe, of "phrasing" contours, by "treating each section of outline as a sequence of contour units, usually curved and most but not all of them convex," in order to "create rhythmical figures by means of continuous series of linked contour-units, giving them fresh starts, breaks, and calculated overlaps so that lines seem to end and begin again," while "the phrasing suggests the way in which the slices are piled one above the other." Significantly, he adds: "In really strong drawing each segment and each chain of segments will have a pronounced two-dimensional movement. In some styles a slice is only suggested by one of its sides (Far Eastern drawing; occasionally in Rembrandt), and no enclosed area or volume is suggested" (*D*, 104–105). This appears to describe well the open, mainly convex contour brush strokes of Rembrandt's "Hendrikje Asleep" (fig. 91), one of the most widely admired drawings of all Western traditions.[3] At the mark level, where, as typically, Rembrandt varies his strokes, almost every unit remains identifiable and clearly characterized, and the picture primitives are not far removed from them in character. Enclosures are minimal, and not from a single gesture—reminding us of Rembrandt's reported teaching: "Give the outlines their proper swing, not in one pull which runs like a black wire around the form, but indicate them piece by piece with a light hand."[4]

Regarding the interweaving of transferred perceptual cues and effects that are specific to drawing as drawing, Rawson states that the trick of such phrasing is that our imagined perception of depth will partly be given by our knowledge of what is being depicted by a given line, but also "partly by its place in the phrase"—that is, by its place in a sequential drawing phrase (*D*, 105). To test this, let us look more closely, in Rembrandt's drawing, at a set of seven roughly parallel, angle-curved, convex lines (so typical of this artist), composed mainly of single strokes of noticeably different qualities. We

move down through a dry-brush surface-contour stroke for the shoulder; wet-tip then drier-brush occluding contours for the lower sleeve and the cloth fold below it; then the driest, a convexity for the hip and an occluding contour line, which is caught up by a broad wet-brush shadow indication for the backside curve. Brought into the transitive "depth-slice" relationship with these by the marks for hair, above we find a drier shadow curve for the left cheek, shaped rather like that for the backside curve. A few diagonals, beginning with the adjustment for the wrist, connect these two shape markings. Finally, out of this depth-slice sequence, a broad, wet sickle-shape, bent like a loaded spring, establishes the figure's resting support. This is immediately reflected by a reversed sickle stroke below it, then glide rotated out from the plane by two more broad, wet strokes. Inextricably woven together here are shading, contour, and occlusion cues, which are transferred from environmental vision, together with an experience of rhythmically related physical markings, which also give a sense of the form.

I have been arguing that this kind of interweaving is made possible because our perception of the marked surface is controlled by concepts such as "drawing" and "depiction" and their varieties, which tell us what kinds of factors might be brought to perceptual understanding—even to subject matter recognition—and how these factors might be combined. To repeat a remark of Rawson's, to approach a drawing as a work of art is to put ourselves in the condition of expectation to do these things (*StD*, 21), much as we put ourselves in a frame of mind to appreciate absurd connections when we think someone is telling a joke. Often the very point of telling a joke is to get people to put themselves into that state, thereby getting them out of another. Some jokers use their abilities to disarm others or to change the tone and direction of conversations or even entire social situations, often exploiting people's readiness, perhaps unknown to themselves, to put themselves into such states—for, as Aristotle observes, "there are always opportunities at hand for raising a laugh, and most people enjoy amusements and jokes more than they should."[5] Thus anyone who thinks that the present account of seeing pictures is rather intricate might start with these everyday observations and begin to trace the dynamics of telling jokes.[6]

A similar "condition of expectation" account holds true of even artistically uninteresting drawings, but it is clearly shown by the artistically interesting ones, which sustain our acts of subject-matter recognition, inviting renewed acts of recognition, revision, and reformulation of recognition—of deeper and wider recognitions—over repeated engagements. Straightforward empirical evidence for that lies in the fact that, in the simple words of the photographer Dorothea Lange, such works are "second lookers": they encourage and reward much revisiting. It is for this reason that collections of them are made and exhibited, shown in reproductions, written about at length, and so forth. This is, of course, not true for most drawings, including historically the most important, with which we began chapter 2. There the appeal to different aspects of ourselves, which we correctly think of as "creative," is severely gated for practical reasons. A recent critic complained, "Art history: it too thinks it knows where its objects are—because they are all in museums. . . . Where is the history of mechanical drawings or 'working drawings,' as opposed to 'idle drawings' or 'art' drawings? Where is the history of blueprints?"[7] In terms of our approach to "all kinds of drawings," these are good questions. Collections and exhibitions of working drawings and of blueprints are in fact held, however, and the selection criterion for "art" drawings is not that they are idle but rather that they reward renewed viewings in a way that working drawings, blueprints, wiring diagrams, and so forth do not and are not designed to do. Part of the reason for this is that the former drawings tend to take in devices from every kind of the latter, to elaborate them for further meanings that the latter were not supposed to bear. The bulk of the drawing—and in fact of the whole imagery technology—in modern societies is designed for limited and transient encounter, and it would be as unfair to judge it by museum standards as it is to judge museum drawings by the others' "working" standards.[8]

DIALOGUES ON DUALISMS

It is necessary to stress these points, given that much popular as well as theoretical thinking about drawings, pictures, and depictions is based on re-

luctance to treat them as what they are: artifacts of specific, overlapping kinds—to treat them *as* drawings, pictures, and depictions. We thus become spectators to a three-way dialogue among the theorists, those of "reputable opinion." Let us briefly describe and put aside the two extreme opposites among the three, before turning to the rather more complex group of positions that are more compromising.

One extreme, perceptual reductionism, demonstrates through impressive experiments how understanding depictive pictures calls centrally on our normal environmental spatial, feature, and object recognition capacities. More emphatic than the Same Mill Principle, on this view, depictive perception simply is environmental perception, although in what Gombrich calls "reduced circumstances," or with strictly pictorial characteristics (such as awareness of pictorial surface) occurring as a sort of noise, to be overcome by progressive techniques. Thus James Cutting remarks that "there is nothing special about picture perception as compared to the perception of natural scenes, except that pictures are particular situations in which such conflicts are typically inherent," succinctly expressing a position inconsistent with our main theme since chapter 8.[9] Such perceptual reductionism shows up in unusual locutions quoted earlier: "a picture is nothing but a more convenient way," "when they cover a plane with colours," "a delimited physical surface processed," and so forth. That is but a development of a common opinion that pictorial perception consists simply in its most salient constituent: environmental perception applied to sometimes "distorted" or sketchy indications in rather different settings, which technologies are at pains to improve, on the path to "realism." Many modern depictive technologies are thus marketed, either to broaden the information band or to cut out what is considered to be pictorial noise. But neither the views of "the many" nor those of the experts consider that, given that the application of normal perceptual recognition to pictorial situations already involves a variety of transfers—what Gombrich called "projections"—other kinds of transfer are not only possible but to be expected in the various contexts of drawing.

An opposite conception, noticing the great importance of these other capacities to our understanding pictures, denies that picture perception depends centrally on our ability to transfer normal perceptual activities to the task at hand. Typically stressing "conventionality" in pictorial perception, this influential position takes picture perception as a kind of "reading of symbols," like the reading of written texts. This view goes wrong in two ways. First, it does not recognize the undeniable visual aspect of depiction that is worked through a continuity with environmental vision. Second, it neglects the overriding project within pictorial perception, which the reductive approach grasps by the handle but holds upside down: the imagined visual recognition of things, characteristics, situations, spaces, events, which constitutes our earliest encounters with pictures and is never left behind, and which artworks sustain and develop through devices unattainable in nature. Between these two extremes is room for a wide spectrum of more plausible views that set out from a dualism in pictorial perception, which they either consider a paradox or simply decline to consider.

"Pictures are paradoxes," says the psychologist R. L. Gregory, "unique among objects; for they are seen as both themselves and as some other thing, entirely different from the paper or canvas." Gregory explains: "Pictures have a double reality. Drawings . . . are objects in their own right—patterns on a flat sheet—and at the same time entirely different objects to the eye. We see both a pattern of marks on paper, with shading, brush strokes . . . and at the same time we see that these compose a face, a house. . . . No *object* can . . . lie in both two- and three-dimensional space. Yet pictures are both visibly flat and three-dimensional."[10] This is a great improvement on the two extremes, for not only does it allow at least two kinds of perceptual activities with pictures, Gregory's "we see both" and "at the same time" deny Gombrich's Incompatibility Principle, allowing the two activities to be simultaneous. Still, that is understood to pose a problem: "Pictures are impossible," "biologically . . . most odd," Gregory continues (32).[11] We also recognize the familiar spatial 2D/3D "spaced out" tilt of Gregory's expression of the alleged dualistic paradox: what other writers call a "disjunction" occurs because, in the case of a picture, having "both a (real) surface and a (virtual) space constitutes its binary nature":[12] as though it were not equally paradoxical that what we see is both a piece of marked

paper and a living creature, a crashing sea, a forest, the Creator, a flat expanse of cold stone.[13] But, as we saw in chapter 8, there is no more paradox in any of these cases than there is in a child treating a bit of wood, plastic, or snow as a living creature: there is what we actually perceive and what we make-believe we perceive, the latter including only some of the features of the former. But, faithful to early dialectical promises, here is the point to say that, given our Part III study of drawing devices, this is not an entirely satisfactory reply to Gregory's "paradox."

Better to understand why, let us consider another option that accepts dualism but is simply sanguine about it, taking it as nothing peculiar to depictive perception. For example, another psychologist, Rainer Mausfeld, holds that not just "conjoint" mental representations but even "competing conjoint representations" (where perceptual interpretations have "antagonistically coupled" parameters) pervade our cognitive activities. To consider simple linguistic examples, adapted from Chomsky, the unexceptional expression "When the kettle boils, would you take it off the burner?—but please don't go through the kitchen door, as it's freshly painted," reverses contents and container, ground and figure, reminding us that, far from being also "biologically odd," "quite typically, words offer conflicting perspectives." This also happens when abstract and physical are subsumed: "She's been working on that book so long that if she ever finishes it we'll be able to use it as a doorstop."[14] Such statements are not taken as puns or even incompatibilities such as "Please put some toast in the toaster for me," which, though getting the job done, still draws comment. Widening his argument, Mausfeld holds that conjoint, even competing-conjoint, 2D/3D perceptual interpretation of pictures is a normal example of simultaneous conflicting perspectives with the same units of meaning, and he pushes his point—congenial with the treatment here—beyond spatial features to include "emotional states and intentions" and much else (46). Less congenially, however, Mausfeld goes so far as to hold that, contrary to both psychological theories and "commonsense taxonomies" (17), "pictorial perception does not constitute a domain of phenomena bound together by some domain-specific explanatory principles"(56). This suggests a new variety of the reduction of pictorial perception to the environmental, differing from the usual in not treating pictorial duality as noise or distraction. Yet Mausfeld's approach is also broad enough to include even "pretense play"—"where the same situation is simultaneously exploited" by two "contradictory" interpretations (45), and that is sufficient for our purposes here, where we have termed such play "make-believe." By arguing that make-believe is sufficiently "domain-specific" within human cognitive and psychological activities, and by subsuming depiction into it, I have already argued in Part II that this attempted reduction to environmental perception fails.

Still, questions remain. Even the treatment of Gombrich's Incompatibility Principle in chapter 8 does not by itself suffice for dealing with pictorial perceptual dualities, as Walton's views on the subject make clear. After all, just as there are devices of art for enabling subject-matter recognition and enhancing vividness of imagining, there are also devices for deferring and distancing imagining, some ancient, some modern, devised for a variety of motives encompassing religious attitudes, decorative interests, irony, and artistic comment about art itself. Also, as Walton observes, such devices often include "focusing attention on the work itself, on its physical properties apart from their role in generating fictional truths, or on the process by which it was made."[15] Thus, "conspicuous brush strokes" in paintings may "call attention to themselves and to their record of the process by which paint was applied to the canvas, possibly intruding on the viewer's participation in his game" of make-believe seeing (277). Walton cites the painter Frank Stella, whom I quote at more length.

> The God-like nature of creation in painting resides in the ability to make a painting that has enough lifelike qualities to keep it alive. In the best moments of sixteenth-century Italian painting, there were always enough of these moments to make it clear that projective reality was the goal of painting and that the job of the artist was to effect successful self-effacement, both of his personality and his craft. This, it seems obvious, is the nature of pictorial illusionism—to make the action surrounded and created by painting seem real, and to make the creator of that action and activity seem remote.[16]

Remoteness, however, is not obvious, for, speaking of "God-like" motives, within that tradition we have the theme of the Incarnation, according to which Christ was not two persons in one body (Nestorianism), nor a new kind of being of fused realities (Monophysitism), nor a being with an illusory human body (Docetism) and so forth, but rather (according to the Council of Chalcedon in 451) "two natures without division." Our own questions, though not that subtle, are still rather subtle, more so than our theorists' "dialogue" has so far indicated. Therefore, working toward drawing as art, it is high time to consider issues of duality in picture perception with less generality, by calling upon more artistically perceptive testimony. Following are two such, by outstanding recent writers about depiction.

The painter and critic Patrick Heron expressed familiar ideas of perceptual duality in describing a Bonnard drawing:

That second in which we read the drawing's figurative content, . . . in which we suddenly feel in the presence of that sultry light . . . we become unconscious for a brief moment of the actual means. . . . It is only after submitting for some seconds to the magical effectiveness of the illusionistic accuracy of the 6B pencil in presenting to us the reality of this view . . . that we may suddenly surface again and once more explore and savour all these scratches and stabs and spottings and smudgings and apparently uncouthly uncontrolled wanderings across the paper of Bonnard's pencil.[17]

This sounds dualistic. Closer to Gregory's "paradox," Heron was to write differently of "that second" regarding Constable's drawings. The passage is worth quoting at length, as it well expresses themes of Part IV:

As in the case of all the greatest figurative art, our apprehension is two-fold at every instant—as our eyes journey back and forth across the surfaces of his drawings. In every square millimetre there is the double experience for the eye—it savours the design of marks at the surface at the same instant that it sinks through and beyond the grey of pencil and the white of paper to the depths of the

outdoor spaces so miraculously evoked. It is one of the greatest thrills of the greatest figurative art, this immediate and total identification of marks at the surface with physical spaces and with a multitude of forms inhabiting, and defining, those spaces, through and behind those very marks. The illusion is total: that lopsided stab of a pencil point, itself a mere square millimetre in extent, is a great tree in full leaf, up on the horizon, that proclaims itself to be precisely half a mile distant from the beholder's eye. . . . But the process is one of the unending conscious absorption of relationships—of our conscious registration of the unbelievably varied intervals between the thousand and one marks of an incredible design—a design, however, whose structure not only fascinates the eye in its own right but which also simultaneously pulls and pushes it back and forth through all the thousands of yards of the illusionistic aerial depth of "the subject."[18]

To avoid again confining the discussion to spatial issues of depth and surface, consider the following observations on duality by Michael Baxandall on Chardin's *The Young Draughtsman,* a small (19.5 × 17.5 cm) oil panel, showing from the back an art student copying a drawing pinned to a wall, and to whose right we see orthogonally a painting stretcher and empty canvas:

As for microshadow or texture, there is almost none in the direct representation; Chardin has effectively appropriated it for the actual facture, for his own performance. . . . [H]e takes microshadow for himself and allows none to the appearances he is playing with, apart from some allowance for different reflectivities. And he has the nerve to represent, disguised as canvas against the wall on the right, a picture of abstracted texture, pure Chardinian facture, as if in competition with the academic drill on the wall. . . .

But the effect of this, in fact, is satisfying. By some odd conflation in the perceptual process, the rich and subtle real texture of the paint surface cues us to supply a sense of texture to the fictive surfaces. The release of perceptual energy involved in this flashover

seems enjoyable in itself, but it also lends vitality to the fiction.[19]

This is splendid, except for "odd conflation," since, as we saw richly through Zou Fulei's "A Breath of Spring," there is nothing odd about it in Chinese art. As noted as early as chapter 2, even the universal appeal of orthographic projection begins to show the simple advantages of "conflation." Such conflation, I have argued, is normal, especially to painting, where we should expect transfer of our experience of the facture, as such, to our imaginative experience of what is depicted. Podro takes up the point in his remarks on the same Chardin:

> A pervasive characteristic of Chardin's painting is the combination of substantiality and elusiveness: aspects of the subject, the bloom on fruit, the surface of silver, . . . of glazed or unglazed pottery, seem to arise in the matière of the paint . . . [providing] the depicted objects with a sense of physical presence, making them palpable. . . . The shift between the real paint surface and the fictive object is given a particular focus in a number of small canvases: in The Scullery Maid . . . the rich paste of the paint emerges to substantiate the apron; this is pressed even further in two very small paintings [including The Draughtsman, where] . . . the figure is set against the other with the sense of contiguous surfaces, the broad back virtually consubstantial with the corresponding area of the panel while the shadow cast by the drawing pinned to the wall . . . seems as much to be cast by the paint as by the drawing. . . . The inscrutability of the border between the painting and its subject is made firmly thematic.[20]

We might go on with such dialogues, building an anthology of perceptive comments on particular works, regarding the issue of when visual depiction is to be understood in terms of a dualism of awarenesses, between—vividly and immersively—a fictional world into which one sees and, keenly, of what is before one as a picture. What, likely, would be our conclusions?

Regarding the dimensionality issue, there would be no denying the basic importance of the oft-noted 2D/3D rivalry in much pictorial depiction. After all, Heron's description of the Bonnard does aim at a truth Walton observes, that our attention can shift between features of the subject and the medium. There is also no point to denying 2D/3D perceptual conflicts in pictures: for Rawson they were basic to drawing as art (D, 79, 81). It is routine for artists and designers actively to exploit just such tensions. Indeed a well-known modern theory claims that this "push-pull" tension generates a more dynamic sense of depth than do the concomitance of devices associated with perspective.[21]

This little dialogue between critics simply leads us back to two points from chapter 11. First (as argued with Dürer's "Saint Jerome") there is no reason to suppose that all pictures will aim at a "harmony" of the different activities they draw forth from us. Second, on even slight consideration of the dimensional issue, harmony and disharmony themselves turn out to be no simple matters. There may be harmonies underlying any conflict. As we saw, some theorists think that our "subsidiary awareness" of the two-dimensional surface optically stabilizes perspectival three-dimensional effects when we see pictures on a slant. But, more basically, our perceptual experience of such deptive effects essentially *depends on* our background application of the commonsense category "picture" (and others as well), which includes that very two-dimensionality. Thus our awareness of the two-dimensional surface may both support and conflict with our imaginative experience of depth.

That conflict should not only be consistent with dependency but presuppose it hardly comes as revelation, in many contexts.

BIOLOGICALLY NORMAL

Depictive pictures, far from being, in Gregory's words, "unique among objects" or "biologically most odd," belong to a wider class of everyday artifacts, generally termed "representations" in the sense presented in Part II. It is true that "pictures are *not* typical objects for the eye," but it is misleading to add: "and must be treated as a very special case."[22] Recognition of subjects through the rendering of effects in pictures such as we have studied is not a special case of visual recognition; it is rather a transfer, to an activity called "understanding depictive pictures," of routines of envi-

ronmental perception, and that act does not consist simply in receiving what is transferred. Indeed, as argued in chapter 8, it typically cannot occur absent a number of other cognitive acts.

That such a thing as depictive experience should have come about may indeed be marvelous and unpredictable, but the same goes for many naturally adapted capacities. Speaking exploits a more biologically basic ability to regulate breath, so much so that it has to be coordinated with breathing. Speaking also exploits our ability to tense our diaphragm muscles, which have other important roles, such as providing a stiffened frame against which large muscles can push. It draws on more subtle abilities of tongue and palate movements, which have other functions in eating and drinking. It would be mistaken however to conclude reductively that speaking is "a very special case" of breathing. Rather it is a naturally evolved adaptation, which takes advantage of other of the organism's standing investments to produce an important capacity. Biologically, this is to be expected, for obvious reasons. Similar situations are common in artificial technologies as well—thus Lewis Mumford's remark that the mechanical clock was just a kind of water mill, though a witticism, is a very good one. Given their powers of thinking, planning, and imagining, it seems clear why humans would derive great advantages by borrowing powers from their extremely developed visual systems. With that platform, drawing exploits also our characteristic eye-hand coordination, to develop technologies for rendering spatial and other dispositions of things real, envisioned, or fantastic.

As Gombrich sought to show, we should expect wide variations in the use of such biologically based powers; thus the role and importance that transfer has in such acts of perception will vary, depending on the kind of drawing. Even if, among representations, depiction requires a certain level of sensory vividness, some depictions will work largely through what he calls "convincing effects," others less so. The environmental perception that an understanding of depictions calls upon varies: compare again Dürer's "Saint Jerome" with the Shih-t'ao (fig. 72). What else goes into the mix, and also how, varies with the work. For example, at one extreme edge of depiction, Ian Hamilton Finlay's concrete poem "Waverock" calls not only on our visual experience with wave shapes and motion, our knowledge of rocks along shore lines, our ability to read two English words, but also on our readiness to summon these abilities and to combine them in just the novel way appropriate to the case: not too much, not too little.

AMPERSAND AESTHETICS

Before rejoining the main theoretical argument, we can hardly avoid considering a famous depictive dualism of an aesthetic nature. In some of the best-known passages from modern visual aesthetics a "formalist" argument, known mainly from the writings of the critics Roger Fry and Clive Bell, shifts the dividing line of dualism into the realm of what we imagine, splitting "figurative" or object-categorial recognition off from everything else that we imagine seeing—including space, movement, tension—while according the former only nonaesthetic or "associative" values. "Creating a work of art is so tremendous a business," writes Bell, "that it leaves no leisure for catching a likeness or displaying address. Every sacrifice made to representation is something stolen from art." And closer to our topic: "We do possess a criterion by which we can judge drawing, and that criterion can have nothing to do with truth to nature."[23] At places this dualism approaches a theory, since it attempts to explain important matters and is based on arguments from relevant data.[24] A central line of the argument seems to run as follows. It is pointed out that artistic value is evident in the forms and patterns of many works that do not depict: therefore depiction does not constitute artistic value there. It is also evident that works that do depict have artistic values ranging from great to nil, and that among the ones of high value the forms and patterns are always good, whereas good form is never present in the ones that are of low artistic value, even though some of these are depictively vivid and interesting in other ways. It would appear therefore (this reasoning continues) that possessing such formal merits is both sufficient and necessary for artistic value. It is also concluded that the depictive and representational factors are artistically extraneous, although they hold other kinds of interest and value.[25]

This argument turns out, in terms of its particular data, to be even weaker than the following from metallurgy: "Iron comes in different quali-

ties, but if you use good iron you can be sure that it will produce a good implement. Carbon also comes in different qualities, but with even the best you cannot hope to make an even passable implement. Now it is possible to make alloys of iron and carbon, some of which produce excellent implements, and in these the iron is always of high quality. It would therefore seem that even in the good alloys carbon makes no contribution to the quality, which must be entirely owing to the iron." The fallacy, of course, is that in the making of steel the molecular structures of the iron and the carbon are affected reciprocally—that is, in certain proportions, at certain temperatures, and in proximity they change each other, and in these changed states relate to each other differently. Plants and atmosphere in proximity are changed and being thus changed, change the other progressively, and so forth. The general principle is well known from other kinds of "chemistry": being together, neither is as before, and being thus changed, each relates to the other differently. People continue or abandon personal and professional relationships because of what they themselves become when they are in them. Regarding depictive drawings, we noted that our experience of two-dimensional drawn patterns is strongly influenced by our imaginative perception of the scenes we take them to depict. That the situation with depiction is basically one example of this very common pattern perhaps explains why expository diagrams showing the contribution of compositional forms to the artistic quality of depictive works (for example, in a diagram of the Michelangelo *Creation of Adam*) are themselves often artistically vapid drawings.[26] Extracted metals somehow kept in their alloyed states might be rather unimpressive too.

Given the great weight of evidence against the formalists' conclusion regarding the artistic irrelevance of depiction, such criticism of their argument should suffice. Yet, once again it would be poor dialectic simply to refute an argument without seeing whether something positive is gained in the process. (In a work titled *Drawing Distinctions* we should recall Goethe's adage that dialectic is the development of the spirit of contradiction, given us to help us recognize distinctions among things.) We have, after all, many instances of modern artists, draftsmen, who have had strong artistic reasons for abandoning figuration in order to free their forms. Besides such classic examples as Kandinsky and Mondrian,[27] we may sample the testimony of a more recent artist, Richard Diebenkorn. To the question, "Does it *matter* if it is a woman in a striped dress or a vertical?" Diebenkorn replied, "Absolutely yes," and also remarked that "abstraction and representation are totally different worlds." John Elderfield explains: "Representation became inhibiting for Diebenkorn not merely because subject and art began to compete for his attention. . . . he has said that he eventually found himself being forced to remove passages he wanted to keep 'in order to make it right with this figure, this environment, this representation. It was a kind of compromise.' "[28] It is hazardous to generalize from such cases however, for as Diebenkorn himself admitted, Matisse apparently felt no such conflict. As in the previous dialogue, so in that begun here, it appears that while the common complacent generalizations about rivalry between attention to evoked fictional worlds and to the evoking work as a work are not sustainable, no easy opposite generalization holds. Which of our activities, capacities, and awarenesses a drawing draws on, and quite how it would have us combine these in the process of sustained recognition, provide a spectrum for artists to investigate in individual works. But we need not despair of generalization: revealing groupings may still be made within this free plurality of cases, so long as we remember, as always, that in these matters theory serves perception, rather than the other way around.

14. drawings as drawn

The formalists' so-called aesthetic hypothesis was yet another dualism seeking to separate recognition of depictive and representational subject matter from something fundamental to our experience of pictures. Particular to the West is a tradition of trying either to expel such recognition from other interests, or they from it, and to overlook glaring solecisms in order to do so. Perhaps nowhere is this so significant as in our usual treatment of visual representation and artists' actions. Here our ordinary vocabulary, our cultural tool kit of communication, falls far short, leaving us without words for what we clearly see—although African and Asian traditions have not engineered such ineffability. Whatever the motives for keeping these factors separate and even opposed, there are, to be sure, honest difficulties of conception in combining them, which our dialectical procedure must recognize. Therefore our first challenge will be to show, in terms of the theories developed here, how it is possible for mental attitudes to be internal to our experience of visual representations, especially those of visual depiction, particularly as they appear in drawings. In terms of our wider project, we need to see how they, too, can be, as Rawson required, "unquestionably visible," like the direction of the lines, in "a marked surface before us"—how they can be an essential part of drawing's resources, essential to art.

THOUGHT BALLOONS

Let us begin with a review of matters leading up to this issue. Walton's theory of depiction combines activities of seeing or perceiving with activities of imagining, in ways stated and illustrated several times: notably, by having the imagining include the seeing, as part of its object. The present issues depend on that. Let us think once more about such objects. Since both perception and imagining are mental activities, they have *objects,* the things we perceive or imagine about, and they also have *contents*—that is, ways in which we perceive or imagine these things. Should that seem unclear, perhaps cartoonists can come to the aid of philosophers, repaying our appreciation of their activities here. Cartoonists have designed graphic devices for showing both objects and contents of such mental activities as perceiving, desiring, intending, imagining, dreaming, planning—devices rather like the breath lines from the Mayan scribe god that curl up to the content of what he says, or our Tintin's speech-bubble. We are perfectly familiar with these, the cloudlike balloons tethered by bubble strings to the depicted heads of thinking or imagining agents. What gets drawn inside the balloon is what the agent thinks, whether in words, symbols, or pictures. If it is a picture, then we have a picture within a picture, and the one inside represents what we are calling the objects and contents of the

mental act of the depicted agent. Even young children soon learn how to represent people this way as imagining, dreaming, wishing. As noticed earlier, they can depict depictions (fig. 59), hence they can also depict thoughts. We know how to depict in this way people perceiving, how to show the thought objects and contents of their perceptions. Thus we are used to cartoons of different people perceiving the same objects or situations in different ways, where what is drawn in the balloons over their heads is different, depending on their conceptions of what they are perceiving. The same goes for representing imaginings. For example, we would know what balloons to draw if we wished to illustrate the situation from *Hamlet* earlier cited, showing the different imagining acts that Polonius performs as he looks at a cloud according to Hamlet's suggestions to imagine seeing now a whale, then a weasel.[1]

To understand depiction we need to consider the common cases of mental acts that have for their objects other mental acts, rather than things, or situations like winning a lottery. Much of our talk is about what somebody said (that often being about what someone else said), we have many thoughts about thoughts (which may be about other thoughts), and so forth. "The moment I saw you, I had an idea you had an idea": we would know roughly how a cartoon might represent that situation. It might be done by representing the production of words (as in our Blazek or Chast cartoons, where one character reports what the other has said), or—with more difficulty—by a thought-bubble containing an image coming from one creature's head, inside another thought bubble coming from the other's. Of course all that applies as well to one's mental acts regarding one's own mental acts. Descartes thinks about his thinking, perceiving, imagining; we can all recall seeing, hearing, feeling something—at least imagine remembering it—and may later recall that. Now, as earlier argued, depiction essentially includes one such situation, that of our perceiving and also imagining something about that act of perceiving. Specifically, it requires imagining of a current activity of seeing a picture that it is the seeing of what the picture depicts. As argued in chapter 6, this is a quite familiar situation; we often imagine something about other of our mental actions while we are doing them. Indeed, for all the senses and their combinations—for sight, hearing, touch, taste,

smell—there are familiar situations in which we are encouraged, enticed, mandated to perceive something, to perceive it in a certain way, and then to imagine something about that perceiving: "As you listen to this, imagine that you are hearing . . ." "Close your eyes and run your hand over this, relax, and imagine that you are touching . . ."

Depictive works sometimes represent these situations—that is, represent people getting themselves or others not only to imagine something but also to perceive something and to imagine of this perceiving that it is the perceiving of yet another thing. For example, in Alfred Hitchcock's film *Vertigo* one character, Scottie, dresses up another, Judy, to look like someone, Madeleine, not only more vividly to imagine Madeleine but also so that he can vividly imagine all his own sense activities regarding Judy as his sense experiences of Madeleine: this includes experiences of scent, look, sound, touch—and so forth. It is essential to that character's imaginative project that he not only imagine vividly about Madeleine but that he also imagine about *himself* and his actions: that he imagine vividly about his own sense experiences while he is having them.[2] If we can answer the question why this character does not simply imagine perceiving and spare the inconvenience for all concerned, we understand what concurrent imagining about one's perceiving is, that people indulge in it—and how the objects and content of perception can affect imagining, while, reciprocally, the imagining closely guides and permeates the experience of perceiving. Meanwhile, what do we, as beholders of the depiction, do? We also go to some expense and trouble to look at images on a screen and to imagine of our looking that it is the seeing of the characters involved in those acts.[3]

Since the argument is about to become awkwardly diagrammatic, consider the difficulty of representing this situation, which is so easily grasped when presented to us, in real life or fiction. Absent the graphic ingenuity of a Harry Beck or Saul Steinberg, it is difficult to represent in words such standard features of mental activity as intentionality, embeddedness, reciprocity, and reflexivity that are central to the case. Consider the hierarchy of embedded mental actions, with different objects and contents, if you should wonder whether I well recall *Vertigo*. You wonder whether I recall having seen the film—that is, whether I recall having seen James Stewart and Kim Novak on the

screen while being prompted to imagine that they are Scottie and Judy—that is, to imagine that my perception of those actors on the screen was the perception of those fictional personages (of course not on screen, and not as fictions), one of whom is attempting, by the use of props, to guide and enhance his perception of the other, for the purpose of more vividly imagining another—who (we and he will learn) she actually turns out to be, but under a different description, since Scottie has the right object with what Judy knows to be a mistaken content (as, alas, he would not love her under the corrected one), which in affairs of passion may be a matter of life and death. Thus love's old sweet song of imagining about what we are doing ("When we kiss, do you close your eyes, pretending that I'm someone else?").[4] But, to work up sympathy for the writing in the next two paragraphs, try making that clear in cartoon balloons, or by Pawahtún's breath-lines.

As such examples show, when we try to represent mental actions as having mental actions as their objects, we encounter interesting situations where these actions' objects have their own objects, and their own contents regarding those objects. Fortunately, to argue here about depictive experience, we only have to diagram two levels of these mental acts. With rough notation, we might represent the main ideas of Walton's theory of depiction exposited in chapter 5 as follows. If we let "I" stand for the self-imagining that is distinctive of depiction, "P" for the act of perceiving the picture surface, and "M" for the relevant visible states of that surface, Walton's specification of depiction from among other kinds of representation might be put as I→P→M. The arrows point to *objects* of the cognitive actions, and there are two of them, for the two objects: we imagine something *of* our perceptual activity, which perceives states *of* the marked surface. The first linkage, I→P, we recall, proved crucial for separating depiction from other kinds of representation. It requires not only that we imagine what is fictional in the work we see but also that we imagine about ourselves—about our seeing of the work. Also, as just argued, the nature of the act of perception very much determines that of the imagining which it has as object. As Walton writes, "The phenomenal character of the perception is inseparable from the act of imagining which takes it as an object" (295). That considered, let us consider, in turn, the visual perception's object re-

lationship, P→M. Again, as just argued, not only what we perceive (the object) but how we perceive it (the content) greatly determines the experience of perceiving.

Combined, these considerations bring us to a very interesting situation. If our depictive imagining experience is partly constituted by the nature of the perceptual experience that is its object, and if that perceptual experience is in turn largely determined by the object and the way we see it, then our depictive imagining experience will be partly determined by the object and content of the perceptual experience. Therefore, what is going on at the P→M level of activity greatly affects what is happening at the I→P level. If we are seeing differently, to that extent we will be imagining differently.[5] Our analysis of the situation does not end there, of course, for there remains the question of what is available to perception, M. For any theoretical account of the actions of perceiving marks on surfaces, much will depend on what is accepted as relevantly "clearly visible" there. Given what has just been argued, what we accept will impact our account of the imaginative experience. Since, on Walton's theory, such imagining is definitive of depiction, it also impacts the theory of depiction itself. But we have been studying for some time now the various aspects of "what is unquestionably visible in a drawing as a marked surface before us," and we have found this to include—besides spatial characteristics of the marks, picture primitives, and shapes—such characteristics as tone, facture, relationship to the ground, and dynamic qualities and relationships. It follows from the argument just given that, absent reasons why some of these are not *relevant* visible aspects of M, any or all of these are candidates for being constitutive, not only of our experience of the work but also of our experience of the *depiction.*

The implications of this conclusion are considerable, the main one being that any or all of these factors may be internal to depiction. This destroys the basis of long-standing dualisms of depictive form and content, according to which some of the visible aspects of drawings pertain to what it represents and depicts, while others are relevant only to what it expresses. It shows that drawings can depict by their facture, including their materials and what they show of their process histories, even as they may depict by the shapes, positions, and tones of their markings. This was made clear from the ex-

amples of Part III, but that is not all. We are now in position to address one of the main, long-standing theoretical riddles concerning any kind of depiction: how we can see in a picture not only what is depicted there but a seeing of it.

WAYS OF SEEING

That might be called seeing "a way of seeing." But here we must be careful. Consider what is sometimes called "ways of seeing" in pictures, for example, in the sense we find in Wölfflin's observation "It is not only that Rembrandt's pictures are built up on a different system from Dürer's, things are seen differently," since in Dürers (for example, "Saint Jerome") the independent figures are unities organized by light and perspective, whereas, in Rembrandts, parts of subject matter "give up their rights" to emerge from the whole.[6] Since Wölfflin's important and relevant conception of "ways of seeing" is not sufficient for what I am arguing, let us discuss it first.

We are well prepared for it. First, it is clear that what is depictively important about depictions is not only what they depict—that is, what things, situations, events, and properties they get us to imagine seeing when we look at them—but how they depict them. For example, to go back to our classic controversy between drawings with clear bounding contours and drawings that work up figures out of shaded masses, situations could be depicted either way as much the same and yet be experienced very differently. Compare Goya and Michelangelo. Or, to cite Wölfflin again, "Every picture has recession, but the recession has a very different effect according to whether the space organizes itself into planes or is experienced as a homogeneous recessional movement."[7] Even confining ourselves to contour, seeing something drawn by the "long linear shapes which are virtually single marks" of an Asian brush artist will be a significantly different depictive experience from seeing the same things in Western drawings where, as Rawson stated, artists "have repeatedly gone over their drawn marks, which are usually short, single strokes, revising and modifying them, rubbing them out and redrawing" (D, 27). Max J. Friedländer noted how European artists of the classical tradition worked volumetrically from an object-centered, anatomical canon, while Brueghel's

telling contours are ever-varied silhouettes of squat shapes (including clothing) in motion. As we have seen in our comparisons of Dürer's and Shih-t'ao's scholars in chapter 11, such differences literally affect our activities of seeing: first, seeing the drawings, since they affect the activities required to work up a relevant imagined seeing from the marks on the surface before us; second, our ways of conceiving the subjects depicted: Jerome in a world of distinct things unified by insubstantial light; a Chinese scholar as one facet of the flux of nature, requiring no such unification.

Let us consider these subtopics of "ways of seeing" separately. The former, less philosophical point is sometimes put in terms of "reading" pictures. Nelson Goodman remarked that "we have to read the painting as well as the poem. . . . Much of our experience and many of our skills are brought to bear and may be transformed by the encounter. The aesthetic 'attitude' is . . . less attitude than action: creation and re-creation."[8] Michael Baxandall influentially argued that such "readings" may go wrong if we try to understand one kind of picture with perceptual habits fit for a very different kind. "Much of what we call 'taste,'" he wrote, "lies in this, the conformity between discriminations demanded by a painting and skills of discrimination possessed by the beholder. . . . The negative of this is the man without the sorts of skill in terms of which the painting is ordered: a German calligrapher confronted by a Piero della Francesca, perhaps."[9] Thus Leonardo was unfair in criticizing pre-perspectival painters for making "the houses of men and other surrounding buildings in such a way that the gates of the city do not come up to the knees of the inhabitants even though they are closer to the eye of the observer than the man who indicates that he wishes to enter therein," and (not only illustrating but emulating Vitruvius, it seems): "We have seen porticos laden down with men, and the supporting column like a thin cane in the fist of the man who leans on it . . . without perspective nothing can be done well in the matter of painting."[10]

Since on the present theory depiction is defined partly in terms of the experience of seeing drawings, differences of the kinds cited will be internal to the depiction, rather than belonging to some other aspect of the pictorial experience that might be called, say, "expression," and any general theory of drawing or of depiction that cannot account for

that fact falls seriously short. Still, the phrase "ways of seeing" may mean something else when applied to conceiving what it depicts. To be sure, children who depict their parents largely through enclosure and one-dimensional primitives, stressing topological characteristics of containment, continuity, and order, do conceive them that way on paper. If we are to understand such pictures we must see them in those terms (possibly not imputing relief to circular forms), but it would be risky to carry that over to the child's thoughts about the object. As Norman Freeman has pointed out, some traits of child drawings probably reflect practical, "executive" procedures, not "conceptual" ones, and the same may apply to the most advanced drawing as well.[11]

Even where conceptual differences are registered in drawings, we must be careful about characterizing that fact in the second, more philosophical sense of "ways of seeing." We considered one broader meaning in chapter 10 when discussing Blake's reactions to resources that break continuous bounding contour in drawing. Rawson, too, boldly attributed cultural, even ontological differences to some of the drawing differences between Europe and East Asia. "A Japanese artist such as Utamaro conceptualizes only the sinuous movement of lines across his ground. He does not conceptualize intelligible enclosures, nor plastic volumes, nor tonal gradations" (D, 21), he writes, making clear reference to our chapter 10 resources. "In this," writes Rawson, "the artist's idea of visual reality is reflected." In general, "implicit in every drawing style is a visual ontology, i.e. a definition of the real in drawing terms" (D, 19). These, he alleged, sometimes link to broader differences of culture: "We know that in Japan the accepted idea of the real as a 'floating word' had its roots in a mixture of adapted Chinese Taoism and Buddhism, which denied any permanence, solidity, or absolute value to separate objects. Things existed for Utamaro as episodes in a process of shifting limits, not as separate, self-contained entities. And so he developed the linear language of the Far East in the direction of fluidity and elegance. . . . In sharp contrast, an artist like Titian came in the end virtually to obliterate all trace of distinct lines in his drawings," with "no edges or outlines asserted anywhere."[12] Yet, in defense of art's autonomy, Rawson would not himself use the phrase "ways of seeing": "I cannot stress too strongly that drawing is not seeing. It is one of the commonest fallacies, entertained by many people who ought to know better, that a work of art is the record of something seen." He continues: "A language of form or structure creates its own kind of reality. It may be 'second nature' as Goethe called it, parallel and related to the first nature. But it *is* not the first. To talk of an artist's 'vision of the world' is misleading unless the terms are further defined. This word 'vision' does not mean that he sees the real world—so! but that he always makes an image of his world—so!"[13]

From this little dialogue regarding "ways of seeing" we discover that views may be held concerning the relations of three, not just two, issues: (1) abilities and activities specific to pictorial perception; (2) related abilities and activities—often practical ones—of nonpictorial perception, which may be general or culturally specific; and finally, (3) wider cultural forms. Thus Baxandall argues for strong influence of the second factor on the first; Rawson, while warning against assuming influence of the first upon the second, is willing to place the first within the third. To round things out, the aesthete Oscar Wilde suggested that the second was formed by the first, while "historicists" from Hegel onward would explain the first in terms of the third; and Gombrich repeatedly warned against any such assimilations.[14] All this could be the subject of a book: fortunately, that is not our central concern here, where it was only necessary to review familiar ideas concerning depictive "ways of seeing" in order to distinguish them from the next stage of the argument, for which the same phrase is used.

APPRECIATING INTENTION

From at least Part II, our discussions of drawing have been driven by what is clearly before us in any drawing: marks on surfaces. Our central project has been to find the relevant kinds of descriptions under which that situation is to be described. According to Michael Podro, we will never understand depiction until we distinguish "between the artist's *material,* the marks and surfaces he employs, and his *medium* in the sense of those materials used with the purpose of 'raising the ideas of bodies in the mind.'" Regarding the dualist's problem of how we relate our experience of the medium and our experience of the subject, Podro continues:

"If we identify the features of the object as lines drawn to show or define a form rather than as marks on a surface, the problem does not arise. The representational force of the artist's marks, and the intention that they should have that force, would be there from the start." Then, he writes, "the appreciation of intention" will not be understood as something "added to the feat of recognising a subject in or projecting a subject on the object, but as internal to that recognition. In this way depicting would be like talking or singing: in neither case do we want to say that we make or listen to sounds to achieve a further end of conveying or understanding something. Talking and singing are done in the sounds, and depiction is done in the lines and marks of pigment."[15] Podro here explicitly argues that the drafter's *purposes* in drawing can be part of what we see when we look at them. If this is so, then, by the earlier schematic argument, such intentions can also be internal to them as *depictions*. Let us now exposit these neglected observations using the theoretical tools we have developed. This will be done in a series of steps.

The perception of marks in terms of makers' purposes and intentions has been part of our account of drawing all along. Purpose was introduced with the very terms "draw," "drawing," "design drawing," "engineering drawing," and so forth, regarding what was called in chapter 4 a "certain kind of intentional physical action" and its products. Next, as argued in chapter 8, it is important to remember that "drawing" is a name of familiar functional artifacts, as are "abacus," "bowl," "car": things made, on purpose, for use—and the next word in that alphabetic list might easily be "drawing." Most drawings belong to one familiar kind of artifact, "visual displays," which means that they are further understood purposively, given that displays are situations made visible with the purpose of being perceived—indeed, with the purpose that this very intent be recognized.

Here again our Paleolithic ancestors may instruct us. Clear evidence for the existence of such animals as cave bears, mammoths, lions, and rhinos thirty thousand years ago is found in overlapping markings on the walls of Chauvet Cave and other sites in Europe (fig. 70). However the evidence for the presence of these animals differs. For the bears, the evidence is scratches on the walls (along with their bones on the floor), whereas for the other three the evidence is based on radiocar-

bon dating of charcoal drawings that depict them. Possibly both kinds of markings are what I am calling "displays"—that is, in case one of the functions of the bears' claw marks were to show their presence to other animals. But even were so, the two kinds of displays would be very different, as are their evidential bases for two arguments for the existence of ancient animals. Both bases are causal, but, as Descartes distinctly perceived (*Meditations* III), the evidence for the other three animals' existence then and there involves what the ursine incisions could not: an intentional content of the charcoal marks as depictions, in addition to the relevant facts of their reality as physical entities (Scots pine charcoal granules with radiocarbon datings), which they shared with the claw marks.[16]

Drawings, including depictive ones, are highly purposive things—more so than are simple displays. How can we, on the basis of this, argue Podro's position that "the appreciation of intention" may be more than "added to the feat of recognising a subject in or projecting a subject on the object"—that it can be "*internal* to that recognition"? A first mistake would be to attempt to base the argument on Part II, on what we found in our discussion of Gombrich's introduction to "the beholder's share": for example, Michelangelo's "rapid scrawls where he intended to indicate statues," which "would not make sense by themselves, but . . . do in their context." We recall that Gombrich's aim in introducing his phrase "the beholder's share" was to explain how the use of depictions as visual displays is carried out by beholders. His point was that although the Michelangelo (or Leonardo: fig. 58) is a design thinking-drawing, it is an incomplete one, and whether or not we take it as a work of art (as these drafters would not), just to understand it we need to follow his purposes through the marks, lines, enclosures, contours, and shapes the artist made, to see what he has done, in order to accomplish something else. That alone makes such drawings different from many functional artifacts.

This makes the situation different, even, from many human display artifacts, for to understand drawings like Michelangelo's or Leonardo's sketches we need to understand something about their formative process, to know what the artists were doing in making those ink traces visible on the surface. And it is pretty clear, looking at such drawings in relevant contexts, what they were up

to. As in the case of the child and of our ancient forebears in many places in the world, their lines *look* drawn—indeed, sometimes scribbled—and they clearly look as though they were drawn for definite purposes, with the representational intentions Gombrich indicates. There is even an aesthetic of such appearances, based on an interest people can find in drawings, whether or not they are works of art, and whether or not they were made to serve that interest. Because drawings leave their separate marks salient, we sometimes like to look at them in order to follow the thinking of the creator. We do this a bit with children's drawings, and, as Gombrich elsewhere remarks regarding studies or preliminary drawings, for some "the drawing was even more valuable than the finished product, because it recorded the process of creation."[17] Autographs have value in various visual arts, East and West: thus for example a Renaissance artist like Mantegna might have been concerned even about "the registering of his own hand in the engraving" of plates in the early days of such reprographic techniques.[18] That said, however, the present argument must not rest on such cases, as it needs to extend to drawings that are not incomplete, and drawings for which there is not the sort of interest Gombrich here identifies.

We might therefore seek a broader basis in Part III from our next source, Rawson, who declares that we should understand all drawings temporally, in terms of their actual sequences of production (his "kinetic" aspect). He holds that "there always lies at the bottom of every drawing an implied pattern of those movements through which it was created"—to which he adds that "no drawing that suppresses its marks entirely and loses their rhythms, can ever amount to much" (*StD*, 25–26)—although, as we noted, he may be speaking only of drawings as art. We have confirmed the existence of such a pattern of movements in a variety of drawings, East and West. In itself process history does not reveal visible agency or purpose: after all, we see process in geological strata without thereby sensing intentions.

But I have held back the fact that Rawson is also willing to say something else of drawings: "all intentions show in the artifact" (*D*, 43). That constitutes a significant step beyond our considerations of his views in Part III, but one that those considerations seem to warrant. A drawing's obviously looking like a thing done means that purpose and human action generally need to be added to our list of relevant visible factors in drawing marks, for one could hardly perceive the implied pattern of movements in their facture without taking them as purposive—as purposely controlled or not, even as purposely uncontrolled. For example, Bonnard's varied drawing marks look to be made in certain ways—they look just as his grand-nephew described them: "He immediately took from his pocket a piece of paper, which he held in his hand, and a stub of pencil so short that it disappeared between his thumb and index finger, and drew this silvery vision" of olive leaves wet by rain.[19] To be sure, that kind of facture is not nearly so apparent in many drawings. It need not be to make the point. Even where we are not much interested in such temporal aspects of drawings as Rawson emphasizes, there remains the more basic point: that drawing, as a purposive activity, takes place and is perceptible as purposive at each level at which we may say that something "has been drawn."

Thus, besides marks and lines and shapes, things, people, details, and expressions are drawn, and so are patterns, textures, relationships, situations, events. Groupings and compositions are drawn, parts and wholes of pictures are drawn; they are drawn with certain materials and in certain ways. Even when a drawing does not have so specific a look of having been made by sequence or as Rawson claims, few drawings—none illustrated here—appear to be made up of elements, whether marks or picture primitives or shapes at higher orders, that got onto the surface by accident. As we considered with "the blob," some drawings contain, even thematize, accident to a high degree, but such are not usual cases. Most drawings *look like* they were constructed largely on purpose, by means of sequences of marks set down more or less deliberately. Such is one instance of a general aspect of perception, since it is normal for people, regarding what seem to be normal categories of things, to "attribute their identity to the processes of their origin."

Yet it is a highly distinctive instance, added to the other ways in which perceiving drawings differs from perceiving nature, even where aspects of the latter are transferred to the former. Nature and drawing do have it in common that when an object's resting base is higher up in our visual field, or the object subtends a smaller angle, we take this as a strong cue for the object's being further away, but

(with a qualification soon noted) it is only in the drawing that we also see that these characteristics were put there, successfully or not, in order to work as a cue. The causal explanations why these visual facts obtain are thus of radically different orders in the two cases. Only in the latter case must the explanation appeal to a purpose: "in order to suggest depth." Earlier we considered why Goya included a shadowed angle and added a heavy chain to his "Two Prisoners in Irons." While there is point to a famous photographer's saying that in photographs there are no unexplained shadows, we see how, in an opposed way, there would be none in a Goya, either. This is because the explanation would not be in terms of natural causes but rather in terms of reasons guiding purposeful actions. Whether in the simple cases of children's drawings or with works of art, this is an aspect of how all drawings look. Therefore, since all the descriptions just indicated are purposive, a drawing may look intentionally made in any of these ways. Such being their visual aspects, given the preceding argument with diagrams, any are possibly relevant "visual facts"—the states denoted by M—of what we perceive in them, which states may help determine the nature of our perception of the marked surface before us, P, and thereby of our depictive imagining of that perception, I. They are therefore possible constituents not only of the experience of drawings but also of the *depictive* experience of them. That is, if one's act of seeing a drawing is imagined to be the act of seeing what the drawing depicts, it may include imagining seeing something as done with purpose or intent.

Once again we find ourselves accounting in a rather complicated way for what appears to be an obvious, important aspect of our experience of drawings and of depictions generally, one that sets it apart from environmental perception. When we see something depicted in a drawing, we imagine that we are seeing that thing, and we can imagine seeing it *through* the perception or conception of someone. It may be replied that whenever we perceive something we perceive it as perceived or conceived by someone—that is, by ourselves. Knowing that, we confirm, correct, and supplement our perceptions by varying them and by correlating them with the perceptions of others. The point is well taken; still, depiction is different. Depiction allows us the remarkable experience of imagining seeing things as conceived or perceived by another, or by

ourselves at different times. Of course, whether that matters—whether this aspect of drawing's perceptual resources is exploited in a particular case—depends on the kind of drawing and on our use of it. But that holds for every drawing resource we have studied. It would be pointless to claim its relevance for many drawings or for many uses of them. Still, it clearly matters a great deal for most kinds of drawing that are *art*, and it matters for other kinds of drawings as well: sometimes crucially.

This intentionality argument holds for many media, but drawing provides a particularly good means for making it. The thesis of the present chapter is that long, open lines or those formed of many short, worked strokes are clearly visible as having been made in those ways to define for our perception the form of a depicted body. Thus the marks we see that define a contour will usually look as though they were put there for the purpose of defining a depicted contour for our imaginative experience—to be, as Podro states, "lines drawn to show or define a form rather than as [just] marks on a surface." It is often said that drawings appeal by their "intimacy" or "spontaneity," and that in them we "see the creative process at work"—an idea put with typical lucidity by the art historian and teacher Joshua Taylor: "Because of the directness of their execution drawings often give a particularly clear indication of an artist's vision, . . . aims and formal means. Often in a drawing we feel that we have made a close contact with the artist . . . , as if we were present at the moment the artistic idea was first formulated. Possibly, also because of this directness and the simplicity of means, we are especially conscious, in drawing, of the medium employed."[20] That would need qualifying, but even in its looser expressions it makes an important point: a salience of individual marks and picture primitives is virtually definitive of drawings, which present these visible elements *as drawn*, that is, as the effects of actions guided by the purpose of building a depiction—much as (Podro reminds us) audible speech presents itself as utterances, not just as sounds.

Drawing, as understood in this book, is an extraordinarily good way to consider the visible levels of formative actions, beginning with the visible properties of the marks. To make a rather Leibnizian point, of course we see the marks that constitute paintings and other kinds of depictions; otherwise they would be invisible. But we are not

typically quite so aware of all the individual marks in paintings as we are with drawings, given a tendency of painters to cover their tracks. The same region outlined by dots or a line, closed or open, depicts differently: why else would Rembrandt have told his students not to enclose forms "with a single pull of the pen"? This transparency of the levels of action also makes clearer to us where the action's emphasis is going. For example, it is pretty clear that Leonardo cares not only what his shapes look like but also his contours, the flow and duct of the individual lines that constitute them (figs. 58, 77). By contrast Cézanne little cares what his lines look like as individual constituents. We can imagine him using a variety of them for the same purpose, since all his attention is turned to what he is doing with them (fig. 89).

Again, we may ask how this compares with nondepictive perceptual experience. To be sure, not only are many nonpictorial artifacts made as suitable for sight, we sometimes perceive them that way, as being shaped for display. In architecture, landscaping, and other kinds of design, the overall form, contour, texture, and shadow modelling of an artifact can assist or baffle our perception of its form; indeed they can also appear to have been produced for the purpose of guiding our perception along such ways. Some of the design drawing discussed in Part I is precisely for production of such effects. In some cases, so appearing can even be part of their function: these aspects are then displays, in the sense defined. For example, many articles of clothing and bodily adornment fit this description: people in all societies usually dress up in part to look like they have dressed up. However, depictions are a specific kind of display, in which perceptions of intent may be part of the content of what is imagined about: they may be objects of imagining.

SEEING THE FUN

Once perception of a drawing as an activity is allowed into our experience of depictions at such basic levels as those of the physical marks and the indicated picture primitives, the question arises, What limit can be set to visible intention there? There are two dimensions to the question. First, I have argued that all levels of depiction built on these perceptually fundamental elements might also be experienced in terms of actions. Aspects of our perceptual experiences of pictures would then radiate through the layers of interpretation of the picture built on the marks, primitives, depicted scene features, objects, and relations. But now there is a second strategic point to add to the arguments, that these acts may be qualified by the whole range of mental, psychological, and moral traits by which we qualify conceptions of things. "Thought balloons, indeed," skeptics will say, reminding us of psychological studies concerning what is called "overattribution of agency." However, psychopathology also identifies a phenomenon of underattribution of agency, and—as Wollheim argued—loss of mental content means loss of meaning, entailing loss of art.[21]

To answer such skeptics, let us consider cartoons and caricatures, which have already come to our aid several times. Maybe a step toward saying how drawings can be art is saying how they can be funny. This seems no trivial matter, it being a positive scandal that most approaches to depiction provide little or no resource to account for how a drawing could be funny, or anything else. Among the worst are the strictly spatial approaches, especially those built on projection. Regarding humor, such approaches might at best attempt to tell how drawings can depict objects and situations, which might then turn out to be funny—that is, drawings of funny things. To be sure, many captioned cartoons are a bit that way, the humor lying in the situation and in what is said. Some are jokes that would work simply by being told, but most need at least to show a situation with some legibility, with some manner of drawing signaling the setting to be humorous (figs. 29, 30). Nevertheless, it is standard to cartoons that the drawings themselves be humorous, not just the situations they depict. Cartooning is, after all, a kind of depiction, not a kind of depicted subject matter. Send in the clowns? Hardly: cartoons are not depictions of clowns dressed up with false noses, on stage sets, lit and arranged so as to look ridiculous. This is made clearer by considering classical pot paintings that are. Although such works, along with terracotta figurines, can easily be mistaken for comic depictions, they are actually depictions of actors from the comic stage—and therefore depictions of representations (fig. 92).

By contrast, mostly what look ridiculous in cartoons are not meant to be grotesques, but creatures

Fig. 92. Tarentine red-figure bell krater, with scene of Cheiron pushed onto stage, 380–370 B.C. Detail. British Museum, London. Author's rendering.

like ourselves in situations like our own. In short, although some humor in cartoons lies in the *what* of depiction, much of it is in the *how*—through absurd or otherwise risible ways of seeing. Our studies have begun to account for these familiar facts, first by explaining how some of the basic means by which drawings depict determine how the things and situations depicted are seen—that is, by which visual activities. For example, our ability to see people as comic, through metaphorical transfer of perceptual categories for all manner of other things, is perceptually widespread. Independent evidence for that exists in the vivid descriptions people find for human physiognomies, and in

nicknames—themselves verbal metaphors, exhibiting transfer, for not all Rawson's "secondary forms" go unremarked. It takes not much introspection to see how often one's environmental perceptual categories are enriched (or afflicted) by such imaginative transfers.[22] Thus many cartoon ways of seeing are already there for the cartoonist to explore, and recognizing a drawing as a cartoon prepares viewers for transfer activities. But further, with an intentional account we can begin to explain how, by indicating a head as an attenuated $3_{1,\ 2/3,\ 2/3}$ egg shape, via a loose enclosure, via a line, or via a quick mark, a cartoonist can make a joke of the very fact of this noble object being conjured

through an egg shape. As in mime, it is usual for cartoons to seem funny by the fact that a trait—a nose on a face, the way people's legs bend, their facial expressions—can be rendered by such means (fig. 57, p. 96). Even this point could be taken much further, since modern cartoon humor has a spectrum of attitudes. Some types make fun not only of what they depict but also of their very acts of depiction, of their own productive processes, often by disarming simplicity or regressive crudity of drawing methods, including emphasis on apparent ineptitude with tool-kit devices for rendering shapes and dimensions by marks and primitives (fig. 29, p. 32). The absurdity of the means of drawing then lends itself to absurdity in what the drawing means—that is, an absurdity in the way something is done and conceived.[23] Others are executed with suave assurance (fig. 30).

The comic, ridiculous, and satiric are only a few examples of conceptions we form of the depictive content of drawings. Normally we look to depictive artworks such as drawings for more meaningful kinds of conception or perception. Since we considered Chardin's depictions recently, we may also recall Igor Stravinsky's remark that "Chardin could display a richer representation of life in his kitchen than other painters managed with all of Versailles."[24] Such richness of representation implies something more than beauty or aesthetic fullness; it implies a conception internal to the depiction. The question is whether we are now in a position to represent this theoretically.

THE ARTIST'S VISION AND OUR OWN

Aristotle said that in inquiries like ours theory should make sense of received ideas. Let us remind ourselves how, theories apart, we normally describe depictive drawings as works of art. As we considered only a few groups of open contour strokes in Rembrandt's "Hendrikje Asleep" (fig. 91, p. 208) Epco Runia's short description of that drawing may show how far we have advanced from there.

Perhaps Rembrandt's most unusual drawing is his sketch of the sleeping Hendrikje, the woman he lived with from about 1649 . . . lying down and wearing nothing but a shirt, which heightens the intimacy of the scene.

The expressivity with which Rembrandt has entrusted the scene to paper, by means of a few apt strokes, is unsurpassed. This is one of the few instances where he used only brush. Quick dashes—occasionally with a somewhat drier brush—indicate the major contours: the arm on which the head rests, the curve of the body, the folds of the shirt, the bare ankle. With every stroke he has taken into account the incidence of light from above right: the broader lines at lower left suggest both shape and shadow. A few touches in two different tints delineate the face. Rapid but telling, for the round features are unmistakably those of Hendrikje as she appears in Rembrandt's paintings. With the simplest of resources, the artist has created a highly original impression of his beloved asleep.[25]

As usual, we here describe a fictional world in which we imagine seeing and also show interest in finding relationships between things in that world and nonfictional things and events. Also, as usual, we describe what we see that the artist has *done* to evoke this experience. Thereby we refer not only to properties of the materials, marks, picture primitives, shapes, and so forth but to what these achieve depictively. This is perfectly normal. Again, normally, we do all that in terms of drawing actions, described at various levels of intentionality with such terms as "sketch," "touches," "used," "entrusted," "taken into account," "delineate," "created," and so on. Such descriptions pretty well represent our perceptual experiences when we see such drawings in the normal way—that is, drawings as drawings.

As applied even only to that phrased set of about ten contour lines and less than fifteen markings we earlier considered in the Rembrandt, what this means is that, in the first place, we see them all as drawn—that is, as put there with specific depictive and decorative intentions, by easily recognized physical marking actions. The same goes for all the other drawn marks that evoke the figure. For example, the pair of contours that form her ankle are concavities—as that contour would be in reality—breaking the rule-of-thumb convexity principle earlier explained. However, we may recall from chapter 10 that Rawson emphasized Rembrandt's strong rejection of convex "phrased contours": be-

sides, these "exceptions" seem to emphasize the figure's vulnerability. Regarding perception of basic drawing actions, for any bit of this drawing we have a pretty good sense of the extent to which it is not controlled, as one aspect of the quality of the drawing lies in what may be called its "looseness" and spontaneity of the handling. Part of its greatness is that the placement of the marks seems spontaneous, casual, yet nearly unerring. That is, we have a sense that they could have been otherwise and that things would still have been all right. This means, in everyday terms, that as perceivers we feel that we, like the drawing, are in good hands, in fact the best.

The theoretical argument about such cases is that all this perception is transferred to our imagining seeing the depicted scene. That is, as we notice the strokes, which we can hardly avoid doing, we find a large blob under the figure suggesting deep shadow, which is also understood as a push under the form, as is the added stroke at the right temple, while that at the left is a push back of the skull form, but the broader brush sweep that shadows the figure's bottom is a lift. "Sustaining recognition" means that we can move back down the hierarchies of means. Already in making out the figure from the marks, we can look back to the marks, led by what we have recognized in the subject, and notice, for example, that—as can be seen by imagining it missing—the added stroke under the hand pushes the wrist back, making the figure's support appear more as a bright, bent surface. Once seen as tucking into the figure, that wrist and hand increase the sense of the shoulder plane's depth, making it look more foreshortened and thereby more reflective of light. The scene is organized in several ways, one of which is by the angular relationships of the lines, most of which are bent at only a few angles, their segments in fact related in two sets of approximately right angles, set by the square shadow of the right sleeve. This is a method based on "two-dimensional rectangular relationships" (D, 131), as Rawson notes, whereby "strokes in a drawing are related at right angles to one or other segment of the principal thematic idea." Indeed "Rembrandt very much made this method his own in his later years, and it seems to be the principal element in his late 'classicism'" (D, 131).

Although much more of the kind could be said, it would actually be a mistake for our general pur-poses to keep the description of deliberate actions at that level, since, as is normal for human actions, all these are done to accomplish something, under whose description they also fall. The dipping and moving of the brush is the making of a mark, which may be the drawing of a line or the filling in of a region, which in turn may be the drawing of a contour or the shadowing and pushing back of forms, and so forth. Where, as here, the result is the production of a figure seen in a certain way, all those acts are qualified by that description as well.

Rawson refers not to Hendrikje in a shirt but to "a sleeping girl wrapped in a blanket," and one might reconsider the direction of illumination ascribed in Runia's description quoted above. Such uncertainties are common: it is conjectured that Goya's wounded man and one of his bearers wear uniforms from the Spanish War of Independence, but this is not certain.[26] But some ways in which these figures are imagined seen, and also not seen, are clear at a glance. We can be sure that Rembrandt's is not a funny picture or a caricature of someone, that it presents no ironic, sardonic, lascivious, or idealized views of a woman. The view we have of the figure is neither condescending, frivolous, possessive, clichéd, nor sentimentalized. Neither is it cool, distant, or of a carnivalesque sensibility as in Tiepolo's view (fig. 79). It is observant and respectful: as so often with Rembrandt, the person we imagine observing is unaware of us, with an interior world of her own. Rawson remarks that Rembrandt's figures "usually seem to be wrapped in an intensely personal interior vision." More fully, Jakob Rosenberg wrote: "Rembrandt's people, wrapped in their own thoughts, are in communication, not with the outside world, like those of Rubens, Van Dyck, or Frans Hals, but with something within themselves that leads, at the same time, beyond themselves." Typically with Rembrandt all depicted things, animate or not, are "tied up with the creative process of all earthly life and subject to dynamic changes . . . never separated from their source and reposing in their own beauty, as for example, the classic View of Delft by Jan Vermeer."[27] These are, as Rosenberg remarks, philosophical differences, and they are based on the uses of all the drawing resources that we have considered, including in Rembrandt's case his avoidance of closed contours. There needs adding to this that, as another wise source, Otto Benesch, wrote, whether depicting humans, natural scenes,

or artifacts, Rembrandt's vision "consisted not merely in sharp observation, but he let himself be imbued with nature. . . . It is a closer identification with nature than any other artist before him ever achieved"—perhaps, we should add: in the Western tradition.[28] Goya's compassion, in his unswerving vision of horror and folly, is of a different quality from Rembrandt's. All this is "unquestionably visible": how is that possible?

Modern skeptics will say that it is not possible, arguing, as Wollheim aptly pointed out, from a level of psychological sensitivity that in real life would deprive them of all society, lovers, friends. Phyllis Diebenkorn remarked that she could tell how Robert's day at the studio had been by the sound of the gate click. The challenge here is not to show that it is possible to see more intentional characteristics in a drawing by Diebenkorn, it is to explain in theoretical terms how it would be possible to see any at all. Because we see Rembrandt's drawing in terms of the intentional actions that bring it successfully about, we understand these actions accordingly. Which actions? It may be helpful to recall Nicolaïdes' standard life-study instruction quoted in chapter 6: "Imagine that your pencil point is touching the model instead of the paper . . . *wait* until you are *convinced* that the pencil is touching that point on the model upon which your eyes are fastened." It is no great jump for beholders, also, to imagine Rembrandt's figure being drawn that way. The stroke that forms the figure's lit cheek and jaw line, obviously shorter and drier than the resembling one that fixes the support, is not only amazingly sure and successful, it is also compassionate. The still drier one, also resembling it, that, twice breaking to show the shoulder blade angle and the loose cloth, transforms itself from occlusion contour of the figure's shoulder to surface contour of the sleeve, produces the crucial plane break that hunches forward the front shoulder plane into protective containment (as may again be seen by covering it). Rembrandt's action, understood in its purpose, is also seen by us as showing feeling—possibly transferring to our perception impressions of the gesture that adjusts the blanket of a sleeping figure. And since that mark is understood under all these purposeful descriptions, our imagining about our seeing of it may include all this as internal to the depictive experience, along with our various perceptions of space, light, and texture. With the Rembrandt, as with Chardin,

the result belies Roger Fry's comment that in the presence of the work of such artists we are forced to think more of the artist than of the subject.[29] There is no difference.

"LIKE THE EFFORT OF A PHILOSOPHER"

It would be a mistake to take the foregoing as suggesting the only direction for perceiving drawings in terms of actions of drawing, including even morally determined actions. The matter is far more complex. For example, earlier we considered Cézanne, whose depictions, whether of nature or of people, do not give us a sense of depicted things from the inside, as do Rembrandt's, but indeed express what is often felt to be a general "aloofness from mankind and from life"—as Novotny says, even an absence of any "mood."[30] Yet there is Picasso's well-known remark to Christian Zervos, "What forces our interest is Cézanne's anxiety—that's Cézanne's lesson"—anxiety regarding the artist's well-known commitment to what he termed "realizing my sensations." Strictly, that may seem to lie outside our project, since it has basically to do with color: thus Cézanne's late comment, "I cannot attain the intensity that unfolds itself before my senses. I do not have the magnificent richness of coloring that animates nature."[31] Still, it applies as well to his drawings. In writing about Cézanne's seriousness, Meyer Schapiro stresses features of his art that illustrate main themes argued in Part IV: the bankruptcy of dualisms, attention to features of the marks as drawn marks with depictive purposes, our sense of the artist's conception in the work. Schapiro expresses it well: "The apple looks solid, weighty, and round, but these properties are realized through tangible touches of color each of which, while rendering a visual sensation, makes us aware of a decision of the mind and an operation of the hand."[32]

Schapiro continues with a remark that applies to the present argument on those themes: "In this complex process, which in our poor description appears too intellectual, like the effort of a philosopher to grasp both the external and the subjective in our experience of things, the self is always present, . . . mastering its inner world by mastering something beyond itself." Chastened, as philosophers we must go forward, with help from Schapiro's insights. According to Schapiro what we

experience in any mature picture by Cézanne, drawing or painting, is great seriousness before the objects of perception, such seriousness as to require us to put aside the tool kit that we have been considering and then—as indicated in chapter 12—deliberately refashion tools from it, one by one, reconsidering their uses, never taking them for granted. (That radical reworking may help explain Giacometti's cheerful art history: "Drawing is the basis of everything. But the Byzantines were the only ones who knew how to draw. And then Cézanne. That's all.")[33] For example, parts of linear perspective are employed, but never as a system, while parts of it—such as convergences and vanishing points of any kind[34]—are studiously avoided. As Rawson notes, the floor falls out; as Schapiro adds, barriers are thrown in the way. Even though something as basic as object contour is much employed, that is only after being entirely reconsidered: first as line with direction, with dividing function, with continuity; then as contour for boundary, for enclosure—so that when line and contour do serve these standard functions our perception of them can never be automatic. Thus Cézanne's "surprising discontinuities of edges" (17), deformations of objects' shapes—especially regarding symmetries—and so forth increase "the effect of freedom and randomness in the whole," and the beholder's effort to follow the organization becomes a paradigm of what Podro called "sustaining recognition." Close to our present theme of the intention of the drawing marks as part of the content of the imagining of the subject, Schapiro writes: "We see the object . . . as formed by strokes, each of which corresponds to a distinct perception and operation." Thereby, regarding Cézanne's "aloofness," there is this to conclude: "The coming into being of those objects through Cézanne's perception and constructive operations is more compelling to us than their meanings or relations to our desires" (18, 19).

To sum up: by brief consideration of the examples of Rembrandt and Cézanne, we find that both the attitude of the drawing action and its location in our experience of a drawing may differ. That holds for an open variety of cases. For example, Cézanne's humility before nature, sensed in the very facture of his pictures, is different from that of Chinese artists such as Zou Fulei, often characterized as working effortlessly through their identification with nature. Cézanne's questioning of the Western tool kit is also different from the self-conscious, ironic questioning of it by some twentieth-century artists, because of his dedication to nature and vision that they tend to lack. In such cases, the way to understand drawing as an art is opened once we consider drawing as drawing and depiction as depiction. Then, rather than thinking of either as a reduced form of ordinary perception, we may understand such transferred perceptions as main elements, playing their parts along with many others, usually including the artist's purposive actions. We thereby escape the embarrassing dualisms of most picture theory, and such ampersand aesthetics as "representation & form." Thus a theoretical analysis and account. Since moral and mental qualities, like those of stylistic form and skill, are important observable aspects of pictures—"things that can actually be found in drawings by looking," as Rawson said—I have attempted to explain "clearly and consistently," if sketchily, how they can be there and we see them there. Anything less than that attempt would have been a failure even to propose a theory of drawing.

Drawing as art is, of course, only one kind of drawing, and not a unified one. This book began with the argument that drawing would be an absolute necessity for modern life even were there no arts of it, just as it would be if there were no truly depictive uses of it, artistic or not. And where it is practiced as art, such full use of drawing resources as we considered is by no means necessary. Just as Rembrandt could produce great art while avoiding the ancient, universal technique of full contour definition, and just as Cézanne could, without Rembrandt's touch and human feeling, so others can do so, absent depictive figuration or any signs of process history. Indeed, for any kind of drawing resource discussed—the making of marks, the drawing of lines, shapes, letters, constructional drawings—without much effort we can find a variety of artists, even traditions, for whom that one resource alone has been sufficient for much artistic meaning. Explorations in drawing of what might seem the most rudimentary topics, such as topological matters of continuity, enclosure, and separation, still find themes sufficient for such meaning. With our theoretical basis it should be easier to investigate the richness of unique cases. As stated at the beginning, all the theory was in aid of the practices of drawing and of their appreciation. Long before theories, books, writing, the language

in which this is written or its roots, long before the wheel or our other clever devices, one of our ancestors several times drew the contour of a cave bear's head (fig. 66, p. 124) by three strokes, just as we might today: "The first line draws the forehead and then stops and ends in a comma to indicate the nostril. The second draws the mouth, while the third depicts chin and the cheek."[35] So let us continue—in whatever kind of drawing or "drawing" we do, whether art or not art, with pencil, brush, physical structure, or camera—to follow the good advice of an oft-quoted imperative allegedly from Michelangelo: "Draw, Antonio, draw, Antonio, draw and do not waste time." *Nulla dies sine linea.*

notes

PREFACE

1. "He sighed, glanced at the drawing he'd just done, and closed the book"; James Lord, *A Giacometti Portrait* (New York: Museum of Modern Art, n.d., ca. 1965), 44. There are similar remarks in other traditions, such as Hokusai saying that at seventy-three he has learned a little about the structure of nature, and has hopes for more at ninety to a hundred and ten.

2. Nelson Goodman, *Languages of Art: An Approach to a Theory of Symbols,* rev. ed. (Indianapolis: Hackett, 1976). At my first meeting with Goodman in 1965 he emphasized his review of Gombrich's book, although, as he remarked to me some years later, "Gombrich is not a systematic thinker," an issue addressed in chapters 7 and 9.

3. Wilde continued, "This results not only from Life's imitative instinct, but from the fact that the self-conscious aim of Life is to find expression, and that Art offers it certain beautiful forms through which it may realise that energy"; Oscar Wilde, "The Decay of Lying," *Intentions* (New York: Nottingham Society, 1909), reprinted in *Aesthetics,* ed. Susan Feagin and Patrick Maynard (Oxford: Oxford University Press, 1997), 44.

4. John Dewey, *Art as Experience* (New York: G. Putnam's Sons, 1934). Dewey's first publication was in 1890. Goodman's subsequent writings included *Ways of Worldmaking* (Indianapolis: Hackett Publishing, 1978), but the note taken by philosophers and psychologists was limited to only a few of Goodman's topics. Goodman's case for the autonomy of art was even broader than indicated here: in the typically inimitable words of Wollheim, Goodman "pulverized analytical aesthetics as it had been practiced, and in doing so . . . brought art this side of the philosophical horizon," by allowing art "meaning and content," thus ending "three or four dismal decades" of spectator-based, aesthetic judgment dominance; Richard Wollheim, "The Core of Aesthetics," *Journal of Aesthetic Education* 25, no. 1 (spring 1991): 39.

5. For a central statement of Goodman's cognitivist approach, see *Languages of Art,* 255–262.

6. Richard Wollheim, "On Pictorial Representation," *Journal of Aesthetics and Art Criticism* 56, no. 3 (summer 1998): 217–226.

7. Ibid., 221–222, and more fully in Richard Wollheim, *Painting as an Art* (Princeton, N.J.: Princeton University Press, 1987), 46–51.

8. For the story of Enlightenment reconstitution of the mimesis family, see extracts from Paul Kristeller (with an appended quotation from Goethe), Batteux, and d'Alembert in Feagin and Maynard, *Aesthetics,* 382.

9. Patrick Maynard, "A Study of Depiction" (Ph.D. diss., Cornell University, 1970), and "Depiction, Vision, and Convention," *American Philosophical Quarterly* 9, no. 3 (July 1972): 243–250. That paper, much cut down at the editor's request (Ted Cohen said I left out the best bits), is also one of the first treatments of M. H. Pirenne, *Optics, Painting and Photography* (Cambridge: Cambridge University Press, 1970), indicating my interest in perspective and perceptual psychology by that time.

10. Patrick Maynard, "Seeing Double," *Journal of Aesthetics and Art Criticism* 52, no. 2 (spring 1994): 155–167. As remarked there, Michael Podro's work in the 1980s and a 1987 paper by Susan Feagin ("Pictorial Representation and the Act of Drawing," *American Philosophical Quarterly* 24, no. 2 [April 1987]: 161–170) were crucial factors for the conceptual breakthrough.

11. Patrick Maynard, *The Engine of Visualization: Thinking through Photography* (Ithaca, N.Y.: Cornell University Press, 1997).

12. This book does not have the full advantage of acquaintance with John Willats, *Making Sense of Children's Draw-*

ings (Mahwah, N.J.: Lawrence Erlbaum, 2005), written contemporaneously with it.

13. Wollheim, *Painting as an Art*, 7.

14. The publications are "Drawings as Drawn: An Approach to Creativity in an Art," in *The Creation of Art: New Essays in Philosophical Aesthetics*, ed. Berys Gaut and Paisley Livingston, 53–88 (Cambridge: Cambridge University Press, 2003); and "Pictures of Perspective: Theory or Therapy?" in *Looking into Pictures: An Interdisciplinary Approach to Pictorial Space*, ed. Heiko Hecht, Robert Schwartz, and Margaret Atherton, 191–211 (Cambridge, Mass.: MIT Press, 2003). I hope that my subsequent publications on cartoons fill out my participation at the conference in Leuven, organized by Jan Baetens and edited by him in *The Graphic Novel* (Leuven: Leuven University Press, 2001). In *Drawing Distinctions* I have been careful not to "orphan" these papers, or those earlier listed, by drawing too heavily upon their texts and illustrations, hoping that they remain independently interesting contributions with their own shapes.

15. Paris: Seuil, 2001, translated by Paul G. Bahn as *Chauvet Cave: The Arts of Earliest Times*, ed. Jean Clottes (Salt Lake City: University of Utah Press, 2003).

16. Wollheim, *Painting as an Art*, 8.

17. David Mamet, "Action," in *True and False: Heresy and Common Sense for the Actor* (New York: Random House, 1997), 84–85.

INTRODUCTION

1. Walter E. Broman, review of *Boredom*, by Patricia M. Spacks, *Philosophy and Literature* 20 (1996): 507.

2. E. H. Gombrich, *The Story of Art*, 16th ed. (London: Phaidon, 1995).

3. Giorgio Vasari, *Lives of the Artists*, vol. 1, trans. George Bull (London: Penguin Books, 1987), 27. David Allen's eighteenth-century portrayal of this episode (in the National Gallery, Edinburgh) is well known. Different cultures, different technologies: since the Buddhist monk Huaguang's (d. 1123) famous tracing of the moon-cast shadow of a blossoming plum branch upon the paper windowpanes of his cell would presumably have been done with watery ink and soft brush strokes, we need not assume that what he drew was an outline. With Zou Fulei's great drawing in Part IV we will consider some of Huaguang's legacy.

4. Harold Rosenberg, *Saul Steinberg* (New York: Whitney Museum of Art; Alfred A. Knopf, 1978), 25.

1. PICTURE OF A DRAWN WORLD

1. As our topic is the technical design essential to the existence of the modern world, we need to distinguish that from topics of modern "design." One short, informative account of modern design of goods for consumer markets is Thomas Hauffe, *Design: A Concise History* (London: Laurence King, 1998). Hauffe first defines "design" generically in roughly our main sense, "the drafting and planning of industrial products" (10), but his subject is the more contemporary one of "the drafting and planning of a product or a service . . . a process in which the form of a product comes into existence alongside the determination of . . . an entire web of functions whose effect is aesthetic, semantic, or symbolic communication" (16). Within the latter he distinguishes commercial design from industrial design (14–15). While addressing some aspects of user-centered commercial design (also termed "graphic" and "communication" [15]) in chapter 3, the present study of design, motivated as it is by a project on drawing, will not address that large topic of market-driven "modern" and "postmodern" consumer design, which are self-conscious and aesthetic in the following sense: that an important aim of such design is that (for marketing purposes) the design product appear to have been (distinctively) designed or styled and, moreover, appear to have been designed to appear that way—like the Bauhaus chair in our 1934 *Tintin* (fig. 26). The present exclusion of such topics is not due to an avoidance of the appearance of processes in products. In later chapters we will be much concerned with the appearance of the productive processes in drawings.

2. In *Engineering and the Mind's Eye* (Cambridge, Mass.: MIT Press, 1992) Eugene Ferguson offers an argument for drawing and nonverbal thinking as essential constituents of engineering education at a time when, Ferguson believes, their appreciation is being lost: see, e.g., xi, 5, 150, 169.

3. This is from the first edition of Arnold Pacey, *The Maze of Ingenuity: Ideas and Ideals in the Development of Technology* (Cambridge, Mass.: MIT Press, 1974), 19. This part of his introduction is not included in the second, revised edition cited below.

4. Ferguson, *Engineering and the Mind's Eye*, 148. Much of early modern science involved not only such thinking in variables, rather than in essences of substances, but in choosing the right variables. Perhaps the most familiar of these is the single dependent-variable diagram, with changes in a given property indicated along one axis and time running along the other. Among image-making techniques, photography has an important place in the history of mechanical systems for making images of this kind: see, for example, Marta Braun, *Picturing Time: The Work of Etienne-Jules Marey (1830–1904)* (Chicago: University of Chicago Press, 1992).

5. Pacey, *Maze of Ingenuity*, 50–51.

6. Booker, *History of Engineering Drawing*, 67.

7. The term "thematize" as used throughout is due to Richard Wollheim, *Painting as an Art* (Princeton, N.J.: Princeton University Press, 1987), 20.

8. Isaac Newton, preface to the first edition of *The Mathematical Principles of Natural Philosophy* (1687), trans. I. B. Cohen.

9. See, for example, James Robert Brown, *Philosophy of Mathematics: An Introduction to a World of Proofs and Pictures* (London: Routledge, 1999).

10. *The Mustard Seed Garden Manual of Painting: Chieh Tzu Yüan Hua Chuan, 1679–1701*, trans. and ed. Mai-Mai Sze (Princeton, N.J.: Princeton University Press, 1977), 295, 260.

11. Nikolaus Pevsner, *An Outline of European Architecture*, 7th ed., London: Penguin Books, 1963), 180.

12. William M. Ivins, Jr., *The Rationalization of Sight* (1938; repr., New York: Da Capo, 1973), 7 (cf. 13: "the rationalization of sight . . . was the most important event of the Renaissance"). Ivins immediately compares it with "the fall of Constantinople, the invention of printing from movable types, the discovery of America, the Reformation or the Counter Reformation" (7).

13. One is tempted to compare the implied attitude toward Sassetta, Botticelli, and Michelangelo, none of whom was much impressed by perspective, to the rebuke to a dullard in the British time-travel TV series *Blackadder*: "The Renaissance was just something that happened to other people, eh?"

14. Erwin Panofsky, *Perspective as Symbolic Form*, trans. Christopher S. Wood (New York: Zone Books, 1991), 29; originally published as "Die Perspektive als Symbolische Form," *Vorträge der Bibliothek Warburg*, 1924–1925 (Leipzig and Berlin), 258–330. Citations to this translation are provided, although I sometimes quote from the more accurate, undated, samizdat New York University English typescript translation of the text (lacking notes and most figures, but presumably by Panofsky or approved by him).

15. Aristotle, *Eudemian Ethics* 1214b: "To examine all the beliefs that some people hold about happiness is a waste of time, for many things appear to children, or sick or deranged people, about which no one with any sense would raise puzzles."

16. My main reason for investigating linear perspective along the turning path of dialectic is that, there, seemingly straightforward "Cartesian" approaches mostly go wrong—often catastrophically—by violating their own method and concealing simple confusions and nonsequiturs in a deceptively simple basic vocabulary. A second reason is that excellent systematic accounts have already been done; see, for notable example, John Willats, *Art and Representation: New Principles in the Analysis of Pictures* (Princeton, N.J.: Princeton University Press, 1997).

17. Ferguson, *Engineering and the Mind's Eye*, 5.

18. Ibid., 97.

19. Aristotle, *Topics* 100a, 101a. See further his remarks on examining controversies: "The equality of contrary reasonings would seem to be productive of a puzzle. For whenever we reason on both sides, and everything appears to follow by each of the contrary arguments, we are puzzled about which one we should act on" (*Topics* 145b). This exposition of dialectic in Aristotle and Plato stays clear of controversies about Socratic method, especially as involving the exposure of contradictions in people's views (called in law "impeaching the witness"). A stimulating, developed, contested account of this may be found in the writings of Gregory Vlastos, who separates Aristotle's dialectic sharply from the "elenctic" Socratic kind in Plato; see Gregory Vlastos, *Socratic Studies* (Cambridge: Cambridge University Press, 1994), 13–16, and *Socrates: Ironist and Moral Philosopher* (Ithaca, N.Y.: Cornell University Press, 1991), 111–113. For a fuller account of Aristotle on dialectic, see Terence Irwin, *Aristotle's First Principles* (Oxford: Oxford University Press, 1990).

20. *Topics* 101a 27–101b3.

21. For criticism of this see Elizabeth Eisenstein, *The Printing Press as an Agent of Change: Communications and Cultural Transformation in Early-Modern Europe* (Cambridge: Cambridge University Press, 1979). Already in 1672 an updated (parody) version of the pen being mightier than the sword was produced by Andrew Marvell: "O Printing! how hast thou disturb'd the Peace of Mankind! that Lead, when moulded into Bullets, is not so mortal as when founded into Letters!" (*The Rehearsal Transpos'd* [1672]).

22. The phrase "new methods of graphic representation" is from Erwin Panofsky, "Artist, Scientist, Genius: Notes on the 'Renaissance-Dämmerung,'" in *The Renaissance: Six Essays*, ed. Wallace K. Ferguson et al., 121–182 (New York: Harper and Row, 1962), 145. The three remarks are from his "Renaissance and Renascences," in *Renaissance and Renascences in Western Art* (1960; repr., New York: Harper and Row, 1969), 108, and "Artist, Scientist, Genius," 140, 147. The first and third of these are criticized by Elizabeth Eisenstein in "The Advent of Printing and the Problem of the Renaissance," *Past and Present* 45 (1969): 30–36, esp. 36n45 ("Panofsky's suggestion that the capacity to see the past from a fixed distance is 'quite comparable' to optical effects produced by focused perspective seems to me somewhat far-fetched and liable to mislead when stretched further"), and *The Printing Press as an Agent of Change*, 269 ("In my view, it is an exaggeration to launch modern science with the advent of perspective renderings and to regard pictorial statements as sufficient in themselves").

23. Ferguson, *Engineering and the Mind's Eye*, 77.

24. Ibid., 210n7.

25. Samuel Y. Edgerton, Jr., "The Renaissance Development of the Scientific Illustration," in *Science and the Arts in the Renaissance*, ed. John W. Shirley and F. David Hoeniger, 168–197 (Washington, D.C.: Folger Shakespeare Library, 1985), 169. The next quotation is from Michael Mahoney's exposition of Edgerton's views, in, Michael S. Mahoney, "Diagrams and Dynamics Revisited," draft for workshop on "Pictorial Means of Early Modern Engineering," Max Planck Institute for History of Science, Berlin, July 26–28, 2001, 2: available at http://www.princeton.edu/mike/articles/drawings/mpipaper.htm (quoted with permission of author).

26. E. H. Gombrich, *Art and Illusion: A Study in the Psychology of Pictorial Representation*, 3rd ed. (London: Phaidon, 1968). Remarks by Gombrich, which we will examine extensively in Part II, include the notion that the history of (depictive) art "may be described as the forging of master keys for opening the mysterious locks of our senses to which only nature herself originally held the key. . . . Like the burglar who tries to break a safe, the artist has no direct access to the inner mechanism" but finds it by inspiration, and trial and error (359); and, "The question is not whether nature 'really looks' like these pictorial devices but whether pictures with such features suggest a reading in terms of natural objects" (360).

27. Michael S. Mahoney, "Diagrams and Dynamics: Mathematical Perspectives on Edgerton's Thesis," in Shirley and Hoeniger, *Science and the Arts in the Renaissance*, 201.

28. Lynn White, Jr., *Medieval Technology and Social Change* (Oxford: Oxford University Press, 1962), chap. 3, "The Medieval Exploration of Mechanical Power and Devices,"

117–118. Although Carl F. Barnes Jr. points out that the Villard shows just a water-powered saw and not a whole mill, we relax usage here.

29. It may be observed, however, that it lacks two important mechanisms, waterwheel gearing for changing planes and directions of rotary motion, and cranks. Quoting a remark by Lewis Mumford, White says: "Students of applied mechanics are agreed that 'the technical advance which characterizes specifically the modern age is that from reciprocating motions to rotary motions,' and the crank is the presupposition of that change. The appearance of bit-and-brace in the 1420's[,] and of the double compound crank and connecting-rod about 1430, marks the most significant step in the late medieval revolution in machine design" (114–115). The overhead spring effect of Villard's design was in use much later with pole lathes. For illustration and further discussion, see Frances Gies and Joseph Gies, *Cathedral, Forge, and Waterwheel: Technology and Invention in the Middle Ages* (New York: Harper-Collins: 1994), 199.

30. Samuel Y. Edgerton, Jr., *The Heritage of Giotto's Geometry: Art and Science on the Eve of the Scientific Revolution* (Ithaca, N.Y.: Cornell University Press, 1991), 112–114.

31. While the standard term for this is "nominal," a synonym could be "categorial," a term introduced here as a bridge to Part II, which will draw on a different set of psychological theories about what are called "categories" in an attempt to link the two topics.

2. INSTRUMENTS OF CHANGE

1. Eugene Ferguson, *Engineering and the Mind's Eye* (Cambridge, Mass.: MIT Press, 1992), 5, 9.

2. See Peter Jeffrey Booker, *A History of Engineering Drawing* (London: Chatto and Windus, 1963), chap. 9

3. Other ambiguities of words and classifications emerge when we begin to consider all these drawing systems nonprojectively—notably, with regard to the "secondary geometry" of the drawing surface. Then the axonometric and oblique are grouped together. For a lucid diagram and illustration of two methods of grouping, see John Willats, *Art and Representation: New Principles in the Analysis of Pictures* (Princeton, N.J.: Princeton University Press, 1997), 39, 42.

4. Among clear, illustrated, and practical introductory sources for these methods and their properties, see Robert W. Gill, *The Thames and Hudson Manual of Rendering with Pen and Ink* (London: Thames and Hudson, 1973).

5. Apparently, this is because they have different historical origins: see Booker, *History of Engineering Drawing*, chap. 15, for a history of this through technical drawing education on the two sides of the Atlantic in the nineteenth century. As Booker relates, "first angle" (or quadrant) development in Europe and "third angle" (quadrant) development in North America are often understood operationally, at first in terms of tracings from an object onto a paper, with either the paper or the object doing the moving, later in terms of orthogonal projections—according to third angle heuristics, as traced on the outside surfaces of an imaginary glass box in which the model is suspended, the (six-sided) box then being opened out or "developed."

6. Alas, design terminology confuses the situation by calling the nonorthographic projections "metric," sometimes "pictorial," and even more misleadingly, "perspectival."

7. William Farish, *Isometrical Perspective* (1820), quoted in Booker, *History of Engineering Drawing*, 116.

8. Ivins gives the early sixteenth-century Viator (Jean Pélerin) credit for discovering that in perspective "form and position were functions of each other and thus were relative and not absolute, and that no two-dimensional statement of form and position in three-dimensional space could be made in anything short of a four-or five-term relation." William Ivins, Jr., *Art and Geometry: A Study in Space Intuitions* (1946; repr., New York: Dover Books, 1964), 76.

9. Jean Michel Massing argues that a pen-and-ink drawing of this with interesting construction lines of its own, in the Kupferstichkabinett, Berlin, is a study for the woodcut. See Jay L. Levenson, ed., *Circa 1492: Art in the Age of Exploration* (New Haven: Yale University Press, 1991), 292–293.

10. Leon Battista Alberti, *Della Pittura* (1435–36), translated by John R. Spencer as *On Painting*, 2nd ed. (London: Routledge and Kegan Paul, 1967), 51. The Venetian 1547 Italian translation, *La Pittura* (repr., Arnaldo Forni Editore, 1988), of the Latin version reads here: "a modo di vetro, & transparante di forte, che tutta la piramide visiva passasse" (11).

11. Albrecht Dürer, *Underweysung der Messung*, translated on facing pages by Walter L. Strauss as *The Painter's Manual* (New York: Abaris Books, 1977). The woodcuts, with Dürer's detailed comments on them, may be found on 386–395 and 430–437, divided between the main 1525 edition and the short posthumous part 2: "revised by himself while he was still alive and expanded by thirty-two figures which were all drawn by himself as any artisan will recognize, and now again published for the use of all who love art/ 1538" (399). Dürer terms the method in his woodcut of the nude "more practical than using a glass plane because it is less restricted" than is Keyser's method in the urn woodcut, which he explains (431) as controlling the relationship of the variables of image size to rates of foreshortening and diminution, whereas the 1525 portrait and lute woodcuts were not described this way.

12. As for Dürer himself, his written comments on these drawings historically propel the standard fallacies of conflation, notably in referring to the focus as a "point of sight." In what looks like a comment on the urn woodcut, he elsewhere writes that a silk string is "attached one end to point of sight o," and continues: "It is for him as useful as if his right eye were in its place." See Martin Kemp, *The Science of Art: Optical Themes in Western Art from Brunelleschi to Seurat* (New Haven: Yale University Press, 1990), 171–173, for this and a different treatment of the four diagrams. A free, working interchange of sight lines and string lines had been known to builders from time immemorial, however.

13. William M. Ivins, Jr., *The Rationalization of Sight* (1938; repr., New York: Da Capo, 1973), 12. There is a danger of exaggerating the distinction. If, as we saw Ferguson insist,

a good design is a spatially perspicuous one for the people using it, we will have to take into account something perceptual—at least "to the mind's eye"—and more than "purely schematic and logical extensions."

14. Erwin Panofsky, "*I Primi Lumi*: Italian Trecento Painting," in *Renaissance and Renascences in Western Art*, 114–161 (1960; repr., New York: Harper and Row, 1969), 128.

15. Erwin Panofsky, *Perspective as Symbolic Form*, trans. Christopher S. Wood (New York: Zone Books, 1991), [1–2], 27, 31.

16. Two philosophical notes: Speaking of Cartesian coordinates (which Descartes did not use), students of metaphysics will note that Panofsky here links drawing procedures to the shift from Aristotelian substances to the Early Modern mechanical philosophy's extensive magnitudes, of which Descartes is the most famous proponent. This raises large questions, paralleling Leibniz's of how we tell one thing from another in a modern space without substantials, as expressed typically wittily in his letter to Arnauld of April 30, 1687 (G. W. Leibniz, *Philosophical Essays*, trans. R. Ariew and D. Garber [Indianapolis: Hackett, 1989]). As for perception, a "Villardian," object-centered position is argued here dialectically (as being presupposed by perspective theory), not as a preferred orientation. No association is implied with alleged differences (at least since John Locke) between object-isolating and volume-sensing touch (or a kinaesthetic sense), and a scene-unifying and 2D-presenting sensing of sight, as we find, for example, in the works of Adolf Hildebrand and Alois Riegl. (For a comparative exposition, see Michael Podro, *The Critical Historians of Art* [London: Yale University Press, 1982]; and Margaret Iversen, *Alois Riegl: Art History and Theory* [Cambridge, Mass.: MIT Press, 1993], which relates Panofsky's ideas to those of his predecessor.)

17. Photographic cameras encourage some to attempt overcoming these problems by expanding linear perspective theory to include shade and shadow, the theory of which was developed closely with it, by Leonardo and others.

18. James Cutting, "Reconceiving Perceptual Space," in *Looking into Pictures: An Interdisciplinary Approach to Pictorial Space*, ed. M. Atherton, H. Hecht, and R. Schwartz, 211–238 (Cambridge, Mass.: MIT Press, 2003). We shall several times revisit this topic in Part III.

19. Ivins, *Rationalization of Sight*, 9.

20. Erwin Panofsky, "Artist, Scientist, Genius: Notes on the 'Renaissance-Dämmerung,'" in *The Renaissance: Six Essays*, ed. Wallace K. Ferguson et al., 121–182 (New York: Harper and Row, 1962), 124.

21. Where he is sharply criticized by Michael S. Mahoney, "Diagrams and Dynamics: Mathematical Perspectives on Edgerton's Thesis," in *Science and the Arts in the Renaissance*, ed. John W. Shirley and F. David Hoeniger, 198–220 (Washington, D.C.: Folger Shakespeare Library, 1985), esp. 202–217.

22. Samuel Y. Edgerton, Jr., "The Renaissance Development of the Scientific Illustration," in Shirley and Hoeniger, *Science and the Arts in the Renaissance*, 174.

23. Panofsky, "Artist, Scientist, Genius," 148n30, 153–155.

24. For the first, see Bert S. Hall, "The Didactic and the Elegant: Some Thoughts on Scientific and Technological Illustrations in the Middle Ages and Renaissance," in *Pic-*

turing Knowledge: Historical and Philosophical Problems concerning the Use of Art in Science, ed. Brian S. Baigrie, 3–39 (Toronto: University of Toronto Press, 1996), 34; for the rest, James Ackerman, "The Involvement of Artists in Renaissance Science," in Shirley and Hoeniger, *Science and the Arts in the Renaissance*, 107; and Samuel Y. Edgerton, Jr., *The Heritage of Giotto's Geometry: Art and Science on the Eve of the Scientific Revolution* (Ithaca, N.Y.: Cornell University Press, 1991), 141.

25. Edgerton, "Renaissance Development," 179, 183, 195n1; and *Heritage of Giotto's Geometry*, 126–131. On Taccola's exploded views, see also Ferguson, *Engineering and the Mind's Eye*, 82. Edgerton refers to Taccola (Mariano di Jacopo) as "the grandfather . . . of modern engineering drawing" (126). I find no basis in Taccola's drawings for Edgerton's remark that this hydraulic engineer "was the first artist-engineer to take advantage of . . . the perception of a picture as a window through which the viewer gazes from a single point of view, and the sense that the sizes of all objects within this fictive window appear in scale, according to their relative distances apart" (ibid.).

26. Edgerton, *Heritage of Giotto's Geometry*, 128.

27. Through an ingenious use of the simple mechanism of the verge-and-foliot medieval clock (see fig. 9), in which the top and bottom of a turning wheel move in opposite directions, the screw at the base of Brunelleschi's hoist (its box drawn in reverse perspective) raises or lowers the vertical shaft, allowing either the upper or lower crown wheels to engage the large vertical one. The winding direction of the hoist is thereby reversed without the trouble of turning and rehearsing the ox, thus illustrating Mumford's principle of circular and reciprocal motions. Featuring a horse instead of an ox, Taccola's "exploded" drawing shows machine parts by various obliques, but nothing in perspective, and clearly shows how the gizmo reverses the direction of winding.

28. Booker, *History of Engineering Drawing*, 23.

29. Villard also drew a plan and an elevation of the west facade of the former Cathedral of Notre-Dame at Laon (Aisne), France. No implication is made here that Villard was a professional architect: indeed his being an amateur would strengthen the case for the professional practice of the time. On such questions see Carl F. Barnes, "Villard de Honnecourt," *Macmillan Dictionary of Art* (London, 1996), 32:569–571.

30. Caroline Elam, *Design into Architecture* (Oxford: Christ Church Picture Gallery, 2001), n.p. [4–5]. Elam refers to Leon Battista Alberti's ten-volume *De Re Aedficatoria* (1452; 1st printed edition, 1485).

31. Michael Hirst, *Michelangelo and His Drawings* (London: Yale University Press, 1989), 75, 94.

32. Wolfgang Lotz, trans. and ed., *Studies in Italian Renaissance Architecture* (Cambridge, Mass.: MIT Press, 1977), 20–21. I have further edited this passage.

33. See Hirst, *Michelangelo and His Drawings*, 95; and Ross King, *Brunelleschi's Dome: The Story of the Great Cathedral in Florence* (London: Chatto and Windus, 2000), 73.

34. Willats, *Art and Representation*, 38.

35. Mahoney, "Diagrams and Dynamics," 218n12.

36. We have already encountered Leonardo's term "*parieto di vetro*": whether Leon Battista Alberti, in his famous

Della Pittura of 1436 thought the same way is disputed. In one passage, as we have seen, Alberti writes that painters should treat the work "plane as if it were of transparent glass"; in another he refers to his own painting surface as like "an open window through which I see what I want to paint," with no reference to glass; elsewhere he writes of an actual projection device rather like Dürer's: a "thin veil" (68).

37. Willats, *Art and Representation,* 12–13, 37–40, 369–370. It is typical of Booker's modesty and understatement that he should introduce his crucial primary/secondary geometry distinction with this remark: "it might be well for us to make an interesting observation which will help save much misunderstanding in our study of drawing" (*History of Engineering Drawing,* 5). To save notes in this discussion, page references to these two books will be put in the text, context making clear which is meant.

38. See, for example, a highly praised book on perspective, Hubert Damisch, *The Origin of Perspective,* trans. John Goodman (Cambridge, Mass.: MIT Press, 1994).

39. Panofsky, *Perspective as Symbolic Form,* [1], 28. I have substituted for his words "sight" and "the eye," which, together with mention of light rays, is both canonical and the worst error in expositions of perspective projection.

40. Alberti, *On Painting (Della Pittura),* 51.

41. For the (pirated French) texts of Viator's books, with discussion, see Ivins, *Rationalization of Sight.* For further discussion of the *tiers point* development by Jean Cousin, see Kemp, *Science of Art,* 64–68.

42. Since we are considering solid (3D) angles, there are an indefinite number of 45° DVPs in a circle round the CVP, but only two on the horizon, left and right.

43. Panofsky gives not the corner view, but oblique drawing generally, extended attention in a note to *Perspective as Symbolic Form* (150–153n71), attributing its Northern origins to a Northern (as opposed to Italian) insistence on mass.

44. As Professor Alex Potts pointed out to me. Still, as I have argued elsewhere, Dürer was never entirely at ease with perspective, not in his theoretical presentation nor in his use of it. See Patrick Maynard, "Perspective's Places," *Journal of Aesthetics and Art Criticism* 54, no. 1 (winter 1996): 23–40, notably regarding Dürer's handling of orthogonals in a pen drawing of Saint Jerome in his study, dated just before the first edition of Dürer's *Underweysung der Messung.*

45. How much early Renaissance artists brought geo 1 perspective considerations into their geo 2 working procedures in painting and sculpture is another question, to which chapter 9 is more pertinent. As Alberti's text and the Alberti-like sketch by Leonardo (see fig. 58) suggest, even before those High Renaissance and Baroque decorations (such as Andrea Pozzo's famous ceiling of S. Ignazio in Rome) that clearly presuppose sophisticated geo 1 rules, figuring by geo 1 could be a part of the largely geo 2 drawing procedure.

46. Erwin Panofsky, "The History of the Theory of Proportions as a Reflection of the History of Styles," in *Meaning in the Visual Arts: Papers in and on Art History* (New York: Doubleday Anchor Books, 1955), 57–59.

47. One of the main arguments of Ferguson's book is that, in modern engineering, precision has become dangerous without it. Ferguson, *Engineering and the Mind's Eye,* chaps. 6, 7. See Edmund Snow Carpenter, *Eskimo* (Toronto: University of Toronto Press, 1968).

48. Elam, *Design into Architecture,* [13].

49. For brevity, I exclude from this particular discussion *shape,* a most important topic, which we will continue to develop.

50. S. S. Stevens, "Mathematics, Measurement, and Psychophysics," in *Handbook of Experimental Psychology,* ed. Stevens, 1–49 (New York: Wiley, 1951), esp. 26–29. My application of these standard categories to drawing is inspired by Cutting, "Reconceiving Perceptual Space."

51. For discussion, see Ted Cohen, *Jokes: Philosophical Thoughts on Joking Matters* (Chicago: University of Chicago Press), 52–53.

52. Panofsky, *Perspective as Symbolic Form,* 31.

53. Ivins, *Rationalization of Sight,* 12.

54. E. H. Gombrich (*Art and Illusion,* 6) suggests demonstrating such constancy to oneself by examining the surprisingly small area cleared by a fingertip on a vapor-fogged bathroom mirror, just to reveal one's head.

55. Aristotle, *Eudemian Ethics* 1235.

56. Samuel Y. Edgerton, Jr., review of *The Psychology of Perspective and Renaissance Art,* by Michael Kubovy, *Word and Image* 4 (1988): 739.

3. DRAWING AND GRAPHIC DISPLAYS

1. Edward R. Tufte, *The Visual Display of Quantitative Information* (Cheshire, Conn.: Graphics 1983), *Envisioning Information* (Cheshire, Conn.: Graphics 1990), and *Visual Explanations* (Cheshire, Conn.: Graphics 1997).

2. Tufte, *Envisioning Information,* 46–47. Further on relation of signage to user's abilities, compare the London slogan "Mind the Gap" with the Roman "Lasciare scendere prima di salvio. Fare attenzione allo spazio fra treno e banchina," accompanied by, for Italy, a not very impressive graphic.

3. For an interesting and informative account of Beck's diagram, see Ken Garland, *Mr Beck's Underground Map* (London: Capital Transport Publishing, 1994).

4. Ibid., 7. Garland characterizes Beck's achievement as the invention of "a way to represent London's underground network in a diagrammatic form, laying emphasis on its connections rather than its geography"—for "a derisory fee," even though "the public loved it" (20–21).

5. As for usefulness of the timetable, not even that would be satisfactory were the scale not also linked to an absolute or clock-time assignment for each departure, allowing us to correlate it with other events—for example, those for which we "have to be there by then." *Metric* scales also allow equal ratios to be read, which requires a nonarbitrary zero point. Thus it makes sense to say that a 7.56-liter (two-gallon) pot holds four times as much water as does the 1.89-liter (two-quart) pot; whereas, if the temperatures of the water in the one is 100° C and 50° C in the other, we must not say that the former is twice as hot as the latter. Nevertheless, differences in temperature can be metrically or proportionally stated: thus, should the water

in the cooler pot be heated to 80°, that is 60 percent of the additional temperature needed to bring it, too, to boiling.

6. A clearer case is the electric circuit schematic diagram, only approximated at the top of our illustration, which, following one of our themes here, is hybrid with an orthographic projection of the machinery.

7. For the later rectification of the Thames on the diagram, see Garland, *Mr Beck's Underground Map*, 44–45; for "chartjunk" see Tufte, *Envisioning Information*, 34.

8. Garland, *Mr Beck's Underground Map*, 34. Garland's history is largely a relating of a number of other historical adaptations, necessary or foolish, sometimes by other hands.

9. See ibid., 34, 51, 63. For connoisseurs, there are still subtler features to the guide's history of trade-offs: for example, if in the double forking of the Northern Line one line continues straight up, will that make it seem like it is the main line?

10. Garland reports Beck's getting "rid of the nonsensical duplication and triplication of station names" (ibid., 37).

11. Tufte, *Envisioning Information*, 33.

4. DRAWING/DISEGNO

1. Giorgio Vasari, *Lives of the Artists*, trans. George Bull (London: Penguin Books, 1965), 1:64–65.

2. Anna O. Shepard, *Ceramics for the Archaeologist* (Washington, D.C.: Carnegie Institution of Washington, 1956), 268. A classic work on symmetry analysis for drawing is Shepard, "The Symmetry of Abstract Design, with Special Reference to Ceramic Decoration," *Contributions to American Anthropology and History* 9, no. 44–47 (Carnegie Institution of Washington, 1948), 209–293 (with, incidentally, interesting use of gender pronouns for that time). I am grateful to J. Peter Denny for directing me to Shepard's work.

3. As for mirror symmetry, Shepard's mention of starfish reminds us that since they, like ferns, often curve and flex back, simple "book folding" of their forms seems not to capture the symmetry we sense in their twisting axes, often reflected in designs. Shall we think of this in terms of two operations: first a mirror reflection along a straight axis, then a twist? The psychologist Michael Leyton has suggested that we think of it as a single operation. Imagine, says Leyton, that internal to the form and always tangent to its contours is an moving circle, capable of expanding or contracting with dilations and neckings of the form, the locus or trajectory of the center of the circle as it moves along defining the symmetry axis of the most complex of such forms. Michael Leyton, "Inferring Causal History from Shape," *Cognitive Science* 13 (1989): 357–387.

5. THE FORMS OF SHAPE

1. The exposition now follows John Willats, *Art and Representation: New Principles in the Analysis of Pictures* (Princeton, N.J.: Princeton University Press, 1997); "Drawing Systems Revisited: The Role of Denotation Systems in Children's Figure Drawings," in *Visual Order: the*

Nature and Development of Pictorial Representation, ed. Norman Freeman and M. V. Cox, 78–100 (Cambridge: Cambridge University Press, 1985); "The Representation of Extendedness in Children's Drawings of Sticks and Disks," *Child Development* 63 (1992): 692–720. The initial exposition parallels my "Drawing Distinctions I: The First Projects," *Philosophical Topics* 25, no. 1 (spring 1997): 231–253.

2. Willats, "Representation of Extendedness," 697; see also *Art and Representation*, 100.

3. See Claire Golomb, *Young Children's Sculpture and Drawing: A Study in Representational Development* (Cambridge, Mass.: Harvard University Press, 1974), 13, citing earlier psychologists. For her later treatment, see Golomb, *The Child's Creation of a Pictorial World* (Berkeley: University of California Press, 1992).

4. For "index of extension," see Willats, "Drawing Systems Revisited," 91–92; *Art and Representation*, 100–104, 367.

5. Inscriptions in Turkish at the top and bottom of the figure read, according to the Metropolitan Museum of Art: "Sulaiman, son of Selim Khan, ever victorious"; and, in gold: "This is the noble, exalted, brilliant sign-manual, the world-illuminating and adoring cipher of the Khakan [may it be made efficient by the aid of the Lord and the protection of the Eternal]. His order is that . . ." Although there is some figuration here, the main depiction is not figurative.

6. Golomb, *Young Children's Sculpture and Drawing*, 4–11. "Reading-off" she uses for post hoc attribution; a third expression, "verbal designation," she applies to a more advanced stage of ad hoc verbal accompaniment (10).

7. Willats's picture ideas are influenced (through the Canadian psychologist J. Peter Denny) by the linguistic cases that Stephen Pinker mentions in *The Language Instinct: How the Mind Creates Language* (New York: W. Morrow, 1994), 233.

8. Regarding habitual ways of thinking, although European languages do not have dimensional markers, we often group things that way. For example, it has been observed that products manufactured by the 3M Company have 2D salience: sandpaper, adhesive tapes, floppy disks.

9. There are discussions of "tadpole" drawings throughout Willats, *Art and Representation*, and Golomb, *The Child's Creation of a Pictorial World*.

10. An exception, for child drawing, is Jean Piaget and Bärbel Inhelder, who declare in a section titled "Drawing" in their introductory presentation, *The Psychology of the Child* (New York: Basic Books, 1969): "The first spatial intuitions of the child are, in fact, topological rather than projective or consistent with Euclidean geometry." And they assert that while early drawing "shows no awareness of perspective or metrical relationships, it does show topological relationships: proximity [tangency?], separation, enclosure, closedness and so on," until about the age of seven, when "projective intuitions" appear (66–67). Willats treats topological characteristics in *Art and Representation*, chap. 3 (crediting Piaget and Inhelder on 288–289; see also "Drawing Systems Revisited," 86). I make a case for topological values in "Drawing Distinctions I." Topological values figure in the analysis of drawings in terms of T, L, Y, arrow, and end junctions in artificial in-

telligence and cognitive psychology. For example, figure 44 is a thing of T junctions.

11. For axis shape see Michael Leyton, *Symmetry, Causality, Mind* (Cambridge, Mass.: MIT Press, 1992).

12. Kimon Nicolaïdes, *The Natural Way to Draw: A Working Plan for Art Study* (Boston: Houghton Mifflin, 1941), 21.

13. While not using the word "contour" for that, an influential discussion of the origins of such lines (with Marc Antonio Raimondi and Lucas van Leyden) and their history is William M. Ivins, Jr., *Prints and Visual Communication* (Cambridge, Mass.: MIT Press, 1953), esp. chap. 3. The *opus vermiculatum* quotation is from Theodore Feder, *Great Treasures of Pompeii and Heraculaneum* (New York: Abbeville, 1978), 52, regarding a famous portrait of a woman in the Naples Museum of Archaeology.

14. Philip Rawson, *Drawing*, 2nd ed. (Philadelphia: University of Pennsylvania Press, 1987), 94.

15. I here distinguish these two more than Willats does. In "Drawing Systems Revisited" Willats treats them in one discussion, even suggesting that projection enters the picture before local shape, although in *Art and Representation*, 316, he is more circumspect.

16. Roger Kaupelis, *Learning to Draw* (New York: Watson-Guptill, 1976), 21–22.

17. Walter Crane, *Line and Form* (London: George Bell and Sons, 1900), 1–3. For Willats's reservations about silhouettes for showing three-dimensional shapes, see *Art and Representation*, 214–219.

18. Harold Speed, *The Practice and Science of Drawing* (Seeley Service, 1917), 43, 45.

19. Norman H. Freeman, *Strategies of Representation in Young Children: Analysis of Spatial Skills and Drawing Processes* (London: Academic, 1980).

20. See Golomb, *Young Children's Sculpture and Drawing*, 31–34, where she stresses that "at every step the child's representational intention outstrips his ability to draw and model" and that "representation is hard work" for the three-year-old (32–33). As mentioned in the preface, many artists feel the same way.

21. Willats, "Drawing Systems Revisited," 96.

22. This pencil drawing began with the beak, named before completing, progressed to the tree, nest, eggs. (The word "parrot" at the top was written by dictation, then copied.)

23. See Willats, *Art and Representation*, 12, 38.

24. Leon Battista Alberti, *On Painting*, 2nd ed. (London: Routledge and Kegan Paul, 1967), 51.

25. James J. Gibson, "A Theory of Pictorial Perception," *Audio-Visual Communication Review* 1 (1954): 14; Stephen Pinker, *How the Mind Works* (New York: W. W. Norton, 1997), 215–216. I criticize such implicit appeals in "Pictures of Perspective: Theory or Therapy?" in *Looking into Pictures: An Interdisciplinary Approach to Pictorial Space*, ed. Heiko Hecht, Robert Schwartz, and Margaret Atherton (Cambridge, Mass.: MIT Press, 2003), 199–202.

26. For Willats's work on child development, see, for example, "How Children Learn to Represent Three-Dimensional Space in Drawing," in *The Child's Representation of the World*, ed. G. Butterworth, 189–202 (New York: Plenum, 1977); "Drawing Systems Revisited"; and "Representation of Extendedness."

27. This is no small point. E. H. Gombrich based much of his theory of "the Greek revolution" in visual art on a narrative of "the eyewitness principle," derived from literature, regarding what could and could not be seen from a certain vantage point; see Gombrich, *Art and Illusion: A Study in the Psychology of Pictorial Representation*, 3rd ed. (London: Phaidon, 1968), 129, 136. He developed this in defense of linear perspective in Gombrich, "Standards of Truth: The Arrested Image and the Moving Eye," in *The Language of Images*, ed. W. J. T. Mitchell (Chicago: University of Chicago Press, 1980), reprinted in Gombrich, *The Image and the Eye: Further Studies in the Psychology of Pictorial Representation* (Ithaca, N.Y.: Cornell University Press, 1982), 256–258.

28. Roger Fry, *Last Lectures* (London: Cambridge University Press, 1939), 52.

29. Following the work of David Marr: see Willats, *Art and Representation*, 19–20, 151–152. I discourage the use of the term "viewer," however, as it encourages fallacies, especially about perspective. "View," even as in the everyday expressions "scenic view," "room with a view," "view of the mountains," "shared point of view," quite suffices for the distinction without encouraging postulation of a viewer—notably of a "privileged" or "monocular" one, to follow out current fallacies.

30. Alberti, *On Painting*, 51.

31. See Willats, *Art and Representation*, 46–49, for fuller discussion. The later work includes Willats, "The Third Domain: The Role of Pictorial Images in Picture Perception and Production," *Axiomathes* 13 (2002): 1–15.

32. The instruction about the lamps is a diversion from the real topic of revealing how most people, while emphasizing the convergence angle of the curb lines (like drawing a railroad track), greatly underemphasize that of the roof lines, which should be drawn at the identical angle. Remarkably, many subjects even run the perfectly horizontal stringcourses upward. For the experiment results and an interpretation, see Willats, *Art and Representation*, 186–190.

33. For example, fig. 53, with note 22. Willats treats these matters at more length in *Making Sense of Children's Drawings* (Mahwah, N.J.: Lawrence Erlbaum Associates, 2005).

6. DEPICTIVE DRAWING

1. Ivins attributes this technique to Goltzius: see William M. Ivins, Jr., *Notes on Prints* (1930; repr., Cambridge, Mass.: MIT Press, n.d.), 87.

2. Albrecht Dürer, *The Painter's Manual*, trans. Walter L. Strauss (New York: Abaris Books, 1977), 365; Leonardo, *Codex Urbino*, 106r, in *Leonardo on Painting*, ed. Martin Kemp, trans. Martin Kemp and Margaret Walker (New Haven: Yale University Press, 1989), 88.

3. The seventh-century Isidore of Seville, in his *Etymologies*: "A picture is an image expressing the appearance of some things, which, when it is seen, brings back an image [of its original] to the recalling mind." (Isidore is now the hacker's patron saint.) According to Peirce, something is "a *sign*, or representation," when as we take "a mediatory interest in it, in so far as it conveys to a mind an idea about

a thing," and among these are "*likenesses, or icons; which serve to convey ideas of the things they represent simply by imitating them*"; Charles S. Peirce, "What Is a Sign?" in *The Collected Papers of Charles Sanders Pierce,* ed. Charles Hartshorne and Paul Weiss (Cambridge, Mass.: The Belknap Press of Harvard University Press, 1960), 2:281, 285.

4. While the Steinberg is whimsical, many other kinds of self-portraits represent not only the artist but the depiction itself being made. Sometimes the portrait is depicted, other times it is only represented (that is, we cannot see it there). Reflexivity, like embeddedness (further investigated in Part IV), is a typical feature of mental life.

5. Clear cases are hand shadows and shadow puppetry, which I have discussed in other contexts, e.g., Maynard, *The Engine of Visualization: Thinking through Photography* (Ithaca, N.Y.: Cornell University Press, 1997), 160.

6. Plato, *Sophist* 234b7.

7. E. H. Gombrich, *Art and Illusion: A Study in the Psychology of Pictorial Representation,* 3rd ed. (London: Phaidon, 1968), 99.

8. These comments alone are not meant to mark out depictions at this point, as the same locutions will be used of design, even constructional drawings, for reasons later indicated. On verbal make-believe and pictorial representations, see Kendall Walton, *Mimesis as Make-Believe* (Cambridge, Mass.: Harvard University Press, 1990), 220–224.

9. For the "German linear scheme" see Ivins, *Notes on Prints,* 61. Ivins stresses that Marcantonio Raimondi studied Dürer's method and combined it with Italian methods of indicating volume in figures—techniques we will take up in chapter 10.

10. Ludwig Wittgenstein, *Philosophical Investigations* (Oxford: Basil Blackwell, 1958), pt. 2, sec. xi, 202e.

11. Walton, *Mimesis as Make-Believe,* chaps. 6, 7. I exposit this material at length in *Engine of Visualization,* 98–101.

12. Kimon Nicolaïdes, *The Natural Way to Draw: A Working Plan for Art Study* (Boston: Houghton Mifflin, 1941), 9. Among numerous other examples are Edward Laning, *The Act of Drawing* (New York: McGraw-Hill, 1971), 50, who instructs you to "tell yourself that your pencil on the paper is your finger touching the contour of the form you are looking at," and Robert Kaupelis, *Learning to Draw: A Creative Approach to Expressive Drawing* (New York: Watson-Guptill Publications, 1966), 22, who insists, "You must imagine that the pencil is actually touching the form of the thumb."

13. Wittgenstein, *Philosophical Investigations,* bk. 1, 127, 50e.

14. Ibid., bk. 2, xi, 194e.

15. Richard Wollheim has argued this position in a number of places, notably, as here, in *Painting as an Art* (Princeton, N.J.: Princeton University Press, 1987), 46; at length in *Art and Its Objects,* 2nd ed. (Cambridge: Cambridge University Press, 1980), 12–22, 205–226; and very briefly in "Pictures and Language," *Art Issues* 5 (summer 1989): 9–12.

16. See Walton, *Mimesis as Make-Believe,* 52–53.

17. Ibid., 295.

18. Nelson Goodman, *Languages of Art: An Approach to a Theory of Symbols,* rev. ed. (Indianapolis: Hackett, 1976), 36. Part of Goodman's problem is that he uses the terms "depiction" and "pictorial representation" without distinction.

19. Walton, *Mimesis as Make-Believe,* 295n3, 300–301.

20. David Hume, *An Inquiry concerning Human Understanding* (1748), sec. 5, pt. 2. According to his last edition of this work (1777), Hume lifted this passage from his 1739 *Treatise of Human Nature,* bk. 1, pt. 3, sec. 8, from which he dropped only the word "strange" from "strange superstition."

21. Michael Baxandall, *Painting and Experience in Fifteenth Century Italy: A Primer in the Social History of Pictorial Style,* 2nd ed. (Oxford: Oxford University Press, 1988), esp. 40–56.

7. CONVINCING DEPICTION

1. The next two sections are tailored to the needs of our specific topic of the visual perceptual in depiction. They do not attempt a full outline of Gombrich's work on representation.

2. For Walton's account of the place of such correspondences or "similarities" in depiction, see Kendall Walton, *Mimesis as Make-Believe* (Cambridge, Mass.: Harvard University Press, 1990), 297–315.

3. E. H. Gombrich, *Art and Illusion: A Study in the Psychology of Pictorial Representation,* 3rd ed. (London: Phaidon, 1968), 5, 291. By "illusion" Gombrich denied meaning a tendency to false belief: "Only in extreme cases . . . are the illusions of art about our real environment. But they are illusions all the same" (277). He usually contrasted it with "delusion," noting "the difference between an illusion and a delusion—we don't believe we see a solid object but we have the illusion of solidity" (E. H. Gombrich, "The Evidence of Images," in *Interpretation: Theory and Practice,* ed. C. S. Singleton [Baltimore: Johns Hopkins University Press, 1969], 60). In later writings, Gombrich may have regretted "illusion" and, unaware of Walton's work, looked for a word to "correspond with the term 'fiction' in literature," continuing: "Fiction can be vivid and convincing in evoking an imaginary event without anyone taking it to describe a real happening"; Gombrich, "Paintings on Walls: Means and Ends in the History of Fresco Painting," in *The Uses of Images: Studies in the Social Function of Art and Visual Communication* (London: Phaidon, 1999), 19. His and our word "vivid" seems to do the job.

4. E. H. Gombrich, *The Story of Art,* 16th ed. (London: Phaidon, 1995), 594, as quoted and cited by Gombrich in his "recapitulation" of the main theses of *Art and Illusion,* 395. (*The Story of Art,* first published in 1950, being six times revised and much expanded by its author, page numbers in different editions may not correspond. All references here will be to the sixteenth edition.)

5. Gombrich, *Story of Art,* 562.

6. Gombrich, *Art and Illusion,* xii. Hereafter cited by page number in the text.

7. For the useful term "legibility" see E. H. Gombrich, "Action and Expression in Western Art," in *Non-Verbal Communication,* ed. R. A. Hinde, 373–393 (Cambridge: Cambridge University Press, 1972); reprinted in Gombrich, *The Image and the Eye: Further Studies in the Psychology of Pictorial Representation* (Ithaca, N.Y.: Cornell University Press, 1982), 78–104, to which page citations refer. I first

argued in support of a "vivacity" account in Patrick Maynard, "Depiction, Vision and Convention," *American Philosophical Quarterly* 9, no. 3 (July 1972): 246–249.

8. For a clear statement that Gombrich treated "the skill of illusion" as only one factor in the historical story, see Michael Podro, "Misconceived Alternatives," *Art History* 7, no. 2 (June 1984): 244–245. Unfortunately, for all his emphasis on explaining in terms of different functions of images, Gombrich sometimes exaggerated this factor: for example, "art has a history because the illusions of art are . . . the indispensable tools for the artist's analysis of appearances" (*Art and Illusion*, 30). Rudolf Arnheim saw a dilemma: "His insistence on illusion is, at first, puzzling. One cannot assert that all representation aims at illusion without expanding the meaning of the term to an extent unlikely to be acceptable to the author. If, however, illusion is but one variety of pictorial effect, then one cannot treat representation in a book on illusion without severely mutilating one's subject. . . . That it has only one meaning can hardly be maintained by anybody who studies Gombrich's numerous and varied examples"; Rudolf Arnheim, "Art History and the Partial God," in *Toward a Psychology of Art: Collected Essays*, 151–161 (Berkeley: University of California Press, 1967), 153.

9. Gombrich, *Art and Illusion*, xi, 330. What I here count as Gombrich's first two principles are usually expressed by him as one, in terms of "making comes before matching" (see, for example, Gombrich, "Action and Expression," 78).

10. This has been my hard-earned approach to the subject, even before my "Depiction, Vision and Convention."

11. Gombrich, "Action and Expression," 78. Gombrich repeated his "basic responses" idea in "Image and Code: Scope and Limits of Conventionalism in Pictorial Representation," in *Image and the Eye*, 285–286.

12. Throughout, I will be using "transfer" in a loose, nontechnical sense, to mean the use of an ability in a cognitive domain other than where it resides and is well developed. By "continuity" I mean the natural conditions that allow such shifts to occur.

13. Gombrich's "Meditations on a Hobby Horse" was first published in *Aspects of Form: A Symposium on Form in Nature and Art*, ed. Lancelot Law Whyte, 209–228 (Bloomington: Indiana University Press, 1951), and reprinted in Gombrich, *Meditations on a Hobby Horse and Other Essays on the Theory of Art* (London: Phaidon, 1965), 1–11; EHG 9 and 10 are from pages 6 and 4. In *Art and Illusion*, 412–413, Gombrich qualifies his "Meditations on a Hobby Horse" account by calling it "tentative applications . . . to the problems of primitive art." Gombrich continued to seek biological bases of explanation. For example, in his 1993 interview with Didier Eribon he stated: "I believe in the fundamentally biological foundation of our reactions" (*Art Newspaper* 28 [May 1993]: 18). Use of the term "continuity" here conforms with Gombrich's in "On Information Available in Pictures," in "Letters," *Leonardo: International Journal of the Contemporary Artist* 4, no. 2 (spring 1971): 195–197.

14. "Rediscovered": Gombrich might have devoted more than a single footnote (in *Art and Illusion*, 405) to Hermann von Helmhotz's clear, accessible essay "The Rela-tion of Optics to Painting," beyond a footnote to its German original, in *Art and Illusion*, 405. These quotations combine Gombrich's twofold use of the basic "like looking" idea. "Meditations on a Hobby Horse" addresses a historical question: the roots and developments of image making generally. But even there a secondary use is suggested, to be developed nine years later, for he wrote that such responses as face-seeing will "recur—as was to be expected" in subsequent uses of images (10); for, he insisted, "the contrast between primitive art and 'naturalistic' or 'illusionistic' art can easily be overdrawn. All art is 'image-making' and all image-making is rooted in the creation of substitutes" (9).

15. Gombrich, "Evidence of Images," 46, 65.

16. Ron Bowen, *Drawing Masterclass* (Boston: Little, Brown, 1992), 79. We will later consider a different meaning of "contour line" in drawing: lines that flow over the whole surfaces of faces, for example, like contour lines in relief maps.

17. Gregory Bateson, "Metalogue: Why Do Things Have Outlines?" in *Steps to an Ecology of Mind* (New York: Chandler Publishing, 1972), 27.

18. Eugène Delacroix, *The Journal of Eugène Delacroix*, trans. Walter Pach (New York: Viking, 1972), 539; see also 538: "Contours no more exist in nature than do touches. . . . What is a drawing in black and white, if not a convention to which the spectator is accustomed, and one which does not prevent his imagination from seeing in that translation of nature a complete equivalent?"

19. William C. Seitz, *Abstract Expressionist Painting in America* (1955; repr., Cambridge, Mass.: Harvard University Press, 1983), 11. Seitz's immediate refutation of this "cliché" by reference to grass stalks and wire still allows it as applied to the edges of things. Some have insisted that drawn outlines are derived from normal perception. Thus William Blake: "How do we distinguish the oak from the beech, the horse from the ox, but by the bounding outline? How do we distinguish one face or countenance from another, but by the bounding line and its infinite inflexions and movements?" Blake, "A Descriptive Catalogue . . ." (1809), in *Blake: Complete Writings*, ed. Geoffrey Keynes (Oxford: Oxford University Press, 1969), 585.

20. The sources of these six remarks are (1) Jan Gordon, *A Step Ladder to Painting* (Faber and Faber, 1934), 18; (2) Otto G. Ocvirk et al., *Art Fundamentals: Theory and Practice* (Dubuque, Iowa: 1960), 32; (3) Bernard Chaet, *The Art of Drawing*, 2nd ed. (Boston: Holt, Rinehart and Winston, 1978); (4) Philip Rawson, *Drawing*, 2nd ed. (Philadelphia: University of Pennsylvania Press, 1987), 1; (5) Robert Beverly Hale, *Master Class in Figure Drawing* (New York: Watson-Guptill, 1985), 79; (6) Edward Laning, *The Act of Drawing* (New York: McGraw-Hill, 1971), 32. Of many more references we may include Daniel M. Mendelowitz, *Drawing* (New York: Holt, Rinehart and Winston, 1966), 287: "Although lines do not exist in nature, as we most frequently use them in drawing, to indicate the boundaries of forms, they are one of the oldest conventions in the arts"—and, given his influence—Harold Speed, *The Practice and Science of Drawing* (Seeley Service, 1917), 50: "Most of the earliest forms of drawing known to us in history, like those of the child . . . are largely in the

nature of outline drawings. This is a remarkable fact, considering the somewhat remote relation lines have to the complete phenomena of vision." Speed, like Gordon, is discussed in Marion Milner (Joanna Field), *On Not Being Able to Paint* (New York: International Universities Press, 1957). It needs to be added that Speed is not so adamant as the others. "Outlines can only be said to exist in appearances as the boundaries of masses. But even here a line seems a poor thing," he remarks, "as the boundaries are not always clearly defined, but are continually merging into the surrounding mass and losing themselves" (50).

21. A letter of 1878, from Walter Crane, *An Artist's Reminiscences* (London, 1907), 185. We noted in chapter 5 that Crane himself supposed a direct transfer of perceived outlines to drawing surfaces.

22. Theophilus, *On Divers Arts*, trans. John G. Hawthorne and Cyril Stanley Smith (New York: Dover, 1979), 14.

23. For a critical review of "theories of outline" see John M. Kennedy, Igor Juricevic, and Juan Bai, "Line and Borders of Surfaces, Grouping and Foreshortening," in *Looking into Pictures: An Interdisciplinary Approach to Pictorial Space,* ed. Heiko Hecht, Robert Schwartz, and Margaret Atherton, 321–354 (Cambridge, Mass.: MIT Press, 2003). Through his work with blind drafters, Kennedy has shown that the depictive efficacy of contour would not be entirely due to visual shadow effects: see Kennedy, *Drawing and the Blind* (New Haven: Yale University Press, 1993); and "How the Blind Draw," *Scientific American* 276 (January 1977): 60–65. This is welcome news for the position later argued here: that drawing as an art must be characterized by the transfer of much more than visual activities.

24. Gombrich, *Art and Illusion,* 260–261, referring back to 181, 203.

25. Gombrich, reference misplaced.

26. Ironically, Gombrich did not treat perspective in the "tool kit" manner here urged. Rather, he usually looked to global features—which too (I shall later argue) is defensible: we need both accounts. Thus I consider his first error to be one of omission, but his second error to be that of losing the *visual experience* of perspective, in an otherwise insightful and valid defense of perspective in terms of sameness of information. It needs to be kept in mind that Gombrich's discussion of perspective in *Art and Illusion* (as "the most important trick in the armoury of illusionist art"), which is the source of a number of controversies and other extended treatments of the subject by him, occurs as what he termed "a digression" there from his main topic of "the beholder's share in the illusion of space" (258, 243). Gombrich thought that, properly understood, linear perspective does not lead into the general problem of ambiguity in depiction, which he was there arguing (258). For a review and defense of Gombrich's views of perspective against various criticisms, see David Topper, "Perspectives on Perspective: Gombrich and His Critics," in *Gombrich on Art and Psychology,* ed. Richard Woodfield, 78–100 (Manchester: Manchester University Press, 1966).

27. James Cutting, "Reconceiving Perceptual Space," in Hecht, Schwartz, Atherton, *Looking into Pictures,* 237n6.

28. Nelson Goodman, *Languages of Art: An Approach to a Theory of Symbols,* rev. ed. (Indianapolis: Hackett, 1976),

11. Goodman's discussion of perspective comes explicitly at the point of his disagreement with Gombrich's treatment in *Art and Illusion,* which Goodman finds inconsistent with the rest (10). See also his remark in his 1960 *Journal of Philosophy* review of the book, reprinted in Nelson Goodman, *Problems and Projects* (Indianapolis: Bobbs-Merrill, 1972), 141–146: "despite Gombrich's unwillingness to count perspective as conventional (his treatment of this subject is often puzzling)" (145).

29. For example, Christopher Peacocke, "Depiction," *Philosophical Review* 96, no. 3 (July 1987): 383–410.

30. Brook Taylor, *New Principles of Linear Perspective...* (London, 1719), 2: available in facsimile reproduction as book 3 of Kirsti Andersen, *Brook Taylor's Work on Linear Perspective* (New York: Springer Verlag, 1992), which also includes Taylor's 1715 *Linear Perspective* as book 2.

31. Even for the Dürer *line* drawings the modern version looks hopeless. Dr Taylor's written account is better in that regard, better than his own diagram (fig. 25). Since it starts from what is in the picture, rather than what is in the represented object, and speaks of "directions," it avoids the fiction of rays from the object penetrating a picture plane.

32. I will not attempt to judge how well this example matches Gombrich's own treatment of perspective—where Goodman argued he went wrong.

33. Among leading psychologists, J. J. Gibson was outspokenly skeptical, as is William H. Ittelson. R. L. Gregory is cautious and thoughtful in *The Intelligent Eye* (New York: McGraw-Hill, 1970). For a list of leading psychologists skeptical about continuity, see Cutting, "Reconceiving Perceptual Space," 125–126.

34. The first two statements are from Gombrich, "Evidence of Images," 47; the third is from *Art and Illusion,* 270. In "On Information Available" Gombrich also rejects "a tremendous gulf" imputed by Gibson (195).

35. Gombrich, "Evidence of Images," 47, 51; see also "Mirror and Map: Theories of Pictorial Representation," in *Image and the Eye,* 172–214, where the gulf is "the tremendous difference" (197). Gombrich's "static with regard to viewer motions" (which applies as well to moving pictures) does not mean that apparent shapes of pictures do not change, but rather that the left-right, top-bottom (etc.) ordinal arrangements of shapes do not change as we move relative to the picture, as they may in nature, as one thing shifts in front of another. Gombrich meant this, too, by the next quotation's "freezing of the flow."

36. Gombrich, "Action and Expression," 79.

37. Gombrich, *Art and Illusion,* 215.

38. Gombrich, "On Information Available," 195. In such statements (see also "Standards of Truth: The Arrested Image and the Moving Eye," in *The Image and the Eye: Further Studies in the Psychology of Pictorial Representation* [Ithaca, N.Y.: Cornell University Press, 1982]) Gombrich is chiefly concerned with Gibson's theory of visual perception, which stresses invariance through flux.

39. See Gombrich, "Action and Expression," 79.

40. Gombrich invokes "projection" at crucial points in *Art and Illusion,* e.g., 105–109, 182–191, 199–203. He states that "all representation relies to some extent on what we have called guided projection" (203) and suggests "the possibil-

ity that all recognition of images is connected with projections and visual anticipations." See also "Action and Expression," 100. On consistency tests, see Gombrich, *Art and Illusion*, esp. 230–232, 238–239, 282–285 (where he refers to these in terms of possibility: "a possible category of experience," "a possible world" [238, 283]); "Illusion and Visual Deadlock," in *Meditations on a Hobby Horse*, esp. 158.

41. The first phrase is from *Art and Illusion*, 222, the second from "Action and Expression," 100.

42. For "vista space" and pictures, see Cutting, "Reconceiving Perceptual Space." Gombrich himself convincingly drew on vista space effects in argument with Gibson, in the different context of the latter's thesis (later abandoned) that acquaintance with pictures is responsible for our awareness of the "visual field": Gombrich, "Letters," *Leonardo* 4 (1971): 195–197, 308. For an insightful review of Gibson's changing ideas on that question, see David Topper, "Art in the Realist Ontology of J. J. Gibson," *Synthese* 54 (1983): 75–77.

43. J. J. Gibson, *The Ecological Approach to Visual Perception* (Boston: Houghton Mifflin, 1979), 271; quoted in Topper, "Art in the Ontology of Gibson," 79. This is also Gibson's reply to Gombrich in "Letters," *Leonardo*, 197–198, where he holds that he had abandoned the meaning that Gombrich gives to "information," and that "a successful caricature is not a reduction of the information in a natural array but an enhancement of it."

44. Gibson continues the "invariant features" remark by saying that "it follows that an arrested member of that unique family will have at least some of those invariants": my point about *eidos* or visual form is that some have more than others.

45. Henri Matisse, "Exactitude Is Not Truth," trans. Esther Rowland Clifford, in *Henri Matisse: Retrospective* (Philadelphia: Philadelphia Museum of Art, 1948), reprinted in *Matisse on Art*, ed. Jack D. Flam (London: Phaidon, 1973), 81–82.

46. Dashiell Hammett, *Selected Letters of Dashiell Hammett, 1921–1960*, ed. Richard Layman and Julie M. Rivett (Washington, D.C.: Counterpoint, 2001), 24–25. Similarly with "Our Lady of I-19," since, "although there is no facial detail," a "shimmering pattern of iridescent blues, reds and whites . . . clearly shows the head-and-shoulders outline of a hooded figure with head inclined" (Robin Breon, "Our Lady of the I-19," *Globe and Mail* [Toronto], January 18, 1997, D4).

47. Gombrich, "Evidence of Images," 54.

48. Gombrich, *Art and Illusion*, 186. Gombrich stresses the trio of "the medium, the mental set, and the problem of equivalence" (368), which is his theme throughout this book.

49. For his part, Gombrich refers to the Chaplin film in this context regarding a more extreme kind of "projection": one "into all sorts of dissimilar objects" ("Meditations on a Hobby Horse," 7). The ball named "Wilson" in *Castaway* was a particular conceit of the directors, developed in production, and a more plausible Robinson Crusoe presumably would, by sharing food, have made friends with some of the living animals available on a remote tropical island of that size, and so not have to depend so much on sustained imaginings. (Even Lindberg in *The Spirit of St. Louis* [1957] on his solo flight talks to a fly.)

50. E. H. Gombrich, "Art and Scholarship" (1957), in Gombrich, *Meditations on a Hobby Horse*, 118. See also *Story of Art* and *Art and Illusion*, where Gombrich makes clear his opposition to holistic "folk psychology" or communal "ways of seeing" as explanatory principles which he associates with Hegel.

51. For "the function of the image" as Gombrich's methodological principle, see *Story of Art*, *Art and Illusion*, "Action and Expression," and *Uses of Images*; for "beholder's collaboration" see *Art and Illusion*, 250.

52. For example, on Jan van Eyck's *Marriage of the Arnolfini*, painted on oak in the year 1434 and explained by Panofsky exactly five hundred years later, see Panofsky, "Jan Van Eyck's Arnolfini Portrait," *Burlington Magazine* 64 (1934): 117–127. Typical of the iconological approach, Panofsky goes right for such meanings in the picture as, literally, the meaning of the Latin inscription on the wall, but also the meanings of the mirror reflection, the lighted candle, the presence of a dog, the image of St. Margaret carved on the chair, the position of Arnolfini's hands, the statuelike arrangement of the figures—even to the realism of detail itself: "what is possibly meant to be a mere realistic motive can, at the same time, be conceived as a symbol," whereby symbols are "*disguised*, so to speak, as ordinary pieces of furniture," which "impresses the beholder with a kind of mystery and makes him inclined to suspect a hidden significance in all and every object" (126). Such interpretations must be fitted into a theory of drawing, and we are providing a basis for that connection. For Gombrich's own iconological work, see, for example, E. H. Gombrich, *Symbolic Images: Studies in the Art of the Renaissance* (London: Phaidon, 1979).

53. Erwin Panofsky, *Studies in Iconology: Humanistic Themes in the Art of the Renaissance* (1939; repr., New York: Harper Torchbooks, 1962), 9.

54. Gombrich, *Art and Illusion*, 191, 195, 199, 202.

55. That is, "the true aim of the Impressionists" (*Story of Art*, 522). Chapter 6 of *Art and Illusion* presents the movement called "Impressionism" as an important stage in a broader phenomenon of pictorial "impressionism."

56. See Gombrich, *Art and Illusion*, 3, and the title of its introduction.

57. Ibid., 232.

58. Some of these traumas are described in Oliver Sacks, *The Man Who Mistook His Wife for a Hat and Other Clinical Tales* (New York: Summit, 1985). For a modern aesthetic classic on categories in the perception of art, see Kendall Walton, "Categories of Art," *Philosophical Review* 79, no. 3 (July 1970): 334–367.

8. DEPICTIONS AS DEPICTIONS

1. The title of this section names a large area of current cognitive inquiry. Among generally accessible sources, including the "classics," are L. S. Vygotsky, *Thought and Language* (Cambridge, Mass.: MIT Press, 1962); Eleanor Rosch and B. B. Lloyd, eds., *Cognition and Categorization* (Hillsdale, N.J.: Lawrence Erlbaum, 1978); Frank Keil,

Concepts, Kinds, and Cognitive Development (Cambridge, Mass.: MIT Press, 1989); Barbara Burns, ed., *Percepts, Concepts and Categories* (Amsterdam: North-Holland, 1992); and L. Hirschfeld and S. Gelman, eds., *Mapping the Mind: Domain Specificity in Cognition and Culture* (New York: Cambridge University Press, 1994). Particularly appropriate are Noam Chomsky's remarks on "lexical items" throughout *New Horizons in the Study of Language and Mind* (Cambridge: Cambridge University Press, 2000).

2. See E. H. Gombrich, "The Evidence of Images," in *Interpretation: Theory and Practice,* ed. C. S. Singleton (Baltimore: Johns Hopkins University Press, 1969), 51.

3. Intra language "Mondegreens" such as "the girl with colitis goes by" are common regarding popular songs.

4. E. H. Gombrich, *The Story of Art,* 16th ed. (London: Phaidon, 1995), 562. See also "Evidence of Images," 48–49, where Gombrich calls the effect "automatism."

5. Nelson Goodman, *Languages of Art: An Approach to a Theory of Symbols,* rev. ed. (Indianapolis: Hackett, 1976).

6. Noam Chomsky, *New Horizons in the Study of Language and Mind* (Cambridge: Cambridge University Press, 2000), 20.

7. I introduced the idea of displays in Patrick Maynard, *The Engine of Visualization* (Ithaca, N.Y.: Cornell University Press, 1997), 27–33.

8. There is a great difference between Walton's account of mimetic representation as essentially an appeal to the imagination and Gombrich's restriction of it to what he terms "projection." Thus, when Gombrich writes, "Any picture, by its very nature, remains an appeal to the visual imagination," he restricts that observation to what is not shown on the surface. He continues: "It must be supplemented in order to be understood," whereas the concept of depiction in terms of a fictional world means that imagining is mandated even where projection is unnecessary or impossible. See Gombrich, *Art and Illusion: A Study in the Psychology of Pictorial Representation,* 3rd ed. (London: Phaidon, 1968), 242–243, and his comment that "all representation relies to some extent on what we have called 'guided projection'" (203).

9. No doubt, environmental vision is shaped by borrowed pictorial categories. It is important to note that in *Art and Illusion* Gombrich stresses the importance of what he calls "categories" in the visual experience of nature and of art. Indeed, that book, based on a set of lectures titled "The Visible World and the Language of Art" (viii), insists on an analogy between depictions and linguistic items: "Everything points to the conclusion that the phrase the 'language of art' is more than a loose metaphor"; "it is precisely because all art is 'conceptual' that all representations are recognizable by their style" (87). Nevertheless, Gombrich overlooks the hierarchy of just-mentioned categories implied by what he calls style and its components, notably, the category "picture." "The idea of art," as he says, has "set up a context of action" that "has taught us to interpret the images of art as records and indications of the artist's intention": but we must not take for granted the basic intention of making works of art, notably depiction.

10. This is not to charge Gombrich with being confused. As I remarked in my brief account of "naturalism" in chapter 1 and in this chapter's discussion of the Same Mill Principle's theses of continuity and transfer, there are genuine questions about which environmental powers are recruited to pictorial perception and with what force.

11. For a critical review of current psychological debates about compensation for angular subtense viewing of pictures, see, for example, A. Nicholls and John M. Kennedy, "Angular Subtense Effects on Perception of Polar and Parallel Projections of Cubes," *Perception and Psychophysics* 54 (1993): 763–772.

12. E. H. Gombrich, "Meditations on a Hobby Horse," in *Meditations on a Hobby Horse and Other Essays on the Theory of Art* (London: Phaidon, 1965), 6. Gombrich observes that "whenever anything remotely facelike enters our field of vision, we are alerted and respond" (*Art and Illusion,* 103). In *Art and Illusion,* as in "Meditations on a Hobby Horse," Gombrich argues for this phenomenon as a likely prehistorical root of the practice of visual depiction. Concerning the idea of "release mechanisms," see Gombrich's terse statements of indebtedness to Konrad Lorenz's "releaser" theory, with the crucial line "man is not exempt from this type of reaction," in "Meditations on a Hobbyhorse," 6, 163n11; also see *Art and Illusion,* 101, with its informative note on 412–413.

13. Roger N. Shepard, *Mindsights* (New York: W. H. Freeman, 1990), 201. Like Gombrich, Shepard points to our increased tendency to project under "altered states of the brain." Shepard's general argument for transfer may be found on page 187, in a section whose title modifies Gombrich's: "Art as Illusion."

14. There are many such cases, the problems of the Ford Scorpio being only one that comes to mind. As remarked below, this phenomenon is alleged to be a quite important issue in Japan.

15. Albertus Magnus, *Book of Minerals,* quoted in Paul Hills, *Venetian Colour: Marble, Mosaic, Painting and Glass 1250–1550* (London: Yale University Press, 1999), 45.

16. Robin Breon, "Our Lady of the I-19," *Globe and Mail* (Toronto), January 18, 1997, D4.

17. Ludwig Bemelmans, *Madeline* (New York: Simon and Schuster, 1939), n.p.; Shakespeare, *Antony and Cleopatra,* 4.14.2–7.

18. Leonardo, *Codex Urbinus Latinus 272,* as quoted by Gombrich, *Art and Illusion,* 188. Typically, Gombrich carries us past standard treatments of Leonardo's advice.

19. Gombrich, *Art and Illusion,* 331.

20. E. H. Gombrich, "The Art of the Greeks," in *Reflections on the History of Art: Views and Reviews,* ed. Robert Woodfield, 11–22 (Berkeley: University of California Press, 1987), 16. That Gombrich is perhaps too hard on himself here may be seen in the last two chapters of *Art and Illusion,* which concern caricature and expression, and not as side issues. For Gombrich's other essays on light and physiognomic effects see his *Meditations on a Hobby Horse* and especially his *Heritage of Apelles* (London: Phaidon, 1976), notably the first two essays in the section "Light and Highlights," to be considered in Part III.

21. Gombrich, *Art and Illusion,* 279 (see also 5–6, 236, 238, 249, 329), and "Illusion and Visual Deadlock," in *Meditations on a Hobby Horse,* 159. For criticisms of this view, see

Richard Wollheim, "Reflections on Art and Illusion," in *On Art and the Mind* (Cambridge, Mass.: Harvard University Press, 1974), esp. 278–280; and Maynard, "Seeing Double," *Journal of Aesthetics and Art Criticism* 52, no. 2 (spring 1994): 155–167. For Michael Podro's criticism of what he calls Gombrich's "reciprocal neglect thesis," see Podro, review of *Art and Its Objects*, by Richard Wollheim, *Burlington Magazine* 24, no. 947 (February 1982): 100–102, 100; and Podro, *Depiction* (London: Yale University Press, 1998), 6–7. I would like to agree with Podro that this thesis "has been generally neglected as failing to correspond to our experience" (*Depiction*, 6), but it seems entrenched, not only in language and conception but in the technological and marketing developments of our time. Therefore it will be necessary to argue against it not only here but again in Parts III and IV.

22. Gombrich, *Art and Illusion*, 396–397; Gombrich thus sums up the project of his book. In addition to this methodological commitment, Gombrich also subscribed to the common "transparency" thesis: "While we scan a picture . . . the surface is irrelevant to our processing and disappears from our awareness" ("Evidence of Images," 57). In Part IV we will consider Gombrich's anti-delusive qualification of this in the latter passage.

23. Podro, *Depiction*, 6.

24. This is not to deny the existence of illusion in sculpture. The carved drapery of the Naples "Veiled Christ" by Giuseppe Sanmartino, for example, may be illusionistic, but it is quite unlike the Greek works.

25. See http://www.thebritishmuseum.ac.uk/compass. The following argument is unaffected by the fact that such figures were once painted, had inset eyes, that "Iris" had a bronze girdle etc.

26. These two quoted passages occur in Gombrich, *Story of Art*, 99.

27. Of course, it is consistent with this that vivid depiction should involve some actual illusionistic effects.

28. Gombrich, *Story of Art*, 313.

29. Kendall Walton, *Mimesis as Make-Believe* (Cambridge, Mass.: Harvard University Press, 1990), 296.

30. On "standard of correctness" for representations, see Richard Wollheim, *Painting as an Art* (Princeton, N.J.: Princeton University Press, 1987), 48–51; for Walton's comments on correctness, see *Mimesis as Make-Believe*, 184–187.

31. Walton, *Mimesis as Make-Believe*, 58–61. For present purposes, we need not be concerned that these "game worlds" are fictional worlds: that is, that they, too, are mandated.

32. Gombrich speaks of such "screens" for "projection" in *Art and Illusion*, 228. Appreciating such cases allows us to observe a somewhat different one: that a given face or expression can also seem to "take" on trees, stones, and so forth—that is, can seem to *manifest* itself there. We find this in devotional examples like "Our Lady of I-19"—and, having mentioned Dickens's story before, it is what we find with Marley's first manifestation to Scrooge, on the door knocker, in *A Christmas Carol*.

33. Gombrich allows "simultaneous processing of visual information" in "Evidence of Images": "We cannot perform two different operations simultaneously with the same message. This does not mean, however, that we cannot

process different messages at the same time. Of course we can" (65)—and he gives examples of seeing things in mirrors embedded in wider visual fields. He provides no reason against the possibility of "the same message" being simultaneously, even interactively, interpreted in different ways by two visual subsystems.

34. See Walton, *Mimesis as Make-Believe*, 208–213.

35. According to technical accounts, "ingredients used in the making of glass, combined with the chemical tint that filters out sunlight, sometimes produces this effect when water from outside sprinklers . . . combined with a high burst of wind and sand on a hot day, will result in an iridescent, rainbow-like wave that may permanently bake into the glass" (Breon, "Our Lady of the I-19," D4), and sometimes the action of palm fronds is suggested. The *Salt Lake Tribune* remarked: "The culprit seems to be the sprinkler. The issue is, is the culprit that good an artist or did it have divine help?" (ibid.)

36. Thus Walton writes: "Most paintings and drawings are not reflexive" (*Mimesis as Make-Believe*, 117; cf. 56–57). In the Steinberg drawing (fig. 2) we see one way in which drawings and paintings can be reflexive depictions.

37. As a case in point, Edward Laning writes, "All contour lines in the body are convex, never concave. If you think you see a concave contour line you will find on closer study (feeling) that it is in reality a series of convexities" (*The Act of Drawing* [New York: McGraw-Hill, 1971], 135).

38. Jan Koenderink and Andrea van Doorn, "The Shape of Smooth Objects and the Way Contours End," *Perception* 11 (1982): 129–137.

39. For an inconographical interpretation, see Francis Robicsek and Donald M. Hales, *Maya Book of the Dead: The Ceramic Codex* (New Haven, Conn.: Yale University Press, 1981), vol. 1, vessel 56. The labels were taken from the Maya Vase Database website.

40. See John M. Kennedy, Christopher D. Green, and John Vervaeke, "Metaphoric Thought and Devices in Pictures," *Metaphor and Symbolic Activity* 8, no. 3 (1993), for a discussion, history, and bibliography.

9. DECORATIVE DEPICTION

1. Samuel Y. Edgerton, Jr., review of *The Psychology of Perspective and Renaissance Art*, by Michael Kubovy, *Word and Image* 4 (1988): 739.

2. E. H. Gombrich, "Meditations on a Hobby Horse," in *Meditations on a Hobby Horse and Other Essays on the Theory of Art* (London: Phaidon, 1965) 10.

3. E. H. Gombrich, *Art and Illusion: A Study in the Psychology of Pictorial Representation*, 3rd ed. (London: Phaidon, 1968), 74.

4. Suzanne Langer, *Feeling and Form* (New York: Charles Scribner's Sons, 1953), 61. I would like to reserve the term "ornamental" for another important kind of reflexive visual representation, featuring limited participation, which is discussed by Kendall Walton in *Mimesis as Make-Believe* (Cambridge, Mass.: Harvard University Press, 1990), esp. 280–282, 296–297. In terms of wall painting, this would correspond to Roman Third Style. Our ordinary uses of both terms include much that is not reflexive.

5. Good photographs of the pot may be found in Michael Coe and Justin Kerr, *The Art of the Mayan Scribe* (New York: Harry N. Abrams, 1998).

6. British Museum Vase E 804 (GR 1860.12-1.2): red-figured astragalos, Athens, 460–480 B.C., attributed to the Stades Painter.

7. Norbert Aujoulat et al., "The Techniques of Parietal Art," in *Chauvet Cave: The Arts of Earliest Times*, ed. Jean Clottes, trans. Paul G. Bahn (Salt Lake City: University of Utah Press, 2003), 157.

8. Philip Rawson, *Seeing through Drawing* (London: British Broadcasting System, 1979), 14.

9. Among the masses of exceptions to these generalizations are layouts in magazines and other print media and still photography that stress the surface.

10. William H. Ittelson, "Visual Perception of Markings," *Psychonomic Bulletin and Review* 3 (1996): 171–187.

11. This account has interest as a combination of our earlier-discussed ancient account of signs as artifacts that "put us in mind" of states not present, rather than themselves (ibid., 182)—which makes no mention of dimensions—and the modern approach to depiction, indeed drawing, in terms of 2D/3D. An advantage of this marriage is that it at least drops the pervasive third-dimensional conception. Ittelson includes among his examples of unlocated markings the "decorative frieze running around" a plate, and he mentions graffiti: "If I spray-paint my name on the side of a building, I am defacing the surface; if I paint a mustache on the Mona Lisa, I am defacing the Mona Lisa, not a surface," adding: "All this is in accord with everyday usage" (171).

12. E. H. Gombrich, *The Story of Art*, 16th ed. (London: Phaidon, 1995), 310.

13. Ibid. For Gombrich's further thoughts on wall decoration, see his "Paintings on Walls: Means and Ends in the History of Fresco Painting," in *The Uses of Images: Studies in the Social Function of Art and Visual Communication* (London: Phaidon, 1999), 14–47, which begins with Leonardo's disapproval of multiple scenes on single surfaces.

14. According to Vitruvius, the evolution of what we call the Roman First and Second Style follows the account just given: "The ancients who established the beginnings of painting plaster first imitated the varieties and placement of marble veneers, then of cornices and the various designs of ochre inlay. Later they entered a stage in which they also imitated the shapes of buildings, and the projection into space of columns and pediments, while in open spaces like exedrae . . . they painted stage sets . . . and adorned their walkways, because of their extensive length, with varieties of landscape" (Vitruvius, *Ten Books on Architecture*, ed. Ingrid D. Rowland and Thomas Noble Howe, trans. Ingrid D. Rowland [Cambridge: Cambridge University Press, 1999], 91). The first, faux effects depict little depth; whereas the "projection into space of columns and pediments" is sometimes forward, it being left to "the stage sets" of Second Style to open deep vistas beyond—often with framing architecture projecting forward: all techniques richly developed in later European art.

15. For further comment, see Leopold D. Ettlinger and Helen S. Ettlinger, *Raphael* (London: Phaidon, 1987), 96.

10. ADVANCING THE DRAWING COURSE

1. Harold Rosenberg, *Saul Steinberg* (New York: Whitney Museum of Art and Alfred A. Knopf, 1978), 235. For detailed criticism of modern drawing teaching practices, with developed positive alternatives, see John Willats, *Making Sense of Children's Drawings* (Mahwah, N.J.: Lawrence Erlbaum Associates, 2005).

2. Philip Rawson, *Seeing through Drawing* (London: British Broadcasting System, 1979), 9.

3. On the decline of the basis of European music in home performance, see for example Charles Rosen, "Steak and Potatoes," *New York Review of Books*, March 14, 2002, 19–20.

4. Rawson, *Seeing through Drawing*, 9, 7.

5. For emphasis on the precedence of shape over object recognition, see John Willats, *Art and Representation: New Principles in the Analysis of Pictures* (Princeton, N.J.: Princeton University Press, 1997), 19–23, 123; e.g.: "Recognizing objects in real scenes depends, in most cases, on our being able to recognize their *shapes*. . . . The same argument applies to pictures" (22).

6. Instructions on this may be found in a variety of sources, for example, in Kimon Nicolaïdes, *The Natural Way to Draw: A Working Plan for Art Study* (Boston: Houghton Mifflin, 1941); Frederick Franck, *The Awakened Eye* (New York: Random House, 1979), 35–38; Betty Edwards, *Drawing on the Right Side of the Brain* (Los Angeles: P. Tarcher, 1979); Howard S. Hoffman, *Vision and the Art of Drawing* (Englewood Cliffs, N.J.: Prentice-Hall, 1989), 27–33, 63–64. That the immersive, quieting effects of this routine are beneficial and that it sometimes dramatically frees people from stultified habits should not be confused with its value as a positive drawing procedure, which is limited. Part of what the vogue of this method overlooks is that, based as it is a simple "view-centered" routine, it provides the drafter no "object-centered" procedures. But what many drafters often need is effective object-centered techniques, not simply the destruction of ineffective object-centered habits.

7. Rosenberg, *Saul Steinberg*, 235, about drawing from life.

8. Jack D. Flam, ed., *Matisse on Art* (London: Phaidon, 1973), 170n6. Related remarks by Matisse include: "At the École des Beaux-Arts one learns what not to do. It's an example of what to avoid," and "One day Toulouse-Lautrec cried, 'At last I don't know how to draw' " (145).

9. Joseph Meder, *Die Handzeichnung: Ihre Technik und Entwicklung* (1919), revised and translated by Winslow Ames as *The Mastery of Drawing*, 2 vols. (New York: Abaris Books, 1978). Rawson considers it the "one great classic book on the art of drawing," limited, however, by "characteristic works of a single historical phase" (*Seeing through Drawing*, vi). "Course of" is actually Ames's single translation of Meder's *Werdegang* for both "artist" and "drawing," *Laufbahn* for the artist's "career," and *Weg zu* for standard "drawing training," and I take advantage of the historical connotation of Ames's happy English expression.

10. Meder, *Mastery of Drawing*, 1:217. Meder reports that in the Italian tradition the next two stages after copying were drawing in studio from solid objects (*rilievo*) and

from nature—to which the Renaissance added ancient sculpture—then the human figure, but that many students stopped at the exacting second stage and "went off into non-pictorial branches of art and handicraft" (ibid.). Only after these three stages were students set to do composition drawings (see 236–257). Copy work would be anathema now; representative evidence of earlier rejection in favour of immediate *rilievo* studies in drawing education may be found in, for example, Butler Williams, *A Manual for Teaching Model-Drawing from Solid Forms . . .* (London: John Parker, 1851): "[Copy work] fails to exercise judgment. . . . [The student] fails to acquire a habit of observing and seeing correctly, and is unable, after years of labour spent in these purely mechanical exercises, to represent correctly the simplest natural objects" (14). Such objections, however, do not seem to address actual traditional practices. For recent scholarly studies of studio practices, see, for example, Francis Ames-Lewis, "Training and Practice in the early Renaissance Workshop: Observations on Benozzo Gozzoli's Rotterdam Sketchbook," as well as other essays in *Drawing 1400–1600: Invention and Innovation,* ed. Stuart Currie (London: Ashgate, 1998).

11. Quoted in Stephen Addis and Wai-kam Ho, *The Century of Tung Ch'i-Ch'ang 1555–1636: A Short Guide to the Exhibition Expositions* (Kansas City: The Nelson Gallery Foundation, 1992), n.p.

12. Henceforth Rawson, *Drawing,* will be cited in the text as *D;* and Rawson, *Seeing through Drawing,* as *StD.*

13. Chang Yeng-yüan, "Brushwork," in *Early Chinese Texts on Painting,* ed. Susan Bush and Hsio-yen Shih (Cambridge, Mass.: Harvard University Press, 1985), 61.

14. See Han Cho (ca. 1100 A.D.), in *Early Chinese Texts on Painting,* ed. Bush and Shih, 168; or, for a more recent account, Mai-mai Sze, *The Way of Chinese Painting: Its Ideas and Technique* (New York: Random House, 1959), 134.

15. Quoted by Antoine Terrasse, "Bonnard the Draftsman," in *Bonnard: Drawings from 1893–1946* (New York: American Federation of Arts, 1972), n.p.; also in *Drawings by Bonnard* (London: Arts Council of Great Britain, 1984), 5–6.

16. Paul Klee, *Pedagogical Sketchbook,* trans. Sibyl Moholy-Nagy (London: Faber and Faber, 1953), 16.

17. Although line is usually considered in dynamic relationship, matters of art elude summary generalization. Thus compare with Klee's remark this one by William Seitz, writing about Robert Motherwell: "A line is a clean-cut element. When, at some phase in the process of revision and realignment, a line is drawn on the objective picture surface, it has an identity as clear as that of a horsehair floating in a saucer of milk" (William C. Seitz, *Abstract Expressionist Painting in America* [Cambridge, Mass.: Harvard University Press, 1983], 22). Some would hold that the key to drawing as an art lies in the kinetics of marks and shapes, so that any account of drawing that hopes to deal with it as an art should set off at once in that direction. Nonetheless, the present account will not, for two reasons. First, we are continuing an investigation of the course of drawing that not only began with figurative drawing but that also follows Rawson's exposition, which runs that way. Second, relevant and persuasive theoretical

expositions of such "formal" factors prove difficult, and we will attempt only a little of that.

18. Rawson, *Seeing through Drawing, 27;* Rawson, *Drawing,* 27. See also his comment in his companion book on ceramics, that in decoration we should "recognize the distinction between the Oriental and the Western hands. . . . The Western hand tends to repeat short, scarcely varied touches, which are combined in transverse rhythms"; Rawson, *Ceramics* (1971; repr., Philadelphia: University of Pennsylvania Press, 1984), 153.

19. Pliny, *Natural History,* bk. 35, lines 67–68, cited in *Cave to Renaissance: Great Drawings of the World,* by Benjamin Rowland, Jr. (London: Studio Vista, 1965), 27.

20. For difficulties in translation of *Plastik,* see Meder, *Mastery of Drawing,* 1:1, 441–444. Ames's translation does not preserve Meder's division of his book into four parts, the third being devoted to this topic, distinguished as such. Although Rawson does not explicitly mark the distinction, he seems strongly influenced by it in both *Drawing* and *Seeing through Drawing.* In the introductory *Seeing through Drawing* Rawson seems to observe it by a division called "Deep Space" (43), which treats floor, depth-bands, and perspective. In the longer, systematic *Drawing,* Rawson spreads his discussion of drawing resources between chapters 3, "Technical Methods," and 4, "Rhythm and Space," and has to carry treatments of several devices across that divide. Thus he treats depth-slices on page 105 but revisits it on 155 and 201; facetting or side-surfaces is introduced on 157 and discussed again on 175 and 200. For simplicity of exposition I will be relying more on Meder's distinction than does Rawson.

21. Peter Jeffrey Booker, *A History of Engineering Drawing* (London: Chatto and Windus, 1963), 12.

22. This distinction has recently been emphasized, for example, by Paul Hills, criticizing a fifteenth-century engineer for confounding "two problems . . . in a manner characteristic of the period: the first concerns how to model—the challenge of creating relief, the second how to establish recession from foreground to distance—the construction of space" (Hills, *Venetian Colour: Marble, Mosaic, Painting and Glass 1250–1550* by [London: Yale University Press, 1999], 94).

23. In the *Seeing through Drawing* version of this, Rawson stresses more our next topic, corporeal volume, than three-dimensional space: "Great draughtsmen of the past all spent a great deal of effort on developing techniques for conveying a sense of three dimensions, and for making the near parts of forms seem to advance, whilst establishing at the same time a strong and expressive unity and balance of the surface" (35).

24. Rawson, *Drawing,* 81 (where perhaps "darks" is a misprint for "marks").

25. Robert Beverly Hale, *Drawing Lessons from the Great Masters* (New York: Watson-Guptill, 1964), 78. The advice is standard. See, for example, Edward Laning, *The Act of Drawing* (New York: McGraw-Hill, 1971), 135 (see chap. 8, note 37 above).

26. See also Philip Rawson, *Creative Design: A New Look at Design Principles* (London: Macdonald, 1987), 160: "One of the principal functions of lines is to enclose."

27. Rawson, *Drawing,* 106–107.

28. For useful accounts, see Robert Beverly Hale and Terence Coyle, *Anatomy Lessons from the Great Masters* (New York: Watson-Guptill, 1977), 106; and (for the shoulder girdle) Robert Beverly Hale, *Master Class in Figure Drawing* (New York: Watson-Guptill, 1985), 73–77.

29. Quotations from Hale and Coyle, *Anatomy Lessons*, 36; Hale, *Master Class*, 37. On the two girdles, see Hale, *Drawing Lessons*, 154. A typical comment from Hale: "Everybody, in drawing the model, should put in these landmarks. If you don't know exactly where they are . . . try to put them in anyway. At least you know lots of places where they're not. They're not over in Jersey City. They're on your pad. . . . So try to put them in. As the months go on, you'll get them nearer. . . . But you have to start thinking about the pelvic points to guide you . . . in your massing and perspective" (*Master Class*, 37).

30. See, for example, Hale, *Master Class*, 48.

31. See ibid., 17.

32. For connoisseurship of what is actually called "Studies of a Reclining Male Nude," see Pierpont Morgan Library, *Drawings by Michelangelo from the British Museum* (New York: Pierpont Morgan Library, 1979), 40–42, in which J. A. Gere records disagreements about direct attribution to Michelangelo. Even if the British Museum drawing is not up to the artist's standards, it will do for us here.

33. Millard Meiss, *Andrea Mantegna as Illuminator: An Episode in Renaissance Art, Humanism and Diplomacy* (New York: Columbia University Press, 1957).

34. Hills, *Venetian Colour*, 104.

35. Hale, *Master Class*, 45. There Hale also explains adductors: "Once you get the leg out, you have to get it back—otherwise it would be terribly awkward. . . . so you have to have muscles that pull it back inward. They're called adductors, while the ones that pull it out . . . are called abductors or kidnappers. They move it away from the center line of the body. You can think of the ones that bring it back . . . as the FBI."

36. Hale, *Drawing Lessons*, 35.

37. Nicolaïdes, *Natural Way to Draw*, 32.

38. Michael Leyton, "Inferring Causal History from Shape," *Cognitive Science* 13 (1989): 358. Leyton actually says this of "natural objects," not just living ones.

39. The French reads: "par ligne, . . . anciens prenaient par les milieux." This is cited by Rawson, *Drawing*, 161. A classic distinction of the two aesthetics is Heinrich Wölfflin's between "linear" and "painterly" approaches: "linear style sees in lines, painterly in masses. Linear vision," he writes, "means that the sense and beauty of things is first sought in the outline . . . that the eye is led along the boundaries . . . , while seeing in masses takes place where the attention withdraws from the edges, where the outline has become more or less indifferent to the eye as the path of vision" (*Principles of Art History: The Problem of the Development of Style in Later Art* [New York: Dover, 1972], 18).

40. Jakob Rosenberg, *Rembrandt: Life and Work,* 3rd ed. (London: Phaidon: 1968), 298.

41. Theophilus, *Of Diverse Arts,* quoted in Paul Hills, *The Light of Early Italian Painting* (London: Yale University Press, 1987), 24. It is to be noted that Theophilus is referring to the "laying in" and "modelling" stages of painting here, and that, as Hills makes clear, colors are being considered for their tone or value, rather than hue.

42. Gombrich quotes this in *Art and Illusion: A Study in the Psychology of Pictorial Representation,* 3rd ed. (London: Phaidon, 1968), 226, adding: "Hogarth knew that shade had a defining character only where it is used to plot a foreshortening." Presumably this allows for the unshaded face to be foreshortened, where the light is from that direction and the front plane is shaded.

43. Ansel Adams, *Natural Light Photography* (New York: Little, Brown, 1952), 8–9. A related effect of "outline photography" is gotten by the process of solarization, also called the Sabbatier effect.

44. For a critical review of this hypothesis see John M. Kennedy, Igor Juricevic, and Juan Bai, "Line and Borders of Surfaces, Grouping and Foreshortening," in *Looking into Pictures: An Interdisciplinary Approach to Pictorial Space,* ed. Heiko Hecht, Robert Schwartz, and Margaret Atherton, 321–354 (Cambridge, Mass.: MIT Press, 2003).

45. A wonderful exposition of the differences between shading and the two kinds of shadow may be found in Michael Baxandall, *Shadows and Enlightenment* (London: Yale University Press, 1995), 1–4, 14–15, which borrows Lecat's seventeenth-century expression "holes in the light." I exposited this material in *The Engine of Visualization* (Ithaca, N.Y.: Cornell University Press, 1997), chap. 6, "In Praise of Shadows."

46. D. Waltz, "Understanding Line Drawings of Scenes and Shadows," in *The Psychology of Computer Vision,* ed. P. H. Winston, 19–91 (New York: McGraw-Hill, 1975).

47. Meder, *Mastery of Drawing,* 440.

48. E. H. Gombrich, *Shadows: The Depiction of Cast Shadows in Western Art* (London: National Gallery Publications, 1995), 16. Gombrich uses the term "attached shadow" for that "cast by an object on the ground on which it rests" (37), and that does pick out a very important class of cast shadows. In connection to our chapter 6 mention of Leonardo, Gombrich observes that his writings on shadow are mostly concerned with that from diffuse light, and he adds that it is "strange that Leonardo, the most innovative master of chiaroscuro effects, apparently did not embody in his own paintings the varieties of shadows he had studied so meticulously in his writings" (20–21).

49. See Laning, *Act of Drawing,* 69–70.

50. Hale, *Master Class,* 17.

51. Laning, *Act of Drawing,* 157.

52. See Paul Hills, *The Light of Early Italian Painting* (London: Yale University Press, 1987), and Baxandall, *Shadows and Enlightenment.*

53. Baxandall, *Shadows and Enlightenment,* 146–147. Interestingly, Baxandall understands Rawson, *Drawing,* 105–119, as considering slant/tilt shading to be "modelling tone." Harold Speed had earlier claimed that it was Leonardo who discovered "light and shade" beyond the ancient technique of shading in from outlines, and he, too, wonders why it took so long to be discovered (Speed, *The Practice and Science of Drawing* [Seeley Service, 1917], 51).

54. Jan J. Koenderink, "Pictorial Relief," *Philosophical Transactions of the Royal Society of London* 356 (1998): 1080.

55. Both Matisse quotations are from "Notes d'un peintre sur son dessin," *Le Point* (Paris) 21 (July 1939): 145; see Flam, *Matisse on Art* (London: Phaidon, 1973), 81–82. Otto Benesch wrote, "One of Rembrandt's most stupendous achievements was his ability to make the uncovered surface of the paper shine forth as if it were a source of light" (Otto Benesch, *Rembrandt: Selected Drawings* [London: Phaidon, 1947], 14).

56. Blake, "A Descriptive Catalogue," in *Blake: Complete Writings*, ed. Geoffrey Keynes (Oxford: Oxford University Press, 1969), 564, 585.

57. From Blake's annotations to Joshua Reynold's *Discourses*, in *Blake: Complete Writings*, ed. Keynes, 464. Bateson quotes "the slobbering school" in "Why Do Things Have Outlines?" in *Steps to an Ecology of Mind* (New York: Chandler Publishing, 1972), 28.

58. Speed, *Practice and Science of Drawing*, 62.

59. Marion Milner (Joanna Field), *On Not Being Able to Paint* (New York: International Universities Press, 1957), 17.

60. Jacques Rivière, "Sur les tendances actuelles de la peinture," *Revue d'Europe et d'Amérique* 15 (March 1912): 384–406, excerpts translated by Edward F. Fry as "Present Tendencies in Painting," in Fry, *Cubism* (New York: McGraw-Hill, [1966?]), 75–80.

61. Hale, *Master Class*, 17.

62. Regarding figure modelling, Hale writes: "Cast shadows cause brutal contrasts, which should be reserved for the meeting of the great planes of the body" (ibid., 108), and: "Cast shadows are used, but they are used by a master and *sparingly*" (*Drawing Lessons*, 68). Cast shadow has come to be a very useful technique of Western art, however. For a discussion of the Rembrandt see Maurice Merleau-Ponty, "Eye and Mind," in *Primacy of Perception* (Evanston: Northwestern University Press, 1964), 167, and for further discussion see Michael Podro, *Depiction* (London: Yale University Press, 1998), 7–8.

63. John Rewald, ed. *Paul Cézanne, Letters*, 4th ed. (New York: Hacker Art Books, 1976), and a letter to Léo Larguier, both quoted and discussed in Lawrence Gowing, "The Logic of Organized Sensations," in *Cézanne: The Late Work*, ed. William Rubin (New York: Museum of Modern Art, 1977), 57.

64. Hale, *Drawing Lessons*, 66, 62.

65. Patrick Cavanagh and Yvan G. Leclerc, "Shape from Shadows," *Journal of Experimental Psychology: Human Perception and Performance* 15 (1989): 3.

66. See John Kennedy, *Drawing and the Blind* (New Haven: Yale University Press, 1993), esp. chap. 3.

67. I discuss this at more length in *Engine of Visualization*, chap. 6.

68. Rawson generalizes as follows in *Creative Design*, 166–167: "The methods of dramatic composition . . . traditional in the West were mostly based upon images of complete human figures that confront each other striking postures, making gestures, and wearing facial expressions that tell the spectator clearly what each of them is feeling about what is going on."

69. Meder, *Mastery of Drawing*, 301–325. On Signorelli's earlier emphasis on musculature, see Claire Van Cleave, "Luca Signorelli's Studies of the Human Figure," in *Draw-*

ing 1400–1600: Invention and Innovation, ed. Stuart Currie, 91–108 (London: Ashgate, 1998).

70. Max J. Friedländer, *From Van Eyck to Breugel: Early Netherlandish Painting* (London: Phaidon, 1965), 138–139.

71. Thus Martin Clayton, "Poussin was not a naturally gifted draughtsman"; *Poussin: Works on Paper* (Houston: Museum of Fine Arts, 1995), 8. The Polyphemus drawing is not among Poussin's more complex compositions.

11. FORMS AND FRAMEWORKS

1. Regarding horizon ratio studies, see Sheena Rogers, "Truth and Meaning in Pictorial Space," in *Looking into Pictures: An Interdisciplinary Approach to Pictorial Space*, ed. Heiko Hecht, Robert Schwartz, and Margaret Atherton, 302–320 (Cambridge, Mass.: MIT Press, 2003). On perceptual ground planes, in that same volume see H. A. Sedgwick, "Relating Direct and Indirect Perception of Spatial Layout," 60–75.

2. See Aristotle's terse testimony, *Poetics* 4.1449a: "Three actors [besides the chorus] and scene painting were introduced by Sophocles."

3. See James Cutting, "Reconceiving Perceptual Space," in Hecht, Schwartz, and Atherton, *Looking into Pictures*, 128–129.

4. See Philip Rawson, *Indian Painting* (London: Studio Vista, Dutton, [1972]).

5. I illustrate this look with another Dürer "Jerome," an ink drawing, in "Perspective's Places," *Journal of Aesthetics and Art Criticism* 54, no. 1 (winter 1996): 23–40, 30–31, and consider "pictorial space" in terms of general "looks" in "Drawings as Drawn: An Approach to Creativity in an Art," in *The Creation of Art: New Essays in Philosophical Aesthetics*, ed. Berys Gaut and Paisley Livingston (Cambridge: Cambridge University Press, 2003), 70–74.

6. For discussion of the rise and fall of the Jerome motif, see Eugene F. Rice, Jr., *Saint Jerome in the Renaissance* (Baltimore: Johns Hopkins University Press, 75–76. From Dürer's hand we have a pre-perspective woodcut of Jerome taking a break from translation to doctor the lion, from the artist's early period in Basle (see Willi Kurth, ed. *The Complete Woodcuts of Albrecht Dürer* [London: W. and G. Foyle, 1927], 10–11), a 1512 drypoint, an oil painting in the National Gallery in London, and a late pen drawing in the Staatliche Museen in Berlin.

7. Or rather, this is Winslow Ames's sense, since his translation of *Raumplastik* as "creating the illusion of concavity (space)" makes a chapter (16) out of the second section of part 3 of Meder's *Die Handzeichnung*.

8. Erwin Panofsky, *The Life and Art of Albrecht Dürer*, 4th ed. (Princeton, N.J.: Princeton University Press, 1965), 155. For more recent, similar comments ("coziness and lived-in comforts") see James Snyder, *Northern Renaissance Art: Painting, Sculpture, the Graphic Arts from 1350 to 1575* (Englewood Cliffs, N.J.: Prentice-Hall, 1985), 337. For a general treatment of "absorptive" pictures, in which we seem to look upon figures unaware of us, see Michael Fried, *Absorption and Theatricality: Painting and Beholder in the Age of Diderot* (Berkeley: University of California Press, 1980).

9. Photoreproductions of Dürer's print trio do not do jus-

tice to the extraordinary tonalities (for example, the metallic look of the bell in "Melancholia") Dürer was able to attain with the relatively young technology of copper engraving.

10. Panofsky, *Life and Art of Dürer*, 155.

11. Angela Huss, "A Double Honor: Albrecht Dürer."

12. Panofsky, *Life and Art of Dürer*, 155.

13. William M. Ivins, Jr., *The Rationalization of Sight* (1938; repr., New York: Da Capo, 1973), 42.

14. Lawrence Wright, *Perspective in Perspective* (London: Routledge and Kegan Paul, 1983), 124.

15. Panofsky, *Life and Art of Dürer*, 154.

16. Heinrich Wölfflin, *The Sense of Form in Art: A Comparative Psychological Study*, trans. Alice Muehsam and Norma A. Shatan (New York: Chelsea Publishing, 1958), 44. Originally published as *Die Kunst der Renaissance: Italien und das deutsche Formgefühl* (Munich: F. Bruckmann, 1964).

17. Jonah 4:6–10: "a gourd, which came up in a night and perished in a night."

18. Rice, *Saint Jerome*, 112.

19. See Michael Podro on pictures "making us aware of our view as one in a continuous series and the subject as independent of the viewer" (*Depiction* [London: Yale University Press, 1998], 70), where he includes two Rembrandt Saint Jeromes.

20. But of course it can mean changes, as literature often shows: "The sunlight on the garden hardens and grows cold." Among paintings, Poussin's great Louvre *Orpheus and Eurydice* thematizes exactly that kind of dramatic change, with a shadow mass that will transform the scene: see Maurice de Sausmarez, "Maurice de Sausmarez ARA on Poussin's 'Orpheus and Eurydice,'" in *Painters on Painting*, ed. Carel Weight (London: Cassell, 1969).

21. This point was well taken in Michael Polanyi, "What Is a Painting?," *American Scholar* 39, no. 4 (autumn 1970): 655–669, where Polanyi reminds us how aerial and ground observations of sites inform one another, rather than just providing complementary information, and that the experience of binocular vision itself depends upon "fusion of" different views, not just our supplementation (660–663). My argument in "Seeing Double" (*Journal of Aesthetics and Art Criticism* 52, no. 2 [spring 1994]: 166–167) is much indebted to Polanyi.

22. On Dürer's treatment of this *"Meisterstich,"* or master cut, see Panofsky, *Life and Art of Dürer*, 156; and Charles W. Talbot, ed. *Dürer in America: His Graphic Work* (New York: Macmillan, 1971), 147n3.

23. In "Perspective's Places" and "Pictures of Perspective: Theory or Therapy?" (in Hecht, Schwartz, and Atherton, *Looking into Pictures*) I have argued at length against the fallacy of trying to understand the use of perspective in pictures as a function of its geo 1 description and, more particularly, against the fallacy of supposing that the construction point is the viewer's point.

12. DRAWING'S OWN DEVICES

1. Kimon Nicolaïdes, *The Natural Way to Draw: A Working Plan for Art Study* (Boston: Houghton Mifflin, 1941), 5.

2. Daniel M. Mendelowitz, *Drawing* (New York: Holt, Rinehart and Winston, 1966), 25–26.

3. We also find richly suggestive passages, such as the following from Colin Eisler, *The Seeing Hand: A Treasury of Great Master Drawings* (New York: Harper and Row, 1975), 1:

> Drawing is when the magic begins—and sometimes ends. With a single stroke, light is separated from dark, and space and scale are evoked from a void. In the beginning of all the arts lies this graphic act . . . from which, all else flows. . . . Line has many lives. Enclosing form by continuous containment, it can assume the precise, fixed character of a die. . . . Lines may break and scatter like waves over a rock, to define form with extraordinary proficiency in shifting cascades. . . . Other masters choose a freer line that seems to define itself as it goes along, adding a unique spontaneity to the graphic process. . . . Placement of the forms on the page, *mise en pages,* is a major yet elusive aspect of drawing . . . a subtle way of defining and animating the page.

4. For independent theoretical arguments that many nonfigurative works may also be called representational, see Kendall Walton, *Mimesis as Make-Believe* (Cambridge, Mass.: Harvard University Press, 1990), 54–57; Richard Wollheim, *Painting as an Art* (Princeton, N.J.: Princeton University Press, 1987), 62–63. An influential proponent of nonfigurative, dynamic composition is Hans Hofmann: see Hofmann, *Search for the Real* (1948; repr., Cambridge, Mass.: MIT Press, 1967).

5. For an extended account of "shifting," with explanatory diagrams, see Allen Leepa, *The Challenge of Modern Art*, rev. ed. (New York: Perpetua, 1961), chaps. 7, 8.

6. Robert Beverly Hale, *Drawing Lessons from the Great Masters* (New York: Watson-Guptill, 1964), 65. There are many outstanding exceptions to this rule.

7. Most of Cézanne's drawings being in private collections, we have to do our best here with what is available in museums. Much better drawings for showing this effect may be found in Adrien Chappuis, ed., *The Drawings of Cézanne: A Catalogue Raisonné*, 2 vols. (Greenwich, Conn.: New York Graphic Society, 1973), notably figs. 792 ("In a Forest"), 913 ("Trees"). A Cézanne painting that exploits the effect is *The Big Trees* in the National Gallery of Scotland.

8. These comments were made to Emile Bernard. The one about the Gauguins and Van Goghs is quoted in Herschel B. Chipp, ed., *Theories of Modern Art: A Source Book by Artists and Critics* (Berkeley and Los Angeles: University of California Press, 1971), 19; the others are quoted in Lawrence Gowing, "The Logic of Organized Sensations," in *Cézanne, the Late Work,* ed. William Rubin (New York: Museum of Modern Art, 1977), 68, 59. Like Gowing, Fritz Novotny takes Cézanne's drawings coloristically, in connection with his painting, as "a form of outline the aim of which is not so much to isolate the objects it encloses as to form the connecting link between two contiguous colour-values . . . as a line of demarcation between colours"; otherwise, to quote another line from the artist, "the planes

fall on top of one another." See Fritz Novotny, *Cézanne* (London: Phaidon, 1961), 10; and Gowing, "Logic of Organized Sensations," 68.

9. However, "abstract" is an ambiguous term in these contexts: for an interestingly different understanding of the term in connection with modern art, see Joshua C. Taylor, *To See Is to Think: Looking at American Art* (Washington, D.C.: Smithsonian Institution, 1975), 89–109. This is not to deny that associative suggestions are sometimes very important.

Curiously, neither Gombrich nor Rawson seemed fully to grasp these implications of their principles. Gombrich held that "it is never space which is represented but familiar things in situations," and he seemed puzzled about nonobjective art's uses of spatial conflicts (E. H. Gombrich, *Art and Illusion: A Study in the Psychology of Pictorial Representation,* 3rd ed. [London: Phaidon, 1968], 240). Discussing cubism, Gombrich does stress its play with spatial cues, leading to "tensions" (283, 287), but immediately after does not recognize the space-making possibilities of such "tensions" in nonobjective art. Rawson: "Space is not a 'thing' that an artist can somehow seize and mysteriously transfer to paper. He can only suggest it by defining on his flat surface bodies of some kind which we accept must contain volume, and between which we understand inter-spatial relationships to exist" (Philip Rawson, *Seeing through Drawing* [London: British Broadcasting System, 1979], 35). Here Rawson begins correctly by rejecting an imitation view, then appears to overlook the evidence that artists can produce a sense of space without depicting bodies, by interplay of the very devices that he has so well explained to us. Compare, on the same page: "All the drawing techniques we have mentioned can be used non-figuratively. But, as a matter of historical fact, they have been used chiefly to represent recognisable bodies belonging to the real world." And a later comment: "Space as such can neither be photographed nor drawn: the only things that can are either marks which themselves take on the quality of three-dimensional objects, or objects they represent; it is from the meaning we read into the marks alone that we derive our sense of any space" (48). That seems less based on depicted objects.

10. For the idea of sequence facture see Patrick Maynard, "Drawing and Shooting: Causality in Depiction," *Journal of Aesthetics and Art Criticism* 44, no. 2 (winter 1985): 115–129.

11. Gombrich, *Art and Illusion,* 74.

12. John Elderfield, *The Drawings of Richard Diebenkorn* (New York: Museum of Modern Art, 1988), 9.

13. Among many expositions of this narrowly aesthetic conception of art may be found this brief, clear version: Richard Rudner, "Some Problems of Nonsemiotic Aesthetic Theories," *Journal of Aesthetics and Art Criticism* 15 (March 1957): 298–310. For more widely influential versions, see Monroe Beardsley, *Aesthetics: Problems in the Philosophy of Criticism* (New York: Harcourt, Brace and World, 1958); and John Hospers, "Aesthetics: Problems of," in *The Encyclopedia of Philosophy,* ed. Paul Edwards (New York: Macmillan, 1967), 1:46–48, reprinted in *Aesthetics,* ed. Susan Feagin and Patrick Maynard (Oxford:

Oxford University Press, 1997), extracts 24, 35. These selections share the phrase "the . . . itself."

14. David Hume, *An Inquiry concerning Human Understanding* (1748), sec. 7, pt. 2; Linda B. Smith and Diana Heise, "Perceptual Similarity and Conceptual Structure," in *Percepts, Concepts and Categories,* ed. Barbara Burns (Amsterdam: North-Holland, 1992), 237—citing Frank Keil, *Concepts, Kinds, and Cognitive Development* (Cambridge, Mass.: MIT Press, 1989).

15. Michael Leyton, *Symmetry, Causality, Mind* (Cambridge, Mass.: MIT Press, 1992).

16. Rawson is even bolder in the following comment: "What the spectator needs to do is to read back from the artist's hand-marks to re-experience for himself the inner movements of his mind. In the case of a master these will be highly individual, and they will especially include feelings" (Rawson, *Seeing through Drawing,* 22–23).

17. Rawson does qualify this in *Drawing,* 2nd ed. (Philadelphia: University of Pennsylvania Press, 1987), chap. 5, "The Subject: Its Nature and Function."

18. Harold Speed, *The Practice and Science of Drawing* (Seeley Service, 1917), 42–43.

19. See also Rawson, *Ceramics* (1971; repr., Philadelphia: University of Pennsylvania Press, 1984), 15–16. Kimon Nicolaïdes worked on "secondary forms" in drawing another way, by encouraging students to catch the associations (not necessarily of objects) that occur to them when they first look at the motif—even to draw these. The purpose is not surrealism, he writes, but rather, much as Rawson suggests, to "develop your ability to relate the meaningful parts of your experience and gain a better command over those forces . . . which are particularly your own" (*Natural Way to Draw,* 207–210).

20. See especially Wollheim, *Painting as an Art,* 380. I suspect that Wollheim looked to Freud in order to take theoretical account of the "corporeality" theme, rather than deriving the theme from Freud.

21. An example of what is *not* intended would be noticing that the overall form of the Creator, cloak, and train in the *Creation of Adam* fresco resembles a sectioning of a human brain (see Frank Meshberger, "An Interpretation of Michelangelo's Creation of Adam Based on Neuroanatomy," *Journal of the American Medical Association* 264 [1990]: 1837–1841). First, such an interpretation provides no meaning at the required formative levels of the drawing; second, the analogy suggests nothing about how the depiction works perceptually. Since our entire topic here is for Panofsky (see chapter 7) "pre-iconographical," I make no comment on the "iconographical" possibilities of this speculation.

22. Paul Hills, *Venetian Colour: Marble, Mosaic, Painting and Glass 1250–1550* (London: Yale University Press, 1999), 41.

23. A deeply perceptive appreciation of "pictures that metaphorize the body through their figurative content" in terms of architecture is Richard Wollheim's one-page example, Bellini's *St. Jerome and St. Christopher and St. Louis of Toulouse,* in *Painting as an Art* (Princeton, N.J.: Princeton University Press, 1987), 354.

24. John Locke, *An Essay concerning Human Understanding,* bk. 1, chap. 11. Locke contrasts this "judgment," which separates in order "to avoid being misled by similitude,"

with "a way of proceeding quite contrary to metaphor and allusion, wherein for the most part lies that entertainment and pleasantry of wit."

25. Rawson, *Ceramics,* 18.

26. See John M. Kennedy, Christopher D. Green, and John Vervaeke, "Metaphoric Thought and Devices in Pictures," *Metaphor and Symbolic Activity* 8, no. 3 (1993): 253, where Rawson's metaphoric approach might better fit their general thesis that "metaphors in pictures capitalize on some pre-existing way of using pictures and make sense only if the metaphoric devices are understood as violations or modifications of another order" (251). Both approaches to caricature should be consistent with what we have termed Gombrich's first two principles, since exaggeration in the first version may be understood by Kennedy and colleagues as relative to a given kind of drawing.

27. Gombrich, *Art and Illusion,* chap. 10 is devoted to the issue of caricature, which he rightly treats as an excellent arguing case for his own principles, notably the first one, "the difference between likeness and equivalence [of response]" (344). "EHG 4" in chapter 7 of this book is from that discussion. His treatment of the Philopon is on page 344, where he reminds us that *poire* means "fat-head." See also his essay, "The Cartoonist's Armoury," in *Meditations on a Hobby Horse and Other Essays on the Theory of Art* (London: Phaidon, 1965).

28. Michael Podro, *Depiction* (London: Yale University Press, 1998), 9.

29. Chang Yen-yüan, "Brushwork," in *Early Chinese Texts on Painting,* ed. Susan Bush and Hsio-yen Shih (Cambridge, Mass.: Harvard University Press, 1985), 61.

30. Podro, *Depiction,* 9.

31. Walton, *Mimesis as Make-Believe,* 295. This set up the requirement of vivacity that led us into Gombrich's principles of "effective representation," and thus through the further study of drawing devices in chapter 10.

32. R. H. Thouless, "Individual Differences in Phenomenal Regression," *British Journal of Psychology* 22 (1932): 216–241.

33. See Gombrich, *Art and Illusion,* 5 (fig. 2). I am grateful to Dom Lopes for this use of the duck-rabbit example; see his entry, "Painting," in *The Routledge Companion to Aesthetics,* ed. Berys Gaut and Dominic McIver Lopes, 491–502 (London: Routledge, 2001), 499. I am also grateful for his suggestion that "subjective contours" in some standard psychological examples present further cases of mark-pattern perception being influenced by depictive interpretation.

34. Charles W. Talbot, ed., *Dürer in America: His Graphic Work* (New York: Macmillan, 1971), 147.

35. Few of the horizontals actually pass into the illuminated zone, which was drawn as a unit. Magnification is not necessary for seeing this difference in a one-to-one photoreproduction of the engraving, but Panofsky provides enlarged details in *The Life and Art of Albrecht Dürer* (Princeton, N.J.: Princeton University Press, 1965). If such close scrutiny seems unlikely, we must recall that Dürer produced prints of this plate for special presentation to connoisseurs and that, for example, the textural grid for the window frame around the skull was drawn at about four lines per millimeter, which, together with the three white lines these enclose, makes seven.

36. Podro, *Depiction,* 13.

37. G. W. Friedrich Hegel, *Aesthetics: Lectures in Fine Arts,* trans. T. M. Knox (Oxford: Clarendon, 1975), 1:30–32; reprinted in Feagin and Maynard, *Aesthetics,* 192–197), where the quote continues:

> For instead of real wool and silk, instead of real hair, glass, flesh, and metal, we see only colours, instead of all the dimensions requisite for appearance in nature, we have just a surface, and yet we get the same impression which reality affords. In contrast to the prosaic reality confronting us, this pure appearance . . . is therefore the marvel of ideality . . . , an ironical attitude to what exists in nature and externally. For think what arrangements nature and man must make in ordinary life . . . in order to produce things like those depicted. . . . On the other hand, the imagination, out of which art creates . . . draws from its inner being everything on which nature, and man in his natural existence, have to work hard. (194)

38. Robert Hughes, "Goya," in *Nothing If Not Critical: Selected Essays on Art and Artists,* 50–64 (New York: Penguin, 1990), 52. Part IV will explore the significance of something else contained in this and similar descriptions: that inextricable from this perceptual process is our awareness of the purpose with which the medium is thus worked.

39. On the topic of visual traumas and "realism" in painting, see Michael Fried, *Realism, Writing, Disfiguration: On Thomas Eakins and Stephen Crane* (Chicago: University of Chicago Press, 1987).

40. Photoreproduction is notorious for filtering facture and the physical facts such as size in images. There exist also pseudodemocratic ideologies that celebrate this, and also marginalize connoisseurship: see, for example, John Berger, *Ways of Seeing* (London: Penguin, 1972). Fortunately, the real democratic institutions continue to be the great museums and galleries of the world that make available an enormous variety of what survives of the cultures of many peoples and ages.

41. Michael Podro describes this as recognition through difference, and his account of it leads to explicit criticism of Gombrich's Incompatibility Principle: see Podro, *Depiction,* 5–7.

42. Ibid., 2. In this and other quotations Podro uses painting as his leading example for discussing depiction, but he takes that "to cover representational painting, drawings, prints and relief sculpture, where this does not lead to confusion," and also to apply to free-standing sculpture.

43. Sustaining recognition of depicted things is the target of one of the most famous passages of modern aesthetics, by the English critic Clive Bell: "Few pictures are better known or liked than Frith's *Paddington Station*: certainly I should be the last to grudge it its popularity. Many a weary forty minutes have I whiled away disentangling its fascinating incidents and forging for each an imaginary past and an improbable future. But certain though it is that Frith's masterpiece, or engravings of it, have provided thousands with half-hours of curious and fanciful pleasure, it is not less certain that no one has experienced before it one half-second of aesthetic rapture—and this al-

though the picture . . . is by no means badly painted": Clive Bell, "The Aesthetic Hypothesis," in *Art* (London: Chatto and Windus, 1914), reprinted in Feagin and Maynard, *Aesthetics*, 18–19.

44. Podro, *Depiction*, vii.

45. *Republic* (trans. G. M. A. Grube) 362d5.

13. DRAWING'S DUALISMS

1. In philosophy, a general modular approach to theories of cognitive activity is perhaps most strongly associated with the work of Jerry Fodor, notably his *Modularity of Mind* (Cambridge, Mass.: MIT Press, 1983). That account treats perception in terms of distinct "input systems," which mediate our sensory interaction with our environments and our central system's mental representations of these environments, postulating that input systems are "informationally encapsulated." Part of what I have been arguing, however, is that drawing renders stages of environmental perception less encapsulated, less hidden from conscious experience, and thereby takes advantage for meaning of what nature normally puts aside for purposes of efficiency.

2. I mean in normal experience, since specialists of many kinds, including chefs, have long been in the business of separating the perceptual factors. Much of the previous chapters have been at pains to show how, historically, drawing, like psychology, has "drawn" such lines for its domain. Also, by "blending" I do not mean total unawareness even in normal experience, and it is important to the thesis of Part IV that strong modularity not hold for perception of drawing.

3. The drawing, brush in brown ink, with white body color, 24.6 × 20.3 cm., is in the British Museum.

4. Samuel van Hoogstraten's testimony, in *Rembrandt: Selected Drawings*, by Otto Benesch (London: Phaidon, 1947), 14.

5. *Nicomachean Ethics* 1128a13–14.

6. For (at last) a start on that in connection with art, see Ted Cohen, *Jokes: Philosophical Thoughts on Joking Matters* (Chicago: University of Chicago Press, 2001).

7. John Tagg, quoted in Joanne Lukitsh, "Practicing Theories: An Interview with John Tagg," in *The Critical Image*, ed. Carol Squires, 220–237 (Seattle: Bay, 1990), 224.

8. This is consistent with our frequent treatment of working drawings (such as that by Michelangelo previously discussed) in ways that the drafter would not have recognized, let alone approved. We are interested in Michelangelo's thinking processes in ways in which he was not. This is because we look back at such drawings in ways different from that of the drafters. It is also consistent with the fact that modern working or design drawings are often appreciated for artistic and other reasons and are thus collected, studied, and form parts of exhibitions.

9. James Cutting, "How the Eye Measures Reality and Virtual Reality," *Behavior Research Methods, Instrumentation, and Computers* 29 (1997): 33, in a section titled "Pictures as Simulations of Information Conflict."

10. R. L. Gregory, *The Intelligent Eye* (New York: McGraw-Hill, 1970), 32. It should be observed that this is the somewhat rhetorical opening of a popular lecture and that Gregory is an interesting and thoughtful researcher on the subject.

11. James Cutting takes this situation to be "cue-conflict," which we overlook: "There is nothing special about picture perception as compared to the perception of natural scenes, except that pictures are particular situations in which such conflicts are typically inherent" ("How the Eye Measures Reality," 9).

12. See David Topper, "Perspectives on Perspective: Gombrich and His Critics," in *Gombrich on Art and Psychology*, ed. Richard Woodfield, 78–100 (Manchester: Manchester University Press, 1966), 84, citing Gibson's views.

13. Gregory does continue, "There are other kinds of paradoxes in pictures besides depth paradoxes"; but then he says (his emphasis): "We may say that for a picture to be paradoxical, rather than merely unusual, it must present incompatible *spatial* information" (*Intelligent Eye*, 59). In chapter 6 we encountered Ittelson's attempt to combine the dualism of ancient sign theory with more recent 2D/3D dualisms. As indicated in the preface, the most sustained theoretical rejection of these dualisms, also holding steady to a perceptual account of depictive experience, has been Richard Wollheim's "seeing-in" approach, according to which depictive perception is not constituted of two kinds of perception but is, sui generis, a kind of experience possessing two aspects: awareness of the picture surface, "the marks as they have fallen on the surface," and recognition—"seeing something in the surface," figurative or not. "These are two aspects of a single experience," he holds, "not two experiences," although "each aspect of the single experience is capable of being described as analogous to a separate experience"; Richard Wollheim, *Painting as an Art* (Princeton, N.J.: Princeton University Press, 1987), 21, 46. While somewhat resembling it, the present theory differs from Wollheim's in several important ways. I treat depictive perception as perception under a purposive artifact conception, which essentially involves imagining and self-imagining, whereas Wollheim explicitly rejects Walton's theory (see, for example, his rejections of Walton in "On Pictorial Representation," *Journal of Aesthetics and Art Criticism* 56, no. 3 [summer 1998]: 217–226, and in "A Passionate Sightseer," review of *Depiction*, by Michael Podro, *Times Literary Supplement*, April 23, 1999), 20. I discuss Wollheim's theory in more detail in "Seeing Double," *Journal of Aesthetics and Art Criticism* 52, no. 2 (spring 1994): 158–161.

14. "Conjoint Representations and the Mental Capacity for Multiple Simultaneous Perspectives," in *Looking into Pictures: An Interdisciplinary Approach to Pictorial Space*, ed. Heiko Hecht, Robert Schwartz, and Margaret Atherton, 17–60 (Cambridge, Mass.: MIT Press, 2003), 42. Mausfeld cites the container, door, and book examples (adapted here) from Noam Chomsky, *New Horizons in the Study of Language and Mind* (Cambridge: Cambridge University Press, 2000), 128. The phrase "conflicting perspectives" is taken from page 126.

15. Kendall Walton, *Mimesis as Make-Believe* (Cambridge, Mass.: Harvard University Press, 1990), 276.

16. Frank Stella, *Working Space* (Cambridge, Mass.: Harvard University Press, 1986), 40.

17. Patrick Heron, "Colour and Abstraction in the Drawings of Bonnard," in *Bonnard: Drawings from 1893–1946*, ed. Patrick Heron and Antoine Terrasse (New York: American Federation of Arts, 1972), n.p.

18. Patrick Heron, "Constable: Spatial Colour in the Drawings," in *Constable, a Master Draughtsman*, ed. Charles Leggatt, 45–50 (Dulwich, England: Dulwich Picture Gallery, 1994), 45–46.

19. Michael Baxandall, *Shadows and Enlightenment* (London: Yale University Press, 1995), 141–142, replacing what appears to be a typo "for" with "from."

20. Michael Podro, *Depiction* (London: Yale University Press, 1998), 152–153.

21. A classic for the "push-pull" thesis is Hans Hofmann, *Search for the Real* (1948; repr., Cambridge, Mass.: MIT Press, 1967). It comes as a shock to find Gombrich admitting that when he wrote *Art and Illusion* he had not known the common artist's expression "losing the surface" ("The Evidence of Images," in *Interpretation: Theory and Practice*, ed. C. S. Singleton [Baltimore: Johns Hopkins University Press, 1969], 59).

22. Gregory, *Intelligent Eye*, 50.

23. Both quotations from are Clive Bell, *Art* (London: Chatto and Windus, 1913). The first is from "Aesthetics and Post-Impressionism," 38, the second from "Simplification and Design," 155. See also his account of the "fusion" of representation and form in the latter, 150–151.

24. See also Roger Fry, *Vision and Design* (London, 1920), and Bell, *Art*.

25. Bell says he "has sought a theory which should explain the whole of my aesthetic experience and suggest a solution of every problem" (*Art*, 6), and he takes this seriously in his famous "The Aesthetic Hypothesis" essay. Premises for my version of the argument may be found among statements in that essay such as the following: "My immediate object will be to show that significant form is the only quality common and peculiar to all the works of visual art that move me" (19); "We are all familiar with pictures that interest us and excite our admiration, but do not move us as works of art. To this class belong what I call 'Descriptive Painting' . . . for who has not said that such and such a drawing was excellent as illustration, but as a work of art worthless?" (22); "As a rule primitive art is good—and here again my hypothesis is helpful—for, as a rule, it also free from descriptive qualities. In primitive art you will find no accurate representation; you will find only significant form" (25); "A realistic form may be as significant, in its place as part of the design, as abstract. But if a representative form has value, it is as form, not as representation" (27). Nonetheless, I think that there is much truth in the formalist position, and it also needs adding that Bell's and Fry's "formalist" efforts had the positive purpose of liberalizing taste for (fairly) modern art and for non-European art in the period before World War I, and that Fry's 1910 "Post-Impressionist Show" at the Grafton Galleries, continued as the Armory Show in New York and Toronto, was successful in this.

26. For further criticism of that kind of formalism, see Richard Wollheim, "On Formalism and Pictorial Organization," *Journal of Aesthetics and Art Criticism* 59, no. 2 (spring 2001): 128–137.

27. Kandinsky's "Reminiscences" is a standard text here, cited by Podro in his discussion of this topic in *Depiction*, 23–26. For an English translation of the Kandinsky text see *Modern Artists on Art: Ten Unabridged Essays*, ed. Robert L. Herbert (Englewood Cliffs, N.J.: Prentice-Hall, 1964), 20–44.

28. John Elderfield, *The Drawings of Richard Diebenkorn* (New York: Museum of Modern Art, 1988), 25, 38. Elderfield's own view is that "we see . . . in virtually all drawings, how abstraction and representation cannot finally be separated but inherently coalesce" (19).

14. DRAWINGS AS DRAWN

1. That is easy to draw. However, adequately representing the situation being analyzed, of Polonius not only imagining seeing a whale or a weasel but also imagining of that visual act that it is the seeing of a whale or weasel, poses a graphic conundrum. Fortunately, all we need from the cartoon technique is a nontechnical understanding of what is meant by "intensional" contents and objects.

2. Imaginative works—works of art—are frequently themselves about imaginings, and imaginings are almost always self-imaginings. I argue this regarding popular music and musical comedy in Patrick Maynard, *The Engine of Visualization* (Ithaca, N.Y.: Cornell University Press, 1997), 87–97. On the importance of "occurrent imagining," see Kendall Walton, *Mimesis as Make-Believe* (Cambridge, Mass.: Harvard University Press, 1990), 16–20. Hitchcock's films of the two subsequent years, *North by Northwest* and *Psycho*, explore opposed examples of identity pretense: the first not imaginative, the second insane.

3. If we assume that objects of imagining must be real things, there being no Scottie or Judy, they are not objects of our imagining, although our actions of perceiving the film are. It is also quite likely that the actors, James Stewart and Kim Novak, as well as its San Francisco settings, are objects about which we imagine: we imagine them (Walton, *Mimesis as Make-Believe*, 26–27). Strange that a leading depth-psychology philosopher, Wollheim, should in his last challenge to Walton's theory fail this simple screen test: "How to understand the core project, of imagining one perceptual experience to be another. For, if we succeed, in what way does the original retain its content? For, what is left of the experience of seeing the surface when I successfully imagine it to be some other experience?" (Richard Wollheim, "On Pictorial Representation," *Journal of Aesthetics and Art Criticism* 56, no. 3 [summer 1998]: 224).

4. A, kissing B, has distinct fantasy options: imagining someone kissing C (say, recalling a scene in a film), merely self-imagining (or recalling) kissing C, self-imagining that this kissing of B is A's kissing C. The William Engvick lyric for Georges Auric's "Song from 'The Moulin Rouge'" indicates the third, Scottie-like, option.

5. Also, given the reciprocity of the situation, this will affect how we carry on with the seeing, given that, as Walton writes, "the imaginings called for when one looks at a picture inform the experience of looking at it." This feature

of his account, though important, is not logically necessary for the present argument.

6. Heinrich Wölfflin, *Principles of Art History: The Problem of the Development of Style in Later Art* (New York: Dover, 1972), 158. He specifically contrasts the two regarding drawing, using the terms "tactile" and "visual" (32–33). However, we recall from his discussion of "Saint Jerome" that, relative to the Italians, Wölfflin finds a more "unified movement" in Dürer; Heinrich Wölfflin, *The Sense of Form in Art: A Comparative Psychological Study,* trans. Alice Muehsam and Norma A. Shatan (New York: Chelsea Publishing, 1958), 56.

7. Wölfflin, *Principles of Art History,* 82.

8. Nelson Goodman, *Languages of Art: An Approach to a Theory of Symbols,* rev. ed. (Indianapolis: Hackett, 1976), 241–242.

9. Michael Baxandall, *Painting and Experience in Fifteenth Century Italy: A Primer in the Social History of Pictorial Style,* 2nd ed. (Oxford: Oxford University Press, 1988), 34.

10. Leonardo, in *Leonardo on Painting,* ed. Martin Kemp (New Haven: Yale University Press, 1989), 51–52.

11. See Norman Freeman, "Do Children Draw Men with Legs Growing Out of the Head?," *Nature* 254, no. 5499 (April 1975): 416–417.

12. Philip Rawson, *Drawing,* 2nd ed. (Philadelphia: University of Pennsylvania Press, 1987), 19. Further on Asian drawing: "Far Eastern ontology conceives reality to be predominantly an infinite process of unique movements and never-repeated change" (99; cf. 21, 93); for more on Titian's method having "striking ontological overtones, in contrast with the method of total plastic definition by tone" among other Western draftsmen, see 173.

13. Rawson, *Drawing,* 22–23; this needs to be made consistent with Rawson's earlier mentioned views about the educational effect of drawing on ordinary vision.

14. Samples of Wilde's and Hegel's ideas may conveniently be found in *Aesthetics,* ed. Susan Feagin and Patrick Maynard (Oxford: Oxford University Press, 1997), extracts 4, 27. For Gombrich's views see *Art and Illusion: A Study in the Psychology of Pictorial Representation,* 3rd ed. (London: Phaidon, 1968), 9–22; and *In Search of Cultural History* (Oxford: Clarendon, 1969).

15. Michael Podro, review of *Art and Its Objects,* by Richard Wollheim, 2nd ed., *Burlington Magazine* 124, no. 947 (February 1982): 100–101. As Susan Feagin points out, "To put marks on paper is . . . not, in itself, to *draw* anything, not even lines, though by putting marks on paper one may turn out to have produced (at least part of) a pictorial representation of something. . . . Thus one may represent something pictorially when one hasn't drawn it, even though one *has* made the marks . . . which end up counting as a pictorial representation of it." She argues that, since drawing is an action, like writing a sentence or folding a piece of paper, not merely a sequence of movements, it requires "an integrated mental representation of what is *drawn,*" even where that is a simple shape. (See Susan L. Feagin, "Pictorial Representation and the Act of Drawing," *American Philosophical Quarterly* 24, no. 2 (April 1987): 162–163.) My inference from Podro's and Feagin's sensible, factual observations is that perceiving something as a drawing normally involves understanding it as the product of drawing actions. This is similar to the other cases, where we perceive not just a string of words but writing, not just creased paper but a carefully folded letter. The extent to which this aspect of a drawing is more or less salient and matters to us depends upon the kind of drawing and our interests in it. Variability of both salience and relevance is typical of artistic interests.

16. A survey of the simple facts of cases like this should go a long way to clear up long-standing quibbles on the topic of art and "intention." The limestone walls of the caves, made of calcium carbonate from the shells of more ancient marine creatures, have no natural purpose, though the shells of the creatures did. The ancient microscopic spores of the Scots pine found at the sites had a natural purpose, but when we wonder about the purpose (if any) of the bear scrapes, the subject is changed, though it be still of natural purpose, as we now consider actions of agents to whom we ascribe intent. The human markings, including inadvertent hand- and footprints, negative handprints placed by pigment spray, "stumped" pigments signs, drawings, and so forth, similarly ascend to purposive action and then intent, regarding displays. In a common, weaker sense of "display," displays, too (like the leopard's spots depicted in Chauvet Cave), may be natural and purposive although not due to agents' actions, but my use takes display up to the level of actions.

17. Gombrich is referring to a late Renaissance "reversal of values": E. H. Gombrich, "New Revelations on Fresco Painting," in *Reflections on the History of Art: Views and Reviews,* ed. Robert Woodfield, 46–53 (Berkeley: University of California Press, 1987), 49.

18. Alison Wright, "Mantegna and Pollaiuolo: Artistic Personality and the Marketing of Invention," in *Drawing 1400–1600: Invention and Innovation,* ed. Stuart Currie, 72–87 (London: Ashgate, 1998), 75.

19. Michel Terrasse, "Pierre Bonnard at 'Le Bosquet,'" in *Bonnard at Le Cannet* (London: Thames and Hudson, 1988), 21. Cf. George Besson's comment that Bonnard "scrawled them with a burnt match, even a broken pen, but he had a predilection for an indescribably blunt pencil that was so short that a landscape or a nude seemed to spring from the ends of his three fingers compressed around an invisible point"—quoted by Sargy Mann, "'Let It Be Felt That the Painter Was There . . . ,'" in *Drawings by Bonnard* (London: Arts Council of Great Britain, 1984), 8.

20. Joshua Taylor, *Learning to Look: A Handbook for the Visual Arts,* 2nd ed. (Chicago: University of Chicago Press, 1981), 78. (Only a couple of gendered pronouns are removed, as unnecessary and possibly distracting.)

21. For a good, polemical statement, see Richard Wollheim, "The Core of Aesthetics," *Journal of Aesthetic Education* 25, no. 1 (spring 1991): 39–40. Alas, rejecting Walton's approach, Wollheim tried to capture this just by saying that representation features "permeability to thought." See Wollheim, "On Pictorial Representation," 224.

22. Representing that very mental process of transfer is itself part of the stock in trade of comic depictions in various visual media: the picture in the thought-bubble above the cartoon character's head, cuts in Charlie Chaplin films, and so forth.

23. That a drafters' ineptitude or banality can be just that, however, is displayed by Art Spiegelman in his homage to Charles Schultz, "Abstract Thought Is a Warm Puppy," *New Yorker,* February 14, 2000, 61–63.

24. Igor Stravinsky and Robert Craft, *Retrospectives and Conclusions* (New York: Alfred A. Knopf, 1969), 83. Perhaps Stravinsky recalls a justly famous piece on Chardin by Marcel Proust. For an English translation, see Sylvia Townsend Warner, trans., *Marcel Proust: On Art and Literature 1896–1919* (New York, Carroll and Graf, 1984). In agreement with positions argued here, Proust's topic is the artist's way of seeing what he represents, and the artist's development of our way of seeing, both for his art and for the world around us. Next, Proust explicitly stresses what the artist has done rather than what the artist intended to do. Finally, although Proust says little about how Chardin works his effects, he several times remarks on the mixtures of otherwise unrelated situations that Chardin's art has us find. For example, the skate he paints "mixes the foreign charms of the sea, the calms, the tempests it matched and outrode, with the cravings of gluttony, as though a recollection of the Museum of Natural History traversed the delicious smell of food in a restaurant."

25. Epco Runia, *The Glory of the Golden Age: Dutch Art of the 17th Century, Drawings and Prints,* trans. Barbara Fasting (Amsterdam: Waanders Publishers; Zwolle and Rijksmuseum, 2000), 73. This drawing was labelled at the exhibition in Amsterdam "Hendrikje stapend, penseel en bruine inkt." In this connection, Rawson observed that there is a kind of drawing mark "made intentionally with heavily pressed chalk or a loaded pen. This is the occasional line which gives the impression of cutting into the surface of the paper where a deep shadow naturally lies. . . . Rembrandt's famous brush drawing . . . of a sleeping girl wrapped in a blanket contains a high proportion of such strokes" (*D,* 115). For other passages about Rembrandt that well apply to our example, see 131, 163, 252, 266.

26. Pierre Gassier, *Francisco Goya Drawings: The Complete Albums,* trans. James Emmons and Robert Allen (New York: Praeger, 1973), 486.

27. Rawson, *Drawing,* 267–268; see also Michael Podro, *Depiction* (London: Yale University Press, 1998), 71, 75; Jakob Rosenberg, *Rembrandt: Life and Work,* 3rd ed. (London: Phaidon: 1968), 299.

28. Otto Benesch, *Rembrandt: Selected Drawings* (London: Phaidon, 1947), 15.

29. Roger Fry, *Last Lectures* (London: Cambridge University Press, 1939), 11–13.

30. Fritz Novotny, *Cézanne* (London: Phaidon, 1961), 7; see also Novotny, "The Late Landscape Paintings," in *Cézanne: The Late Work,* ed. William Rubin (New York: Museum of Modern Art, 1977), 107–111.

31. Quoted in Lawrence Gowing, "The Logic of Organized Sensations," in Rubin, *Cézanne, the Late Work,* 64. Picasso's remark is from "Conversations avec Picasso," *Cahiers d'Art* 10 (1935).

32. Meyer Schapiro, *Paul Cézanne* (New York: Harry N. Abrams, 1965), 10.

33. James Lord, *A Giacometti Portrait* (New York: Museum of Modern Art, n.d., ca. 1965), 35.

34. Schapiro, *Paul Cézanne,* 17, 66.

35. Dominique Baffier and Valérie Feruglio, "The Bears," in *Chauvet Cave: The Arts of Earliest Times,* ed. Jean Clottes, trans. Paul G. Bahn (Salt Lake City: University of Utah Press, 2003), 193.

index of personal names

index of subjects

mosaic, 77
museums, xxii–xxiii, 58, 110, 176, 182, 202, 210

naturalism, 13, 15–18, 20, 35, 95–96, 126, 242n, 245n
nonfigurative (abstract), 64, 73, 128, 186, 188, 195, 203, 252n; Gombrich and Rawson on, 252n, 255n; Walton and Wollheim on, 251n

occlusion, 38, 152, 165, 176, 178–179, 189. *See also* techniques, spatial rendering: depth-slices
ornament, 128, 196, 246n
Our Lady of I–19, 113, 120, 244n, 246n
"out of drawing," 61
outline, 4, 32, 38, 73, 77, 86, 99–100, 121, 125, 139, 148, 150, 152, 157, 160, 166, 200, 209, 251n

painting, 63, 93, 201–202, 212, 229
"Panofskian," 13, 43, 50–51
pelvic points, 156, 195
perspective, aerial, 102, 174, 209
perspective, Graeco-Roman. *See* Roman (Graeco-Roman) images
perspective, linear, 8, 16, 20–21, 28–29, 31–39, 41–48, 50–52, 79, 101, 120, 126, 128, 131, 133, 150, 156, 163, 174, 183, 207, 220, 230; central, 45–46, 179; as concomitance, 101, 126, 175–176, 180, 207; crating, 47; as crucial to modern design, 8, 12–13; distance-point, 46–47; Gombrich on, 243n; look, 176; models of, 32–34; points (one-, two-, three-), 28, 35, 45–46, 49, 179; Rawson's criticisms of, 174–175, 180, 183. *See also* "total and rationalized view"
perspective, postlinear, 40–41, 48, 56
perspective, Renaissance, 8, 13, 20, 39, 51, 127, 133; renascence of, 36, 41, 48
perspective, reverse, 21, 28, 42
philosophy, xxiii, 3–4, 229; dialectic method of, 13–14, 17, 49, 51, 94, 98, 116, 211–212, 214, 216–217, 220–221, 228, 235n; of art, 194, 207, 229–230
picturesque, 174
plane, picture/projection. *See* surface, picture/projection
polarity, line, 121, 160, 167. *See also* shading: from contours
preiconographical recognition. *See* iconographical recognition
primitives (drawing, picture, scene), 73, 95, 106, 131, 145, 150, 154, 170, 178, 188–189, 197, 209, 221, 223, 227
process history, 12, 66, 191, 219, 223, 230
projection, generally, 79, 101, 156, 175–176
projection, parallel family: 20–21; axonometric, 22–23, 26; isometric, 24–25, 30; oblique, 21–22, 26–27, 29–30, 81–82, 168, 238n; orthogonal and nonorthogonal, 22; orthographic, 22–24, 29–30, 44, 79, 82, 86, 122; orthographic development, 24; orthographic values, 24, 28, 30–32, 48, 56, 86, 180, 189, 214, 49
projection, perceptual, 104, 114, 118, 121, 129, 211, 243–245n
projection, terms for: source, ray, scrim, screen, 22, 170; projector, object, plane, 21–22, 44

projection, transformations of, 24, 28, 56, 86: metrical, 24, 176; conformal, 24, 26; affine, 24, 182; perspective, 28, 182. *See also* perspective, linear
projections, cartographic, 21–22. *See also* maps/mapping
props, 89

"rationalization of sight (space)," 35, 94, 126–127, 131
"rationalized view, total and," 20–21, 35–36, 38, 40, 42, 56
reciprocity, xx, 50, 165, 199–201, 216, 218, 255n
recognition, 87, 96–97, 101, 105, 112–113, 117, 123, 129, 197, 215, 222, 247n, 253n; sustaining, 91, 201–210
reflexivity. *See* representation and depiction: reflexive
regions. *See* enclosures
relief, *rilievo*. *See* space: recession and relief
representation, generally, xix, 64, 86–89, 94, 202; autonomy of, xviii, 102
representation and depiction: convincing (effective), xvii–xviii, xx, 94–95, 102, 114, 138, 176, 186, 201, 215; reflexive, 120, 126–127, 132, 241n, 246n, 255n; transparency and, 109, 114, 246n
Roman (Graeco-Roman) images, 35, 77–78, 95, 113, 126, 131–132, 160, 163, 246–247n

San Marco (Venice), 196
scales: nominal, 50, 76; interval, 50, 56, 127, 138; ordinal, 50, 56, 86, 122, 127, 181; metrical, 50, 127, 238–239n
sculpture, 110, 114, 116–117, 154, 246n
"seeing-in," xix, 254n
semiotics (sign, symbol), xviii, xx, 88, 202, 247n
shade and shadow, 84–85, 87, 90, 102, 139, 144, 160–165
shading: bracelet, 157; from contours, 125, 160, 167, 187–188; slant/tilt, 100, 161, 163, 249n
shadow paths, 168, 185, 188
shadows, 87, 89, 113; attached (self), 161, 166, 180, 249n; cast, 87, 161–162, 166–168, 180, 187–188, 250n; first and second rationale, 163–164; Waltzian, 162, 181, 200
shape, axis, 77, 110, 138; forms of, 62, 66, 71, 75–76; negative, 138, 171, 185, 188, 194
"shifting," 186, 251n
space: *l'espace limite/l'espace milieu*, 140; recession and relief, 148–168. *See also* depth-bands
stick (pin) figures, 77
style, Gombrich's "riddle of," 106
subject-matter, 193, 202–203. *See* recognition, identification
surface, picture/projection (as different), 14, 15, 28, 32, 34–36, 40, 141, 176; and ground, 140; "losing," 255n
symmetry, 56, 64–65, 76, 128–129; bilateral (mirror), 65, 76, 113, 195, 239n; radial, 65; rotational, 65, 185; translation, 65, 239n; glide, 65, 168

"tadpole" drawings, 75–76, 189
techniques, spatial rendering: 185, 248n; bracelets, 157; bubbles, 157; depth-bands, 173; depth-slices, 148, 150–154, 157, 159, 170, 173–175, 179, 189, 208, 210; facets, 157, 159, 163; linked bodies, 170, 179; ovoids, 157, 159, 166, 175, 179, 189, 195; plan section, 154–156, 168
technology, 8, 175, 183, 192

templates, 43, 64, 127

tension. *See* dynamics, pictorial

thematization, 10, 56, 61, 98, 127, 162, 166, 170, 174, 176, 201, 223, 234n

tool-kits, conceptual (analytic tools), for drawing, xvi–xviii, 60–61, 84, 94, 120, 122, 125–126, 140, 179, 184, 203, 207, 217

tool-kits, drawing, 41, 49, 78, 81, 84, 95, 98, 101, 103, 120, 138–139, 170, 174, 183, 186–188, 209, 227, 230, 243n

tone, 84, 140, 157, 159–160, 162–165, 168, 250–251n

topology, topological values, 24, 55–57, 75–76, 79, 81, 86, 94, 122, 129, 132, 150, 162, 168, 189, 207–209, 221, 230

"total and rationalized view," 20–21, 35–36, 38, 40, 42, 56

touch, 78, 99, 165, 188–189

tracing, 10, 24, 43, 64–65, 82

transfer, perceptual, 16, 78, 97–98, 100, 125, 138, 162, 174, 183, 188, 202, 207–209, 210–211, 214–215, 223, 226, 228, 230, 242n, 243n

transparency, 109, 114, 246n

vanishing points (VP), 44–45, 176; DVP, 45–47, 238n; CVP, 45, 47, 179, 181

Velcro, 64

Vertigo (film), 218–219, 237n, 255n

Villard's saw, 15–18, 40, 48, 81, 102

"Villardian," 38, 49–50, 56, 61, 114, 170, 181, 185–186, 237n

vista. *See* depth-bands

vivacity, 91, 93, 95, 123, 152, 176, 183, 215, 242n. *See also* representation and depiction: convincing (effective)

volume, 148–168

"ways of seeing," 220–221, 224–229

"whole wretched question" (Gombrich's), 105, 108, 111

window, picture as, 36, 52, 120, 126–127, 131

windowpane, 33, 36, 40, 44, 47, 52, 120, 126–127, 131–132